Wisdom With Understanding is Better Than Rubies

Lurine Karon Greenberg
Fine Arts Collection

GREAT
PAINTINGS

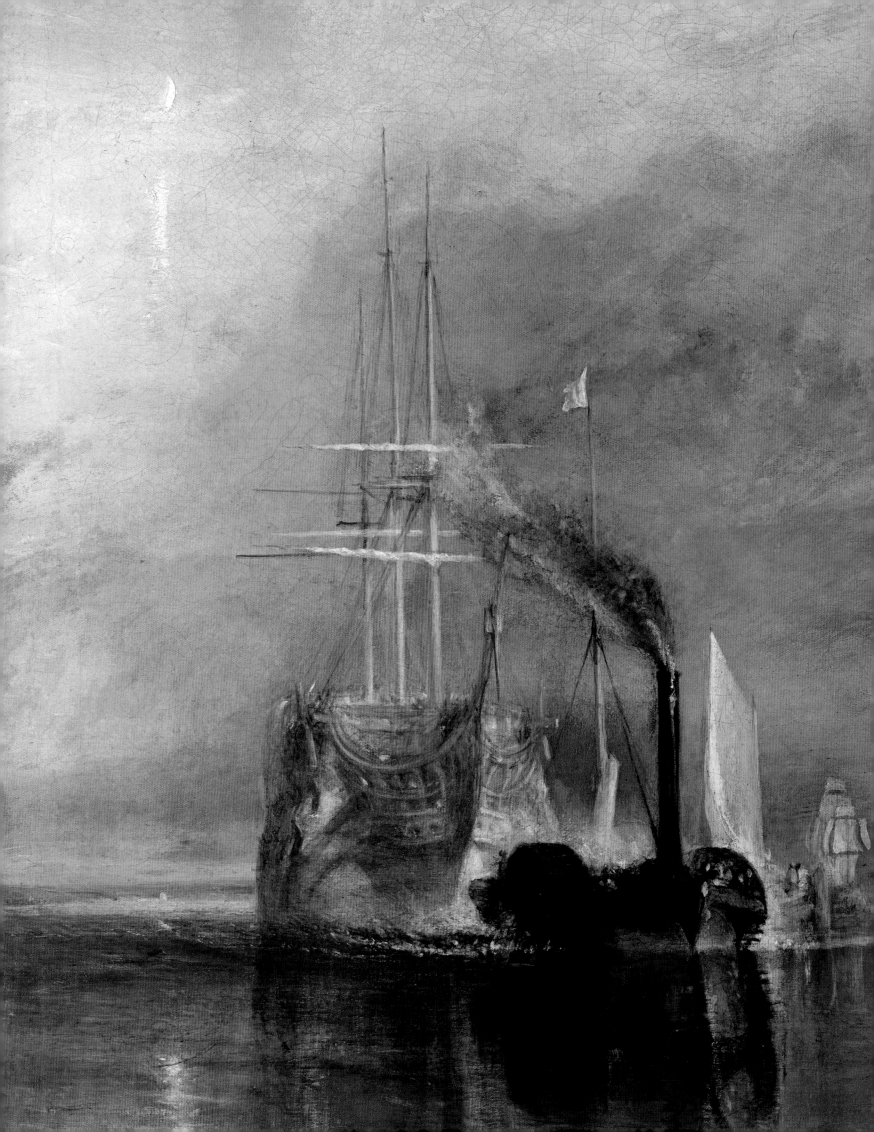

GREAT
PAINTINGS

contents

LONDON, NEW YORK, MUNICH,
MELBOURNE, DELHI

Senior Editor Angela Wilkes
Senior Art Editor Michael Duffy
Editors Anna Kruger, Hugo Wilkinson
Production Editor Tony Phipps
Production Controller Mandy Inness
Picture Research Sarah Smithies
Managing Editor Stephanie Farrow
Managing Art Editor Lee Griffiths
US Editors Shannon Beatty, Rachel Bozek

DK INDIA

Managing Art Editor Ashita Murgai
Managing Editor Saloni Talwar
Project Art Editor Rajnish Kashyap
Project Editor Garima Sharma
Senior Art Editor Anchal Kaushal
Assistant Designer Diya Kapur
Production Manager Pankaj Sharma
DTP Manager Balwant Singh
DTP Designers Shanker Prasad
Mohamad Usman
Managing Director Aparna Sharma

First American Edition, 2011
Published in the United States by DK Publishing,
375 Hudson Street, New York, New York 10014

11 12 13 14 15 10 9 8 7 6 5 4 3 2 1
001–177857–October/2011

1700–1800 1800–1900 1900 to present

Published in Great Britain by Dorling Kindersley Limited.

A catalog record for this book is available from the
Library of Congress.

ISBN 978-0-7566-8675-8

DK books are available at special discounts when
purchased in bulk for sales promotions, premiums, fund-
raising, or educational use. For details, contact DK
Publishing Special Markets, 375 Hudson Street, New
York, New York 10014 or SpecialSales@dk.com

Printed and bound in Singapore by
Star Standard Industries

Discover more at www.dk.com

CONTRIBUTORS

Karen Hosack Janes
Arts and culture educationalist, who teaches History of Art at Oxford University Department for
Continuing Education. Formerly Head of Schools at the National Gallery, London and now an advisor
to several arts and education projects. Has written two series of art books for children, as well as
articles for the Times Educational Supplement.

Ian Chilvers
Writer and editor, whose books include The Oxford Dictionary of Art, A Dictionary
of Twentieth-Century Art, and The Artist Revealed: Artists and their Self-Portraits.
Chief consultant on Art: the Definitive Visual Guide.

Ian Zaczek
Writer, whose books include The Collins Big Book of Art, Masterworks, Art: the Definitive
Visual Guide, and The Story of Art

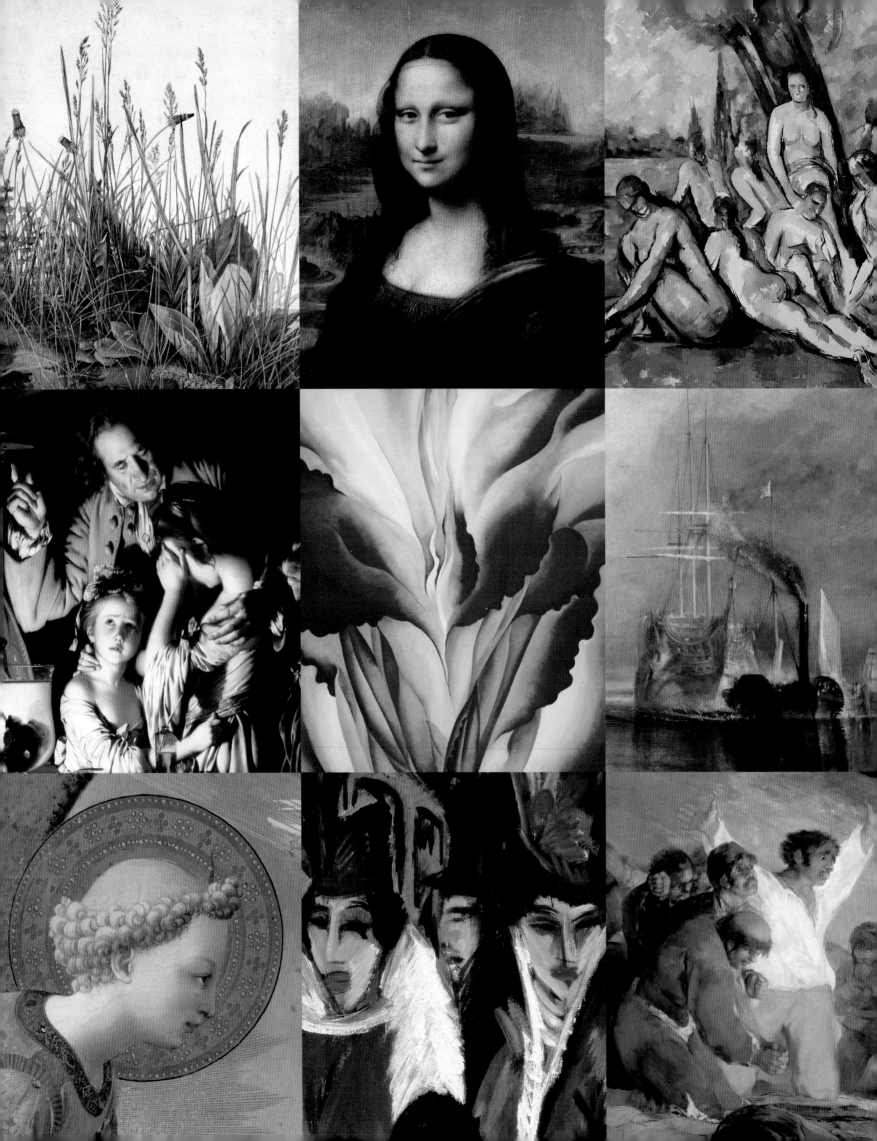

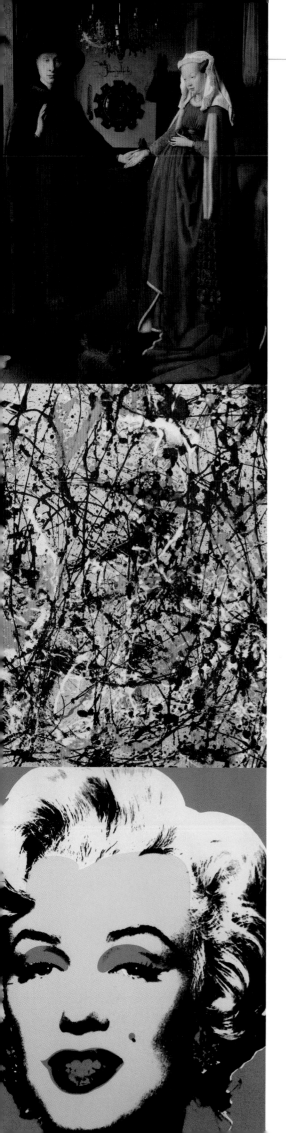

Looking at Paintings

Great paintings come in many guises. The smallest could be held in one hand, while the largest extend magnificently across the vast ceilings of palaces and chapels. Paintings vary just as much in other respects too, ranging from microscopic depictions of the natural world to bold, swirling abstracts, and from beguiling, intimate portraits to interpretations of key moments in history, myth, or literature. The 66 paintings in this book span many centuries and they represent a huge wealth of human experience. Some tell stories, some transport you to faraway places, and some celebrate beauty; others are scenes of almost unbearable horror. Each painting, however, is unique.

Looking at any painting is a personal experience, but one that benefits from broader knowledge—the more you know about works of art, the closer you look at them, and the more you see and enjoy. Like a helpful guide standing next to you in a gallery, museum, or church, this book will help you to look at each painting with fresh eyes and expert knowledge: you will find out about each painting's background, its historical context, and the artist who created it. You will also learn about the techniques of the world's greatest painters— how they have used color, perspective, light, and shade to capture a likeness or a moment in time, and to convey the feelings that it inspired. Perhaps more importantly, this book will lead you through the key details of each painting, elements you may barely notice at first—a tiny reflection in a mirror, a crescent moon high in the sky, a slipper dangling carelessly on a foot—that help to reveal what a painting is really about.

Great paintings often have hidden levels of meaning, but once you start to unravel the clues, everything begins to make sense. Finding your way into a great painting is like setting off on a voyage of discovery—endlessly fascinating and deeply rewarding.

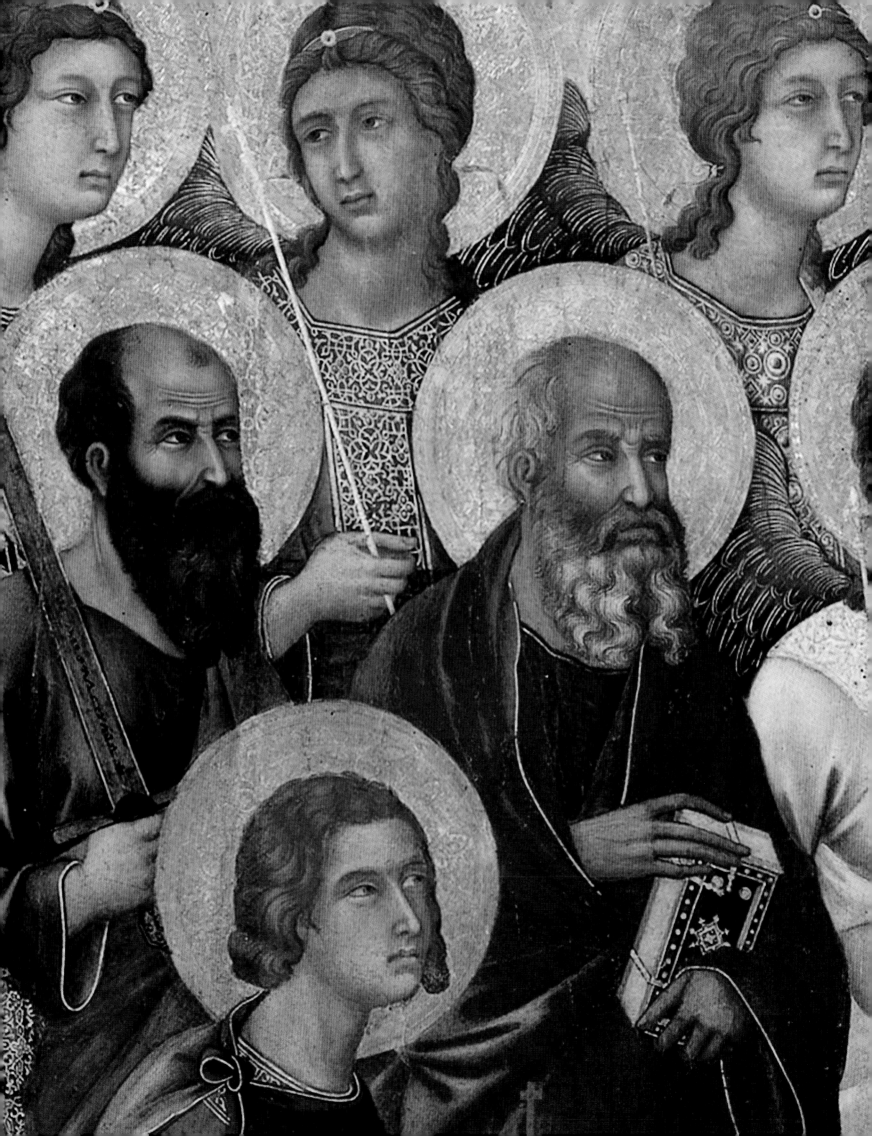

1100–1500

The Qingming Scroll

c.1100 ▪ INK AND COLOR ON SILK ▪ 10in × 17ft 3in (25.5cm × 5.25m) ▪ PALACE MUSEUM, BEIJING, CHINA

ZHANG ZEDUAN

SCALE

Astonishing in its intricacy, this magnificent silk painting on a handheld scroll depicts scenes of everyday city life in 12th-century China. The scroll was designed to be held by the viewer, who would unroll an arm's length at a time, starting from the right. Below you can see the central section of the scroll. With its bustling streets and beautiful arched rainbow bridge spanning a curving river, the urban landscape is full of vivid, narrative detail.

View of an ideal city

The city shown in the painting is thought to be the Northern Song capital, Bianliang (modern Kaifeng), in Henan Province, although the artist has not included specific features, such as a famous temple, that would make identification certain. The word "Qingming" in the title has perplexed scholars over the years. It was thought to relate to a festival that took place 100 days after the winter solstice, when ancestral graves were swept with willow brooms. There is, however, little evidence of the willows in the painting: branches would have been hung up on house roofs but none are shown. Other objects associated with the festival, such as displays of paper houses outside shops, are also missing.

An alternative interpretation of the painting, which the lack of unique landmarks would seem to bear out, is that it portrays an idealized cityscape. "Qingming," which literally means "bright-clear" and "peaceful and orderly," would then refer to a splendid city where all members

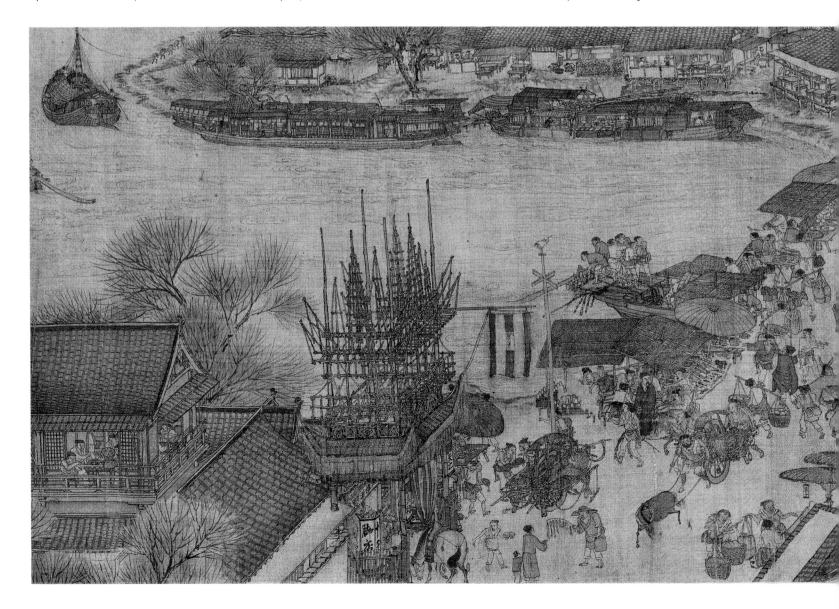

of society live harmoniously. Indeed, if you look carefully at the painting, there is no evidence of poverty and people from all social classes are mingling in the streets.

The scroll begins at the far right with a morning scene in the country (see p.13), and at its midpoint the artist, Zhang Zeduan, has depicted its most striking feature— the crowded bridge and the drama taking place on the river below. Very little information exists about the artist, and his reasons for painting this masterpiece have not been documented. Yet from the colophons (written notes) at the end of the scroll, it seems likely that Zhang was trying to recall and recapture the illustrious past of the Northern Song dynasty in China—a period of peace, prosperity, and high artistic achievement.

ZHANG ZEDUAN

c.1085–1145

The Qingming Scroll is the only surviving documented work by Zhang Zeduan, but this alone establishes him as one of the great painters of the Northern Song period (960–1126).

What we know about the artist is revealed only in the colophons of *The Qingming Scroll*. In addition to notes from the various Chinese owners of the scroll, together with their seals, Zhang's place of birth is given as Dongwu (now Zhucheng, Shandong Province), China, although there is no date. He traveled to the Northern Song capital, Bianliang, to study painting when he was young, and may then have become a member of the Imperial Hanlin Academy. This was set up to support contemporary artists by Emperor Huizong, who reigned from 1100 to 1126. Zhang Zeduan's great skill was in depicting everyday scenes in exquisite and extraordinary detail on the high-quality silk that was widely produced in the region.

> With each viewing, the observer gains new understanding of the people and the city shown in such vivid detail

VALERIE HANSEN *THE BEIJING QINGMING SCROLL AND ITS SIGNIFICANCE FOR THE STUDY OF CHINESE HISTORY*, 1996

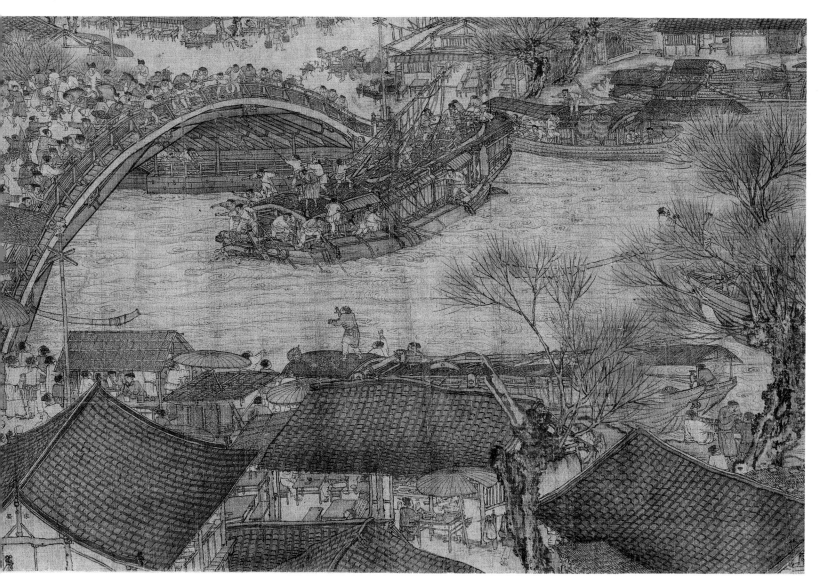

Visual tour

KEY

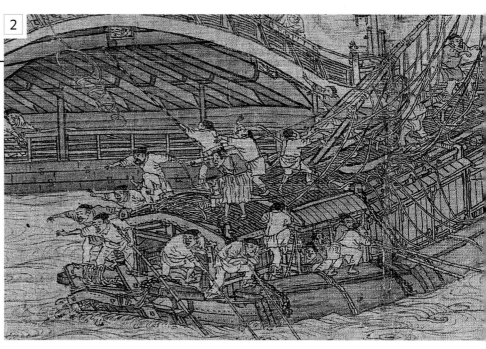

> **BOAT ADRIFT** On the river below the bridge, boatmen struggle to regain control of a large boat; it has a broken tow rope, and has been pushed off course by the powerful current. Some of the crew are trying to lower the mast, while others attempt to steady the boat with poles. One man is trying to reach the bridge above with a long boat hook. Onlookers lean over the bridge, shouting warnings or words of encouragement, and one has thrown down a rope that is uncoiling.

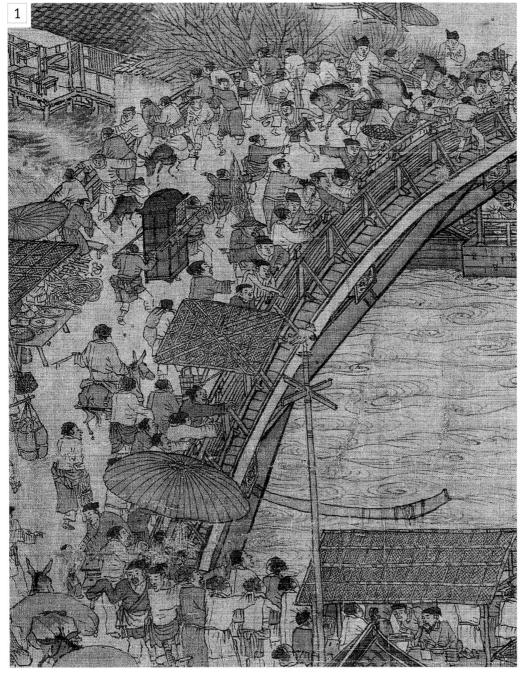

▲ **INTERACTION** A sense of drama is conveyed by the reaction of the spectators watching the drifting boat. Although you cannot make out the details of their faces, they are all intent on the action and are pointing or gesturing. The man above is standing on the roof of his boat, gesticulating at the drifting vessel. The river is high and the water is swirling dangerously.

◀ **RAINBOW BRIDGE** The main focus of this part of the painting, and indeed of the whole scroll, is the beautiful, arched rainbow bridge spanning the river. It is thronged with people, traders, and animals. Food is being cooked and sold at stalls, with room for sitting and eating. Other vendors display their goods on the ground, sheltered under temporary awnings. Although this rainbow bridge is very distinctive, similar bridges also existed in other Chinese cities besides Bianliang, the Northern Song capital.

▼ HOUSEBOATS Long, flat houseboats are moored along the side of the river—one even has its own potted garden. Behind them, the riverbank is lined with cafés. The tables are not yet occupied. In the evenings, the cafés and restaurants would have been lit by lanterns.

`4`

ON **TECHNIQUE**

Zhang Zeduan drew the buildings and other structures in *The Qingming Scroll* with a fine brush, and used a ruler to help him draw straight lines. The colophons (written Chinese characters) at the end of the scroll refer to this technique as "ruled-line painting." It is also known as *jiehua*, which means "boundary" or "measured" painting. Most of the scroll is monochrome and has faded to brown with age, but a few details are in color, such as the green buds of the willow trees. Zhang has drawn most of the scenes from overhead, enabling you to see the tops of roofs, umbrellas, and people's heads. However, sometimes the perspective shifts so that the viewer can explore other angles. From certain viewpoints you can see both the top and the underside of the bridge.

`5` **◄ WHEELBARROW** It takes two men to maneuver this wheelbarrow with a giant wheel—one at the back, and another at the front, who pulls with the aid of a donkey. There is room for passengers on either side.

IN **CONTEXT**

Following the course of the day from morning until mid-afternoon, the scroll begins on the right with a quiet, rural landscape and ends on the left in the busy capital city. Signs of commerce appear throughout the scroll, from the donkeys laden with wood on their way to market in the opening scene to a pharmacy with two female customers in the final one. *The Qingming Scroll* is a unique and precious historical document that provides a fascinating glimpse of what life was like in China 800 years ago.

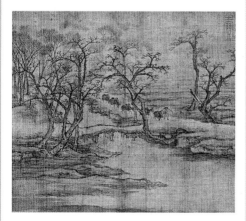

▲ The first scene of *The Qingming Scroll*, to the far right of the scroll, shows the river meandering through a peaceful rural scene in the country.

`6` **▼ TAKEOUT** The scroll is full of incidental detail, depicting characters going about their everyday lives. Here you can see a man carrying two bowls of takeout food—probably noodles—and chopsticks.

`7`

▲ SEDAN CHAIR The wealthy traveled in enclosed sedan chairs, carried on poles by bearers. The servants of the person inside this one are disputing who has right of way with the servants of the man on horseback.

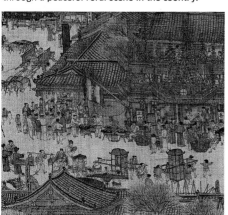

▲ The last scene, to the far left of the scroll, shows the teeming life in the city streets.

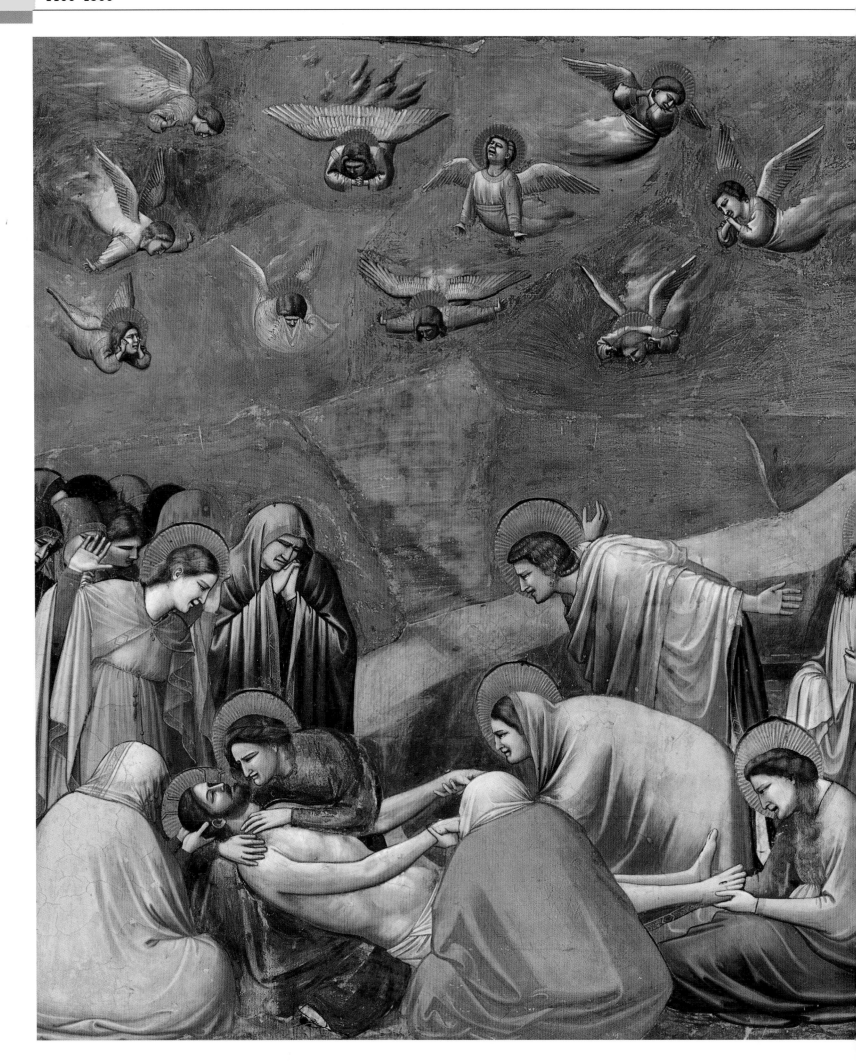

The Lamentation of Christ

c.1305 ▪ FRESCO ▪ 72¾ × 78¾in (185 × 200cm) ▪ SCROVEGNI CHAPEL, PADUA, ITALY

GIOTTO

SCALE

Painted on the wall of the Scrovegni Chapel in the old university town of Padua, the drama depicted in this fresco is unbearably poignant. The griefstricken faces and postures of the figures, the strong composition, and the use of space all convey a sense of tragedy at Christ's death. This scene forms part of a sequence of frescoes depicting episodes from the lives of Christ, the Virgin Mary, and the Virgin's parents, Anne and Joachim, and is in many ways the emotional highpoint of the Chapel.

With these frescoes, Giotto succeeded in breaking away from the artistic conventions of the day, and his new, naturalistic style of painting marked a turning point in the development of Western art. Before Giotto created his innovative images of realistic, three-dimensional people, the stiffness of figures in the Byzantine tradition and the flat, one-dimensional space they inhabited made it difficult for the viewer to experience any real connection with the subject matter. Mosaics had often been used previously for religious images, but these were not only expensive and time-consuming to produce, they were also primarily decorative and were not intended to engage the viewer emotionally. This engagement is exactly what makes *The Lamentation of Christ* so powerful. It portrays the most emotional episode in the sequence of frescoes and Giotto endows the scene with an intensity that is both touching and beautiful.

Bringing the narrative to life

In the biblical account depicted here, Christ's body has been taken down from the cross and is encircled by his grieving family and friends. The Virgin Mary cradling her dead son is the focal point of the painting. Like Christ's large and elongated body, Mary's grief seems unbearably heavy. To Mary's right, John the Evangelist throws back his arms in a gesture that expresses shock and dismay, and Mary Magdalene sits mourning at Christ's feet.

Giotto's use of simple shapes and blocks of color helps the viewer to concentrate on the main areas of emotional expression in the painting: the faces and hands. The solid masses of the figures in the foreground are draped with clothes that describe the shape of the bodies underneath. We do not need to see these people's faces–their sorrow is expressed by their bowed heads and hunched shoulders. The proportions of the composition are realistic and there is a convincing sense of space. In this respect, Giotto anticipates the techniques of perspective that were to be formulated and developed in detail over a hundred years later.

GIOTTO DI BONDONE

c.1270–1337

One of the giants of the history of art, Giotto is generally considered to be the founder of the mainstream of modern painting.

Born in Colle di Vespignano, near Florence, Giotto studied under the Florentine painter Cimabue and went on to create a powerful, naturalistic style that broke away from the flat, remote conventions of Byzantine art, which had been dominant for centuries. His figures seem solid, weighty, and set in real space, and they express human emotion with conviction and subtlety.

This huge achievement was recognized in Giotto's lifetime. He worked in various major art centers, from Florence to Naples, and was the first artist since classical antiquity to become renowned throughout Italy. Unfortunately, many of his paintings have perished over the centuries and his career is difficult to reconstruct in detail. However, his masterpiece–the fresco decoration of the Scrovegni Chapel in Padua–survives in good condition, and this work alone is enough to secure his reputation as one of the greatest artists of all time.

Visual tour

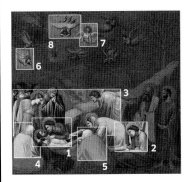

KEY

▶ **MARY MAGDALENE**
The simple figures in Giotto's composition have no objects surrounding them to help us identify them. Here, however, Mary Magdalene is recognizable from her humble posture and actions. The dead Christ's feet rest on her lap and she touches them lovingly, just as two other women touch Christ's hands. Mary Magdalene seems to be weeping at the terrible sight of the wounds. In many images of the period she is shown with a jar of ointment.

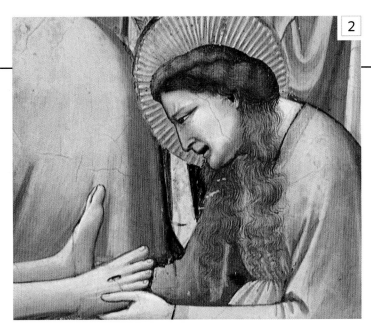

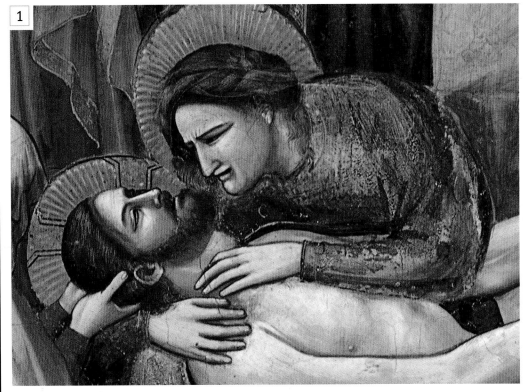

▲ **MOTHER AND SON** The Virgin Mary holds the dead Christ in her arms, an expression of the most intense grief on her face. The close contact between mother and son, their faces almost touching, helps us to empathize with the human tragedy before us. Bereavement is a universal experience and the painting resonates on an emotional and very personal level, whether or not you hold religious beliefs.

▶ **SEATED FIGURES** The people with their backs to us in the foreground of the painting strengthen the composition in several ways. They and the other people in the crowd encircle Christ, giving the scene a greater feeling of intimacy. The space between the two figures also draws us into the heart of the scene, bringing the drama to a human level. It is as though we are offered the choice of watching from afar or becoming emotionally involved.

◄ ANGUISHED ANGELS
Ten angels, like shooting stars—some with flaming trails—look down from the azure sky on the holy scene below. Their tiny, contorted bodies express their anguish eloquently. Some pray, some are clearly weeping, and others simply hold their heads in their hands to show their despair.

ON **TECHNIQUE**

To paint these frescoes, Giotto transferred a preliminary sketch directly on to the plaster of the wall. The outlines of the sketch were pricked, and powdered charcoal was then brushed through the holes. Applying water-based paint while the final layer of plaster was still wet (*fresco* means "fresh" in Italian) allowed the colors to embed. Giotto had to work quickly, completing small sections at a time. Once dry, frescoes become part of the plaster on the wall and some last for hundreds of years. Giotto used gold leaf on the halos, on the angels' wings, and for detailing on clothes. When the chapel candles were lit, the gold would have helped light up the scenes.

IN **CONTEXT**

The series of frescoes, including *The Lamentation of Christ*, was commissioned around 1300 by a wealthy banker and merchant, Enrico Scrovegni, to decorate the walls of the chapel next to his palace in Padua. Giotto was asked to depict stories from both the Old and New Testaments. The vaulted roof of the chapel is decorated like a star-studded blue sky and the walls are lined with the framed panels of fresco. The series ends with *The Last Judgment*, which fills the whole of the west wall facing the altar.

▲ MOURNERS The faces of the mourners are natural and animated, yet have a sculptural quality. They are all inclined toward the body of Christ, as if no one can quite believe their eyes. There is a calm dignity about the group and their gestures are expressive, but not overly theatrical: they hold their hands up in despair or clasp Christ's hands and feet. In their facial expressions you can discern pain and anger—emotions that they are trying hard to keep under control. This acute sense of realism is Giotto's trademark.

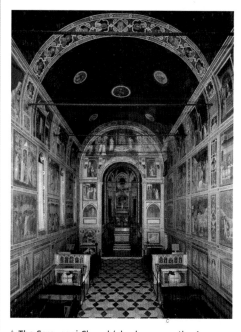

▲ The Scrovegni Chapel (also known as the Arena Chapel) interior, looking toward the altar

▲ STILLNESS AND MOVEMENT The swooping and twisting bodies of the angels in the sky form a strong contrast with the stillness of the scene below. The tension between these two opposing forces helps to create a powerful and somber atmosphere.

The Madonna Enthroned

c.1308-11 ▪ TEMPERA AND GOLD ON PANEL ▪ 7 × 13ft (2.13 × 3.96m)
MUSEO DELL'OPERA DEL DUOMO, SIENA, ITALY

SCALE

DUCCIO DI BUONINSEGNA

Hailed as one of the greatest masterpieces of the age, Duccio's painting helped to change the course of Italian art. For much of the medieval period, the prevailing influence in art came from the East. Byzantine devotional art was powerful and hieratic, but its ancient images were regarded as sacred and painters were expected to copy them faithfully. Originality, personal expression, and any form of realism were not encouraged. Led by Giotto (see pp.14-17) and Duccio, Italian masters gradually broke away from many of these constraints. In Duccio's

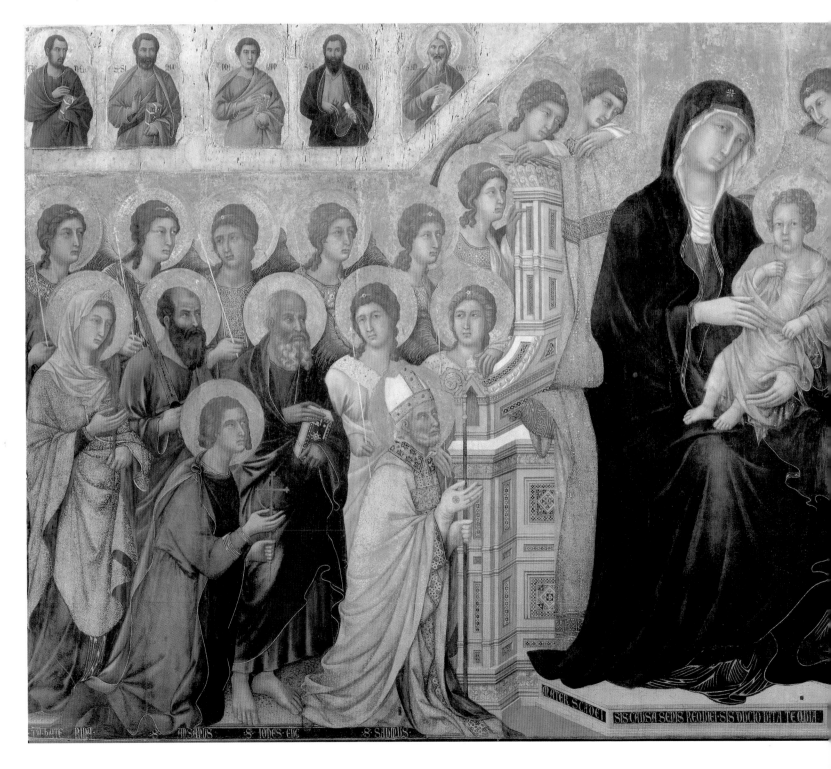

remarkable altarpiece there are signs of human warmth in many of the figures, there is genuine drama in the narrative scenes, and the draperies look far more fluid and natural than in their Byzantine counterparts.

A monumental undertaking

This imposing panel dominated the front of a huge altarpiece commissioned for Siena Cathedral. It represents the *Maestà* (Virgin in Majesty) or *The Madonna Enthroned.* Presiding over the Court of Heaven, surrounded by saints and angels, are the Virgin and Child. Siena's four patron saints kneel at Mary's feet, interceding for her favor. This is entirely appropriate, as the Virgin had been

officially designated as the city's patron and protector. The inscription beneath her throne reads, "Holy Mother of God, bestow peace on Siena."

Duccio was commissioned to produce the altarpiece by Siena's civic authorities. A contract from 1308 has survived, indicating the lavish nature of the project. It is notable, for example, that the patrons pledged to provide all the artist's materials. Accordingly, the Virgin's robes were painted in ultramarine—a rare and expensive pure blue pigment made from lapis lazuli, only found in quarries in Afghanistan. By contrast, the blue coloring in the *Rucellai Madonna* in the Uffizi, Florence, which is attributed to Duccio, was composed of azurite, a much cheaper pigment that is slightly more turquoise in tone.

The altarpiece was completed in 1311 and carried in a triumphal procession to the cathedral. At this stage, it was even more massive than it is now. In addition to the *Maestà*, there were originally scenes from the infancy of Jesus and the Death of the Virgin on the front, with further episodes from the life of Christ on the reverse. Unfortunately, the altarpiece was cut down in 1771 and some sections were lost or sold.

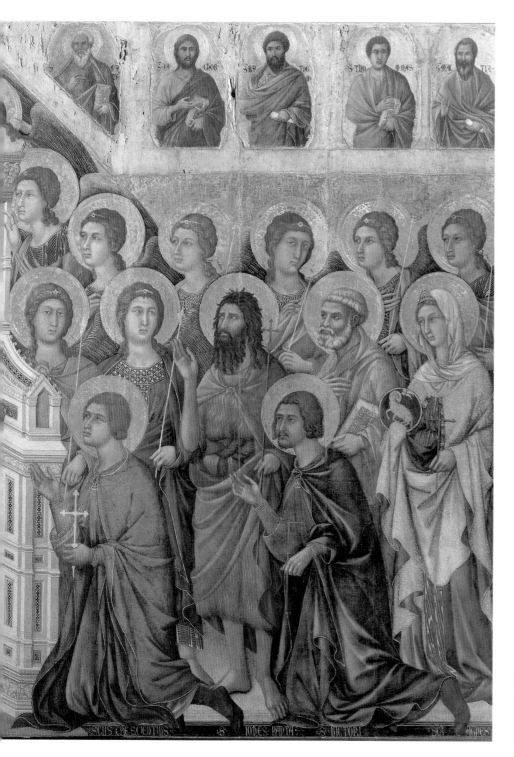

DUCCIO DI BUONINSEGNA

c.1255–c.1318/19

A Sienese painter, Duccio was one of the key figures in the development of early Italian art. He owes his fame to a single masterpiece—the magnificient altarpiece in Siena Cathedral.

Very little is known about Duccio di Buoninsegna's life. There is no reliable evidence about his birthplace or training. Some scholars have suggested that he may have been a pupil of Cimabue or Guido da Siena, but the first documentary reference to him dates from 1278. Records of several commissions have survived, but *The Madonna Enthroned* is the only work that can be attributed to him with absolute certainty. Hints about his character emerge from other documentary material, suggesting that he had a rebellious streak. He was fined for a variety of offenses—for refusing to do military service, for declining to swear an oath of fealty, and perhaps even for a breach of the regulations against sorcery.

Whatever faults Duccio may have had, they were clearly outweighed by his prodigious talent. The Sienese authorities were anxious to secure his services for their most important commission and the reasons for this are plain to see. Along with Giotto, Duccio was instrumental in freeing Italian art from the limitations of its Byzantine sources.

Visual tour

KEY

▼ **ST. ANSANUS** The four figures in the foreground, kneeling before the Virgin, are the guardian saints of Siena: Ansanus, Savinus, Crescentius, and Victor. Their prominent position confirms that Duccio's altarpiece was a civic commission as well as a religious one. This man is St. Ansanus. He came from a noble Roman family, as his aristocratic attire indicates, but he was betrayed by his father for preaching the Gospel. Condemned to death by Emperor Diocletian, Ansanus was thrown into a vat of boiling oil, before being beheaded.

▼ **ST. JOHN THE BAPTIST** This distinctive figure is John the Baptist. He can be identified by his unkempt appearance and his tunic made out of animal skins. These refer to his ascetic lifestyle, wandering in the desert, living off locusts and honey. John was frequently included in paintings of the "Court of Heaven" because of his status as the forerunner of Christ. He was also regarded as a symbolic link between the two parts of the Bible—the last of the Old Testament prophets and the first of the New Testament saints.

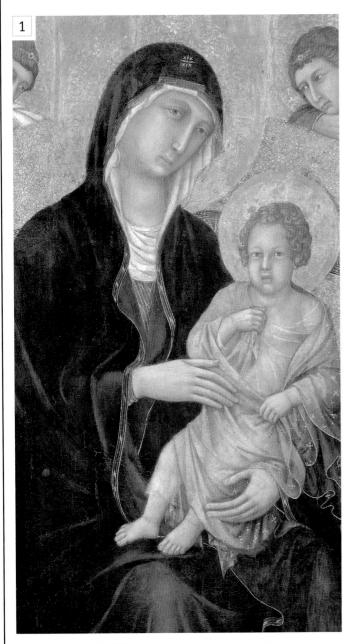

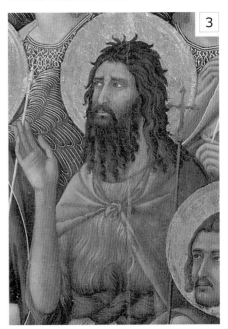

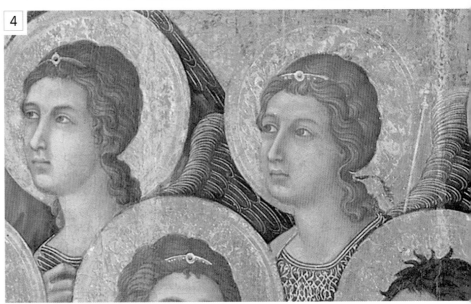

▲ **THE VIRGIN AND CHILD** Italian artists borrowed the theme of *The Virgin Enthroned* from Byzantine sources (see opposite). Early examples can be found in the mosaics at Ravenna in Italy, which for a brief time was the Western capital of the Byzantine Empire. The Virgin represents the Queen of Heaven, as well as the personification of Mother Church. In keeping with the normal medieval practice, she is depicted on a larger scale than the other figures, to underline her importance. The star on her cloak—another Eastern feature—refers to her title, "Star of the Sea."

▲ **ANGELS' FACES** Duccio followed tradition in his depiction of the figures surrounding the Virgin. Artists had developed their own conventions for the physical appearance of many of the better-known saints, based on the accounts of their lives. St. Paul, for example (on the left, immediately above St. Ansanus), was normally shown as a bald man with a dark beard. Angels, on the other hand, were frequently given the same, idealized faces. They were regarded as sexless beings, so painters invariably strove to make them appear androgynous. Sometimes their bodies were omitted altogether and they were represented by a head encircled by three pairs of wings.

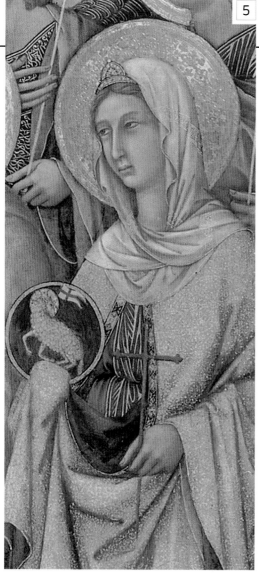

5

◄ **ST. AGNES** This is St. Agnes, a Roman virgin who was one of the many Christians to suffer martyrdom during Diocletian's reign (284–305). She is carrying her traditional attribute, a young lamb. This association probably arose because of the similarity to her name (*agnus* is Latin for "lamb"). Agnes was a young girl, aged about 13, who was thrown into a brothel after refusing the attentions of a high-ranking official.

▼ **NATURALISTIC INTERACTION** The Byzantine models for this type of picture were deliberately stiff and hieratic. By contrast, Western artists gradually adopted a more naturalistic approach. Rather than depicting rows of repetitive figures, Duccio introduced a degree of variety into the scene. His saints and angels exchange glances and appear to commune with each other.

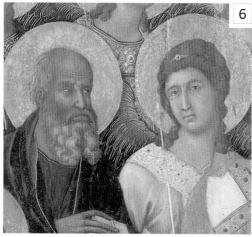

6

ON **TECHNIQUE**

Duccio's Virgin is loosely based on a Byzantine format known as *Hodegetria* (meaning "She who shows the Way"). Here, Mary gestures towards Jesus, indicating that he is the way to salvation. Both figures gaze at the viewer and there is no show of maternal affection. The original was said to be by St. Luke, so painters followed its format, as in the *Virgin of Smolensk*. Duccio was one of the first Italian artists to soften this approach, giving it a warmer, more naturalistic appearance.

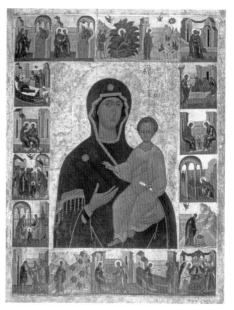

▲ *Virgin of Smolensk*, c.1450, tempera on fabric, gesso, and wood, 53¾ × 41¼in (139 × 105cm), Tretyakov Gallery, Moscow, Russia

IN **CONTEXT**

The back of the altarpiece, which is now displayed opposite the front, tells the story of Christ's Passion in 26 scenes. Duccio made the Crucifixion, the climax of the story, larger than the other panels and gave it a central position.

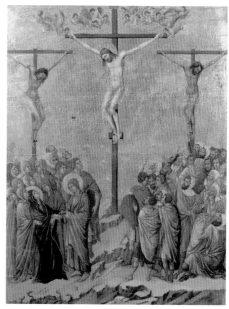

▲ *The Crucifixion*, detail of panel from the back of *The Madonna Enthroned*, 1311, Museo Dell'Opera del Duomo, Siena, Italy

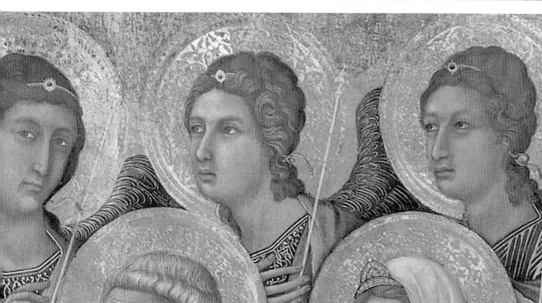

► **FEET AND ROBES** Duccio's career predates the development of mathematical laws of perspective. However, he did make some attempt to create a sense of depth in this picture by showing the feet and robes of some figures overlapping with the edge of the platform. In part, this was to draw attention to the inscriptions on the base, which identified some of the lesser-known saints.

7

The Annunciation

c.1430–32 ■ TEMPERA ON PANEL ■ WHOLE ALTARPIECE 76¼ × 76¼in (194 × 194cm) ■ PRADO, MADRID, SPAIN

FRA ANGELICO

SCALE

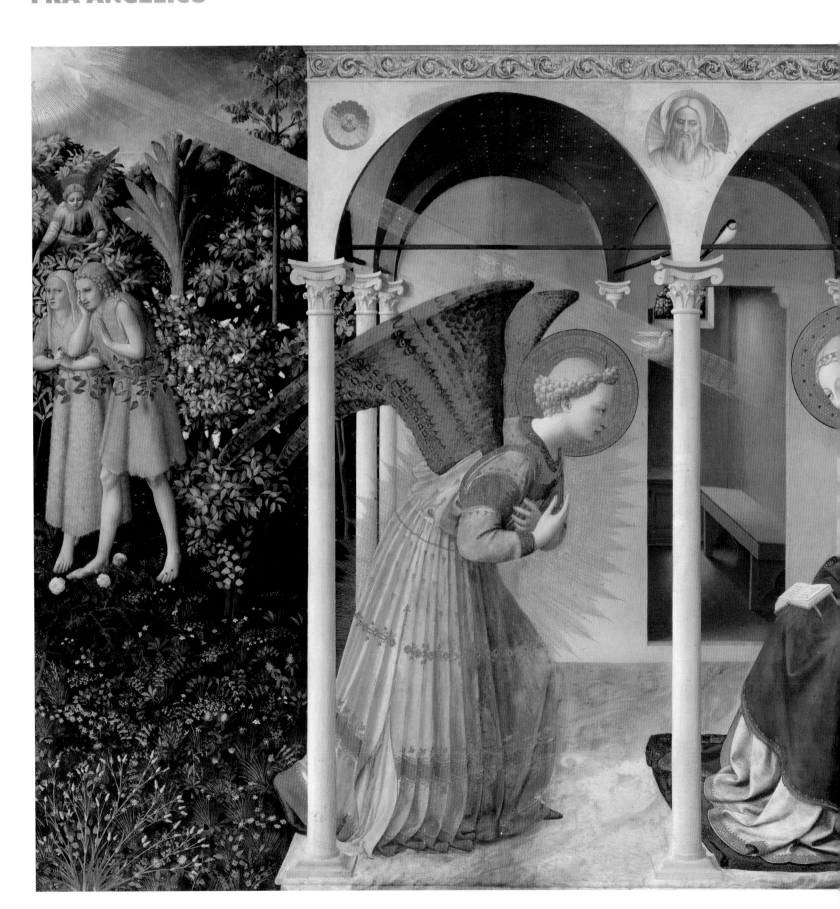

Fra Angelico is not an artist properly so called, but an inspired saint

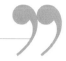

JOHN RUSKIN *MODERN PAINTERS, VOLUME II*, 1846

In a portico filled with light and color, we witness a significant encounter between two haloed figures. Both adopt a similar attitude of graceful humility, inclining their heads and crossing their hands. This still, meditative tableau depicts one of the defining moments of the Christian tradition, when the Archangel Gabriel announces to the Virgin Mary that she has been chosen by God to be the mother of Christ. *The Annunciation* as interpreted by Dominican friar Fra Angelico was created as a devotional panel for the altar of San Domenico in Fiesole, near Florence. The painting has a predella (horizontal panel of religious scenes) below it, hence its square shape.

The diagonal shaft of holy light falls on Mary, illuminating the intense ultramarine of her cloak and the complementary peach tones of her dress. On the other side of the central column, Gabriel's shining, gold-patterned robe, a similar shade to Mary's dress, also complements the rich, saturated blue. The angel's rounded back harmonizes with Mary's graceful pose and is echoed by the curve of his massive, exquisitely detailed wings. The tips of Gabriel's wings project beyond the portico structure into the first section of the painting, which takes up a quarter of the composition and depicts a scene from Genesis, the first book of the Bible. It is the expulsion of Adam and Eve from the Garden of Eden, an episode that adds drama to the whole painting and sets the Annunciation in context: Christ will be born on earth to save humanity from original sin.

Color, light, and space

This precious work displays Fra Angelico's keen observational skills and fine craftsmanship. The use of light, glowing color and the naturalness of the poses animates the figures of Mary and Gabriel, giving them weight and making them lifelike. The architectural structure also reveals Fra Angelico's command of perspective. With its receding columns and the open chamber at the rear, the composition has a sense of depth and creates the impression that both figures inhabit a real, physical space. In this respect, it is possible to see the influence of other early Renaissance painters such as Masaccio—Fra Angelico's contemporary and one of the first artists to paint convincingly lifelike figures in settings that appeared three-dimensional. Fra Angelico's work, however, possesses delicacy and gracefulness that set it apart from that of his contemporaries.

Fra Angelico painted numerous altarpieces and frescoes, including several Annunciation scenes, all characterized by simplicity of line and vivid color. For him, painting was an act of spiritual devotion and his works seem to convey the strength and inspiration he derived from his Christian faith, as well as the beauty he saw in the world around him.

FRA **ANGELICO**

c.1395-1455

A devout friar, Fra Angelico painted many fine frescoes and altarpieces. His fine line and use of light and pure color inspired other Renaissance artists, including Piero della Francesca.

Born Guido de Petro, Fra Angelico was already illustrating or "illuminating" manuscripts when he joined the Dominican order at Fiesole, near Florence. He was known as Fra Giovanni; the epithet "Angelico" (angelic) was probably added after his death. What little is known about Fra Angelico is derived mainly from the writings of Giorgio Vasari.

Apart from the church's patronage, Fra Angelico also received other commissions and he traveled widely in his later years. He is perhaps best known for the beautiful frescoes that he painted in the monks' cells of the monastery of San Marco, Florence, c.1440. He was later referred to as "Beato (blessed) Angelico" and was in fact officially beatified in 1982.

Visual tour

KEY

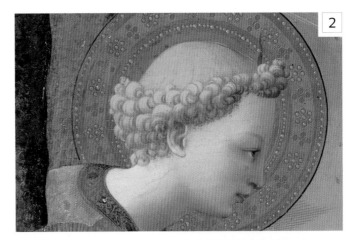

◄ **ARCHANGEL GABRIEL** The glowing halo around Gabriel's head, which has been painted with gold leaf and then burnished and tooled, reinforces the divinity of God's chief messenger. Gabriel's respectful pose is as graceful as Mary's submissive gesture and the two figures, each framed by an arch, complement each other perfectly. Fra Angelico has skilfully portrayed the intensity of their encounter, yet there is also a sense of stillness, which gives the altarpiece a meditative quality.

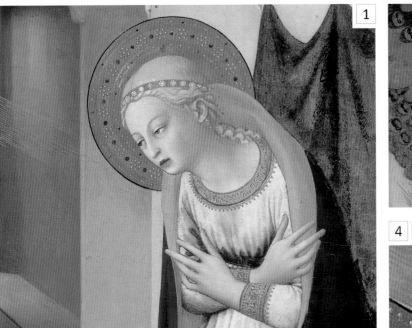

◄ **WINGS** Fra Angelico has given Gabriel a solid, human form and his stance is realistic. In contrast, the beautifully shaped wings define him as a divine being. Each feather is carefully depicted, and the overall impression is of a real bird with a large wingspan. You can almost feel the weight of the wings on the angel's back.

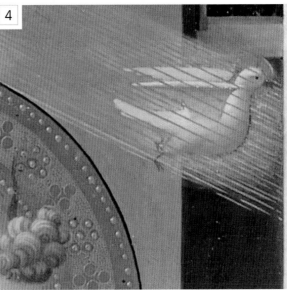

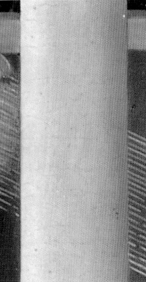

▲ **SHAFT OF LIGHT** The divine light cutting diagonally through the painting represents the all-powerful presence of God. From its fiery source in the first section of the painting, the golden beam touches the archangel's gilded halo and diffuses softly in front of Mary, linking the two different narrative episodes. Within the heavenly light a white dove, symbolizing the Holy Spirit, is making its descent, which marks the moment of conception.

◄ **VIRGIN MARY** In the delicate portrayal of Mary's face you can see Fra Angelico's expertise at painting detail. As an illuminator of manuscripts, he would have needed an aptitude for fine, small-scale work. Mary's pose, with her hands crossed, symbolizes her submission to God's will. As protector, she played a central role for the Dominican friars, Fra Angelico's order.

➤ **ADAM AND EVE** Beyond the confines of the portico, we see the dejected figures of Adam and Eve who have fallen from God's grace and are being expelled from the fertile Garden of Eden. The forbidden fruit under their bare feet, they move beyond the frame of the painting. Fra Angelico contrasts their sinfulness with Mary's immaculate state and reminds us that Christ was born to redeem the sins of humanity.

▼ **GOD THE FATHER** Above the central column of the portico is the sculpted head of a bearded male. This is an image of God, the wise, all-seeing Father.

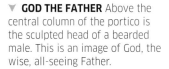

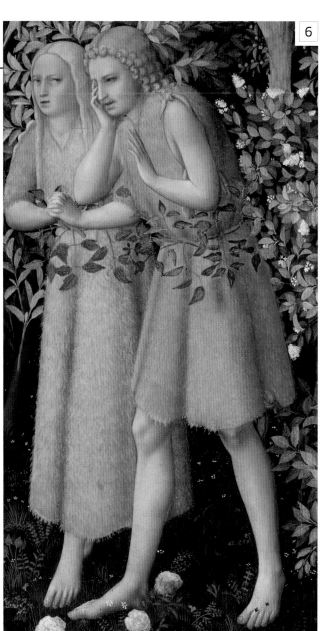

▲ **DECORATIVE PLANTS** The Garden of Eden, which lies beyond the portico and takes up the first quarter of the painting, is so richly patterned with plants that it resembles a medieval tapestry. In the stylized treatment of the meadow flowers in the foreground, Fra Angelico's work reveals the influence of the earlier Gothic style.

◄ **SWALLOW** Perched on the central column, above the heads of Mary and Gabriel and below the image of God, is a swallow. It probably symbolizes the resurrection of Christ. Just as Christ dies and is then reborn, so the swallow disappears, then returns each spring. Its presence in the painting brings together the trinity of God the Son, God the Father, and God the Holy Spirit.

ON **TECHNIQUE**

Fra Angelico uses linear perspective to convince the viewer that the area within the classical portico structure is a real, three-dimensional space. The Corinthian columns decrease in size and appear to recede into the background, as do the arches of the star-studded ceiling. A small room can be seen through the doorway, with a window set into its back wall. There is, however, no single vanishing point and the perspective is not completely resolved. Fra Angelico was working at a pivotal point in Florentine art, when the Gothic conventions were giving way to more sophisticated techniques.

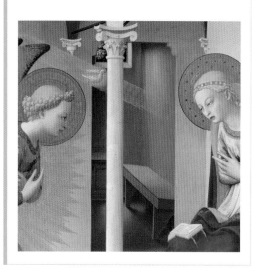

IN **CONTEXT**

Fra Angelico revisited the theme of the Annunciation in paintings and frescoes made at different times in his career. The Madrid *Annunciation* was made at roughly the same time as another altarpiece for the church of San Domenico in Cortona, Tuscany. Although the two are similar in composition, the Cortona altarpiece is more decorative and features gold text flowing from the mouths of the archangel and Mary. Fra Angelico created a third celebrated *Annunciation*, a fresco (shown below), for the convent of San Marco, near Florence, where it can be seen on the wall at the top of the dormitory stairs. Compared with the two earlier versions, which are dramatic and colorful, it is a pure, serene image of contemplation.

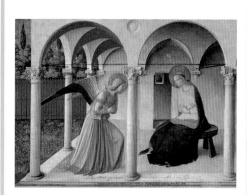

▲ *The Annunciation*, Fra Angelico, c.1438–45, fresco, 90½ × 126¼in (230 × 321cm), Convent of San Marco, Florence, Italy

The Arnolfini Portrait

c.1434 ▪ OIL ON PANEL ▪ 32¼ × 23½in (82.2 × 60cm) ▪ NATIONAL GALLERY, LONDON, UK

SCALE

JAN VAN EYCK

The exquisite detail in Jan van Eyck's masterpiece and the level of precision in the painting give this celebrated double portrait an authenticity that is very convincing. The sense of space is realistic, the light is handled with immense skill, and the composition is tightly controlled. In a richly furnished room, a prosperous couple stand together, the reflections of their backs glimpsed in an elaborately carved mirror at the center of the tableau.

There has been much speculation about the identities of the man and woman in the double portrait. They were long thought to be the Italian merchant Giovanni di Arrigo Arnolfini and his wife, who lived in Bruges, and the painting was known as *The Arnolfini Marriage*, until it was established that the couple was married some years before the 1434 date written on the wall in the painting. It is now thought that the painting depicts Giovanni's cousin and his wife. Central to the composition and beautifully illuminated by the light from the window, their hands touch in a display of togetherness.

Social documentation

Most people who see the painting wonder whether Arnolfini's wife is pregnant. Apart from her rounded stomach, which was considered a becoming feature in women and often seen in portraiture at the time, there are other small details that may suggest pregnancy. However, it is possible that she is simply holding up her dress to display the folds of its sumptuous fabric. Indeed, the main purpose of the painting was probably to emphasize the couple's wealth and social standing in 15th-century Bruges. The interior of the fashionable Flemish house is richly furnished, both sitters are dressed in fine clothes, and particular visual symbols, which were employed by other artists and would have been understood by cultured

audiences of the day, underline their strong moral principles and beliefs. The proportions of both figures also emphasize their stature in society. Their bodies appear elongated, emphasizing the volume of their garments and reinforcing the impression of wealth and status.

It is, however, the skill of the artist that is perhaps the most striking aspect of this work. Van Eyck perfected the technique of oil painting at a time when tempera (pigment mixed with egg) was still the most popular medium. By carefully building up layers of paint and adding detail and texture, he created the illusion of real objects and surfaces. The fur linings of the couple's heavy robes are painstakingly reproduced and look soft to the touch. The patina of the wooden floor with its worn grain seems accurately depicted, and the oranges on the table and the windowsill look good enough to eat.

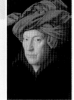

JAN **VAN EYCK**

c.1390–1441

One of the greatest artists of the Northern Renaissance, van Eyck was an early master of oil painting. He was famed for his ability to produce detailed paintings.

In his early years, van Eyck probably trained as a manuscript illuminator. This might account for his immense skill in observing and representing objects and figures in great detail. His earliest known works show his interest in painting people in a landscape, which was very unusual at the time.

Van Eyck is first recorded working as an artist in August 1422 in the Hague. There he took up the post of court painter to the Count of Holland, John of Bavaria. After the Count's death, he moved to Bruges and became painter to the court of Philip the Good, the Duke of Burgundy. This post offered opportunities for travel and van Eyck was inspired by the scenery and works of art he encountered. *The Arnolfini Portrait* and the *Ghent Altarpiece* are his most celebrated works and display not only his his acute powers of observation, but also his naturalism and superb craftsmanship, particularly when describing the fall of light.

Van Eyck's **inspired observations of light** and its effects, executed **with technical virtuosity**…enabled him to create a brilliant and lucid kind of reality "

SISTER WENDY BECKETT *THE STORY OF PAINTING*, 1994

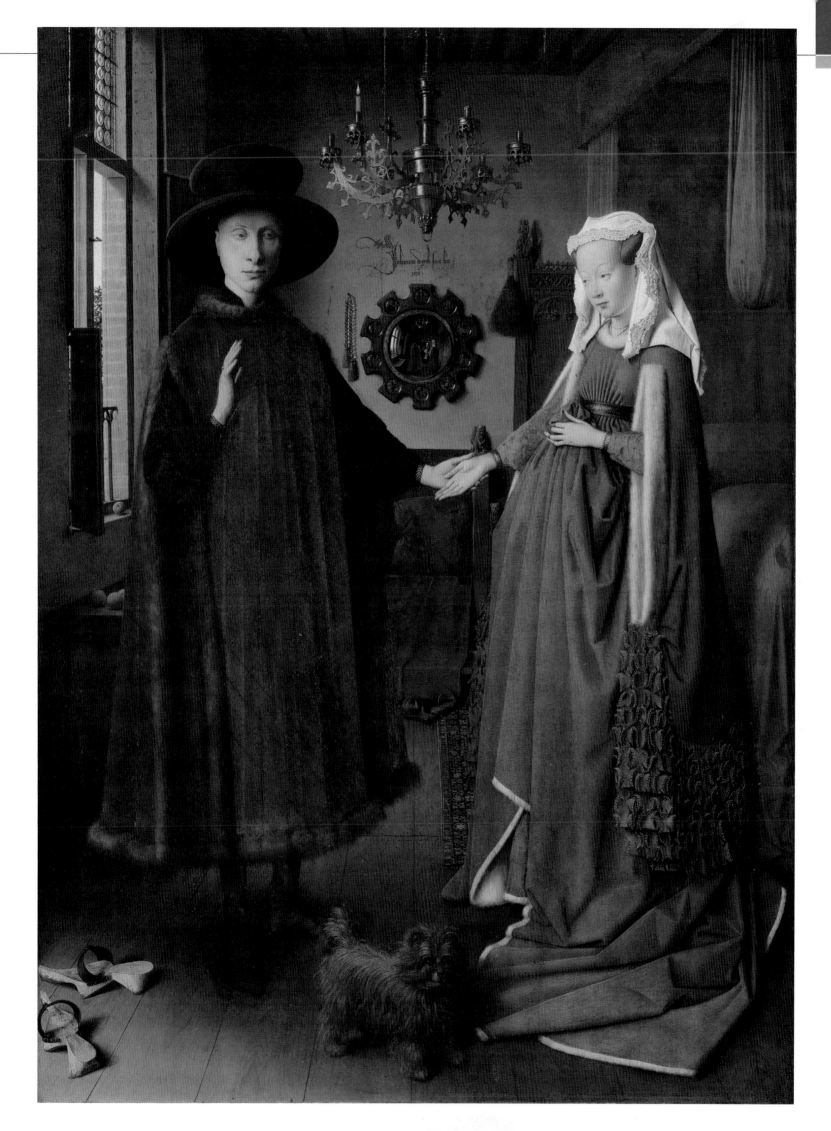

Visual tour

KEY

▼ **COSTLY FABRIC** The superb modeling of the folds of the emerald-green gown emphasize the fabric's quality and heavy weight. The fabric is probably velvet, which was extremely expensive at the time. The intricate ruffles and pleats on the sleeves increase the overall impression of luxury and opulence.

▼ **ARNOLFINI** Crowned by an enormous hat, the figure of Arnolfini conveys the impression of great wealth and status. His eyes are downcast and his expression is serious. This is in contrast to the welcoming gesture of his right hand, almost like a wave, as he moves to place it into his wife's open palm.

◄ **CARVED STATUE** The figure of St. Margaret with a dragon has been carved into the high back of what is probably the bedpost, and the hanging brush to the left is associated with St. Martha, patron saint of housewives. St. Margaret is the patron saint of childbirth, which would support the view that the wife is pregnant.

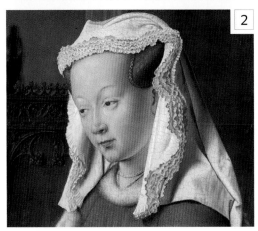

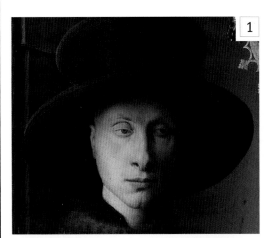

▲ **ARNOLFINI'S WIFE** A headdress of fine linen with an intricate frill frames the youthful face of Arnolfini's wife, which is bathed in light. Both the husband and wife's faces are seen in three-quarter view. Van Eyck employed this angle in other paintings and it brings a natural human quality to the figures.

◄ **SHOES** In the bottom left-hand corner of the painting Arnolfini has taken off his wooden, clog-like shoes. Look closely at them and you can see the fine detail of the wood grain and splashes of mud. The wife's daintier red shoes are visible in the background, under the bench beneath the mirror.

◀ **CHANDELIER** There is a solitary candle burning in the impressive brass chandelier. The single flame symbolizes the all-seeing eye of God. Together with other signs of devotion, such as the prayer beads on the wall and the miniature paintings of the Passion of Christ around the mirror, it demonstrates the couple's strong Christian beliefs.

ON **TECHNIQUE**

Van Eyck used oils rather than tempera to bind powdered pigments (finely ground particles). He attained a level of precision using oil paint that had not been seen previously and his techniques were innovative and influential. Using layers of translucent glazes to build effects for a multitude of textures, he was able to depict light on surfaces with extraordinary skill. In *The Arnolfini Portrait* you can see his mastery of oil paint in the glints on the chandelier and the magical reflective quality of the mirror.

▲ **DOG** For its association with loyalty and its reputation as a faithful companion, the dog was widely used as a visual symbol. In this painting, the dog stands between the feet of its owners, uniting them in fidelity.

ON **COMPOSITION**

Van Eyck uses perspective to add a sense of depth and create the illusion of interior space. The straight lines of the floorboards, echoed by the angle of the bed and window frames, draw your eye toward the central focus of the composition, the mirror on the back wall. This is the vanishing point of the painting where the lines meet, as can be seen in the overlay below.

◀ **CENTRAL MIRROR** Ten miniature paintings encircle the round, convex mirror. They depict in astonishing detail the events leading up to and including the crucifixion of Christ. The craftsmanship in such a piece would have been highly valued in the Netherlands at the time. At least four figures can clearly be seen reflected in the mirror. Two of them are the couple seen from behind, the third is probably van Eyck, and the identity of the fourth person is unclear.

◀ **SIGNATURE** The Latin inscription on the wall with the date 1434 can be translated as "Jan van Eyck was here." Van Eyck often signed and dated his paintings in creative ways.

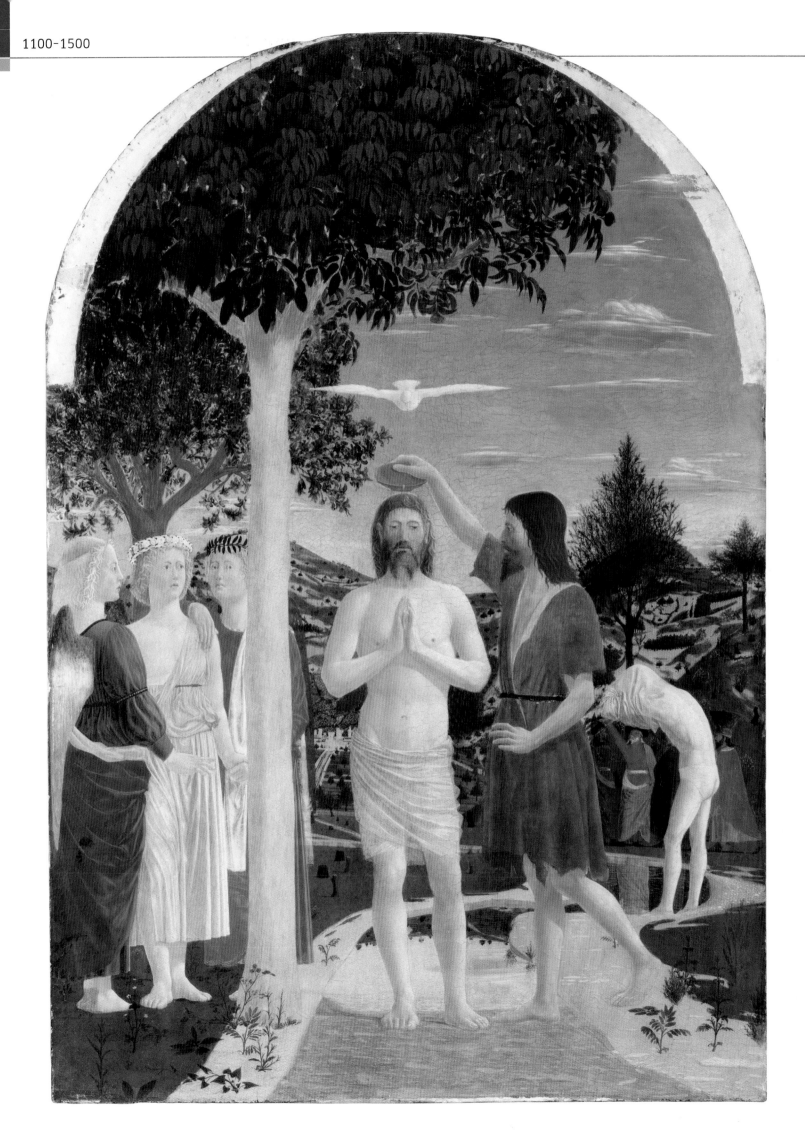

The Baptism of Christ

c.1450 ■ TEMPERA ON PANEL ■ 65¾ × 45½in (167 × 116cm) ■ NATIONAL GALLERY, LONDON, UK

PIERO DELLA FRANCESCA

SCALE

Solemn in mood yet ravishing in coloring, lofty in attitude yet full of earthy details, this altarpiece exemplifies the perfect balance between science and poetry that makes Piero's art so memorable. He was a profoundly thoughtful artist who worked slowly and deliberately in a rational, scientific spirit (in his old age, when fading eyesight perhaps made him give up painting, he wrote treatises on mathematics and perspective). His love of lucidity and order was matched by an exquisite feeling for color and light, however, so his paintings never seem like dry demonstrations of theories. He was influenced by some of his great Italian predecessors and contemporaries in this handling of color and light, but an innate sensitivity to the beauty of nature must have been equally important to him.

A fresh look at a popular theme

Nothing is recorded about the commissioning of this picture, but circumstantial evidence indicates that it was painted as an altarpiece for a chapel dedicated to St. John the Baptist (one of the two principal figures in the painting) in an abbey in Sansepolcro in Tuscany. When the abbey closed in 1808, the painting was transferred to Sansepolcro's cathedral, which sold it in 1859, an indication that Piero was regarded as a minor figure at that time, rather than far and away the town's greatest son, as he is now. Two years later, it was bought by the National Gallery, London, whose director at the time, Sir Charles Lock Eastlake, played a leading role in Piero's rediscovery. There is no external evidence to help with dating the painting, but because it has such a feeling of springlike freshness, it is generally considered to come from fairly early in Piero's career. It is perhaps the first work in which he revealed his full powers.

The Baptism of Christ has been a popular subject from the earliest days of Christian art, and many aspects of Piero's painting can be paralleled in works by other Italian artists of the time. None of them, however, rivaled Piero in creating a scene of such monumental dignity and authority. Nor did any of them give the event such a lovely setting. In the biblical accounts, Jesus is baptized by his cousin John in the River Jordan. Piero, however, places the scene in the kind of hilly countryside that he saw around his own hometown. Indeed the town (with its fortified towers) that can be glimpsed between Jesus and the tree bears a strong resemblance to Sansepolcro, which has changed comparatively little since Piero's day.

> Painting is nothing but a representation of surface and solids…put on a plane of the picture…as real objects seen by the eye appear on this plane

PIERO DELLA FRANCESCA *DE PROSPECTIVA PINGENDI,* c.1480–90

PIERO DELLA FRANCESCA

c.1415–92

Piero's majestic powers of design, combined with his extraordinarily sensitive handling of color and light, have made him one of the most revered figures in Renaissance art.

Piero spent most of his life in his hometown of Borgo San Sepolcro (now known as Sansepolcro) in the Tiber valley, southeast of Florence, Italy. It was a prosperous town, but not particularly distinguished artistically, so he also found employment in several other places, including major art centers such as Florence and Rome.

Much of Piero's work has been destroyed over the centuries, and few of his surviving paintings are well documented, so his career can be followed only in broad outline. He was highly respected in his lifetime and worked for some of the most eminent patrons of the day, but after his death his reputation faded. This was largely because his major works were in rather out-of-the-way places. Before the days of photography and easy travel, they therefore tended to be overlooked. It was not until the late 19th century that his reputation began to rise to its present exalted heights.

Visual tour

KEY

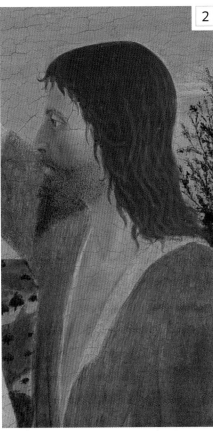
2

◀ **JOHN THE BAPTIST** John was the forerunner or herald of Jesus, and the baptism marked the beginning of Jesus's public ministry. In art, he is often depicted as something of a "wild man"–an ascetic who lived in the desert and dressed in animal skins. Piero, however, shows him as rather better groomed than Jesus.

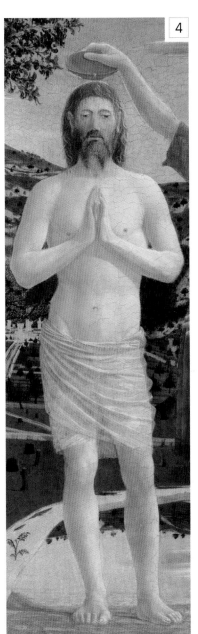
4

▼ **JESUS** In Renaissance paintings, Jesus is usually depicted as fine-featured and otherworldly, emphasizing his divine nature. In contrast, Piero gives him the look of a robust farmer, the kind of figure he could have seen working in the countryside at any time around Sansepolcro. In this painting, Jesus is far from conventionally handsome–his ears are large, his lips thick, and his hair rather lank. Nevertheless, there is nobility in his bearing, and his grave, pensive expression leaves no doubt as to his holiness.

▶ **CENTRAL AXIS** Jesus is very much at the center of the painting. The water pouring from John the Baptist's bowl creates an imaginary central line. The line runs vertically through the picture, bisecting Jesus's head and praying hands. Piero prevents the effect from being stiff or obvious by giving a slight twist to Jesus's lower body. He stands naturally and convincingly, his weight solidly on the ground.

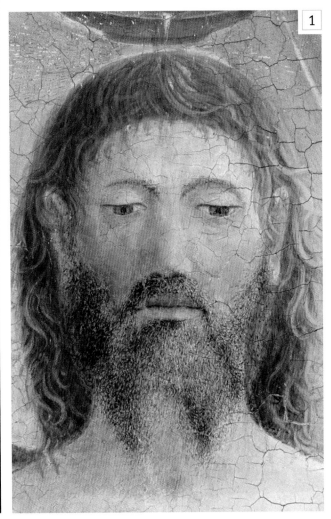
1

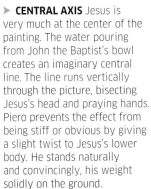
3

▲ **DOVE** The biblical accounts say that when Jesus was baptized the Holy Spirit descended on him from Heaven like a dove, and it became common in art to depict an actual dove hovering above him. A dove was used in a similar way in other religious scenes, and often as a generalized symbol of peace, innocence, or good tidings. Piero's renowned skill in perspective and foreshortening is shown in the difficult head-on position in which he has chosen to depict the bird. The dove's shape also echoes the shapes of the clouds.

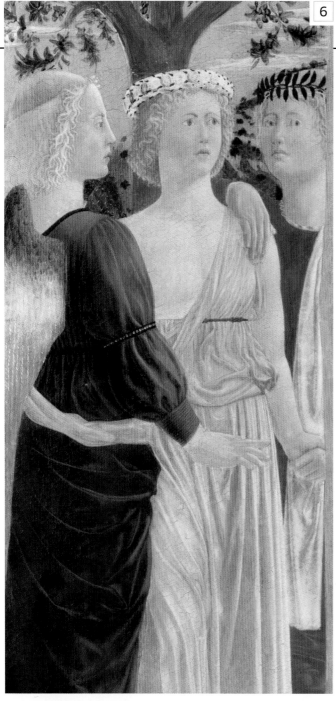

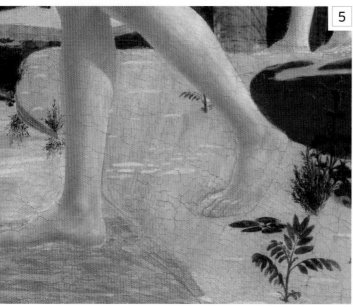

◄ ANGELS Paintings of the Baptism of Christ often include two or three angels standing to one side, sometimes holding Christ's garments, but sometimes used more ornamentally or to balance other features of the composition. Piero's angels are among the most individual and lovable ever painted. Like the figure of Jesus, they seem based on the observation of real people rather than conventional ideas of celestial beings. They look like chubby, blonde-haired peasant children who have dressed up for a village festival, and one leans on the shoulder of another with a delightfully casual gesture. However, for all this charm, they do not detract from the picture's solemn atmosphere.

◄ FEET ON THE GROUND The monumental grandeur of Piero's style is encapsulated in Jesus's legs, which almost seem like marble columns and are as firmly planted on the ground as the tree alongside them. Yet there is great subtlety in the way the light molds their form and in the way the water is observed around the ankles. In reality, Jesus's baptism may have involved total immersion, but Piero, like many artists of the time, reduces a substantial river, the Jordan, to a small stream winding through the painting. According to the biblical accounts, the event took place "during a general baptism of the people," and the legs to the right of this detail belong to a man who is stripping off to take his turn.

ON **TECHNIQUE**

Piero's lifetime coincided with the introduction of oil paints in Italy. By the end of his career, he had adopted them, appreciating—like many other artists—their flexibility and versatility. When he painted *The Baptism of Christ*, however, he was still using the older technique of tempera, in which pigments are mixed with egg rather than oil. Tempera can produce beautiful, durable results, but it is difficult to master, requiring patient craftsmanship. Colors cannot easily be blended (whereas they can with oils), so effects have to be painstakingly built up, layer after layer, touch after touch. Sometimes, paintings in this transitional period were begun with tempera and finished with oils.

IN **COMPOSITION**

Piero was a mathematician as well as an artist and his paintings often have almost geometrical lucidity. The painting has a round top, and in its basic proportions it is made up of a square topped by a circle—two of the fundamental geometric forms. Less obviously, the diagonal of John the Baptist's left leg is part of a triangle whose apex is formed at Jesus's hands. In this way, even the most dynamic part of the composition—as John leans forward with the baptismal bowl—is anchored in geometrical order.

The Hunt in the Forest

c.1470 ▪ TEMPERA AND OIL ON PANEL ▪ 29 × 69¾in (73.3 × 177cm) ▪ ASHMOLEAN, OXFORD, UK

SCALE

PAOLO UCCELLO

A striking panorama, this hunting scene displays Uccello's mastery of the new techniques of perspective, in which objects and figures appear to grow smaller with distance, creating the illusion of space and depth. Riders, horses and huntsmen, either galloping or running alongside their dogs, move directly toward the center of the painting. Here a stag disappears into the the forest and the lines of vision converge in a central vanishing point.

Uccello cleverly uses perspective to evoke the excitement of the chase and to draw us further into the darkness as we follow the men with their horses and hounds as they disappear rapidly into the trees. The bright vermilion of the hunters' hats and jackets, the beaters' leggings, and the horses' harnesses stand out dramatically against the verdant grass and foliage and the dark background, giving the composition a decorative, jewel-like quality.

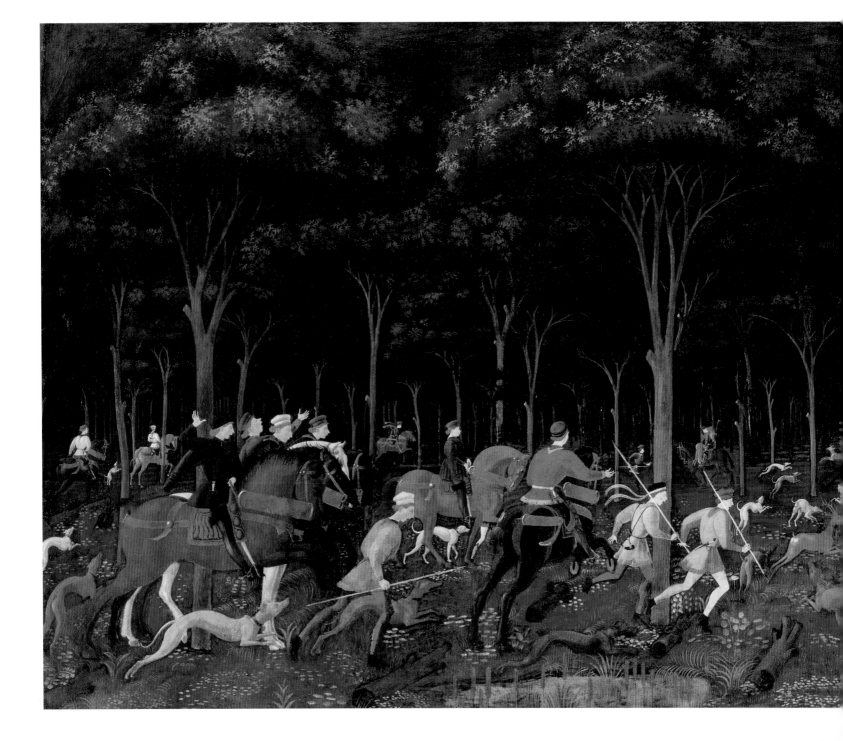

The meaning of *The Hunt in the Forest* is not immediately clear. The stylized setting and symbolic motifs create an air of pageantry and suggest that this is a scene of chivalric make-believe rather than a realistic depiction. One interpretation is that the painting is an allegory of the quest for love. This quest, which can lead into the darkness of unknown territory, is perhaps represented symbolically by the hunt, and the painting may have been intended as a wedding gift, such as a decoration for the headboard of a large bed.

Alternatively, the painting may simply have been commissioned from Uccello by a sophisticated nobleman who wanted a unique and ornamental scene by a contemporary artist that could be set into the wooden paneling of a grand interior.

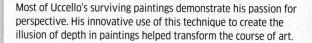

PAOLO **UCCELLO**

c.1397–1475

Most of Uccello's surviving paintings demonstrate his passion for perspective. His innovative use of this technique to create the illusion of depth in paintings helped transform the course of art.

Born Paolo di Dono in Florence, this artist was nicknamed Uccello (*uccello* is Italian for "bird") because of his love of birds and animals. He trained in the workshop of the Florentine sculptor, Lorenzo Ghiberti. The chronology of his career is difficult to establish, but records show that he was invited to Venice to work on mosaic designs for the Basilica di San Marco (St Mark's Cathedral) in 1425. In Florence he worked on *The Creation of the Animals* and *The Creation of Adam,* two frescoes for the cloisters of the church of Santa Maria Novella, and later produced two more. He also designed stained glass windows for Florence Cathedral, the *Duomo,* two of which survive. *The Hunt in the Forest,* the three panels that make up *The Battle of San Romano* (see p.37), and *St. George and the Dragon* are perhaps his most famous paintings.

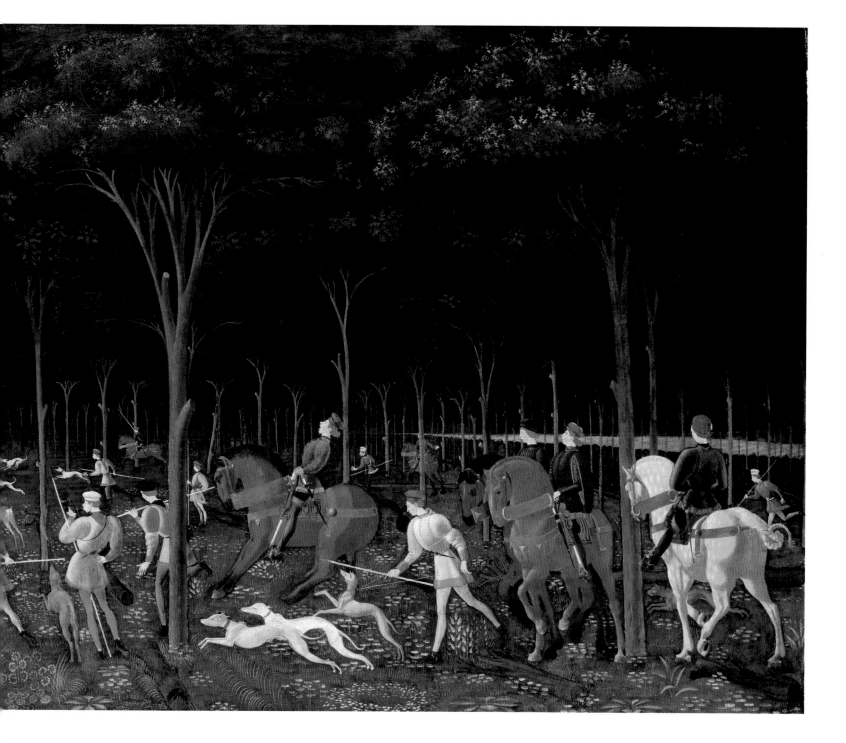

Visual tour

KEY

1

2

▲ ▶ **HUNTERS** All the hunters in the painting have similar faces. Even though some adopt different poses and others appear to be shouting, they all have the same distinctive nose, eyes, and facial proportions. Most of the hunters are shown in profile and this makes it easier to spot the similarities between them. This repetition, together with the use of bright red for their clothing and hats, gives the scene a pattern-like uniformity and makes it seem like part of an imaginary world.

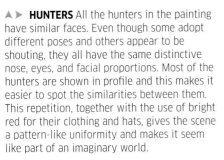

3

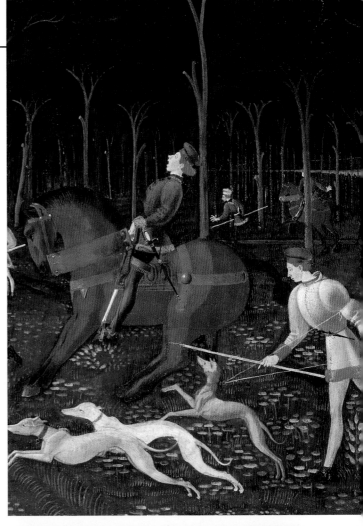

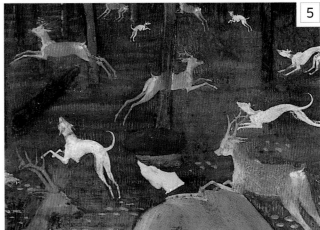

5

4

▲ **STAGS** The stylized forms of the stags are, at first glance, similar to those of the dogs. However, when comparing the two, you can see that the dogs are running, whereas the stags are leaping. Uccello's skill in depicting the forms of animals with a strong degree of realism, however stylized and decorative the treatment, is clear when you study the painting closely.

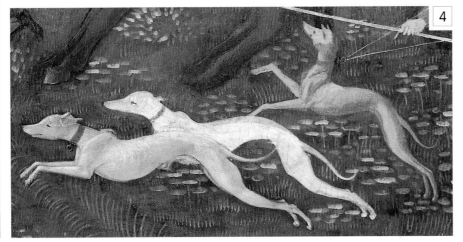

◀ **DOGS** The speed at which the hunting dogs are running is expressed by their outstretched legs and arched backs. Some look almost identical and parts of their bodies overlap to give the picture a three-dimensional quality. The dogs' collars are exactly the same shade of vermilion as the hunters' jackets. This complements the green of the grass in the foreground, adding to the vibrancy of the painting.

6

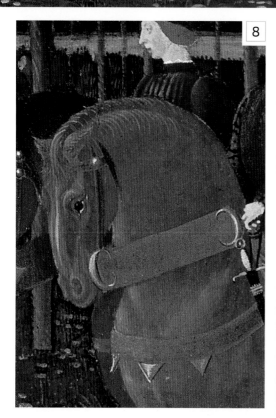

8

9

◄ **HORSES** Uccello loved painting animals and would have made many preliminary drawings of horses, using real animals as models, for this and other works. He would then simplify the forms of the animals so they were in harmony with the overall composition of the painting.

▼ **MOON** In the center of the dark blue sky is another reference to Diana, a slender crescent moon. Whether this suggests evening or nighttime, this detail is almost impossible to see without the aid of a magnifying glass.

7

ON **COMPOSITION**

Uccello's skilful use of perspective can be seen clearly from the diagram below. Here the radial lines that make up a grid system to guide the artist in the initial design have been overlaid on the painting. Above the horizon line, the trees diminish in size and appear to recede into the distance, whereas everything below the horizon converges on a central vanishing point. The tree trunks on the ground and patterned areas of foliage also follow the lines. The principles of perspective as applied to painting were first described in a treatise written by Leon Battista Alberti in 1435.

IN **CONTEXT**

Uccello's battle scene below is one of three that were once in the Medici Palace. It was assumed that they were commissioned for it but research published a few years ago shows that they were painted for the Bartolini Salimbeni family and were later seized by Lorenzo de Medici.

Uccello has used the same perspective devices in this painting as in *The Hunt in the Forest*. Note how the lances on the ground point toward a spot above the white horse's head. The lines in the fields also lead your eyes into the distance, although they converge at a different point.

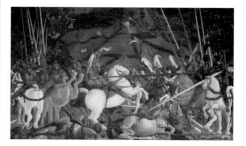

▲ *The Battle of San Romano*, Paolo Uccello, c.1456, tempera on panel, 71½ × 126in (182 × 320cm), Uffizi, Florence, Italy

▲ **CRESCENT MOTIF** The symbol of the Roman goddess of hunting, Diana, is a crescent moon. Gold crescents decorate the horses' reins and appear on the harness straps on their rumps. Diana is the protector of chastity. It was more common for wedding gifts to depict Venus and Mars, the god and goddess of love.

◄ **TREES** We can see that the trees are oaks from the shape of their leaves, some of which would once have been decorated with gold leaf. Uccello made sure that there were no branches below the canopy to obstruct our view of the hunt. Oak groves were sacred to the Roman goddess Diana.

The Birth of Venus

c.1485 ▪ TEMPERA ON CANVAS ▪ 68 × 109¾in (172.5 × 278.5cm) ▪ UFFIZI, FLORENCE, ITALY

SANDRO BOTTICELLI

SCALE

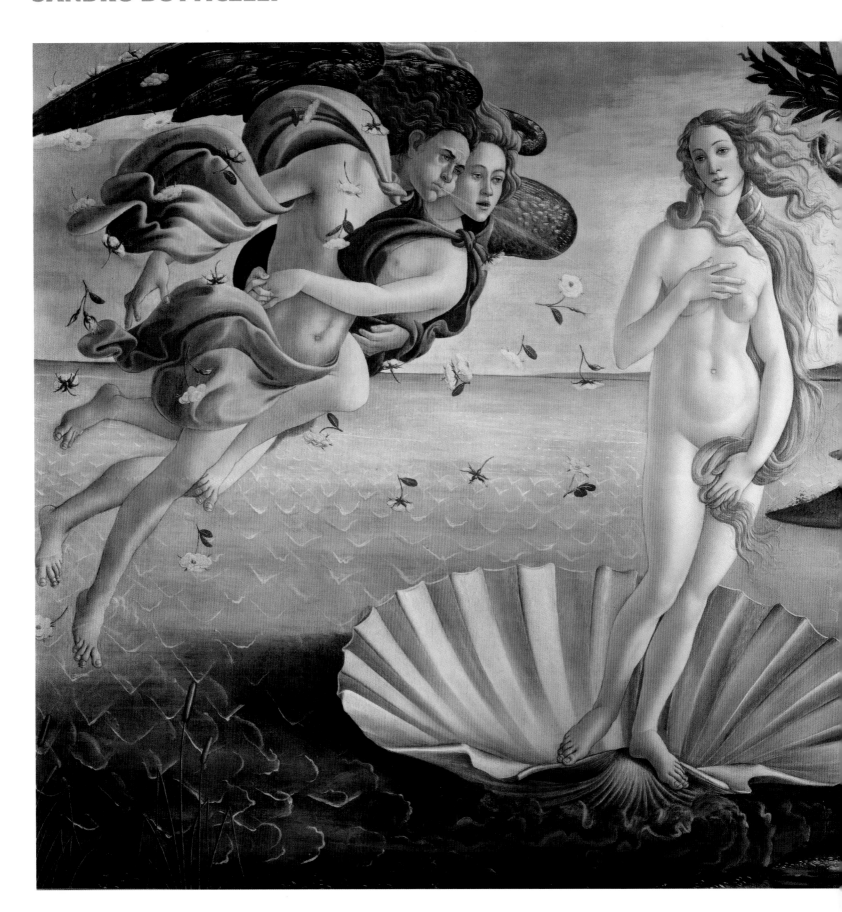

This supremely graceful painting is full of gentle movement and harmony. It depicts the arrival of Venus, Roman goddess of love, beauty, and fertility, on the island of Cyprus. All around her are signs of spring, which is a time of new beginnings and renewal. The extraordinarily beautiful, iconic figure of Venus is positioned right at the center of the perfectly balanced composition. Botticelli's Venus embodies the Renaissance ideal of beauty. Her pale limbs are long and elegant, her shoulders slope, and her stomach is sensuously rounded, yet there is something otherworldly about her, especially the expression on her exquisite face.

The painting was probably commissioned by a member of the wealthy Medici family, Lorenzo di Pierfrancesco de' Medici, for his villa at Castello near Florence. A cultured individual, he would have been familiar with the stories of classical Greek and Roman mythology as well as the philosophy of Plato, so Botticelli's Venus can be seen as the physical manifestation of a divine and perfect beauty.

In Renaissance Italy, mythological scenes were usually commissioned to decorate wooden furniture such as *cassone* (wedding chests). Religious images, on the other hand, were created on a grander scale and used in churches, often as altarpieces. In creating the *The Birth of Venus,* Botticelli broke with tradition, producing the first work on canvas to feature a mythological image that was comparable in size to a large-scale religious painting.

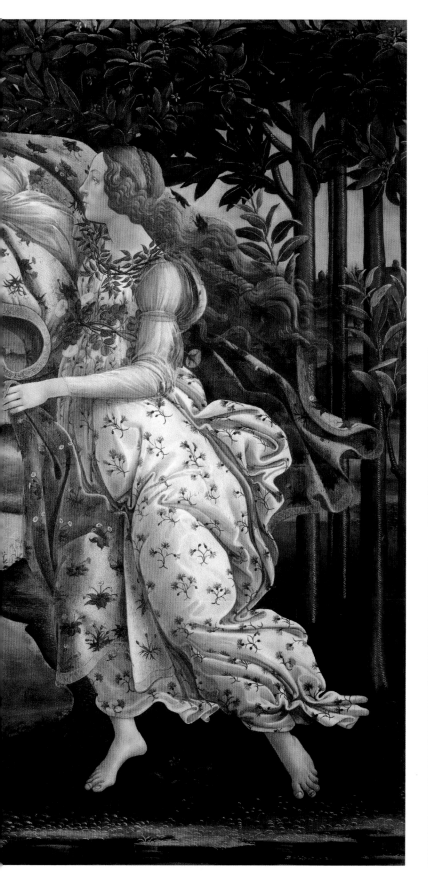

> Aphrodite **the fair**… she with the **golden wreath**…was conveyed by the **swelling breath of Zephyrus**, on the waves of the turbulent sea "

HOMERIC HYMN TO APHRODITE, c.5000 BCE

SANDRO **BOTTICELLI**

c.1445–1510

One of the most celebrated painters of the Renaissance, Botticelli developed a graceful and ornamental linear style that harked back to elements of the Gothic style in art.

Alessandro di Mariano Filipepi, known as Sandro Botticelli, was born in Florence. He worked as an apprentice in the studio of Fra Filippo Lippi, then established his own workshop c.1470. At the high point of his career Botticelli was producing work for Florence's churches as well as receiving commissions from the most powerful families in Florence, particularly the Medici. By 1481, his reputation was such that he was summoned to Rome to paint frescoes in the Sistine Chapel. Botticelli's good fortune did not last, however. The Medici family was expelled from Florence, his style of painting went out of fashion, and he died in poverty and obscurity. It was only in the late 19th century that interest in his work revived.

Botticelli's masterpieces were his large mythological paintings, *The Birth of Venus* and *Primavera* (see overleaf). *The Mystic Nativity*, 1500, another of his great works, was the only painting of his that was signed and dated.

Visual tour

▽ **SHELL** Venus is about to alight from her boat, a scallop shell, which anchors her in the center of the composition. Despite the painting's title, the moment of her birth occurred under less poetic circumstances. According to Greek mythology, Venus emerged from the fertile foam that was created when her father Uranus's severed genitals were thrown into the sea.

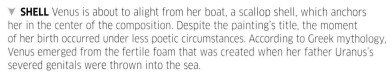

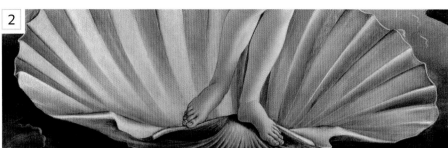

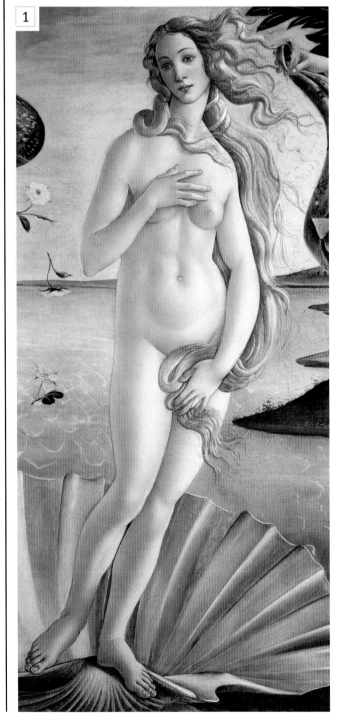

◁ **VENUS** The mythological goddess emerges as a fully grown woman. Her right hand covers one of her breasts, while her left holds long skeins of golden hair over her pubic area. Her classical pose is known as the *Venus pudica*, the modest Venus; some artists portrayed the goddess as a more erotic figure. Botticelli's Venus represents the 15th-century Italian ideal of female beauty—she has a small head, an unnaturally long neck, steeply sloping shoulders, and a rounded stomach. Apart from the pink roses wafting down on her, Venus is pictured without her usual attributes, such as her pearl necklace or Cupid, her son.

▲ **ROSES** Around Zephyrus and Chloris, delicate pink roses tumble, each with a golden heart and gilded leaves. Known as the flower of Venus, the beautiful and fragrant rose is a symbol of love, with thorns that can cause pain. It also represents fertility.

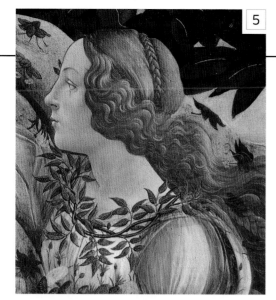

◀ **FLORA** The female figure on the right is generally identified as Flora, the goddess of flowers, who appears similarly attired in Botticelli's *Primavera*. An allegorical figure, she represents spring, the time of rebirth. Around her neck she wears leaves of the myrtle, a tree sacred to Venus; her dress is sprigged with cornflowers, and she wears a high sash of roses. There are more spring flowers on the billowing pink cloak she holds out to the naked Venus.

▼ **GOLD HIGHLIGHTS** The foliage of the orange trees is picked out in gold leaf, as are the individual feathers on the wings of Zephyrus. All the figures have gold highlights in their hair, and the veins of the shell, the stems and centers of the roses, and the grass stalks in the foreground are similarly gilded. With these gold details the whole painting would appear to glimmer after dark when lit by candlelight.

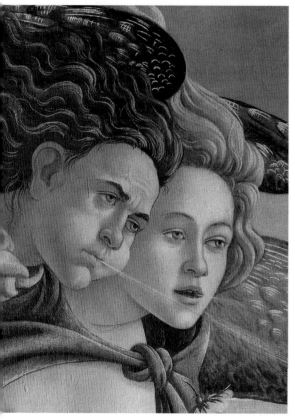

▲ **ZEPHYRUS AND CHLORIS** The personification of the west wind, the winged Greek god Zephyrus brings movement to the scene. His cheeks are puffed out as he blows the waves that cast Venus toward the shore. He is clasped by a semi-clad female, probably Chloris, a mortal nymph abducted by Zephyrus to be his bride. Chloris was later transformed into the goddess Flora, the gorgeously clothed figure on the right of the painting. In terms of composition, Zephyrus and Chloris are balanced by the graceful figure of Flora.

▶ **LAPIS LAZULI** The intense blue of the cornflowers on Flora's dress comes from ultramarine, an expensive pigment made by crushing lapis lazuli, a semiprecious stone. Botticelli's wealthy patron clearly spared no expense when he commissioned this painting.

ON **TECHNIQUE**

In the painting, Venus stands with her weight on her left leg, giving her body a graceful S-shaped curve. The pose is based on that of classical statues. Venus's stance, and the way in which she has been painted without shadows, give her delicacy and make her seem almost to float. In Botticelli's ink drawing (below), the female figure adopts the same pose, this time with her weight on her right leg. Being able to represent a figure in this relaxed pose was greatly esteemed by Renaissance artists.

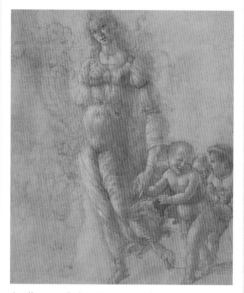

▲ *Allegory of Abundance or Autumn*, Botticelli, 1480–85, pen and ink on paper, 12½ × 10in (31.7 × 25.2cm), British Museum, London, UK

IN **CONTEXT**

There is much debate as to whether *The Birth of Venus* is a companion piece to Botticelli's other allegorical masterpiece, *Primavera*, perhaps commissioned by Lorenzo di Pierfrancesco de' Medici about five years earlier. Both are symbolic representations of the cycle of spring and both depict Venus, Zephyrus, Chloris, and Flora. *Primavera* (which means "spring" in Italian) is, however, painted on wood rather than canvas. In this painting, Flora has Chloris and Zephyrus on her left and Venus on her right. Venus is fully clothed and can be identified by her son, Cupid, who is flying overhead. On the left is Mercury, the messenger of the gods, and next to him are the three Graces, Venus's handmaidens.

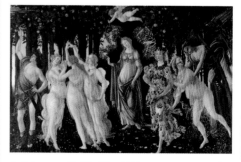

▲ *Primavera*, Botticelli, c.1482, tempera on panel, 78 × 123½in (203 × 314cm), Uffizi, Florence, Italy

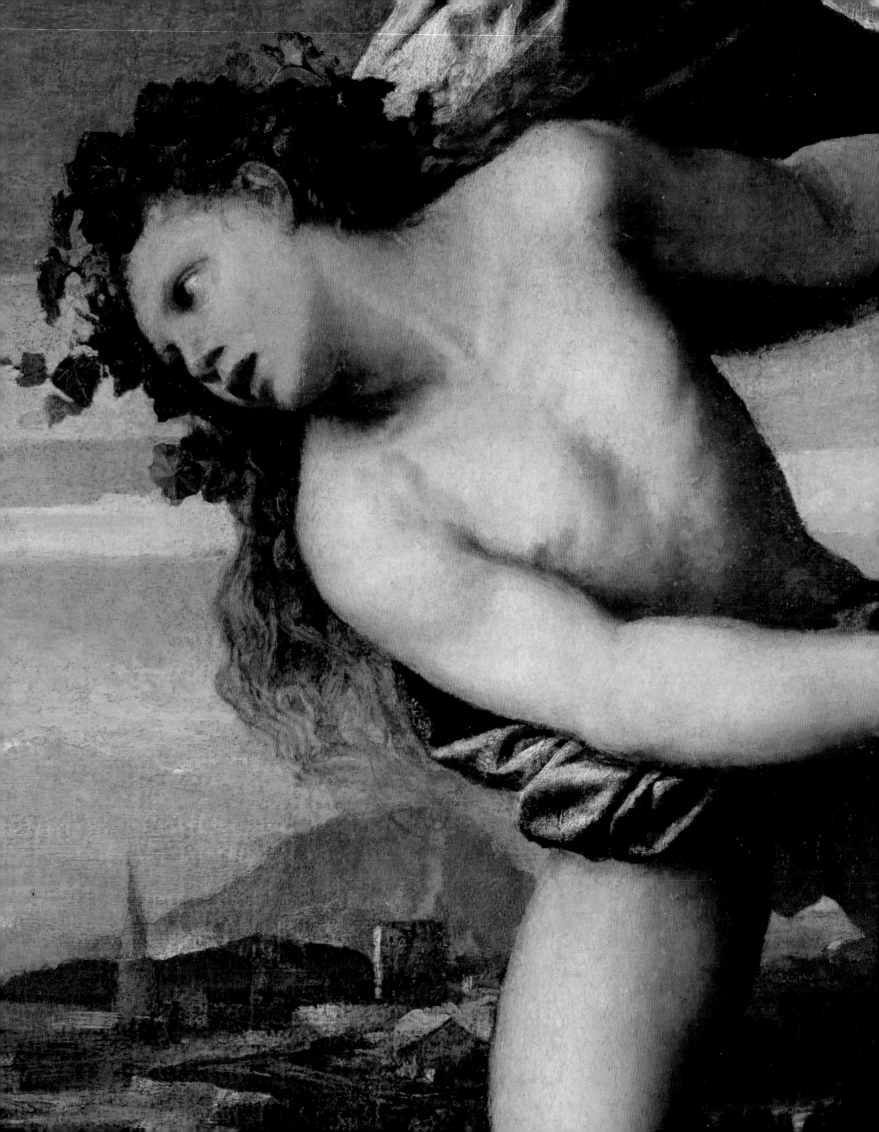

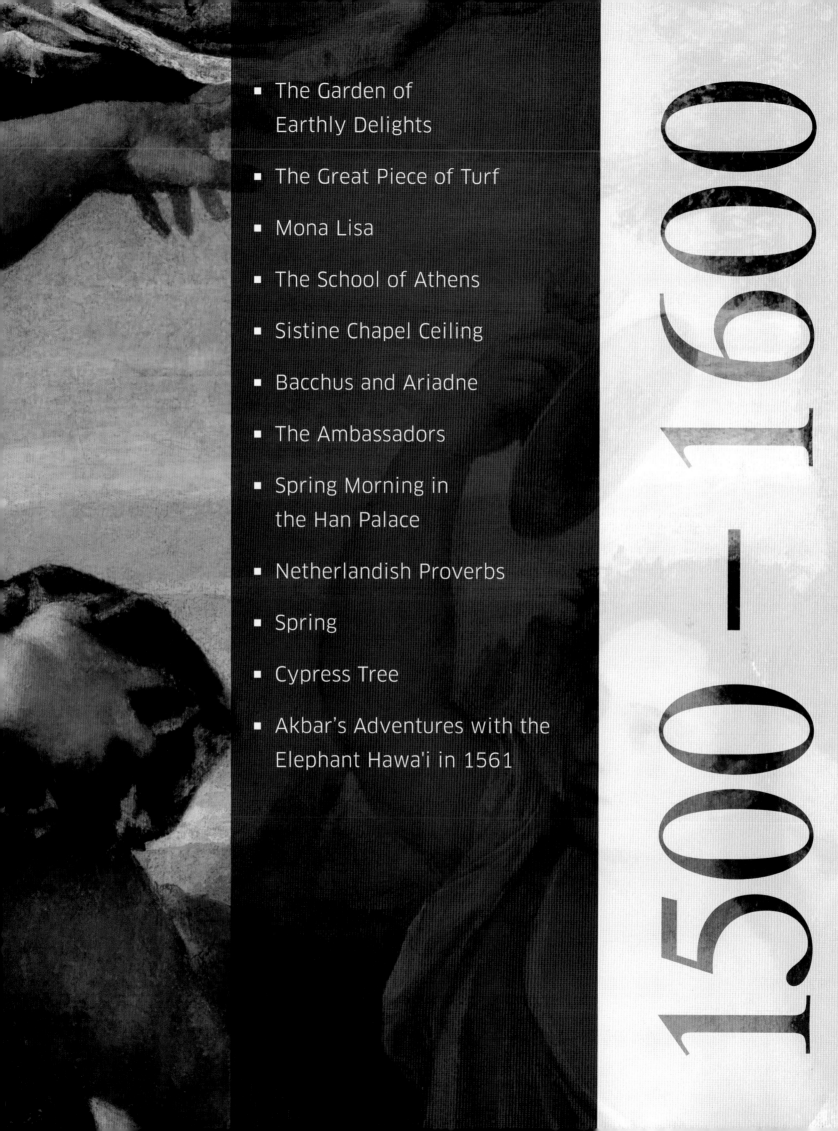

1500 — 1600

The Garden of Earthly Delights

c.1500 ▪ OIL ON PANEL ▪ 86½ × 153in (220 × 389cm) ▪ PRADO, MADRID, SPAIN

HIERONYMUS BOSCH

SCALE

Across three large panels an astonishing vision unfolds. Scores of figures—some human, some monstrous—inhabit a visionary world that encompasses radiant beauty as well as scenes of hideous torment. The two outer panels depict the Creation of Eve on the left and Hell on the right. In the central panel, teeming nude figures engage in unbridled sexual activity in a luscious garden. Although many of the details are baffling to the ordinary observer, the general idea of the painting seems clear—God gave man and woman an earthly Paradise, but the sins of the flesh have led them to the tortures of Hell. However, because the painting is so unconventional and the circumstances of its creation are unknown, there has been endless commentary on how exactly it should be interpreted.

Open to speculation

The painting was first documented in 1517, the year after Bosch's death, when it was said to be in a palace in Brussels belonging to Count Hendrik—Henry III of Nassau. Paintings in triptych (three-paneled) format were very common as altarpieces in Bosch's time, but this one is so personal that it was almost certainly created for a private patron rather than a church, and in the absence of other evidence it is reasonable to assume that this patron was Hendrik or one of his relatives.

Bosch left behind no letters or other writings, and there are no reminiscences by people who knew him. There are numerous contemporary documents relating to him, mainly preserved in the municipal archives of 's-Hertogenbosch. While they provide some information about the outline of his life, they throw no light on his character. The gaps in our knowledge have been filled with a wealth of speculation by modern writers, who have portrayed Bosch as everything from a scholarly theologian to a heretic with a disturbed mind. It has been proposed, for example, that the figures in the central panel of *The Garden of Earthly Delights* are members of an obscure sect who practised ritual promiscuity to try to recapture the initial innocence of Adam and Eve. Bosch is

alleged to have belonged to the sect and, therefore, to have exalted lust in the painting rather than condemned it. Such theories can be entertaining, but they are based on little or no hard evidence.

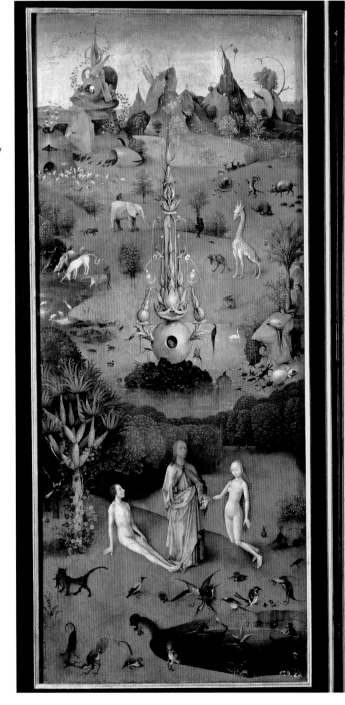

Instead, all the contemporary records indicate that Bosch was a respected member of society who held conventional religious views. Aspects of his work that seem strange to us probably reflect the popular culture of his time rather than bizarre personal views. Religious pageants and plays, for example, sometimes used repulsive demon masks to suggest the horrors of Hell.

> …it is his ability to **give form to our fears** that makes his **imagery timeless**

LAURINDA DIXON *TIMES HIGHER EDUCATION*, 2003

HIERONYMUS **BOSCH**

c.1450–1516

Bosch produced some of the strangest and most perplexing paintings in the history of art. Very little is known of their creator, inspiring much speculation about his character and motives.

As far as is known, Bosch spent all his life in the town after which he is named, 's-Hertogenbosch, which is now in the southern Netherlands, near the Belgian border. In Bosch's time, when the map of Europe was very different from that of today, the town was in the Duchy of Brabant. Bosch was the leading painter of the day in 's-Hertogenbosch, which was prosperous and a notable cultural center. By the end of his life, his work was sought by leading collectors in Italy and Spain as well as his homeland. His paintings continued to be admired and influential throughout the 16th century, but thereafter they were long neglected. It was not until about 1900 that there was a serious revival of interest in him.

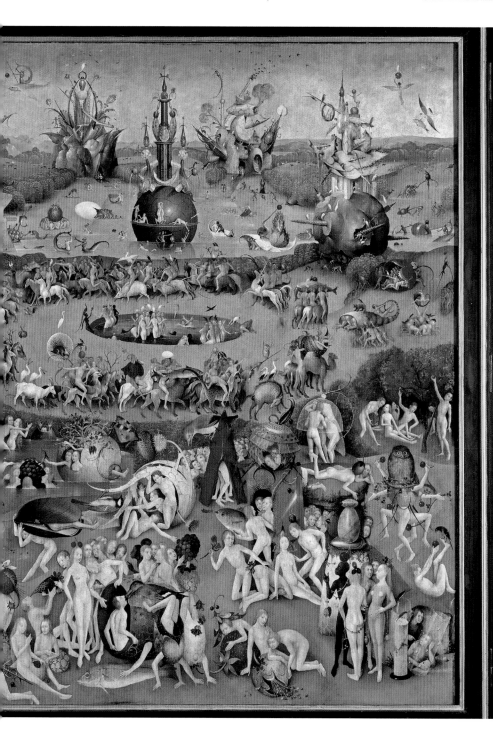

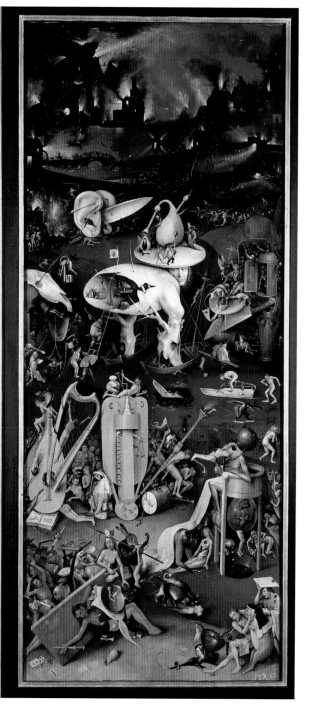

Visual tour

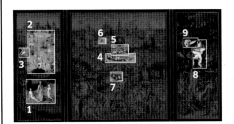

▼ **FOUNTAIN OF LIFE** This strange and beautiful structure in the left-hand panel is the Fountain of Life, from which the rivers of Paradise flow. It is not mentioned in the biblical account of creation, but it appears in Christian art from the 5th century onward.

◄ **ADAM AND EVE** In the biblical account of the first days of the world, God creates Eve from a rib he has taken from the sleeping Adam. Here God, looking very like the traditional image of Christ, takes Eve's wrist and presents her to Adam. With his other hand, he makes a gesture that confers blessing on their union.

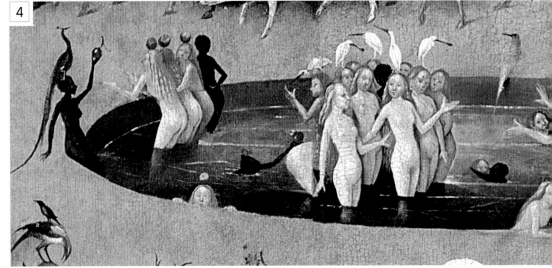

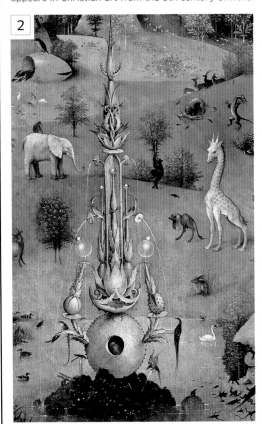

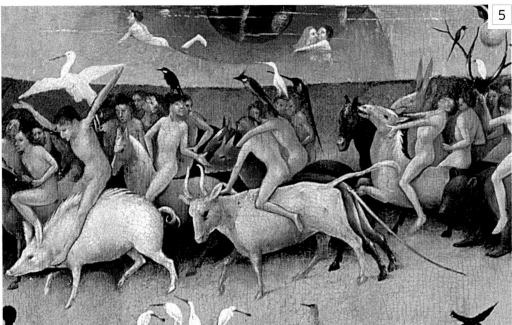

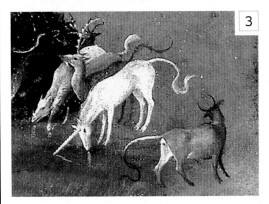

▲ **EXOTIC ANIMALS** Scenes of the Garden of Eden allowed artists to depict all manner of animals, both real and imaginary, to illustrate the abundance of God's creation. The mythical unicorn was adopted into Christian art as a symbol of purity.

▲ **NAKED MEN RIDING ANIMALS** Groups of men—mounted on real and imaginary animals—energetically circle a pool, from which women look out invitingly. Animals were traditionally associated with the lower or carnal appetites of humankind, and in Bosch's day, as now, the act of riding was often used as a metaphor for sexual intercourse.

▼ **GIANT STRAWBERRY** In art, the strawberry was sometimes interpreted as an allusion to drops of Christ's blood. However, it was also used as a sexual metaphor, its juicy voluptuousness suggesting carnal activity.

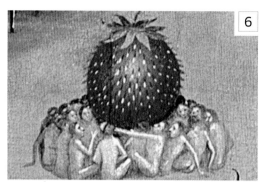

▼ **BUTTERFLY AND THISTLE** Few details in the painting have escaped symbolic interpretation. The butterfly has been seen as an allusion to inconstancy or capriciousness and the thistle to corruption. In other contexts, however, both can have positive associations.

ON **TECHNIQUE**

Bosch was a free spirit in terms of technique as well as imagery. Most of his contemporaries in the Netherlands cultivated smooth, tight, precise handling of paint, but Bosch's brushwork is fluid and vigorous. He was also one of the first artists in northern Europe to produce drawings intended as independent works. This typically lively example is a variant of the tree man in *The Garden of Earthly Delights*.

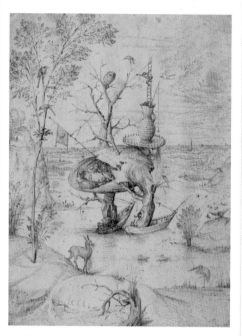

▲ *The Tree Man*, Hieronymus Bosch, c.1505, quill pen and brown ink, 11 × 8¼in (27.7 × 21cm), Grafische Sammlung Albertina, Vienna, Austria

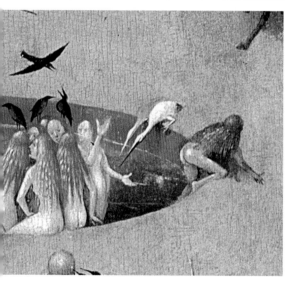

▲ **POOL OF NAKED WOMEN** In the middle of the central panel is a pool full of naked women who excite the circling men. Medieval moralists writing on sexual matters invariably saw women as temptresses—following the example of Eve. This "Fountain of Flesh," a kind of crazy merry-go-round of courtship, can be seen as a sinful counterpart to the Fountain of Life depicted in the first panel of the triptych.

▶ **TREE MAN** Part man, part egg, part tree, this weird construction defies precise analysis, but it is surely intended as Hell's counterpart to the Fountain of Life on the left-hand panel. It has been suggested, although without any real evidence, that the haunting, pale face is a self-portrait of Bosch. On his head, demons lead their victims around a disc, which in turn supports a bagpipe, an instrument that often had sexual connotations.

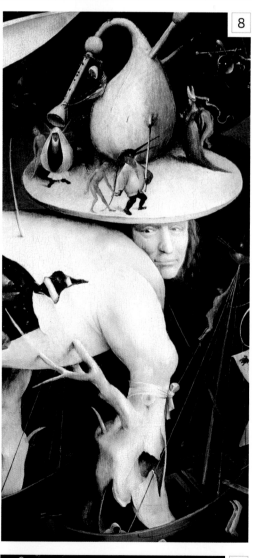

▶ **KNIFE AND EARS** A pair of ears and a knife present an obviously phallic appearance. The knife bears the letter "M", as do other blades in paintings by Bosch. Various explanations have been offered for this. One suggestion is that the letter stands for *mundus* ("world" in Latin).

IN **COMPOSITION**

The hinged side panels of the triptych can be closed over the central panel to form an image of the Earth, painted in shades of grey. God can be seen top left; his creation of the world—shown here as barely formed and unpopulated—forms a prelude to the creation of Eve inside.

▲ *Creation of the World*, the monochrome exterior side panels of *The Garden Of Earthly Delights* as they appear when the triptych is closed

The Great Piece of Turf

1503 ▪ WATERCOLOR, PEN, AND INK ON PAPER ▪ 16 × 12½in (40.8 × 31.5cm) ▪ ALBERTINA, VIENNA, AUSTRIA

SCALE

ALBRECHT DÜRER

The minute detail in this exquisite painting of a simple piece of meadow turf is of almost photographic precision. Painted more than 500 years ago, it is one of the first great nature studies.

Here, Dürer has given us an insect's perspective of nature. He has recreated the small, tangled plants with such clarity that it is possible to identify each one, making it one of the first European studies of biodiversity. *The Great Piece of Turf* is a masterpiece in its own right but, like his Italian contemporary, Leonardo da Vinci, Dürer made his nature studies primarily to increase his understanding of the natural world and to help him with the detail in his engravings, such as *The Fall of Man*, 1504, his woodcuts, and his large-scale paintings, such as *The Feast of the Rose Garlands*, 1506.

Dürer has used watercolor here, enabling him to work relatively quickly and concentrate on the colors and textures of the plants. With watercolor, unlike oil paint, which Dürer used in his large works, it is easy to mix subtle shades quickly and layer washes of paint on top of each other without having to wait too long for them to dry. Dürer mixed the different shades of green with great accuracy, both to differentiate each plant from the others and to create a sense of depth in the composition.

ALBRECHT **DÜRER**

1471–1528

Surely the greatest of all German artists, Dürer was a brilliant Northern Renaissance draftsman, printmaker, and painter. His work was characterized by accuracy and inner perception.

Born the son of a master goldsmith in Nuremberg, a center of artistic activity and commerce in the 15th and 16th centuries, Dürer was apprenticed with Michael Wolgemut, whose workshop produced woodcut illustrations, then travelled as a journeyman, making woodcuts and watercolors. He visited Italy twice and was deeply influenced by Italian Renaissance art and ideas. Back in Nuremberg, Dürer took printmaking to new heights. He completed several series of revolutionary woodcuts on religious topics, studied the nude, and published books on proportion in the human body and perspective. Dürer became an official court artist to Holy Roman Emperors Maximilian I and Charles V. He was also the first artist to produce several self-portraits.

Visual tour

KEY

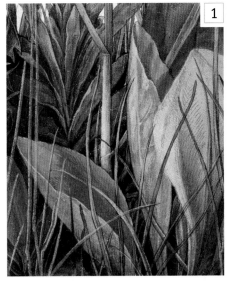

▲ **KEEN OBSERVATION** The fleshy leaves of a greater plantain stand out among the grasses. Note how Dürer has used fine, dry strokes of a deeper green to model the forms of the leaves, and fine white lines to highlight the veins and the edges of the leaves.

◀ **PALE BACKGROUND** This detail shows a spent dandelion head. You can trace the fading stem of the plant down to its familiar tooth-edged leaves. The top of the painting is covered with a pale wash so that the plants are delineated clearly against it.

▲ **SILVERY ROOTS** Dürer has not limited his study to what grows above the ground. He has cleared the soil away in places to reveal the fine, threadlike roots of the plants and has set them against a dark wash to make them more visible. The dark sepia tones weave around the bases of the plants and give the composition depth and solidity.

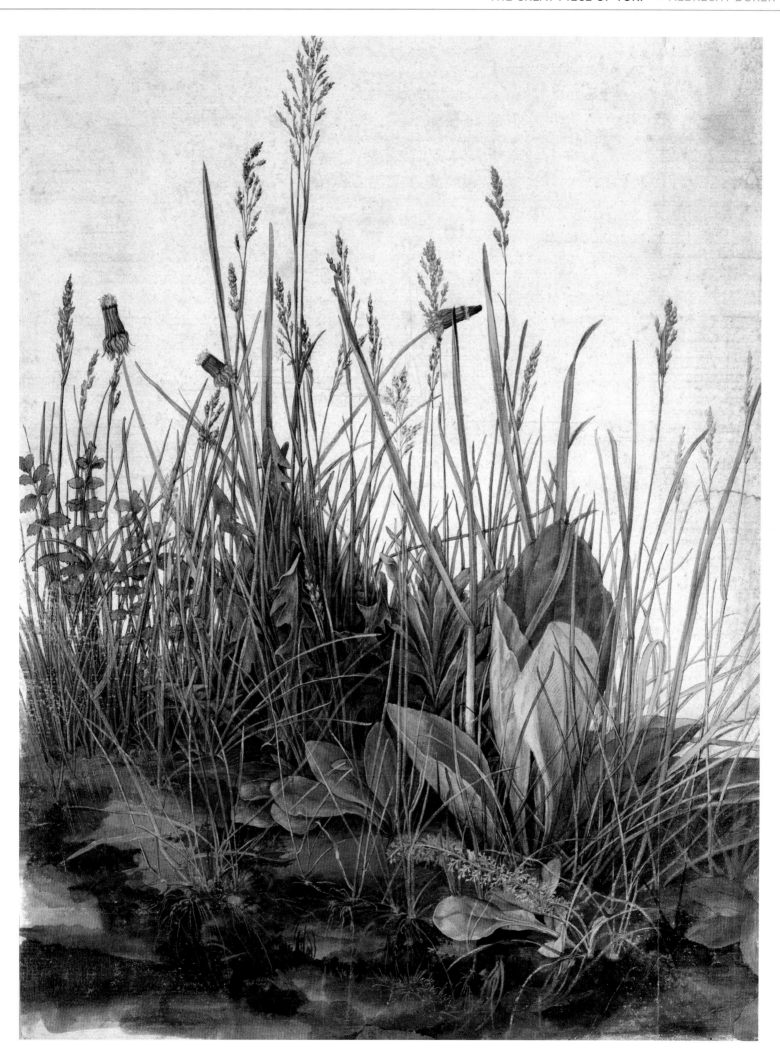

Mona Lisa

c.1503-06 ▪ OIL ON POPLAR ▪ 30¼ × 22in (77 × 53cm) ▪ LOUVRE, PARIS, FRANCE

SCALE

LEONARDO DA VINCI

From behind bulletproof glass in the Louvre, France's national gallery, *Mona Lisa* (also known as *La Gioconda*) looks out at her adoring crowds. Mystery surrounds this beautiful woman, not only because her identity has been debated for so long, but also because her facial expression is ambivalent: strangely open and yet quietly reserved at the same time.

She sits turned slightly toward you as if on a terrace, with an imaginary landscape in the background. Framed by two barely visible columns, she smiles and gazes almost straight into your eyes, but her folded arms keep you at a distance. With this amazing image, Leonardo established a sense of psychological connection between the sitter and the viewer, an innovation in portrait painting that was soon taken up by other artists.

Realism in portraiture

Leonardo's great skill was to breathe life into this remarkable portrait. It is almost as if a real person is sitting in front of you. The softness of Mona Lisa's skin, the shine on her hair, and the glint in her eyes are all achieved by minute attention to detail. Plainly dressed and appearing relaxed, she is particularly renowned for her smile, often described as enigmatic. It is very difficult to determine her exact mood from the mouth or eyes alone. The flicker of a smile plays on her lips, yet her eyes show little sign of humor.

The fashion in portraiture at the time was to paint women as mythological, religious, or historical figures embodying desirable female traits, such as beauty or grace. Such portraits exaggerated women's features to realize these ideals: noses were elongated and necks lengthened. Mona Lisa is represented neither as Venus, the Roman goddess of beauty, love, and fertility, nor as the Madonna—both popular and idealized roles for women at the time. In celebrating this woman's own perfectly balanced features without any need for allegorical embellishment, or even decorative jewelery or costume, Leonardo was clearly breaking with tradition.

There are no existing records of a commission for this portrait and what we know about the sitter comes from biographies of Leonardo. She was probably Lisa

Gherardini, the wife of Francesco del Giocondo, a wealthy Florentine merchant, hence her other title, la Gioconda. *Monna* meant "Mrs." Giocondo's purchase of a new home around the time the portrait was painted, as well as the birth of the couple's third child in 1502, are both plausible reasons for commissioning a portrait. Mona Lisa is seated in a half-length composition, one of the earliest Italian examples of this kind of pose in a portrait.

> She has the **serene countenance** of a woman sure she will **remain beautiful** forever

THÉOPHILE GAUTIER
GUIDE DE L'AMATEUR AU MUSÉE DU LOUVRE, 1898

LEONARDO **DA VINCI**

1452-1519

A genius of the Renaissance, Leonardo is now famous for the range and variety of his talents, embracing science as well as art. He is regarded as the main creator of the High Renaissance style.

Born in or near Vinci, close to Florence, Leonardo served an apprenticeship in the workshop of the Florentine artist Andrea del Verrocchio. He then spent most of his career between Milan and Florence. His last years were spent working for the French monarchy and he died in Amboise, France.

The diversity of Leonardo's interests meant that he produced few finished paintings, but he left behind many sensitive, highly detailed drawings and notebooks. Among other subjects, he studied anatomy, the flight of birds and insects, the forms of rocks and clouds, and the effects of the atmosphere on landscape. All of his observations informed his paintings, in which he combined grandeur of form and unity of atmosphere with exquisite detail. Leonardo's mastery of composition and harmony can be seen in another of his most celebrated works, *The Last Supper* (c.1495-97). Sadly, the painting has deteriorated badly over time because of the experimental technique he used.

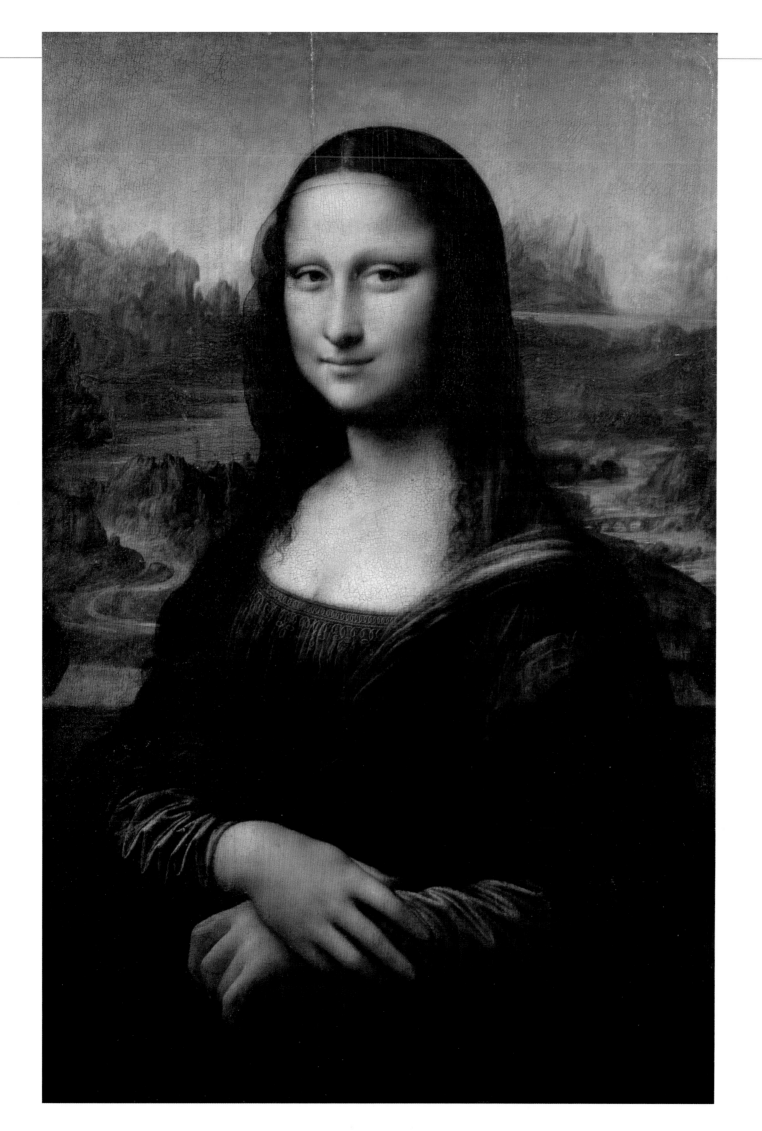

Visual tour

KEY

1

> **ENIGMATIC SMILE**
Leonardo introduced a painting technique known as *sfumato*, which makes subtle use of blended tones. Used here to great effect, it gives Mona Lisa's smile a mysterious softness. Her lips tilt gently upward at the edges, but her expression is hard to read. Alongside other aspects of her pose, this gives *Mona Lisa* an air of remote calmness.

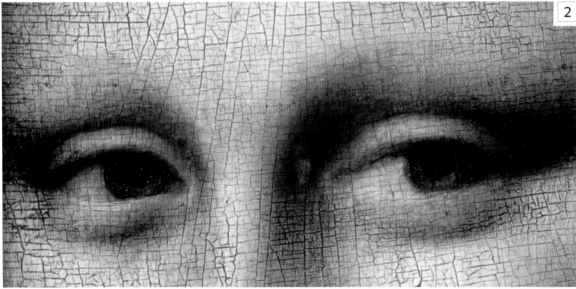

2

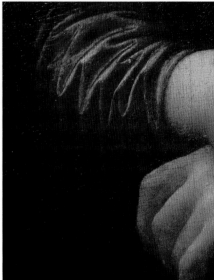

▲ **EYE CONTACT** It is natural to look into someone's eyes. As is the case with many portraits, Mona Lisa's eyes seem to look straight back at you and to follow you around if you move. Leonardo achieves this illusion by directing the left eye squarely at the viewer, and positioning the right eye slightly to one side.

3

> **HAIR** Look carefully at this part of the painting and you can see a dark veil over Mona Lisa's head and to the side of her face, probably indicating her virtuousness. Her hairline and eyebrows may have been plucked, as was fashionable at the time.

▲ **ARMS AND HANDS**
Mona Lisa's folded arms form the base of a triangle that reaches up from each arm to the head. Leonardo used this compositional technique to place his model within a harmonious space—in a geometrical sense—that is pleasing to the eye. Mona Lisa wears neither rings nor bracelets, and her hands look youthfully plump. Her hands and arms look relaxed, as if she is sitting comfortably.

Leonardo would have made studies of every aspect of the portrait, sketching each part individually beforehand. Such attention to detail was unusual and helped to give his paintings their realistic quality.

This study of drapery shows how Leonardo modelled the material using charcoal, chalk, and wash to create the impression of creases. He used the same technique with oil paint on the sleeves of the *Mona Lisa*.

Leonardo dipped rags in plaster to help him paint drapery. The plaster held the fabric in place and emphasizied its folds, giving Leonardo the time to make detailed drawings.

▲ *A Study of Drapery*, Leonardo da Vinci, 1515–17, charcoal, black chalk, touches of brown wash, white heightening, 6½ × 5¾in (16.4 × 14.5cm), The Royal Collection, London, UK

IN **CONTEXT**

This iconic image has been subverted through the ages, perhaps most famously by Marcel Duchamp in his 1919 "readymade," *L.H.O.O.Q.* (below). Duchamp drew a beard and moustache on a postcard of the portrait with those letters beneath it—a crude pun in French suggesting that Mona Lisa is a sexually available woman. Duchamp may also have intended to underline the ambiguity of the sitter's gender.

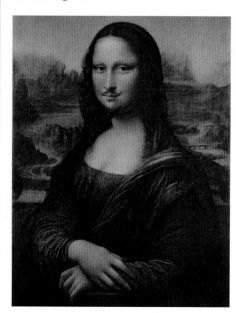

▲ *L.H.O.O.Q.*, Marcel Duchamp, 1919, pencil on card, 7¾ × 4in (19.7 × 10.5cm), Centre Pompidou, Paris, France

▼ **BRIDGE IN PERSPECTIVE** Just behind the right shoulder, you can make out the arches of a bridge spanning a river. As with other parts of this imaginary landscape, Leonardo has painted it so that you look down on it. Mona Lisa's eyes, however, are at the same level as the viewer's.

▲ **SOFT FOCUS** The hazy appearance of the landscape has been achieved with a technique called glazing, in which layers of thinned, transparent oil paint are applied one over the other. Each layer of paint has to be dry before the next is applied. Blue emphasizes the dreamlike effect of the landscape and helps to create the illusion that the background is receding.

▼ **SLEEVES** Leonardo's skilful application of oil paint can be seen in the modeling and tones of the sleeves. Originally these sleeves would have been saffron yellow, but the pigment has faded over many years and the varnish applied to the surface to conserve the paint has also darkened the color.

▲ **WINDING PATH** In an early drawing, Leonardo had already used the pictorial device of a long path or river to lead the viewer's eye into the distance. Visually, the feature appears simply to be part of the landscape but the device is used very cleverly to give the painting depth and to make the space appear less flat and one-dimensional.

The School of Athens

c.1509–11 ■ FRESCO ■ 16ft 4¾in × 25ft 3in (500 × 770cm) ■ VATICAN, ROME, ITALY

RAPHAEL

SCALE

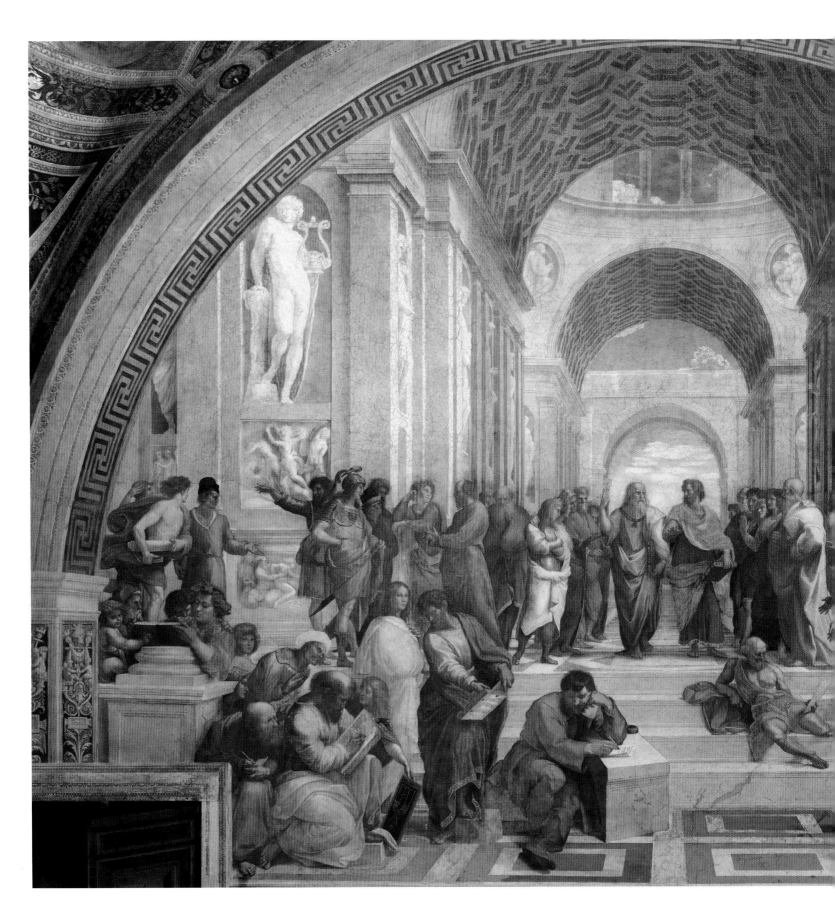

The School of Athens is the most famous of the frescoes commissioned by Pope Julius II when he remodeled his private chambers in the Vatican Palace. Raphael and his assistants undertook the task of decorating all four of these *stanze* (grand rooms) in 1508. They continued their work under Julius's successor, Leo X, but Raphael died before the rooms were completed. This monumental fresco, which depicts an imaginary gathering of classical philosophers and scholars, sits above head height on the wall of the *Stanza della Segnatura* with its vaulted ceiling. It is justly famous for the graceful poses of its figures, the sense of movement they embody, and their expressiveness—all of which Raphael achieved after making hundreds of detailed studies and sketches. The painting's other outstanding feature is the harmony of its composition.

Pursuit of truth and knowledge

The pictorial scheme of the *Stanza della Segnatura* shows that it was used as the papal library and private office. The theme of the frescoes on all four walls is the search for truth and enlightenment, and *The School of Athens* represents the pursuit of rational truth through philosophy. Central to the composition are the figures of the two great classical Greek philosophers, Plato and Aristotle, who represent different schools of thought.

The majestic style of *The School of Athens*, the serene movements and gestures of the figures, and the grand architectural composition with its sense of symmetry and spatial depth all combine to make this work a masterpiece of the High Renaissance. In the brilliant portrayal of the subject matter and the assured style of its execution, Raphael has encapsulated the classical ideal of the pursuit of knowledge.

RAPHAEL

1483-1520

The precociously talented Raphael took on major commissions at a young age. Together with Michelangelo and Leonardo da Vinci, he dominated the High Renaissance period.

Born in Urbino in central Italy, Raffaello Sanzio initially trained with his father, Giovanni, who was a poet as well as a painter. He later assisted in the workshop of the painter, Perugino. In 1508, with his reputation already established, the 25-year-old Raphael was summoned to Rome by Pope Julius II and given a prestigious commission—the decoration of the papal apartments.

Other major commissions followed but these were increasingly executed by assistants in Raphael's workshop. The workshop was so well organized that it is often hard to tell how much workshop contribution there is in a painting. Apart from *The School of Athens* and the other frescoes of the *Stanza della Segnatura*, Raphael's designs for the 10 tapestries for the Sistine Chapel are considered to be among his finest work. He also painted several portraits. Under Julius's successor, Pope Leo X, Raphael became Papal Architect. He died in Rome of a fever, aged just 37.

Visual tour

KEY

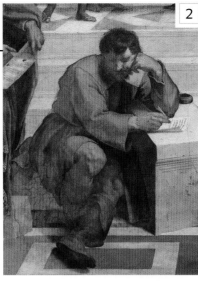

◄ **HERACLITUS** The expressive body language of this figure gives him an air of melancholy. He represents the pre-Socratic Greek philosopher Heraclitus, commonly known as the "weeping philosopher." His well-built frame leans on a block of marble and he seems to be writing dark thoughts on a piece of white paper. This figure is a portrait of Michelangelo, another of Raphael's contemporaries, who was working on the nearby Sistine Chapel when Raphael was painting *The School of Athens*. Raphael is paying the artist a great honor by depicting him in such illustrious company.

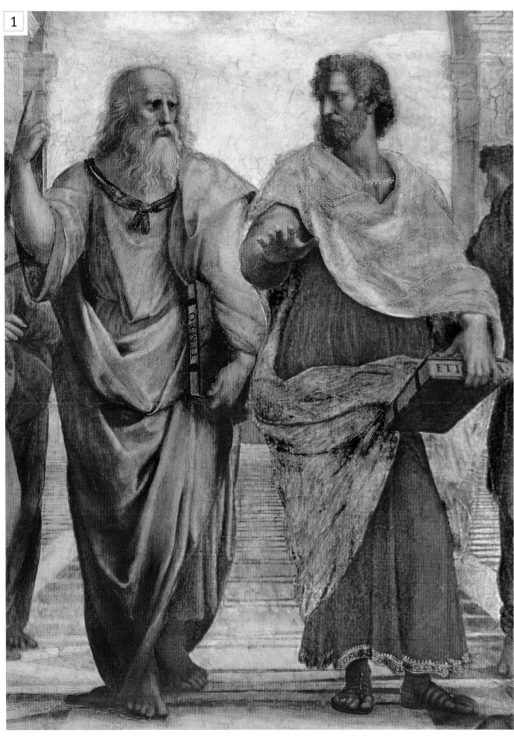

▲ **DIOGENES** A controversial character in Greek philosophy, Diogenes chose to drop out of society and live in poverty inside a barrel. He is pictured here lounging on the steps partially clothed, but he is usually depicted as a beggar living on the streets, unwashed and dressed in rags.

◄ **PLATO AND ARISTOTLE** These two great Greek philosophers represent theoretical and natural philosophy. Under his right arm Plato holds the *Timaeus*, one of his dialogues. Plato believed that a world of ideal forms existed beyond the material universe, so Raphael shows him pointing towards the heavens. He looks like Raphael's contemporary, Leonardo da Vinci, to whom the artist is paying tribute. Aristotle is holding his famous *Ethics* and is gesturing towards the ground. Unlike Plato, Aristotle held that knowledge is only gained through empirical observation and experience of the material world.

▶ **SELF-PORTRAIT** The figure looking out of the painting straight at the viewer is Raphael himself. Wearing a dark beret, the customary headgear of the painter, he is not only identifying himself but possibly making a link between the worlds of the past and the present.

▼ **EUCLID** Leaning over and demonstrating a mathematical exercise with a pair of dividers, the Greek mathematician Euclid is surrounded by a group of young men. Known as the "Father of Geometry," Euclid's writings include observations on "optics," which is closely related to perspective. The figure is a portrait of the architect Bramante.

▲ **PYTHAGORAS** On the opposite side of the painting to Euclid, we find the celebrated Greek philosopher and mathematician Pythagoras. He is demonstrating theories of geometry and, like Euclid, is being watched eagerly by a group of students. One of them holds up a diagram on a slate.

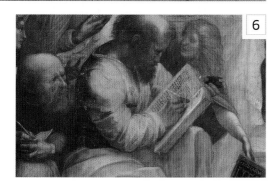

▲ **ZOROASTER AND PTOLEMY** By bringing together philosophy's greatest minds in this painting, Raphael took the opportunity to depict discussions that could never have taken place. Here we see Zoroaster, prophet and philosopher of ancient Persia, talking to Ptolemy, the Greek mathematician, geographer, and astronomer. Ptolemy, who believed the earth was the center of the universe, holds a terrestrial globe in his left hand; Zoroaster is holding a celestial sphere.

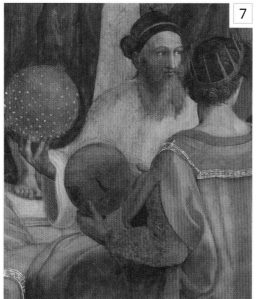

IN **CONTEXT**

Raphael worked on the fresco scheme of the *Stanza della Segnatura*, where each fresco represents one of four themes, between 1508 and 1511. Besides *The School of Athens*, there are three other frescoes in the vaulted *Stanza*. On the wall opposite is the *Disputation of the Most Holy Sacrament* (see below), a representation of theology. Above the painted horizon is the Holy Trinity with saints and martyrs arranged in a semicircle; below them are the Church's representatives on earth, similarly arranged with the Sacrament in the center.

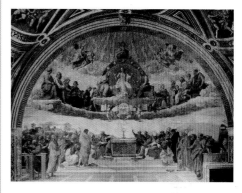

▲ *Disputation of the Most Holy Sacrament*, Raphael, 1509–10, fresco, 16ft 4¾in × 25ft 3in (5 × 7.7m), Vatican, Rome, Italy

ON **COMPOSITION**

The architectural setting of the fresco is imaginary, but its scale and splendor represent the ideals of the High Renaissance. The setting was inspired by the plans of Raphael's friend and distant relative, the architect Donato Bramante, for the papal basilica of St. Peter's. It is an acknowledgment of Rapahel's admiration for Bramante.

In *The School of Athens*, the large central arches decrease in size, creating the illusion of depth. Raphael has placed the two most important figures, Plato and Aristotle, in the center of the painting, where the horizon line converges with the central vertical (see overlay below). Lines radiate outwards from this point. These can still be seen in the original drawing made for the fresco.

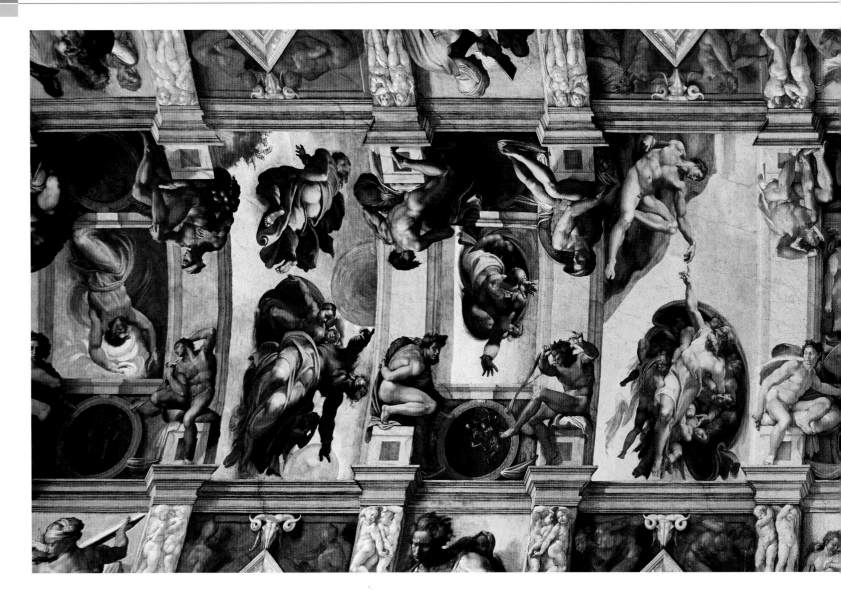

Sistine Chapel Ceiling

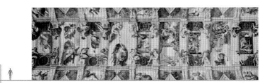

1508-12 ■ FRESCO ■ 45 × 128ft (13.7 × 39m) ■ VATICAN, ROME, ITALY

SCALE

MICHELANGELO

Painted single-handedly over a period of four years and including almost 300 figures, this superhuman achievement earned its creator the title *il Divino* (the Divine) during his lifetime. Michelangelo, an artist with a profound religious faith, also planned the whole imaginative design, making hundreds of detailed, preliminary drawings for the frescoes and skilfully working out the complicated perspective needed for the large, curved surface that would be seen from 20 meters below. His elaborate scheme divides the vaulted roof into narrative scenes, each illustrating a key episode from the creation story in the book of Genesis. Between the scenes are naked, muscular youths, known as *ignudi*. Like all the other figures on the ceiling, they reveal Michelangelo's

deep admiration of classical Roman sculpture and the way it expressed the beauty of the human body. In the niches below the *ignudi*, Old Testament prophets alternate with sibyls, the female seers of ancient Greek mythology. Michelangelo filled the arches around the high windows with more paintings of biblical scenes.

Summoned to the Vatican

Leading Renaissance artists, such as Botticelli and Perugino, had been commissioned to decorate the walls of the Sistine Chapel some 20 years earlier, and Pope Julius II, an ambitious and authoritarian figure, was determined that Michelangelo should renovate the ceiling, which had been painted to resemble a star-studded sky. After initial

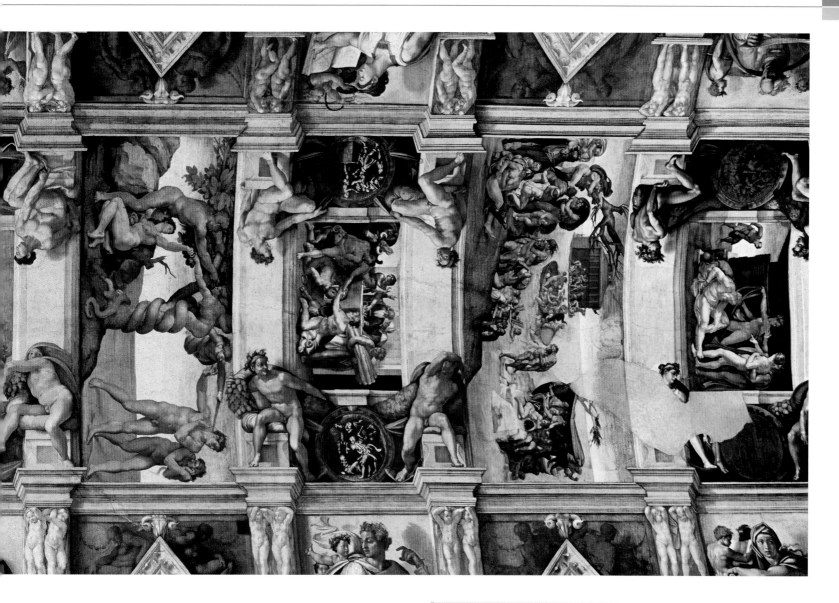

reluctance—Michelangelo saw himself primarily as a sculptor not a painter—the special scaffolding designed by the artist was put in place and Michelangelo embarked on years of lonely and physically demanding work, while beneath him church services were conducted as normal. The great ceiling fresco was finished in October 1512.

Before the most recent restoration work, which was completed in 1992, Michelangelo's biblical scenes looked dark and muted. Once hundreds of years' worth of accumulated grime had been expertly removed, however, the brilliance of the colors shone through. Even in reproduction the ceiling is an awe-inspiring sight as well as a fitting testament to the extraordinary vision and artistic genius of this intensely spiritual man.

> ## As we look upwards we seem to look into…a world of more than human dimensions ""
>
> **ERNST GOMBRICH** *THE STORY OF ART*, 1950

MICHELANGELO

1475-1564

One of the greatest artists of the Renaissance, Michelangelo Buonarroti was a sculptor, painter, architect, and poet. No other artist has ever equalled his mastery of the nude male figure.

Born near Arezzo, Tuscany, into a minor aristocratic family, Michelangelo worked as an apprentice in the workshop of the painter Domenico Ghirlandaio, where he learned fresco painting. Soon afterward, he joined the household of Lorenzo de' Medici and made figure drawings based on the works of Giotto and Masaccio. After Lorenzo's death, Michelangelo moved to Rome, where he made his name with the beautiful, sorrowful *Pietà*, the marble sculpture of the Virgin Mary cradling the dead Christ. His technical mastery was also evident in *David*, the colossal statue he created for the city of Florence, completing it in 1504.

A year later, Pope Julius II commissioned Michelangelo to create sculptures for his papal tomb, but this grand scheme was scaled down dramatically. Meanwhile, the deeply devout artist had embarked on another prestigious commission for Julius—the Sistine Chapel ceiling. Michelangelo was just 37 years old when he finished it. Other commissions, some for the Medici family and several for the papacy followed, notably the painting of *The Last Judgement* on the altar wall of the Sistine Chapel, which was commissioned by Pope Paul III. This huge fresco depicts the terrible fate of corrupt humanity.

Michelangelo was appointed architect to St. Peter's in Rome in 1546, and the last years of his life were devoted mainly to architecture, notably redesigning the great dome of the church. He died in Rome.

Visual tour

KEY

◀ **1 SEPARATION OF LIGHT FROM DARKNESS** "Let there be light" (Gen. 1:3-5). In the first of Michelangelo's scenes depicting the biblical creation of the world, the figure of God is shown directly overhead. Stretched out full-length, he seems to be twisting through the stormy atmosphere. He is separating light from darkness with his powerful arms.

▼ **CREATION OF PLANTS, SUN, MOON, AND STARS** In this scene, Michelangelo shows the third and fourth days of Creation, with two massive figures representing God. The figure with swirling robes seen from the back is a depiction of God creating vegetation and fruit trees on earth. The bearded figure with outstretched arms points to a ball of golden light, the sun. The other beautifully modeled hand points back to the moon, the second "light" in the heavens.

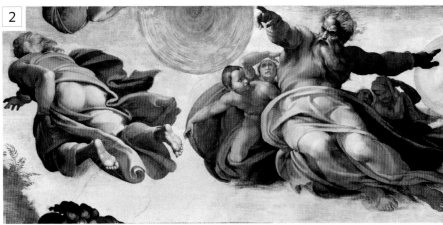

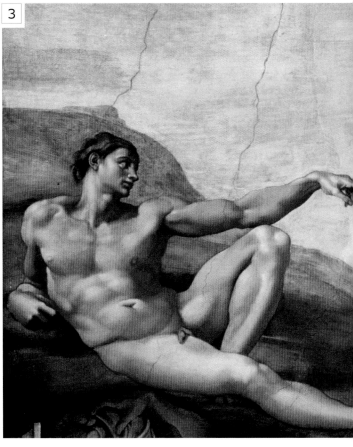

▶ **CREATION OF EVE** On the sixth day of creation, God created Adam "in his own image." After sending him into a deep sleep, God made Eve, the first woman, from one of Adam's ribs. Here Eve is shown emerging, her hands raised to the cloaked figure of God, who appears to be gesturing for her to rise.

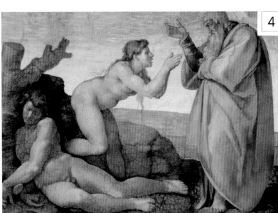

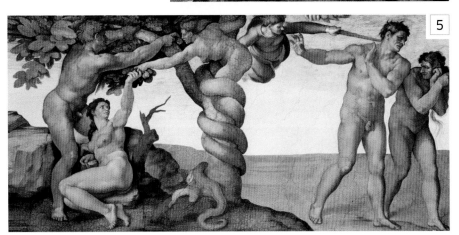

▲ **THE CREATION OF ADAM** Probably the most celebrated scene of the whole *Sistine Chapel*, this famous image is recognizable from the central detail alone–two beautifully sculpted fingers on the point of touching. God, the grey-haired, authoritative Father, is a dynamically charged figure who extends his physical and spiritual energy out toward Adam. With his athletic body and lovely face, Adam embodies beauty that is divine in origin. The anatomical accuracy and youthful grace of this figure recall the perfection of *David*, which Michelangelo created in 1501-04.

◀ **THE FALL AND EXPULSION** This scene depicts two separate episodes from the Book of Genesis. On the left, Adam and Eve are in the Garden of Eden and a serpent with a powerful female body and a coiled tail is offering Eve the forbidden fruit from the tree of knowledge of good and evil. To the right, the sinful couple, ashamed and remorseful, are being banished from leafy Eden by a warrior angel and are heading into a barren landscape.

THE FLOOD In a scene of great turbulence, Michelangelo shows people fleeing from the rising flood waters–God's punishment for humanity's corruption. In the background floats Noah's wooden ark, while in the foreground families struggle to higher ground, hair and clothes whipped about by the wind. Chaos and panic reign.

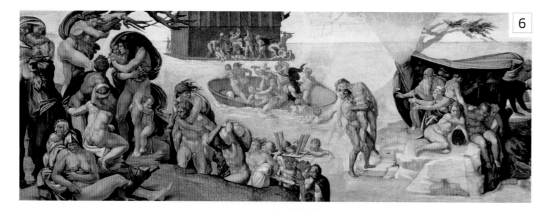

6

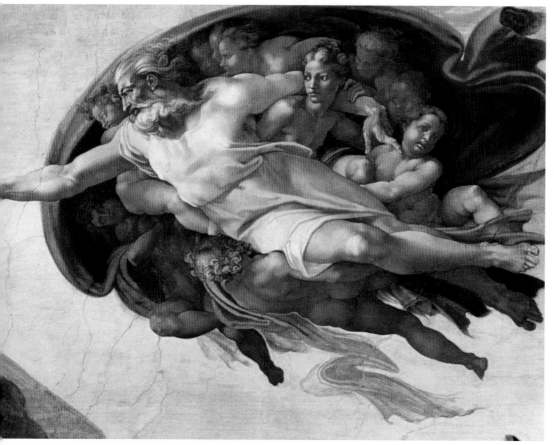

ON **TECHNIQUE**

Michelangelo's depiction of male figures on the ceiling of the Sistine Chapel shows that he was greatly influenced by the classical marble sculptures of antiquity, such as the *Belvedere Torso* (below). Signed by Apollonius, a Greek sculptor, little is known of the statue's origins, but by 1500 it was considered one of the world's greatest works of art, together with the *Apollo Belvedere,* and Michelangelo probably made many studies of it. The similarity between the rugged *Belvedere Torso* and Michelangelo's powerful, anatomically exact male forms is most apparent in the muscular, seated figures of the *ignudi* at the sides of the ceiling's central scenes.

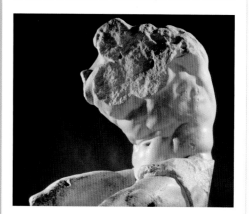

▲ *Belvedere Torso*, Apollonius, 62½in (159cm) high, Vatican Museums, Rome, Italy

IN **CONTEXT**

In 1535, Michelangelo was commissioned to paint *The Last Judgement* on the altar wall of the Sistine Chapel. In this monumental work, a commanding, vengeful Christ is at the center of the composition, delivering the final verdict on human souls. It is a vision from which the artist's earlier idealism is absent; instead, the fresco reflects Michelangelo's own spiritual anguish. *The Last Judgement* was censured by Catholic elders, who objected to the level of nudity on display, and after Michelangelo's death, some strategically placed painted drapery was added.

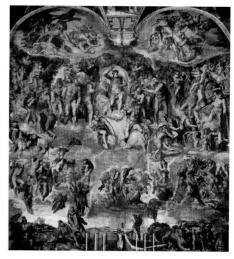

▲ *The Last Judgement*, Michelangelo, 1536-41, fresco, c.48 × 44ft (14.6 × 13.4m), Sistine Chapel, Vatican, Rome, Italy

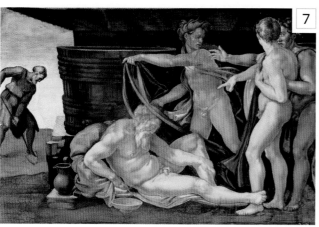

7

◄ **DRUNKENNESS OF NOAH** According to the book of Genesis, Noah cultivated vines, became drunk on his own wine, and fell asleep unclothed. When one of Noah's sons saw his father naked, he called his two brothers. The three are shown attempting to cover Noah's nakedness while averting their gaze. In his depiction of the drunken Noah, Michelangelo may have been inspired by antiquities displayed in the papal collection: the pose resembles that of a classical Roman river god. Noah's sons, too, are barely covered and their sturdy bodies look very sculptural.

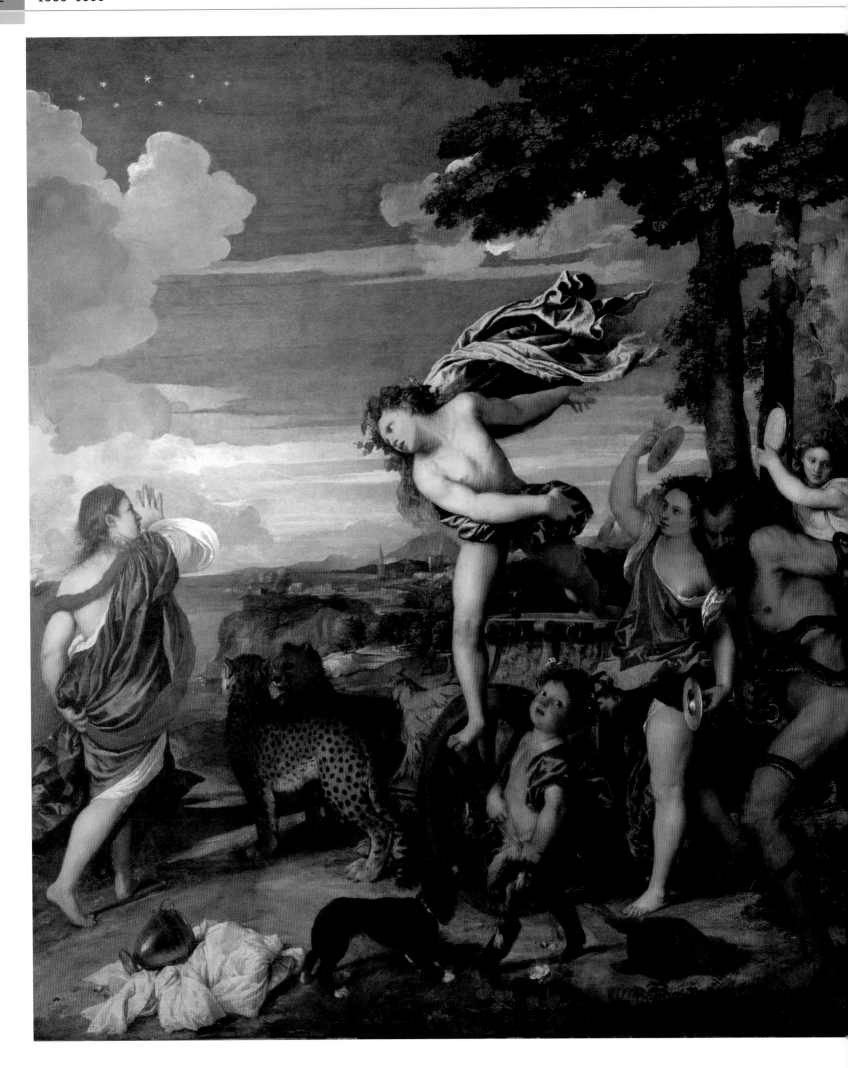

Bacchus and Ariadne

1520-23 ▪ OIL ON CANVAS ▪ 69½ × 75in (176.5 × 191cm)
NATIONAL GALLERY, LONDON, UK

 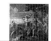

SCALE

TITIAN

This dynamic scene captures the highly charged moment when Bacchus, Roman god of wine, first sets eyes on Ariadne, daughter of King Minos of Crete, and the pair fall in love. The painting is full of movement, from the leaping Bacchus with his rippling cloak to the dancing forms of the revelers who follow the god and play their musical instruments. This rather chaotic retinue fills the lower right-hand section of the painting, while the left side is dominated by the beautifully draped figure of Ariadne. Bacchus, apparently caught in midair, is the focal point of the composition, the astonished expression on his face elegantly captured. The painting truly glows: Titian's brilliant colors, especially the pure ultramarine of the sky and the women's garments, give the painting exuberance and harmony. It is an uplifting work, brimming with energy and passion, that brings this celebrated mythological love story alive.

The details of *Bacchus and Ariadne* closely follow those in the original Latin poems by Ovid and Catullus. After helping her lover, Theseus, slay the Minotaur—the fabled beast imprisoned in a labyrinth—Ariadne has been abandoned on the Greek island of Naxos. When Bacchus arrives on the island in his chariot and sees Ariadne, it is love at first sight and the two later marry. Alfonso d'Este, Duke of Ferrara, a wealthy patron of the arts, commissioned *Bacchus and Ariadne* as part of a series of mythologically themed paintings for his small private picture gallery, the *camerino d'alabastro* (alabaster cabinet). Titian took on three of the paintings—the other two are the *Worship of Venus*

and *Bacchanal of the Andrians*—after much persuasion by the duke. *Bacchus and Ariadne* was the second painting and the artist, who was in great demand and working on big religious and secular commissions, took two and a half years even to start it. The patronage of such a sophisticated, cultured nobleman as Alfonso was important for the ambitious Titian and he created a magnificent celebration of love that would both please the duke and flatter his intelligence.

TITIAN

C.1488-1576

The greatest painter of 16th-century Venice, Titian was a master colorist and one of the most successful artists of the High Renaissance.

Born Tiziano Vecellio in a small town in Italy's Dolomite mountains, Titian was apprenticed in Venice at a young age. At that time Giovanni Bellini was the city state's official painter. When Bellini died in 1516, Titian had few rivals. He became the greatest painter of the Venetian school and brought a new vitality and expressiveness to altarpieces, mythological scenes, and portraits. Titian's innovations in composition can be seen in religious works such as the *Pesaro Altarpiece*, 1519-26; his mythological canvases are vibrant, colorful, and sensuous; and his equestrian portrait of Emperor Charles V, leader of the Hapsburg dynasty, set the standard for royal portraiture.

A jubilant shout of a painting…with its immensity of implausibly pure ultramarine

MARK HUDSON *TITIAN: THE LAST DAYS,* 2009

Visual tour

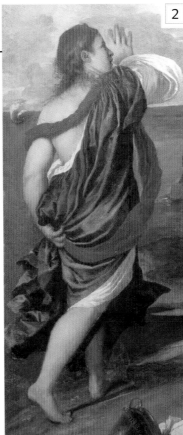

KEY

◀ **BACCHUS** The dynamic, leaping figure of the Roman god is the focus of the painting. Bacchus is recognizable by the crown of laurel and vine leaves around his head and his expression has been painted by the artist with great sensitivity. His beautifully modeled pink cloak unfurls behind him like a pair of wings, and he seems to be launching himself toward Ariadne. The clouds in the sky above Bacchus emphasize his trajectory.

◀ **ARIADNE** The abandoned princess appears shocked by Bacchus and his rowdy followers. With her body turned and her hand raised high towards her lover's departing ship, she is caught unaware. The twist of her body as she looks over her shoulder at Bacchus is skillfully depicted and the spiraling movement is emphasized by her streaming robes, sash, and hair. The rich, bright red of Ariadne's sash is echoed in the pink of Bacchus's cloak and provides a visual link between the two figures. The shape of Ariadne's billowing right sleeve is also picked up by the cloud forms directly above.

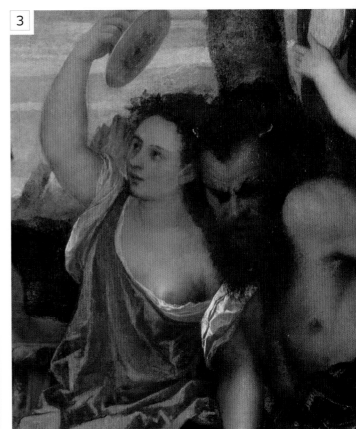

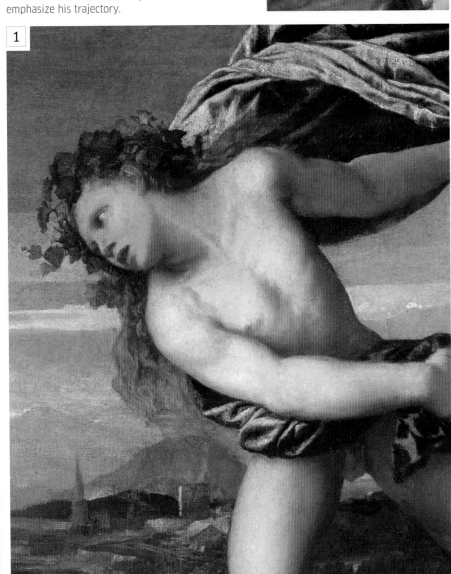

▲ **THESEUS'S SHIP** On the distant horizon is a boat with white sails, towards which Ariadne appears to be reaching. This tiny detail refers to the earlier part of the mythical story—Ariadne's abandonment by Theseus, who could not have killed the Minotaur and escaped from the labyrinth without her help. Theseus brought her from Crete to the island of Naxos then sailed away, leaving her alone. Titian was creating a work that would be seen by a cultured audience, so all the details, however small, had to be correct.

CROWN OF STARS The stars above Ariadne's head are a reference to the romantic ending of the myth. After falling in love with her, Bacchus promises Ariadne the sky if she will marry him. When she agrees, he takes her crown and throws it in the air, where it is transformed into a constellation of stars.

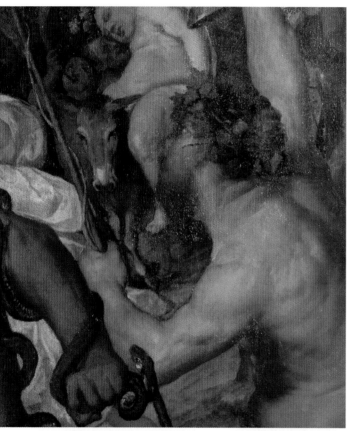

BACCHANALIAN REVELLERS The god of wine and the bringer of ecstasy (Dionysus in Greek myth) was usually accompanied by a noisy retinue that included satyrs. With pointed ears, small horns, and hairy bodies that usually ended in a goat's tail, these creatures were lecherous nature spirits who liked to chase nymphs through the forests. The writhing, muscled figure in the foreground, wrapped in snakes, is based on Laocoön, a Trojan priest in the classical sculpture, *Laocoön and His Sons*. It had been discovered in 1506 and was greatly admired by Renaissance artists.

CHEETAHS Echoing Bacchus and Ariadne's first electrifying glance, the cheetahs pulling the god's chariot look meaningfully into each other's eyes. According to some accounts, Alfonso d'Este had a menagerie which housed cheetahs. Titian had been a guest at the duke's court, so this inclusion is a personal reference. Usually, Bacchus's chariot would have been pulled by leopards.

URN The bronze urn resting on the piece of yellow fabric bears the Latin inscription, *TICIANUS F(ECIT)*, which means "Titian made this." It is a novel way to sign a painting and, perhaps, as a discarded vessel from the partying group, refers to Titian's own extravagant lifestyle.

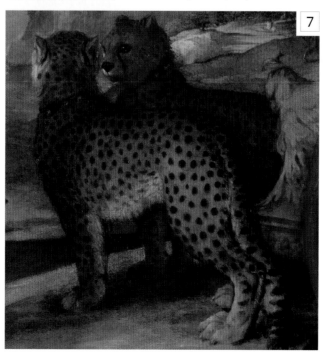

ON **TECHNIQUE**

The exquisite ultramarine of Ariadne's robe is made from finely crushed lapis lazuli, a costly semiprecious stone. When used in its purest form, as in the darkest areas in the painting, the paint dries very slowly and is prone to cracking as the surface shrinks. These cracks are visible in the original painting.

When the painting was X-rayed, it was clear that Ariadne's bright red sash had been painted on top of the flesh tones of her shoulder, and that both shoulder and sash had been applied over the background of sea. This helps to explain how Titian worked on the painting. It appears that he did not create an underdrawing to map out the position of the figures but adopted a more flexible approach to the composition.

IN **CONTEXT**

Once the theme for his private gallery was established, Alfonso d'Este wished to commission the best Italian artists of the day. He commissioned Bellini's painting *The Feast of the Gods* (1514) and approached Raphael and Fra Bartolomeo. Both artists produced preliminary drawings but died shortly after, so Titian took on the commissions.

Shown below is one of the two other mythological scenes Titian created for Alfonso, *Bacchanal of the Andrians*. A celebration of the effects of a flowing stream of red wine on the inhabitants of an island blessed by Bacchus, it is a sensuous, energetic work.

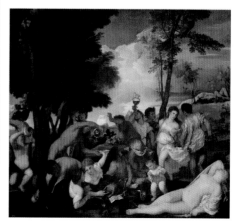

▲ *Bacchanal of the Andrians*, Titian, 1523–26, oil on canvas, 69 × 76in (175 × 193cm), Prado, Madrid, Spain

The Ambassadors

1533 ▪ OIL ON PANEL ▪ 81½ × 82½in (207 × 209.5cm) ▪ NATIONAL GALLERY, LONDON, UK

SCALE

HANS HOLBEIN THE YOUNGER

The powerful realism of this double portrait, which stands taller than the average man, is startling. The ambassadors of the title are two distinguished young men posing against a rich emerald-green backdrop. Gazing directly out from the composition and shown full-length, each with an arm resting proprietorially on a what-not (a table with shelves for ornaments), they immediately engage our attention. Every detail of their clothing–and of the scentific, musical, and astronomical instruments arranged between them–has been immaculately depicted. The heavy, beautifully textured robes, the selection of objects, and the confident posture of both men testify to their powerful status, wealth, and learning; and both are less than 30 years of age.

Symbols and reference points

Holbein portrayed his subjects in a realistic yet deeply respectful fashion. *The Ambassadors*, commissioned by Jean de Dinteville, the sumptuously attired man on the left, is one of his most magnificent works. De Dinteville, the young French Ambassador to the English Court of Henry VIII, is pictured with his friend, Georges de Selve, Bishop of Lavaur, during a visit to England in 1533 at a time of political and religious crisis in Europe. Holbein, who had left Switzerland in 1532, painted them in London, where they were on a difficult and ultimately unsuccessful mission to prevent Henry from severing ties with the Roman Catholic Church.

It was usual to portray learned men with their books and personal objects, but what makes this painting so remarkable is the extraordinary attention to detail and the amount of information it contains. The objects on the upper shelf on which de Dinteville and de Selve are leaning are scientific instruments, while those on the lower shelf indicate other intellectual and artistic pursuits, such as music. However, the most unusual element in the painting is the strange distorted disk, set at an angle in the foreground between the two men. It is a stretched-out skull that becomes recognizable when the painting is viewed from a point to the right. Holbein may have been displaying his technical abilities by

incorporating this perspective device to emphasize the transitory nature of life. The youth of the sitters, their wealth and status, along with the precious objects in the painting must be seen in the context of this central reference to human mortality.

Holbein's double portrait is even more complex than it first appears. With its many, sophisticated symbols, it serves as a memorial to the two young ambassadors.

> A chilling reminder that amidst all this wealth, power, and learning, death comes to us all

JEREMY BROTTEN *THE RENAISSANCE BAZAAR*, 2003

HANS **HOLBEIN THE YOUNGER**

c.1497-1543

The greatest German painter of his generation, Holbein is famed mainly for his penetrating portraits. But he was a highly versatile artist, with many other sides to his talent.

Holbein was born in Augsburg, Germany, into a family of artists, and he spent his early career mainly in Basel, Switzerland. He quickly became the leading artist of the day there, producing book illustrations (it was a major publishing center), altarpieces, murals, and designs for stained glass, as well as portraits.

In spite of his success, religious strife between Catholics and Protestants encouraged him to try his fortune elsewhere and, in 1526, he moved to England. He returned to Basel in 1528, but in 1532 he settled in England permanently. By 1536, he was working for Henry VIII. He is now most famous for portraits (drawn and painted) of members of the royal family and court, in which he memorably captured the intrigue, as well as the glamour, of the age. When he died in London–probably of the plague–he was still in his forties and at the peak of his powers.

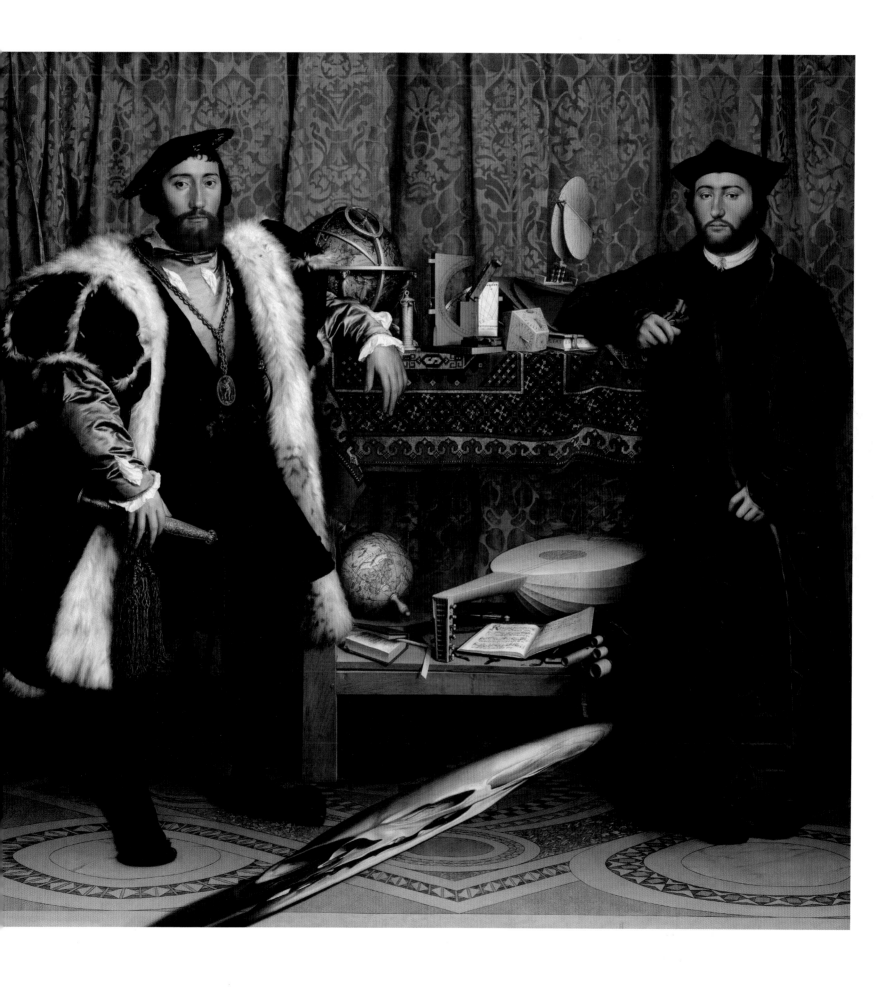

Visual tour

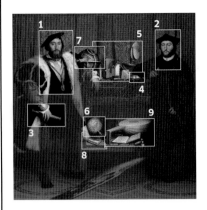

KEY

> **JEAN DE DINTEVILLE** The French nobleman wears a heavy black coat with a lynx-fur lining. The texture of the fur has been rendered in exquisite detail and there is a beautiful sheen on the pink silk beneath. On de Dinteville's hat is a skull, his personal insignia, and his gold chain bears the pendant of a high chivalric order.

▼ **THE FRIEND** Georges de Selve was a classical scholar and became Bishop of Lavaur. He was sent to many European countries as an ambassador and was in London in 1533. This painting commemorates his stay.

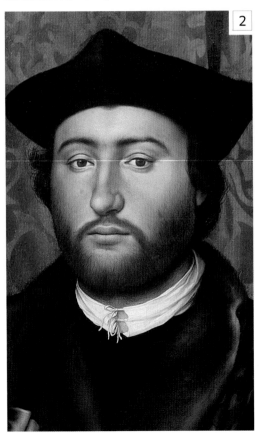

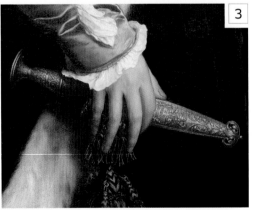

▲ **MEASURING INSTRUMENTS** On the top shelf is a range of instruments including a sundial for measuring the time of day and a navigational instrument for finding the position of stars. Both men lived in an age of great discovery, when advances in the development of scientific instruments made the circumnavigation of the globe possible. The instruments clearly place the painting in its historical context.

◄ **DAGGER** Jean de Dinteville has his hand on a dagger in a gold sheath. On it are embossed the characters *AET. SUAE 29*. These are in Latin and, in abbreviated form, refer to de Dinteville's age— 29 years. This is an ornamental, ceremonial knife, rather than one designed for combat.

◄ **BOOK** The Latin text written on the edges of the pages of the book under George de Selve's right arm reads *AETATIS SUAE 25*. Like the inscription on de Dinteville's dagger, it tells us the sitter's age—25. The book could be a bible, complete with a decorative clasp.

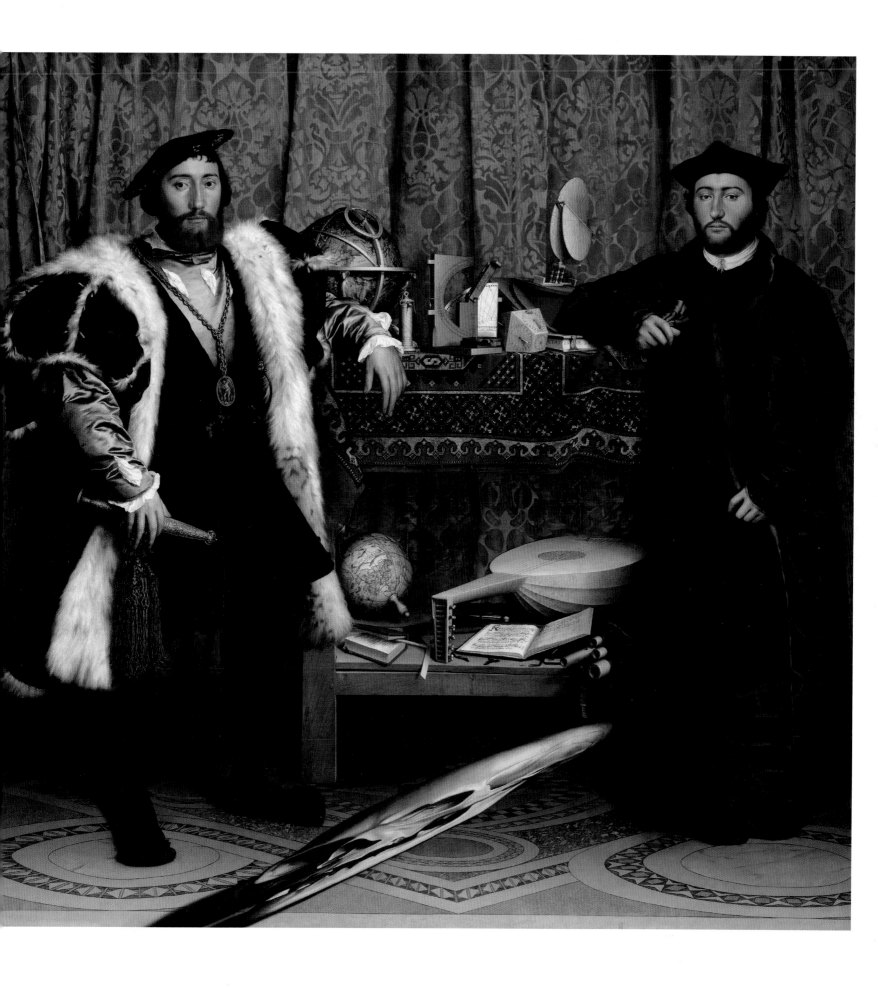

Visual tour

KEY

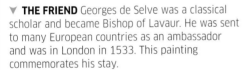

▶ **JEAN DE DINTEVILLE** The French nobleman wears a heavy black coat with a lynx-fur lining. The texture of the fur has been rendered in exquisite detail and there is a beautiful sheen on the pink silk beneath. On de Dinteville's hat is a skull, his personal insignia, and his gold chain bears the pendant of a high chivalric order.

▼ **THE FRIEND** Georges de Selve was a classical scholar and became Bishop of Lavaur. He was sent to many European countries as an ambassador and was in London in 1533. This painting commemorates his stay.

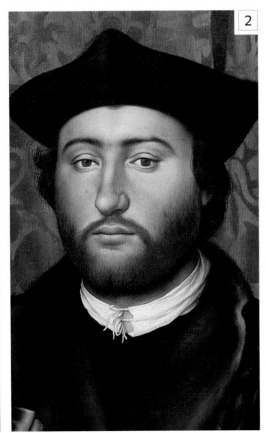

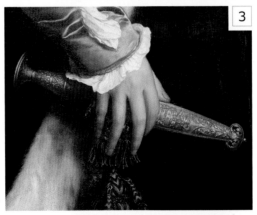

▲ **MEASURING INSTRUMENTS** On the top shelf is a range of instruments including a sundial for measuring the time of day and a navigational instrument for finding the position of stars. Both men lived in an age of great discovery, when advances in the development of scientific instruments made the circumnavigation of the globe possible. The instruments clearly place the painting in its historical context.

◀ **DAGGER** Jean de Dinteville has his hand on a dagger in a gold sheath. On it are embossed the characters *AET. SUAE 29*. These are in Latin and, in abbreviated form, refer to de Dinteville's age— 29 years. This is an ornamental, ceremonial knife, rather than one designed for combat.

◀ **BOOK** The Latin text written on the edges of the pages of the book under George de Selve's right arm reads *AETATIS SUAE 25*. Like the inscription on de Dinteville's dagger, it tells us the sitter's age—25. The book could be a bible, complete with a decorative clasp.

▼ TERRESTRIAL GLOBE Turned on its side, the globe has been positioned to show places important to de Dinteville, under whose right hand it is positioned. Polisy, near Troyes, the name of Jean de Dinteville's château, is one of the few places marked on the globe. The painting first hung in the château.

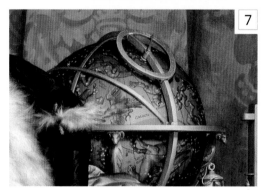

▲ CELESTIAL GLOBE This globe was used by astronomers to find and map the positions of stars, the moon, and the planets. The stars are highlighted in gold and the patterns of the constellations are depicted with background illustrations.

◄ MATH BOOK AND T-SQUARE A German mathematics book, published in 1527, has been included on the lower shelf, complete with T-square. It signifies that both figures are men of great intellect and broad education.

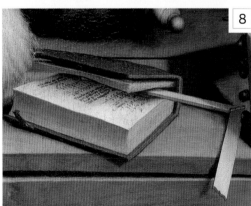

► LUTE The collection of musically themed objects on the lower shelf of the table includes a lute, a Lutheran hymn book, and a set of cases for flutes. Although barely visible, one of the lute's strings is broken—a possible reference to the increasing discord between Catholics and Protestants. The hymn book has been seen as a plea for religious harmony.

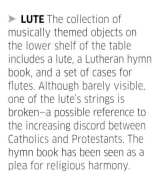

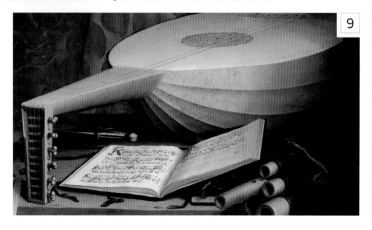

ON **TECHNIQUE**

The Ambassadors may have been designed to hang in a stairwell or beside a doorway so that it would be approached from the right-hand side. Only from this viewpoint is the skull seen in the correct perspective. This technique of distorting objects is known as anamorphosis. Artists usually employed it in works of a lighthearted nature as a piece of visual trickery, intended to amuse.

The diagrams below attempt to demonstrate how Holbein might have achieved the distorted perspective. He would probably have planned out the skull on a grid of squares first. This image was then transferred and fitted into a grid of rectangles in the required ratio.

IN **CONTEXT**

The Ambassadors was painted at a time of religious conflict throughout Europe following Luther's call for the reform of the Catholic Church and the establishment of Protestantism. Pope Clement VII's refusal to annul the marriage of King Henry VIII and Catherine of Aragon had also resulted in a major religious crisis in England. In 1534, Henry defied Rome and set up the Church of England with himself as its leader.

There is a partially hidden crucifix behind the green curtain (above de Dinteville's right shoulder). This may refer to the religious conflict. It has also been convincingly argued that the painting is concerned with what was thought to be the 1500th anniversary of Christ's Crucifixion.

Spring Morning in the Han Palace

c.1542 ▪ INK AND COLORS ON SILK ▪ 12in × 18ft 10in (30.6cm × 5.74m)
NATIONAL PALACE MUSEUM, TAIPEI, TAIWAN

QIU YING

SCALE

This exquisite silk handscroll shows an imaginary scene inside the grounds of a Chinese imperial palace. Although made around 1542, the painting is set over 2,000 years ago, during the Han dynasty, which ended in 220 BCE. Qiu Ying, a Ming dynasty artist, was commissioned by the celebrated collector Hsiang Yüan-pien to make this painting during a period when China was reasserting its cultural and political identity. The meticulously decorated scroll was designed to be unfurled an arm's length at a time and read much like a book, starting from

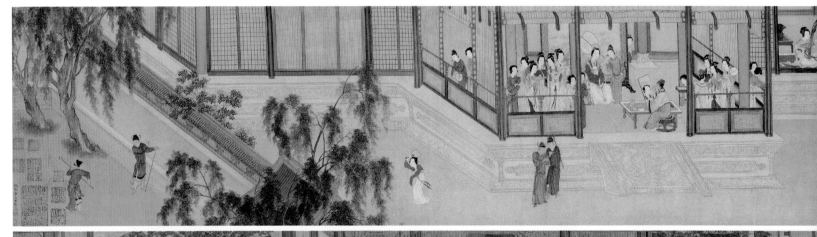

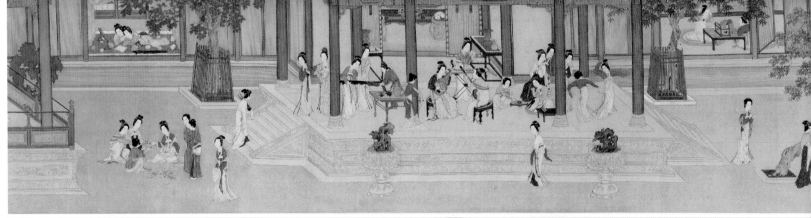

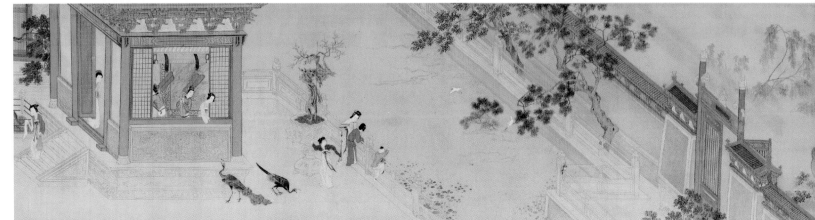

the right (bottom right below), then following the narrative all the way along to the far left (top left below). Beautifully shaped trees and rocks adorn the grounds of the imperial palace, and pillars and porticos define the structure of the pavilions. The panoramic narrative depicts the concubines of the imperial court taking part in various leisure activities on a spring morning. Through open screens we see into the enclosed and privileged world of the palace, where concubines make music or play chess, dance, have tea, entertain their children, or take a stroll.

These exquisitely dressed females are all slender, delicate, and similar in size. The beautiful patterns and colors of their garments, however, are subtly different. The decorative elegance of the whole scroll is achieved with a limited palette of muted orange, with touches of green, bright red, and blue spread throughout. Rhythm and pattern are created by urns, plants, fencing, and latticework, which help to unify the composition, and also by the loose black chignons of the concubines, which punctuate the painting and look, to a Western viewer, almost like notes on a musical score.

A story within the story

Inside the first pavilion on the left sits the court artist Mao Yen-shou. According to a famous story, Mao was ordered by Emperor Yüan-ti to paint the portraits of all the imperial concubines, to help the Emperor remember who was who. Each concubine bribed Mao to make her look more beautiful than she really was, except for the virtuous Wang Chao-chün. The artist made her portrait less attractive, and the emperor, believing it to be a true likeness, married her off to a northern barbarian chieftain. When he saw Wang Chao-chün, however, he realized that she was the most beautiful of all and in a fit of rage ordered that the artist be executed.

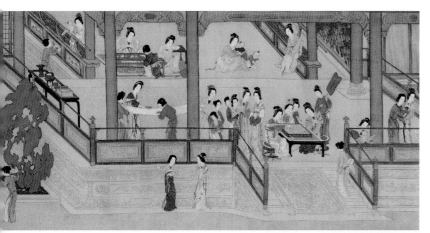

> The **marvelous visual effects** …may explain why **Qiu's** name became so **intimately connected** with this kind of **courtly-style painting**

LUTHER CARRINGTON GOODRICH AND CHAOYING FANG
DICTIONARY OF MING BIOGRAPHY, 1976

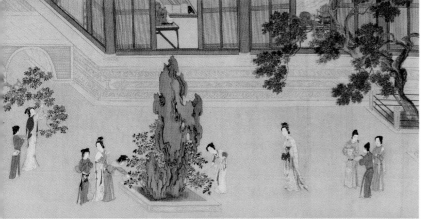

QIU YING

1494–c.1552

One of the "Four Great Masters" of Chinese painting of the Ming dynasty (1368–1644), Qiu Ying was renowned for his decorative landscapes and depictions of palace life.

Born into a family of modest means in Jiangsu Province, Qiu Ying made his income from selling his paintings. He was not technically a member of the *literati*—highly educated men who were not obliged to earn a living, but painted, studied calligraphy, and wrote poetry to express themselves—but he associated with them and was ranked alongside *literati* painters.

After studying with Zhou Chen, who also taught Tang Yin—one of the other Four Great Masters—Qiu Ying learned to paint in many styles and genres, tailoring them to the tastes of his prosperous patrons. Showing great skill in many techniques, he made exact copies of ancient T'ang and Sung dynasty masterpieces, incorporating his own ideas about color into the work. Qiu Ying painted landscapes in translucent blues and greens with a sensuous delicacy that appealed to the tastes of wealthy Ming dynasty collectors, and his beautifully defined figures show his exquisite draftsmanship.

Visual tour

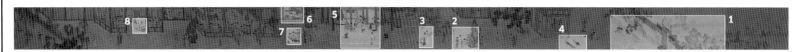

KEY

> **PALACE GATES** Unrolling a handscroll is both like setting off on a journey and starting to read a story. Starting at the right, you begin by moving through a misty wood of graceful Oriental trees, then come across the boundary of the palace's walled garden. The ornate red gate is open, and once inside the garden, the mist suddenly clears and you see birds. Spring is in the air.

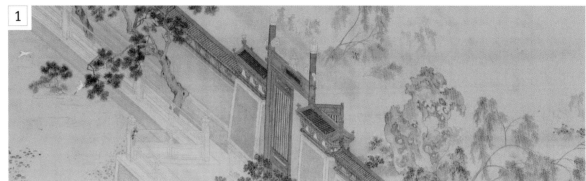

> **TENDING THE GARDEN** Here two women converse, while a third bends over to tend a shrub, which softens the strong outline of an ancient rock. Qiu Ying creates rapport between the numerous figures shown in the scroll by arranging them in harmonious small groups engaged in different activities— a characteristic of his personal style.

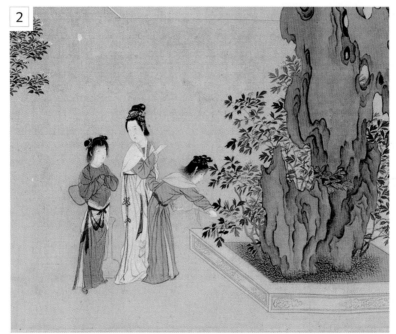

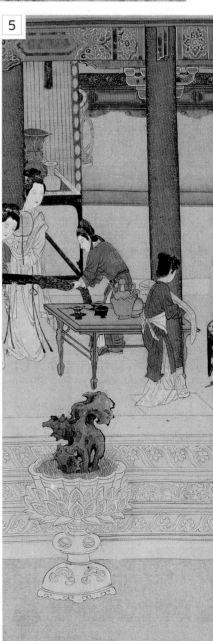

▼ **ELEGANT COSTUMES** Although the setting of the painting is imaginary, the elaborate garments worn by the concubines are faithful reproductions of Han dynasty costumes. The willowy forms of the palace ladies are draped in flowing silk robes that enhance their beauty and graceful gestures.

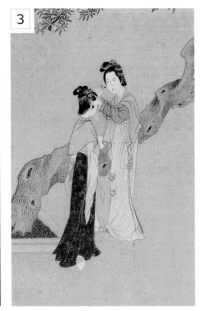

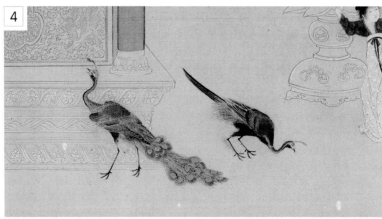

▲ **ROYAL PEACOCKS** A pair of peacocks forage for food near the palace gates. They are standing parallel to each other, their tails pointing in opposite directions, echoing the diagonal lines of the moat and the garden wall. These diagonals are repeated in the palace architecture throughout the scroll, creating a sense of rhythm and continuity. The peacock, with its crown of feathers and ornamental tail, has long been a traditional symbol of royalty in both Asian and European art.

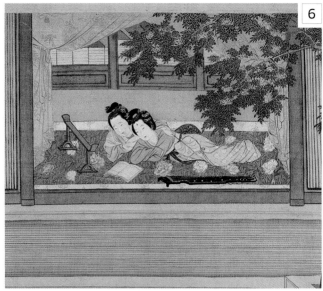

6

◀ **IDEAL BEAUTY** These two women are reading quietly. Resting on their elbows, their perfectly oval faces are turned slightly sideways. They may represent a form of ideal beauty: their eyes are exactly halfway between their chins and hairlines, their eyebrows and lips are fine, and their noses are shown in profile and drawn with a single line.

▼ **LADIES OF LEARNING** The way in which the imperial concubines pass their time shows how educated and cultured they are, emphasizing their status. Some play chess or learn the art of calligraphy. Others are shown painting or playing music. The rapt gestures of the women convey their lively enthusiasm for aesthetic and intellectual pursuits.

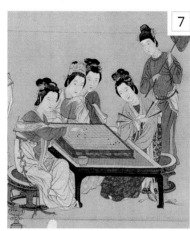

7

8

▲ **PORTRAIT PAINTER** One of Emperor Yüan-ti's concubines is having her portrait painted. This small scene is a reference to the famous story about the court artist Mao Yen-shou and the beautiful Wang Chao-chün (see p.71).

◀ **MUSIC AND DANCE** Many concubines were artistically gifted. Here three women play musical instruments, underlining the sense of harmony in the painting, while others dance.

ON **TECHNIQUE**

Qiu Ying was a master of the *gongbi* technique, in which lines had to be painted with the utmost precision, using a fine brush. Objects and the postures and proportions of figures also had be drawn accurately at the first attempt. This technique was in contrast to the faster, more expressive freehand style of painting known as *xieyi*. In the *gongbi* technique, even lines were painted on nonabsorbent paper or silk. Any expression had to be created, therefore, not with the flick of a brush, but with perfectly placed lines that described movement or the flow of fabric, for example (see below). Once in place, the outlines were filled in with colored ink washes, to create subtle shading. Qiu Ying, with his acute sense of observation and remarkable drawing skills, excelled at this technique.

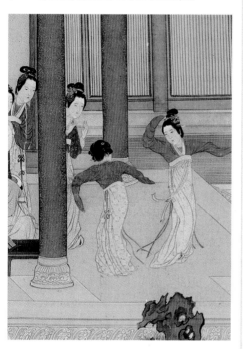

IN **CONTEXT**

Like many handscrolls, *Spring Morning in the Han Palace* has colophons—written notes in Chinese characters—at each end of the scroll, sometimes on additional sheets of silk. Colophons could contain information from the painter himself, or comments added by friends, viewers, or collectors at a later date. Some of these would sign their comments with personal seals bearing their names. These red seals (see below) denoted an artist's pride, a viewer's approval, or a collector's ownership.

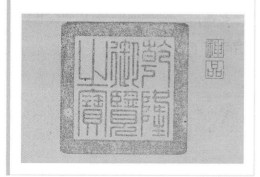

Netherlandish Proverbs

1559 ▪ OIL ON PANEL ▪ 46 × 64¼in (117 × 163cm) ▪ GEMÄLDEGALERIE, STAATLICHE MUSEEN, BERLIN, GERMANY

 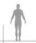

SCALE

PIETER BRUEGEL THE ELDER

Rich in detail, this famous painting is a masterful example of Bruegel's organizational skill and comic invention. Illustrations of more than a hundred proverbs and moral sayings are displayed in an imaginary village, where folly holds sway. This type of subject had been popularized by Sebastian Brant's satirical bestseller *The Ship of Fools*, 1494, and was also a favorite theme for engravers such as Frans Hogenberg. Hogenberg's *Blue Cloak* may have provided Bruegel with inspiration for his picture, as with the man in the foreground crawling into a globe (illustrating the saying, "A man must stoop low if he wishes to get through the world").

A world of folly

Bruegel rapidly outstripped his sources. His complex setting created an illusion of perspective that none of the printmakers matched. He also introduced an element of interaction between some of the scenes. The cuckold in the blue cloak, for example, is watched with interest by two women who represent a maxim about gossips, while to his right a man who is feeding roses to his pigs gazes in disbelief at another act of folly. Bruegel continued to incorporate this material into his work, sometimes focusing on a single proverb. The blind leading the blind, for example (just visible on the horizon, top right), became the subject of one of his greatest masterpieces.

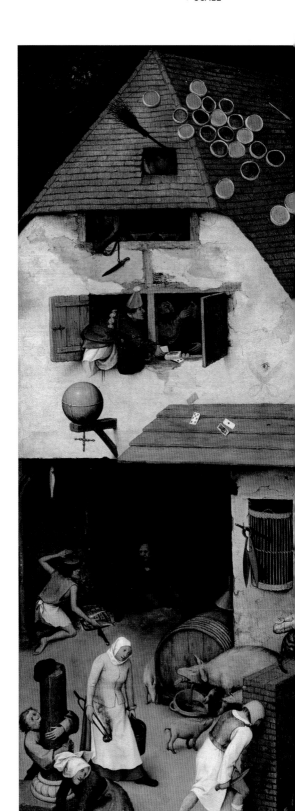

PIETER **BRUEGEL** THE ELDER

c.1525–69

One of the outstanding figures of the Northern Renaissance, Bruegel had an impressively varied repertoire. He is famed for his grotesque fantasies, his lively peasant scenes, and his pioneering landscapes.

The details of Bruegel's early life are sketchy. He may have been born near Breda, now in the Netherlands, but he trained in Antwerp, where he became a master of the Painters' Guild. His teacher was probably Pieter Coecke van Aelst, whose daughter he later married. In c.1552, he embarked on a lengthy tour of Italy, and upon his return worked mainly for the printseller Jerome Cock, chiefly employed as a designer of engravings. Bruegel's compositions from this period are often crowded with scores of tiny figures, and he deliberately exploited the continuing demand for Hieronymus Bosch's nightmarish creations (see pp.44–47). All this changed after 1563, when he moved to Brussels and began working for a more courtly clientele. His figures became larger and his themes more ambitious. Almost all his greatest masterpieces date from this final, glorious phase of his career.

After Bruegel's death, his reputation became somewhat distorted. He was characterized as "Pieter the Droll," a purveyor of comical peasant scenes. Some even believed that he had been a peasant himself. In reality, though, he was a cultivated man with an impressive roster of patrons. He used the kind of popular imagery that was normally found in prints but applied it to the most serious issues of the day—preaching humility and moderation at a time when his homeland was being torn apart by religious and political strife.

There are few works by his hand that
the observer can contemplate solemnly
and with a straight face

KAREL VAN MANDER *THE BOOK OF PAINTERS*, 1604

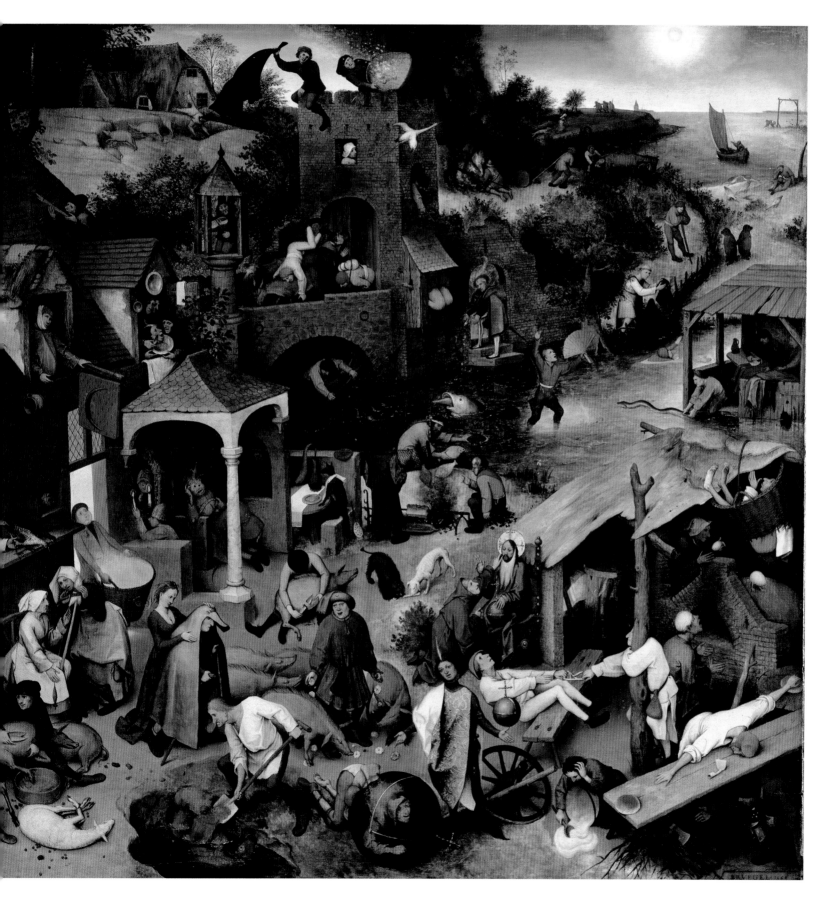

Visual tour

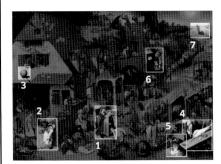

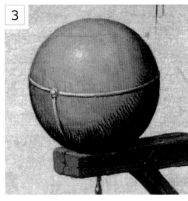

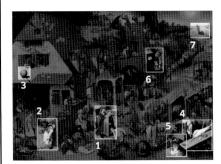

KEY

▶ **"BANGING ONE'S HEAD AGAINST A BRICK WALL"** No one portrayed lumpen stupidity with greater verve than Bruegel. The futility of attacking a wall is obvious enough, but the artist took delight in imagining the type of idiot who might try. His fool has donned a breastplate and is carrying a sword. The rest of his attire is rather less martial. He appears to have put his armor on over a nightshirt and is only wearing one shoe. There is a bandage on his leg, which hints that he has injured himself before, while undertaking another of his ridiculous ventures.

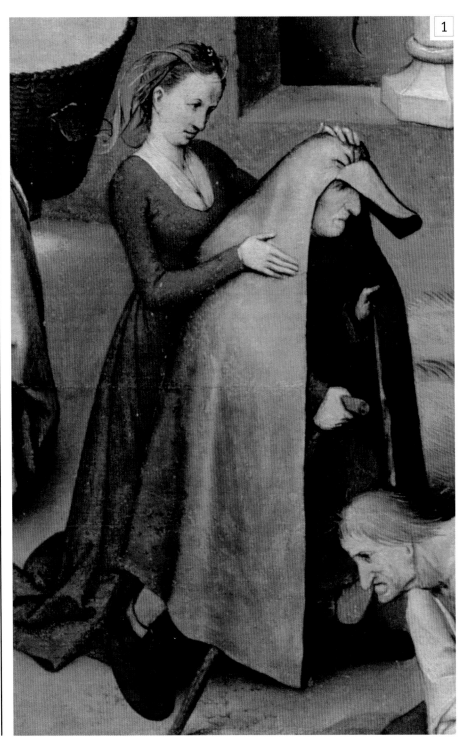

▲ **"THE WORLD TURNED UPSIDE DOWN"** In Christian art, a globe surmounted by a cross represents the world. The cross should always point upward, like the one held by Christ in the lower right corner of the painting. When inverted, the globe represents a topsy-turvy world. Its prominent position here indicates that the entire village is governed by folly.

◀ **"THE BLUE CLOAK"** "She hangs a blue cloak around her husband" or, in other words, she makes him a cuckold. At the time, the color blue was a traditional symbol of deceit. Bruegel's version bears some similarities to Hogenberg's *Blue Cloak* print, but he gives the image a much livelier, more anecdotal flavor. The husband is older, walks with a stick, and seems oblivious to his wife's actions, while she is young, tall, and well-endowed.

▼ **"DON'T CRY OVER SPILLED MILK"** In this case, the fool is trying to scoop up gruel rather than milk. In keeping with the country setting, many of the proverbs revolve around food production and farming. Apart from the gruel, there are loaves, tarts (on the roof), eggs, chickens, geese, and other forms of livestock.

▼ **"THROWING MONEY DOWN THE DRAIN" AND "BIG FISH EAT LITTLE FISH"** Several of the proverbs feature in other works by Bruegel. For example, in 1556 he had designed an outlandish version of "Big Fish Eat Little Fish" for the print market. It was very much in the style of Bosch and, indeed, the publisher tried to pass it off as one of Bosch's creations.

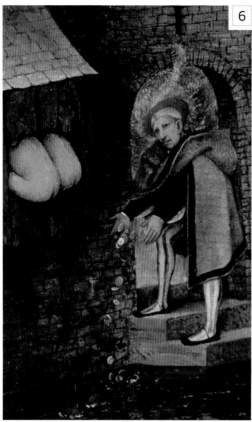

▲ **"SET SAIL WHEN THE WIND BLOWS"** Two popular sayings have been linked with this tiny detail: "It is easiest to sail when the wind blows" and "He has one eye on the sail" (in other words, he stays alert). Bruegel lived in a major port, so it is hardly surprising that he often included boats in his pictures.

◄ **"HE CANNOT MAKE ENDS MEET"** The original version is "He cannot reach from one loaf to the next." In other words, he cannot afford to buy enough food. There is nothing comical or moral about the saying itself, but Bruegel has managed to turn it into an entertaining visual pun. His peasant is simply too stupid to move one of the loaves.

ON **COMPOSITION**

This kind of composition was extremely popular in Bruegel's day. It was known as a *Wimmelbild* (a picture teeming with tiny figures) and was more commonly found in prints than in paintings. The idea of the *Wimmelbild* was to depict dozens of separate incidents, packing them together in a single image. This should have been a recipe for chaos, with one episode blocking out the one behind, but artists could achieve the desired effect by adopting a high viewpoint and bending the laws of perspective. In *Netherlandish Proverbs*, Bruegel tilted up his landscape, shifting his viewpoint as he moved into the scene. He also ignored the rules of foreshortening, showing most of his figures head on, even though they were being viewed from above.

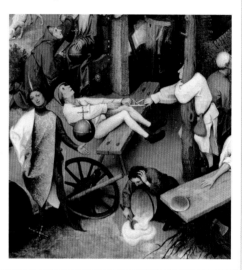

IN **CONTEXT**

Not all paintings of peasants were humorous or moralizing. In 1565, Bruegel produced a marvellously atmospheric series of six panels, collectively known as *The Months*, for one of his chief patrons, an Antwerp merchant called Niclaes Jongelinck. *Harvesters* represents the months August and September, and shows laborers gathering in wheat or resting in the relative shade of a pear tree. *The Months* were to prove highly influential. They shaped the course of the northern landscape tradition, and looked forward to the work of artists such as Courbet and Millet, who also depicted peasants in the rural landscape.

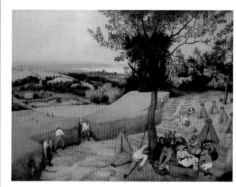

▲ *Harvesters*, Pieter Bruegel the Elder, 1565, oil on panel, 45¾ × 62¾in (116.5 × 159.5cm), Metropolitan, New York, US

Spring

1573 ▪ OIL ON CANVAS ▪ 30 × 25in (76 × 63.5cm) ▪ LOUVRE, PARIS, FRANCE

GIUSEPPE ARCIMBOLDO

SCALE

The sheer cleverness of this painting is instantly arresting. It is easy to admire the leap of Arcimboldo's imagination that conceives a woman's head as being made up of flowers and to marvel at the skill with which the idea has been carried through. Arcimboldo's contemporaries likewise enjoyed his wit and trickery, but they also saw deeper meanings in such paintings, for at the time it was common to present serious ideas in fanciful form. This was especially true at the highly sophisticated courts at which Arcimboldo worked.

The Hapsburg emperors whom Arcimboldo served ruled vast areas of Europe, and the art that was created for them often paid tribute to their power, either directly or indirectly. Arcimboldo's paintings are subtle allegories of their authority and influence. *Spring* is part of a set of four paintings representing the seasons. They were commissioned by Maximilian II as a gift for a fellow ruler

Augustus I, Elector of Saxony. Individually, the paintings convey the bounty of Habsburg rule and collectively they suggest that the dynasty will endure, just as the seasons follow one another in an endless cycle.

GIUSEPPE **ARCIMBOLDO**

c.1527-93

Arcimboldo created a novel type of portrait head. His paintings were virtually forgotten for centuries, but since their rediscovery they have continued to delight and fascinate viewers.

Arcimboldo began and ended his career in his native city of Milan, Italy. However, he made his memorable contribution to art in Central Europe, in Vienna then Prague, in the service of three successive Holy Roman Emperors: Ferdinand I, Maximilian II, and Rudolf II. He was acclaimed in his time, but after his death his works tended to be regarded as mere curiosities. The revival of interest in his paintings began with the Surrealists, who shared his love of visual puns and paradox and regarded him as a forerunner of their movement.

Visual tour

KEY

▶ **YOUTHFUL BLOOM** Spring's face is mainly made up of roses, which suggest the beauty and fragrance of youth. The four seasons were often depicted as being four different ages— with Winter the oldest. So, in effect, they could also represent the Ages of Man (the number of ages varied from three to seven, although four was common). Flowers have often been used to symbolize the passage of time and the insubstantiality of all earthly achievement— even the most beautiful bloom must wither and die.

▶ **FLORAL HAIR** The flowers making up Spring's hair (or perhaps hat) create an enchanting, tapestry-like effect. They are more delicately painted than the flowers and leaves in the enclosing frame, which is thought to have been added during the 17th century.

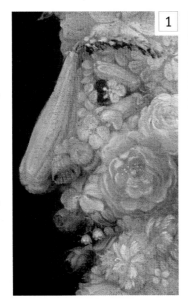

1

▲ **IRIS** Spring is holding an iris. Like many flowers, its symbolic associations vary with context—the "language of flowers." Here, it probably alludes to earth's renewal after the chill monotony of winter.

3

▲ **VEGETABLES** The shoulder and torso are made up of various vegetables. These have less resonance in art than flowers, tending to represent nature's general abundance rather than specific qualities. Still, the artist has lavished as much diligent craftsmanship on the humble vegetables as on the glamorous flowers.

4

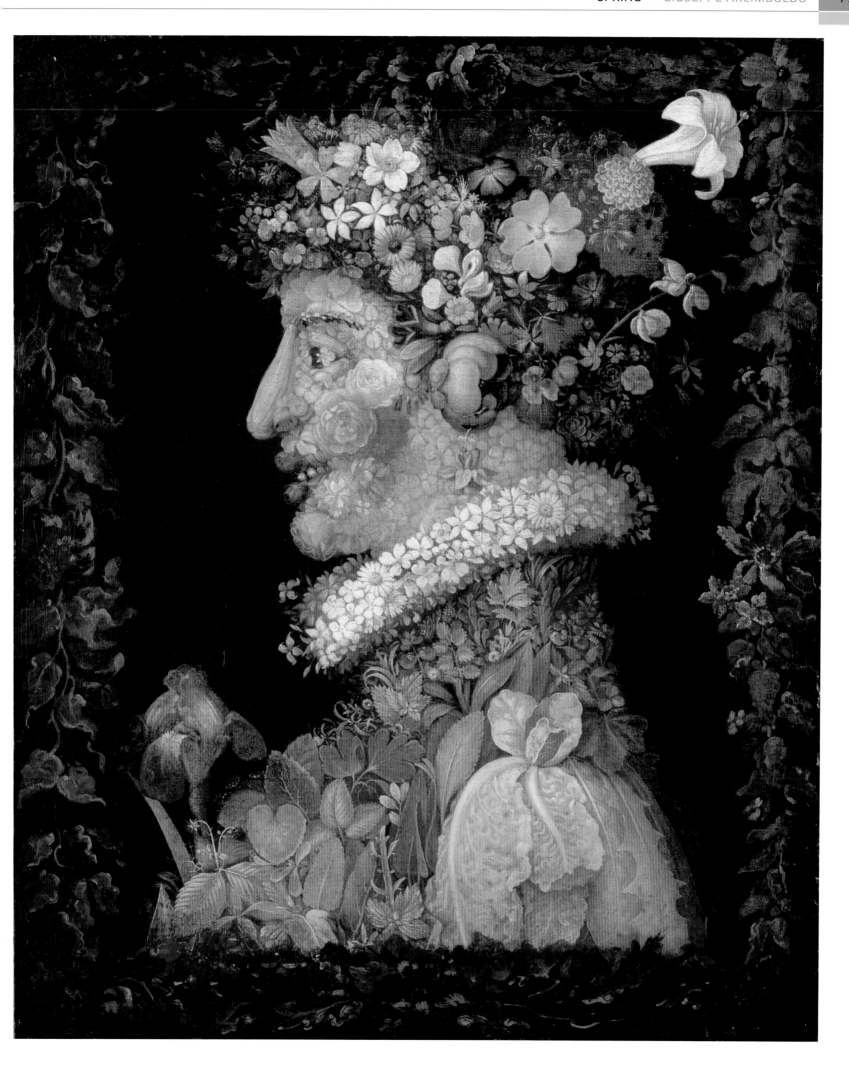

Cypress Tree

c.1580-90 ▪ EIGHT-PANEL SCREEN, COLOR AND GOLD LEAF ON PAPER
▪ 5ft 6¾in × 15ft 1in (1.7 × 4.6m) ▪ TOKYO NATIONAL MUSEUM, JAPAN

SCALE

KANŌ EITOKU

Bold and beautiful in its design, Eitoku's magnificent folding screen (*byōbu*) is dominated by the mighty trunk and twisted branches of an ancient cypress tree, outlined against a shimmering background of golden clouds. The painting was commissioned during Japan's celebrated Momoyama period (1573-1615), when powerful warlords unified the country, building splendid castles with lavishly decorated interiors. The huge tree perhaps represented the strength and power of the painting's military patron, while the extravagant gold leaf—a symbol of wealth and status—would have reflected any available light in the dim castle interior, transforming the already striking work into a beautiful, glowing panorama.

Eitoku was trained in the Chinese art of ink painting by his famous grandfather Kanō Motonobu, and his mastery of the technique is apparent in the expressive lines of the

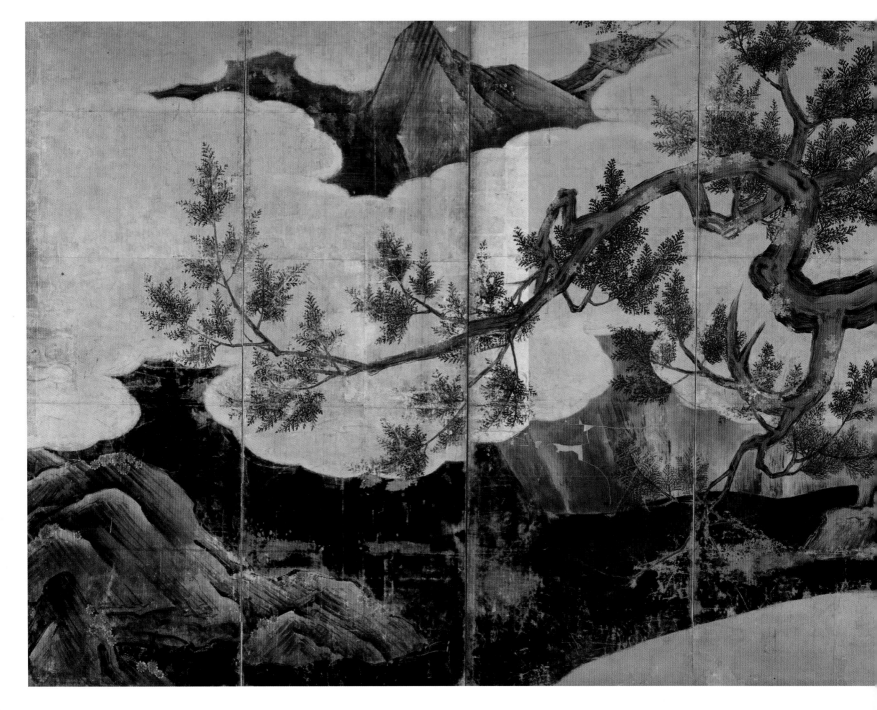

work. However, the decorative quality and flat, bright colors follow the Japanese tradition known as *yamoto-e*, and the grand scale and bold brushwork evident here and in Eitoku's other compositions were truly innovative.

The majestic, lichen-encrusted cypress extends across the eight panels of the screen, its gnarled form depicted with sweeping brushstrokes. Yet we can only see the midsection of the huge tree: the bottom of the trunk is hidden from view and the upper boughs disappear into lustrous golden clouds pierced by a jagged mountain peak. The foreground dominates and the background space is almost flat, creating a sense of pattern rather than depth. Strikingly asymmetric, the composition is supremely bold and confident, and its scale and dynamism convey the strength and grandeur of the monumental tree.

KANŌ **EITOKU**

1543–90

Part of an established family of professional artists, Eitoku forged a new style and became the most sought-after painter in Kyoto, creating large-scale, decorative works for Japan's feudal warlords.

Eitoku was the great-grandson of Kanō Masanobu, founder of the Kanō school, which was the most influential school of Japanese painting for over 300 years. Eitoku displayed prodigious talent from an early age, and the opulence of Japan's Momoyama period suited the large-scale compositions for which he became renowned. He created monumental, decorative works, often sliding doors (*fusuma*) or folding screens, with bold, opaque color and lavish backgrounds of gold leaf, and these innovative paintings ensured that the Kanō family continued to enjoy the patronage of Japan's military rulers. Most of the castles containing his paintings have been destroyed, along with their contents, as a result of civil war, but some works, such as the pair of six-panel folding screens *The Hawks in the Pines* (Tokyo University of the Arts), have survived. Eitoku died in his forties.

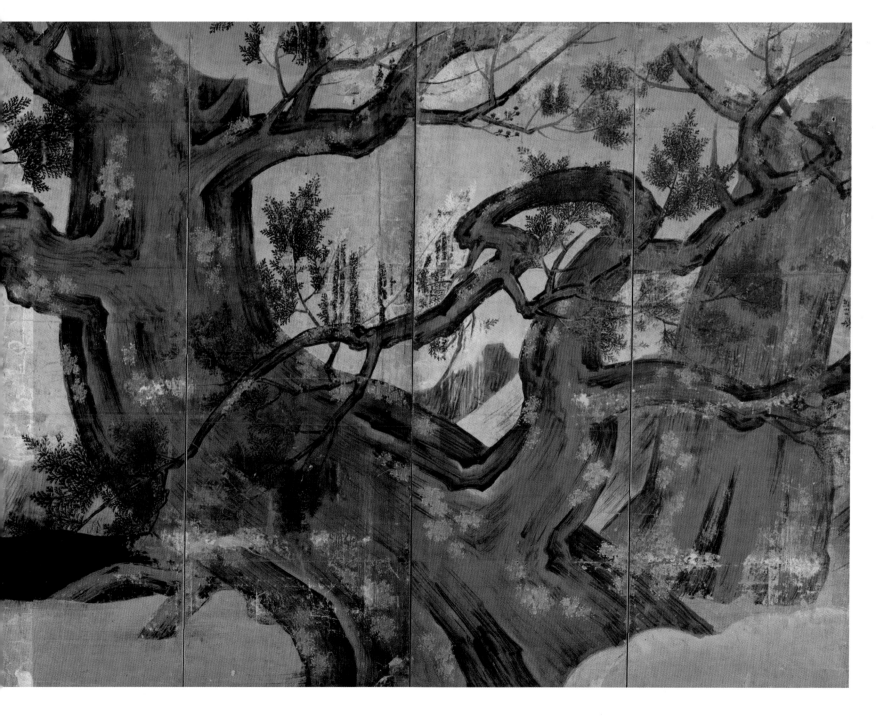

Visual tour

KEY

▼ **TRUNK** The massive trunk of the cypress is the main focus of the composition. It emerges diagonally from the base of the three panels on the left side of the screen, and its contorted branches extend sideways over all eight panels in a bold, graphic manner. Eitoku has shown neither the top nor the bottom of the tree, and this cropping emphasizes both its solidity and size, while its off-center position creates an arresting design.

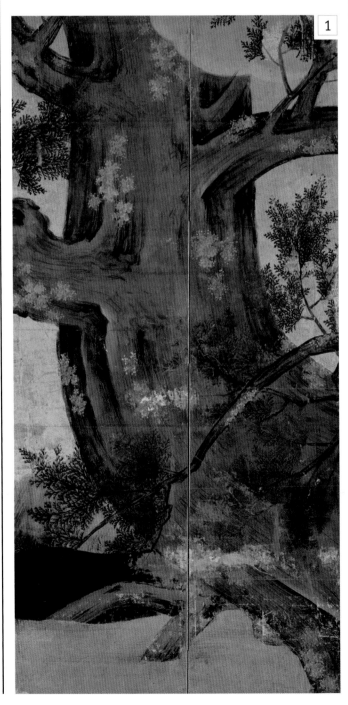

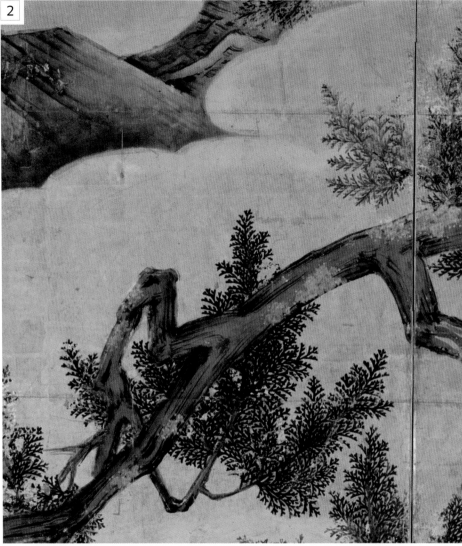

▲ **LICHEN** The pale, grey-green patches of lichen are repeated over the rugged surfaces of the venerable tree and give an impression of texture; more importantly, they add rhythm and create a strong sense of pattern throughout the composition.

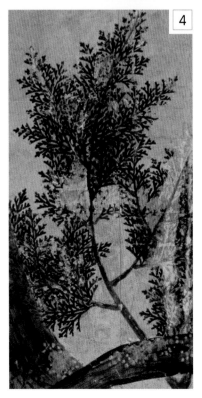

▶ **FINE DETAIL** Small, delicate brushstrokes in deep green describe the tree's needlelike leaves and contrast with the large, sweeping strokes of the trunk and branches. Silhouetted against the golden clouds, the leaves form exquisite patterns.

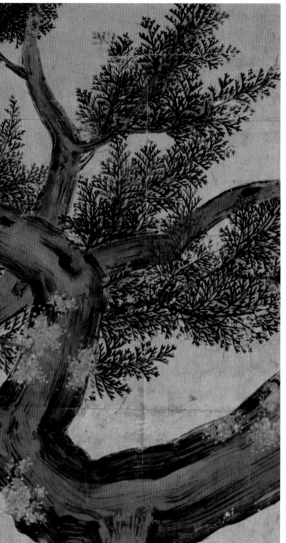

TWISTING BRANCHES Sharply delineated against the shimmering gold background, with their strong shapes outlined in black, the gnarled and twisted branches seem to be alive with a powerful energy. Their sinuous forms snake over the whole screen and inject movement and rhythm into the painting. With branches reaching down to the earth and up into the clouds, the cypress perhaps represents the absolute power of the Momoyama warlords and the huge territories over which they held sway.

GOLD-LEAF CLOUDS The billowing shapes of the clouds echo the twisted form of the tree and the lustrous gold leaf lights up the branches. At night, this costly material would have cast a beautiful glow in the opulent, candlelit rooms of the warlord's castle.

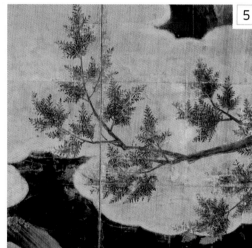

5

6

ROCKS AND WATER On the far-left panel, bare rocks jut out of the deep water. The solidity of their forms, created by strong diagonal brushstrokes and layering, echo and balance the massive trunk of the cypress; the same lichen patterning appears on both tree and rocks. The age of the screen makes it difficult to be sure of the original color of the water, but it is possible that it was a much brighter azure blue, which would have made a striking contrast with the rich gold of the clouds.

ON **TECHNIQUE**

Eitoku limited his colors and tonal range, and there is little modeling on the trunk of the tree (see below). The patches of lichen seem to float over the surface of the bark and are perhaps used as a motif to give the overall design a sense of pattern, rather than as a naturalistic feature. The artist's consummate skill at depicting the natural form of the tree lies in the confident, sweeping brushstrokes, which give a strong impression of the life force flowing within the tree. To create his dramatic designs on such a grand scale, Eitoku is said to have used a large, coarse straw brush, making the rapid, energetic strokes that render the tree so eloquently and with such immediacy.

IN **CONTEXT**

Eitoku's early work was equally distinguished. *Birds and Flowers of the Four Seasons* was part of a commission for the Jukoin sub-temple of Daitoku-ji, Kyoto. The 23-year-old Eitoku already outshined his father (and Kanō school leader) Kanō Shōei in ability, and he worked on the most important rooms in the sub-temple. This panorama of the seasons unfolds over four sets of sliding screens (*fusuma*), starting with spring (below), which shows the first plum blossoms of the year. The delicate depiction of nature in this early masterpiece, painted in ink with a faint gold wash, later evolved into the lavish, more decorative style seen in *Cypress Tree*.

▲ *Birds and Flowers of the Four Seasons* (detail), Kanō Eitoku, 1556, sliding door panels, ink on paper, 5ft 4in × 4ft 8in (1.75 × 1.42m) per panel, Jukoin sub-temple, Daitoku-ji, Kyoto, Japan

Akbar's Adventures with the Elephant Hawa'i in 1561

c.1590–95 ▪ OPAQUE WATERCOLOR AND GOLD ON PAPER ▪ 13 × 7¾in (33 × 20cm)
VICTORIA AND ALBERT MUSEUM, LONDON, UK

SCALE

BASAWAN AND CHETAR

Richly detailed and with a fine sense of drama, this jewel-like miniature depicts an episode in the *Akbarnama (Book of Akbar)*, the authorized chronicle of the reign of the 16th-century Mughal emperor Akbar, a tolerant ruler and patron of the arts. Written between 1590 and 1596 by Abu'l Fazl, the *Akbarnama* contains 116 miniatures made by numerous artists.

This episode celebrates Akbar's bravery and masterfulness. The emperor is shown mounted on a ferocious elephant that is in hot pursuit of another elephant. They are charging across a pontoon bridge toward Agra Fort in northern India, dislodging the boats beneath them and spreading chaos in their wake. All around them, animated figures dressed in vivid colors struggle to control their boats or climb to safety.

Stylistically, the painting shows the influence of Persian Safavid manuscript illustration on Indian art during the Mughal Dynasty. However, the realistic modeling of the figures and the sense of perspective seen in the fort in the background also suggest the influence of northern European art of the time.

BASAWAN

Active c.1556–1600

One of the most talented artists in the Imperial Mughal workshops, Hindu painter Basawan contributed to the lavishly illustrated manuscripts of the Mughal dynasty for 40 years.

The artists who worked at the Imperial Mughal workshops came from all over India, but followed the Persian Safavid practice of drawing the outlines of the picture first, then filling in with color. Basawan, who drew *Akbar's Adventures with the Elephant Hawa'i in 1561*, was assisted by an artist called Chetar, who did the color work. Basawan is credited with developing a clear, narrative style in Mughal painting and is renowned for his vivid detail and dramatic color contrasts, which were characteristic of the Hindu painting tradition.

Visual tour

KEY

▲ **AKBAR AND HAWA'I** Many of the stories illustrated in the *Akbarnama* demonstrate the emperor's strength of character. Akbar is riding Hawa'i, his wildest Imperial elephant. Wedging his foot under the elephant's harness for stability, he looks calm and in control. He has set the elephant in combat against an equally dangerous beast.

◀ **RAN BAGHA** Thundering ahead across the bridge of boats is Ran Bagha, Hawa'i's fierce opponent. When Akbar recounted this episode to historian Abu'l Fazl, he explained his rash actions in terms of his absolute trust in God. If displeased, God would allow the elephants to kill him. The painting illustrates Akbar's courage and firm leadership.

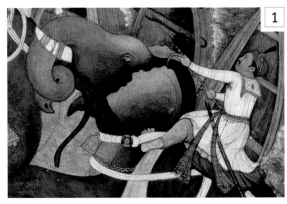

◀ **PONTOON** The collapsing bridge across the River Jumna creates a strong diagonal in the painting. Seen from above, a man lies flat on the ground, trampled underfoot, his turban unwound beside him. The elephants, by contrast, are drawn side-on.

◀ **MINOR FIGURES** The scene is full of activity and interest, from the boatmen trying to steady the pontoon in the foreground to the fishermen skirmishing in the background. The artist has depicted each individual character with imagination, skill, and attention to detail.

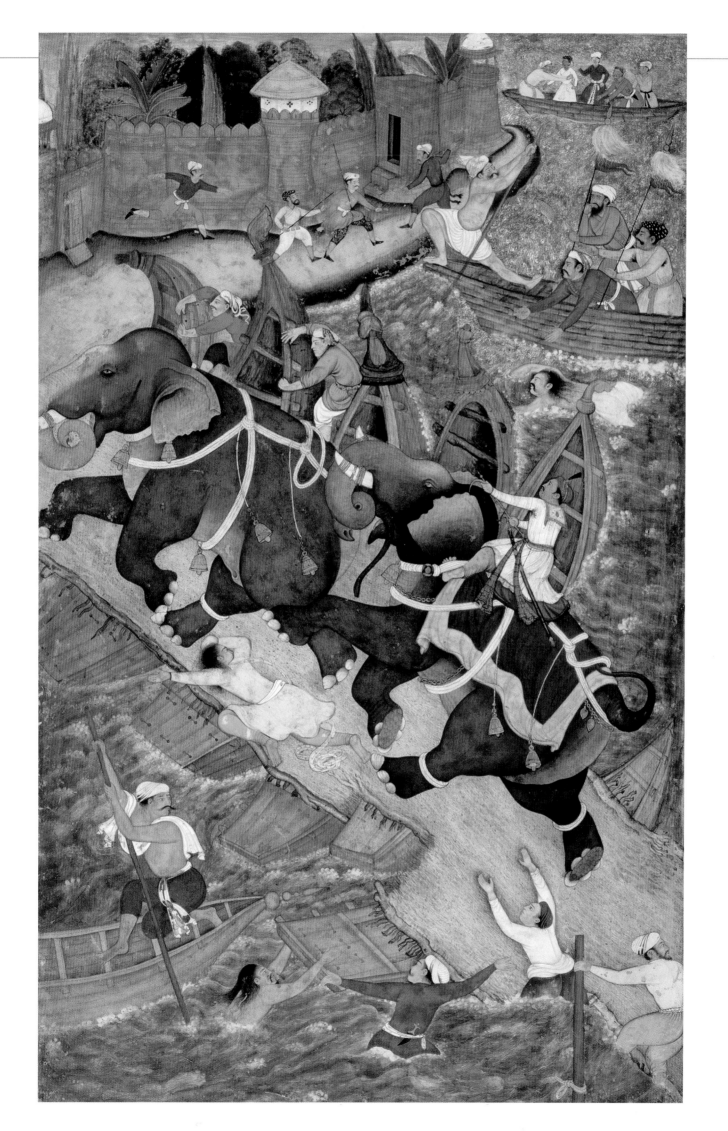

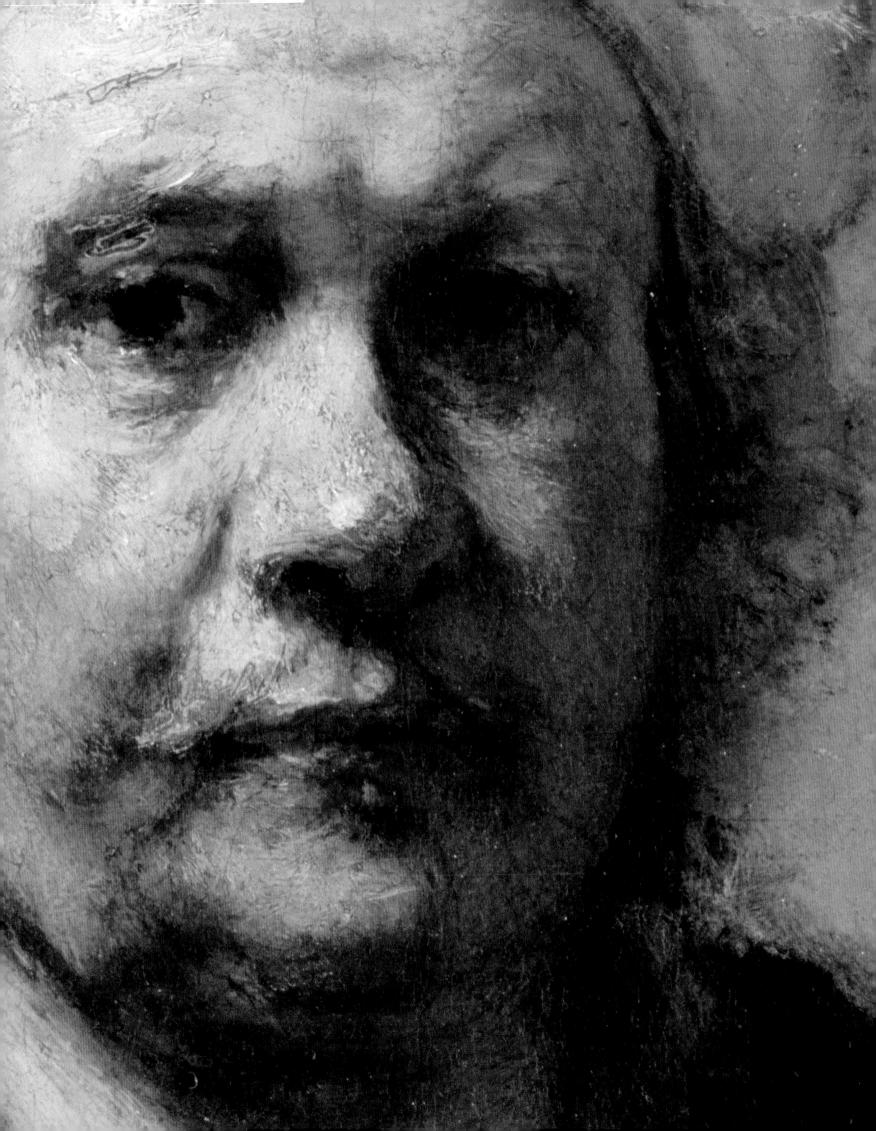

1600 – 1700

David with the Head of Goliath

c.1609-10 ▪ OIL ON CANVAS ▪ 49¼ × 39¼in (125 × 100cm) ▪ BORGHESE GALLERY, ROME, ITALY

SCALE

CARAVAGGIO

This shockingly realistic image of a young boy holding out a severed head is one of Caravaggio's most striking paintings. It depicts the climax of the biblical encounter between David, an Israelite shepherd boy, and Goliath, a Philistine giant. David killed Goliath with a slingshot, then cut off his head with the giant's own sword.

The dramatic use of light and shadow in the painting is startling. Caravaggio used a technique known as chiaroscuro (meaning "light/dark" in Italian), in which bright light forms a powerful contrast with deep shadow, creating a theatrical effect. David appears to have stepped forward into a spotlight, which also illuminates one side of Goliath's face and glints on the blade of the sword. The brightly lit areas draw attention to the figures' faces, emphasizing the human aspect of the biblical tale.

David is likely to be modeled on a youth from the streets of Naples, as Caravaggio preferred to depict characters who looked like real, solid people in his religious paintings. The head of Goliath is a self-portrait. Caravaggio was seeking a papal pardon after killing a man in a fight, and the painting has been interpreted as the artist offering up his painted head rather than his real one. It is said that as Caravaggio's life became increasingly troubled, his paintings grew darker, and this is one of the last he ever made.

MICHELANGELO MERISI DA **CARAVAGGIO**

1571–1610

Stark realism and dramatic contrasts of light and shade are Caravaggio's trademarks. He broke with the Mannerist tradition in art, creating paintings with solidity, grandeur, and depth of feeling.

Born in Milan in northern Italy, Caravaggio settled in Rome in about 1592. His work was popular with the Catholic Church during the Counter-Reformation because he reinterpreted well-known biblical stories in a realistic manner, more relevant to the lives of real people, and created paintings with a powerful sense of drama and heightened emotion. Although some contemporaries found his approach to religious topics challenging, his work was in great demand and had a profound impact on Italian and, indeed, European art. Caravaggio led a troubled and turbulent life. In 1606, he killed a man in a fight and spent his last four years as a fugitive from justice.

Visual tour

KEY

▶ **DAVID** Light falls on one side of the shepherd boy's face from a single, bright source, while the other side is in deep shadow. The light reveals a poignant expression on David's face. He looks resigned, rather than jubilant.

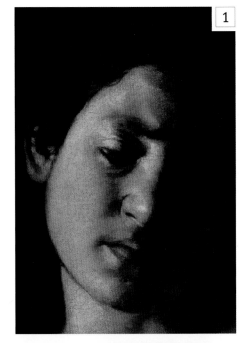

1

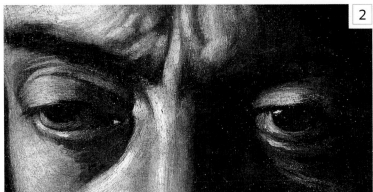

2

▲ **GOLIATH** Although the giant's head has been just severed from his body and is dripping with blood, as in a horror film, it still looks alive. Goliath's brow is furrowed with pain, he looks as if he is gasping, and his left eye stares straight at the viewer.

ON **COMPOSITION**

The central area of the composition is rectangular in shape. Imaginary lines connect Goliath's right eye, the diagonal of the sword, David's barely visible right arm, and his left arm, which is holding Goliath's head.

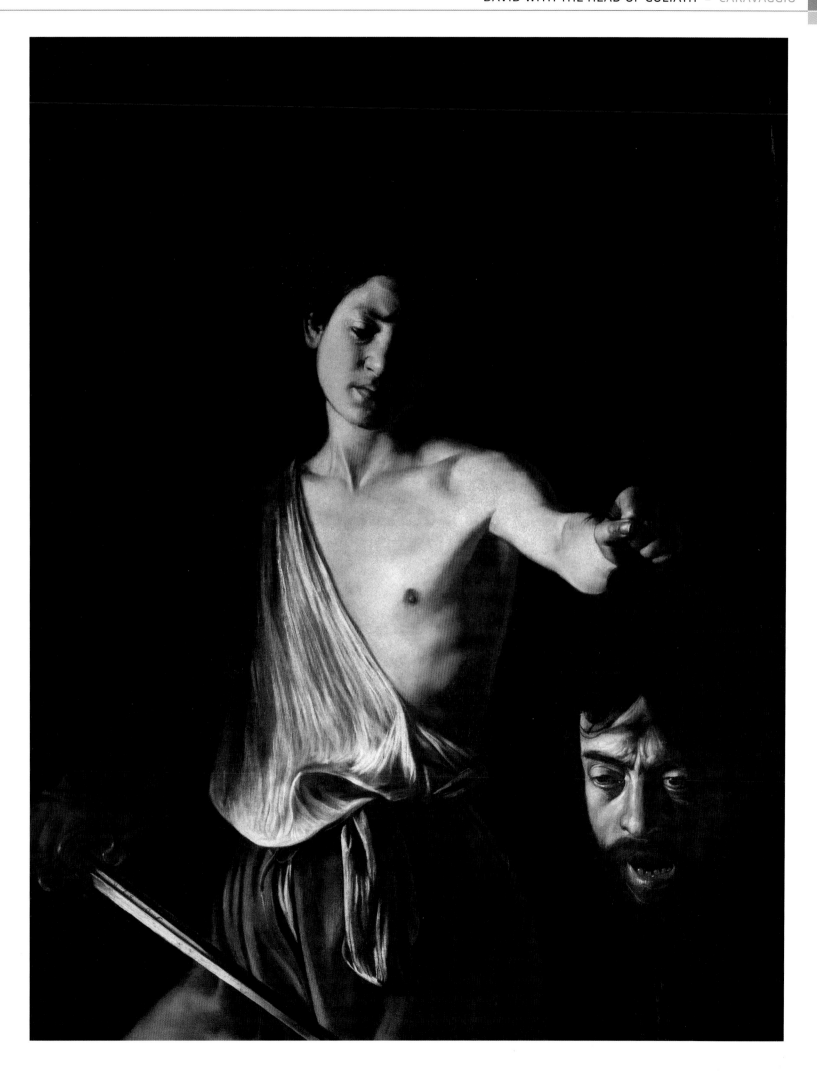

The Judgement of Paris

c.1632–35 ▪ OIL ON PANEL ▪ 57 × 76¼in (144.8 × 193.7cm) ▪ NATIONAL GALLERY, LONDON, UK

SCALE

PETER PAUL RUBENS

This painting tells a complex story, but clues to its meaning can be found in the form of attributes (identifying objects) that belong to the mythological characters portrayed. The story follows a classical text: Lucian's *Dialogue of the Gods*. Paris, the young Trojan prince, is about to award a golden apple, inscribed with the words "To the Fairest," to one of the three Roman goddesses: Juno, Minerva, or Venus. The beauty contest came about after Eris, the Goddess of Strife, grew angry at not being invited to a wedding feast. She tossed the golden apple into the crowd for Jupiter, the king of the gods, to choose a deserving winner. Her action led to chaos and strife, and eventually Jupiter sent Mercury, the messenger of the gods, to ask Paris to judge who was the fairest. Each goddess offered a bribe to Paris to try to persuade him to pick her.

This is the moment that Rubens chose to illustrate. The scenario gave him an opportunity to paint the voluptuous female nudes for which he is famous— the word "Rubenesque" was coined to describe them. Naked, the three goddesses display themselves to best advantage for Paris's sensual pleasure. They present an image of ideal beauty, based on female figures painted by earlier masters including Titian (see pp.62–65) and Leonardo (see pp.50–53), both of whom Rubens admired. Like his predecessors, Rubens also used colors to create the illusion of space. The bright blue of the sky and hills on the horizon recedes, creating the impression of depth. Green is the dominant color in the middle ground, leaving the darkest reds and browns to push forward, making the foreground feel closer.

Over time, the oil paint Rubens used has deteriorated and become more transparent. Fascinatingly, the changes Rubens made to the composition as he went along are therefore now visible. One such underlying image is the original position of Paris's right leg. And next to the peacock's tail, it is possible to make out the chubby arms of an earlier Cupid.

PETER PAUL **RUBENS**

1577-1640

Rubens enjoyed a career of such resounding international success that a contemporary described him as the "prince of painters and painter of princes."

Rubens was far and away the leading artist in 17th-century Flanders (roughly equivalent to modern Belgium), creating an enormous amount of work in virtually every branch of painting practiced at the time. He lived in Antwerp for most of his career, but he traveled extensively and his style and artistic outlook were mainly formed in Italy, where he was based from 1600 to 1608. Throughout his career, he aspired to match the heroic grandeur of Italian Renaissance art, but his work also has a deeply personal warmth and vitality. He combined his artistic career with diplomatic duties and was justly proud that he helped to negotiate peace between England and Spain (he was knighted by the kings of both countries). His personal life, too, was richly fulfilling, his love of his family shining through many paintings (he was twice happily married and fathered eight children).

In the hands of Rubens, the bodies of women came alive in eddies and whirlpools of nacreous paint

ANNE HOLLANDER *SEEING THROUGH CLOTHES*, 1993

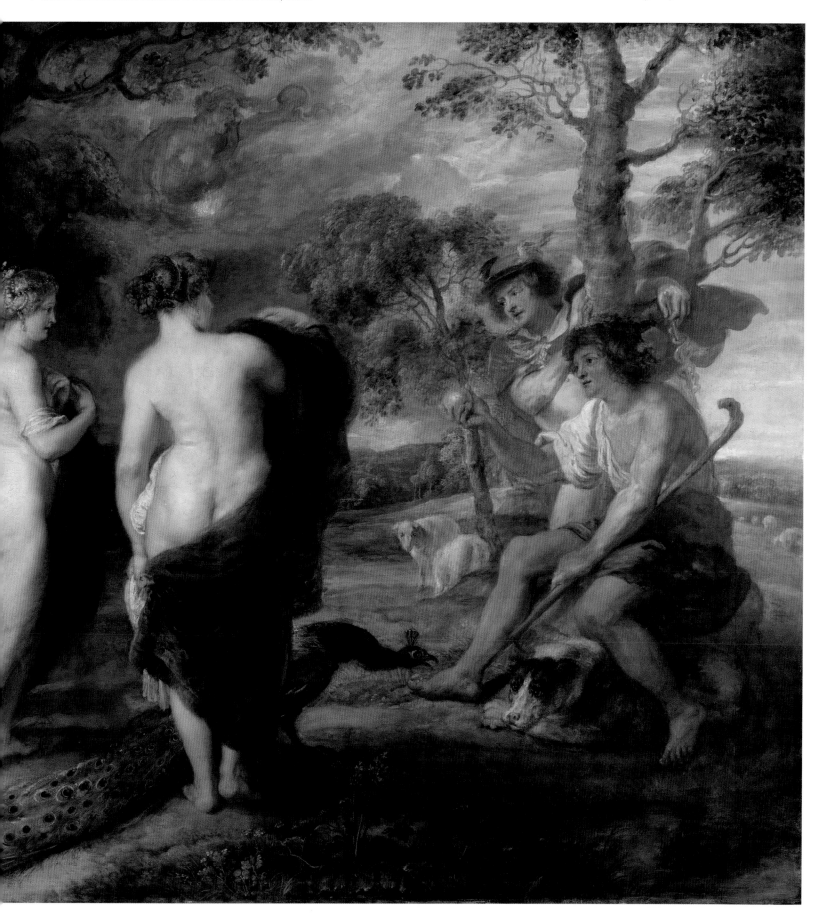

Visual tour

KEY

▶ **VENUS** The goddess of love, beauty, and fertility has roses—symbols of love—in her hair. Pearls are also entwined in her blonde locks, linking to the legend of her birth: she came ashore at Cyprus aboard a shell. Venus tells Paris that if he chooses her as the fairest she will make the most beautiful woman in the world fall in love with him. Her bribe works and she wins the contest.

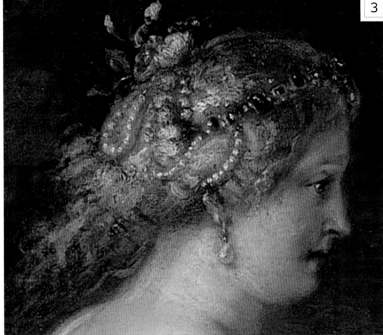

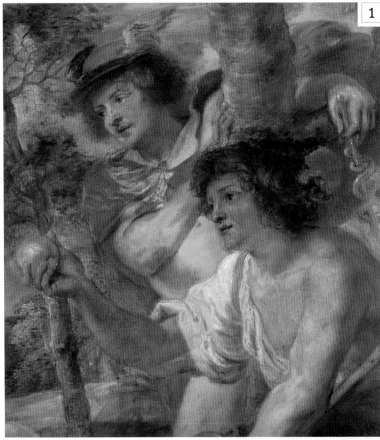

▲ **PARIS AND MERCURY** Paris, the Trojan prince, is dressed as a shepherd in a reference to his birth. According to legend, his mother abandoned him as a baby after dreaming that her son would destroy Troy, and it was a shepherd who rescued him. Mercury, the messenger of the gods, is standing behind Paris, wearing a winged hat and holding his *caduceus*, a wand wrapped with two snakes.

▶ **MINERVA** The goddess of war and wisdom stands on the far left, posing with her hands above her head. She promises Paris that if she wins the golden apple she will grant him victory in battle. She also promises him her powers of insight.

▲ **HELMET AND SHIELD** Minerva can be identified by two objects: a helmet, lying on the ground behind her, and a shield with an image of Medusa, the snake-haired monster who turned people to stone with just one glance. Minerva had helped the Greek hero Perseus to kill the monster.

▶ **OWL** An owl, symbol of wisdom, sits on the tree behind Minerva's head, observing the proceedings. Like the helmet and shield, the owl is an attribute of Minerva and helps identify her.

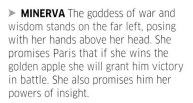

▶ **CUPID** The god of love is often shown as a mischievous baby. He has wings and a quiver to hold his golden arrows, which he fires at people to make them fall in love. His mother, Venus, is about to send him off to Helen to fulfill her promise to Paris.

▼ **FURY IN THE SKY** Flying menacingly through the sky, holding a snake in her hand, is Alecto the Fury. She whips up the thundery clouds to announce that trouble is on its way. This sets the mood for the next part of the story, not shown by Rubens. Paris abducts the beautiful Helen, wife of King Menelaus, from her home in Sparta. As Venus had promised, Helen falls in love with Paris, but the abduction leads to the Trojan War.

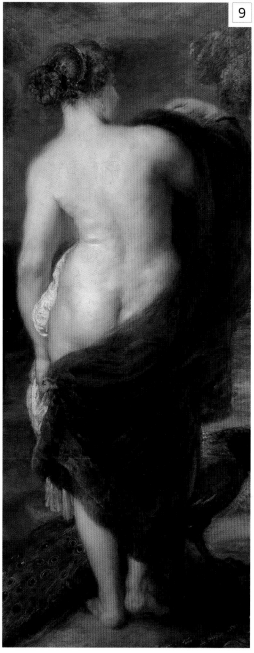

▲ **PEACOCK** Juno stands next to her attribute, a peacock. With a crown of feathers on its head and jewel-like eye echoed in the patterns of its long graceful tail, the bird is a natural choice to symbolize royalty.

▲ **JUNO** The queen of the goddesses, wife of Jupiter, poses for Paris, holding a fringed shawl in striking red and green, with the texture of velvet. Her bribe to him is an abundance of wealth in land and other riches.

ON **TECHNIQUE**

The translucence of the flesh tones in this painting comes from using a smooth, primed oak panel instead of a canvas. The smoothness of the surface allowed Rubens to apply oil paint thinly, so that the white ground glowed through. He used fluid strokes of warm red, yellow, and white, offset with touches of blue, for the tints of milky skin. His palette was limited, although his use of red gives an impression of rich color.

IN **CONTEXT**

Rubens was greatly influenced by Renaissance and classical artists. He copied their work and sketched from antique sculptures, reproducing typical poses for the goddesses in *The Judgement of Paris*. Rubens has cleverly painted a female nude in the round, meaning that the same model is shown from three different angles. Minerva is seen from the front, Venus from the side, and Juno from behind, all visually linked with white shawls. It is likely that Rubens based the figure on his second wife, Hélène Fourment.

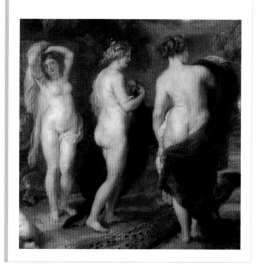

Charles I on Horseback

c.1637 ▪ OIL ON CANVAS ▪ 12ft ½in × 9ft 7in (3.67 × 2.92m) ▪ NATIONAL GALLERY, LONDON, UK

SCALE

ANTHONY VAN DYCK

This life-size equestrian portrait of Charles I, Stuart king of England, Scotland, and Ireland (1600–1649), is clearly intended to convey power and majesty. An extravagant monarch, unpopular with his subjects, Charles believed in the divine right of kings and absolute monarchy. This painting is a superb piece of propaganda designed to bolster his public image. Elegantly mounted on a massive stallion, Charles is clad in armor, as if about to ride into battle, and a servant holds up his helmet. Charles has a commander's baton in one hand, and controls his mighty steed with the other. On the right side of the painting is a great oak tree, a symbol of strength, that bears a plaque with the Latin inscription *Carolus Rex Magnae Britaniae*– "Charles, King of Great Britain."

As a court painter, van Dyck had to portray the king in a flattering light, so reality is tempered with a degree of fantasy. Charles I was a small man, but is given added stature by being set high on a horse. English kings were rarely portrayed on horseback, whereas the tradition was strong in Italy and dated back to Roman times. Van Dyck, a great admirer of Titian, perhaps consciously echoed Titian's *The Emperor Charles V on Horseback*, painted in 1548, which is similar in size and composition. Charles gazes nobly into the distance, seemingly unaffected by the growing dissent in his kingdom. In 1649, following a civil war, he was to be publicly executed.

ANTHONY **VAN DYCK**

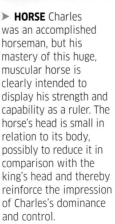

1599-1641

Van Dyck ranks second only to Rubens among 17th-century Flemish painters. In his speciality of portraiture, he outshines even Rubens and stands among the greatest artists.

A child prodigy, van Dyck was working as Rubens's chief assistant by the age of 18. He was barely 20 when he was launched on a glittering international career of his own. He painted numerous religious works (he was a devout Catholic), and he always sought opportunities to create the huge decorative schemes at which Rubens excelled. However, his services were increasingly in demand as a portraitist, first in Italy, where he lived from 1621 to 1627 and, later, in England, where he was court painter to the art-loving Charles I from 1632. His portraits of Charles, his family, and his courtiers have a matchless grace and glamour, inspiring other painters for generations, particularly in Britain, where van Dyck was revered by Gainsborough among other artists.

Visual tour

KEY

▶ **CHARLES I** Unlike the rest of the painting, which we look up at, the king's face is painted as though we are looking at it head on, in half-profile. Around his neck, Charles wears a golden locket decorated with an image of St George, martyr and patron saint of England, fighting the dragon. This is symbolic of Charles's role as defender of the realm.

◀ **SPURRED BOOT** The painting was probably hung at ground level at the end of a long gallery. Given its vast height, the approaching viewer would have had a good look at the king's boot, and was probably meant to feel duly humbled.

▶ **HORSE** Charles was an accomplished horseman, but his mastery of this huge, muscular horse is clearly intended to display his strength and capability as a ruler. The horse's head is small in relation to its body, possibly to reduce it in comparison with the king's head and thereby reinforce the impression of Charles's dominance and control.

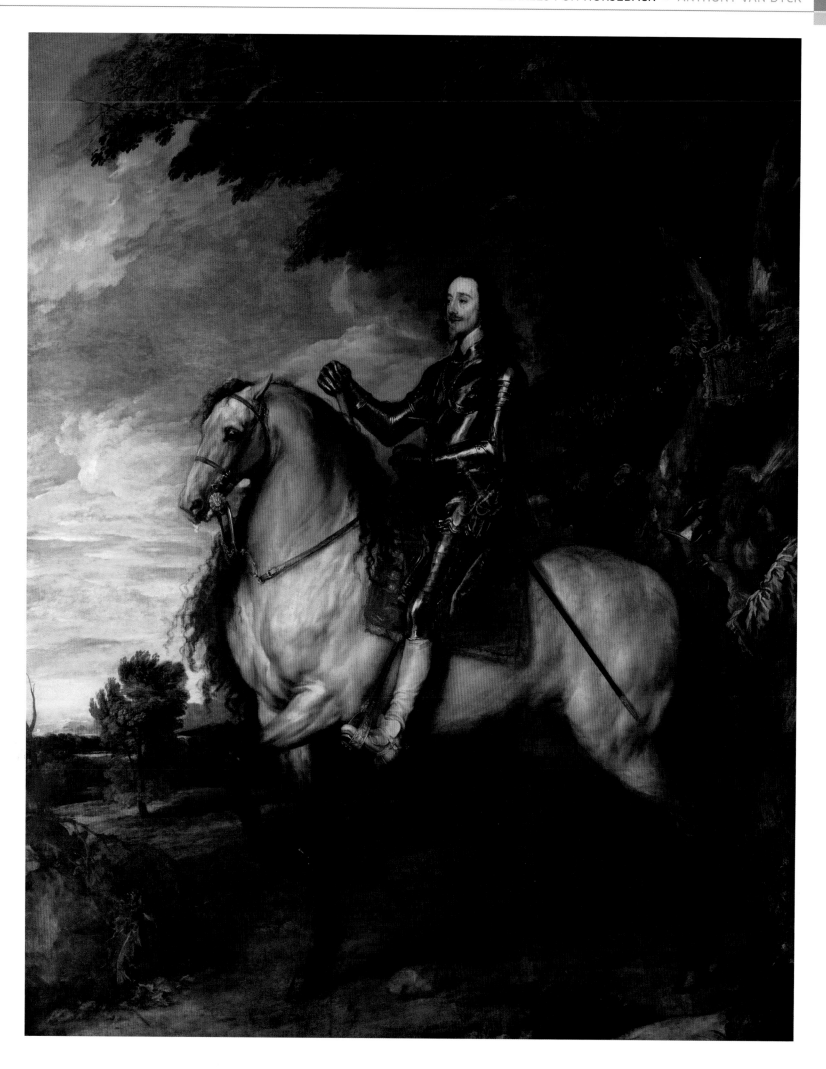

Self-portrait as "La Pittura"

c.1638–39 ▪ OIL ON CANVAS ▪ 38 × 29in (96.5 × 73.7cm) ▪ THE ROYAL COLLECTION, LONDON, UK

SCALE

ARTEMISIA GENTILESCHI

A strongly built woman leans forward to apply paint to the canvas. Her gaze suggests intense concentration and her pose creates a vigorous diagonal across the picture. It is a suitably powerful image to represent the outstanding woman painter of the 17th century, a formidable personality who achieved success against the odds in what was very much a man's world. However, the picture is more than a self-portrait—it is also a representation of the art of painting (*La Pittura* in Italian). Since the mid-16th century, there had been a tradition in Italian art of depicting a woman as the personification of painting, as well as of the sister arts of sculpture and architecture. Such personifications were described in a book called *Iconologia* by the Italian writer Cesare Ripa, which was first published in 1593. Artists often used it as a guide, and Artemisia has adopted some of the features it describes as part of the image of *La Pittura*.

The picture is first documented in the collection of Charles I, and Artemisia probably painted it when she was in London working at his court, from about 1638 to 1641. She had other royal patrons—an indication of the renown she enjoyed. After her death, her reputation declined, but since the 1960s she has again been recognized as one of the major painters of her time, as well as celebrated as a feminist heroine—almost all her pictures feature women in central rather than subordinate roles.

ARTEMISIA **GENTILESCHI**

1593–c.1654

One of the greatest of all women painters, Artemisia Gentileschi was renowned in her lifetime, and in the modern age has won new fame as a feminist heroine.

Artemisia was born in Rome, the daughter of the painter Orazio Gentileschi, a gifted follower of Caravaggio. She showed remarkable talent from an early age, but her youth was blighted when, at the age of 17, she was raped by a fellow painter, Agostino Tassi. At his trial, she was tortured to test her evidence. Soon afterward she was "married off" but about a decade later she separated from her husband and subsequently led a life that was remarkably independent for a woman of her time. She eschewed the "ladylike" subjects, such as flowers, preferred by other women painters, concentrating instead on serious figure compositions—traditionally the greatest test of a painter's mettle. In these, she was a match for virtually any male painter of her time. She lived mainly in Rome early in her career and later in Naples, but she also worked in Florence, Venice, and England.

Visual tour

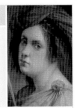

KEY

▼ **SLEEVES ROLLED UP** Painters at this time liked to stress the intellectual aspects of their art, but Artemisia's powerful arm seems to suggest that—in a profession dominated by men—she is not afraid of the physical labor involved in her craft.

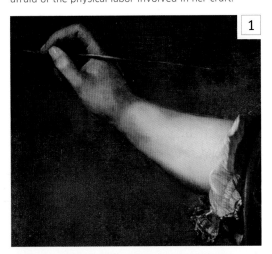

1

▼ **FACE AND HAIR** Artemisia's handsome but rather severe face is topped with a mass of disheveled hair. Such hair is specified in Cesare Ripa's book *Iconologia* as part of the standard image of *La Pittura*, to show the "fury of creation."

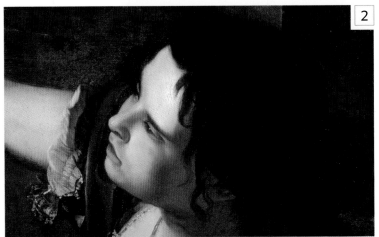

2

3

▲ **PALETTE AND BRUSHES** In her left hand Artemisia holds a palette and brushes. The shape that is vaguely indicated under the palette perhaps represents the stone slab on which artists ground raw materials to make paints. Their work involved laborious craftsmanship as well as lofty inspiration.

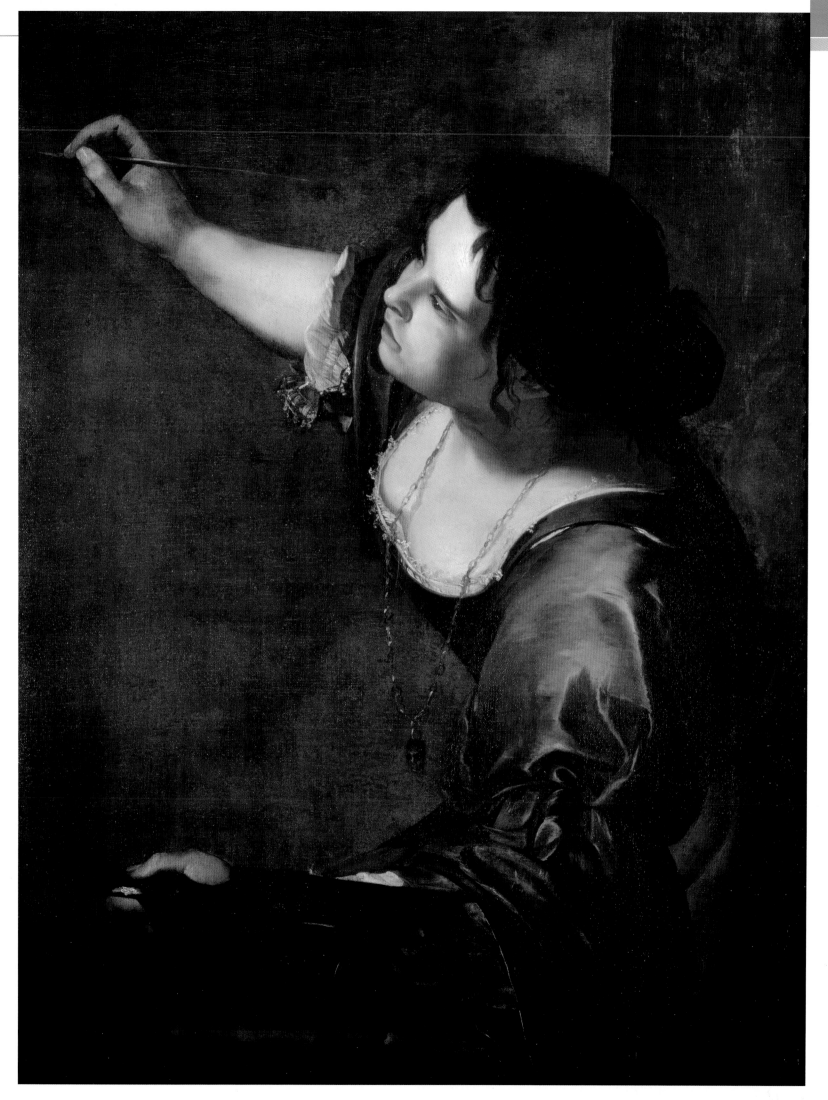

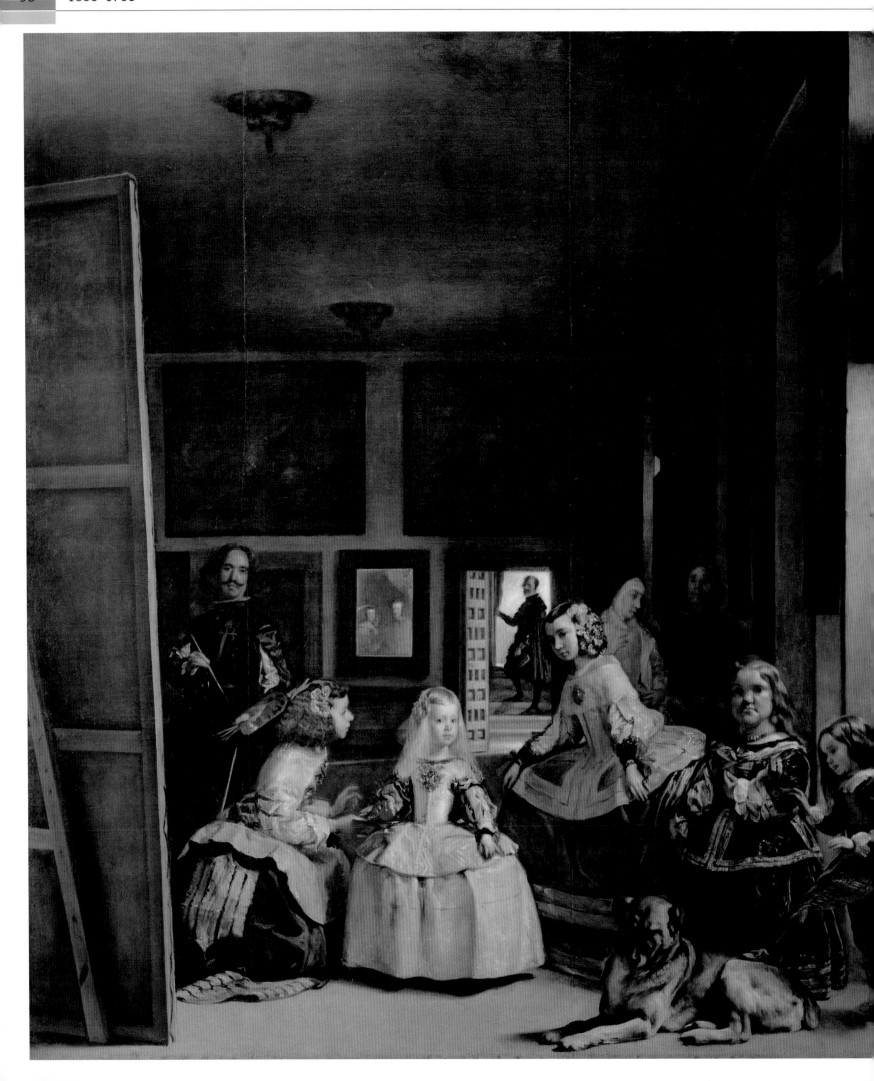

Las Meninas

1656 ▪ OIL ON CANVAS ▪ 125¼ × 108¾in (318 × 276cm) ▪ PRADO, MADRID, SPAIN

DIEGO VELÁZQUEZ

SCALE

Brush in hand, poised as if considering his next stroke, Velázquez is at work on a huge canvas, of which you see only the back. The setting is a large room that he used as a studio in the Alcázar Palace in Madrid, and the other figures are members of the court. The golden-haired little girl in the center is the *Infanta* (Princess) Margarita, aged about five at the time. She is flanked by two *meninas* (maids of honor), who give the painting its familiar title, although this was not adopted until the mid-19th century. Earlier the painting was known by more prosaic names, such as *The Family of Philip IV*. Philip himself, with his second wife, Mariana of Austria, is seen reflected in the mirror on the back wall.

Different interpretations

The painting conveys an astonishing sense of reality: the figures seem caught in an instant of time and to inhabit a palpable space. However, in many ways it is enigmatic, and a huge amount of scholarly commentary has been expended in trying to unravel what exactly is happening in the scene and what Velázquez's intentions were in painting it. It is often suggested that he has shown himself at work on a portrait of the King and Queen, whose little daughter and her retinue have interrupted him. Equally plausibly, it has been proposed that these roles are reversed—Velázquez is painting a portrait of the Princess (whose attitude perhaps suggests that she is tired of posing) when the King and Queen pay a visit to the studio. Certainly it is known that the art-loving Philip IV enjoyed watching Velázquez at work, but whether he was painting the King and Queen or the Princess, it is unclear why he should need such a big canvas.

On a subtler level, *Las Meninas* has been interpreted as a kind of personal manifesto by Velázquez, in which he set forth his claims for the nobility of his profession. He cared deeply about his status in the world, and although he had acquired wealth and prestige, he had long craved the crowning honor of a knighthood. At the Spanish court—a place of rigorous formality—it was no easy matter to achieve this. Even though Velázquez had been the King's favorite for decades, artists were thought to rank low in the social order.

At first his candidature for knighthood was rejected, but Philip obtained special permission from Pope Alexander VII to bestow the honor, and Velázquez was eventually knighted in November 1659, a few months before his death. In *Las Meninas* he proudly wears on his breast the cross that denotes his knighthood. As the picture was finished in 1656, this detail must have been added later. According to legend, Philip painted it himself, but it is much more likely that it is the handiwork of Velázquez or one of his assistants.

> There is **no praise that can match** the taste and skill of this work, **for it is reality, and not painting**

ANTONIO PALOMINO *LIVES OF THE EMINENT SPANISH PAINTERS AND SCULPTORS*, 1724

DIEGO **VELÁZQUEZ**

1599-1660

The greatest of all Spanish painters, Velázquez is renowned chiefly for his portraits. However, he also created superb works in other fields—from religion and mythology to everyday life.

Velázquez was born and brought up in Seville, in southern Spain, but he spent most of his adult life in Madrid. When he was only 24, he became the favorite painter of King Philip IV, and he was unchallenged in this position for the rest of his life. Philip admired Velázquez so much that he gave him various prestigious posts in the royal household, and these limited the time he could devote to painting. Nevertheless, he produced an unforgettable array of portraits of the Spanish court, including not only members of the royal family land aristocracy but also the dwarfs and buffoons who were kept to amuse their masters. He made two visits to Italy, from 1629 to 1631 and 1648 to 1651. During the second stay, he painted a portrait of Pope Innocent X that was immediately acclaimed as a masterpiece. His career culminated in a knighthood—an unprecedented honor for a Spanish painter.

Visual tour

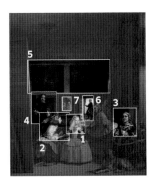

KEY

▶ **MAID OF HONOR** Kneeling in front of the young Princess, one of the maids of honor offers her a tray with a drink. Her charming profile and the silver ornaments in her hair are suggested by Velázquez with a few masterly strokes of the brush.

▼ **INFANTA MARGARITA** The Infanta Margarita (1651–73) was the favorite child of Philip IV, who called her "my joy." (Philip had seven children by his two wives and at least 30 illegitimate children.) In addition to her appearance in *Las Meninas*, Margarita is the subject of several superb individual portraits by Velázquez. In 1666, she married the Holy Roman Emperor Leopold I (her uncle) and died at the age of 21 after bearing four children.

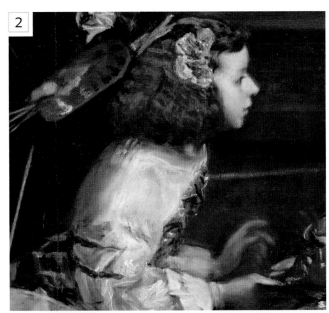

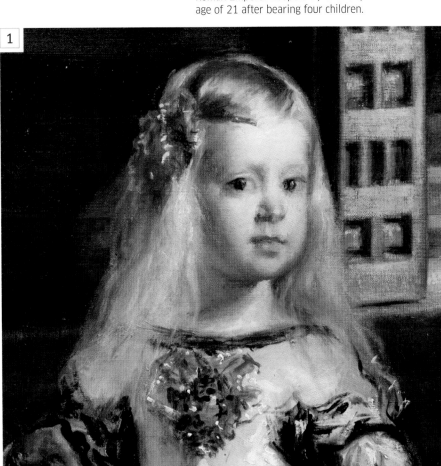

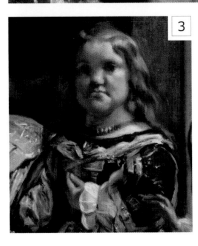

◀ **MARIBÁRBOLA** Contrasting with the delicate Princess and the pretty maids of honor is the lumpish form of Maribárbola, who is described in Antonio Palomino's biography of Velázquez, 1724, as "a dwarf of formidable appearance." Like her companions, however, she is beautifully dressed. Palomino's biography is an invaluable early source of information on *Las Meninas*, providing the first detailed account and identifying the people portrayed.

▶ **SELF-PORTRAIT** Velázquez depicts himself as a serious and handsomely dressed gentleman. To him, painting is not a manual trade but an intellectual pursuit. Palomino wrote of "the high opinion that even noblemen had of him...for his deportment, his person, his virtue, and his honorable conduct."

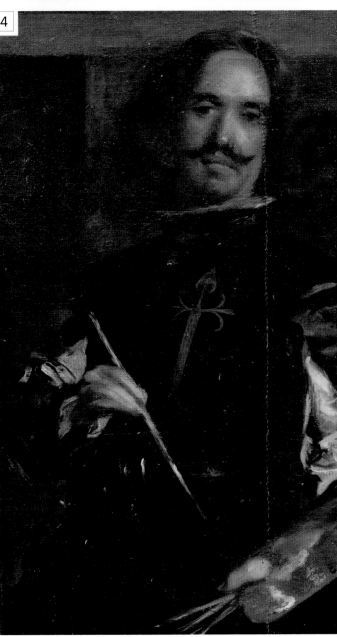

▼ **MYTHOLOGICAL PAINTINGS** The dimly lit paintings hanging in the background can be identified from old palace inventories. Their subjects are taken from mythological stories in which mortals engage in artistic contests with the gods. In both stories the mortals are punished for their presumption, and Velázquez perhaps includes the pictures as a gesture of humility, tempering the high claims he makes for his own art.

ON **TECHNIQUE**

Velázquez began his career working in a solid and somber style, often showing an acute feeling for highly realistic detail. He always maintained a sense of truth and naturalism, but his way of expressing this changed enormously over the years: he tended more and more to sacrifice detail to overall effect. In his final works, his touch was extraordinarily free and vigorous, so that when seen close-up, as in the detail of the Infanta's dress (below), his brushwork looks almost abstract. Palomino summed this up when he wrote: "One cannot understand it if standing too close, but from a distance it is a miracle." According to Palomino, Velázquez sometimes used long-handled brushes to help achieve his effects, but those he holds in *Las Meninas* seem to be of normal size.

▲ **KING AND QUEEN** Velázquez and his workshop produced many individual portraits of Philip and several of Mariana. As far as is known, he never painted them together as a couple, apart from this intriguing mirror image. It has been suggested that they are standing in the position of the spectator or that the mirror reflects what Velázquez has painted on the canvas.

◄ **JOSÉ NIETO** The figure silhouetted in the doorway is José Nieto, Queen Mariana's chamberlain and head of the royal tapestry works. Velázquez so convincingly suggests he is pausing that it is hard to decide whether he is just about to enter or to leave the room. Although the features are blurred, Palomino said that Velázquez had captured a good likeness. Nieto lived until 1685 and Palomino (1655–1726) conceivably spoke to him and to others in the picture (the two dwarfs lived into the 18th century).

IN **CONTEXT**

Like most of Velázquez's work, which was largely inaccessible in royal palaces, *Las Meninas* was little known to the world at large until it went on public display when Spain's national museum, the Prado, opened in Madrid in 1819. The painting quickly became famous. Among its greatest admirers was another celebrated Spanish artist, Pablo Picasso (see pp.218–21), who in 1957 made a series of 58 paintings inspired by it.

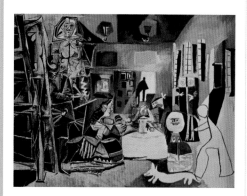

▲ *Las Meninas (group)*, Pablo Picasso, 1957, oil on canvas, 76¼ × 102¼in (194 × 260cm), Museu Picasso, Barcelona, Spain

Self-portrait

c.1665 ▪ OIL ON CANVAS ▪ 44¾ × 37in (114 × 94cm) ▪ KENWOOD HOUSE, LONDON, UK

SCALE

REMBRANDT VAN RIJN

Battered by life's blows, but still proud and defiant, Rembrandt gazes out at us in an image of noble authority. He painted himself many times, but this is perhaps the most imposing of all his self-portraits. Earlier in his career, he had often portrayed himself flamboyantly, playing out some role in fancy costumes or showing off his success in expensive clothes. Now, however, nearing 60, he is content to express the dignity of his profession. The picture's feeling of monumental strength stems partly from the almost geometrical simplicity of the frontal pose, and partly from the breadth of the brushwork. Indeed, the handling is so sketchy virtually everywhere except the head that many experts think the painting is unfinished.

Series of self-portraits

There is no contemporary evidence to explain why Rembrandt portrayed himself so often, but modern writers have made suggestions ranging from the mundane to the metaphysical. It has been proposed, for example, that he used self-portraits to show potential clients how good he was at capturing a likeness—the client could compare the real Rembrandt with the painted image. At the other extreme, the self-portraits have been interpreted as a kind of painted autobiography, in which he charted not only his changing appearance but also his spiritual journey through life. This approach, which was once very popular, is now generally disparaged, not least because it tends to involve reading into the paintings what we happen to know of the triumphs and tragedies of Rembrandt's career.

He was an artist of great diversity, so it is likely that he had not one but several reasons for portraying himself. In his youth he provided a convenient and free model for trying out facial expressions, for example, and later he

was probably inclined at times to celebrate his success and social status. It is also likely that his self-portraits found a ready market, for even in his financially strained later years he remained an admired figure. Very little is recorded about the whereabouts of his self-portraits in his own lifetime (this one, for example, is first documented in 1761), but it is known that Charles I, one of the greatest collectors of the day, owned one as early as 1633.

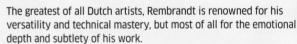

REMBRANDT VAN RIJN

1606–69

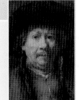

The greatest of all Dutch artists, Rembrandt is renowned for his versatility and technical mastery, but most of all for the emotional depth and subtlety of his work.

The son of a prosperous miller, Rembrandt was born in Leiden, then the second largest town in the Dutch Republic. He showed brilliant talent from an early age. After he settled in the capital, Amsterdam, in 1631 or 1632, he quickly became the leading portraitist in the city. His career was successful for another decade, but in the 1640s his worldly fortunes declined as he began to work more to please himself than his wealthy clients. At this time, he had personal problems, too, not least the death of his beloved wife Saskia in 1642. In the 1650s he had increasing financial troubles (brought about partly by his extravagance) and narrowly escaped bankruptcy, but he recovered with the help of his mistress, Hendrickje, and his son, Titus. Their premature deaths marred his final years, but the quality of his work remained undimmed. In addition to the portraits that were his mainstay, Rembrandt excelled in religious subjects and made occasional but memorable contributions in other fields, including landscape and still life. He was also a superb and prolific draftsman and—by common consent—the greatest of all etchers.

> **If Rembrandt's self-portraits** constitute a diary, as in a sense they do, **it was a diary** at least partly intended **for publication**

MICHAEL KITSON *REMBRANDT, 1969*

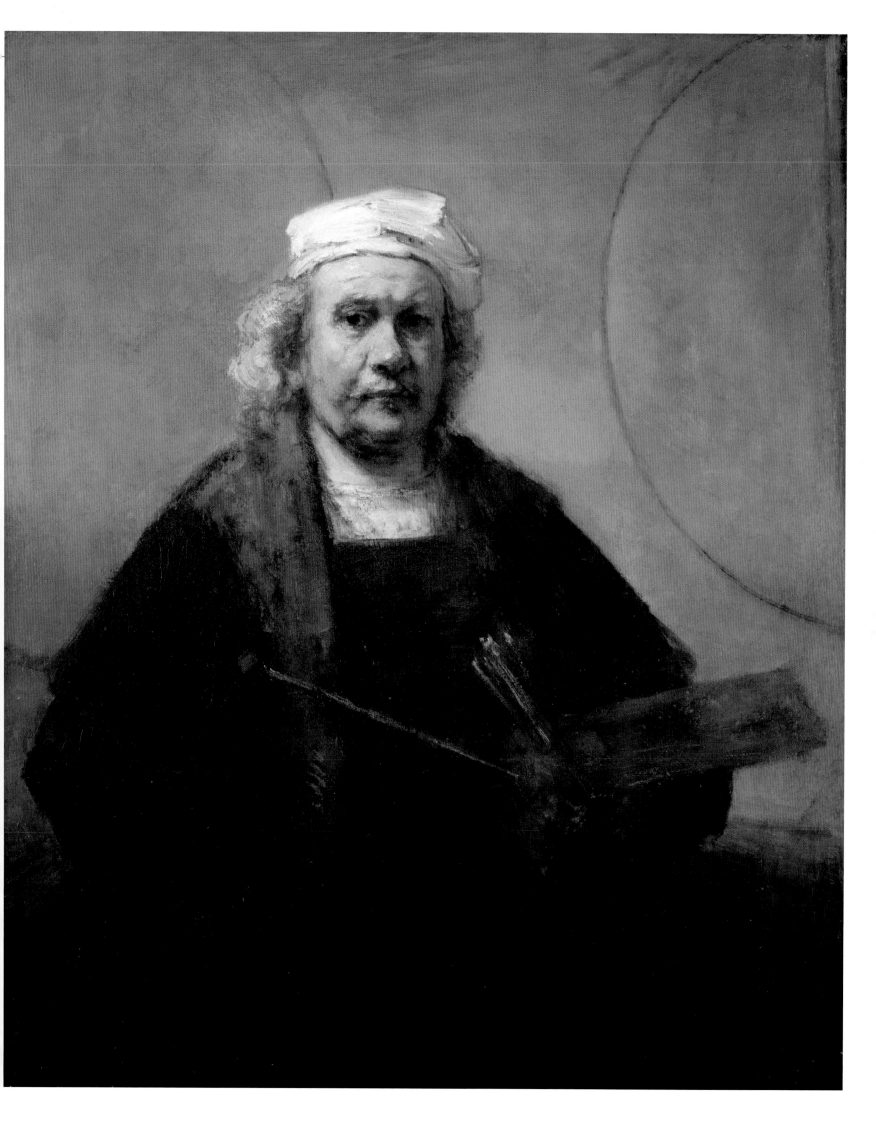

Visual tour

KEY

► **EYES** The eyes are often regarded as the most revealing part of the face—"windows into the soul." Rembrandt shows them in heavy shadow, with no highlights in the pupils, helping to create a somber mood. His look of impassive stoicism contrasts with the showiness that was characteristic of many of his early self-portraits, and suggests the setbacks he had lived through.

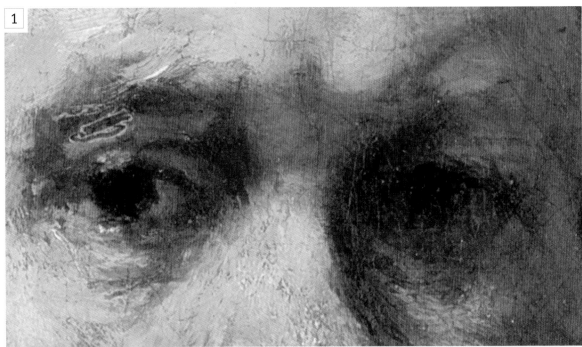

◄ **FUR ROBE** Rembrandt is wearing a fur-lined robe over a red smock and a white undergarment. In his extravagant younger days, he collected costumes, as well as art and curios of all kinds, and although his collection was sold in the 1650s to pay his creditors, he retained a fondness for wearing expensive furs when he depicted himself. The treatment here is so sketchy that it is hard to tell whether his garments are contemporary or historical.

▲ **TOOLS OF THE TRADE** In his left hand Rembrandt is holding a palette, brushes, and maulstick (a rod, padded at one end, that could be used to support the painter's hand). X-rays of the painting show that he originally held these tools in the other hand, accurately reflecting what he would see in a mirror. When they depict such tools in a self-portrait, most artists "correct" the mirror image and show the palette in the left hand, but some do not bother. Rembrandt must have been undecided for a while. The lower part of the picture is painted very broadly (there is almost no indication of the hand), with little sense of depth, so attention is concentrated on the magnificent head.

◀ CIRCLES ON WALL The two enigmatic circles on the wall behind Rembrandt have attracted much speculation. It has been suggested, for example, that they are a kind of rough representation of the twin hemispheres found on contemporary maps of the world. However, some scholars consider them purely abstract, included simply because Rembrandt thought they made an effective design.

▼ WHITE CAP Several of Rembrandt's earlier self-portraits feature expensive or "fancy dress" headgear. Here, however, he wears the kind of plain white cap that was part of everyday indoor clothing for men of the time. The inventory of his possessions drawn up at his death in 1669 lists 10 "men's caps" among the linen. Rembrandt has painted the cap with bold, thick strokes and it stands out forcefully against the muted background.

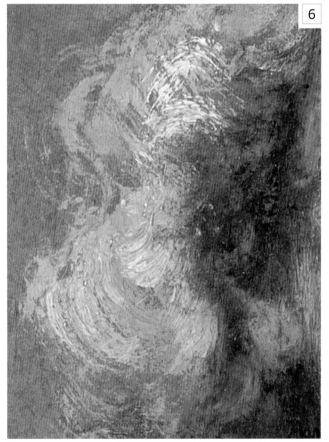

▲ HAIR Grey hair tumbles from under Rembrandt's headgear and falls over his right shoulder. It is depicted with vigorous dabs and swirls of paint, showing his mastery of bold brushwork. Unruly hair is a feature of many of Rembrandt's self-portraits, but in some of the more formal ones he shows himself carefully groomed.

◀ NOSE Rembrandt's large nose was one of his most distinctive features. In many self-portraits, he seems to exult in its bulbous shape, rather than trying to disguise it. Here it is given the face's main highlight, boldly rendered with single dabs of white and red.

ON **TECHNIQUE**

Rembrandt was one of the supreme masters of oil paint, exploring its full expressive potential. In his early paintings, his technique was highly polished, particularly in his commissioned portraits, the subjects of which demanded expertise in depicting the details and textures of their expensive clothes. From the 1640s onward, however, his touch became broader, freer, and more spontaneous, leading to the magnificent breadth and richness of his later works. An early biographer, Arnold Houbraken, wrote with justifiable exaggeration that Rembrandt's final paintings, when seen close-up, "looked as though they had been daubed with a bricklayer's trowel."

IN **CONTEXT**

About 30 painted self-portraits by Rembrandt are known, the first produced when he was in his early 20s, the last in 1669, the year of his death. They are spread fairly evenly over this 40-year period, but there are fewer from the 1640s than from the other decades. In addition to these independent works, Rembrandt sometimes included a self-portrait among the subsidiary figures in a religious or historical painting. He also produced about two dozen self-portrait etchings and about a dozen drawings. Most of these date from the early part of his career—there are few after 1640.

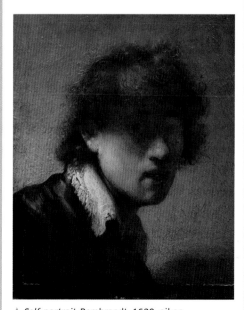

▲ *Self-portrait*, Rembrandt, 1629, oil on panel, 6 × 5in (15.2 × 12.7cm), Alte Pinakothek, Munich, Germany

The Art of Painting

c.1666-68 ■ OIL ON CANVAS ■ 47¼ × 39¼in (120 × 100cm)
KUNSTHISTORISCHES MUSEUM, VIENNA, AUSTRIA

SCALE

JOHANNES VERMEER

The sense of reality is so intense that at first glance it is easy to imagine that this picture is an almost photographically exact image of a 17th-century painter's studio. From the heavy curtains in the foreground to the creased map on the wall and the glittering brass chandelier above it, every color and texture rings true, exquisitely bathed in light that enters from unseen windows on the left. However, this is not a straightforward scene of a painter at work, but rather a glorification of the art of painting. The main clue to this is in the painter's costume—these are not working clothes, but a fanciful, old-fashioned outfit. The model is dressed as Clio, the muse of history, whose trumpet will proclaim the painter's fame.

Ironically, fame was a long time in coming to Vermeer. His output was very small (there are only about 35 surviving paintings by him), and as his work was superficially similar to that of other Dutch painters, it simply got lost in the vast outpouring of pictures by his contemporaries. Sometimes his paintings were admired but thought to be by other artists. It was not until about 1860 that his work began to be rediscovered. This was mainly because of the brilliant connoisseurship of a French writer, Théophile Thoré, who identified about two-thirds of the Vermeers known today.

Personal possession

The Art of Painting evidently had special significance for Vermeer, who perhaps created it as a demonstration of his skills. It was still in his possession when he died, and his widow unsuccessfully tried to keep it in the family when she was forced by debt to sell the other works of art in his estate. Its whereabouts were uncertain throughout the 18th century, but in 1813, it was bought by an Austrian aristocrat, Count Czernin. At this time, it was thought to be by Pieter de Hooch, one of Vermeer's Dutch contemporaries. It remained in the possession of the Czernin family in Vienna until 1940, when it was bought by Adolf Hitler for his private collection. By then, it was acknowledged as one of Vermeer's supreme masterpieces. After the war, the Czernin family claimed the picture had been sold under duress and should be restored to them, but in 1946 it became the property of the Austrian state.

JOHANNES **VERMEER**

1632-75

Although he is now one of the most beloved figures in world art, Vermeer made little impact in his lifetime and was virtually forgotten for two centuries after his death.

As far as is known, Vermeer spent his whole life in Delft, which at this time was the fourth largest town in the Dutch Republic and a prosperous center of trade and culture. Little is recorded of his career, although he appears to have been a respected figure among his fellow artists, who twice elected him as the governor of the Painters' Guild. He worked as an art dealer as well as a painter, but he had difficulty supporting his large family. His financial problems were increased by wars against England and France, which depressed the previously buoyant Dutch art market. When he died at the age of 43, he left his widow (and their 11 surviving children) with heavy debts.

> **It stands apart** from his **other works** in its **imposing scale** and pronounced **allegorical character**

ARTHUR K. WHEELOCK JR.
JOHANNES VERMEER: THE ART OF PAINTING, 1999

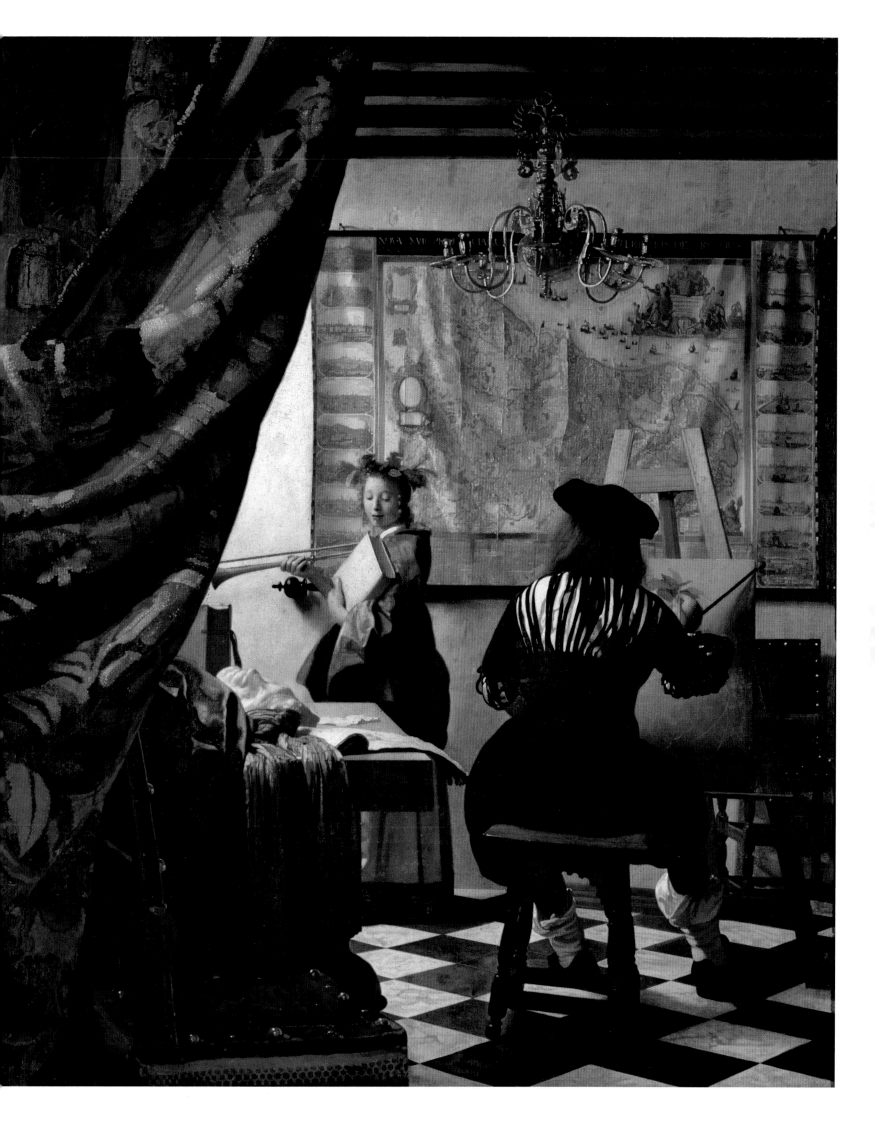

Visual tour

KEY

▶ **THE MUSE OF HISTORY** Various objects that the woman wears and carries identify her as Clio, the muse (goddess of creative inspiration) of history. The crown of laurel leaves symbolizes glory, the trumpet represents fame, and the book indicates the historical record. These features correspond with the description of Clio in Cesare Ripa's book *Iconologia*, a guide to allegorical figures that was much used by artists in the 17th century. A Dutch translation of the book appeared in 1644 and Vermeer presumably owned a copy.

2

1

▲ **THE PAINTER** The figure of the painter has often been described as a self-portrait. There is no way of telling, as the back view reveals so little about his appearance, and there are in any case no undeniably authentic portraits of Vermeer with which to make a comparison. However, the figure does perhaps reflect Vermeer's own working methods—sitting, rather than standing, at the easel and using a maulstick (a stick with a padded end on which the artist could steady the brush hand when painting detailed passages).

3

➤ **CURTAINS** Dutch artists often showed heavy curtains partially pulled aside as a flanking element in their paintings (Vermeer used the device in several other pictures). It helped to create a feeling of intimacy by suggesting that they have been drawn back to allow us a glimpse into a private world. Such curtains also gave painters an opportunity to show virtuoso skill in depicting complex fabrics. No one was better at this than Vermeer, who convincingly conveys the weight as well as the roughness of the fabric.

▼ **MASK** On the table in front of the woman posing as Clio is a plaster mask. Although it could be interpreted as just a studio prop lying around, a mask can have various meanings and associations in art. In this context, it is almost certainly intended to symbolize imitation. Cesare Ripa's *Iconologia* (see top left) mentions a mask as being one of the attributes (distinguishing symbols) of the personification of painting.

ON **TECHNIQUE**

There are no known drawings by Vermeer and it is probable that—like the painter he depicts here—he drew directly on the prepared canvas rather than making preliminary designs on paper. He almost certainly made use of a device called a *camera obscura* (the Latin term for "dark chamber"), an apparatus that works on the same principle as the photographic camera, but which projects an image of a scene onto a drawing or painting surface. Various features of his pictures, such as the slightly out-of-focus highlights on the chandelier, shown below, replicate the effects of the relatively unsophisticated lenses used in the *camera obscura*. Although this helps to explain certain aspects of Vermeer's work, the sparkling beauty of his brushwork and his delicate sense of balance depend on sensitivity and skill rather than mechanical trickery.

▲ **CHECKERED FLOOR** The same type of checkered floor occurs in several of Vermeer's paintings. He presumably had such a floor in his own house and used it as a model. The strong pattern helps to create a sense of depth. About a dozen of Vermeer's paintings have pin marks (usually visible only in X-rays) at the vanishing point of the perspective scheme, indicating that Vermeer stretched a string along the canvas from this point to help him create the floor pattern accurately.

◀ **MAP** The map on the wall has been identified as one published in 1636. It may make a patriotic allusion to the history of Vermeer's country, the Dutch Republic, which is shown to the right of the central crease. The Spanish Netherlands, (roughly the same area as modern Belgium) is to the left. The Dutch Republic effectively won its freedom from Spanish rule in 1609, but this was not formally recognized by Spain until 1648; the southern territories remained under Spanish rule throughout the 17th century.

IN **CONTEXT**

Clio, as depicted by Vermeer, was one of nine muses, who in classical mythology each watched over a branch of learning or the arts. Here, Clio (on the left) is shown with two of her sisters—Euterpe, the muse of music, who plays the flute, and Thalia, the muse of comedy, who holds a theatrical mask.

▲ *Clio, Euterpe, and Thalia*, Eustache le Sueur, c.1652–55, oil on board, 51 × 51in (130 × 130cm), Louvre, Paris, France

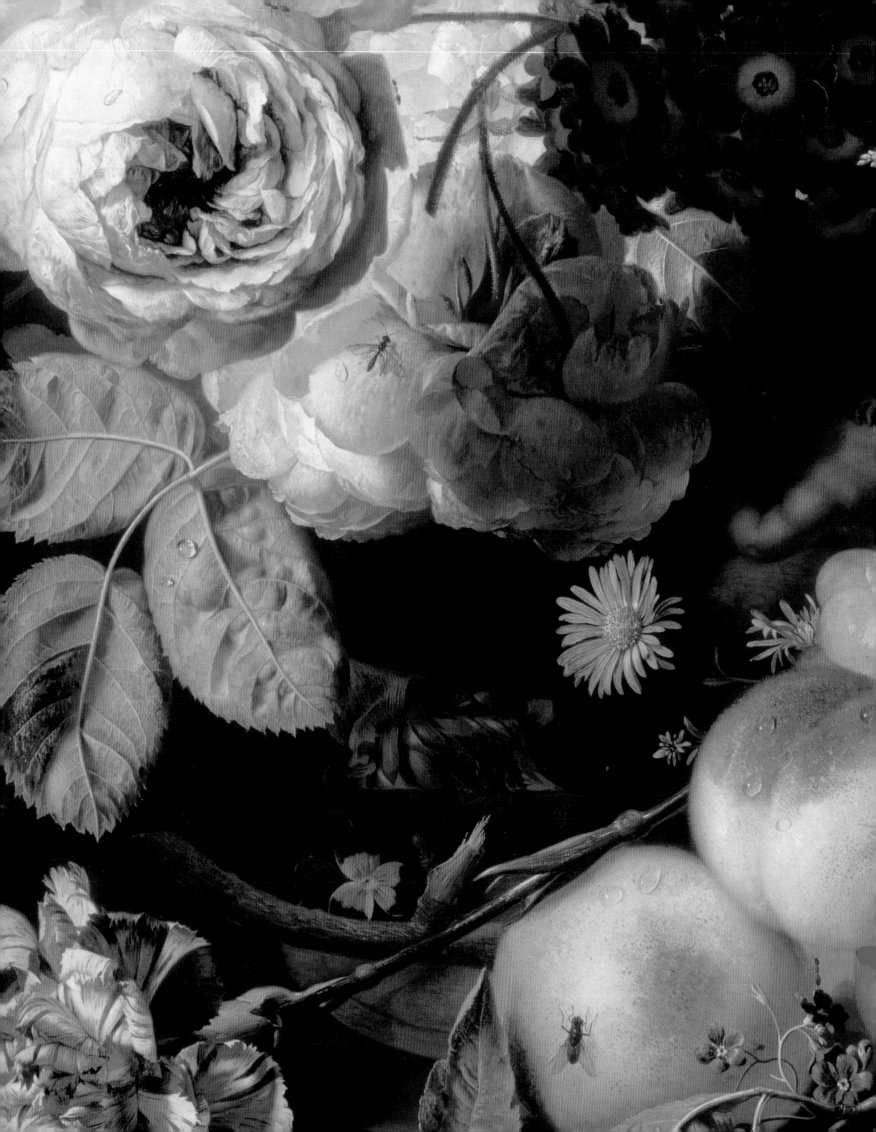

1700 – 1800

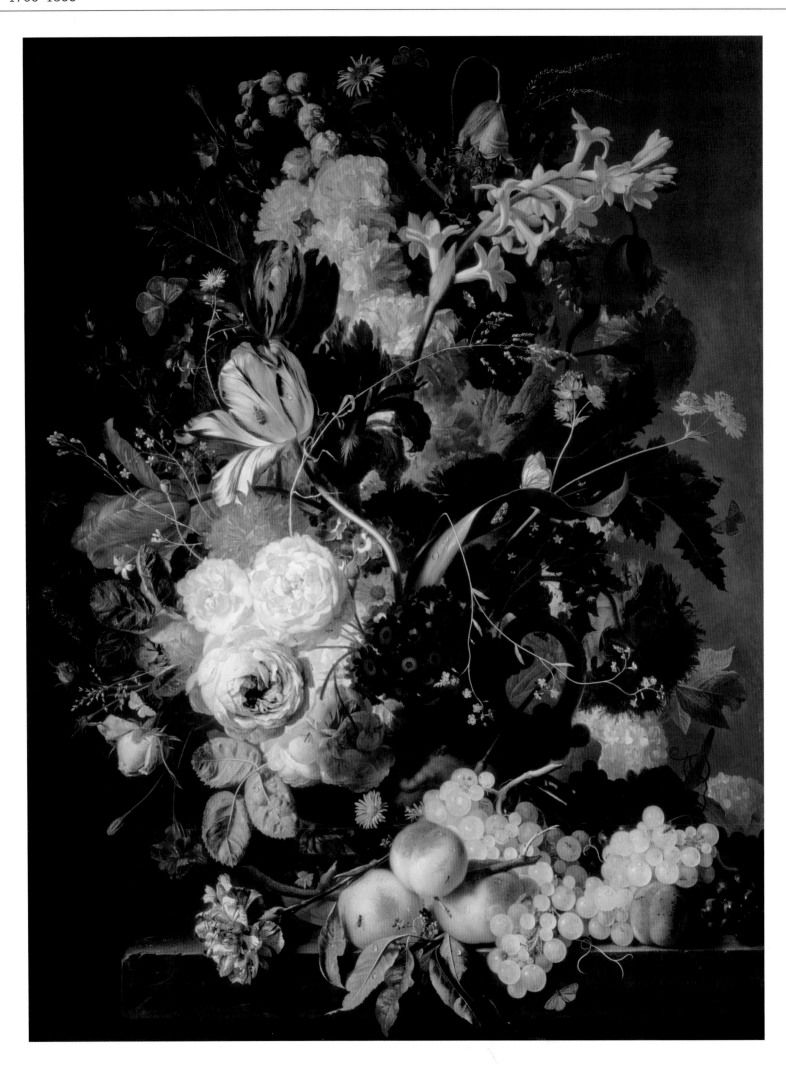

Still Life with Flowers and Fruit

c.1715 ■ OIL ON PANEL ■ 31 × 24in (78.7 × 61.3cm) ■ NATIONAL GALLERY OF ART, WASHINGTON, US

SCALE

JAN VAN HUYSUM

The opulent abundance of this panel represents Dutch still-life painting at its most magnificent. The tightly packed flowers and fruits are arranged with sweeping rhythms and gloriously variegated colors to create a breathtaking display. And beyond the general effect, the detail of each individual bloom is a marvel of precise observation and polished craftsmanship.

Everything is so convincing, down to the tiniest petal and drop of moisture, that it is easy to imagine such a dazzling floral arrangement once really existed. In fact, Jan van Huysum was a master of artifice who took flowers and fruits from different seasons and combined them in his imagination.

He was secretive about the methods with which he achieved his enamel-smooth perfection of surface, refusing to allow anyone—even his brothers—into his studio when he was working. He did once reluctantly agree to accept a pupil, Margareta Haverman, but he is said to have dismissed her when she became deceptively good at imitating his work.

An important insight into van Huysum's methods, however, comes from a letter he wrote to a patron in 1742. In it, he says that he would have completed a painting the previous year if he had been able to obtain a yellow rose; he also lacks grapes, figs, and a pomegranate to finish a fruit piece. From this it seems that he always worked directly from a model in front of him. He occasionally dated his pictures with two consecutive years, suggesting that he did indeed sometimes put a work aside and continue it when he had found the required flower or fruit.

Some scholars have argued that paintings such as this were meant to be deeply pondered by the viewer, as well as admired for their beauty—that they contain subtle symbolic meaning. It is true that some Dutch painters intended symbolic significance, for they included inscriptions to underline their moralistic points. However, there has been a recent tendency to over-interpret Dutch paintings, finding hidden meanings everywhere, and van Huysum's work does not require any intellectual props to sustain our interest.

> Considered the **greatest** of all flower-painters…his drawing is superb…**his coloration rich**, and his **compositions** admirably **light and free** "

INGVAR BERGSTROM *DUTCH STILL-LIFE PAINTING*, 1956

JAN VAN **HUYSUM**

1682-1749

Although he sometimes painted other subjects, mainly landscapes, van Huysum's reputation rests on his pictures of flowers. In this field he ranks as one of the greatest masters of all time.

Jan van Huysum was born into a family of artists in Amsterdam, the Netherlands, where he lived and worked throughout his life. He often visited nearby Haarlem (a major center of horticulture even then) to study flowers. He was taught by his father, Justus van Huysum the Elder, who was primarily a flower painter, and had three painter brothers, two of whom also concentrated on flowers. In terms of the wealth and prestige he achieved in his lifetime, van Huysum was perhaps the most successful flower painter ever. Contemporary writers sang his praises. He had an international clientele, including some of the most distinguished collectors of the day, among them the kings of Poland and Prussia. The famous English connoisseur Horace Walpole commissioned four paintings from him. His work inspired other Dutch painters into the second half of the 19th century, and his reputation has remained high.

Visual tour

KEY

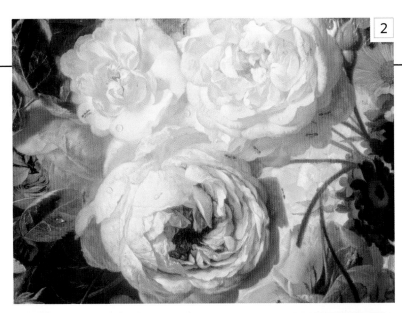

▶ **PALE PINK ROSES** Of all flowers, roses have the richest tradition in art, with many associations, particularly with the Virgin Mary, who was described as a "rose without thorns"—in other words, sinless. Their prominence in still-life painting, however, owes more to their sheer beauty than to any other factor. Pink was the most common color among wild roses and has also been much favored by horticulturists. Roses generally bloom later in the year than tulips, but it is possible that van Huysum could have had specimens of both to work from at the same time.

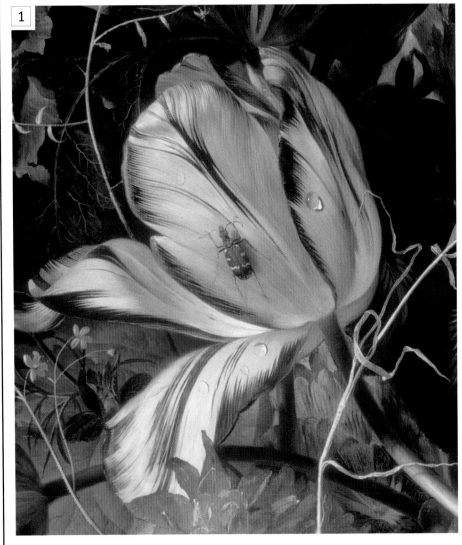

▲ **STRIPED TULIP** Tulips are among the most commonly seen flowers in van Huysum's work and in Dutch still-life painting in general. The tulip was introduced to Holland from the Ottoman Empire in the 16th century and became a status symbol because of its rarity and beauty. Huge prices were paid for prize bulbs at the height of "tulip mania." But speculation got out of hand and in the 1630s the tulip-bulb market crashed. In spite of this, the tulip remained enormously popular with the flower-loving Dutch.

▶ **PEACHES AND INSECTS** The peaches illustrate the extraordinary finesse of van Huysum's technique, as he evokes their voluptuous, round forms and soft, velvety textures. The tiny insects not only emphasize, by contrast, the pristine surfaces of the fruit, but may also have some symbolic significance. Insects are short-lived and, therefore, were sometimes interpreted as an allusion to the brevity of human existence. A butterfly, on the other hand, could stand for resurrection and rebirth.

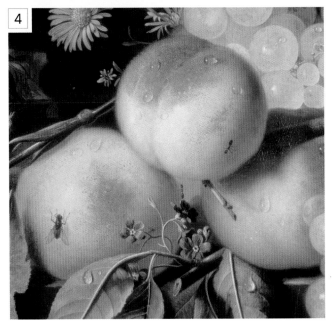

5 ◄ **LIGHT AND SHADE** Van Huysum was a master at placing contrasting shapes, tones, and textures against one another. Here the lovely, soft form of a rose—with a tiny butterfly hovering above it—stands out against the dark, flat background. He makes his effects seem natural, although they were in fact contrived.

▼ **STRIPED CARNATION** A single, beautifully observed carnation bloom lies on the ledge in the foreground. Like the rose, the carnation has had a long tradition in art, often being associated with love and romance. As with roses, most examples at this time were pink.

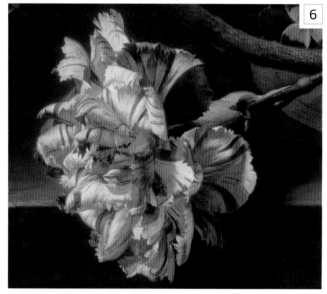

6

▲ **DARK BACKGROUND** In the earlier part of his career, van Huysum invariably used a dark background in his pictures, in common with most other Dutch flower painters, the brightly lit blooms thereby standing out all the more clearly. From the 1720s, however, he began to use light backgrounds, as his paintings became increasingly airy and lively. This was in line with a move from the weighty Baroque style of the 17th century to the more frothy Rococo style of the 18th century.

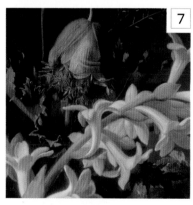

7 ◄ **COLOR CONTRASTS** Van Huysum was a vibrant and subtle colorist, keeping a great variety of tones and hues in delicate balance. Here he sets one color off strongly against another, where the red of the poppy stands out against its white neighbors.

8 ◄ **GRAPES** The translucent skins of the grapes provide another challenge to van Huysum's powers of verisimilitude, which he meets with his customary panache. Grapes were common in still-life paintings. On some occasions they may be a deliberate allusion to the wine of the Eucharist and therefore to Christ's blood.

ON **TECHNIQUE**

17th-century Dutch flower painters generally favored static compositions, arranged more or less symmetrically in a centrally placed vase. Van Huysum, however, introduced a sense of lively movement, with curling lines and the flowers overflowing towards the viewer. Often an S-shaped curve flows through the composition. Unlike most of his peers, van Huysum made numerous drawings, usually in chalk or ink—some are vigorous compositional sketches for his paintings.

IN **CONTEXT**

Still-life painting flourished in the 17th-century Netherlands, expressing the Dutch taste for subjects that celebrated their surroundings and hard-won peace and prosperity. It grew so popular that there were sub-specialities such as shells or breakfast tables. Flowers were perhaps the one area in which 18th-century Dutch artists such as van Huysum rivaled or even surpassed the achievements of the 1600s.

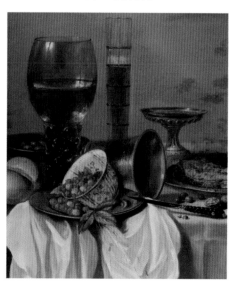

▲ *Still Life with Drinking Vessels*, Pieter Claesz, 1649, oil on panel, 25 × 20½in (63.5 × 52.5cm), National Gallery, London, UK

Marriage à-la-Mode: The Marriage Settlement

c.1743 ▪ OIL ON CANVAS ▪ 27½ × 35¾in (69.9 × 90.8cm) ▪ NATIONAL GALLERY, LONDON, UK

SCALE

WILLIAM HOGARTH

In the grand interior of a London house, a wealthy merchant and an earl are negotiating a marriage settlement that will benefit them both in different ways. The merchant (in the red coat) is buying his way into the aristocracy by marrying off his daughter to the son of Earl Squander (sitting opposite), who, as his name suggests, has frittered away his wealth. The groom (in the blue coat) seems oblivious to the proceedings, a lawyer is whispering into the bride's ear, and an accountant is pushing another unpaid bill towards the earl. This lively scene is the first in a narrative sequence of six paintings by master satirist Hogarth depicting the unfortunate course and tragic conclusion of the ill-conceived marriage. A satirical look at marrying for money, it is an uncompromising but comic depiction of human weakness and moral failings.

Innovative visual satire

Hogarth's satirical paintings were innovative in terms of both their form and subject. Taking the form of narrative sequences—as opposed to single works—on topical themes, they revealed his cynical view of 18th-century London society and its materialism, his subversive attitude, and his love of mischief-making. With these "modern moral subjects," as they were known, Hogarth estabished a new genre of painting.

The Marriage Settlement is typical of his other works in this genre in that it resembles a theater set and the whole sequence tells an entertaining story, rather like the unfolding scenes of a stage play. In this first painting the young couple seem uninterested in the proceedings and sit with their backs to each other. From this unpromising beginning a horrid melodrama is about to unfold, featuring infidelity, sexually transmitted disease, indolence, self-indulgence, violence, and death.

The painting is humorous, cleverly composed, and well executed. There is abundant detail to enjoy, from the expressions of the characters to the paintings on the walls and the scene outside the window. Hogarth developed this style of painting because he was unable to make enough money from producing either portraits or history paintings, but *The Marriage Settlement* and the other five paintings in the series were not well received at first. He found it difficult to sell his work, but once he had turned the painted images into high-quality engravings and circulated prints of them on subscription, they reached a wide audience and generated a considerable income.

Hogarth's satirical paintings continue to fascinate because their gritty themes have a timeless appeal and the narrative is acted out to its unpleasant conclusion in a series of engaging set pieces. Given their topical themes, they were, perhaps, the 18th-century equivalent of today's soap operas.

WILLIAM **HOGARTH**

1697-1764

An innovative painter and engraver, Hogarth was instrumental in popularizing British art through printmaking. He also established artists' copyright.

At the age of 23, after serving an apprenticeship with an engraver, Hogarth started his own printing business in London. He also studied painting at Sir James Thornhill's free academy in St Martin's Lane, London. Later, he set up his own art school there.

During the 1730s, Hogarth painted informal group portraits, known as "conversation pieces," for wealthy families but his portrayals were insufficiently flattering for his client's tastes and had limited success. In the same period, Hogarth began developing his own genre of satirical paintings. These became hugely popular and made him a wealthy man. Indeed, he was one of the first British artists to work independently without financial patronage. His best-known series are *A Harlot's Progress*, c.1731, *A Rake's Progress*, 1735, and *Marriage à-la-Mode*, c.1743.

All Hogarth's scenes look like scenes of a crime. The viewer is invited to cast a detective eye, left and right, picking up clues… the artist has carefully placed

TOM LUBBOCK *THE INDEPENDENT,* 2008

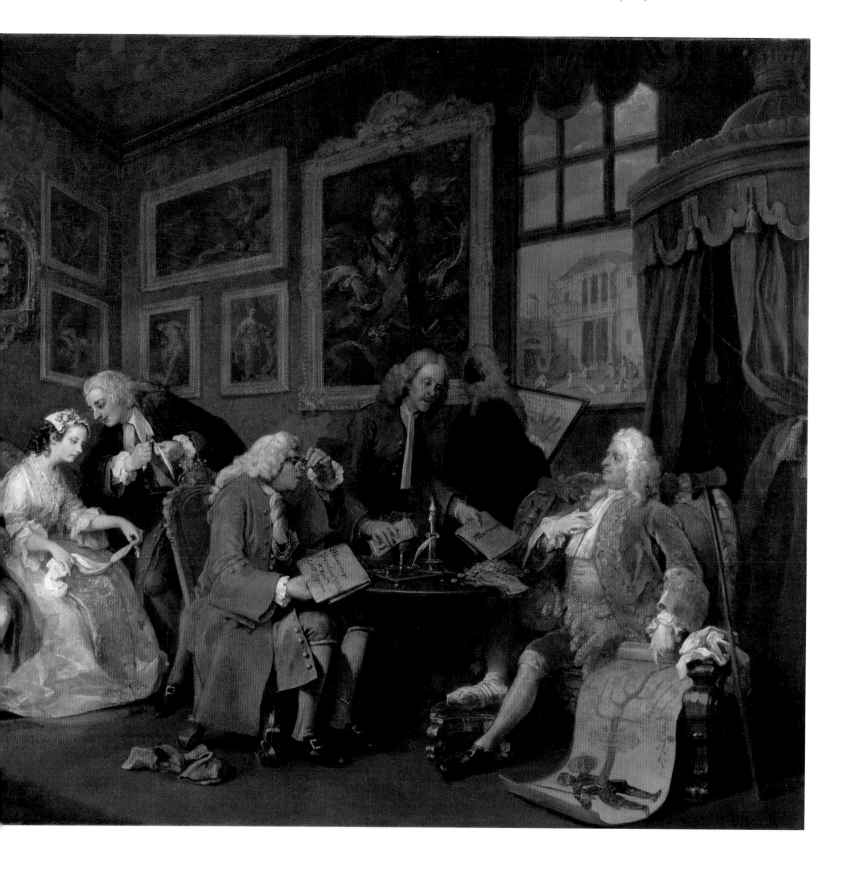

Visual tour

KEY

▶ **CITY MERCHANT**
In the center of the composition, resplendent in a bright red coat, the wealthy father of the bride-to-be is scrutinizing the marriage contract. With his back to his daughter, he is peering through his spectacles at the print.

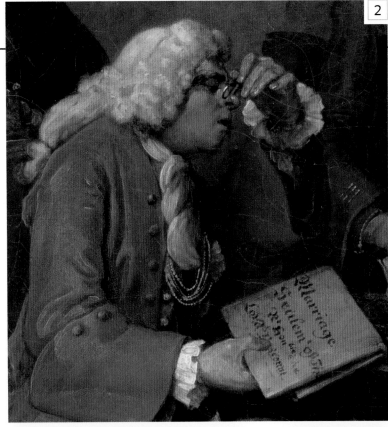

▼ **EARL SQUANDER** Bewigged and distinctly pompous looking, Earl Squander is doubtless requesting a substantial sum in return for accepting the merchant's daughter into his aristocratic family. Hogarth has added wonderful comic touches, such as the partly unrolled family tree dating back centuries, with the earl proudly pointing at its illustrious branches. Earl Squander's self-indulgent nature is clearly indicated by his bandaged, gout-afflicted foot, which he rests on a stool adorned with the family crest. Gout, known as "the rich man's disease," was attributed to excessive consumption of rich food and fine wines.

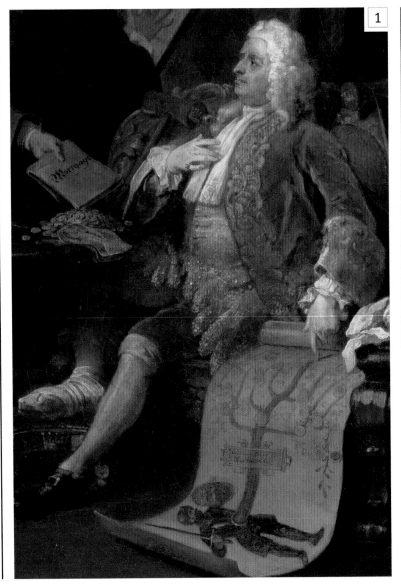

▲ **BUILDING WORKS** Through the window, we can see a grand building complete with scaffolding. This is the earl's new home, another detail that Hogarth has included to indicate the scale of the earl's ill-advised spending. The building is unfinished, suggesting that the earl has run out of money.

▶ **UNPAID BILLS** The accountant is showing Earl Squander a document, possibly setting out the amount owing on his new mansion. In juxtaposing the unpaid bill and the marriage settlement, Hogarth is satirizing the union, which is a cynical business deal between the two fathers.

▼ **THE GROOM** The puny Viscount seems to be more interested in admiring his reflection in the mirror than looking at his bride-to-be. Dressed in the latest French fashions, the earl's son has no doubt been to the Continent. Like his father, he leads a life of dissipation: the black mark on his neck is a symptom of syphilis, popularly called "the French pox."

▲ **THE BRIDE** Dressed rather plainly in comparison with her vain husband-to-be, the daughter of the merchant is listening intently to what the lawyer, appropriately named Silvertongue, is whispering in her ear. This is an early indication of his dishonorable intentions. Later in the series we learn that the lawyer has seduced her.

ON **TECHNIQUE**

Hogarth was a skilled engraver and the painting of *The Marriage Settlement* was used as a model for the engraving print below. To make an engraving, the image was incised into a copper plate, which was then used to make black-and-white prints. The image was reversed as a result of the printing process. Because the print would not be in full color like the painting, areas of tone had to be created in a different way. The engraver would use crosshatching (intersecting parallel lines) to create areas of tone, incising lines very close together and in different directions on top of each other to build up the darkest areas of tone. The paler areas of the image would have been created with lighter crosshatching, or left almost blank.

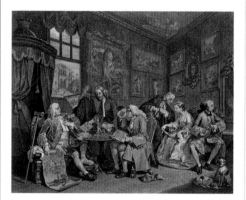

▲ *Marriage à-la-Mode: the Marriage Settlement*, William Hogarth, 1745, engraving print on paper, Victoria & Albert Museum, London, UK

5

6

7

◄ **MEDUSA** On the wall between the bride and groom hangs a painting of a screaming Gorgon, rather like Caravaggio's *Medusa*, made in 1597. This Greek mythological monster with snakes for hair probably indicates the horrors that will befall the ill-matched couple.

▼ **DOGS** Echoing the unhappy union of the bride and groom and their sorry fate, the two dogs in the bottom left-hand corner are shackled together.

IN **CONTEXT**

The painting below is the second episode in Hogarth's *Marriage à-la-Mode*. It depicts the newlyweds at home the morning after the night before. It is midday and both seem exhausted after their separate nocturnal entertainments. The viscount lolls in a chair, another woman's cap poking from his pocket with the dog about to retrieve it. His wife might be signaling to someone out of sight, possibly a lover who had to make a quick exit, hence the upturned chair. On the left, a servant clutching unpaid bills walks out of the room making a gesture of despair.

8

▲ *Marriage à-la-Mode: The Tête à Tête*, William Hogarth, c.1743, oil on canvas, 27½ × 35¾in (69.9 × 90.8cm), National Gallery, London, UK

Mr. and Mrs. Andrews

c.1750 ▪ OIL ON CANVAS ▪ 27½ × 47in (69.8 × 119.4cm) ▪ NATIONAL GALLERY, LONDON, UK

THOMAS GAINSBOROUGH

SCALE

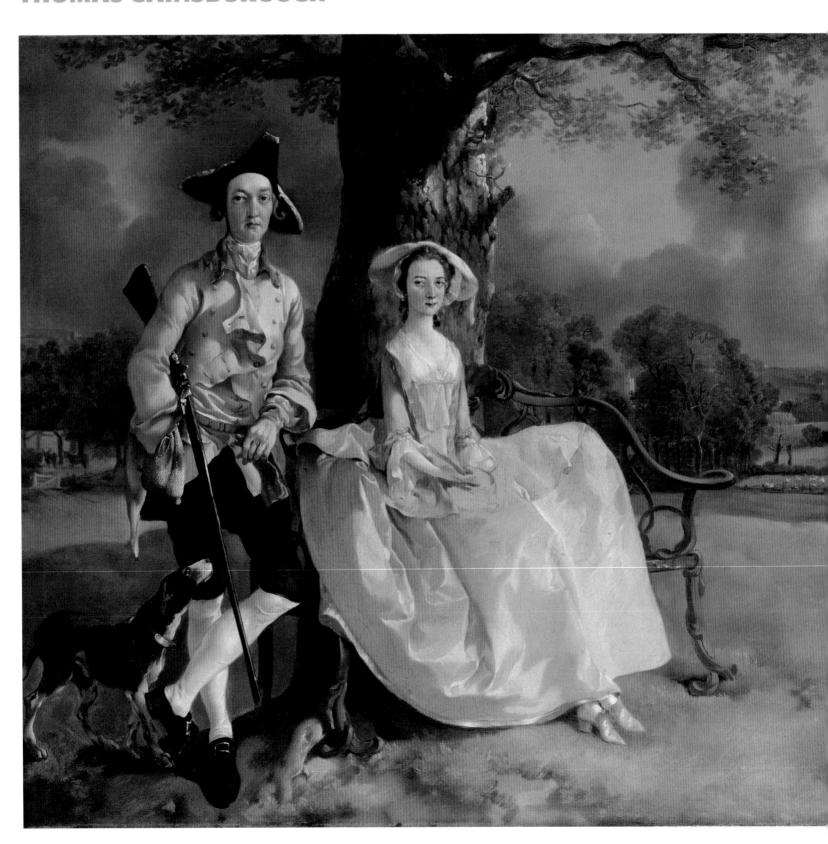

One of the first painted scenes of provincial English country living, *Mr. and Mrs. Andrews* started a fashion for informal portraiture among the wealthy classes of the 18th century. Gainsborough was commissioned to paint this celebrated double portrait early in his career, just after he had moved back from London to Suffolk, but landscape painting was his real passion and this striking composition displays his brilliance in both genres.

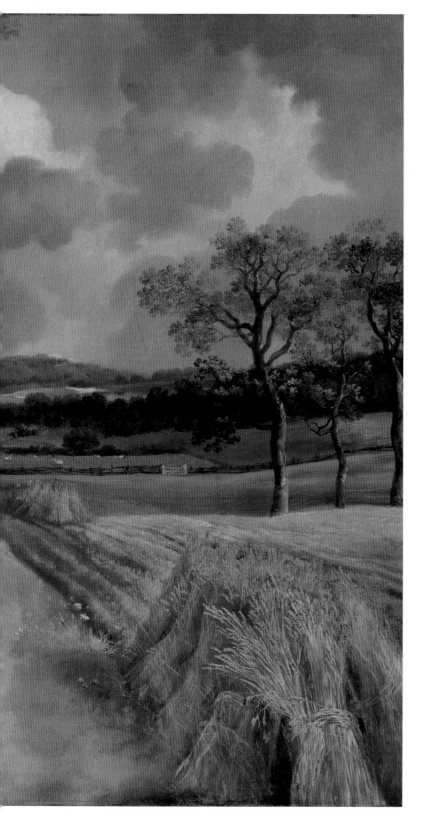

Mr. and Mrs. Andrews was probably commissioned to commemorate the couple's recent wedding and this fresh, luminous portrait is above all a statement of their social standing. The newlyweds are pictured in open fields at Auberies, Mr. Andrews's family estate near Sudbury, in eastern England, which had been extended as a result of the marriage. Not only the landscape but also the couple's faces seem quintessentially English. Gainsborough has chosen to place his sitters off-center, with their lands unfolding expansively to the right. Mr. Andrews, every inch the country gentleman, leans informally on the bench beside his new wife and proudly displays the extent of his fertile domain, the visible proof of his wealth and status. The latest farming methods are also alluded to in the painting, to show that the couple are forward-looking as well as prosperous. Although Mr. Andrews wears the clothes of a country squire, his wife is elegantly attired in the latest French-inspired fashions and the Rococo-style bench is further evidence of their cosmopolitan tastes.

Evocative landscape

In this great painting, Gainsborough has lavished as much attention on the Suffolk landscape as he has on the young couple. The green and gold fields, the billowing clouds, the carefully observed ties around the sheaves of corn, and the cow parsley growing wild in the fields are all testament to the artist's deep love of nature and make this an English rural idyll. Gainsborough found it hard to make a living from landscape painting alone but was fortunately in such great demand as a society portrait painter that he was able to subsidise his real love.

THOMAS **GAINSBOROUGH**

1727–1788

One of the great masters of 18th-century painting, Gainsborough was best known for his portraits and for his lyrical and naturalistic depiction of the English countryside.

Born and educated in Sudbury, Suffolk, Gainsborough moved to London when he was 13, to study drawing and etching with the French draughtsman and engraver Hubert Gravelot. He may also have studied at the academy set up by William Hogarth in London in 1735.

Around 1748, Gainsborough returned to Suffolk, where he worked for 10 years, painting the portraits of local gentry and merchants. He developed a naturalistic approach and often painted head-and-shoulder portraits rather than conversation pieces.

In 1759, he moved to Bath, where he found a ready demand for his portrait skills. Seeing the works of Van Dyck inspired a new, elegant style that appealed to his wealthy clients and in 1768 he was elected a founder member of the Royal Academy. Gainsborough settled in London in 1774.

Visual tour

KEY

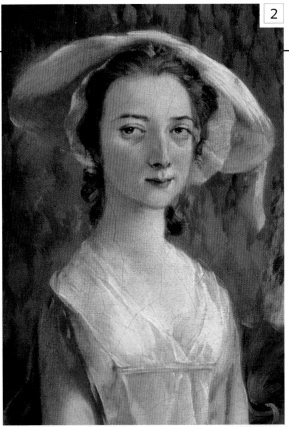

◄ **FRANCES MARY ANDREWS**
Mrs. Andrews is thought to have been 16 years old when she got married. Gainsborough painted her with a tiny head to emphasize her dainty physique. Her feet and unfinished hands are also disproportionately and flatteringly small and almost doll-like: at the time petite features were very fashionable. Mrs. Andrews's slightness and sitting postition also emphasize her husband's dominance of the composition.

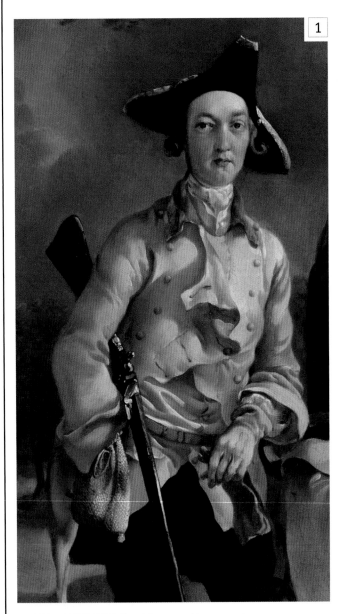

▲ **ALL SAINTS' CHURCH** Just visible through the trees is the church of All Saints' in Sudbury, where the couple were married in November 1748. The tower of Holy Trinity Church, in the nearby village of Long Melford, can also be glimpsed above Mr. Andrews's left elbow. These small details help to identify the actual location of the Andrews's estate.

▲ **ROBERT ANDREWS** Presiding over his possessions: his ancestral land, his dog, and, in accordance with the social conventions of the time, his wife, Mr. Andrews appears satisfied with his life and looks directly at us. The gun under his arm symbolizes virility and is echoed by his stance—he leans casually on the bench with his legs crossed, to show off the musculature. A member of the landed gentry and a graduate of Oxford University, Mr. Andrews was around 22 years old at the time the portrait was painted.

▲ **MODERN METHODS** The bushels of corn are a symbol of fertility, both of the land and perhaps also of the couple. The neat rows show us that Mr. Andrews's farm is both orderly and modern. The agricultural revolution of the 18th century brought about new farming methods, helped by inventions such as the mechanical seed drill. Before such inventions, the rows would have been far less uniform in shape. Enclosed fields and selective breeding were also introduced to increase yields of wool and milk, as indicated by the fenced field of sheep in the distance.

▼ **EMPTY LAP** Gainsborough has depicted the soft folds and delicate sheen of Mrs. Andrews's silk dress with consummate skill, but the area where her hands rest on her lap is left puzzlingly unpainted. A popular theory is that the space was intended for a bird shot by Mr. Andrews, but his wife would surely not have sullied her expensive dress with a carcass. A craft bag is a more plausible explanation.

▼ **DOG** The gun dog, a pointer, looks obediently at his master, waiting for his next command. The line of the dog's head directs our gaze towards Mr. Andrews's face, reinforcing the painting's principal point of focus. As a symbol of loyalty, the dog is included to represent the couple's fidelity and appears as a frequent motif in other Gainsborough portraits.

ON **TECHNIQUE**

Gainsborough would have taken his sketchbook outdoors to make detailed studies of the local landscape. He would not, however, have expected his sitters to pose outside and Mrs. Andrews's fashionable footwear is hardly appropriate for outdoor wear. Preparatory work for the portrait would have been carried out in the comfort of the couple's home and when they were unavailable, mannequins—small, clothed, articulated wooden dolls—would have been substituted.

This painting clearly displays the sensitivity and delicacy of Gainsborough's brushwork, particularly in the fabric of Mrs. Andrews's sky-blue dress with its shimmering highlights.

▲ **OAK TREE** In formal portraits a classical column was frequently employed as a compositional device. Here, Gainsborough uses the trunk of a mature oak tree. Traditionally used in shipbuilding, the "mighty" oak is a symbol of great strength and stability as well as being particularly evocative of the English countryside.

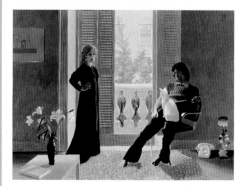

IN **CONTEXT**

It is tempting to draw comparisons between Gainsborough's *Mr. and Mrs. Andrews* and the 20th-century painting by British artist David Hockney of the late fashion designer, Ossie Clark, and his wife, textile designer Celia Birtwell. Both paintings are double portraits of newlyweds and in both of them the fashionable clothes and style of furniture set them firmly within a particular epoch. In Hockney's painting, it is the woman who is standing and assuming the dominant pose. The man is seated and is accompanied by a cat, rather than a dog, possibly introducing the idea of infidelity rather than loyalty.

◀ **CLOUDY SKY** The grey tones of the clouds to the right suggest that the weather is about to change and that rain is on its way. A cloudy, as opposed to a bright, sunny, sky was unusual in a commissioned portrait. It is more commonly seen in narrative paintings to warn of problems looming ahead.

▲ *Mr. and Mrs. Clark and Percy*, David Hockney, 1970–71, acrylic on canvas, 8½ × 12in (21.3 × 30.5cm), Tate, London, UK

Allegory of the Planets and Continents

1752-53 ▪ FRESCO ▪ 62 × 108ft (c.19 × 33m) ▪ RESIDENZ, WÜRZBURG, GERMANY

GIAMBATTISTA TIEPOLO

SCALE

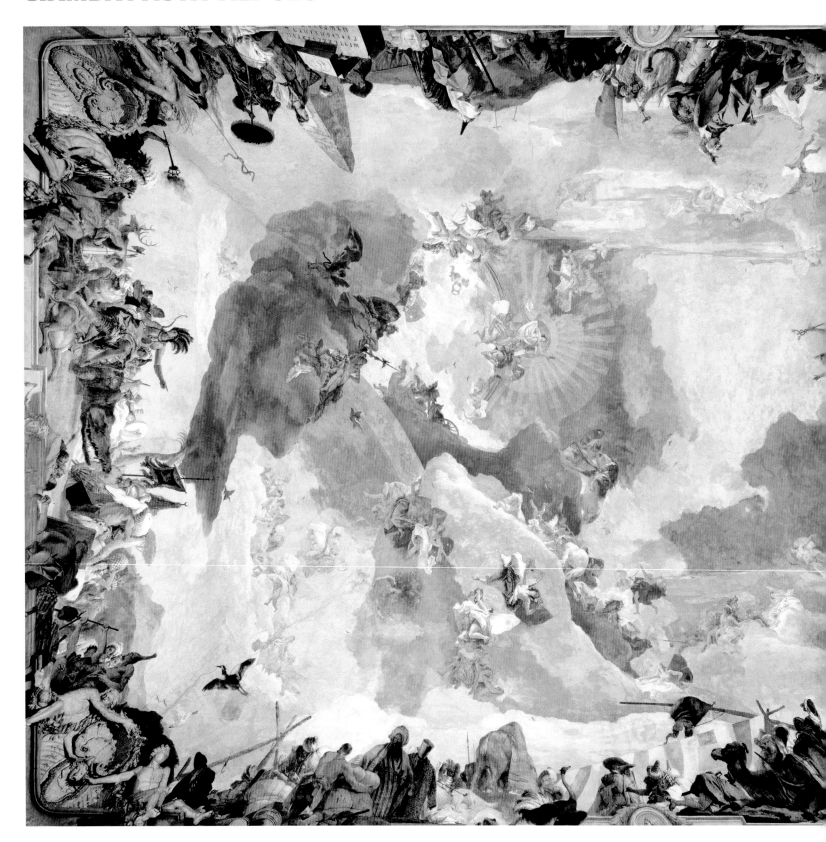

He is **full of wit, with boundless inspiration, a dazzling sense of color,** and works with **amazing speed**

COUNT CARL GUSTAV TESSIN LETTER, 1736

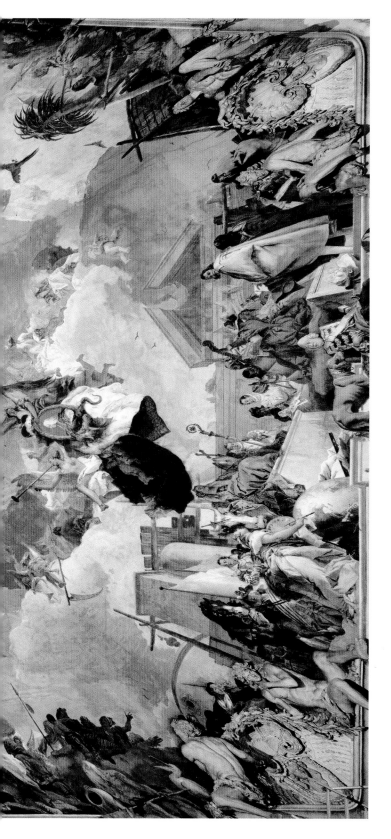

This breathtaking ceiling soars over the main staircase of one of the most magnificent palaces in Europe—the Residence of the Prince-Bishops of Würzburg in southern Germany. The Prince-Bishop who commissioned this masterpiece was Karl Philipp von Greiffenklau, who reigned from 1749 until his death in 1754. Although very wealthy, he was a figure of only minor historical importance, but Tiepolo, with superb confidence and inventiveness, has immortalized him in this painting as though he were a mighty hero. Figures representing the four quarters of the globe (all the continents that were known at the time) are arranged around the edges of the ceiling, and each one, improbably but gloriously, pays tribute to Karl Philipp, whose portrait is held aloft over Europe. The gods of Olympus join in.

Tiepolo was renowned for the speed at which he worked, and was extraordinarily inventive: he overflowed with ideas even when given the unpromising task of glorifying a minor German ruler. The ceiling is full of vividly imagined and characterized details, not just among the humans but also in the animals, such the enormous crocodile on which the figure of America rides. Even more impressive than the exuberant details, however, is the way in which Tiepolo blends them into a coherent and vibrant whole. The ceiling is enormous and must have involved months of backbreaking effort, but Tiepolo makes it seem as light and spontaneous as a sketch.

GIAMBATTISTA **TIEPOLO**

1696–1770

The greatest Italian painter of the 18th century, Giambattista Tiepolo had a hugely successful international career, working mainly on resplendent fresco decorations in palaces and churches.

Tiepolo was born in Venice, Italy, and spent most of his life there, but he was employed in many other places in northern Italy; he also worked in Würzburg, Germany, from 1750 to 1753, and spent the last eight years of his life in Madrid, in the service of Charles III of Spain (earlier he had turned down an invitation to decorate the royal palace in Stockholm for Frederick I of Sweden). He was enormously energetic and productive, even in old age. Although he created various kinds of paintings, he is best known as the greatest fresco decorator of his age. He particularly excelled in the difficult art of ceiling frescoes, showing a prodigious ability to orchestrate hosts of figures overhead and create exhilarating effects of light, space, and color. Most of his work is secular, but he also painted many religious pictures—altarpieces as well as frescoes. In addition to paintings, he produced a large number of drawings and was a brilliant, albeit occasional, etcher.

Visual tour

KEY

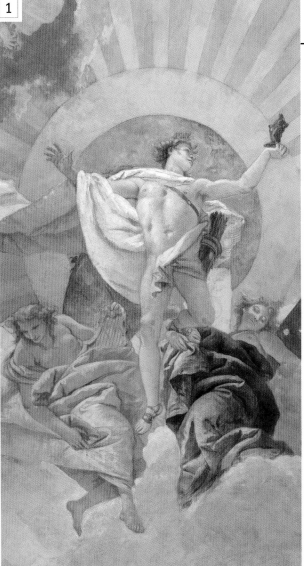

▼ **MARS AND VENUS** Reclining on a cloud are Mars, the God of War, and Venus, the Goddess of Love. Mars was a brutal character, but his aggressive spirit was tamed when he fell in love with Venus, and their relationship was often used in art as an allegory for how love overcame strife.

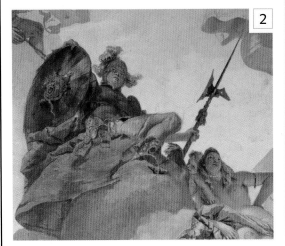

◄ **APOLLO** Near the center of the ceiling, with the rising sun behind him, is Apollo, one of the major gods of the Greeks and Romans. He is traditionally depicted as a beautiful, graceful young man and represents the virtues of civilization and rational thought. Here his radiance symbolizes the life-giving force of the sun over all the continents, as well as the enlightenment of the Prince-Bishop's rule, under which the arts flourish. Apollo is accompanied by two Horae—spirits who symbolized the seasons.

▼ **EUROPE** The figure representing the continent of Europe is less immediately striking than her more exotic counterparts, but she has great dignity. She resembles the traditional image of Juno, the Queen of the Gods, and rests her hand on the head of a magnificent bull—a reference to Europa, the mythological character from which the continent derives its name. Europa was a beautiful princess with whom Jupiter (the King of the Gods and Juno's husband) fell in love; he transformed himself into a white bull and abducted her.

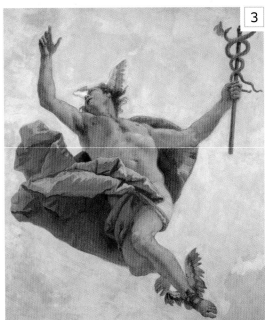

▲ **MERCURY** Hovering near the portrait of the Prince-Bishop is the god Mercury, easily recognized by his winged sandals and hat (symbolizing his speed) and his caduceus or herald's staff (indicating that he was often employed as a messenger by the other gods). Typically he was a bearer of good fortune and he personified eloquence and reason.

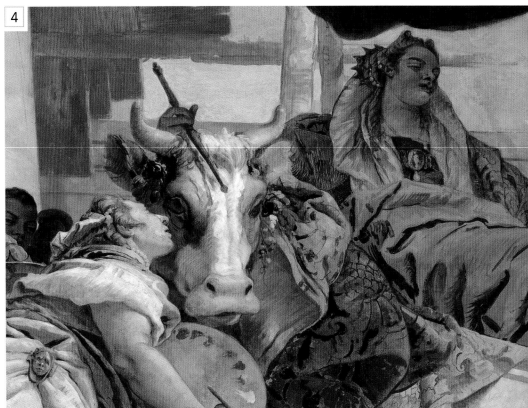

▼ **ASIA** The figure personifying Asia wears a beautiful, jeweled turban and is riding a sumptuously clad elephant. She makes a commanding gesture with her left hand, a pose—as we look up at her—that shows off Tiepolo's formidable skill as a draftsman. This skill underpinned all his work and he made many preparatory drawings for the ceiling.

▼ **AMERICA** With her spectacular feather headdress, America is one of the fresco's most arresting figures. At this time, the Americas were generally regarded by Europeans as barely civilized, and Tiepolo shows the woman as a noble savage with a bow slung over her shoulder. Several of the figures who accompany her are of warlike aspect or engaged in hunting.

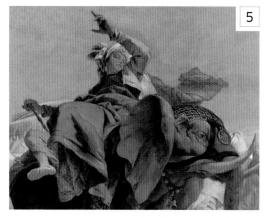

◄ **AFRICA** Like America, Africa is bare-breasted, but she is more finely attired. Her dark skin contrasts strikingly with her white draperies and the huge gold earrings she wears. She rides a camel and is accompanied by figures and still-life details that suggest the great wealth of the continent. In Tiepolo's time, the coastal areas of Africa were virtually the only parts that were known to Europeans. A great deal of trade was carried on with them, notably in slaves.

▲ **FATHER AND SON** Tiepolo freely mixes imaginary and real figures, including—tucked in a corner of the area devoted to Europe—portraits of himself and his eldest son, Giandomenico (or Domenico for short). Tiepolo had ten children, seven of whom survived to adulthood. Two of his sons, Domenico and Lorenzo, became painters; both accompanied their father to Würzburg. Lorenzo was a boy at the time, but Domenico was already a talented painter and valued assistant.

ON **TECHNIQUE**

Tiepolo had to be highly organized to carry out his immense workload. He prepared for his frescoes with drawings and oil sketches. This is a detail from an unusually large sketch he made for the Würzburg ceiling, which he would have shown to the Prince-Bishop for approval. It sets out the essentials of the design, but Tiepolo made many changes in the finished work. He used assistants on his frescoes, including his sons, but orchestrated his team so well that even experts have difficulty in detecting any hand other than his own. The assistants presumably handled parts, such as the sky or architectural background, that did not need his personal touch.

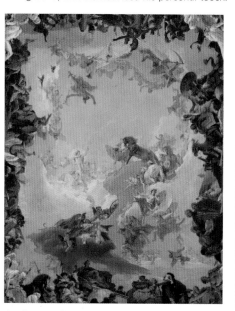

▲ *Allegory of the Planets and Continents*, Giambattista Tiepolo, 1752, oil on canvas, 73 × 55¾in (185.4 × 139.4cm), Metropolitan, New York, US

IN **CONTEXT**

Several architects worked on the Residenz, but the most important was Balthasar Neumann, who was occupied with the vast building for most of his career. He is regarded as the greatest German architect of the 18th century, and this majestic staircase forms a fitting setting for Tiepolo's most famous ceiling painting.

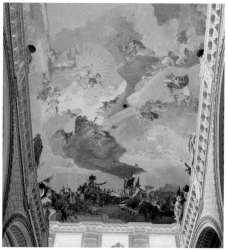

▲ View of the main staircase of the Würzburg Residenz, showing part of Tiepolo's ceiling

An Experiment on a Bird in the Air Pump

1768 ▪ OIL ON CANVAS ▪ 72 × 96in (183 × 244cm) ▪ NATIONAL GALLERY, LONDON, UK

JOSEPH WRIGHT OF DERBY

SCALE

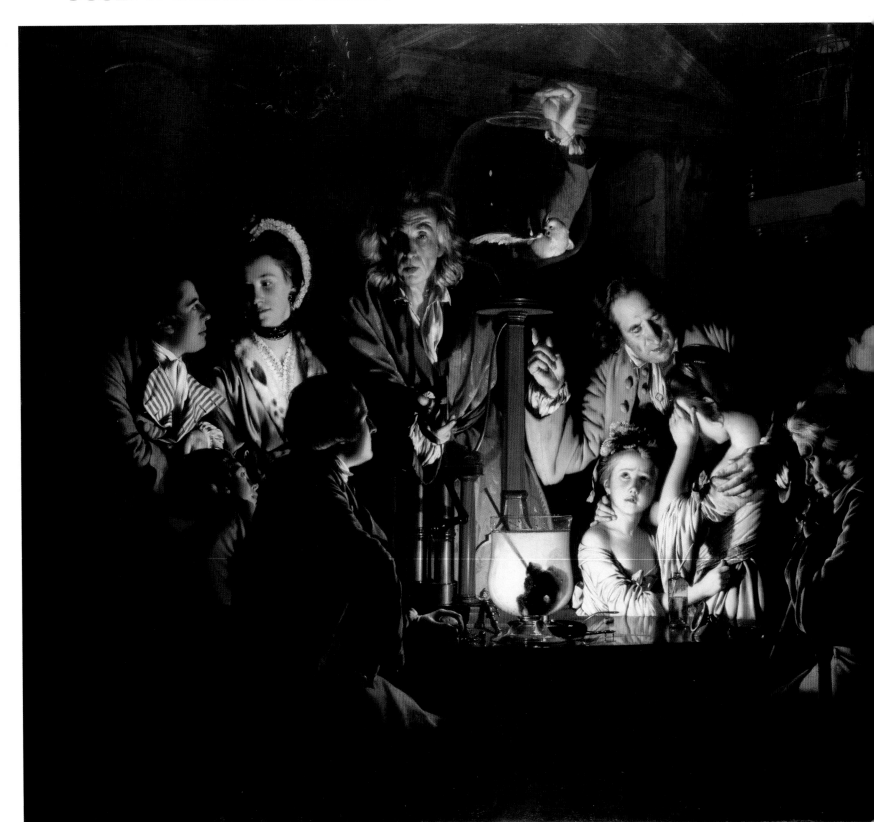

lly lit by a single brilliant light source that
an extraordinary play of shadows, this
painting depicts an unusual domestic scene.
roup is watching the progress of a scientific
t that is being performed in front of them at
responses of the audience are skillfully
nd their exquisitely illuminated faces express
human emotions. Life-size and painted
in a highly polished style that looks
almost photographic, *An Experiment on
a Bird in the Air Pump* is one of Joseph
Wright of Derby's famous and original
"candlelight" scenes.

This painting was created during a period
of major scientific activity in 18th-century
Europe. At the time, it was fashionable for
scientists to travel with their equipment and
perform demonstrations at country houses—
events that were entertaining as well as
educational. Wright took a keen interest
in the new scientific discoveries: he had
probably attended lectures and also sought
to promote interest among the wealthy
classes in the innovations of the day. In his
painting, a living bird has been enclosed in
a large, glass flask and the air then pumped
out to create a vacuum. The experiment has
been set up to demonstrate the effect on
living creatures when they are deprived of
air. We are witnessing the make-or-break
moment when the scientist can choose to
reintroduce air into the flask to revive the
dying bird or let it perish. We can never
know the outcome and Wright offers few
clues. This sense of uncertainty and the
emotional reactions of the group heighten
the human drama of the painting.

Effects of light

By means of strongly contrasting light
and shadow, the technique known as
chiaroscuro, Wright immediately engages
our attention, directing our focus on the
dramatically illuminated figures that are
sharply outlined against the gloom of the
background. The white-haired, magician-
like scientist, his right hand at the top of
the flask, looks directly out at us from the

painting. With his penetrating stare, he is immediately
captivating. The brightly lit faces and gestures of each of
the onlookers—especially the children—register distress,
concern, and even detachment. The background of the
painting is in shadow, except for a second light source—
the full moon in the window on the far right.

Wright was fascinated by the depiction of lighting
effects—a preoccupation he held throughout his life,
whether he was painting scenes of the Industrial
Revolution in Britain or Mount Vesuvius erupting in
Italy. The originality of *An Experiment on a Bird in the
Air Pump* lies in his mastery of light combined with a
highly unconventional subject. It is his best-known
painting and a wonderful insight into the age of the
European Enlightenment.

> Everyone is illuminated by a single source of light…all of them, and us, are capable of being enlightened by the power of science

ROBERT CUMMING *ART EXPLAINED*, 1995

JOSEPH **WRIGHT OF DERBY**

1734–97

The first major English painter to base his career outside London,
Wright excelled at unusual subjects characterized by dramatic
light and shadow.

Wright, the son of an attorney, was born—as his name suggests—in the
Midlands town of Derby. He spent two periods in London training as a
portrait painter before settling in his native town, where his reputation
was soon established. Although Wright went on to paint industrial scenes
and landscapes, portraiture was a consistent and reliable source of income
throughout his career.

In the 1760s, Wright began to experiment with chiaroscuro in his
paintings. His candlelit scenes displayed flair and originality and were
justly celebrated, especially the two depicting serious scientific themes:
A Philosopher Giving a Lecture on the Orrery and *An Experiment on a Bird
in the Air Pump*, exhibited in 1766 and 1768 respectively. Wright continued
his exploration of unusual lighting effects in his landscapes, such as *Grand
Fire Work at the Castel of St. Angelo, Rome*, c.1775, and his views of
Vesuvius erupting, which he witnessed in 1774. Apart from short periods
in Liverpool and Bath and a visit to Italy from 1773 to 1775, Wright spent
his later career working in Derby.

Visual tour

KEY

2

◄ **SCIENTIST** This archetypal wise man with his long white hair stares straight at us. He appears very excited by the high point of the performance: his lips are slightly parted and the skin of his face is flushed pink. The rich, red fabric of his robe further accentuates the sense of drama. Wright appears to be focusing on the scientist's omnipotence. His left hand is on the air valve that will decide the fate of the living creature, so his power over nature is almost godlike.

▼ **YOUNG GIRLS** The youngest child looks up at the dying bird. Her shocked face is depicted with great skill and sensitivity, especially the creased brow and tearful yet fascinated eyes. Her gestures, too, are eloquent. She clings to the dress of the older girl (perhaps her sister, as they wear matching dresses), who has covered her eyes in distress and is being comforted. This self-contained section of the overall composition portraying a tender scene has an almost religious quality.

▼ **THE BIRD** A white cockatoo is slowly suffocating in the bottom of the glass flask. It would have been more usual to conduct such demonstrations using common birds, such as sparrows, rather than a rare, expensive breed. Wright may have chosen the bird for its size and color, which show up well against the dark background. Perhaps the cockatoo was also selected for its resemblance to a dove, a symbol of the Holy Spirit.

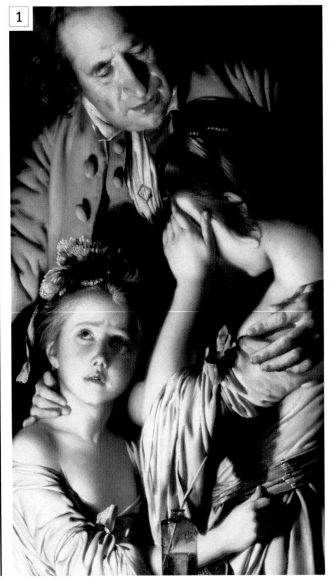

◄ **JAR** At the center of the painting is a brightly lit jar containing an unidentifiable object. It was first thought to be the lung of a pony with a straw inserted so it could be inflated and deflated. In more recent interpretations of the painting, the object has been identified as a partly dissolved skull. The scientist's right index finger appears to be pointing at the skull, possibly reminding the audience that he is in control at this life-or-death moment.

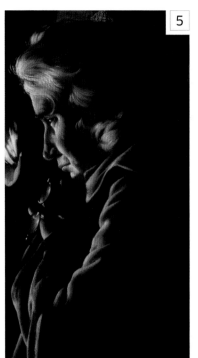

5

◀ **IN CONTEMPLATION** The older man on the right of the frame, his face seen in profile and subtly lit, appears absorbed in his thoughts. Most of his body is in deep shadow and he seems aloof from the demonstration. If we follow his line of vision, it leads directly to the skull in the jar, a symbolic reminder of death. This senior figure may be lost in contemplation of his own mortality.

6

7

▲ **MAN AND BOY** The clock is ticking for the cockatoo. The man on the left of the table holds a pocket watch in his left hand, probably to time the experiment. He may represent the cool, detached observer, while the young boy behind him is clearly captivated by the experiment.

◀ **BOY WITH CAGE** Illuminated only by the moon and depicted in part-shadow, the boy on the far right is on the margins of the group. It is unclear whether he is in the process of retrieving the cage hanging from the ceiling, because the bird will be spared, or hoisting it back up because the creature is about to die.

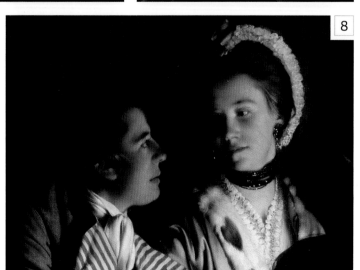

8

◀ **YOUNG COUPLE** More interested in each other than in the experiment, the young couple add a touch of romance. Wright is known to have used friends and family in his paintings and the man is probably his friend Thomas Coltman with his fiancée, Mary Barlow. Wright's painting *Mr. and Mrs. Coltman* celebrated their marriage.

ON **TECHNIQUE**

The main source of illumination for this complex nighttime scene is the light of a single, central candle. It is located immediately behind the glass jar on the round table in the middle of the group (see below). Wright reveals a knowledge of optics in the way he has constructed the scene. A reflection of the candle is just discernible on the left side of the jar. It appears distorted by the curvature of the glass. The light also refracts through the cloudy water, similarly distorting the wand-like rod. The second light source is the softly diffused moonlight from the window on the right, which picks out the face and hands of the boy beneath the bird's cage.

The air pump, too, is brightly lit. The precision with which Wright has painted it implies that he found such instruments beautiful.

IN **CONTEXT**

When Wright's two best-known paintings were shown they caused great excitement. Nothing like them had been exhibited in Britain and they fitted none of the conventional categories.

A Philosopher Giving a Lecture on the Orrery, c.1764 (below), depicts a mechanical device that shows the movements of the planets around the sun being demonstrated to a family group. The device, which illustrated Sir Isaac Newton's theories of planetary motion and gravity, helped to make scientific knowledge more accessible to a receptive public. Wright's great scientific paintings show the profound effects on people of the new discoveries and may well have been created in the same spirit.

▲ *A Philosopher Giving a Lecture on the Orrery*, Joseph Wright of Derby, c.1764–66, oil on canvas, 58 × 80in (147.3 × 203.2cm), Derby Museum and Art Gallery, Derby, UK

The Death of Marat

1793 ▪ OIL ON CANVAS ▪ 65 × 50½in (165 × 128cm)
MUSÉES ROYAUX DES BEAUX-ARTS, BRUSSELS, BELGIUM

SCALE

JACQUES-LOUIS DAVID

Propaganda rarely produces great art, but this is a notable exception. In this stark yet moving picture, David mourns the death of a close friend and fellow revolutionary. The victim, Jean-Paul Marat, was a leading member of the National Convention–the short-lived governing body in France during the Reign of Terror, the most violent days of the Revolution. His extreme views made him many enemies, particularly after the fall of the Girondins (one of the more moderate factions).

On July 13, 1793, one of their supporters, a young woman named Charlotte Corday, was granted an audience with him in his bathroom. This was not unusual. Marat suffered from a debilitating skin condition that required him to take frequent baths, so he used the place as an office. During the meeting, Corday pulled out a knife and stabbed him to death. At her trial, she proclaimed, "I killed one man to save 100,000 lives." On July 17, she was sent to the guillotine.

A revolutionary tribute

On the day after Marat's murder, David was invited by the Convention to arrange the funeral ceremony and to paint a memorial for the dead man. He began work immediately and had completed the picture by November. David was the obvious choice for this task, partly because he knew Marat very well and shared his ideals, and partly because his rigorous, Neoclassical style was well suited to the moral gravitas required for such a theme.

David stripped the scene down to its essentials. He removed the ornate decor of Marat's bathroom and replaced it with a darkened void. This may have been inspired by the gloomy lighting in the Cordeliers (a former church), where the victim's body lay in state. David exchanged Marat's unusual, boot-shaped bath for a more traditional design and focused the viewer's attention on the limp, dangling arm in the foreground, deliberately conjuring up associations with the pose of Christ's body as he was lowered from the Cross. The artist may also have been inspired by memories of an ancient sculpted relief known as the *Bed of Polycleitus*. After the Revolution, the painting proved an embarrassment to

the new regime and in 1795 it was returned to David. It was not exhibited again in France until 1846, 21 years after David's death, when the poet and art critic Charles Baudelaire's lyrical praise restored its reputation.

> This work contains something both **poignant and tender; a soul is taking flight** in the **chill air** of this room, within these cold walls, **around this cold funerary tub**

CHARLES BAUDELAIRE *SALON DE 1846*, 1846

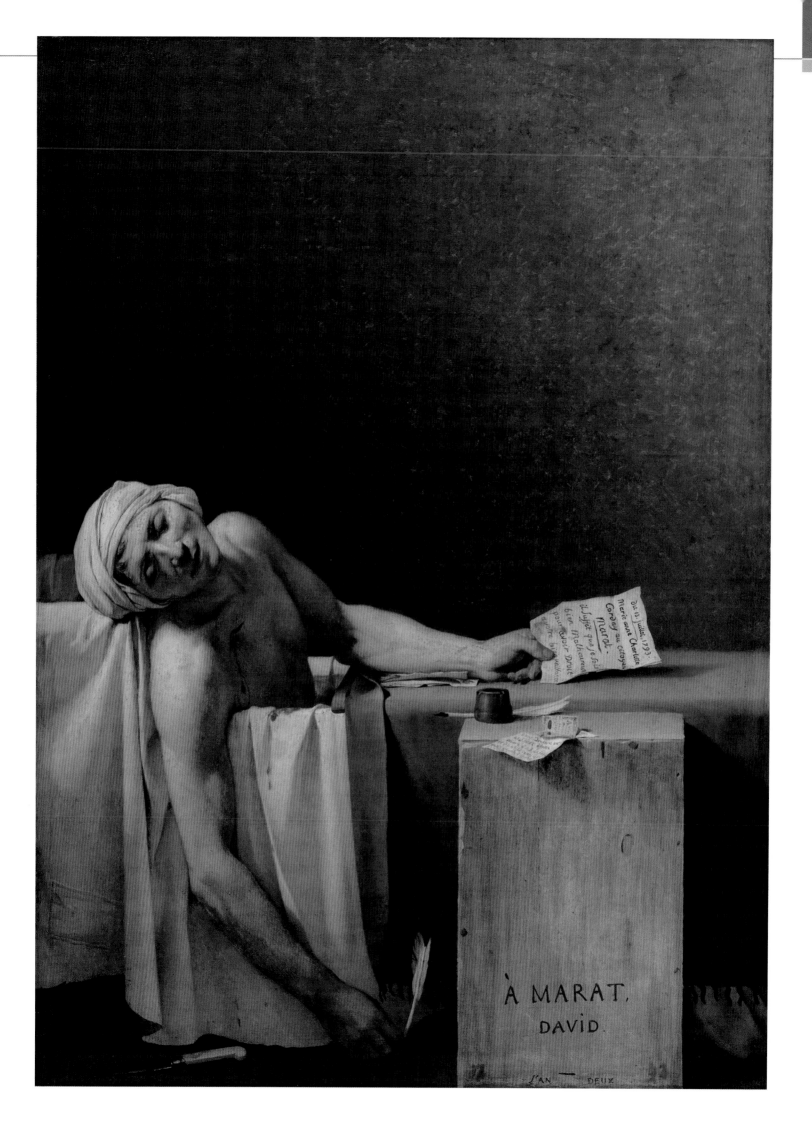

Du 13 juillet 1793.
Marie anne Charlotte
Corday au citoyen
Marat.
il suffit que je sois
bien Malheureuse
pour avoir Droit
à votre bienveillance

À MARAT.
DAVID.

L'AN — DEUX.

Visual tour

KEY

▶ **MARAT** During the Revolution, Jean-Paul Marat was one of the most powerful men in France. He made his mark as a fiery journalist, running a radical paper called *L'Ami du Peuple* (The Friend of the People), in which he railed against the "enemies of the state," calling for their destruction. David's depiction of Marat is more propaganda than portrait. He altered his friend's appearance to make him fit the image of a martyred hero. He removed the discoloration and blemishes from his skin and made him look younger than his 50 years. One detail, however, is entirely accurate. Marat did indeed wear a cloth soaked in vinegar around his head, to ease the discomfort caused by his skin complaint.

▶ **TRACES OF BLOOD** David was anxious to create a tender tribute to his friend, so he deliberately played down the most violent aspects of his subject. There is only a very light sprinkling of blood on the sheet. Similarly, there is virtually no blood on the body of the victim. The stab wound in Marat's chest is largely hidden in the shadows, while the cut itself scarcely looks severe enough to have been a fatal blow. Instead, the goriest indicator of the attack is the fact that Marat's blood has turned the bathwater red. Even here though, David has minimized the effect by adopting a very low viewpoint, so that only a thin streak of blood is visible.

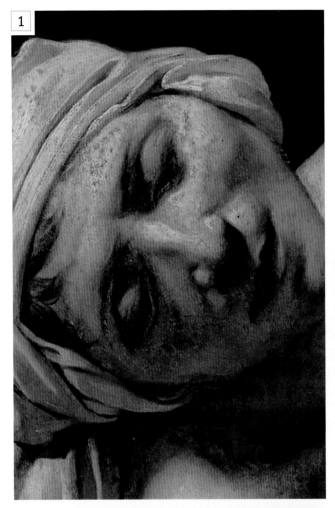

▼ **FURNITURE** David placed considerable emphasis on the spartan conditions in Marat's bathroom, to underline his friend's credentials as a man of the people. This battered old crate served the politician as a makeshift writing desk. Its worn surface also provides an admirable space for the artist to display a dedication—*À Marat* (To Marat)—and his own signature.

◀ **MURDER WEAPON** Corday's knife lies on the floor, as if the assassin has dropped it and fled. In fact, she made no attempt to escape, but waited to be arrested. According to some accounts, the knife remained lodged in Marat's chest, but David excluded any features that would undermine the sense of heroic martyrdom in his picture.

5

◀ **THE SHEET** David's painting displays a compelling mixture of truth and artifice. The artist had visited Marat in his bathroom and was well acquainted with the unpleasant details of his skin condition. He removed the disfiguring marks that the ailment had left on the victim's face, but recorded other elements with great precision. It is perfectly true, for example, that Marat draped a sheet over the surface of his bath, so that his sores would not chafe against its copper lining.

6

◀ **WRITING MATERIALS** One of the highlights of the painting is this superb still-life section. Each of the objects tells its own part of the story. Because of his skin condition, Marat was obliged to spend a considerable amount of time in his bathroom, so he used it as a part-time office. In the foreground, he has left a letter and some money for a war widow. Marat had presumably just completed the note, as the quill pen is still in his hand.

ON **TECHNIQUE**

In common with those of most other Neoclassical artists, David's figures display a smooth, polished finish and a sculptural appearance that is reminiscent of antique statuary. It is no accident that one of the possible sources for Marat is a classical relief. David was also fond of using theatrical lighting effects to highlight the most significant elements in his pictures. So, while Marat's head, arms, and the crate are brilliantly lit, the gorier details are bathed in shadows.

IN **CONTEXT**

David embraced the Napoleonic cause with the same fervor that he had shown during the Revolutionary era. He was appointed Napoleon's *Premier Peintre* (First Painter) in 1804 and went on to produce a series of stunning canvases that glorified the new regime. Ironically, however, the portrait below was commissioned by a British patron, Lord Alexander Douglas.

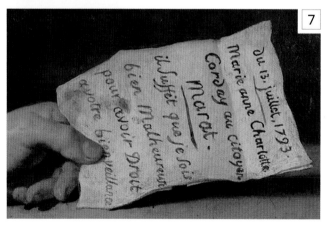

7

▲ **LETTER IN HAND** This is Corday's letter of introduction, smudged with blood in the corner. It reads, "my great unhappiness is sufficient reason to entitle me to your kindness." Once again, David is twisting the truth, to highlight the generous nature of his friend and the perfidy of the killer. In fact, Corday was granted access because she claimed to have information about royalist rebels.

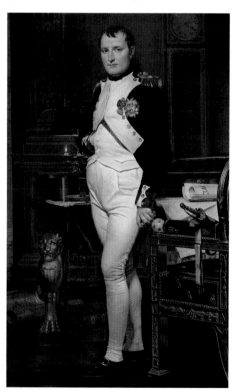

▲ *The Emperor Napoleon in His Study at the Tuileries*, Jacques-Louis David, 1812, oil on canvas, 80¼ × 49¼in (203.9 × 125.1cm), National Gallery of Art, Washington, DC, US

1800 – 1900

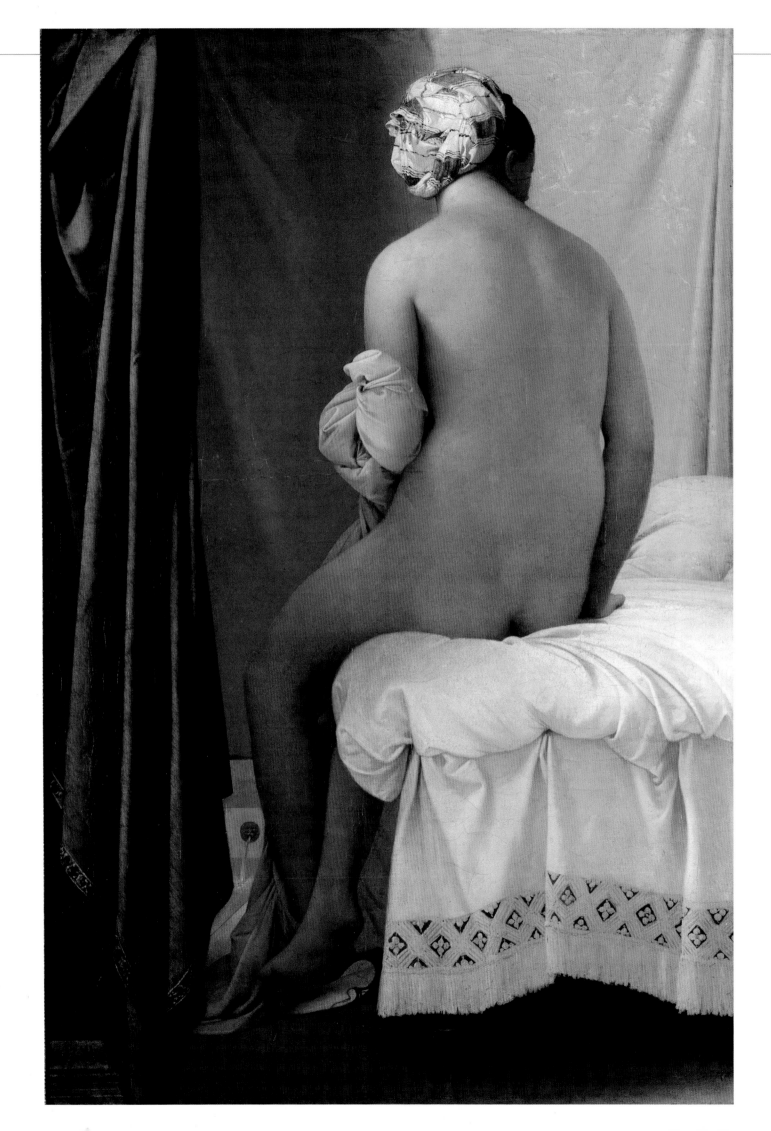

The Valpinçon Bather

1808 ▪ OIL ON CANVAS ▪ 57½ × 38¼in (146 × 97cm) ▪ LOUVRE, PARIS, FRANCE

SCALE

JEAN-AUGUSTE-DOMINIQUE INGRES

In this graceful nude, with its perfect balance of intimacy and grandeur, of detached contemplation and sensuous enchantment, Ingres has created what is surely one of the greatest back views in the history of art. The painting takes its name from a collector who owned it before it was acquired by the Louvre in 1879; originally, it was simply titled *Seated Woman*. Ingres painted it in Rome, where he was a prize-winning student at the French Academy from 1806 to 1810 (he won the highly prestigious Prix de Rome in 1801, but lack of funds during an unsettled time in France delayed his move to Italy). Prizewinners had to send several works back to Paris, so the authorities could make sure that they were making good use of state funding. This was one of the paintings Ingres chose to represent his progress.

Its reception (like that of other early works by Ingres) was cool. Some critics thought that figures such as this were lacking in a traditional sense of three-dimensional solidity, seeming rather boneless and vapid. Ingres, however, looked beyond conventional naturalism and was prepared to modify or exaggerate appearances for the sake of pictorial harmony. He was a superb draftsman and was easily capable of depicting human anatomy accurately when he wanted to. But he had a high-minded conception of art in which the imperfections of nature must be corrected to create an "ideal" beauty.

This outlook was influenced by his main teacher, Jacques-Louis David (see pp.132–35), who was the leading representative of Neoclassicism in painting, aiming to revive the spirit as well as the style of the classical world of the Greeks and Romans. Even more important than David, however, was the effect Rome had on Ingres. He was inspired not only by the remains of ancient art, but also by High Renaissance paintings and, above all, by the work of Raphael (see pp.54–57).

There is a common thread of clarity and balance in classical art and the paintings of Raphael and David. Ingres also loved these qualities, but in some respects he differed greatly from his exemplars. In particular, he was far less severe in outlook than his teacher David, placing a personal emphasis on suave beauty of line and exquisite surface polish. Thus in *The Valpinçon Bather* he is more

concerned with creating flowing contours from the woman's body than with suggesting its underlying bone structure. This is especially apparent in her right leg: it is drawn with superb grace, but when examined closely, it appears to have been grafted onto the draperies above it rather than convincingly connected to the body.

Ingres was a perfectionist who often subtly reworked his favorite themes and motifs. In *The Turkish Bath*, 1863, for example, one of the principal figures is clearly derived from *The Valpinçon Bather*, although she now plays a mandolin. *The Turkish Bath* is an acknowledged masterpiece, with an erotic charge that is remarkable coming from an artist in his eighties. But even Ingres could not improve on the timeless poise he achieved in *The Valpinçon Bather* more than half a century earlier.

> Draw lines, young man, many lines, from memory or from nature

INGRES ADVICE TO THE YOUNG DEGAS, 1855

JEAN-AUGUSTE-DOMINIQUE **INGRES**

1780–1867

One of the giants of 19th-century French art, Ingres is celebrated for the purity and discipline of his style, but his work also has a deeply personal and sensuous side.

Ingres's long career was divided mainly between Paris and Italy, where he lived in 1806–24 and 1835–41. He began his first Italian period as a student at the French Academy in Rome, and he spent the second period as the Academy's Director. In the earlier part of his career, his work was sometimes controversial, as it was considered quirky by conservative critics. However, by the time of his much-honored old age, he was one of the most revered figures in French art. In addition to being one of the greatest portrayers of the female nude, he was renowned for his paintings on historical, mythological, and religious subjects and as a portraitist (he produced exquisite portrait drawings as well as paintings). Ingres left a large bequest of work (by himself and other artists) to his native city of Montauban, now housed in a museum named after him.

Visual tour

KEY

> ▶ **BACK** The broad area of the back creates a set of majestic abstract forms, but at the same time conveys the suppleness of living flesh. Ingres always stressed the primacy of drawing over color, but in fact he often created ravishing color effects, as in this glorious expanse of golden skin. When the painting was exhibited at the huge Exposition Universelle in Paris in 1855, the art critics Edmond and Jules de Goncourt compared Ingres with one of the supreme masters of flesh painting: "Rembrandt himself would have envied the amber color of this pale torso."

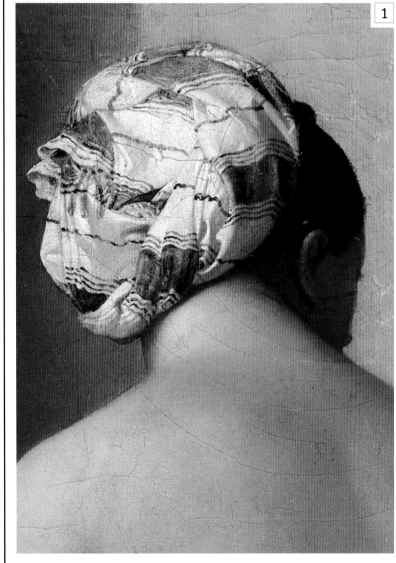

▲ **TURBAN AND FACE** The bather's face is only partially visible, so attention is drawn all the more to her striped headgear. Turbans had appeared in European paintings from the 15th century and in Ingres's day they often appeared in a vein of art called Orientalism. This term describes the fashion for imagery inspired by the Near and Middle East and North Africa. Napoleon's invasion of Egypt in 1798 was a catalyst for the fashion, which flourished in several European countries, particularly France. Some of Ingres's other nudes are more obviously in the Orientalist tradition, depicting odalisques (female slaves or concubines in a harem).

▶ **SHOULDER** The smooth, taut contour of the left shoulder epitomizes Ingres's idealistic approach to depicting the female body. All the angularities and irregularities found in real life, indicating the presence of bone and sinew beneath the skin, are replaced by a serene flawlessness.

➤ ELBOW AND DRAPERY
Elaborate folds of white drapery are swathed around the bather's left elbow. Ingres probably included the drapery here purely for pictorial reasons—to soften what would otherwise have been the pointed outline of the elbow, and to provide a contrast of color and texture with the bather's skin.

➤ LION'S HEAD SPOUT
The only obvious movement in the painting comes from the jet of water gushing from the ornate spout into the sunken pool. Although the setting of the painting is generalized, this small detail hints at some exotic society, distant in time or place.

▼ CURTAINS Ingres was a superb painter of draperies. Here, the curtains—with their dark color and deep folds—help emphasize the unruffled perfection of the bather's skin. There is a black marble column at the bottom of the curtains. Ingres has signed and dated the painting on its base.

▲ FOOT AND SANDAL Some contemporary critics said that the bather seemed boneless and had no ankles. Certainly, Ingres has conceived the forms of this part of the figure broadly, especially compared with the delicate pattern he makes from the sandal's laces.

◀ LEGS AND DRAPERY Ingres had an extraordinarily polished technique: one of his best-known comments on art is that a paint surface should be as smooth as "the skin of an onion." His fastidiousness is obvious in the impeccably crafted forms of this detail.

ON **COMPOSITION**

The Valpinçon Bather has a feeling of monumental dignity, stemming from Ingres's unerring sureness in placing each form. The firm verticals created by the draperies in the picture are subtly echoed in the curvaceous forms of the bather's body. Line takes precedence over color, but he shows great mastery in balancing the broad masses of flesh and fabric against one another.

IN **CONTEXT**

Among Ingres's contemporaries, the most famous sculptor was the Italian Antonio Canova. His *Venus Italica* has a clear kinship with *The Valpinçon Bather*—in the subtle turn of the head, the smoothly rounded forms, and the tension between coolness and eroticism.

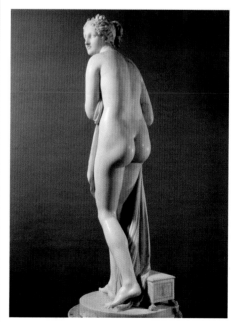

▲ *Venus Italica*, Antonio Canova, c.1812, marble, Galleria Palatina, Florence, Italy

The Third of May 1808

1814 ▪ OIL ON CANVAS ▪ 105½ × 136½in (268 × 347cm) ▪ PRADO, MADRID, SPAIN

FRANCISCO DE GOYA

SCALE

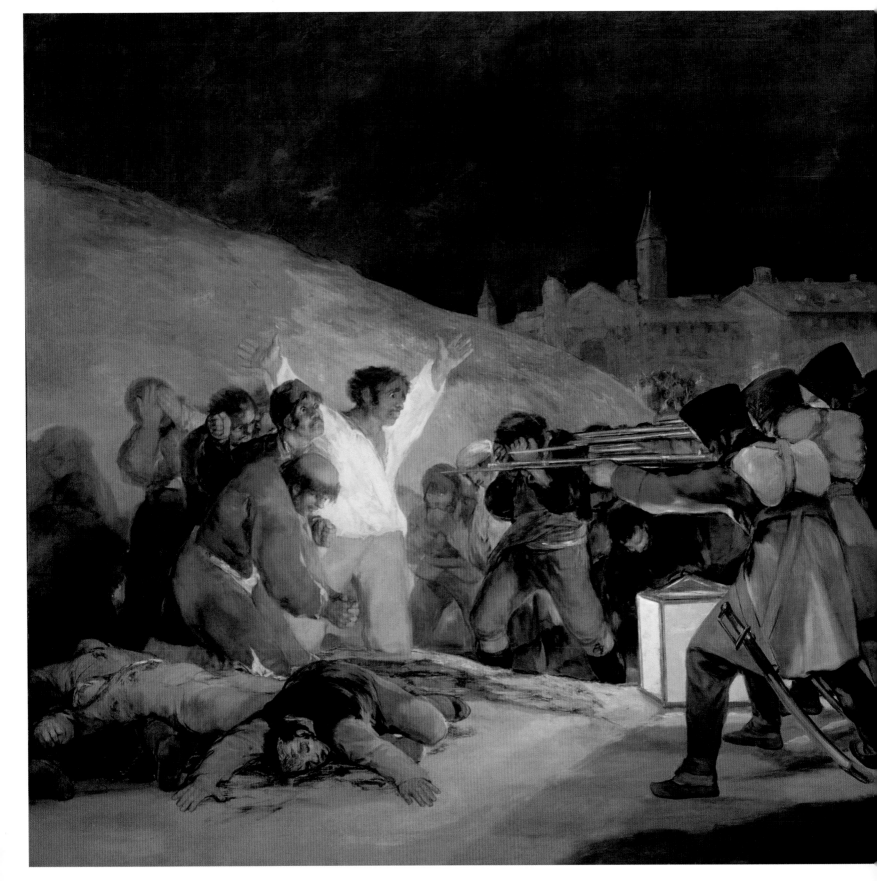

...an kneels in front of a firing squad,
...te shirt reflecting the light of the single
...round. With arms thrown open in a
...gic gesture–the symbolic pose of the
...–he faces a solid wall of uniforms and
...cene of brutal execution on a bare hillside
outside a city where ghostly, fortress-
like buildings are silhouetted against
the night sky. Dense blackness, without
stars or moonlight, fills almost a third
of the composition and intensifies the
nightmarish quality of the scene.

Goya's compelling painting shows
the cruel fate of a group of civilians
who had risen up in rebellion against
the occupying French army during the
Peninsular War in Spain (1808-14).
Following a day of violent insurrection
on the streets of Madrid, the French
soldiers rounded up rebels and innocent
bystanders caught up in the conflict and
shot them the following day–the date
of the painting's title. Nationwide
uprisings and guerilla warfare followed.

Brutality of war

In this painting, Goya not only created
a lasting tribute to the bravery of
the Spanish rebels, he also created a
revolutionary image of the dehumanizing
effect of war. Braced to carry out their
task, the soldiers have their heads
down, but the terror on the faces of
those about to be slaughtered, and their
helpless gestures, are depicted with
heartbreaking eloquence. Unlike other
contemporary painters, such as
Jacques-Louis David (see p.132), Goya
did not try to glorify war in this
painting, or in its companion work,
The Second of May 1808. This is a
shocking image of an act of atrocity
and a graphic condemnation of man's
inhumanity to man.

The tight composition of Goya's
painting increases the sense of doom.
Ranged diagonally on the right, the
soldiers form an impenetrable barrier.

Facing them, the heroic central figure and his ragged
compatriots are on their knees, and a long file of the
condemned men who are next in line straggle uphill.
Goya's colors are muted and somber, there are pools of
deep shadow, and fine detail is scarce. Your attention is
focused on the man in the white shirt, and the awful
inevitability of his next moment.

Goya painted *The Third of May 1808* six years after the
actual event portrayed. He asked for a commission from
the newly restored Spanish monarch, Ferdinand VII, to
commemorate the insurrection against the French in two
companion works. The commission was agreed and Goya
made his two paintings, but this one, his masterpiece, was
not appreciated at first and it was put in storage for 40
years. When it finally surfaced, the painting proved a
source of inspiration to other artists. It remains to this day
one of the most famous paintings of the atrocities of war.

> This is **the first great picture**
> which can be called
> **revolutionary in every sense
> of the word,** in style, in subject
> and **in intention**

KENNETH CLARK *LOOKING AT PICTURES*, 1960

FRANCISCO DE **GOYA**

1746-1828

The Spanish painter and printmaker Goya was one of the
outstanding figures of the Romantic movement. He created
portraits of the aristocracy as well as extraordinary etchings.

Born the son of a master gilder in Saragossa, Spain, Goya was apprenticed
at 14. He later settled in Madrid, where he designed cartoons for royal
tapestries and began to make a living as a portraitist, becoming painter
to the court in 1789. Goya was inspired by the paintings of Velázquez (see
p.98) but developed his own innovative style, bringing out the character
of his royal and aristocratic sitters with an honesty that was not always
flattering. In 1792, a severe illness left Goya permanently deaf. While a
court painter, he created a series of disturbing satirical etchings called
Los Caprichos (The Caprices) in 1799, including *The Sleep of Reason
Produces Monsters*. His other great series of prints, *The Disasters of War*,
published after his death, depicted atrocities on both sides during the
French occupation. In his last years Goya painted his famous murals
known as the *Black Paintings*. He died in France.

Visual tour

KEY

▼ **THE MARTYR** The focal point of the painting is the kneeling man about to be shot, holding his arms out in a pose reminiscent of Christ's crucifixion. There is even a wound similar to Christ's stigmata on his right hand. Brightly lit, his white shirt and pale trousers seem to emit light. Goya has made him larger than life for dramatic effect. If he were to stand up, he would tower above the French soldiers.

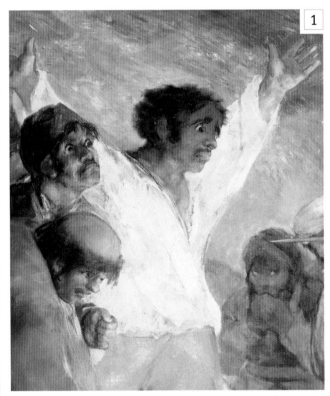

▶ **LANTERN** As the sky is pitch dark, the only source of light in the painting is the huge lantern on the ground in front of the soldiers. It illuminates the condemned men as if they were on a stage and marks a clear line of separation between the riflemen and their human targets.

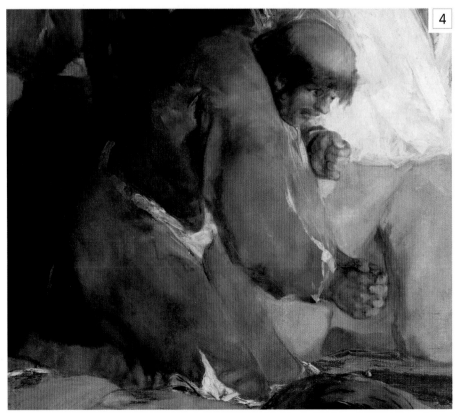

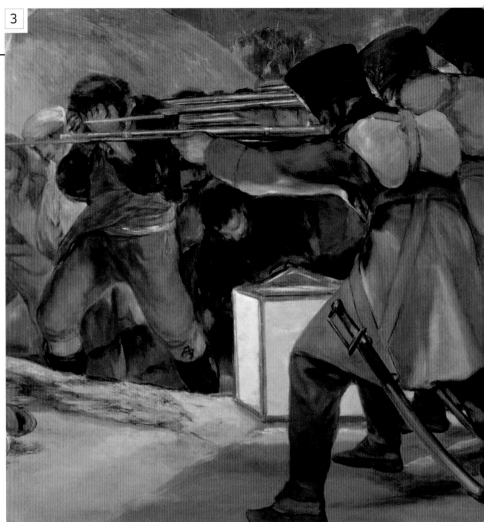

▲ **MONK** Clasping his hands to make a final prayer, even a monk is at the mercy of the firing squad. He may have been included as an oblique reference to the Spanish Inquisition or to the tradition in Christian art of depicting martyrs. He draws attention to the brutal and random nature of such executions. No one is spared.

◀ **FIRING SQUAD** The French soldiers lined up in identical poses are so close together that they have merged into a group and lost all individual identity. Their faces are in shadow and are hidden from view by their hats. The repetition of shapes made by their hats, coats, holsters, and swords emphasize their machinelike brutality and their long rifles and bayonets, pointing at their targets, are cruelly highlighted in white.

▼ **TOWNSCAPE** A town and a church tower loom out against the black night sky. The executions took place near the French barracks outside Madrid, but none of the buildings in the painting can be identified with any certainty. Goya may have imagined them, to create a sinister backdrop.

ON **TECHNIQUE**

Rather than giving a straightforward, narrative depiction of the massacre, Goya used color and form to create an emotional response to his painting. In real life, the shooting took place during the day, but Goya set the scene at night and used a palette dominated by browns, blacks, and greys to create a nightmarish atmosphere. Whereas many of his contemporaries aimed for a polished effect in their paintings, lavishing attention on every detail, Goya painted loosely, using bold, dynamic brushstrokes and manipulating the paint with a palette knife or even his fingers, to create a more expressive style. Goya said, "I see no lines or details…There is no reason why my brush should see more than I do." His dramatic use of color and free handling of paint are clear in this detail of a man's face and the treatment of the white shirt to the right.

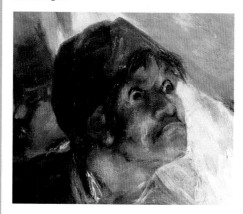

▶ **HUDDLED FIGURES** The condemned men cowering behind the central figure look terrified. They all have different expressions, emphasizing their individuality. Some cover their eyes, but one stares defiantly at his executors. The men's clothing is drab and they seem to be merging into the shadows.

IN **CONTEXT**

Goya was commissioned to create two paintings to commemorate the heroism of the Spanish rebels. *The Second of May 1808* (below), the other painting of the two, shows a crowd in the Puerto del Sol area of Madrid attacking the Mamelukes, the Turkish cavalry in Napoleon's French Imperial Guard, who are charging. The news that the youngest members of the royal family were being taken to France had brought people out on to the streets and Goya's painting shows the scenes of bloody chaos that erupted. The following day the occupying army rounded up the rebels and executed them.

▲ **NEXT IN LINE** A shockingly long line of condemned men trudges up the hill to face the firing squad. Their despair is graphically conveyed in their faces and gestures.

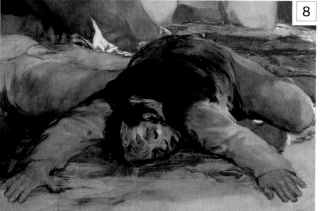

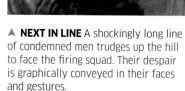

◀ **CORPSE** Slumped in the foreground are two men who have just been shot, one naked. This corpse's arms echo the pose of the central figure in a harrowing reminder, if one were needed, that he too will soon be lying on the bloodstained earth.

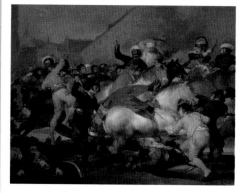

▲ *The Second of May 1808*, Francisco de Goya, 1814, oil on canvas, 105½ × 136½in (268 × 347cm), Prado, Madrid, Spain

Wanderer Above the Sea of Fog

c.1818 ■ OIL ON CANVAS ■ 38½ × 29½in (98 × 75cm) ■ KUNSTHALLE, HAMBURG, GERMANY

SCALE

CASPAR DAVID FRIEDRICH

In this haunting painting, a lone figure stands on a pinnacle of rock, contemplating an awe-inspiring Alpine landscape. Nearby rocky peaks loom up out of the dissolving sea of mist, and a distant mountain rises majestically above the scene against a luminous sky.

The scene is based on sketches of mountains that Friedrich made while staying in Switzerland, but the dense fog obscures what lies between the mountains, creating a sense of mystery. Compositionally, the man is standing right in the middle of the painting, and the horizontal lines of rocks and distant mountain slopes all lead toward him. The striking contrast in tone between the dark silhouette of the man on the rock and the pallor of the fog and sky adds to the impact of the image.

The painting may have been a posthumous tribute to a colonel in the Saxon Infantry—the central figure stands upright and heroic as he contemplates the scene before him—but it can be interpreted in many ways: as a symbol of man's yearning for the unattainable or as an allegory of the journey through life. The work encapsulates Romantic ideas about man's place in the world—the isolation of the individual when faced with the sublime forces of nature. As such, it has become an iconic image of the Romantic individual.

CASPAR DAVID **FRIEDRICH**

1774-1840

A great 19th-century German Romantic artist, Friedrich painted intense landscapes of haunting beauty, which captured the power of nature and gave it a religious quality.

Born in Greifswald, on the Baltic coast of Pomerania, Friedrich had a strict Protestant upbringing. His mother and brother both died when young, which had a marked effect on him. After studying in Copenhagen, he settled in Dresden, where he learnt the latest ideas about Romantic literature and philosophy. Friedrich only took up oil painting in 1807, depicting striking landscapes imbued with strong spiritual or allegorical overtones. One of his paintings, *The Cross in the Mountains*, caused controversy because of the way in which Friedrich filled the landscapes with religious significance.

Visual tour

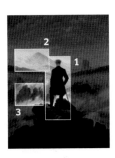

KEY

▶ **THE WANDERER** Friedrich's solitary figure has his back to us, giving him complete anonymity, and gazes down at the scene before him. From his stance, he appears calm and self-possessed, but it is left to us to imagine his expression or his attitude to the dramatic landscape before him.

1 ▼ **SEA OF FOG** The fog conceals much of the landscape, stimulating the viewer's imagination, and blurs our view of the distant mountains, creating a sense of infinity. It also reflects the pearly light from the sky, which gives the painting an eery feeling of otherworldliness.

3

2 ▲ **ROCKY PEAKS** The mountain tops break out of the fog like jagged rocks emerging from the sea. Because the fog obscures the lower-lying landscape, you have no sense of how near or far away the mountains really are. The tiny trees just visible on some of the peaks are the only thing to provide a true sense of scale.

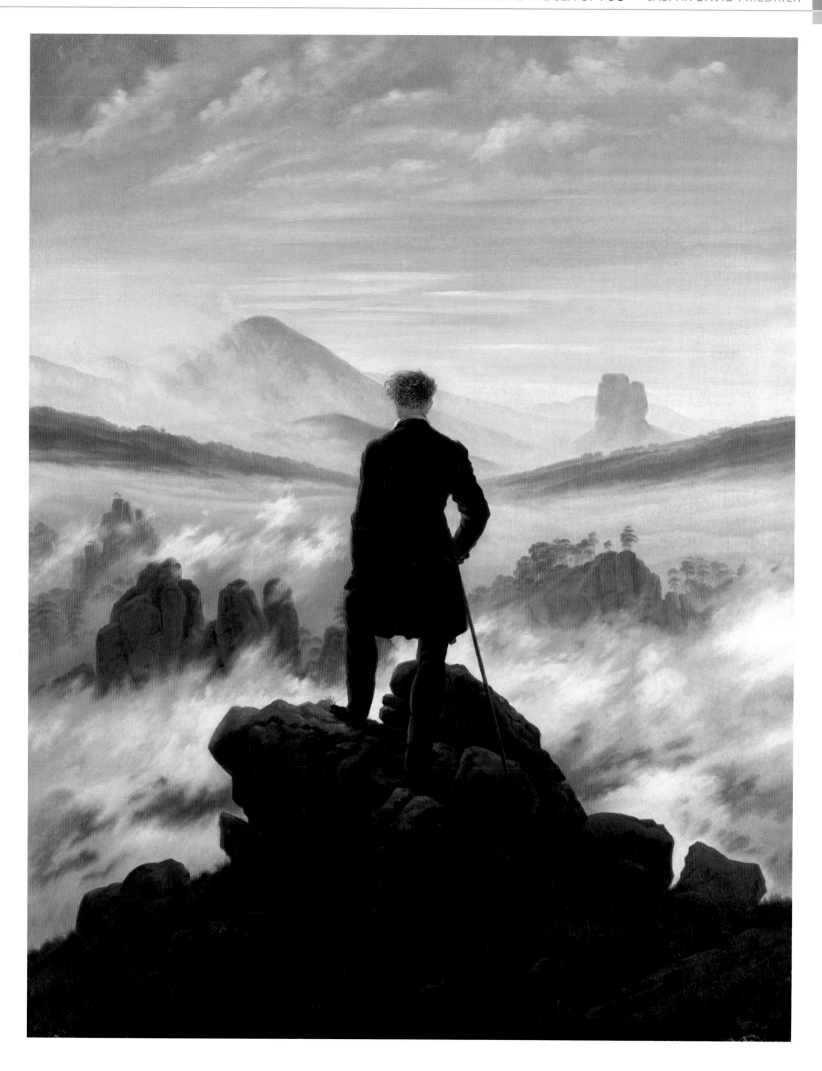

The Hay Wain

1821 ▪ OIL ON CANVAS ▪ 51¼ × 73in (130.2 × 185.4cm) ▪ NATIONAL GALLERY, LONDON, UK

SCALE

JOHN CONSTABLE

This atmospheric painting evokes the feeling of a summer's day in the English countryside. This is where the artist, John Constable, used to play as a boy. The landscape, with two figures in a cart (the "wain" of the title) crossing a shallow river, looks uncontroversial, but when the work was first exhibited in London in 1821, it represented a radical departure from convention in both subject matter and technique and was not taken seriously. Its reception in Paris some three years later, however, was entirely favorable: the painting won a gold medal and its unpretentious subject and loose brushwork were much admired by French artists.

For Constable, the natural world—especially the lush, fertile landscape of Suffolk—was an inspiration and affected him deeply. He sought to communicate his personal response to nature through his paintings, which were novel because they depicted the everyday English landscape on a grand scale. In terms of technique, Constable's expressive brushwork, with its network of dabs and flecks, was misunderstood and criticized for being overly loose. In *The Hay Wain* Constable was attempting to convey the movement, vitality, and reflected light he saw in this beautiful stretch of the River Stour, where he had spent his childhood. The sky, in particular, has a realistic sense of depth; its changing patterns are reflected on the surfaces of both fields and river, and the beautifully painted billowing clouds add rhythm and movement to the scene.

Constable worked slowly and his preparations for large landscapes such as *The Hay Wain* were painstaking. He filled books with sketches made outside in the Stour Valley to take back to his London studio. He then created a full-size oil sketch on canvas to help with the composition, which was an unusual way of working. The oil sketch for *The Hay Wain* is held in the Victoria and Albert Museum's collection in London.

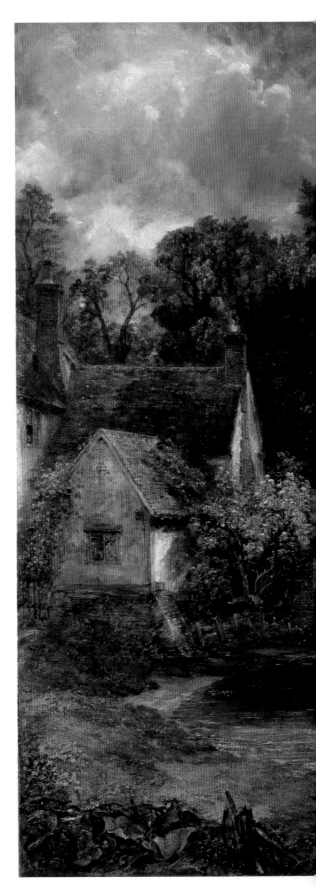

JOHN **CONSTABLE**

1776–1837

One of the greatest painters of the English landscape, Constable brought a new freedom and inventiveness to the subject. Although underappreciated in Britain, his work influenced the leading French artists of the day and, through them, the Impressionists.

Constable grew up in Suffolk, England, and was passionate about painting the local landscape from an early age. Mainly self-taught, he did not attend the Royal Academy Schools in London until he was in his early twenties. Constable's early work was influenced by Gainsborough and 17th-century Dutch landscape artists, but he soon developed his own original style, using vigorous brushwork and highlights to capture the effects of light and weather. Critics considered his paintings unfinished and failed to understand his passion for painting the natural landscape at a time when classical subjects were fashionable. From 1821, Constable lived and worked in London, but spent much of his time painting in his home area in Suffolk, now known as "Constable country." He also painted Hampstead Heath and Salisbury Cathedral. He was finally elected a full member of the Royal Academy in 1829.

Truth immediately strikes the viewer…that delicious landscape…is the true mirror of nature

STENDHAL *SALON OF 1824*, 1824

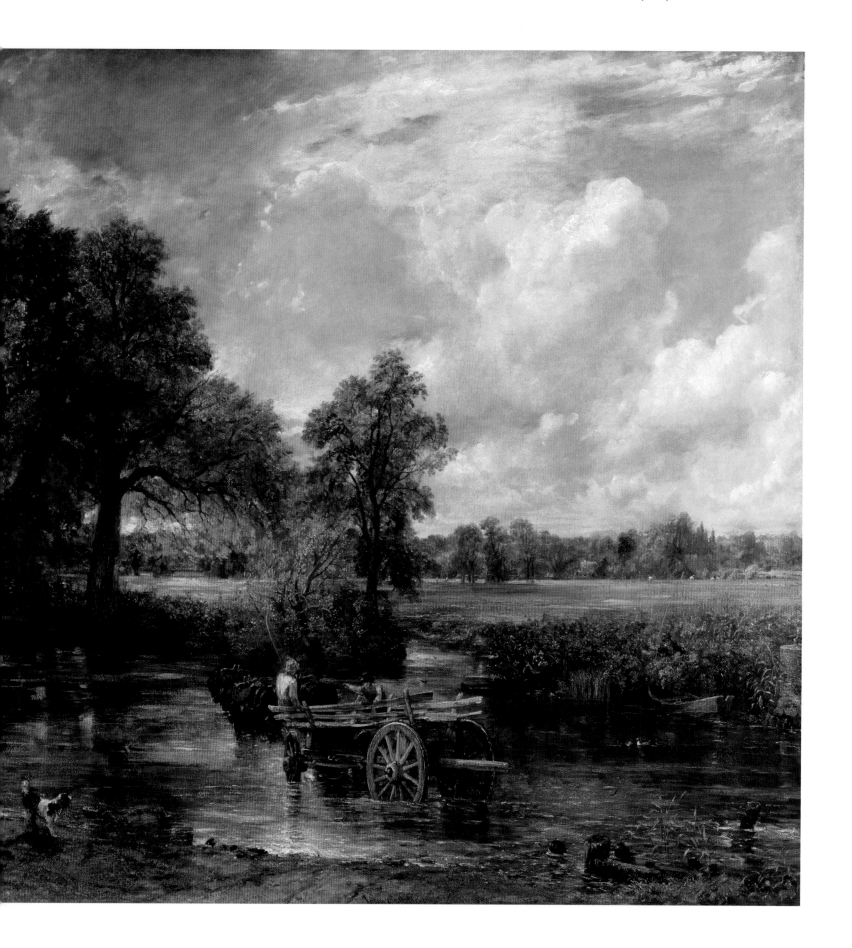

Visual tour

KEY

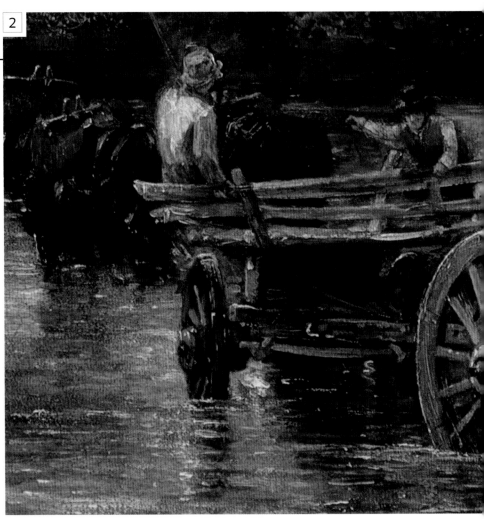

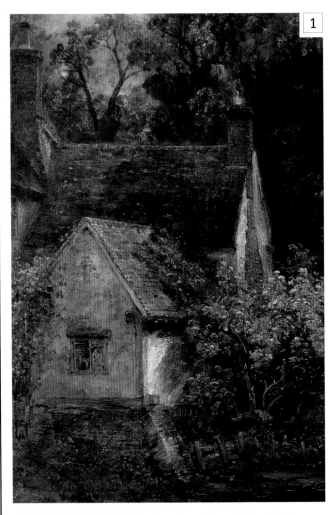

▲ **WILLY LOTT'S COTTAGE** The location of the painting can be identified by the cottage on the left. Constable's father rented it to tenant farmer Willy Lott. The smoke rising from the chimney is a charming detail suggesting the farmer's presence indoors. The cottage is still standing—in an area of Suffolk known as "Constable Country."

▶ **HAYMAKERS** Tiny specks of white, brown, and red paint in the distant field below the line of trees represent laborers harvesting the hay by hand with scythes. You can also make out another cart heavily loaded with freshly cut hay. Note, too, that Constable's depiction of light and shadow on the field suggests the changing pattern of the sky.

▲ **THE HAY WAIN** The focus of Constable's painting is a traditional wooden hay cart that appears to have seen many seasons of use. The two agricultural workers in the cart add human interest to the scene and suggest a way of life that is in tune with the rhythms of nature. The wain is crossing the river at a ford, probably to allow the horses to drink and perhaps to ensure the metal bands around the wooden wheels are fitting properly. Wood shrinks in dry, warm weather, so the metal rims may have become loose, but they could be tightened by immersion in water.

◀ **SUMMER SKY** Fine weather for the summer hay-making season can never be guaranteed in Britain. Constable's fast-moving clouds suggest typically changeable conditions in the big, open skies of this part of East Anglia.

▼ **SPLASHES OF RED** The collars on the horses stop their harnesses from chafing their shoulders and backs. Red, however, would have been an unusual color for working horses. Constable has used splashes of red here and in other areas of the painting to complement and intensify the lush green of the fields and foliage: the fisherman by the boat in the foreground has a red neckerchief; one of the reapers wears a red sash; and there is a tiny clump of poppies in the bottom left-hand corner of the painting.

5

6

◀ **WOMAN WASHING** A woman is kneeling on a landing stage that projects from the cottage. It is unclear whether she is washing clothes in the river or simply collecting water—a terracotta jug stands behind her. Her inclusion, like that of the other figures in this landscape, illustrates an aspect of domestic life in this working rural community.

7

◀ **DOG** Standing at the water's edge, the dog is an important element in the painting and directs our gaze toward its focus. One of the men in the cart gestures toward the animal, hinting at a narrative. The same dog reappears in other works by Constable.

▼ **CONSTABLE'S SNOW** Small flecks of white dotted throughout the painting, particularly on the water (below) and foliage, convey the impression of glittering, reflected light. Critics (and Constable) referred to this technique as his "snow."

8

ON **TECHNIQUE**

Constable made numerous small studies in pencil (see below), pen, chalk, watercolor, and oil paint. These sketches were done fairly quickly in the open air and in all weathers. He would fill small books with them to use as reference when creating his large paintings in his London studio. He once referred to these sketches as "hasty memorandums."

Constable's studies accurately capture the season, time of day, and even the wind direction. Sometimes he jotted quick notes on his sketches to help him with his final piece. In London, he would lie on his back on Hampstead Heath—which was near his studio—for long periods, sketching clouds as they moved into different formations.

▲ *Towpath near Flatford Mill*, John Constable, 1814, pencil drawing, 4½ × 3½in (11.3 × 8.6cm), Victoria and Albert Museum, London, UK

IN CONTEXT

The Hay Wain is one of a series of large paintings known as Constable's "six-footers." Frustrated by his pictures being dwarfed at the annual Royal Academy exhibitions—where paintings were hung frame-to-frame, floor-to-ceiling—and because he considered landscapes to be on a par with history paintings, Constable began to produce large-scale compositions. Not only were his paintings visible from a distance, but the scale of works such as *Hadleigh Castle*, 1829, and *Salisbury Cathedral from the Meadows*, 1831, helped to elevate the subject matter to the status of classical art.

The Fighting Temeraire

1839 ▪ OIL ON CANVAS ▪ 35¾ × 44¼in (90.7 × 112.6cm) ▪ NATIONAL GALLERY, LONDON, UK

J. M. W. TURNER

SCALE

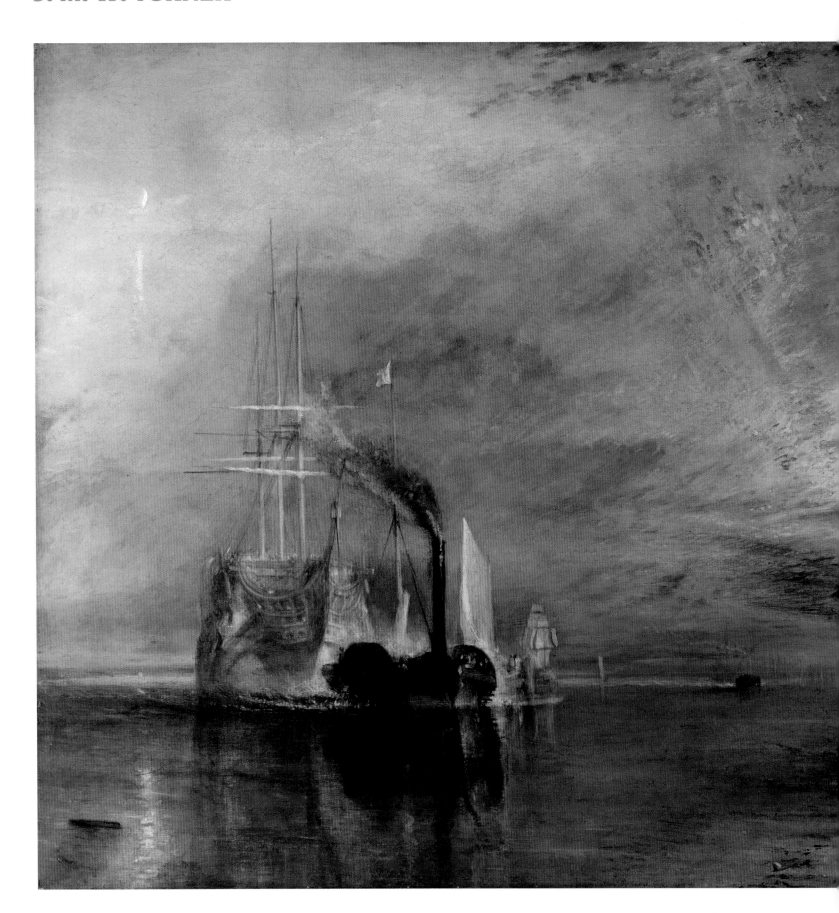

…slow, sad, and majestic, follows the brave old ship, with death, as it were, written on her

WILLIAM MAKEPIECE THACKERAY *BALLADS AND MISCELLANIES,* 1899

Like an apparition, the glimmering spectacle of a tall-masted gunship glides toward us on the still waters of the river Thames. *The Fighting Temeraire* immortalizes the ship on her final journey, which took place 33 years after the Battle of Trafalgar. The *Temeraire* had played a heroic role in the battle, coming to the aid of Lord Nelson's ship the *Victory* when it was locked in close combat. Despite her aura of magnificence, the ship is now in a poor state of repair. Stripped of anything salvageable, she is being towed from Sheerness to Rotherhithe shipyard where she will be broken up. A white flag flies from the tug, symbolizing the *Temeraire's* sad surrender to the breaker's yard.

A moving tribute

Although the Union Jack no longer flies from the mast, the *Temeraire*'s past bravery is acknowledged by Turner in this idealized, theatrical vision. Artistic license has allowed him to manipulate events and he shows the ship traveling east, with a glorious sunset behind her, whereas in real life she would have been traveling west, as Rotherhithe is west of Sheerness.

Many factors combine to make this work so memorable and moving: the sublime setting, the harmonious balance of the composition, the extraordinary quality of light, and the emotion inherent in the visual symbols. A metaphor for the journey of life, the demise of this aged sailing ship represents the end of an era; even the black buoy in the foreground seems to act as a full stop. Turner was in his sixties when he made the painting and perhaps the powerful sentiments echo his own feelings about the passage of time.

When the work was first exhibited, in 1839 at the Royal Academy in London, the nostalgia of the occasion was enhanced by the inclusion in the catalog of two lines from Thomas Campbell's emotionally charged poem *Ye Mariners of England*:
 "The flag which braved the battle and
 the breezes, No longer owns her."
The critics of the day were united in their praise of a painting that not only celebrated a contemporary historical event but also successfully embraced the techniques of the old masters, particularly those of Claude, the 17th-century French landscape painter (c.1604–82), whom Turner admired. The artist refused to sell *The Fighting Temeraire*, calling it "my old darling", and the work was recently voted the most popular painting in Britain.

J. M. W. **TURNER**

1775–1851

The most original artist in the history of English landscape painting, Turner was fascinated by the effects of light.

A gifted and imaginative child, Joseph Mallord William Turner first exhibited a painting at the Royal Academy, London, when he was only 15 years old.

Turner traveled widely and produced a vast amount of work. His style varied considerably over the years, ranging from accurate, topographical watercolors in his early years to grand landscapes in the classical manner that he painted after visiting Italy. By 1805, increasingly influenced by Romanticism, his paintings became freer and more expressive as he sought to capture the power of nature in luminous landscapes depicting violent storms and blizzards. Turner's work was criticized for lack of formal composition, but it also attracted great admirers, notably the critic John Ruskin, who championed his work. When Turner died in 1851, he bequeathed much of his work to the British nation.

Visual tour

KEY

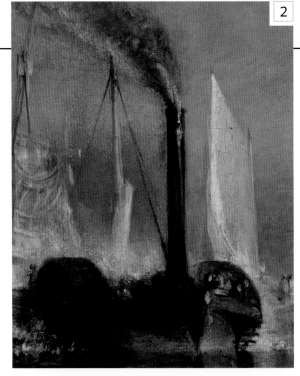

◀ **INDUSTRIAL TUG** On the day of her final voyage, another boat was following the *Temeraire*. Turner has chosen to exclude it, possibly to emphasize the contrast between the ugly, blackened, steam-powered tug and the majestic white sailing ship. The tug has been interpreted as a symbol of the evils of the British Industrial Revolution but Turner's other work does not support this. On the contrary, Turner embraced the steam-powered engineering of the future in his 1844 painting *Rain, Steam and Speed—The Great Western Railway*, a celebration of the age of the train.

▼ **GHOSTLY SHIP** The 98-gun, three-decked *Temeraire* had been moored off the port of Sheerness for several years. Her three masts had been removed, together with all her rigging, and paint was peeling off her timbers. Turner, however, has chosen to present us with an elegant, romantic vision in white and gold, complete with masts—a more fitting farewell for a ship whose name means bold and fearless.

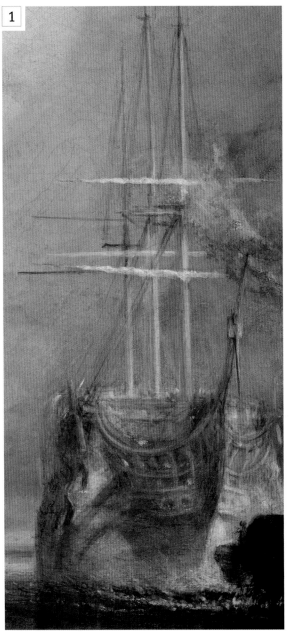

▶ **SHIP IN FULL SAIL** On the horizon, just to the right of the tug, you can just make out the shape of another ghostly sailing ship. Turner may have included it to remind us how the *Temeraire* must have appeared in her full glory. However, this tall-masted ship has almost faded from view, so perhaps it serves to reinforce the theme of the painting: the end of the era of the sailing ship and the irrevocable transition to the age of steam power.

▶ **RISING MOON** A sliver of moon is visible in the sky at the top left of the painting. Its reflection lights up the water beneath, glinting on the rolled-up sails on the masts and on the foam churned up by the paddles of the tug. The silvery light reinforces the ethereal paleness of the ship and contrasts strongly with the fiery tones of the setting sun.

▼ **FLAMING SUNSET** The setting sun is symbolic, representing the passing of the age of sail as well as the demise of the *Temeraire*. The blood-red sky, reflected in the surface of the water, perhaps reminds us of the sacrifices made by the British navy at the Battle of Trafalgar. The *Temeraire* is positioned well to the left of the painting but its visual weight is perfectly balanced by the glowing sunset that dominates the whole right side of the composition. Notice how thickly the paint has been applied above and around the sun, using a technique called impasto.

5

6

◀ **HUMAN LIFE** In the blues and greys in the right-hand corner of the painting, you can just make out the silhouette of a vertical figure standing on a boat. The figure has probably been included to give an idea of scale and help to establish the sheer size of the *Temeraire*. The boats and buildings in the distance also add a human element to the painting.

ON **TECHNIQUE**

Turner's landscapes were influenced by the work of Claude, whose fascination with the qualities of light he shared. Turner painted the sun-drenched clouds in *The Fighting Temeraire* using a technique he learned from Claude. He applied very thin layers of semi-transparent white and yellow oil paint over the darker blue, orange, and red to give the clouds a translucent appearance.

Turner left his works to the British nation on the understanding that some of them be hung next to those of Claude. *Dido Building Carthage* and *Sun Rising Through Vapour* are displayed alongside Claude's *Seaport with the Embarkation of the Queen of Sheba* (below) and *Landscape with the Marriage of Isaac and Rebecca*.

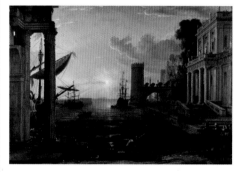

▲ *Seaport with the Embarkation of the Queen of Sheba*, Claude, 1648, 59 × 77½in (149.7 × 196.7cm), National Gallery, London, UK

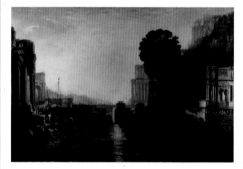

▲ *Dido Building Carthage*, J. M. W. Turner, 1815, 61¼ × 90½in (155.5 × 230cm), National Gallery, London, UK

IN **CONTEXT**

The *Temeraire* played a key part in one of the most famous sea battles in British naval history, the Battle of Trafalgar. On October 21, 1805, the British navy, led by Lord Nelson, was engaged in combat with a fleet of French and Spanish ships off the Cape of Trafalgar, south of Cadiz, Spain. Under the command of Captain Eliab Harvey, the *Temeraire* came to the rescue of Nelson's flagship, the *Victory*, and also captured two French ships. In four and a half hours, the British navy captured over half the enemy ships and one was destroyed. During the fighting, Lord Nelson was fatally wounded, but was informed that the battle had been won and the threat of invasion by Napoleon's forces averted.

The Artist's Studio

SCALE

1854-55 ▪ OIL ON CANVAS ▪ 11¾ × 19¾ft (3.61 × 5.98m) ▪ MUSÉE D'ORSAY, PARIS, FRANCE

GUSTAVE COURBET

This enormous picture is probably the most elaborate piece of self-advertisement ever painted. Courbet shows himself at work in a cavernous studio, in the midst of a varied and enigmatic crowd of people. It is a dramatically arresting scene, painted with magnificent breadth and assurance, but while the individual figures are vividly

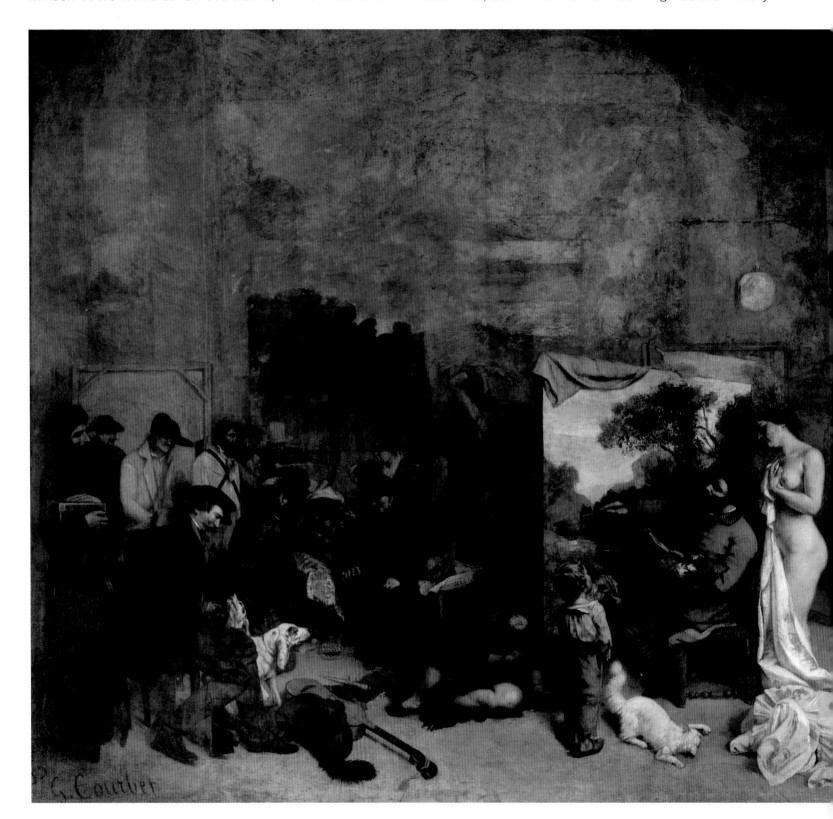

portrayed, collectively they make no obvious sense. Who are all these people and why have they gathered here? Courbet wrote a lengthy description of the painting, but his language is often unclear and open to varied interpretations. What is not in doubt is that this is one of the central masterpieces of 19th-century painting.

The picture was created for the great Exposition Universelle held in Paris in 1855. However, it was rejected by the selection committee, so Courbet—a man of immense self-confidence—staged his own one-man exhibition in a "Pavilion of Realism" he erected at his own expense alongside the official show. Courbet's exhibition was unsuccessful both commercially and critically, but nevertheless it has a momentous place in art history. By challenging the authority of the institutional art world, he led the way for others, including the Impressionists, to follow.

Although Courbet was avowedly a Realist, his paintings often have symbolic aspects, and he gave *The Artist's Studio* a rather baffling subtitle—*A real allegory summing up seven years of my artistic and moral life*. He wrote that the figures on the left represented "the world of commonplace life—the masses, wretchedness, poverty, wealth, the exploited, the exploiters, those who thrive on death." On the right are "my friends, fellow workers, and art lovers"—those who "thrive on life."

> ## It's my way of seeing society with all its interests and passions; it's the whole world coming to me to be painted
>
> **GUSTAVE COURBET**

GUSTAVE **COURBET**

1819-77

Courbet changed the course of French art by bringing a new grandeur and seriousness to scenes of everyday life, and by exhibiting his work outside the traditional venues.

Courbet was born in Ornans, eastern France, into a prosperous farming family. This background was important, for although he worked mainly in Paris, he often depicted earthy, rural subjects. He became famous in 1850 when he exhibited three remarkable paintings at the Paris Salon, most notably *The Burial at Ornans*, a huge and defiantly unidealized scene of country life. These works established him as the leader of the Realist movement, in which artists believed that everyday life could provide subject matter just as serious as the traditional major themes of history, religion, and mythology.

Courbet's radical views also came out in his politics. After France was overwhelmingly defeated in the Franco-Prussian War (1870-71), Paris was ruled for two months by a revolutionary government called the Commune, in which Courbet was head of the arts commission. When the Commune was crushed, he was imprisoned for six months. Fearing further punishment, he moved permanently to Switzerland in 1873. In addition to his ambitious figure compositions, he painted landscapes and portraits.

Visual tour

KEY

◀ **BAUDELAIRE** Seated among Courbet's friends is Charles Baudelaire, one of the leading French poets of the day and also a lively writer on art. He met Courbet in 1848 at the Brasserie Andler, a haunt of artists and intellectuals. It became so associated with Courbet's circle that it was nicknamed "The Temple of Realism."

▼ **ART LOVERS** The couple standing prominently on the right—exemplifying art lovers or collectors— are described by Courbet as "a woman of fashion, elegantly dressed, with her husband." They have not been certainly identified, although various suggestions have been made.

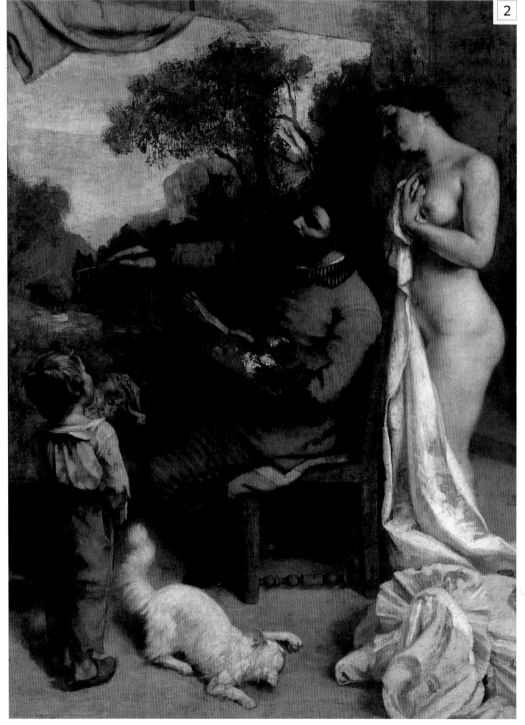

◀ **COURBET** At the center of the social panoply sits the heroic figure of Courbet, making a sweeping gesture of the brush. In reality, he would not have worked at his easel in this awkward, sideways-on position, but he was extremely vain (he painted numerous self-portraits) and adopted the posture to show off what he regarded as his particularly handsome profile. The nude model who stands behind him has been interpreted as an embodiment of truth, and the little boy who gazes admiringly at him has similarly been seen as an allusion to innocence: like Courbet, he views the world freshly, unburdened by artistic conventions.

◄ **CHAMPFLEURY** Jules Husson, who wrote under the pseudonym Champfleury, was a close friend of Courbet and the chief literary spokesman of Realism. Courbet's elaborate description of *The Artist's Studio* first appeared in a letter to Champfleury, written late in 1854 when the painting was far from finished.

▼ **THE UNDERTAKER** Various identifications have been proposed for this figure, who can more accurately be described as an undertaker's mute. Perhaps the most plausible suggestion is that it is a disguised portrait of the journalist Émile de Girardin, a key supporter of Emperor Napoleon III, to whose regime Courbet was opposed.

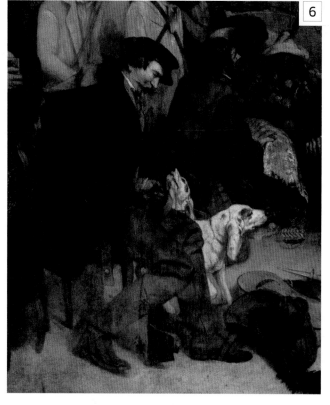

➤ **THE POACHER** The prominent seated figure with the hunting dogs has been convincingly identified as Emperor Napoleon III. The nephew of Napoleon Bonaparte, he was elected President of France in 1848 and assumed the title of Emperor in 1852. Open criticism of his dictatorial policies was impossible at the time because of censorship, but Courbet is perhaps suggesting that he has seized the French Republic for his own ends, just as a poacher bags game. Napoleon was deposed in 1870 after leading his country to a catastrophic defeat in the Franco-Prussian War, and ended his life in exile in England.

ON **TECHNIQUE**

Courbet's technique as a painter was a direct expression of his personality—bold, self-confident, and unconcerned with convention. He usually worked quickly and spontaneously, applying paint with palpable relish, often with a palette knife. He was uninterested in fine detail or a careful finish. *The Artist's Studio* was painted against a deadline to get it ready for exhibition and much of the background is very sketchy in treatment; given more time, Courbet would probably have elaborated it. He had little interest in drawing, but like other painters of the time, he kept a collection of nude photographs, like the one below, to use as reference material.

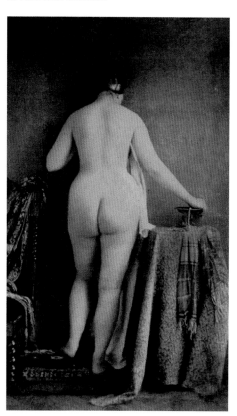

▲ *Female nude, standing*, Julien Vallou de Villeneuve, c.1853, salted paper print from paper negative, Metropolitan, New York, US

IN **CONTEXT**

Courbet lived through an unsettled period in French politics, with numerous changes in types of government. After Napoleon Bonaparte was exiled in 1815, the monarchy was restored under Louis XVIII. His successor Charles X fled when his repressive regime provoked a revolution in July 1830. He was replaced by Louis Philippe, whose reign, known as the July Monarchy, lasted until 1848, when there was another revolution. It resulted in a republican government known as the Second Republic, with Louis Napoleon as President. He became Emperor as Napoleon III in 1852. This inaugurated the Second Empire, which lasted until he was deposed in 1870. It was followed by the Third Republic, which ended when Germany invaded France in 1940.

Olympia

1863 ▪ OIL ON CANVAS ▪ 51¼ × 74¾in (130.5 × 190cm) ▪ MUSÉE D'ORSAY, PARIS, FRANCE

EDOUARD MANET

SCALE

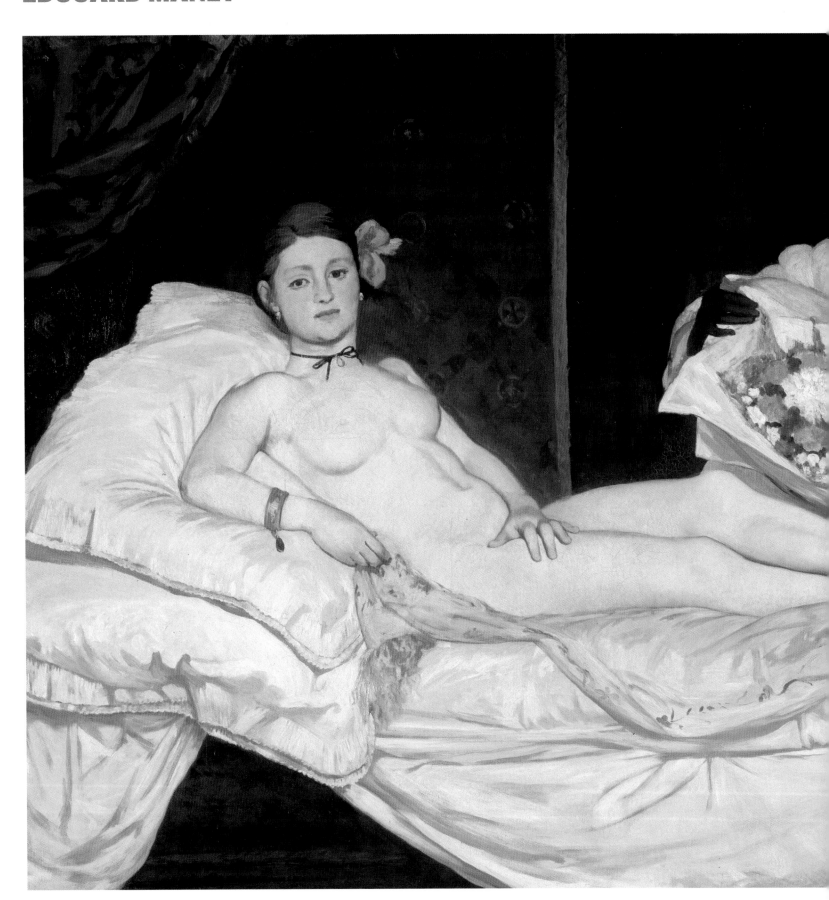

It wasn't just the fact that…she's a lower class nude, but also…she was painted in…an almost childish or unskilled fashion

ANNE MCCAULEY *THE SHOCK OF THE NUDE*, 2010

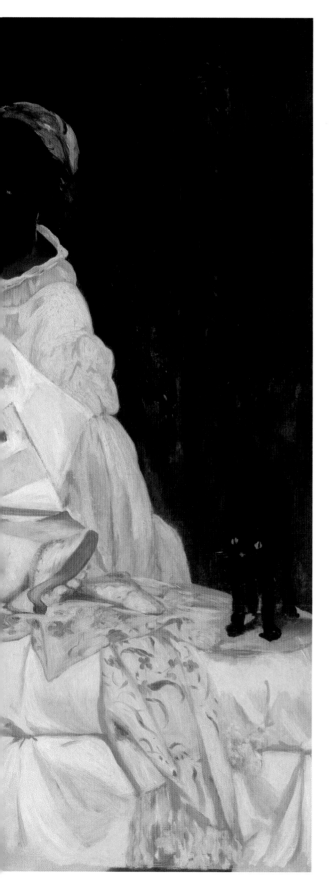

Dating to the most controversial part of Manet's career, this provocative picture helped to establish him as a major force on the French art scene, introducing a new slant on traditional themes. There was nothing unusual about nudity itself—mildly erotic scenes of ancient nymphs and goddesses were a common sight in French exhibition halls. However, *Olympia* did not fall into this category. The model in the painting might be emulating the pose of Titian's *Venus of Urbino* (see p.163), but she was far less respectable. In the eyes of the critics, she was too modern, too ugly, too real and, as such, an affront to public morality.

The revolt against academic art

For much of the 19th century, standards in French art were rigidly controlled. Artists wishing to display their work at the Salon—the official public exhibition in Paris—had to submit their entries to a jury. By the 1860s, resentment was growing against this scrutiny. In 1863, permission was granted for a Salon des Refusés (Salon of Rejected Works). Manet's *Déjeuner sur l'herbe*, 1863, was the star of the show. The critics ridiculed it, but it brought the artist overnight fame.

Manet painted *Olympia* at roughly the same time but did not submit it until 1865. The picture was accepted but, as with *Déjeuner sur l'herbe*, reaction was hostile, largely due to Manet's subversion of the academic process. Both images were loosely based on famous Renaissance paintings. But Manet was also influenced by the Realist trends pioneered in the 1850s by Gustave Courbet (see pp.156–59). Courbet had argued that art could only represent "real and existing objects." So, Manet translated his Renaissance fantasies into modern idioms. For *Olympia*, he could not depict a naked, reclining goddess, so he transformed his nude into the nearest, present-day equivalent.

EDOUARD **MANET**

1832-83

One of the key figures of 19th-century art, Manet gained a scandalous reputation with his unique brand of Realism. His adventurous methods endeared him to the Impressionists, though he was never an official member of their group.

Manet came from a well-heeled, middle-class background, and trained under Thomas Couture, a successful academic artist. Couture made a careful study of the old masters and craved recognition at the Salon, the most prestigious exhibiting body in France. In spite of such conventional roots, Manet produced works that were controversial and original. In the early 1860s, he gained considerable notoriety when *Déjeuner sur l'herbe* and *Olympia* were pilloried as immoral spectacles. As the decade wore on, Manet became something of an elder statesman figure for the young Impressionist circle. He did not share their enthusiasm for painting in the open air, but his memorable scenes of modern Parisian life proved an inspiration for the movement.

Visual tour

KEY

▶ **TORSO** To modern audiences, it may seem surprising that the form of the model's torso came in for particularly hostile criticism. The art lovers of the time were used to seeing sculptural, well-rounded, and idealized figures. Olympia's body, on the other hand, was far too realistic for their tastes. In addition, a number of critics commented unfavorably on Olympia's coloring. One noted that her "flesh tones were grubby," while another described her as an "odalisque with a yellow stomach."

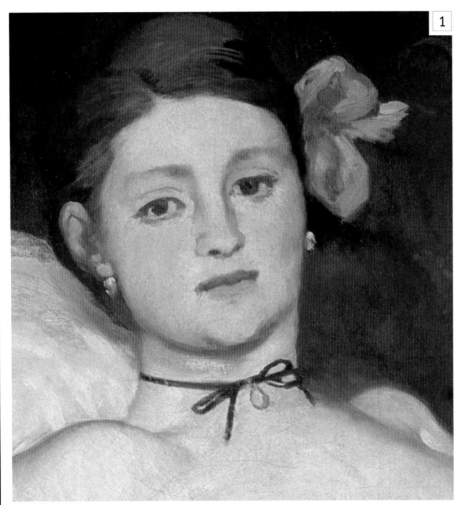

▲ **VICTORINE-LOUISE MEURENT**
Manet used his favorite model, Victorine Meurent, to convey his vision of Olympia. She was no stranger to controversy, having already gained notoriety as the naked picnicker in Manet's breakthrough picture, *Déjeuner sur l'herbe*. Meurent was not a conventional beauty, but her spirited personality created the desired effect. Her self-assured gaze shocked the Parisian public, reinforcing the impression that Manet's subject was a hardened prostitute. Meurent herself was a painter, and several of her works were exhibited at the Salon.

▲ **BOUDOIR SLIPPERS** One of the silk shoes that the girl is wearing has slipped off her foot. Although apparently nothing more than a casual detail, the wearing of a single slipper was a conventional symbol of lost innocence. Accordingly, this tallied with the immoral interpretations of the model's nudity.

◀ **HAND OVER GENITALIA** In both standing and reclining versions of the female nude, this coy gesture is a standard feature of the *Venus pudica* (modest Venus). The pose was extremely common in classically inspired academic art, but its effect is jarring in Manet's picture, as the woman's candid stare is anything but modest.

▼ **BOUQUET OF FLOWERS** When portraying the female nude, artists often liked to heighten the erotic mood of their work by including other forms of sensual stimuli. Thus, the depiction of expensive fabrics and exotic flowers evoked the senses of touch and smell. For Manet's contemporaries, however, *Olympia's* bouquet of flowers struck a more unsavory note. Spectators interpreted it as a gift from an admirer or a prospective client.

6

ON **TECHNIQUE**

The Parisian public was chiefly outraged by the moral implications of Manet's work, but many critics were equally appalled by the artist's technique. Visitors to the Salon were accustomed to seeing a high degree of finish in their paintings. Flesh tones, in particular, were meant to display an enamel-like smoothness, even when viewed from very close quarters. Manet, however, paid relatively little attention to the finer subtleties of modeling and tonal gradation. Instead, he tended to flatten out his figures and their surrounding space. As a result, the critics often likened these to cartoons on playing cards. One pundit described *Olympia* as "the Queen of Spades stepping out of the bath."

Manet was also fond of structuring his compositions around powerful contrasts of light and shade—a trait he borrowed from Spanish art. The critics acknowledged his skill in this regard, but complained about the lack of detail in his somber backgrounds.

5

7

▲ **PULLED-BACK CURTAIN** The moral impact of Titian's *Venus of Urbino* was mitigated by the fact that the nude was placed in a large, well-appointed chamber. In contrast, Olympia is compressed into an extremely shallow space. The dark curtains and the screen block off any background details, forcing you to focus squarely on the provocative, sexual connotations of the model and her rumpled bed.

◄ **CAT** Titian's nude was accompanied by a sleeping dog, a traditional symbol of marital fidelity. Black cats generally had more sinister overtones and the one in Manet's painting, with its arched back, seems decidedly unimpressed with the spectator— or "client"–scrutinizing its mistress.

IN **CONTEXT**

The immediate source of inspiration for *Olympia* came from Titian's *Venus of Urbino*. Manet had made a sketch of this famous masterpiece during his visit to Florence in 1857. It is by no means certain that Titian meant to represent Venus—the figure is not accompanied by any of her traditional, mythological attributes—but the woman's coy smile does at least indicate a warm relationship with the viewer. This is entirely lacking in *Olympia*. There is no hint of recognition or affection in the model's expression. Instead, her gaze is cold and direct, as if she is staring at a total stranger.

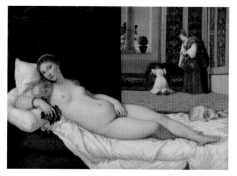

▲ *Venus of Urbino*, Titian, 1538, oil on canvas, 46¾ × 65in (119 × 165cm), Uffizi, Florence, Italy

Arrangement in Grey and Black, No. 1

1871 ▪ OIL ON CANVAS ▪ 56¾ × 64in (144.3 × 162.5cm) ▪ MUSÉE D'ORSAY, PARIS, FRANCE

SCALE

JAMES McNEILL WHISTLER

Grave and pensive, the elderly woman sits in a rigidly formal pose, her hands clasping a white lace handkerchief. Her grey hair is flat and neat, her dark clothes are plain and puritanical. The feeling of austerity is underlined by the subdued color scheme and the strong horizontals and verticals of elements such as the picture frames, the long curtain, and the deep skirting board. Yet for all its severity, a sense of fragile but dignified humanity glows through the painting. Its full title is *Arrangement in Grey and Black No. 1: Portrait of the Artist's Mother*, but it is familiarly known as *Whistler's Mother* and has become enduringly popular as an archetypal image of a sober but sincere matriarch.

Art for art's sake

The artist's mother, Anna McNeill Whistler (1804–81), was widowed in 1849. She left America in 1863 to escape the Civil War and moved to London to live with her son. A few years after this, he began using musical terms—such as symphony, nocturne, or, as here, arrangement—in the titles of his paintings. This practice expressed his belief that painting was more concerned with formal qualities—lines, shapes, colors—than the ostensible subject. Other artists of the time shared this view, but Whistler was a particularly strong and influential spokesman for the "art for art's sake" doctrine because of his personal magnetism and his way with words. "As music is the poetry of sound, so is painting the poetry of sight, and the subject matter has nothing to do with the harmony of sound or of color," he wrote in 1878; and at the same time he commented on this work, "to me it is interesting as a picture of my mother; but what can or ought the public to care about the identity of the portrait?"

Arrangement in Grey and Black, No. 1 was first exhibited at the Royal Academy, London, in 1872. Initially the selection committee rejected it, but Sir William Boxall, the Director of the National Gallery,

London, and a friend of Whistler, used his influence to have it accepted. In general the portrait was poorly received, but it also had admirers, notably the great writer Thomas Carlyle, who thought it had "massive originality." Soon afterward, Whistler painted a portrait of Carlyle in a similar vein, *Arrangement in Grey and Black, No. 2* (1872–73). In 1891, it was bought by the City of Glasgow in Scotland, making it the first Whistler painting to be acquired by a public collection. This was a milestone in Whistler's fortunes, and later that year the portrait of his mother was bought by the French state, which had made him a knight of the Légion d'Honneur in 1889.

JAMES McNEILL **WHISTLER**

1834–1903

One of the most fascinating personalities of late 19th-century art, Whistler was flamboyant in his lifestyle, but subtle and deeply thoughtful in his approach to painting.

Whistler led a cosmopolitan life: an American by birth, he lived in Russia as a boy and spent most of his career in London and Paris (he also worked memorably in Venice). He became one of the best-known figures in London's artistic and literary circles, partly because of his talent, but also because of his wit, dandyism, and love of controversy. Many critics thought that his work, which was atmospheric and restrained, looked unfinished, and in 1877 he sued one of them, the famous John Ruskin, for accusing him of "flinging a pot of paint in the public's face." Whistler won the case, but the judge awarded him derisory damages and the legal costs led to his bankruptcy in 1879. He recovered, however, and his reputation was restored. By the end of his life, he was much honored. In addition to his paintings, mainly portraits and landscapes, he produced numerous prints—etchings (these are particularly admired) and lithographs.

Whistler, if you were not a genius, you would be the most ridiculous man in Paris

EDGAR DEGAS QUOTED BY GEORGE MOORE IN *REMINISCENCES OF THE IMPRESSIONIST PAINTERS*, 1906

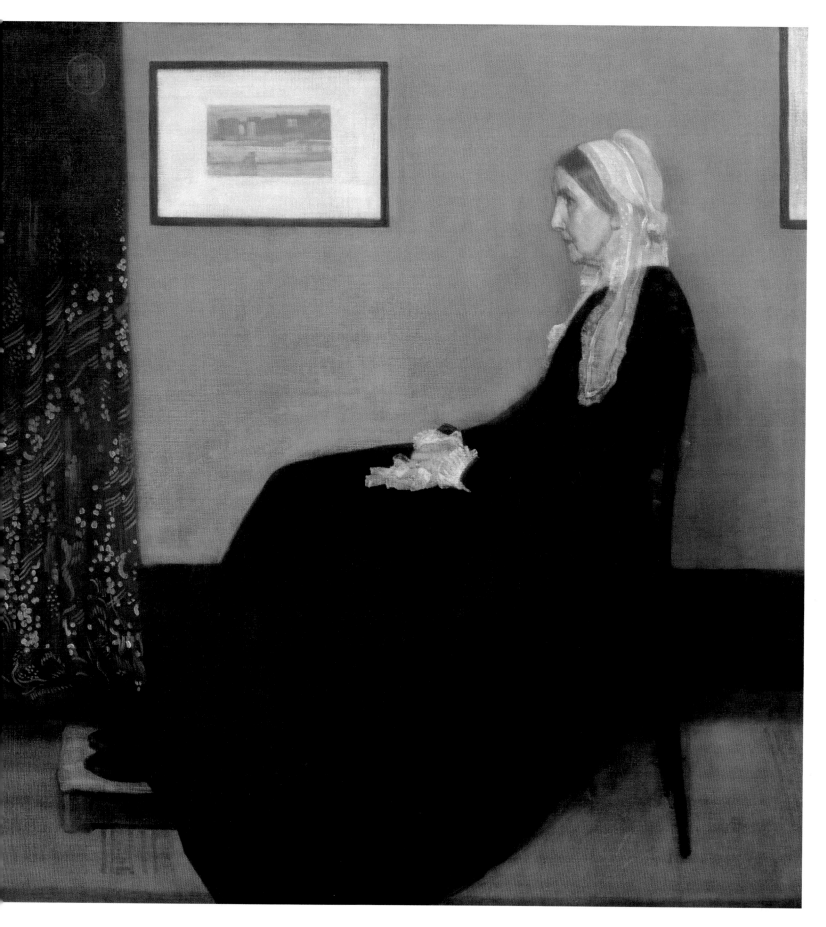

Visual tour

KEY

◀ **CHAIR** This is the only inanimate object in the painting that deviates slightly from strict angularity. Whistler's favorite form of portrait was the full-length standing figure, and initially he is thought to have proposed a standing pose for his mother. However, her age and a recent illness made this uncomfortable for her, so he adopted the sitting pose. Quiet and reserved (the opposite of her son), she was a patient model.

▼ **HANDS AND HANDKERCHIEF** Apart from the head, the most detailed and visually forceful element in the painting is the area showing the hands clutching the handkerchief. Like other portraitists, Whistler often used "props"—such as a glove, a hat, or a fan—to make the sitter's hands look naturally occupied.

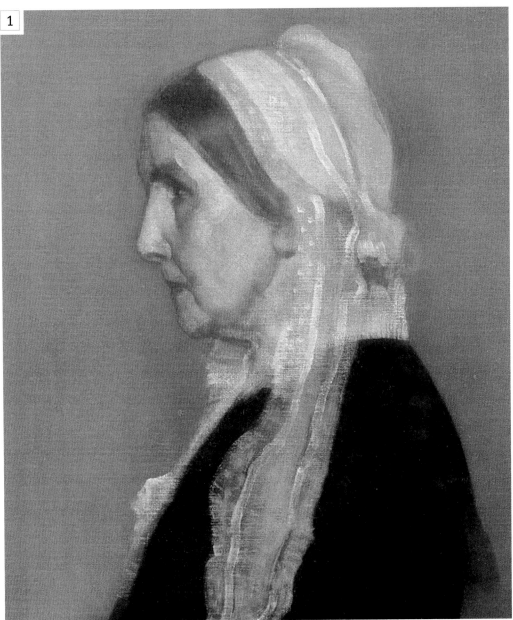

▲ **PROFILE** Whistler has shown his mother in pure profile. This form was much used by Renaissance artists and remained popular in specialist types of art such as coins and medals, but by this time it was rarely seen in conventional portrait painting. It sets the tone for the formal rigor of the picture. The white lace against the black dress recalls the work of Frans Hals, an artist whom Whistler admired.

▲ **ETCHING** This picture is one of Whistler's etchings, *Black Lion Wharf* (1859). It was published in 1871 as part of a series entitled *Sixteen Etchings of Scenes on the Thames*, which helped establish his reputation as a printmaker. Whistler lived near the Thames and the river was one of his favorite subjects.

5 ◄ **JAPANESE INFLUENCE**
The curtain is flecked with a floral pattern, recalling the Japanese screens Whistler admired. Japan isolated itself from other countries until 1853, but in the late 19th century it had a major impact on Western culture. Whistler collected Japanese art and included many references to it in his work.

6 ◄ **FOOTSTOOL** The footstool provides a note of domesticity that slightly softens the overall severity of the composition. X-rays of the painting show that Whistler originally made it higher. Changing it was one of several alterations he made as he worked on the picture: he tried out various positions for the arms and knees, and he originally placed the curtain and picture further to the right.

7 ◄ **TONAL CONTRASTS** Whistler was extraordinarily sensitive to tonal values in painting, and here he achieves a perfect balance of light and dark. He enjoyed creating such subtle, low-key effects, and his emphasis on the flatness of the picture surface, rather than three-dimensional depth, helped to create the conditions from which abstract art later emerged. Although discreet, Whistler's art was also radical.

ON **TECHNIQUE**

Whistler was a self-critical perfectionist and worked very slowly. He often left paintings incomplete (or even destroyed them) when they failed to meet his exacting standards. At other times, he scraped away the paint or rubbed it down on the canvas so that he could start again. Remarkably, his laborious process of creation does not show in his finished works, which display a flawless composure.

Whistler often applied paint very thinly but varied his handling a good deal, and the lightly brushed passages frequently coexist with richer, creamier touches. In the portrait of his mother, the face receives more detailed treatment than anything else. The lace head-covering and the handkerchief are painted with somewhat drier brushwork than the rest of the picture.

IN **CONTEXT**

This famous portrait of a girl in white against a white curtain helped to establish Whistler's name when it was shown at the Salon des Refusés in 1863. It depicts his mistress of the time, Joanna Hiffernan. Whistler originally called the portrait *The White Girl*, but a French journalist referred to it as a "*symphonie du blanc*", and Whistler later adopted the idea, adding the words to the title and using them for other works, too.

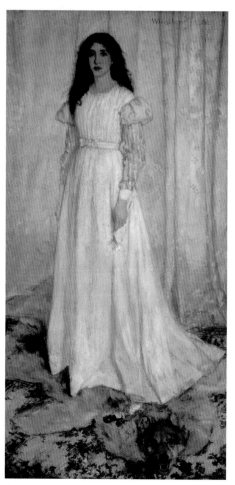

▲ *Symphony in White, No. 1: The White Girl*, Whistler, 1862, oil on canvas, 83¾ × 42½in (213 × 108cm), National Gallery of Art, Washington DC, US

The Dancing Class

1871-74 ▪ OIL ON CANVAS ▪ 33½ × 29½in (85 × 75cm) ▪ MUSÉE D'ORSAY, PARIS, FRANCE

SCALE

EDGAR DEGAS

This beautiful painting is full of movement, color, and charming details. From a position in the left-hand corner of the room, just behind the piano, you see the ballerinas of the Paris Opera in rehearsal. This unusual viewpoint helps to create the illusion that you are standing next to Degas, sharing his privileged access to the ballet class. From the piano, you look along the line of dancers right to the back of the room and, like the artist, can observe each ballerina in turn.

Degas produced several paintings of the young ballerinas of the Paris Opera performing on stage, but he much preferred to depict them in the more relaxed setting of the rehearsal room, where he was a frequent visitor. He spent many hours observing and drawing the dancers as they practiced, and it is this sense of being present during the ballerinas' daily routine that gives *The Dancing Class* such an intimate quality. Although the painting appears relaxed and informal, Degas constantly refined and perfected his work once he was back in his studio. In its apparent spontaneity and realism, the painting resembles a snapshot—and Degas was familiar with the latest advances in photography—but its seemingly casual composition was meticulously arranged. X-rays of the painting indicate that some figures were moved from one position to another until Degas achieved the perfect degree of balance and the right atmosphere.

Respect for the classics

The Dancing Class is a contemporary scene that pays homage to the style of the old masters, whose techniques and draftsmanship Degas greatly admired. As a young man, he spent a great deal of time in the Louvre, studying and copying masterpieces by painters such as Velázquez. It was not until his late twenties, however, that Degas stopped depicting historical or mythological themes in his own work and turned his attention to painting scenes of 19th-century Parisian society, from horse racing to theater and ballet. In emulating the style of great classical works but applying it to less elevated subjects, such as young

girls practicing their dancing skills, Degas was breaking with convention and his work came under strong criticism from the French art establishment.

Degas was the one Impressionist who was successful from the beginning and, although he remained rather aloof from them, he did exhibit in group shows. Like the other Impressionists, he sought to convey a sense of movement and spontaneity in his work. In *The Dancing Class*, the girls appear to have been captured unawares and their gestures and expressions appear completely natural, an effect Degas achieves with his superb drawing skills and confident sense of composition. He also employs other devices to suggest movement, such as the bright red accents in the painting that lead from the girl's hair decoration and the fan in the foreground to the collar of the teacher, and then to the sashes of the two dancers towards the back of the room.

> Watching rehearsals, Degas had an opportunity of seeing bodies from all sides in the most varied attitudes

ERNST GOMBRICH *THE STORY OF ART*, 1950

EDGAR **DEGAS**

1834-1917

Degas was a superb draftsman whose work has a quality of freshness and immediacy. Although he exhibited with the Impressionists, he chose not to be closely associated with them.

Born in Paris into a wealthy, cultured family, Degas decided to become an artist at the age of 18 after studying law. He trained at the academic École des Beaux-Arts under Louis Lamothe, former pupil of French classical painter Ingres. His studies inspired him to visit Italy, where he lived for three years. In 1861, Degas met Edouard Manet (see p.161) who introduced him to the circle of artists later known as the Impressionists. Unlike most of the group, Degas had little interest in landscapes, and preferred to paint ballet dancers, women bathing, and racehorses, and to work in his studio rather than outdoors.

Degas was interested in photography and was a great admirer of Muybridge, the pioneer of "freeze-frame" images. From 1880, when his eyesight began to fail, Degas tended to work with pastels and also made wax sculptures. His most famous sculpture, *Little Dancer, aged 14*, was first shown at the 1881 Impressionist exhibition in Paris.

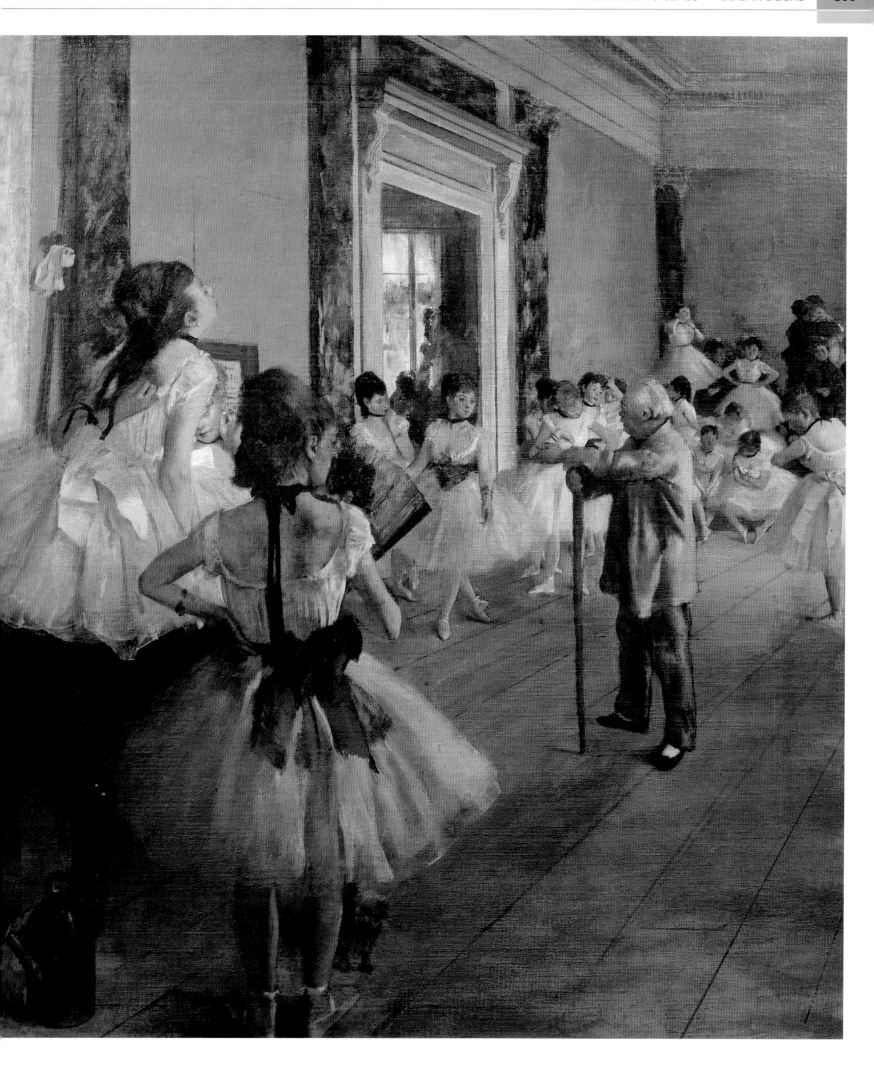

Visual tour

KEY

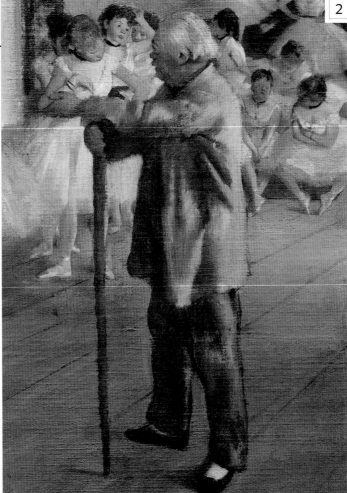

◀ **BALLET MASTER** As the class comes to an end, Jules Perrot, the ballet master, leans on his wooden stick. He is the principal character in the painting and the focus of the dancers' attention. He appears to be instructing the dancer in the doorway. Jules Perrot was himself a famous dancer and is wearing ballet slippers.

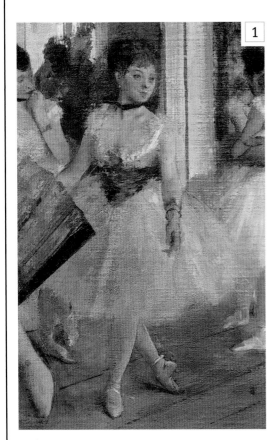

1

▲ **FRAMED FIGURE** Although most of the girls in the painting are relaxing, the dancer framed by the doorway in the center of the painting is being put through her paces by the ballet master. With an expression of concentration on her face, she adopts a classic ballet position.

▶ **BACK VIEW** The dancer in the foreground with her back to us enhances the informality of the scene. X-rays of the painting show that she was originally the other way round, looking out of the painting, but Degas changed her position, reinforcing the impression that we are actually in the room with him and the dancers are oblivious to our presence.

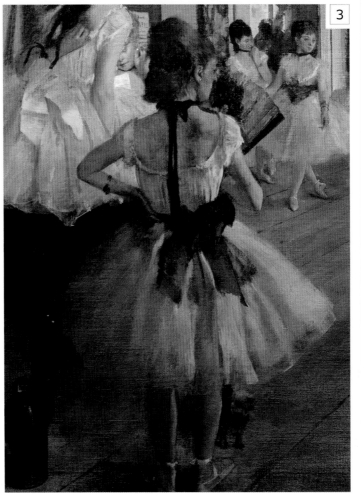

3

► CROPPED EDGES We can see the influence of photography in this painting, particularly in Degas' use of cropping– cutting off details at the margins. Part of the tutu of the girl sitting on the piano lies outside the frame. This helps to create an air of spontaneity, as if the image has been snapped rather than carefully composed. The right-hand side of the painting is similarly cropped.

◄ DOORWAY The view through the door frame draws our gaze beyond the rehearsal space to the next room. A double bass lies next to the doorway, so perhaps there is music playing. The window in the adjoining room is an important source of light in the composition and makes you aware of the world outside.

◄ CHARMING DETAILS Small areas of activity add to the informality and charm of the painting and bring the whole scene to life. Behind the girl sitting on the piano is a dancer playing with her pearl earring. This intimate detail possibly indicates that her attention has wandered.

◄ TAKING A BREAK These ballerinas appear to be relaxing before they perform in front of the ballet master. The three seated girls form a triangle, and this shape is repeated by the ballerina standing just above them with with her hands on her hips This ballerina's pose echoes that of the dancer with the green sash in the foreground.

ON **COMPOSITION**

The perspective diagram below shows how Degas carefully composed the painting around a set of converging lines that meet outside the picture frame. This creates the impression that we are looking into a three-dimensional space. The artist uses the strong diagonals of the floorboards and the line of the cornice and door frame to draw your eye right into the picture. The tops of the ballerinas' heads are aligned in the same way.

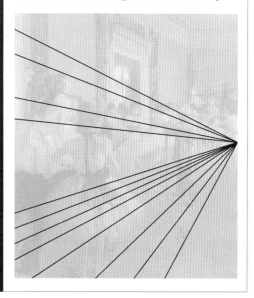

IN **CONTEXT**

Degas often used the same figures in different paintings. The central ballerina in *The Dancing Class*, the girl in front of the doorway, also appears in *Ballet Rehearsal on Stage*, a painting he made a year later, in 1874. The sketch below is the original study for the dancer and you can see the grid lines that Degas drew to help him establish the proportions for the drawing. The head takes up one-sixth of the total figure.

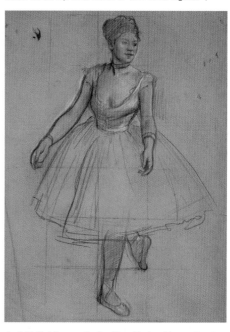

▲ *A Ballet Dancer in Position Facing Three-Quarters Front*, Edgar Degas, 1872-73, graphite and chalk on pink paper, 16 × 11in (41 × 27.6cm), Harvard Art Museums Collection, Massachusetts, US

A Sunday on La Grande Jatte

1884–86 ▪ OIL ON CANVAS ▪ 81¾ × 121¼in (207.5 × 308.1cm) ▪ ART INSTITUTE OF CHICAGO, CHICAGO, US

GEORGES-PIERRE SEURAT

SCALE

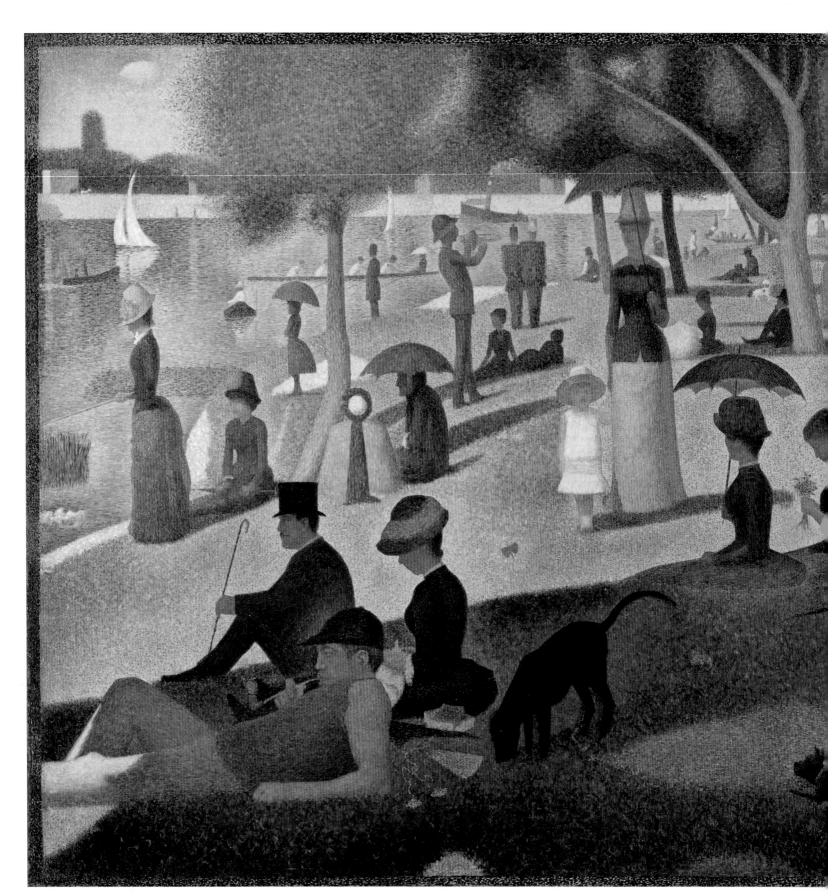

> In his mature paintings Seurat deploys his pointillist method, achieving…unparalleled sensations of color and luminosity

JODI HAUPTMAN *GEORGES SEURAT: THE DRAWINGS*, 2008

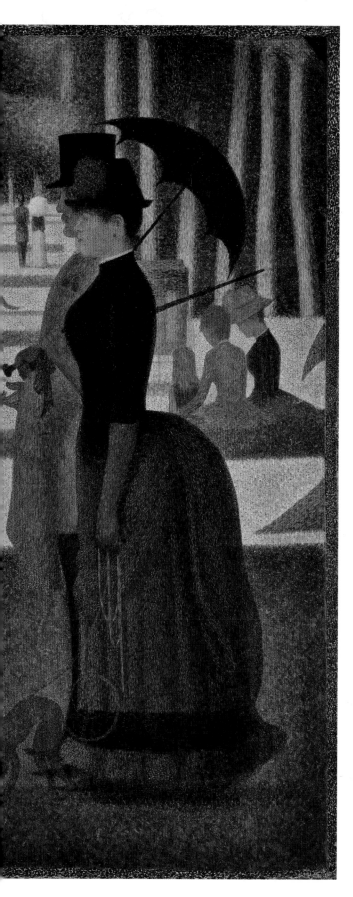

Seurat's luminous masterpiece portrays fashionable Parisians enjoying a Sunday afternoon at a popular beauty spot on the River Seine, but it shows far more than a sunny day's outing. The figures and their island setting are a vehicle for Seurat's innovative experimentation with color, subject matter, and composition.

Birth of a new style

La Grande Jatte created a sensation when it was first shown in May 1886 at the final Impressionist exhibition. It marked the beginning of Postimpressionism: rather than painting intuitively, like the Impressionists, Seurat demonstrated a more systematic and scientific approach to composition and the application of color. Influenced by recent theories on color, he perfected a technique known as divisionism or pointillism over the two years that it took him to produce the painting. This involved placing small dots of pure color next to each other on the canvas, so that they would merge in the mind's eye and create a more vibrant effect than when mixed together on the palette or canvas. The impression of shimmering that this technique creates across the painting brilliantly suggests the effect of warm, hazy sunshine.

Meticulously planned and executed, *La Grande Jatte* has a timeless, monumental quality. Although it depicts a busy scene, most of the figures are stylized and statuesque, and their faces, when visible, are blank and inscrutable. Arranged in static groups across the canvas, they seem frozen in time, forever enjoying their Sunday afternoon.

GEORGES **SEURAT**

1859-91

A brilliant 19th-century French painter and draftsman, Seurat is remembered mainly for his monumental and highly influential pointillist paintings, in which he used myriad dots of pure color to achieve vibrant color effects.

Born in Paris, Seurat enrolled at the École des Beaux-Arts in 1878, but left after a year to do compulsory military service. He returned to Paris in 1880 and concentrated on drawing for two years, producing mysterious, velvety drawings using conté crayon on textured paper. He then started painting, experimenting with styles inspired by Delacroix and the Impressionists. After reading various scientific and aesthetic books that discussed the role of color in art, Seurat tried to formalize their theories in his paintings. His first major project, *Bathers at Asnières*, 1884, was rejected by the Salon but was exhibited at the Salon des Indépendants, an alternative show that Seurat helped to set up, and where he met fellow painters Paul Signac and Henri-Edmond Cross. They helped to develop Seurat's pointillism and Seurat continued to work on the style, becoming interested in how the direction of lines has an emotional effect on the viewer, a theme that he tried to embody in *Le Chahut*, 1890, and *The Circus*, 1890-91. Tragically, Seurat died suddenly of meningitis at the age of 31, having produced only a handful of major paintings.

Visual tour

KEY

▼ **WOMAN AND CHILD** Almost in the center of the composition, a fashionably dressed woman and a child are coming straight towards us, unlike most of the other figures in the painting, who are seen in profile. The white dress of the child and and pink dress of the woman stand out sharply against the green grass. The couple provide a sense of movement in a scene that is otherwise static, apart from the girl skipping behind them, the rowers on the river, and the animals in the foreground.

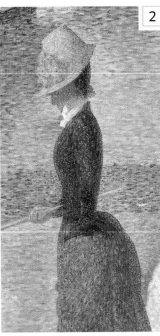

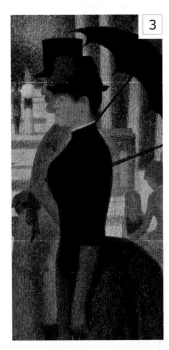

◄◄ **STATUESQUE FIGURES** Seurat's training involved drawing casts of classical sculptures and, perhaps reflecting this, his figures look strangely still, like statues. They are simplified and stylized, and the distinctive shapes of some of them, such as the women with bustles (see left), or the seated women in hats, are repeated across the painting, giving the composition a sense of repetition and rhythm.

▼ **DOTS OF COLOR** If you look closely at the painting, you can see that each color is made up of small dots of contrasting colors, creating a sparkling effect. The bright green of the sunlit grass is flecked with dots of yellow and orange, whilest the shadowy areas are interwoven with blue and pink. The dots change slightly toward the edge of each block of color, such as where the shadows border the sunlit grass.

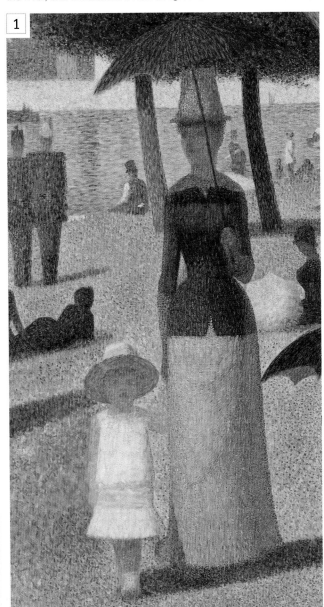

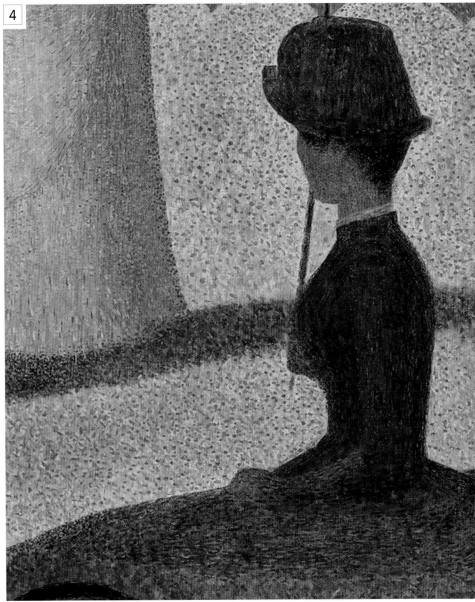

5 ◀ **PAINTED BORDER** Instead of framing *La Grande Jatte*, Seurat painted a border around it. The dots of color in the border are the complementaries of the colors next to them in the painting: red against green, orange next to blue, purple against yellow, for example.

6 ◀ **MONKEY** Capuchin monkeys were fashionable pets at the time. The French word for a female monkey, *singesse*, was slang for a prostitute, so the monkey's well-dressed owner may in fact be a prostitute with her client. The monkey provides a touch of humor as it shrinks away from the dogs.

▼ **SIMPLIFIED FORM** This seated figure has been simplified into a series of geometric shapes. The orange headscarf, however, identifies her as a wet nurse.

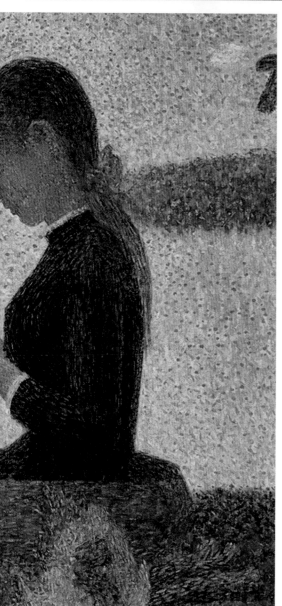

7

8

▲ **FRENCH FLAG** In the background of the painting, through the trees, you can see a boat flying the French flag from its stern—a reminder that Seurat was a patriotic Frenchman. A similar detail is found in Seurat's *Bathers at Asnières* (see right).

ON **TECHNIQUE**

The sheer size of Seurat's painting made it impossible for him to work on it outdoors, as the Impressionists did with their paintings. Seurat made at least 60 drawings and oil sketches of the scene at La Grande Jatte over a number of months, then used them to map out his painting back in the studio, refining the figures and rearranging them in a number of small studies and a large compositional sketch of the whole work. The final picture was meticulously planned, including which colors to use where. Seurat started the painting by covering the canvas with a background layer, then returned to each area to work on it in detail. Rather than being a naturalistic depiction of the scene, the finished painting demonstrates Seurat's interest in color harmonies and their effect on the viewer.

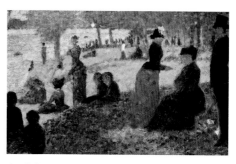

▲ Oil sketch for *La Grande Jatte*, Seurat, 1884, oil on panel, 6 × 9½in (15.5 × 24.3cm), Art Institute of Chicago, Chicago, US

IN **CONTEXT**

La Grande Jatte has an earlier companion piece entitled *Bathers at Asnières*. Both paintings show Parisians relaxing by the Seine, but on nearby stretches of the river. *Bathers at Asnières* was Seurat's first large-scale painting, made before he developed his pointillist technique, but small areas of colored dots can be seen in the water and around the red hat of the boy in the river. This painting shows only men and boys, perhaps on their lunch break from the factories visible in the background. They do not appear in *La Grande Jatte*, which shows more middle-class figures. Seurat's compositional balance and his majestic sense of form have been attributed to the influence of Piero della Francesca (see pp.30–33).

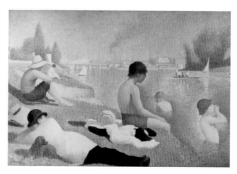

▲ *Bathers at Asnières*, Seurat, 1884, oil on canvas, 79¼ × 118in (201 × 300cm), National Gallery, London, UK

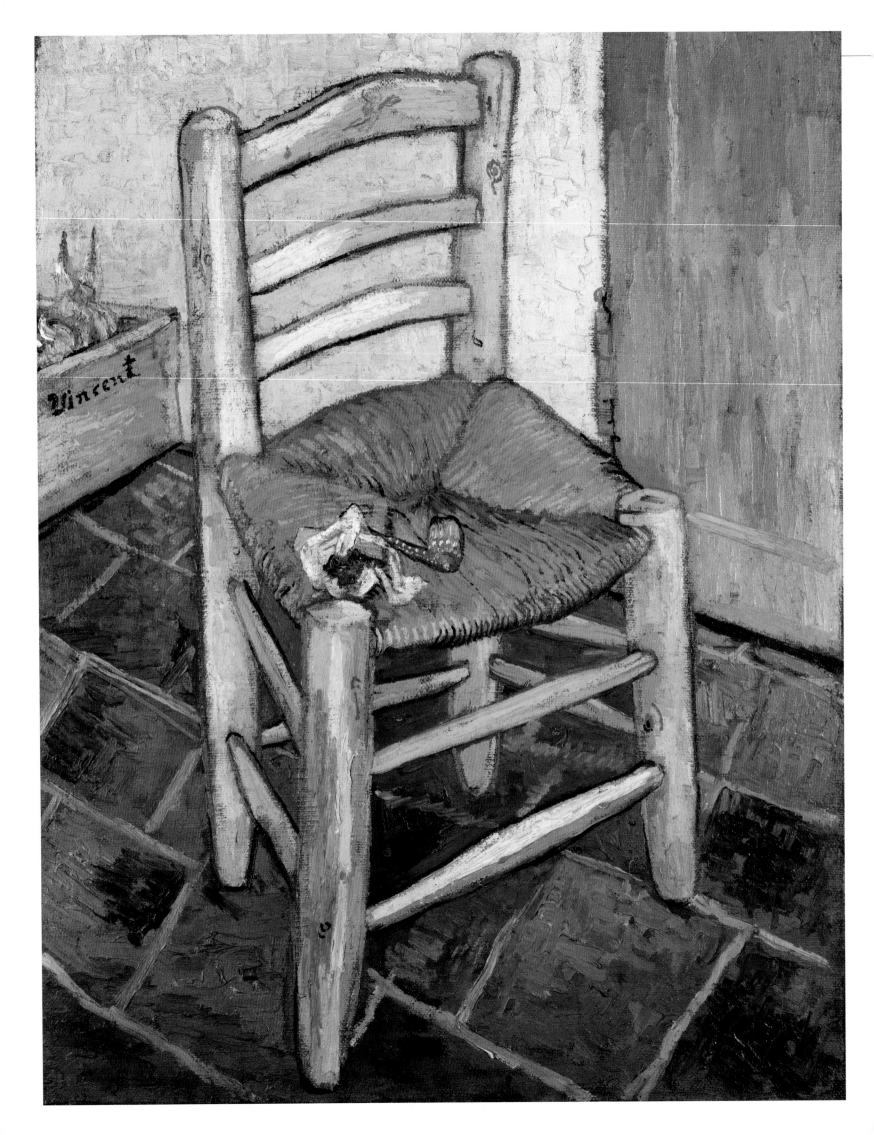

Van Gogh's Chair

1888 ■ OIL ON CANVAS ■ 36 × 28¾in (91.8 × 73cm) ■ NATIONAL GALLERY, LONDON, UK

SCALE

VINCENT VAN GOGH

Looks can be deceptive. At first glance, van Gogh's painting of a simple rustic chair appears to be a straightforward still life—the kind of picture that might have been created in a calm atmosphere, with no emotional or symbolic overtones. In reality, it was painted just a few weeks before van Gogh's breakdown, at a time when his friendship with Paul Gauguin (see pp.182–85) was disintegrating.

When van Gogh moved to Arles, in the south of France, in February 1888 he hoped that it might become the center of an artists' colony. Gauguin's arrival that year seemed a promising start. Van Gogh was delighted. He bought furniture for the house and started painting in a frenzy, to show the Frenchman how far his art had progressed. Unfortunately, it was not long before the dream turned sour. Gauguin had come mainly for practical reasons, as van Gogh's brother was helping him financially, and he rapidly regretted his decision. He disliked the town, feeling "very much a stranger in Arles," and soon quarreled with his host: "Vincent and I generally agree on very little, above all when it comes to painting...."

Van Gogh painted two pictures of chairs—his own and Gauguin's—in early December 1888, when it seemed likely that his visitor would leave. It is possible that he thought they might persuade Gauguin to stay, but more probable that they were a sad acknowledgment of the two men's irreconcilable differences.

A coded portrait

Van Gogh may well have borrowed the idea of using an empty chair as a form of symbolic portrait from a well-known illustration by the British artist Luke Fildes, showing the chair in which Charles Dickens died. The objects on Van Gogh's chairs were definitely designed to identify the sitters. It is also likely that van Gogh had intended the pictures to be a vindication of his art. Gauguin had encouraged him to paint from imagination, rather than from nature. Van Gogh had tried, but found the results unsatisfactory. So, while Gauguin's chair was depicted in dark, artificial conditions, his own was plain and simple, but fulfilled all his needs. As such, it echoed his artistic philosophy: "I cannot work without a model... I exaggerate, sometimes I make changes, but I do not invent the whole picture...I find it all ready in nature."

VINCENT **VAN GOGH**

1853–90

Neglected during his lifetime, van Gogh has since become celebrated as one of the world's most popular painters and a major influence on modern art.

Vincent van Gogh was born in the Netherlands, but spent much of his brief career in France. He worked as a clerk, a teacher, and a lay preacher, before devoting himself to art in 1880. His early work was dark and naturalistic, but his style was transformed after he moved to Paris in 1886. There, he came into contact with the Impressionists and other progressive artists. His palette lightened and he absorbed the influence of Japanese prints. In 1888, van Gogh moved to Arles, his "Japan of the South." Most of his greatest masterpieces date from this final period, when he worked at a furious pace, completing hundreds of canvases. The strain, coupled with a disastrous visit from Gauguin, triggered a breakdown. Van Gogh made a partial recovery, but committed suicide the following year.

> I cannot help that **my pictures do not sell.** Nevertheless the **time will come** when people will see that **they are worth more** than the **price of the paints and my own living**

VAN GOGH LETTER, 1888

Visual tour

KEY

➤ **OBJECTS ON CHAIR** Van Gogh chose very carefully when deciding which objects to include in his chair pictures. They were intended to have a symbolic meaning, referring not only to the person who used the chair but also to the person's artistic approach. In Gauguin's case, the books signified that his work stemmed from the intellect and imagination. On his own chair, by contrast, Van Gogh placed his pipe and a pouch of tobacco. Through these, he meant to show that he required nothing more for his painting than the everyday objects that surrounded him.

2

1

3

▲ **SIGNATURE** Van Gogh did not always sign his pictures, but when he did, he modestly tried to make his signature as unobtrusive as possible. In this instance, it is not in the conventional position at the bottom of the canvas. Instead, the plain lettering blends into the background, resembling a firm's name stenciled onto a box.

4

▲ **HUMBLE CHAIR** As soon as he found out that Gauguin was coming to Arles, van Gogh made special efforts to provide a welcoming atmosphere in the house. Among other things, he bought a set of plain rush chairs. These reflected the image that van Gogh was trying to project to his guest—one of honest, rustic simplicity. In his letters to Gauguin, he was self-deprecating about his own work, saying, "I always think my artistic conceptions extremely ordinary when compared to yours."

◀ **SPROUTING ONION** Some still-life artists might have discarded this detail, preferring to concentrate on pristine items, but van Gogh enjoyed depicting natural objects at every stage of their development. In his famous sunflower pictures, he placed wilted flowers alongside the fresh blooms. The emphasis on organic growth may also have been a symbolic rejection of Gauguin's advice to paint from his imagination.

5

6

▲ **BRUSHSTROKES** One of the reasons why van Gogh's pictures seemed so shocking to his contemporaries was because he made no attempt to conceal his brushstrokes. In academic art, paintings were expected to have a smooth finish, with no visible brushwork. However, van Gogh used so much paint that this was impossible. Often he squeezed the paint directly from the tube onto the canvas, before modeling it with his brush. In his late paintings, such as *The Starry Night*, the sweeping, rhythmic brushstrokes form an essential part of the composition.

◀ **JAPANESE FLOOR** Van Gogh discovered Japanese prints during his time in Paris and they had a huge influence on his art. He liked their bright colors, their bold outlines, and their sheer immediacy. Among other things, Japanese artists disregarded the strict rules of perspective, to bring the viewer closer to the subject. Van Gogh followed suit. Here, he adopts a high viewpoint, but exaggerates the perspective of the tiled floor. This has a dizzying effect, as if the entire composition were sliding toward the viewer.

7

◀ **THICK IMPASTO** Van Gogh was always fond of applying his paint very thickly, a practice that he followed even more enthusiastically in his final years. This gives his paintings an extraordinary texture, which can only be fully appreciated when the picture is viewed in person. However, this was the source of many arguments with Gauguin, who wrote, "in the matter of color, he wants the chance element of thickly applied paint...and I for my part hate mixing techniques."

ON **TECHNIQUE**

During his stay at Arles, van Gogh perfected his unique technique. He used firm, dark contours to outline his forms clearly, drawing his inspiration from Japanese prints. The forms themselves, together with their coloring, were often exaggerated, but they were always rooted in nature. As Vincent explained, "I won't say that I don't turn my back on nature ruthlessly... arranging the colors, enlarging and simplifying, but in the matter of form I am too afraid of departing from the possible and the true."

IN **CONTEXT**

By early December 1888, van Gogh was well aware of the gulf between himself and Gauguin. Everything in his painting of Gauguin's chair is the antithesis of the other painting. This is a nocturnal scene, whereas van Gogh's chair is shown in daylight. Gauguin's seat is more sophisticated: it stands on a patterned carpet, rather than bare tiles. Van Gogh also acknowledged that Gauguin's approach to painting was more intellectual: his attributes are books, rather than tobacco.

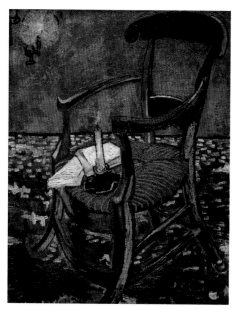

▲ *Gauguin's Chair*, Vincent van Gogh, 1888, oil on canvas, 35½ × 28½in (90.5 × 72.5cm), Van Gogh Museum, Amsterdam, Netherlands

The Child's Bath

1893 ■ OIL ON CANVAS ■ 39½ × 26in (100.3 × 66.1cm) ■ THE ART INSTITUTE OF CHICAGO, US

MARY CASSATT

SCALE

Cassatt was at the peak of her powers when she produced this touching domestic scene. She had absorbed the influence of the Impressionists, sharing their enthusiasm for scenes of modern city life, but had also developed her own, unique slant on the subject. First and foremost, she presented the theme from a female perspective. Cassatt is best known for her paintings of mothers and children, but her repertoire extended far beyond this, and she also produced images of women going boating, having dress fittings, traveling on the bus, and driving a carriage in the Bois de Boulogne.

Influence of Japanese prints

Cassatt's style was equally distinctive. One of her key influences came from Japanese prints, which she had seen at an exhibition in Paris in May 1890. This influence is evident in the striking composition of *The Child's Bath*.

The unusual viewpoint, the strong emphasis on decorative patterns, and the narrow focus on the two main figures all confirm the importance of this source of inspiration.

MARY **CASSATT**

1844–1926

Mary Cassatt was one of the leading figures in the Impressionist movement. She is renowned for her sensitive images of mothers and children, and for her pioneering printmaking techniques.

Cassatt was born in Allegheny, now part of Pittsburgh, US. Her family traveled widely, and although she trained at the Pennsylvania Academy, Philadelphia, her style was formed in France, where she spent most of her career. Cassatt settled in Paris in 1874, the year of the first Impressionist exhibition. A chance meeting with Degas brought her into the Impressionists' circle, and she later contributed to four of their group shows. Degas inspired her taste for striking, asymmetrical compositions and awakened her keen interest in printmaking. Her finest achievement in this field was a groundbreaking series of color prints in a mix of aquatint and drypoint.

Visual tour

KEY

▶ **PROTECTIVE ARM** Several of Cassatt's pictures focused on the tender bond between mother and child. These show her skill in depicting affectionate gestures, and conjuring up an air of quiet, domestic harmony. Although Cassatt had no children herself, she came from a close-knit family and observed her nephews and nieces growing up.

▶ **HEADS** Cassatt's fascination with Japanese prints was at its peak during the early 1890s, which may account for the unusual structure of the composition in this painting. The high viewpoint, looking down upon the figures, is typical of Japanese prints, as is the artist's close proximity to the action, cropping the woman's dress at the picture's edge. The little girl even seems to have slightly Asian features.

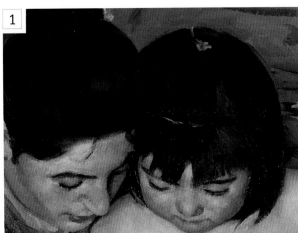

▲ **CHILD'S FEET** Like her friend and mentor Edgar Degas, Cassatt was keen to avoid the clichéd poses that were taught in the academies. Instead, she preferred to depict her models in poses that were unusual and yet also entirely natural.

◀ **WATER JUG** Japanese printmakers were more interested in decorative impact than precise perspective. Cassatt followed this style: the jug is prominent, but its lack of foreshortening does not tally with the steep slant of the carpet.

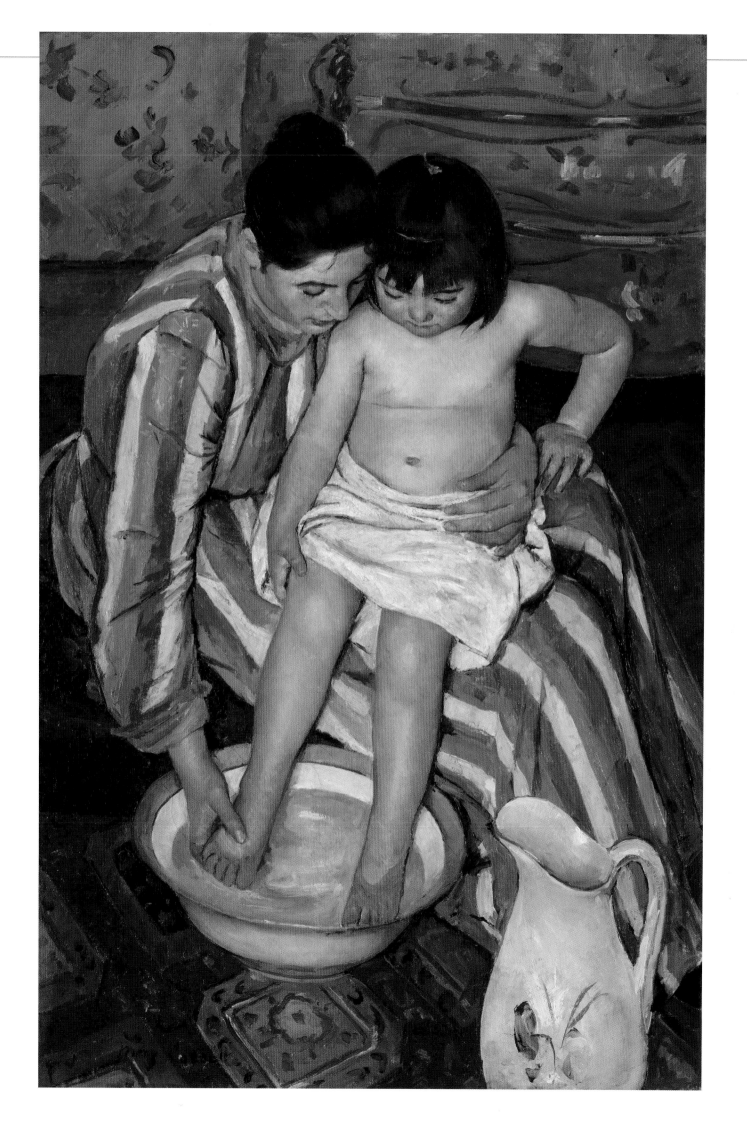

Where Do We Come From? What Are We? Where Are We Going?

1897-98 ■ OIL ON CANVAS ■ 54¾in × 147½in (139.1 × 374.6cm) ■ MUSEUM OF FINE ARTS, BOSTON, US

SCALE

PAUL GAUGUIN

A huge frieze glowing with exotic color, this is perhaps Gauguin's most ambitious painting. The setting is Tahiti, where the artist spent most of the last decade of his life. The solid, sensuous bodies, the sinuous shapes of the trees, and the intense color evoke the tropical paradise, partly real and partly imagined, that inspired him. Like many other of Gauguin's paintings, this one tells a story. Reading from right to left, the figures in the fore- and middle ground depict the cycle of life, reflecting the questions Gauguin poses in the title of the painting. The cycle starts on the right with a sleeping baby, and ends on the far left with an old woman and a bird.

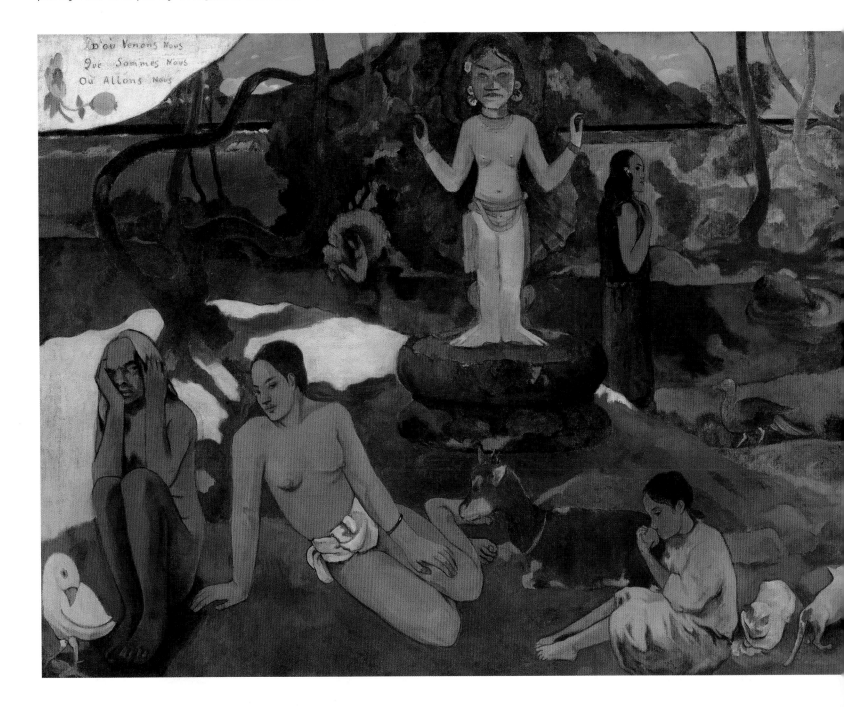

Where Do We Come From? shows Gauguin's characteristic use of areas of saturated color and bold figures with strong outlines to create a flat, almost abstract composition with a strong sense of pattern, influenced in part by Japanese prints. Gauguin employs color in a non-naturalistic manner, juxtaposing the lush blue-greens of the luxuriant flora with the vibrant yellow-gold of the half-naked bodies to create a powerful impact. Color not only had a sensual and decorative function for him, but was also used to suggest ideas and express emotions.

Gauguin considered this painting, rich in symbolism and mythological references, the culmination of his work. It demonstrates the radical use of color and form that made him so influential, paving the way for the Expressionists and abstract art.

PAUL **GAUGUIN**

1848-1903

Reacting against Impressionism and attracted by non-Western art, Gauguin created his own style, using pure color as a form of expression. His life was as unconventional as his paintings.

Born in Paris, Gauguin spent part of his childhood in Peru (his mother was half-Peruvian). He became a successful stockbroker and painted in his spare time. An admirer of the Impressionists, he bought their paintings, and exhibited in their shows. By 1883, he was painting full time but was unable to make a living. Estranged from his wife and five children, he settled in Pont-Aven, Brittany, where he created *Vision of the Sermon*, a work with areas of pure, intense color that marks his abandonment of the Impressionist style.

After trips to Panama and Martinique, Gauguin returned to France, visiting Van Gogh in Arles, where the two famously argued. A troubled and driven man, he set off in 1891 for the French colony of Tahiti. Despite living in poverty and being infected with syphilis, this was one of the most creative periods of his unconventional life. He died in the Marquesas Islands.

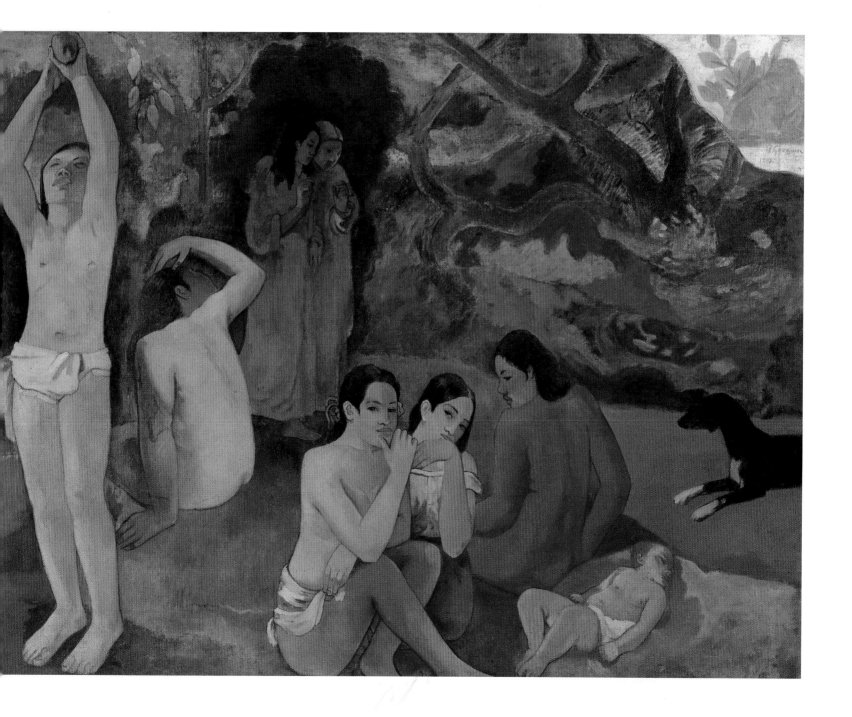

Visual tour

KEY

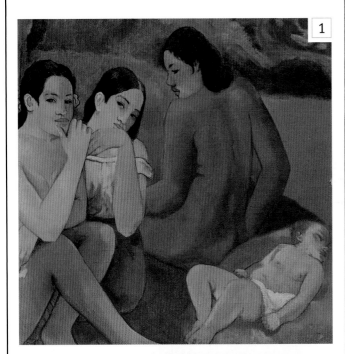

▲ **SLEEPING BABY**
Following the Eastern
convention of reading
from right to left, the
sleeping baby represents
the beginning of the human
life cycle. The small, still
group of the baby and
three women is beautifully
composed and illustrates
Gauguin's reaction
against naturalism and
conventional perspective.

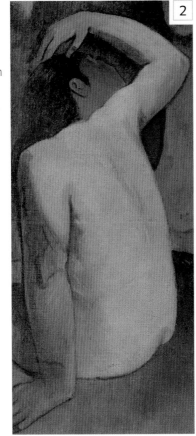

▶ **WOMAN LISTENING**
An oversized figure of a
woman is sitting with her
back to the light. The
luminous color has been
applied in Gauguin's
typically flat style, with
little or no modeling.

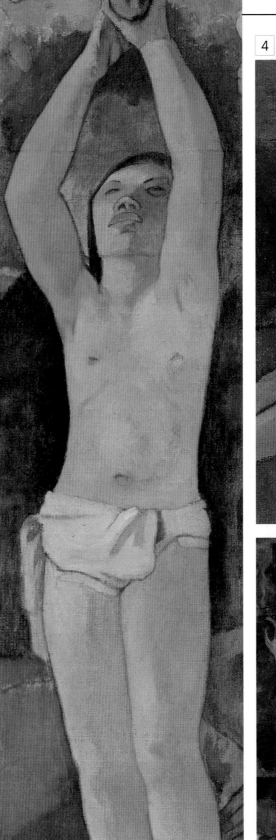

▲ **FRUIT PICKING** Filling the height of the
canvas, the young man reaching up to pick fruit—
perhaps symbolic of life's pleasures, and
reminiscent of Eve in the Garden of Eden—is
the focal point of the painting. As with other
figures, the shape of his body is outlined in black.
The bright tones of his skin are enhanced by the
contrasting blues and greens of the background.

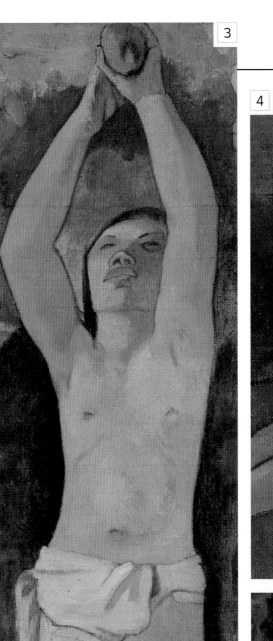

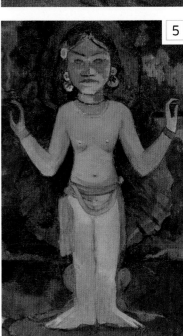

▲ **DEITY** Based on Polynesian
carvings, this standing figure painted
in unearthly blue indicates the world
beyond. The same image appears in
Gauguin's *Day of the God*, 1894. The
artist was horrified by Christian
missionaries' destruction of native
sacred art in Tahiti.

◄ GIRL WITH MANGO In the foreground, a young girl with two cats playing beside her is eating a mango. The pinks, blues, and greys of the earth harmonize with the fruit, injecting an accent of dazzling complementary color. This central part of the composition, which includes the standing youth, depicts scenes from daily life and links to the second part of the title, *What Are We?*.

▼ TAHITIAN LANDSCAPE The strong horizon line brings out the flowing shapes of the island's trees. The branches curve luxuriantly, creating pattern and a sense of harmony.

7

ON **TECHNIQUE**

Early in his career Gauguin painted with spontaneous, visible brushstrokes in the style of the Impressionists. He then reacted against them, using thick paint to stop colors merging into each other. Financial hardship forced Gauguin to make his paint go further, and he found a way to keep colors separate while using thinner paint. He blended the brushstrokes to flatten the color. He also used black lines to separate areas of color, a technique that heightens the abstract quality of the painting.

Gauguin's blocks of flat, matte color and his limited use of shading to suggest three-dimensional form give *Where Do We Come From?* a distinctive design and a pattern-like quality. The painting also shows Gauguin's characteristic juxtaposition of contrasting and complementary colors. In the detail below, the blues and greens of the sky and foliage heighten and intensify the small area of strong orange.

IN **CONTEXT**

Gauguin reuses several figures from his past compositions in this work. It was painted, for lack of money, on cheap sacking rather than on artists' canvas. Gauguin considered it his masterpiece, the painting that brought together elements from all his best work. He also expected it to be his last. By his own account—and he was prone to self-mythologizing—he made a failed suicide attempt after its completion.

The figure of the woman leaning to the right at the bottom left of *Where do We Come From?* appears in Gauguin's painting *Vairumati*, made in the same year (see below). The motif of the white bird with a lizard between its feet is also present in both paintings.

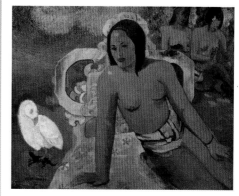

▲ *Vairumati*, Paul Gauguin, 1897, oil on canvas, 29 × 36½in (73.5 × 92.5cm), Musée d'Orsay, Paris, France

6

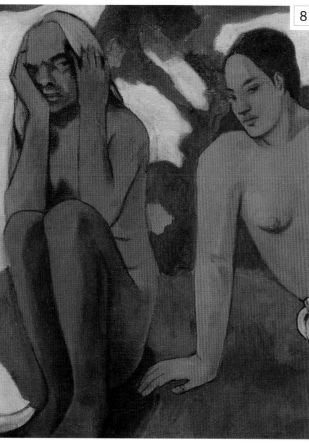

8

▲ TITLE Toward the end of his life, Gauguin gave his paintings questions as titles. This one is in French. Of *Where Do We Come From?* the artist wrote: "Where are we going? Near the death of an old woman. A strange simple bird concludes. What are we? Mundane existence. The man of instinct wonders what all this means…Known symbols would congeal the canvas into a melancholy reality, and the problem indicated would no longer be a poem."

► OLD WOMAN Sitting next to a beautiful young woman is an old woman with dull skin. She crouches in shadow, as if waiting for the end of her life. The white bird may represent the final, unknown stage that follows death.

The Waterlily Pond

1899 ■ OIL ON CANVAS ■ 35¼ × 36½in (89.5 × 92.5cm) ■ MUSÉE D'ORSAY, PARIS, FRANCE

SCALE

CLAUDE MONET

Harmonies of color, tone, and texture combine with the delicate play of dappled sunlight in this quiet, reflective painting of a water garden. The location of the lily pond with its distinctive, arched footbridge is the artist's famous garden at rural Giverny, northwest of Paris. Monet considered his extensive garden his "most beautiful masterpiece" and it occupied him for much of his life, especially in his later years when this painting was made.

Patterns of light

Monet, the quintessential Impressionist painter and cofounder of this group of French artists, sought to record and communicate the impressions and feelings he experienced when painting outdoors–*en plein air.* Throughout his life he was fascinated by the effects of light and atmosphere. In creating his water garden, Monet had the perfect subject for observing light. He could paint it at different times of day and even had a studio built there in 1914.

In *The Waterlily Pond*, short, rapid, brushstrokes and dabs of paint form the water's flower-strewn surface, creating a harmonious pattern of color. Monet has sometimes applied paint with a palette knife to suggest the shapes and texture of the foliage, and the layers of paint have been built up then worked and reworked while still wet to form a thick crust. The invention of the collapsible metal tube for oil paints (patented in 1841) had an important impact on artistic practice. The availability of ready-mixed paints in a range of colors helped to facilitate Monet's style of outdoor painting.

Monet created two separate gardens at Giverny, the flower garden and the Japanese-influenced water garden, studying and painting both over a period of more than 20 years. *The Waterlily Pond* shown here is one of Monet's "series" paintings in which he set out to capture the same subject repeatedly, at different times of day and under different light conditions. The lily pond became the dominant motif in his later years and he

exhibited ten views of it in 1900. This painting encapsulates Monet's strongly held Impressionist ideals, conveying a deep sensitivity to nature as well as his enduring passion for his garden.

> I want to paint **the air**…**the beauty of the air**…and that is nothing other than impossible

CLAUDE MONET

CLAUDE **MONET**

1840-1926

Monet was the leader of the radical Impressionist movement in France. He painted outdoors and was a master of color, texture, and the effects of light.

The son of a wealthy grocer, Monet spent his youth in Le Havre on the northwest coast of France. There he met landscape painter Eugène Boudin, who encouraged him to paint in the open air, and he developed a lifelong passion for capturing the sensation of being part of nature with its changing light, colors, and textures.

Monet enrolled at an independent art school in Paris, the Académie Suisse, and later studied in the studio of Charles Gleyre, where he met fellow Impressionist painter Renoir. During the Franco-Prussian War (1870-71), Monet spent a brief period in London. He studied Constable and Turner and painted the Thames. In 1871, Monet moved to Argenteuil, near Paris, producing some of his finest work there, including *Wild Poppies*, 1873. He exhibited at the first Impressionist exhibition in 1874 but, by the 1880s, the group was beginning to drift apart. Monet, however, remained true to the group's ideals, especially in his "series" paintings. In 1883, he settled at Giverny. His eyesight deteriorated badly in his last years, but his memory for colors was acute. He died at Giverny, a famous and wealthy man.

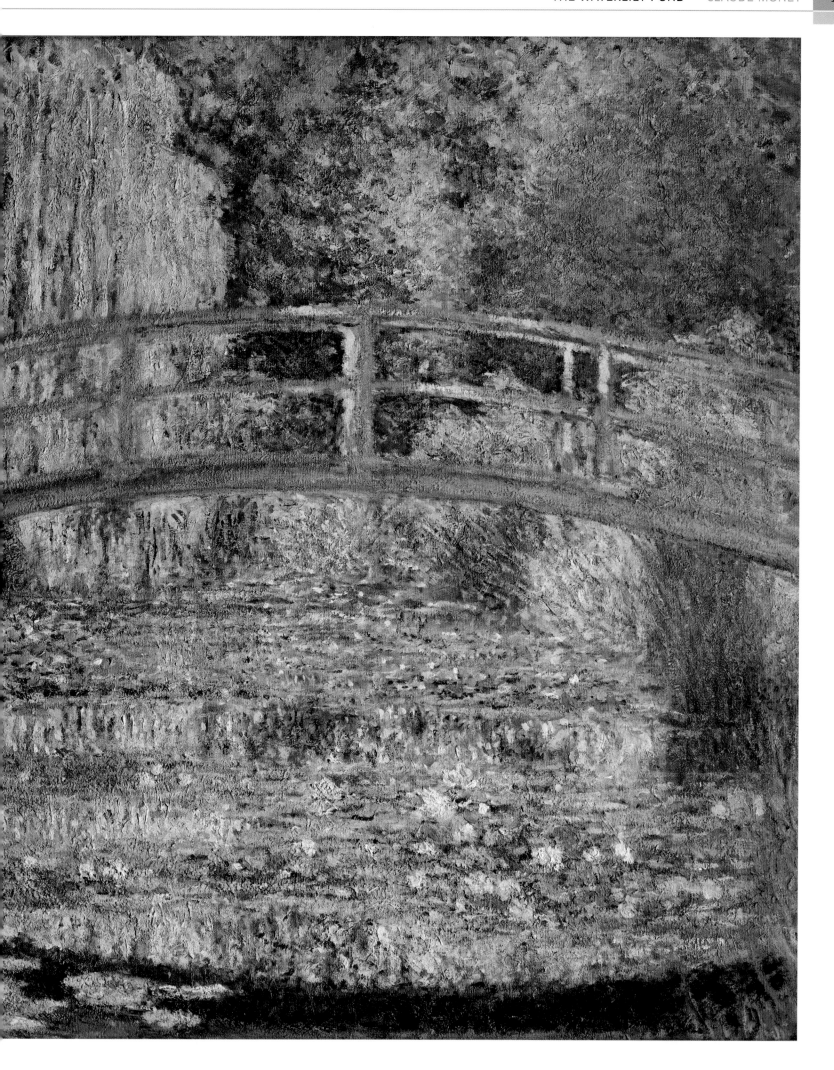

Visual tour

KEY

1

◀ **DAPPLED SUNLIGHT** Monet used flicks of thick yellow and light green paint to convey the impression of sunlight coming through the trees. Once the underlayer of paint was dry, he applied dark green and blue with a slightly drier brush. The darker tones add volume to the trees and the brushstrokes resemble individual clumps of leaves. Further layers of lighter yellow and green pick up the highlights.

▲ **THE BRIDGE** The gentle curve of Monet's bridge bisects the painting. The soft mauve harmonizes beautifully with the lily pond beneath and with the colors of the surrounding foliage. The simple, decorative structure recalls the bridges in the prints of 19th-century Japanese artist Hiroshige, and there are other Oriental references in the planting of the water garden. Many Japanese prints were displayed in the house at Giverny and Monet admired the Japanese reverence for nature. In reality, the bridge is a vivid green with an upper trellis, draped in early summer with white wisteria. Of the five bridges in the water garden, the Japanese bridge is the most impressive.

3

▶ **THE LILY POND** Monet's treatment of the patterns of sunlight on the surface of the pond creates an almost abstract effect. The lily pads are picked out using short, horizontal strokes in blue-green tones. These brushstrokes become smaller and the color graduates to mauve and purple as your eye is led towards the far edge of the pond. The reflections of the trees, particularly the willow at the top left of the frame, can be seen in the clear areas of water and are depicted using vertical strokes of light color.

◄ WATERLILIES With dabs of thick white paint, splashes of pink, and touches of deepest red, Monet captures the delicacy of the lilies floating on the surface of the pond. The petals are more defined than in his later works, such as the huge *Waterlilies*, after 1916. The flowers in those paintings appear to merge into a richly colored pattern with a decorative quality.

▼ SIGNATURE Monet returned periodically to the canvas, adding further touches each time until he was satisfied that he had captured the quality of light. He signed the painting in the bottom right-hand corner, using red paint to complement and contrast with the predominantly green tones of the painting.

ON COMPOSITION

The painting is composed around the shallow arch of the bridge. Below the arch the surface of the pond both stretches towards you and recedes, leading your eyes to a vanishing point through the trees. Seen through the simple structure of the bridge is another spatial plane containing the trees, which enhances the illusion of depth. The surrounding trees and grasses enclose the view of the bridge within a frame of foliage.

IN CONTEXT

Monet was the most dedicated of the Impressionists. This loose group of talented young artists rejected the academically approved art of the day, with its historical or Romantic subject matter, and created a new style of painting. They wanted an art that was immediate, that communicated what the painter really saw at a particular moment. Monet painted outdoors and his style and bright color palette shocked fashionable Parisian audiences. His painting was deemed unpolished at a time when, in the academic style, brushstrokes were rarely visible.

There were eight Impressionist exhibitions in total. The artists—who included Cézanne, Monet, Renoir, Pissarro, and Sisley—were dubbed the "Impressionists" by journalist Louis Leroy who intended a pejorative description when he saw Monet's *Impression: Sunrise* (below) at the first exhibition in 1874.

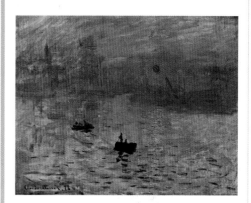

▲ *Impression: Sunrise*, Claude Monet, 1872, oil on canvas, 19 × 24¾in (48 × 63cm), Musée Marmottan, Paris, France

▲ WILLOW TREE The elongated, slender branches of the willow that hang over the surface of the pond are depicted with strong vertical brushstrokes. Shadow is indicated by areas of green and blue and the thick layers of paint suggest a mass of graceful, lush foliage.

▲ GRASSES The curved blades of the grasses growing around the water echo the arc of the bridge and soften the edge of the pond. Unlike the short, angular dabs of paint on the pond's surface, Monet's sweeping brushstrokes follow the strong, linear form of the plants.

1900 to present

Lake Keitele

1905 ■ OIL ON CANVAS ■ 21 × 26in (53 × 66cm) ■ NATIONAL GALLERY, LONDON, UK

AKSELI GALLEN-KALLELA

SCALE

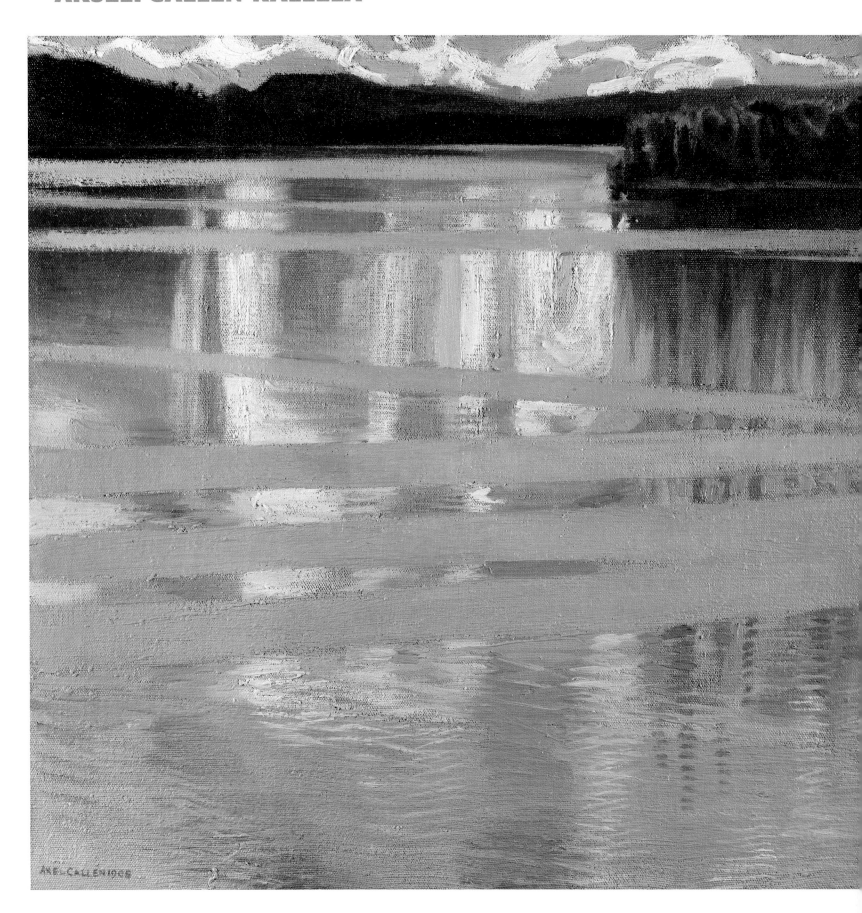

Although it is fairly small, *Lake Keitele*, with its boldly unconventional composition, makes a forceful impact. The high horizon line allows the lake to predominate. The reflections of the sky on the water are cut through by horizontal bands caused by a phenomenon of the wind while, in the foreground, the breeze ripples the surface like a shiver. Severe, concentrated, and bracing, *Lake Keitele* seems almost like a visual equivalent of the music of Sibelius, Finland's greatest composer (of whom Gallen-Kallela painted a memorable portrait). The painter and the composer were exact contemporaries—both were born in 1865—and each played a prominent part in the upsurge of nationalistic pride that accompanied their country's quest for independence from Russia. Finland became a republic in 1919.

A reflection of strength

The patriotism of the period is often expressed in Finnish art of the time. Architects moved on from the polished Neoclassical style linked to Russian and, before that, Swedish rule, taking up granite—a metaphor for Finnish strength—as their favorite material.

There is typically a feeling of granite strength in Gallen-Kallela's paintings too, despite their many subtle qualities, including a sensitive feeling for light.

This is one of several pictures of Lake Keitele inspired by a period when he was recuperating on its shores after contracting malaria in Spain in 1904. The subject is typically Finnish (lakes and forests are the defining features of the country's landscape). But the painting also has aspects that place it in an international context, showing Gallen-Kallela's involvement with the avant-garde European movements of his day—the flattened forms are characteristic of Art Nouveau, and the brooding atmosphere is typical of Symbolism.

AKSELI **GALLEN-KALLELA**

1865-1931

The most famous of all Finnish painters, Gallen-Kallela became a national hero in his country. Although he was so closely identified with his native land, he was also widely admired elsewhere.

Gallen-Kallela was born in Pori, a city on the west coast of Finland. Like many ambitious young Scandinavian artists of the time, he had part of his training in Paris, and he later traveled widely, in Africa and the US as well as Europe, and he exhibited his paintings successfully in many countries. However, he was deeply patriotic and his work was rooted in his native soil. His output was highly varied, ranging from large murals, notably in the National Museum, Helsinki, to the design of jewelry and textiles. He was also an architect, creating, among other buildings, a combined house and studio for himself at Tarvaspää, near Helsinki. This is now a museum dedicated to his life and work.

Visual tour

KEY

▶ **COOL COLORS** Blue and white—with the sky vividly reflected in the water—are predominant in the painting. They evoke the cold, quiet, unspoiled beauty Finland's austere landscape.

◀ **BOLD SIMPLIFICATION** Gallen-Kallela began his career painting in a naturalistic manner, but he came to prefer a flatter, more stylized idiom. The dark reflections of the copse contrast with the white cloud reflections on the other side.

ON **TECHNIQUE**

By the time he painted *Lake Keitele*, Gallen-Kallela was in his full maturity, expressing himself with a fluid, rich, and confident technique. In places, notably the white of the clouds and the white highlights on the water, he applied the paint extremely thickly, so that the pigment stood out all the more brightly from the cool palette of darker surrounding tones.

The Large Bathers

1906 ▪ OIL ON CANVAS ▪ 82¾ × 98¾in (210.5 × 250.8cm) ▪ PHILADELPHIA MUSEUM OF ART, PENNSYLVANIA, US

PAUL CÉZANNE

SCALE

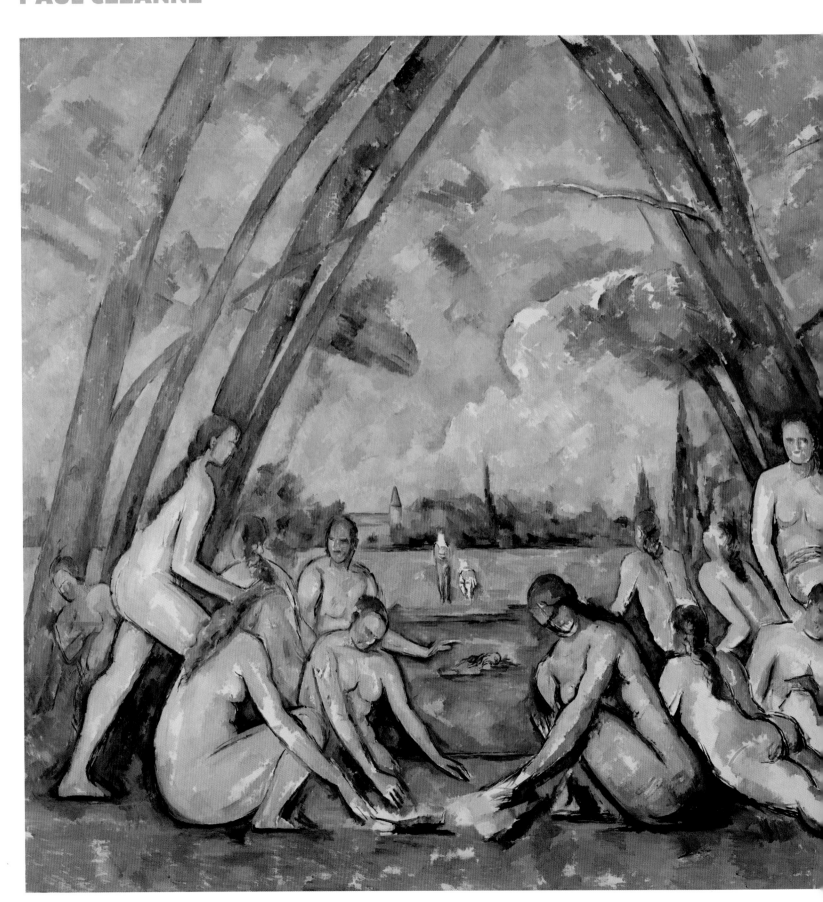

These nude figures have such timeless grandeur that they seem to be "sliced out of mountain rock." The memorable phrase comes from the great English sculptor Henry Moore, who first saw the painting in 1922, when he was a student. It made an indelible mark on him, and 40 years later he recalled, "For me this was like seeing Chartres Cathedral." Many other artists and critics have expressed similar feelings of awe about this picture—the largest Cézanne ever painted and one of the culminating works of his career. In it he combined majesty of form with subtle beauty of color and atmosphere, achieving his goal—in his own much-quoted words—"to make of Impressionism something solid and enduring, like the art of the museums."

Figures in a landscape

The young Cézanne had a fiery temperament, and his early work included highly emotional scenes of violence and suffering. In the 1870s, however, he abandoned such subjects as he came under the influence of Impressionism. From this time his art was based almost entirely on the people and places of the world around him, but there was one imaginative theme that he did not give up—groups of nude figures in a landscape setting. He depicted such figures, generally called "Bathers," throughout his career, in well over a hundred oils, watercolors, and drawings. The groups are usually exclusively male or female. Originally the scenes of female bathers were slightly erotic in feeling, but—as with his other subjects—they became mainly a vehicle for stylistic exploration.

Most of these works are fairly small, but in the final decade of his life Cézanne painted three large oils of female bathers that rank among his most ambitious works. The other two are in the Barnes Foundation, Merion, Pennsylvania, US, and the National Gallery, London. These two were possibly begun as early as about 1895 and were still being worked on by Cézanne just before his death in 1906 (it is often difficult to date his paintings because he worked slowly and sometimes intermittently, putting them aside for a time and then taking them up again).

The Philadelphia painting, on the other hand, may belong entirely to the final year of Cézanne's life and was unfinished when he died.

Subtle brushwork

It is the grandest of the three paintings, the most serene and exalted in feeling, and the most beautiful and subtle in brushwork (in spite of its unfinished state). The whole surface is alive with vibrant touches, and the figures are wonderfully harmonized with their setting, as if sky, trees, and human flesh were all made of the same mysterious substance. This concern with the overall feel and balance of the picture surface was at the heart of Cézanne's great legacy to modern art. It led the way from naturalism to such developments as Cubism and abstract art.

Nature reveals herself to me in very complex forms

PAUL CÉZANNE

PAUL **CÉZANNE**

1839-1906

Dubbed "the father of modern art," Cézanne was a hugely significant figure in painting at the turn of the 19th and 20th centuries.

Born in Aix-en-Provence in southern France, Cézanne initially studied law before turning to art. Like many of his colleagues, he suffered hardship and abuse early in his career, but at the age of 47 he became a wealthy man when his father died, and he was able to devote the remaining 20 years of his life to developing his personal vision.

Cézanne's life was divided mainly between Aix-en-Provence and Paris, where he studied and became involved in the Impressionist movement. Pissarro was an early friend and mentor. However, Cézanne only partially adopted the outlook of the core Impressionists, aiming to combine their naturalness and freshness of spirit with the grandeur of the Old Masters. Although he worked in isolation, by the end of his life he had become a hero to progressive artists and his subsequent influence has been deep and enduring.

Visual tour

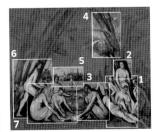

KEY

▶ **SIMPLIFIED SHAPES** Cézanne made drawings of nude models when he was a student, but in later life he very rarely did so. His dealer, Ambroise Vollard, said that "women, even when clothed, frightened him," and it would in any case have been difficult to work from unclothed models in the rather puritanical atmosphere of Aix-en-Provence. Instead, Cézanne based his figures on other sources, particularly drawings he had made much earlier, but also photographs. This approach helps to explain the simplified shapes of his nudes, which sacrifice anatomical accuracy for grandeur.

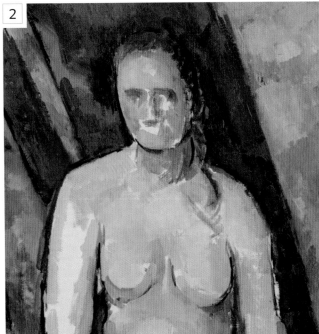

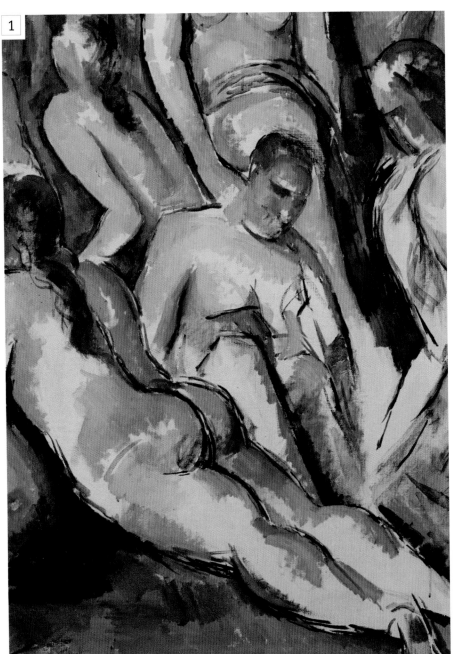

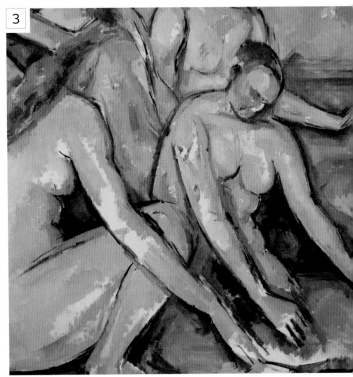

▲ **FORM AND OUTLINE** Cézanne worked slowly and intuitively, constantly feeling his way, subtly blending and overlapping brushstrokes to achieve the exact balance of form and color he was seeking. Whereas the Impressionist ideal was to capture an image of a scene as it existed at a single moment, he tried to present an accumulated vision of it, whether the subject was a real one or imaginary, like this. Every line and every gradation of tone was carefully pondered, and they all interacted. Here, many of the forms of the bathers are firmly outlined, but the lines are combined with delicately modulated areas of tone.

▲ **TIGHT GROUPING** The figures on the right are arranged in a tightly knit group. Although Cézanne sometimes painted pictures of a single bather, he preferred groups. His fascination with the theme may have its origins in happy memories of his boyhood, when he enjoyed swimming with friends in the River Arc. These friends included Émile Zola, who became a famous writer.

4

◀ **TREES** The trees have a feeling of great strength and resilience, but also show Cézanne's delicacy of touch and sensitivity in handling variegated and interlinked colors. The trunks are tinged with touches of blue and green, helping link them with sky and earth.

▼ **LANDSCAPE** Through the center of the composition, across the river, you can see a landscape with open ground, trees, and buildings. The colors Cézanne uses here are closely related to those of the nude figures.

5

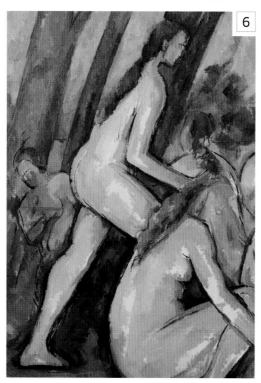

6

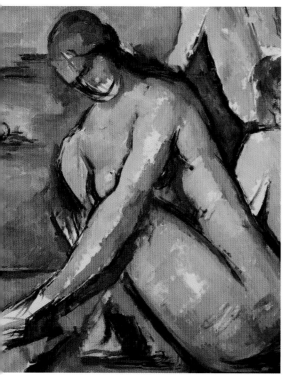

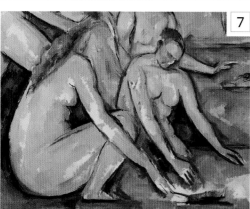

7

▲ **MOVEMENT** Some of the paintings from the early years of Cézanne's career are characterized by violent movement, but his mature work is usually distinguished by dignity and serenity. There is a sense of movement in this striding figure, but it is stately movement, in tune with the lofty grandeur of the work.

◀ **CROUCHING VENUS** The figure on the left here is the only one in the painting known to be based on another work of art. It is derived from an ancient Roman marble sculpture of Venus in the Louvre in Paris. Cézanne knew the sculpture well when he was a student and made drawings of it.

ON **COMPOSITION**

Cézanne was a master at creating a sense of dignified balance and calm resolution in his paintings. Often this was achieved in an understated way, but here his approach is bolder and more direct than usual, with a strong feeling of formal staging. The picture indeed suggests theatrical comparisons: the figures have been described as looking like goddesses in a grand opera, with the great curving forms of the trees above them recalling the proscenium arch at the front of the stage. This tree "arch" forms the sides of a huge, stable triangle around which the composition is based. The feeling of stability is echoed in the figures, which likewise are arranged into evenly balanced triangular groupings at either side of the painting. Beneath the central area of sky, an inverted triangle is formed by the outstretched arms of the bathers. Figures and landscape interlock in majestic harmony.

IN **CONTEXT**

Cézanne had an enormous influence on progressive painters, such as Braque and Picasso, in the early 20th century, particularly after a retrospective of his work was held in Paris in 1907, the year after his death. Many sculptors also had a high regard for his paintings. Among them was Henry Moore (1898–1986), who greatly admired the strength and dignity of Cézanne's figures. Indeed, Moore revered Cézanne so much that in 1960 he bought one of the artist's small paintings of bathers. He hung it in his bedroom and described it as "the joy of my life," adding, "Each of the figures I could turn into a sculpture, very simply."

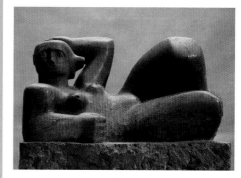

▲ *Reclining Figure*, Henry Moore, 1929, brown Hornton stone, 33in (84cm) high, Leeds Art Gallery, West Yorkshire, UK

The Kiss

1907-08 ▪ OIL AND SILVER AND GOLD LEAF ON CANVAS ▪ 70¾ × 70¾in (180 × 180cm)
ÖSTERREICHISCHE GALERIE BELVEDERE, VIENNA, AUSTRIA

SCALE

GUSTAV KLIMT

The heady mix of sensuality and opulence in this iconic image captures the essence of Klimt's unique approach. He was fascinated by the theme of the human embrace, returning to it on several occasions, but this is the definitive version. The couple are locked together, so absorbed in each other that they are no longer aware of anything beyond their own passion. They are encased in a strange, golden covering, which emphasizes their union and cocoons them from the outside world. Wearing extravagant, multicolored robes that seem to merge into each other, the lovers embrace on a small patch of grass, carpeted with an improbable profusion of flowers. The setting is pure fantasy. In spite of all this, *The Kiss* remains an ambivalent picture. The embrace appears to take place beside an abyss, with the woman's feet dangling over the edge. Is Klimt hinting that both love and passion are precarious, perhaps even dangerous?

An eclectic style

The Kiss was produced at the height of Klimt's career, when he was drawing upon a wide range of influences. It reflects the fashionable taste for Art Nouveau, which was the predominant style of the works exhibited by Klimt and the other artists of the Vienna Secession. Art Nouveau was characterized by a preference for stylized forms and sinuous, linear patterns. Above all, however, it placed more emphasis on decoration than on realism. In *The Kiss* this is evident not only from the amorphous shape of the lovers' robes, but also from the unrealistic dimensions of the woman. She is kneeling down while her partner appears to be standing, suggesting that she is considerably taller than him. However, this is well disguised by the wealth of decorative detail surrounding the lovers.

The theme of *The Kiss* had been popularized by Symbolist artists, such as Edvard Munch. It was often used as a pretext for depicting a femme fatale, although that is not the case here, as Klimt has portrayed the woman in a purely passive role. However, the erotic content and the mysterious, evocative setting are very much in keeping with the spirit of Symbolism.

The greatest influence on the artist's style perhaps came from mosaics. Klimt had always been interested in this medium, but his enthusiasm was fired after studying the Byzantine mosaics in the churches at Ravenna in Italy in 1903. He extended his practice of creating designs from tiny fragments of color so that the painted surface—the man's robe, for example—resembles a painted mosaic. The Ravenna mosaics also reinforced Klimt's conviction that his compositions would look more imposing and atmospheric when set against a golden background, rather than a naturalistic one.

GUSTAV **KLIMT**

1862-1918

An Austrian painter and designer, Klimt dominated the art scene in Vienna in the early 1900s. Nothing evokes this magnificent era more effectively than Klimt's "golden period" paintings.

Born in a suburb of Vienna, Gustav Klimt trained at the city's School of Applied Art. He made his mark quickly, producing large-scale decorative schemes for major building projects. These were well received and a successful academic career appeared to beckon, but Klimt's interests were shifting toward avant-garde art. Finding the official artists' association too staid, he withdrew from it in 1897 and, together with a group of like-minded friends, formed the Vienna Secession.

The Secession functioned mainly as an exhibiting body, opening its doors to painters, architects, and decorative artists working in a broad range of styles. Klimt's controversial new venture curtailed commissions from official sources, but he was in great demand as a portraitist, winning particular acclaim for his sensual depictions of beautiful women. He also continued to produce decorative work for patrons, most notably at the Palais Stoclet in Brussels, Belgium.

> *The Kiss* is the icon of a post-religious age, and Klimt gives it the glitter and grandeur of an altarpiece

JONATHAN JONES *THE GUARDIAN*, 2001

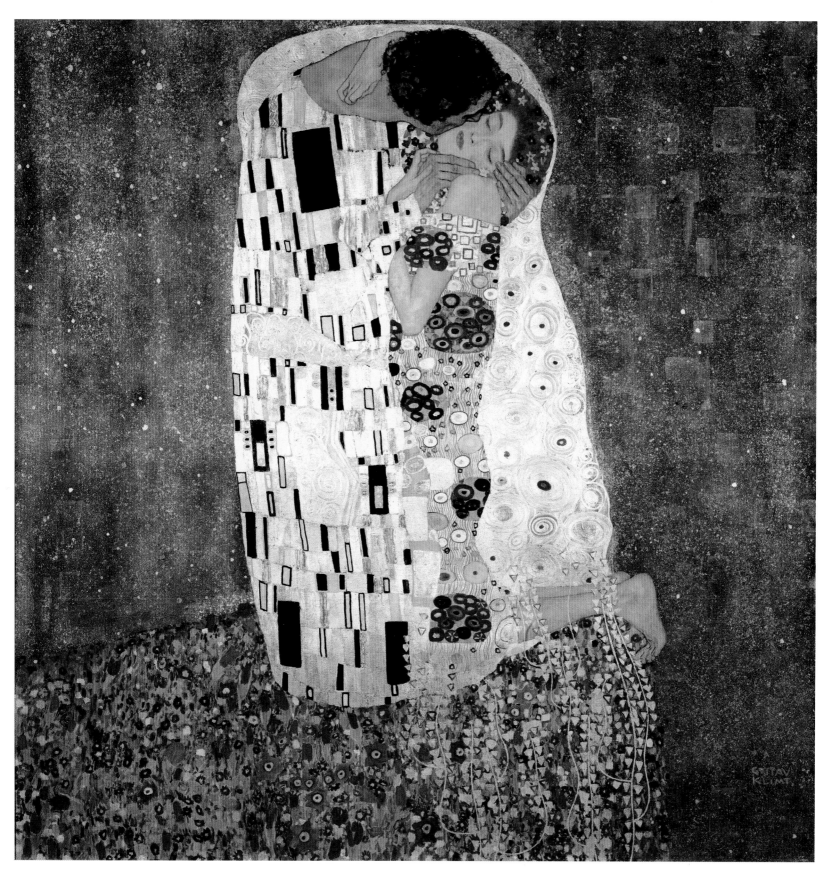

Visual tour

KEY

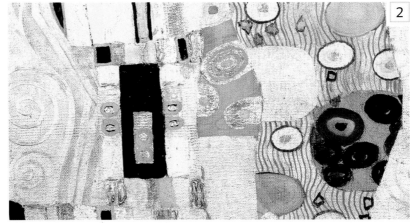

2 ◄ **LUXURIOUS PATTERN** During this phase of his career, Klimt enjoyed experimenting with beguiling combinations of abstract and figurative elements. He portrayed his friends in wildly extravagant, patterned clothing, so that they almost seemed to disappear into their voluminous robes. Often, only their hands and faces were visible and, as in *The Kiss*, the precise outline of their figures was obscured.

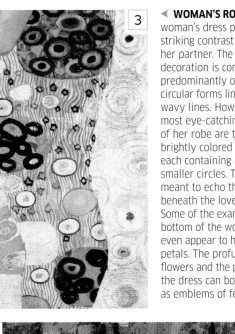

3 ◄ **WOMAN'S ROBE** The woman's dress provides a striking contrast to that of her partner. The golden decoration is composed predominantly of small, circular forms linked by thin, wavy lines. However, the most eye-catching features of her robe are the large, brightly colored rondels, each containing an array of smaller circles. These were meant to echo the flowers beneath the lovers' feet. Some of the examples at the bottom of the woman's robe even appear to have stylized petals. The profusion of flowers and the patterns on the dress can both be read as emblems of fertility.

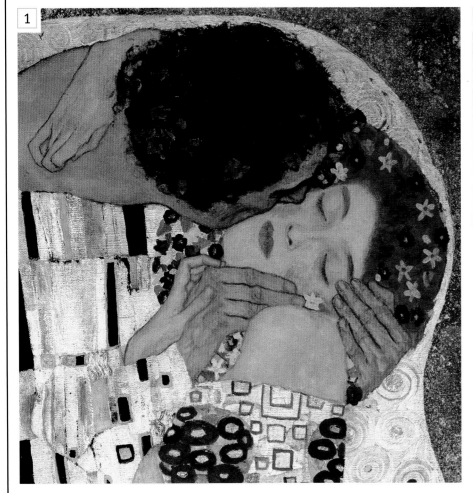

1

▲ **THE KISS** As in Klimt's other versions of this subject, the man's face is largely hidden from view. However, his virile power is conveyed by his robust, bull-necked appearance and by the way that his huge hands dwarf those of his partner. He is also wearing a crown of ivy, a plant sacred to the Greek god Dionysus and his followers, the satyrs. Through these figures, there are associations with both fertility and lust. The woman, by contrast, is entirely passive. Her eyes are closed, presumably in ecstasy, although her ashen complexion and the painfully horizontal tilt of her head may have been inspired by the theme of the severed head, which was fashionable in Symbolist art. In 1901, Klimt had painted *Judith with the Head of Holofernes*.

▶ **BED OF FLOWERS** Klimt used to relax by painting landscapes. These were highly unconventional, focusing primarily on densely packed areas of brightly colored flowers. In part, the inspiration for these came from his studio garden, which he allowed to run wild, but they are also reminiscent of the floral decoration found in early tapestries. In *The Kiss*, the flowery bank provides a platform for the lovers, but it also enhances the air of opulent fantasy. In its own way, it seems as exotic and unreal as the shimmering, golden background.

4

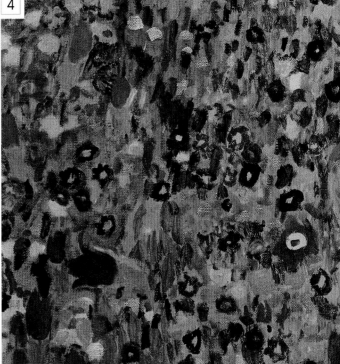

> **TEXTURE** Klimt liked to heighten the sensual impact of his pictures by embellishing them with a variety of precious materials. In the background of *The Kiss* he created a shimmering, granular effect by layering gold dust on an umber background. He achieved a different textural effect on the lovers' robes by modeling some of the patterns in gesso, before painting them gold.

▼ **MAN'S ROBE** Klimt used different symbolic motifs to distinguish between the lovers' robes. The man's attire is decorated with plain, rectangular shapes, which are colored black, white, or silver. These angular patterns were intended specifically to conjure up male attributes, and to contrast with the curved and colorful motifs of the woman's robe.

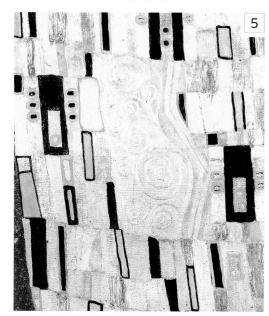

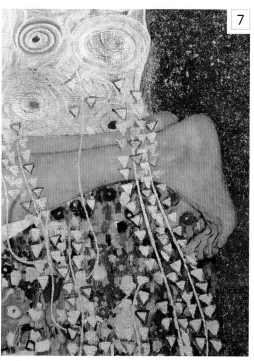

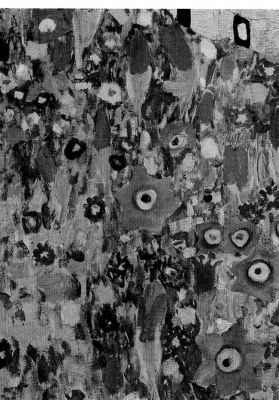

▲ **FEET** In stark contrast to the physical beauty of many of his figures, Klimt's portrayal of their limbs was often quite distorted. The hands are too large, while their fingers and toes may appear twisted or deformed. This trait was probably influenced by the Expressionist style, which was just emerging at the time. In this case, the detail of the woman's feet is quite ambiguous. It may be that her toes are curled in rapture, or else they are desperately clinging on to the last piece of solid ground, at the edge of the precipice. On a similar note, the position of the woman's right hand, along with her unseen right arm, is also extremely awkward.

ON **TECHNIQUE**

Although he is best known as a painter, Klimt had a firm grounding in the decorative arts and this never ceased to affect his style. As a child, he learnt from his father, who was a goldsmith and engraver, and he built on these foundations at the School of Applied Art. In later years, he was chiefly influenced by mosaics, particularly after seeing the outstanding examples at Ravenna, Italy. This prompted Klimt to build up his pictures using brilliantly colored, fragmented forms. In the detail below, the painted mosaic pattern is overlaid with gilded, leafy chains like the stems of a plant twining over the woman's feet.

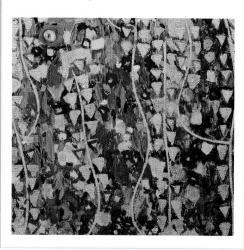

IN **CONTEXT**

Klimt was the first president of the Vienna Secession, which was formed in 1897. The group held their exhibitions in the spectacular Secession Building, which critics disparagingly referred to as "the golden cabbage" because of its glittering dome. The Secession's motto—"To each age its art, to art its freedom"—is inscribed in gold letters above the imposing geometric entrance.

▲ Secession Building (1897–98), Joseph Maria Olbrich, Vienna, Austria

Composition VII

1913 ▪ OIL ON CANVAS ▪ 78¾ × 118in (200 × 300cm) ▪ TRETYAKOV GALLERY, MOSCOW, RUSSIA

SCALE

WASSILY KANDINSKY

Kandinsky made the most important breakthrough of his career in the years leading up to World War I. Working in Munich, Germany, he developed a new pictorial language, which helped him to create pioneering abstract paintings. The cornerstone of his achievement was a series of canvases entitled *Compositions*. Kandinsky regarded these as the definitive statements of his artistic philosophy. He produced only 10 in his lifetime, and each of these was the result of careful meditation and planning. *Composition VII* is widely acknowledged as the finest and the most adventurous of the series.

Inevitably, the *Compositions* proved controversial. Spectators stood in front of the vast, mural-like paintings and were utterly baffled. The paintings seemed chaotic, with no recognizable subject, structure, or natural forms. Kandinsky would not have been entirely displeased with this verdict. "Each work originates in the same way as the cosmos," he wrote, "through catastrophes which, out of the chaotic din of instruments, ultimately bring forth a new symphony."

A spiritual approach

Kandinsky explained the philosophy behind his new approach in an influential treatise, *Concerning the Spiritual in Art*, 1911. He did not believe that the public was ready for art that was totally non-representational, and he certainly did not want his abstracts to be merely decorative. Instead, he believed they could convey his purest and most spiritual feelings. Initially, he drew his inspiration from religious subjects—the Garden of Eden, the Deluge, the Apocalypse—but gradually he suppressed these narrative themes. In their place, he relied solely on form, color, and line, orchestrating these into his sublime creations.

WASSILY **KANDINSKY**

1866-1944

Hailed as one of the creators of abstract art, Kandinsky is universally recognized as one of the greatest pioneers of modern art. His radical experiments, typified by the *Compositions*, proved an inspiration to the Abstract Expressionists.

Kandinsky was born in Moscow, the son of a wealthy tea merchant. He trained as a lawyer but, at the age of 30, decided to become a painter. Moving to Munich, he studied briefly at the Academy of Fine Arts under Franz von Stuck. By now, Kandinsky was mixing in progressive, artistic circles, and his style underwent rapid changes, as he was influenced by Russian folk art, Fauvism, and Expressionism. His private income gave him free rein to experiment, but his daring works shocked contemporaries. From the outset, Kandinsky's primary inspiration came from color and music. In his youth, he had been dazzled by one of Monet's paintings, and he adored the music of Wagner and Schoenberg. Eventually, he managed to combine these passions, making them the basis of his abstract style.

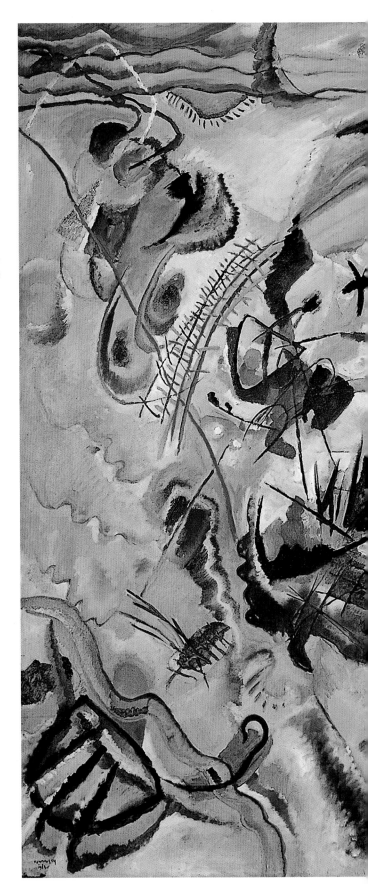

The very word composition called forth in me
an inner vibration…I made it my aim in life
to paint a "composition"

WASSILY KANDINSKY

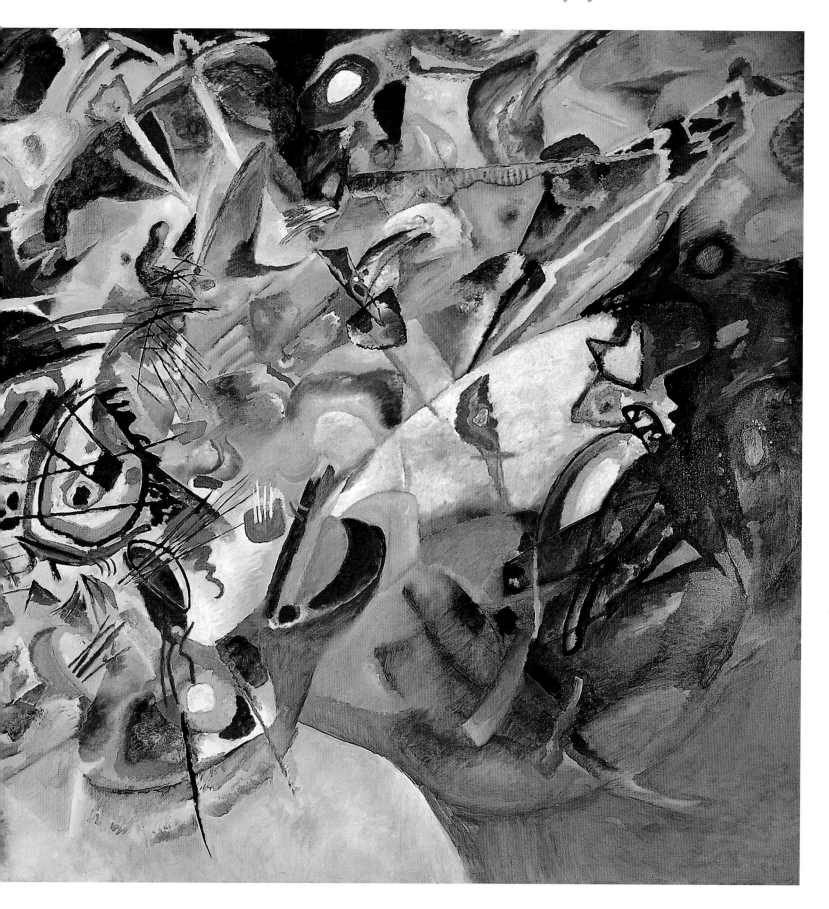

Visual tour

KEY

▶ **COLOR** Kandinsky always regarded color as the most crucial element in his paintings. He was influenced by the writings of philosopher Rudolf Steiner. Steiner had argued that "each color, each perception of light, represents a spiritual tone." Kandinsky took this a stage further and devised his own color code, attributing spiritual and expressive values to each hue.

▲ **LINE** Kandinsky used linear motifs to instil energy and direction into his paintings. Here, the parallel, horizontal lines offer a rare element of stability at the edge of the work while, more importantly, the spidery red diagonal hints at an underlying structure. It seems to trace part of the outline of a very faint lozenge, which is most evident from the thick, right-angled corner at the foot of the canvas. The interplay between line, color, and form was even more effective in *Black Lines I*, also produced in 1913.

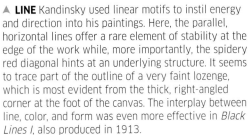

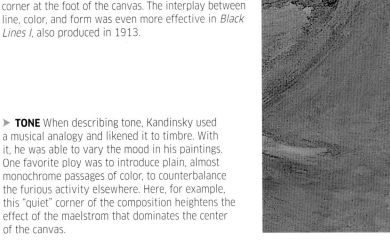

▶ **TONE** When describing tone, Kandinsky used a musical analogy and likened it to timbre. With it, he was able to vary the mood in his paintings. One favorite ploy was to introduce plain, almost monochrome passages of color, to counterbalance the furious activity elsewhere. Here, for example, this "quiet" corner of the composition heightens the effect of the maelstrom that dominates the center of the canvas.

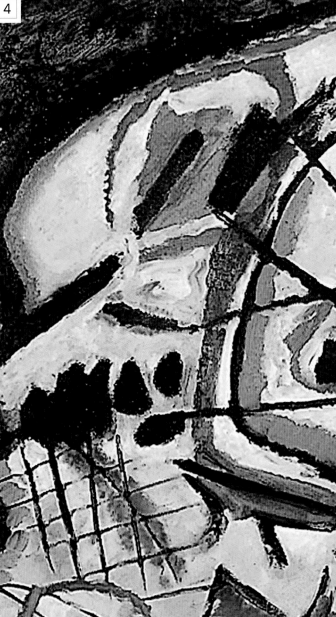

BOAT MOTIF One of Kandinsky's favorite motifs was a boat, which could be reduced to a simple curved shape and a row of lines, representing the oars. In the past, Kandinsky had painted recognizable versions of this image (*Boat Trip*, 1910), but it also became a recurrent theme in *Compositions* because it was relevant to his theme of the biblical Deluge.

HIDDEN IMAGES Kandinsky took great pains to disguise any figurative elements in his abstract works, but a few can still be discerned. This detail is sometimes interpreted as a ladder and a flower. Most elements, though, can usually be identified only by referring to his preparatory studies.

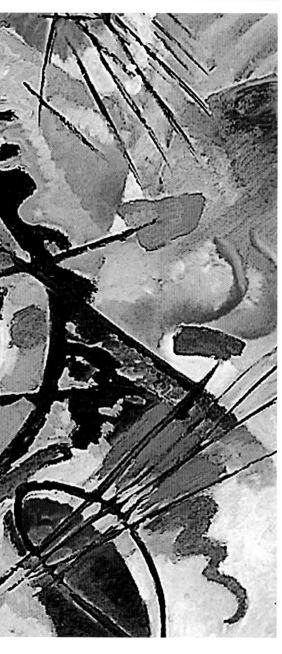

DISSONANCE Kandinsky aspired to mirror the qualities of music. His favorite composer was Arnold Schoenberg, the pioneer of atonal music. Kandinsky admired his approach and felt no compunction about combining harshly dissonant passages. For him, this was just part of the "thundering collision" that was essential to his art.

SHAPE In his preparatory studies, Kandinsky experimented with a broad repertoire of components, as he searched for the right formula. Most of the sketches included a variant of this powerful feature, which dominates the heart of the picture. Critics have likened it to a gigantic, cyclopean eye, establishing contact with spectators and drawing them in. It also functions as an anchoring device, remaining constant while other elements swirl frantically around it.

ON **TECHNIQUE**

Kandinsky's methods varied depending on the type of picture. He produced *Impressions* and *Improvisations* relatively spontaneously. The *Compositions* were a different matter. These evolved slowly, as the artist formulated his ideas for an "expression of inner feeling." *Composition VII* was the most elaborately prepared in the series. More than 30 studies survive, in a range of media. Once these preparations were complete, Kandinsky worked quickly, covering the huge canvas in a little over three days. In structural terms, Kandinsky refined the ebb and flow of his composition, while veiling the figurative elements that had inspired him. In the study below, for instance, a blue-faced angel blows a trumpet (top right). The trumpet-shape appears in the finished picture, but its figurative meaning is removed.

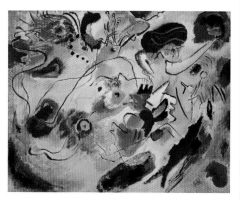

▲ *Study for Composition VII*, Wassily Kandinsky, 1913, oil and tempera on canvas, 31 × 39½in (78.5 × 100.5cm), Städtische Galerie im Lenbachhaus, Munich, Germany

IN **CONTEXT**

In the period leading up to the outbreak of World War I, Kandinsky made rapid progress toward pure abstraction. Just two years before the creation of *Composition VII*, the subjects of his paintings were still usually fairly explicit. Here, for example, Kandinsky depicted a New Year's concert by his friend, Arnold Schoenberg. In addition to the audience, it is possible to identify two broad, white pillars, and the huge, black lid of a grand piano.

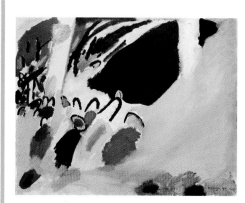

▲ *Impression III (Concert)*, Wassily Kandinsky, 1911, oil on canvas, 30½ × 39¼in (77.5 × 100cm), Städtische Galerie im Lenbachhaus, Munich, Germany

Berlin Street Scene

1913 ▪ OIL ON CANVAS ▪ 47¾ × 37½in (121 × 95cm) ▪ NEUE GALERIE, NEW YORK, US

SCALE

ERNST LUDWIG KIRCHNER

The jagged forms, acidic colors, and tense, mask-like faces give this picture a nightmarish intensity. It is one of a series of street scenes of Berlin—perhaps Kirchner's most powerful and original works—that he painted between 1913 and 1915, after he moved to the city from Dresden in 1911. Whereas Dresden was cosily provincial, Berlin was one of the largest and most culturally vibrant capitals in Europe at this time, and even though he felt lonely there, Kirchner was intoxicated by what he called "the symphony of the great city." Among its many and varied attractions was its decadent night life, and the clothes, as well as the brazen demeanor, of the two central women leave no doubt that they are prostitutes.

The illusion of being close

The claustrophobic atmosphere of the picture is created partly by the feeling that the street is tilted up toward the viewer, so that the figures loom oppressively close. We see the scene as if through the eyes of a friendless wanderer in the city—physically close to other people but emotionally distant. More than any other artist, Kirchner captures the giddy excitement as well as the vulgar materialism of the German capital on the eve of world war.

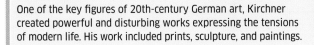

> ### ERNST LUDWIG **KIRCHNER**
>
> **1880-1938**
>
> One of the key figures of 20th-century German art, Kirchner created powerful and disturbing works expressing the tensions of modern life. His work included prints, sculpture, and paintings.
>
> Born in Aschaffenburg, Germany, Kirchner moved to Dresden in 1901. He was the leading member of the first organized group of Expressionists, Die Brücke (The Bridge), which operated from 1905 to 1913. Expressionists used distortion and exaggeration to intensify their work's emotional effect. They were part of a broad movement that was a major force in European art in the early 20th century, particularly in Germany. Kirchner had a mental and physical breakdown while serving in the German army during World War I, and moved to Switzerland when he was recuperating. Although his work had been much admired, in 1937 it was declared "degenerate" (in effect outlawed) by the Nazis, who hated modern art. The following year, Kirchner committed suicide.

Visual tour

KEY

▶ **TWO WOMEN** The fur-collared coats and extravagant feathered hats were typical of prostitutes' dress in Berlin at the time. The women's heavily made-up faces are also characteristic of the profession. As models, Kirchner used the sisters Erna and Gerda Schilling, nightclub dancers he met soon after moving to Berlin.

▶ **MAN SMOKING** The man who rather awkwardly turns his head away from the women—perhaps in embarrassment or disdain—has been interpreted as a self-portrait of Kirchner. He wrote that "an agonizing restlessness drove me onto the streets day and night."

▲ **THE GREEN BUS** In the background is a horse-drawn bus. It is a number 15—a service whose route passed through Berlin's red light district. Motorized buses had first been used in Berlin as early as 1898, but when Kirchner painted this picture horses were still a major form of transport, even in the largest cities.

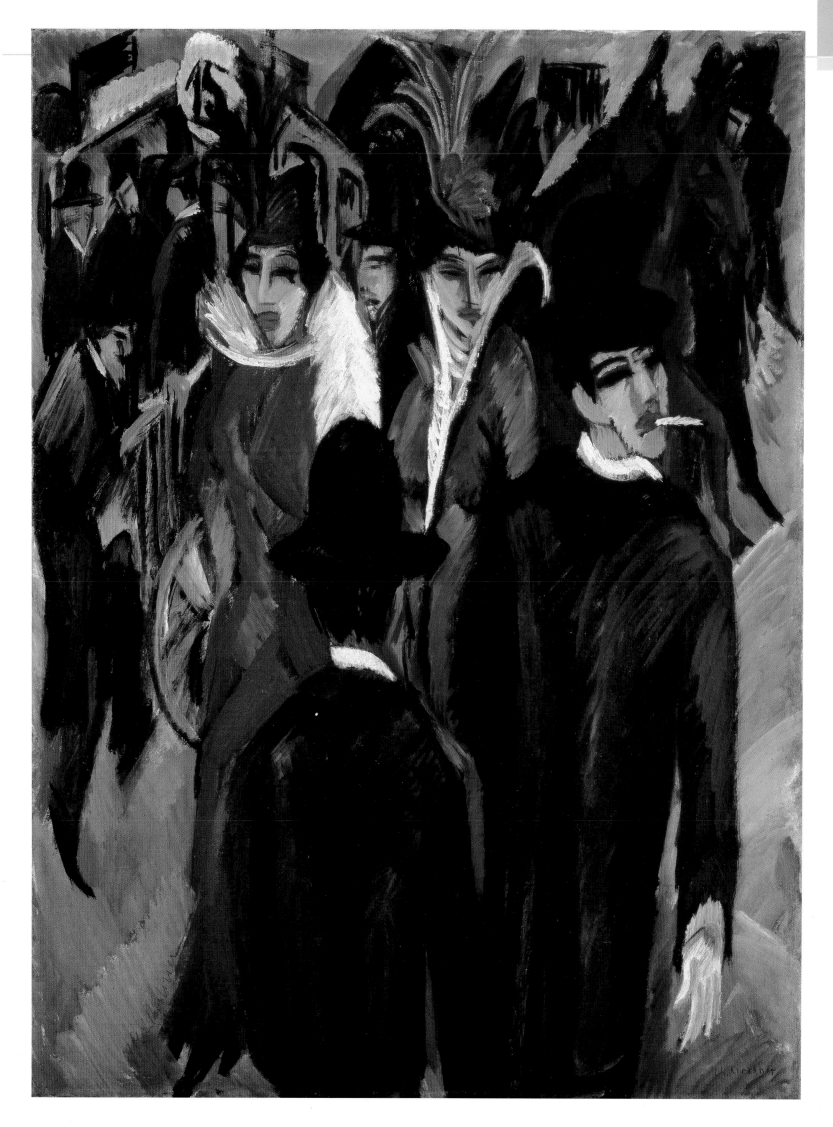

Northern River

1914-15 ■ OIL ON CANVAS ■ 45¼ × 40¼in (115 × 102cm) ■ NATIONAL GALLERY OF CANADA, OTTAWA, CANADA

TOM THOMSON

SCALE

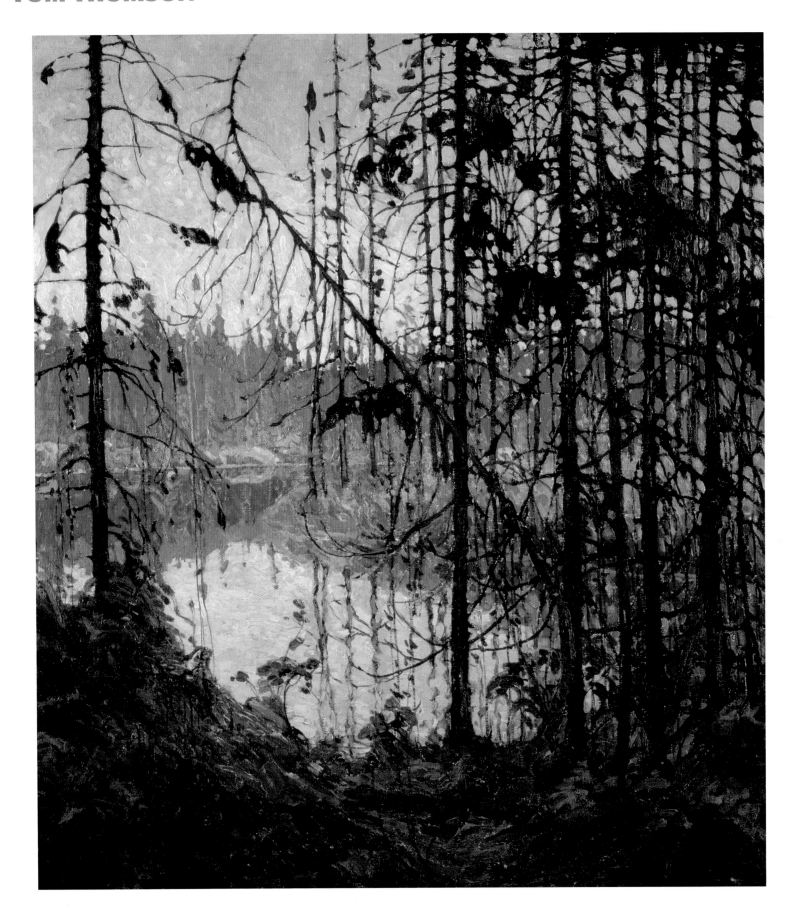

The luminous beauty of northern Ontario's wild places is captured in this evocative late-autumn landscape by Canadian painter Tom Thomson. The mood is still and contemplative: most of the leaves have fallen from the trees and the glowing autumn tones will soon fade. *Northern River* is a keenly observed and innovative depiction of a time of seasonal transition in nature. The vibrancy of the colors, the strong sense of pattern, and the bold, expressive brushwork represented a break with the European tradition of landscape painting that was the norm in Canada. Thomson was not trying simply to make a visual representation of the wilderness, but to communicate something of its spirit.

Inspired by nature

The painting shows a tranquil stretch of river in the Algonquin Provincial Park, a vast area of designated wilderness that fascinated Thomson and which he first visited in 1912. At that time, the area's harsh beauty was not widely appreciated, but he found the landscape inspiring and from 1914 camped there each spring and autumn, working as a ranger and making fluent oil sketches outdoors on small wood panels, often from his canoe.

He immersed himself in nature, observing and painting the changing patterns of light and color through the seasons. During the winter, in the small wooden shack that served as his studio in Toronto, Thomson created *Northern River*. It is an atmospheric and romantic work that combines his instinctive feel for the landscape with a strong sense of design and composition. Thomson died prematurely but his vision was developed by other Canadian artists, such as the Group of Seven collective.

THOMAS **THOMSON**

1877-1917

Internationally recognized for his innovative and expressive painting of wild landscapes, Thomson helped to establish a modern style of painting with a uniquely Canadian identity.

Brought up on a farm in Ontario, Thomson spent time at business college in Seattle before moving back to Toronto in 1905 and working as a commercial artist. While at Grip Ltd., a leading Toronto company, his creative development was encouraged by the senior designer, and he met other young painters there. As a group, they often made weekend painting trips together. From 1914 to 1917, Thomson spent long periods in southern Canada, where he made sketches for works such as *Jack Pine,* 1916–17. He was an expert canoeist and acted as a guide for artist friends and summer visitors, so his death by drowning in Canoe Lake, Algonquin Park, was both mysterious and tragic.

Visual tour

KEY

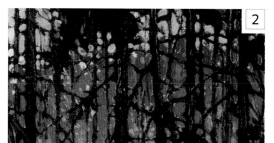

◀ **SILHOUETTES** The dark, outlines of the bare trees that extend almost to the full height of the canvas form a decorative grille. You look through the branches to the brightly colored foliage beyond and the smoky mauve of the horizon line. There is a gentle interplay between foreground and background.

▼ **FRAMING** The intricate tracery of the upper branches of the trees and the strong verticals of their slender trunks frame the background of sky. The darkness of the timber contrasts with the luminosity of the sky and there are splashes of color, notably bright blues and yellows. The juxtaposition of light with the tracery creates an effect similar to that of looking through a stained glass window.

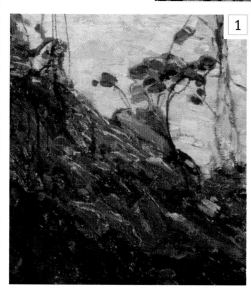

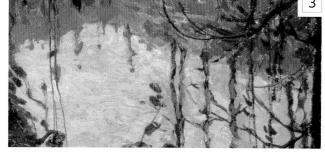

◀ **COLOR** Thomson's use of brilliant color and bold brushstrokes is very striking. Vibrant reds and russets are interspersed with dots of bright complementary blue-mauve and this color is echoed in the conifers on the horizon line.

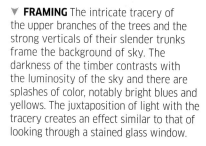

▲ **RIVER** The sweeping curve of the river winds from the foreground into the middle distance. The reflections of the trees in the still water extend and soften the verticals of the trees and help to create a mood of deep tranquillity.

Red Balloon

1922 ▪ OIL ON CHALK-PRIMED GAUZE, MOUNTED ON BOARD ▪ 12½ × 12¼in (31.7 × 31.1cm)
▪ GUGGENHEIM MUSEUM, NEW YORK, US

PAUL KLEE

SCALE

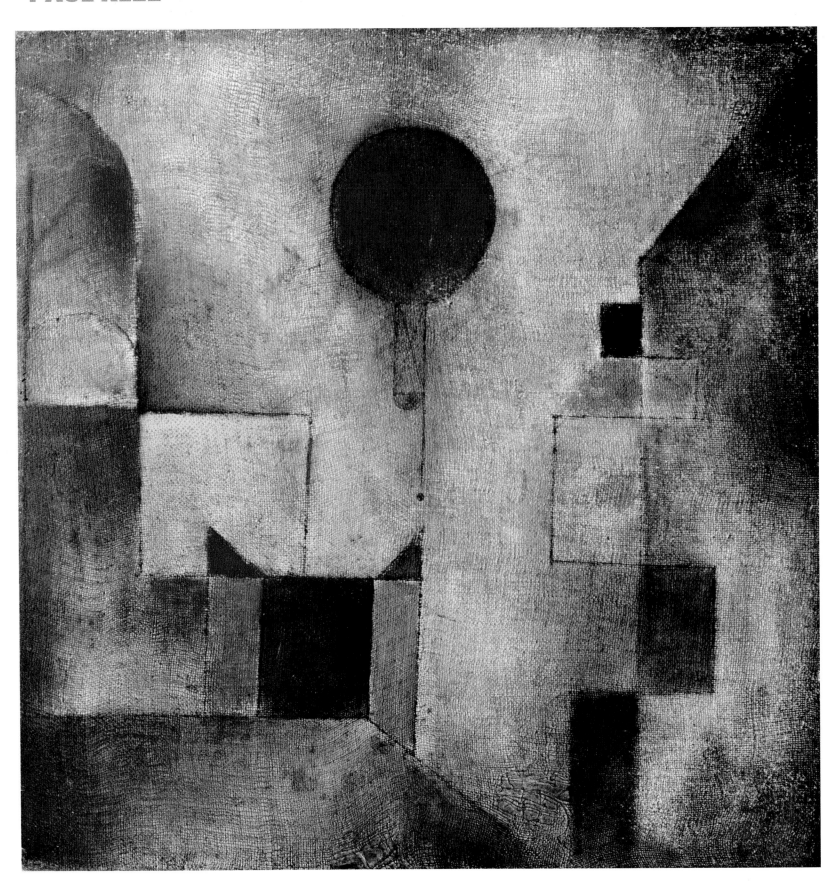

Floating jauntily above a stylized townscape, the balloon seems like a symbol for the whimsical flights of imagination that are so characteristic of Klee's work. His intellectual curiosity was wide-ranging and his mind was nourished by all manner of artistic traditions, both ancient and contemporary. Like many progressive painters of the time, he was interested in types of art that had an untutored sincerity and vitality, in particular children's art. He tried to achieve a childlike freshness of vision in his work, but at the same time it is highly sophisticated: no child could produce the subtle balancing act between abstraction and representation shown in this painting or rival its exquisite color harmonies.

Music, color, and form

Klee was almost as passionate about music as he was about art, and was a talented violinist. In his writing and his teaching he paid a great deal of attention to color, comparing it to music in its ability to enchant and transport the viewer in a way that went beyond rational understanding. However, this sensitivity to intangible qualities was combined with close observation of the natural world, which he considered the essential starting point for artistic creation. Consequently, he rarely painted purely abstract pictures. Here the rectilinear forms evoke an arrangement of buildings, particularly the sloping lines of roofs, and there is the faint suggestion of a tree at the top left.

PAUL **KLEE**

1879–1940

One of the best-loved figures in modern art, Paul Klee created unconventional works of magical wit, color, and beauty.

Klee had a Swiss mother and a German father. He is often described as Swiss, but in fact he was a German citizen all his life. Early in his career he was principally an etcher, but on a visit to Tunisia in 1914 he suddenly became entranced by color and thereafter he worked mainly as a painter. Most of his paintings are small in scale—intimate, lively, and with a joyful spirit that is distinctively his own. For ten years, from 1921 to 1931, he taught in Germany at the Bauhaus, the most famous art school of the time, first in Weimar, then in Dessau, and he was adored by his students. His final years were marred by debilitating illness, but although his work grew darker in mood, it never lost an element of playfulness.

Visual tour

KEY

▼ **CHALKY BACKGROUND**
In matters of technique, Klee was unconventional and experimental. He would often combine painting methods that are normally kept completely distinct—such as oils and watercolor—in the same picture. Here he painted on a fine fabric primed (coated) with chalk, which helped him to create subtle effects of color and texture.

▼ **RED BALLOON** Klee often used a colorful circular form in his paintings: the sun was a favorite motif, and the flowers he depicted often have a sun-like form and radiance. He was fascinated by the subject of flight, and hot-air balloons feature in many of his works from the postwar years. The red pigment of the balloon is applied thickly in relation to the thin wash of the background. Its strong, simple shape is clearly outlined in black.

▲ **GEOMETRIC SHAPES** The blocklike shapes suggest a view over the roofs of a town, with the balloon floating above them, but the variegated, delicately modulated colors come from Klee's imagination rather than from observed reality. "Color possesses me," he once wrote, and he used it emotionally and intuitively rather than descriptively.

Red Canna

c.1924 ▪ OIL ON CANVAS ▪ 36 × 30in (91.4 × 76cm) ▪ UNIVERSITY OF ARIZONA ART MUSEUM, TUCSON, US

SCALE

GEORGIA O'KEEFFE

In this magnificent painting, Georgia O'Keeffe displays her gift for discovering the extraordinary in the everyday –a simple flower is transformed into an organic wonder. This is not a straightforward nature study, but an explosive, magnified close-up of a flower, whose brilliant colors and markings draw us into the picture, just as a real flower attracts an insect.

O'Keeffe studied the abstract qualities of the things she found beautiful and used them as a form of self-expression. Here she tries to capture the essence of the bloom by conveying the energy of its growth, translating her detailed observation of the plant into a composition of lines, shapes, and exaggerated color. Despite the abstract shapes, however, the image is still recognizably a flower: the petals, with their crimped edges, look delicate and you can see lines like the honey guides that lead insects towards the pollen in the center of the flower.

Early in her career, O'Keeffe was influenced by Russian artist Wassily Kandinsky's (see pp.202–05) ideas on the links between the visual arts and music, and in *Red Canna*

the fiery shapes of the petals appear to dance. The flower has movement, form, and warmth. It was bold compositions such as this and her other close-ups of flowers that made O'Keeffe's work so dazzlingly innovative at a time when most other American painters were still producing far more traditional representational art.

GEORGIA **O'KEEFFE**

1887–1986

A major figure in American art, Georgia O'Keeffe was an individualist whose striking paintings of landscapes, flowers, and animal bones were based on the abstract forms in nature.

Born in Wisconsin, O'Keeffe studied art in Chicago and New York. When teaching in 1915, she created an innovative series of abstract charcoal drawings that were exhibited by influential photographer and gallery owner Alfred Stieglitz. O'Keeffe married Stieglitz in 1924 and he championed her work until his death in 1946. During the 1920s, O'Keeffe painted New York City and landscapes. She started painting large-scale close-ups of flowers in 1924 and was soon recognized as one of America's most important artists. In 1929, O'Keeffe spent the first of many summers in New Mexico, painting animal bones and the mountains. The monumental landscape of New Mexico continued to inspire her painting for the rest of her life.

Visual tour

KEY

▶ **FOCAL POINT** You look straight into the fiery center of the flower, where strident pinks and oranges meet—and where the plant's reproductive parts are. O'Keeffe's flower paintings have been interpreted as symbols of female genitalia, but she always vehemently denied that this was her intent.

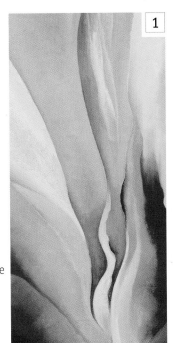

1

2

◀ **SINUOUS LINES** The flowing lines in the painting were developed from a series of abstract charcoal drawings that O'Keeffe made in 1915, influenced by Art Nouveau plant motifs. Note how the lines flow right off the edges of the image.

3

◀ **BOLD SHAPES** The details in the painting are in such dramatic close-up that it feels as if you have an insect's perspective. Each magnified part of the flower is simplified down to a geometric shape and takes on an abstract quality.

ON **COMPOSITION**

You cannot see the whole flowers in O'Keeffe's magnified close-ups. To give her images added dramatic impact, she cropped the edges of the petals so that each flower would fit within the confined space of the picture frame.

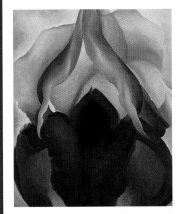

▲ *Black Iris*, Georgia O'Keeffe, 1926, oil on canvas, 36 × 30in (91.4 × 75.9cm), Metropolitan, New York, US

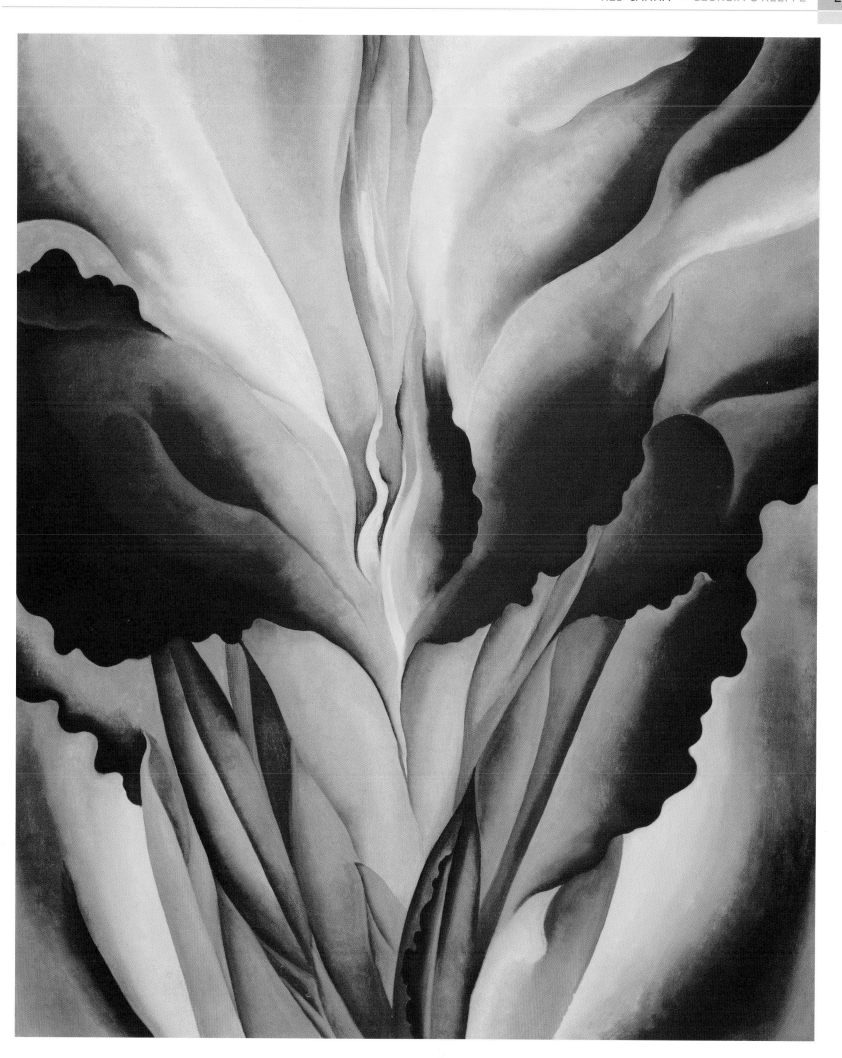

The Metamorphosis of Narcissus

1937 ▪ OIL ON CANVAS ▪ 20 × 30¾in (51.1 × 78.1cm) ▪ TATE, LONDON, UK

SCALE

SALVADOR DALÍ

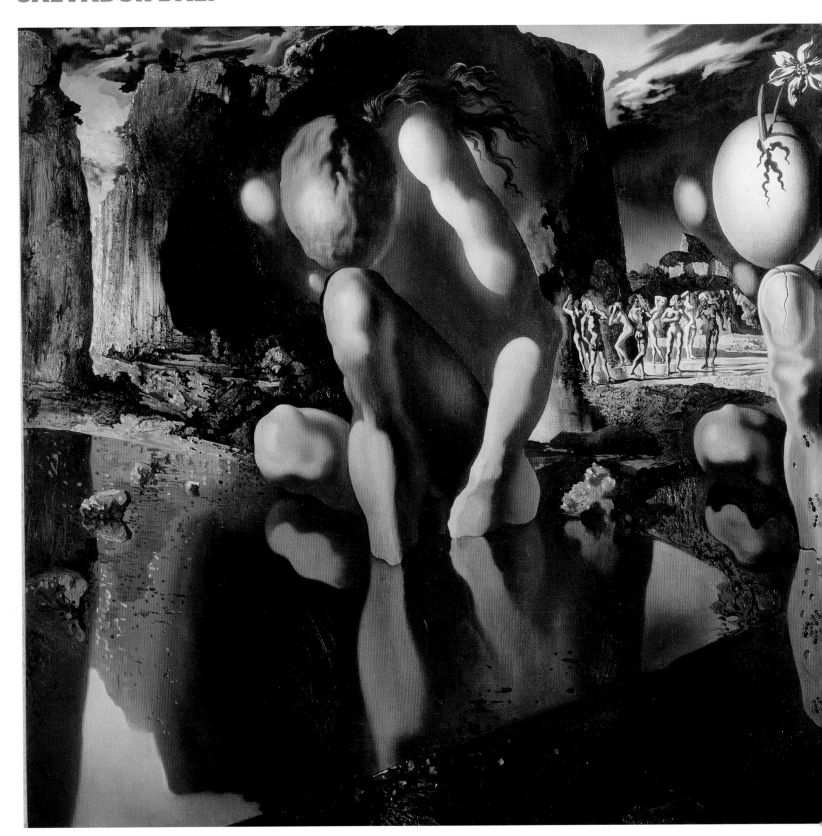

> The only difference between myself and a madman is that I am not mad 〝

SALVADOR DALÍ

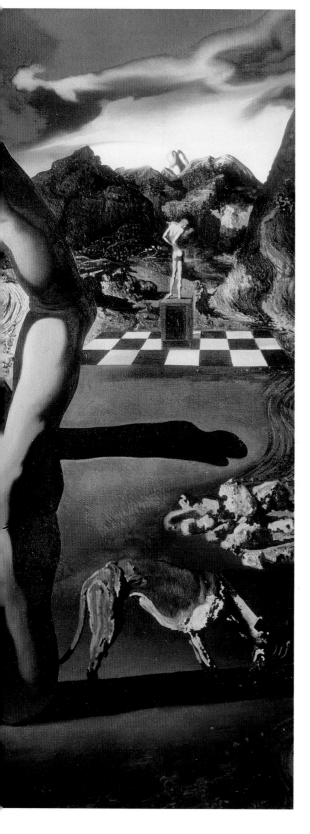

This haunting picture marks the pinnacle of Salvador Dalí's achievements as a Surrealist. Dalí himself was proud of it, regarding it as the finest product of the paranoiac-critical method (see below) that he invented.

The subject of the painting was drawn from classical mythology. As recounted by the Roman poet Ovid, in his book *Metamorphoses*, Narcissus was a beautiful youth who fell in love with his own reflection. Transfixed by it, he became as motionless as a statue, gradually wasting away. At his death, he was transformed into a flower, which bears his name. Dalí was also inspired by a conversation that he overheard between two local fishermen. They spoke of an odd fellow having "a bulb in his head," a Catalan expression for a mental condition. This gave Dalí the idea of portraying the flower bulb bursting through the egg–the transformed skull of Narcissus.

The paranoiac-critical method

The use of the dual image stemmed from the paranoiac-critical method, which Dalí had been developing since the early 1930s. He described this as a form of "reasoning madness," through which he aimed to warp the dividing line between illusion and reality. By simulating a state of mental disturbance, he created a series of striking compositions that are, in effect, self-induced hallucinations. The most typical examples are the double images, where the same elements can be interpreted in different ways– a landscape, for example, might also be viewed as a human face. Some of these pictures were rather gimmicky–one fellow Surrealist dismissed them as "entertainment on the level of crossword puzzles"–but *The Metamorphosis of Narcissus* is far more complex, as it is closely bound up with the artist's interest in psychoanalysis.

Dalí was a keen devotee of the founder of psychoanalysis, Sigmund Freud. He took this painting with him when he met the great man in 1938. Freud had coined the term "narcissism," citing it as a potential cause of a personality disorder, linked with arrested sexuality. Dalí had his own fears in this regard, which had eased only after he met his wife, Gala. In part, this painting is a celebration of the beneficial effect she had exerted, for he described the flower in the egg as "the new Narcissus, Gala–my narcissus."

SALVADOR **DALÍ**

1904-89

A showman, an eccentric, and a self-proclaimed genius, remembered above all for his startlingly original paintings, Dalí was the most famous, as well as the most controversial, of the Surrealists.

Salvador Dalí was born in Figueras, in the Spanish region of Catalonia. He was proud of these roots, and the local landscape–with its strange rock formations–appears as the backdrop in many of his pictures. He trained in Madrid, at the Academy of Fine Arts, and staged his first one-man show in 1925. In his youth, Dalí toyed with a number of different styles before making contact with the Surrealists in 1929.

Surrealism–with its emphasis on dreams, the subconscious, and the theories of Freud–proved an ideal vehicle for Dalí's flights of fancy. Drawing on his own fears and obsessions, he created a series of memorable pictures, which raised the profile of the movement. On a personal level, though, Dalí's right-wing politics and his taste for self-publicity grated with many of the Surrealists. He gradually drifted away from their circle. In addition to painting, Dalí was a writer, a designer, and a filmmaker.

Visual tour

KEY

▶ **GOD OF SNOW** A miniature, disintegrating version of the metamorphosis can be seen in the distance, nestling in a lofty range of snow-capped mountains. But, as Dalí specified in his poem about this picture, the season is spring, when the youth–the "god of snow"–is beginning to "melt with desire."

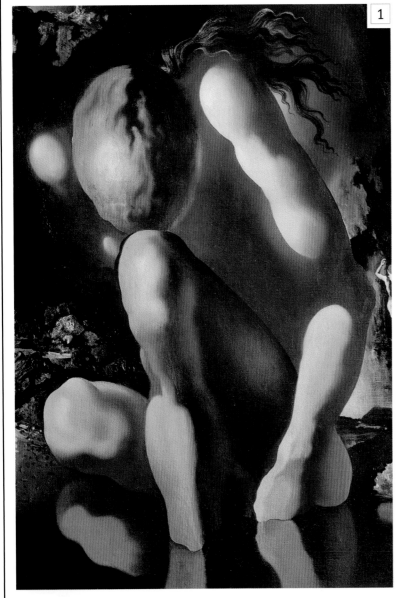

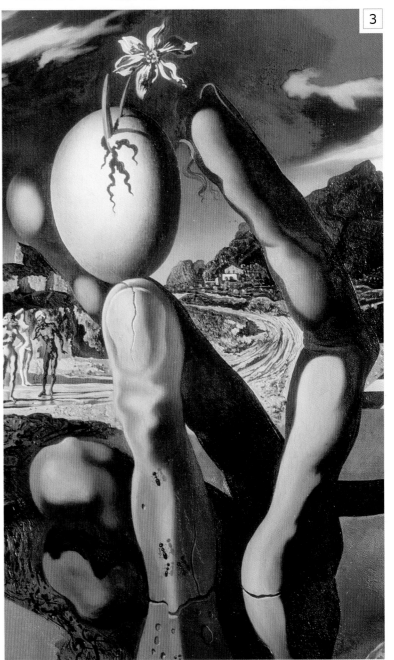

▲ **NARCISSUS** The youth gazes into the pool, obsessed with his own reflection. Face down, immobile, he is already beginning to pine away. A shadow on his scalp resembles the crack in the egg. Dalí advised his viewers to observe the figure in a state of "distracted fixation." If they did, the body would seem to dissolve, melting into the rock formations that surround it.

▶ **HAND HOLDING EGG** This is an imaginative reworking of the tragic end of the mythical tale, when the beautiful youth dies and is transformed into a narcissus. With masterful ease, Dalí manages to juxtapose two important, contradictory themes. For, while the egg and the flower affirm the creation of new life, the hand that bears them is already cracked, ossified, and dead.

◀ **DOG** On the right-hand side of the picture, the dog is associated with the theme of waste and decay. Lean and half-starved, the scavenging creature displays no interest in the transformation of Narcissus. Instead, it gnaws hungrily at a wretched piece of meat. This serves as a reminder that flesh, however beautiful it may appear in its prime, is destined to wither and perish.

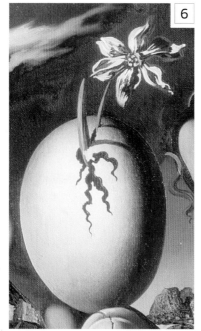

◀ **EGG AND FLOWER** The eye is immediately led toward the narcissus, breaking through the eggshell. It is the brightest part of the composition and, from Dalí's point of view, the most important. Quite different from the legend, it represents the symbolic cure for the sexual ills of narcissism. In Dalí's own case, this cure was his wife.

▲ **ANTS** They appear frequently in Dalí's work as emblems of death. This association stemmed from a vivid, childhood memory: with morbid fascination, he had watched a swarm of ants feast on the decomposing remains of a lizard.

◀ **FIGURE ON PODIUM** This figure is linked with the egg motif directly above it. A beautiful youth stands in glorious isolation, having set himself on a pedestal. He turns his back on the main incidents in the picture. Instead, he appears totally absorbed in gazing down admiringly at his own, naked form.

▶ **GROUP OF FIGURES** In his related poem, Dalí described this strange assembly as "the heterosexual group" waiting in a state of "preliminary anticipation," pondering the impending "libidinous cataclysm." He went on to list the nationalities and characteristics of these devotees of narcissism. They included a Hindu, a Catalan, a "blonde flesh-eating German," an English woman, a Russian, an American, a Swedish woman, and a "tall, darkling Andalusian."

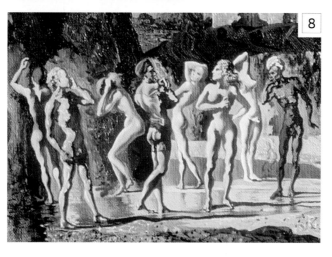

ON **TECHNIQUE**

The impact of Dalí's Surrealist paintings depended on their power to conjure up rich associations in the mind of the viewer. He composed a poem about this picture, but it offers up cryptic hints, rather than a precise guide to its meaning. As with all his best work, the image is ambiguous, open to personal interpretation.

Dalí employed a meticulous, realistic style to endow individual details of his pictures with a dreamlike clarity. Indeed, he described his canvases as "hand-painted dream photographs." On closer inspection, however, the enigmatic shadows, the bizarre landscape, and the inconsistent lighting all emphasize the underlying, irrational tone.

IN **CONTEXT**

Earlier versions of the Narcissus story had appeared in paintings, sculpture, and tapestry. Most were literal versions of the myth, carrying no psychological overtones. However, Dalí may have drawn some inspiration from a picture attributed to Caravaggio. The fulcrum of this bold composition is the boy's knee, which looms out of the dark at a strange angle, enjoying the same prominence as the limbs of Dalí's Narcissus.

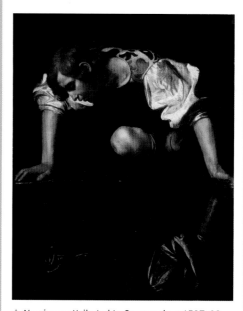

▲ *Narcissus*, attributed to Caravaggio, c.1597–99, oil on canvas, 43¼ × 36¼in (110 × 92cm), Galleria Nazionale d'Arte Antica, Rome, Italy

Guernica

1937 ■ OIL ON CANVAS ■ 11ft 5¾in × 25ft 7in (350 × 780cm) ■ MUSEO REINA SOFÍA, MADRID

SCALE

PABLO PICASSO

One of the most striking images of 20th-century art, *Guernica* is a nightmare vision of violence, pain, and chaos. The painting is full of energy but there is no color and its monochrome, nighttime palette is bleak and disorientating. Picasso uses jagged, fragmented forms and distorted faces to great effect, creating an atmosphere of panic and terror. The painting makes a big impact, both emotionally and physically. More than eleven feet high

and more than twenty-five feet long, it is enormous and its vast scale meant that Picasso had to use a ladder in order to paint the upper sections.

In early 1937, Picasso had been commissioned to create a mural for the Spanish Pavilion at the Paris World's Fair, but he had not decided on a theme for the work. At that time, Spain was in the grip of a civil war and in April 1937, in broad daylight, the population of the small town

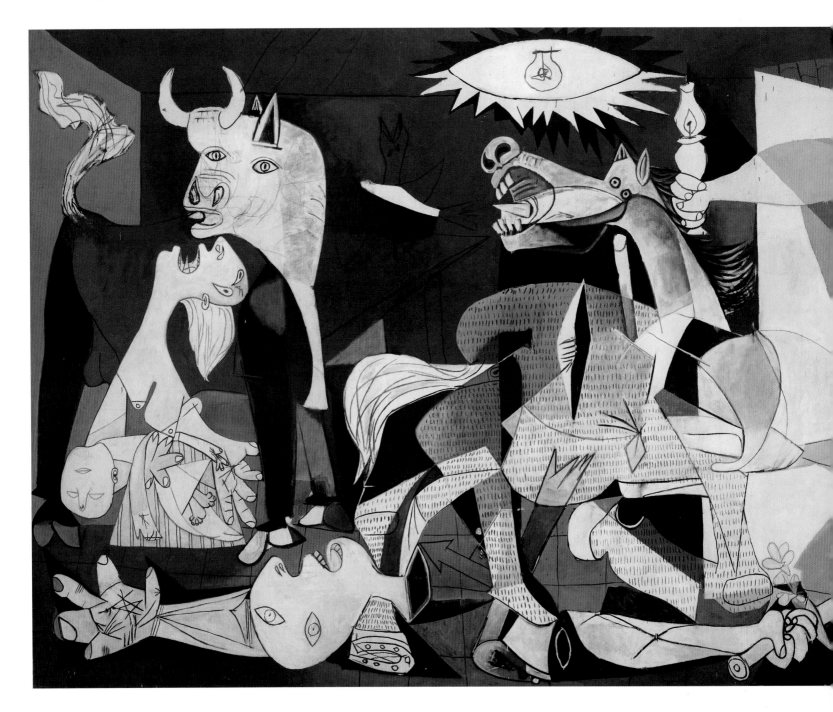

of Guernica in the Republican-held Basque region of Spain was devastated by German bombers and fighters from the Condor Legion acting on General Franco's orders. Picasso, who had allied himself to the Republican cause, read about the massacre of defenseless civilians and the theme of the mural for the Spanish Pavilion suddenly presented itself. The Paris Fair would give him an opportunity to bring the atrocities visited on the defenseless people of Guernica to the attention of the world, and so he set to work.

The power of art

The antiwar message of *Guernica* is fairly clear. Like Goya's celebrated painting, *Third of May 1808* (see p.142), with which Picasso would have been familiar, it is a profound condemnation of the brutal massacre of innocent people. It can also be seen as an anguished response to the tragedy and suffering of war in general. For Picasso, art was an intensely powerful medium and he saw *Guernica* as a political vehicle that would resonate with people on an emotional level. When the work was exhibited, both its subject matter and its artistic style caused great controversy. After Paris, the painting traveled to the United States where it was shown in San Francisco and at the Museum of Modern Art, New York.

Picasso's masterpiece is considered by many to be the greatest painting of the 20th century. Wars are still being fought around the globe and *Guernica* is a humbling reminder of man's destructiveness and inhumanity.

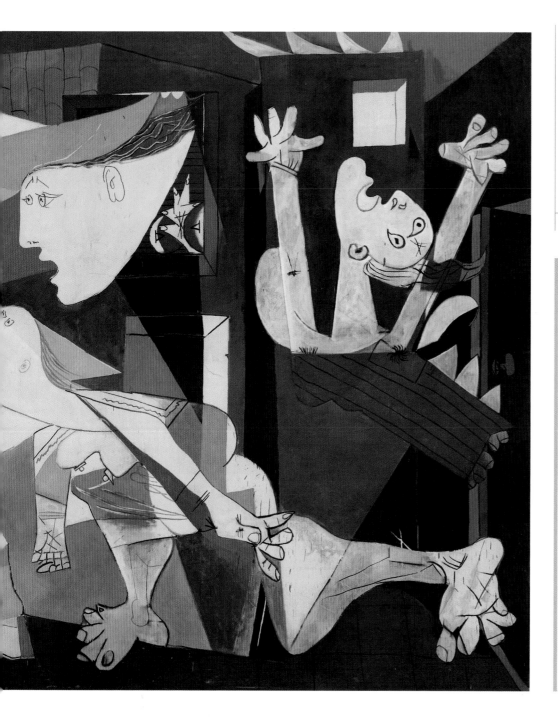

> …painting **is not interior** decoration. It is an **instrument of war** for attack **and defense against** the enemy

PABLO PICASSO

PABLO **PICASSO**

1881-1973

The prodigious and varied career of the innovative painter and sculptor Pablo Picasso provides the backbone of 20th-century art.

Born in Málaga, Spain, Picasso was a precocious art student. As a young artist, he lived in Barcelona before settling in Paris.

Picasso's early career is defined by his Blue Period, when his paintings featured melancholic figures in blue tones, and his Rose Period, when he used pinks and greys to create a lighter mood. From 1909 to 1914, he and artist Georges Braque were the leading figures in the development of Cubism and, after World War I, he took part in the revival of classicism. In 1925, Picasso allied himself with the Surrealists and, after World War II, he took up ceramics. Picasso's work went through many phases inspired by the women in his life, medieval and African art, bullfights, mythology, and old masters, all of which he reprocessed with his unique humor and vision.

Visual tour

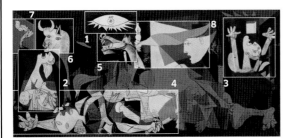

KEY

▶ **MOTHER AND CHILD** The disjointed style of the woman's face conveys an impression of deep anguish. Her head is thrown back in a scream of despair and Picasso has painted a spike for her tongue, a shape that expresses the sharpness of her pain. There is an echo of the Christian image of suffering, the *pietà*, in the way she cradles the lifeless child in her lap.

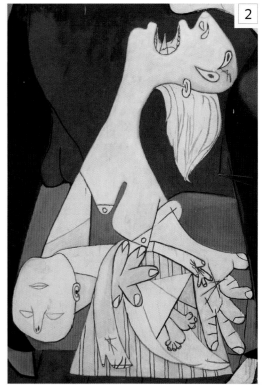

▶ **ELECTRIC LIGHT** The single bulb in the ceiling light illuminates a room of nighttime horror. Its glow has a jagged edge and suggests a burst of light, surely a reference to the incendiary bombs that fell on Guernica. The light also resembles a huge eye that observes everything, perhaps a symbol of the all-seeing eye of God.

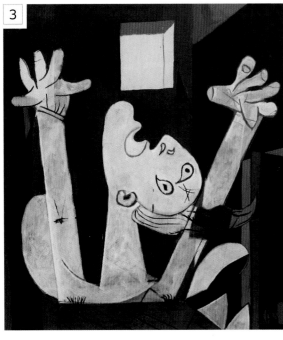

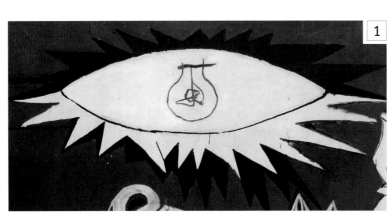

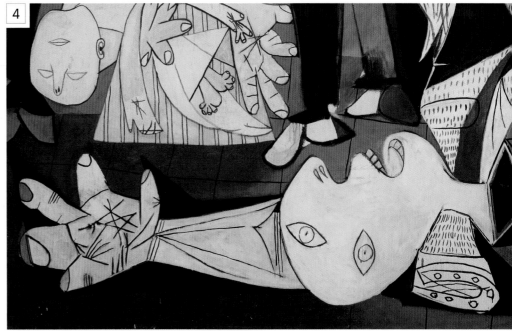

▲ **BURNING FIGURE** Kneeling with arms outstretched, this figure is engulfed by flames. Echoing the shape of the woman's head on the opposite side of the painting, the man or woman—it is difficult to tell which—screams at the sky. Flames lick through the window in front of the figure, suggesting that the rest of the town is also under attack.

▶ **THE HORSE** When asked for his interpretations of the images in the painting, Picasso said that the shrieking horse represented the innocent people. The contorted head and neck of the horse form a dramatic image of panic. A wound that looks like a slash in the canvas has opened in its side and the animal seems to be screaming in agony, its tongue a sharp spike, like that of the bereaved mother.

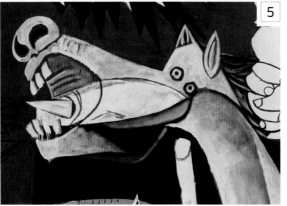

▲ **FALLEN SOLDIER** Perhaps the most difficult image to interpret is the fallen soldier in the foreground. His head and arm have been severed from his body. In his dismembered hand he holds a broken sword, and a single, delicately drawn flower appears to be growing there, perhaps signifying the faintest glimmer of hope. On the outstretched palm of the other hand is a wound that suggests the stigmata of Christ.

BULL An important cultural symbol in Spain, the bull usually signifies strength and the bull or minotaur is a motif that the artist used many times in his work. According to Picasso, who was usually unwilling to offer any analysis of his imagery, the bull in *Guernica* is a symbol of brutality. This bull, however, does not appear particularly aggressive. Perhaps the image is intentionally ambiguous.

BULL'S TAIL It is unclear whether the bull is twitching its tail or whether the tail is actually on fire. The proud bull appears almost helpless in the face of the carnage, and it looks straight out at us with a peculiarly human expression.

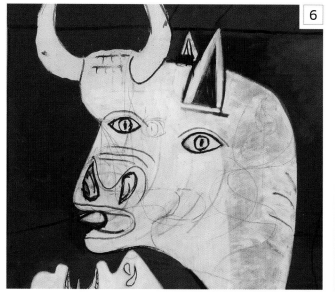

6

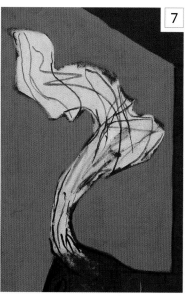

7

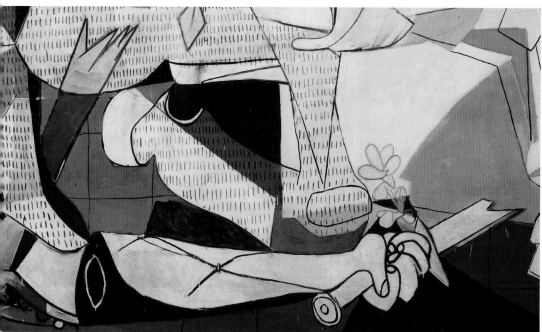

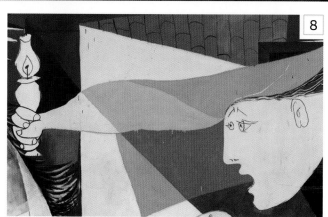

8

◀ FLOATING FEMALE
A female figure flies in through the open door, a lighted candle or a lamp in her hand. This floating woman, whose style is reminiscent of Picasso's surrealist work, could be bringing enlightenment to the scene. Yet her candle flame is next to the electric lightbulb (a symbol of war), drawing attention to the significance of these juxtaposed symbols.

ON **TECHNIQUE**

Picasso concealed several motifs of death in *Guernica* that appear to work on a subliminal level. Focus on the horse in the center of the painting, an important point of the composition, and you will see two hidden symbols. Its nostrils and upper teeth cleverly double up as a skull, a stark symbol of death, an inclusion that serves to increase the intensity of the horse's agony (top). The wounded horse is stumbling and at the angle of its bent front leg, there is the skull-like head of a second bull seen in profile (bottom).

IN **CONTEXT**

The harrowing realities of the front line had been captured by government-sponsored war artists during World War I. Spain was a neutral country, so Picasso was not called up for military service, but he would have seen these powerful war paintings. American artist John Singer Sargent, who had visited the Western Front, created *Gassed*, a harrowing twenty-foot long painting showing a line of soldiers blinded by mustard gas. Blindfolded and holding on to each other, the vulnerable soldiers appear dignified amid the horrors of the battlefield.

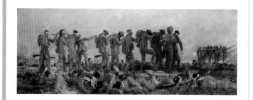

▲ *Gassed*, John Singer Sargent, 1918–19, oil on canvas, 7ft 7in × 20ft ½in (231 × 611.1cm), Imperial War Museum, London, UK

Nighthawks

1942 ■ OIL ON CANVAS ■ 33 × 60in (84.1 × 152.4cm) ■ THE ART INSTITUTE OF CHICAGO, CHICAGO, US

SCALE

EDWARD HOPPER

An iconic image with an unsettling atmosphere, Hopper's powerful painting is, above all, a study of light. An intense, fluorescent glow streams from the windows of a late-night diner into the empty street, creating sharp angles and casting deep shadows. The place is almost empty and its few occupants are starkly illuminated, particularly the pale-skinned woman in the red dress. The composition is simple and strong, and the colors are mostly muted. Moody, downbeat, and yet also romantic, Hopper's painting resembles a still from a classic *film noir*.

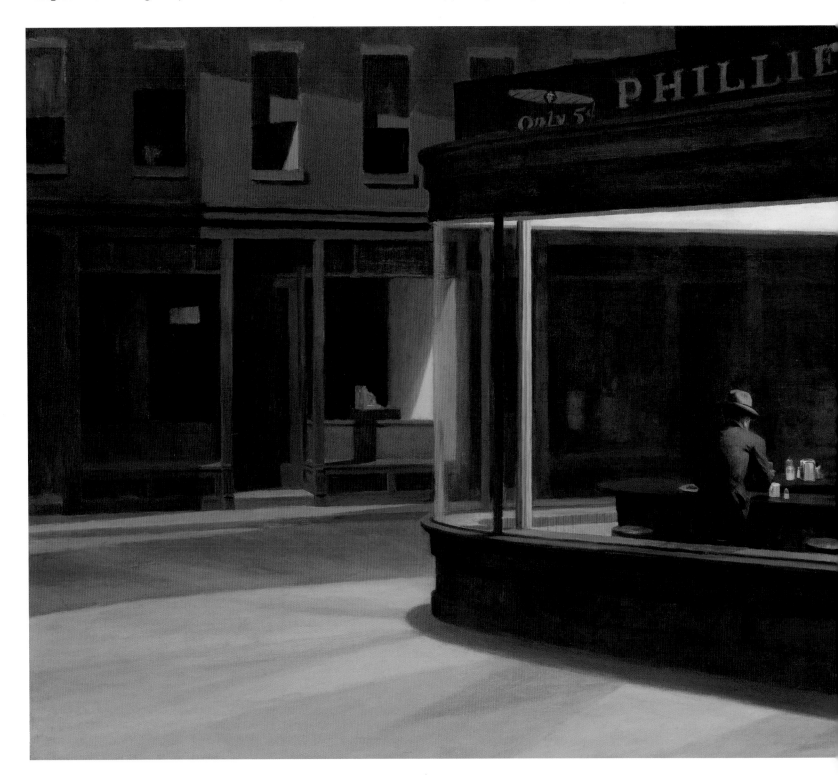

Many of Hopper's paintings depict people, often solitary, who appear alienated from their environment and from each other. There is little interaction between them, or, as in *Nighthawks*, the relationships are ambiguous. It is tempting to inject a narrative into this painting, but, like a film still, a single image cannot tell the whole story.

As a realist painter, Hopper possibly based the location of *Nighthawks* on an exisiting New York street, but the scene has been carefully constructed and it is more likely to be a composite of various elements from different places. The shapes of the buildings have been simplified, the shop fronts have no displays, and the street is

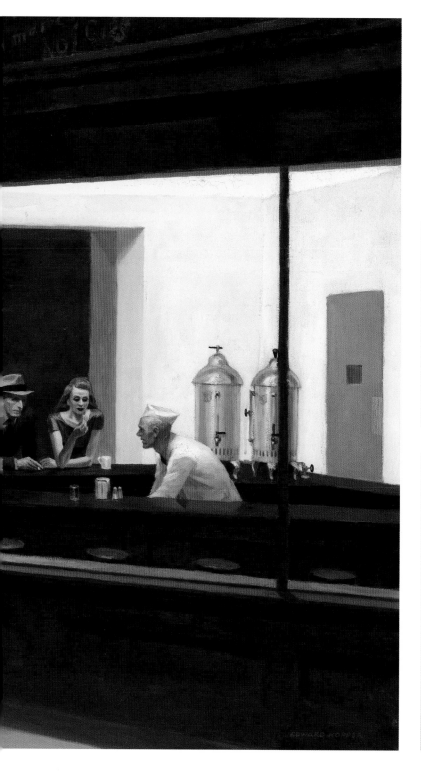

deserted. These compositional devices allow the huge, sweeping curve of the window and bar of the diner to dominate. At the same time the brilliant light from a single source contrasts with the background gloom, focusing our attention on the uncluttered interior.

Emotional landscape

Several elements combine in *Nighthawks* to create a sense of tension and unease. The shadowy, nighttime street is devoid of people or movement, the diner occupants in their glass box appear remote and inaccessible, and a feeling of uncertainty and loneliness pervades the scene. It is difficult to feel any connection with either the characters or the location of the painting, but we can recognize and respond to the emotional space that Hopper has created. Unlike his contemporaries, such as Norman Rockwell, whose images of life in 1940s America are largely sentimental, Hopper invested his everyday scenes with a psychological intensity. His understated style is beautifully expressed in *Nighthawks*, one of this painter's most haunting works.

> A triangle of ceiling, as sharp as it is bright, hangs above them like a blade. **You're the unobserved watcher, the watcher from the shadows,** a kind of private eye "

PAUL RICHARD *WASHINGTON POST*, 2007

EDWARD **HOPPER**

1882-1967

One of the most celebrated painters of modern life, Edward Hopper is best known for atmospheric everyday scenes that explore universal feelings of solitude and loneliness.

Born in New York State, Hopper was the son of devout Baptist parents. He trained at the New York School of Art, studying under the realist painter, Robert Henri, who encouraged him to paint subjects from everyday life. Hopper made two visits to Paris and was attracted by the light effects he saw in Impressionist paintings, but it is debatable whether these influenced his style.

Until 1923, when he sold *The Mansard Roof*, a watercolor, Hopper's sole source of income was his work as a commercial illustrator, but in 1924 he began to paint full time. He studied light obsessively and painted the sunlit buildings and seascapes around Cape Cod, where he and his wife Jo owned a summer house. The distinctive style that made his reputation, most famously in *Automat*, 1927, and *Nighthawks*, 1942, hardly changed throughout his career despite the rise of Abstract Expressionism. He died in New York.

Visual tour

KEY

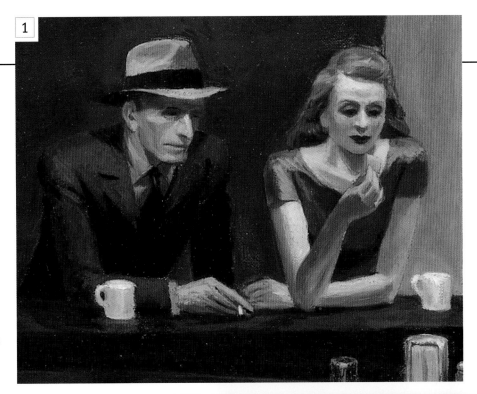

▶ **THE COUPLE** The angular features of the man and woman are accentuated by the stark, fluorescent lighting overhead. They sit in close proximity but there is little suggestion of communication between them and their relationship is ambiguous. The woman stares at a piece of paper, the man looks preoccupied. Both seem lost in their own thoughts. With her distinctive auburn hair, red dress, and red lipstick, the woman is the focal point of the composition.

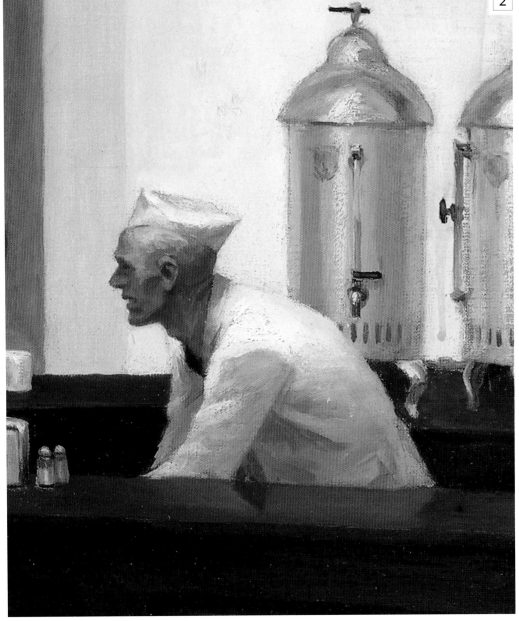

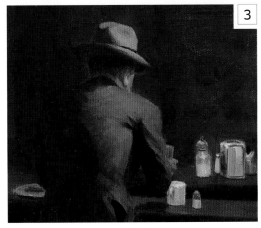

▲ **ANONYMOUS MAN** Balancing the composition of figures around the wooden bar, the smartly dressed man with his back toward us is particularly enigmatic. Hopper has depicted him in half shadow and with great skill: the way the light falls on his face and back, the slightly hunched posture, and the casual handling of the glass add up to a convincing portrayal of a solitary figure who is just passing through.

◀ **PERIOD ITEMS** The white hat and jacket of the waiter and the equipment in the café—the large gleaming urns and the classic sugar shaker and cruet sets—are typical of the period. The waiter appears to be busy but his hands are obscured and the figure, like the others, is curiously static.

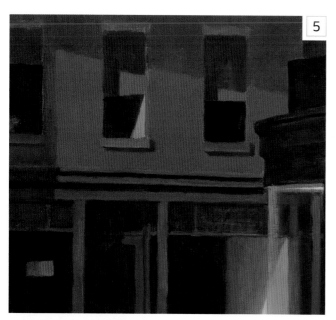

5

◄▼ LIGHTING Hopper expertly contrasts the moody streetscape with the brightly illuminated café. The flat, bleached-out tone of the interior suggests the harsh effect of the overhead lighting, which casts triangular shadows on the pavement in the foreground.

6

4

▲ LINE OF STOOLS Only three stools are occupied in the diner. The sparseness of the setting serves principally to emphasize the sense of isolation. Compositionally, the regular elliptical shapes reinforce the strong lines of the windowsill and the bar.

7

► EMPTY SPACE Hopper used empty (or negative) space to great effect. The simple shapes made by the concrete pavement and road combined with the complete absence of activity or small incidental detail, such as litter, serve to concentrate all our attention on the interior scene.

8

◄ SIGNAGE Hopper's experience as an illustrator and commercial designer can be seen in the strong geometry and graphic style of the painting. The name of the diner appears in a classic, hand-lettered serif font. It is probably fictional, but identifies the diner in what is otherwise a totally anonymous place.

ON **TECHNIQUE**

The wedge shape of the diner projects into the composition, filling two-thirds of the canvas. Its Art Deco-style frontage features huge sheets of glass interrupted by few verticals, and there is no door. The expanse of empty pavement and the shop fronts balance the left side of the painting.

In terms of perspective, the strong lines of the windowsill and roof appear to converge toward a vanishing point somewhere beyond the left side of the frame. Looking more closely at the perspective, however, slight distortions become apparent, such as the way the top of the wooden counter is painted, and these may contribute to the atmosphere of unease. The row of shops on the left, the plain windows and doors represented by simple rectangles, acts as a barrier, as if it is containing the tension within the frame.

IN **CONTEXT**

Hopper was painting during the heyday of Hollywood movies, an era of memorable black-and-white films, some adapted from the crime fiction of popular American writers such as Dashiell Hammett and Raymond Chandler. Hopper was a keen filmgoer and it is interesting to draw parallels between *Nighthawks* and early *film noir* classics with their dramatic lighting, unusual camera angles, and tense, brooding atmosphere.

This same atmosphere of unease pervades many of Hopper's best-known works, including *Gas* (shown below). Superficially, the scene appears unthreatening: a man is attending to one of the pumps at a petrol station. Yet this carefully composed image with its solitary figure, backdrop of dark trees at dusk, empty road, and complete absence of cars, has an eerie stillness. As with many of Hopper's paintings, there is an air of melancholy that continues to resonate.

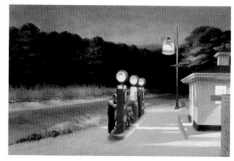

▲ *Gas*, Edward Hopper, 1940, oil on canvas, 26¼ × 40¼in (66.7 × 102.2cm), Museum of Modern Art, New York, US

Without Hope

1945 ■ OIL ON CANVAS MOUNTED ON HARDBOARD ■ 11 × 14¼in (28 × 36cm)
MUSEO DOLORES OLMEDO PATIÑO, MEXICO CITY, MEXICO

SCALE

FRIDA KAHLO

Few painters have been so intensely autobiographical in their work as the Mexican artist Frida Kahlo: of her 150 or so known paintings, more than a third are self-portraits. A few are fairly straightforward renderings of her striking appearance, but many of them are entirely different in approach—deeply personal and highly specific commentaries on the physical and emotional pain of her life. *Without Hope* shows the artist confined to bed in a harsh, barren landscape, a hideous cornucopia of assorted meat and fish in a fleshy cone suspended above her mouth. Even though it is very small, it is one of the most powerful and disturbing of her paintings.

Autobiographical painting

Kahlo's medical problems were mainly the result of horrific injuries (to her spine, pelvis, and other parts of her body) sustained in a bus crash in 1925, when she was still at school. Even before this accident, however, she walked with a limp because of childhood polio, and in later life she suffered from digestive disorders and alcoholism. At the time she painted *Without Hope*, a lack of appetite had caused such serious weight loss that she had to be fed through a funnel. In the painting, the funnel has been transformed to a monstrous size—so big that it has to be supported on a stout wooden frame—and it is filled not with puréed food but with mounds of dead flesh. On the back of the picture, Kahlo wrote an inscription that gives the painting its title: "not the least hope remains to me...Everything moves in tune with what the belly contains."

Although her work had numerous admirers, Kahlo was overshadowed in her lifetime by her husband, Diego Rivera, a huge man with a huge personality. While her paintings were generally small and intimate, his were highly conspicuous:

he specialized in large murals for public buildings—the field in which Mexico made its most distinctive contribution to modern art.

Growing reputation

It was not until about 1980, some 25 years after her death, that Kahlo's reputation began to rise and then to soar, as part of the feminist movement to reexamine and celebrate the work of women artists. She is now firmly established as a feminist heroine, admired not only for the passion and originality of her paintings, but also for the strength of spirit that enabled her to create these works in the face of great suffering. In 2007, the largest Kahlo exhibition ever staged was held in Mexico City to mark the centenary of her birth; it smashed attendance records, attracting more than 360,000 visitors in just two months.

FRIDA **KAHLO**

1907-54

On the strength of her colorful, intense, and often harrowing self-portraits, Kahlo has become one of the most famous of all women painters.

Frida Kahlo spent most of her remarkable life in Mexico City. It was there, at the age of 18, that she suffered multiple injuries in a traffic accident, leaving her permanently disabled and often in severe pain. She began painting during her initial convalescence. In 1929, she married Diego Rivera, the most famous Mexican painter of the time. Their relationship was a stormy one (they divorced in 1939 and remarried in 1940), but it survived until her death. Their shared passion apart from art was politics—both were militant Communists. Kahlo's posthumous reputation has grown so rapidly since the 1980s that her face now adorns all manner of popular merchandise and her flamboyant dress has made her a style icon.

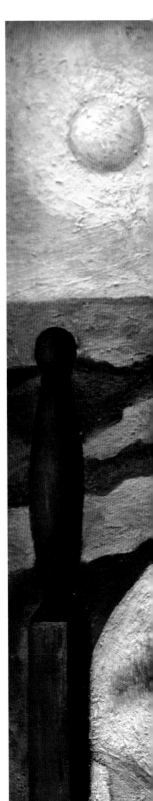

> I paint myself because I am so often alone and because I am the subject I know best "

FRIDA KAHLO

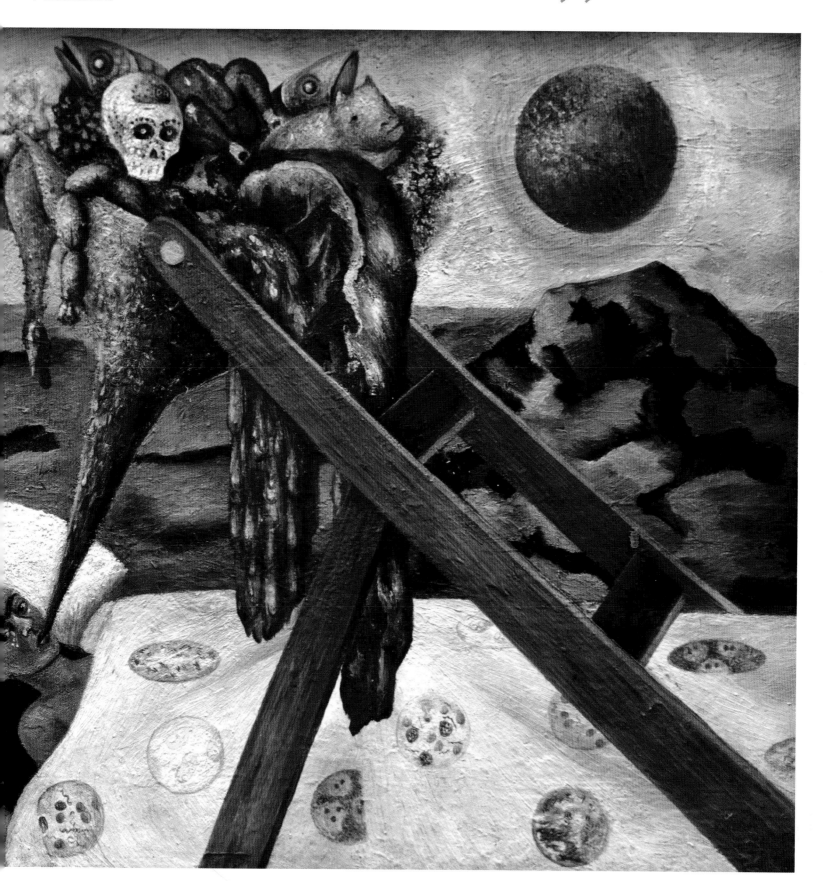

Visual tour

KEY

▶ **FEAST OF DEATH** The huge feeding funnel overflows with a nauseating mix of meat, fish, and poultry. Kahlo probably took the idea of a funnel as an instrument of torture (which is what it seems to represent here) from a book on the Spanish Inquisition she had in her library. The Inquisition used funnels in water torture. On top of the pile is a sugar skull inscribed with Kahlo's name. Such skulls feature prominently in Mexico's annual Day of the Dead celebrations on November 2. This holiday, which blends Aztec with Christian elements (it coincides with the Christian festival of All Souls' Day), is an occasion when Mexicans honor friends and relatives who have died. The skull (a macabre link with Mexico's Aztec past) is an obvious allusion to death, while sugar represents the sweetness of life.

▼ **FACE OF PAIN** Kahlo turns toward the viewer with an imploring look, tears running down her cheeks. Only her head and shoulder project above the bedclothes. This helps to convey a sense of constriction, and during this time Kahlo was indeed forced to spend a great deal of time lying in bed wearing an orthopedic corset. She endured more than 30 operations during the course of her life.

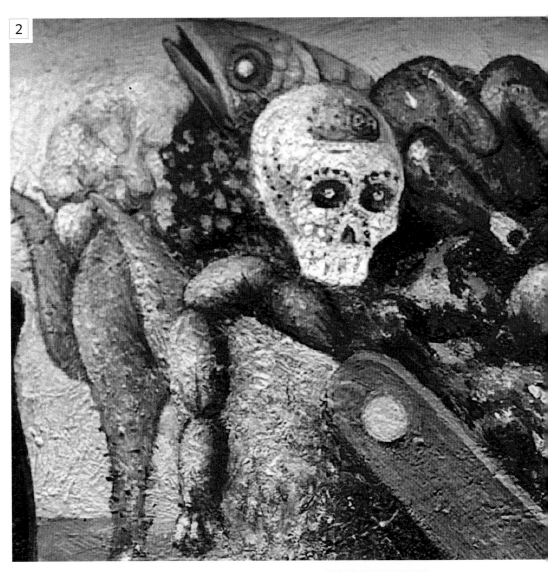

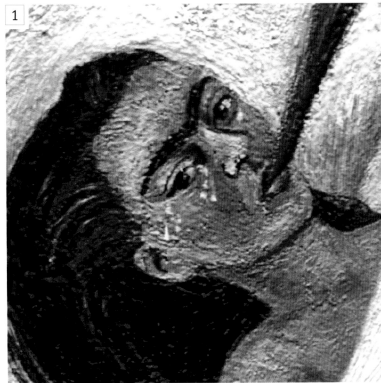

▲ **BEDCOVER** The shroud-like bedcover is adorned with curious patterning. In her book, *Frida: A Biography of Frida Kahlo* (1983), the American art historian Hayden Herrera proposed that the circular forms are biological cells or unfertilized eggs, linking them with the images of the sun and moon in the painting as "opposite worlds of the microscope and the solar system." Herrera's biography was the first major book on Kahlo written in English, and it played an important part in establishing the artist's reputation with a wide audience. It formed the basis for the biographical feature film *Frida* (2002), starring Salma Hayek as Kahlo.

▼ **BARREN BACKGROUND** The landscape setting of the picture is a parched desert. It has been interpreted as a reference to Kahlo's childlessness. The injuries she suffered when she was 18 made it impossible for Kahlo to bear a child. After suffering a traumatic miscarriage at 25, she painted *Henry Ford Hospital* (1932), which depicts her lying in a hospital bed on blood-soaked sheets.

▲ **MOON** On either side of the painting are large images of the moon and sun. These have been interpreted in many different ways, for example, as a way of indicating that Kahlo's pain is relentless and persists throughout both day and night. Alternatively, the pale moon—a traditional feminine motif—has been seen as a symbol of the frail Kahlo herself, its wan light a reflection of the huge, brightly burning sun.

▲ **SUN** Kahlo was passionately interested in the pre-Columbian culture of Mexico, in which sun worship plays a prominent role. The sun sometimes appears in her paintings as a generalized symbol of life-giving energy, but here it may be a more specific allusion to her husband, Diego Rivera, a man of great vigor and confidence. The image may also be a visual reference to the orange marigolds that feature in the Mexican Day of the Dead festivities.

ON **TECHNIQUE**

Kahlo was mainly self-taught and her working methods reflect the unusual circumstances of her life. She began painting in earnest while recuperating at home after the bus crash in 1925. A special easel was fixed to her four-poster bed and an overhead mirror was fitted, so she could see herself while lying flat and act as her own model. Kahlo's brushwork was delicate and nimble, although in her later years, when she was affected by alcoholism, it became coarser.

▲ Frida Kahlo's bed with the overhead mirror

IN **CONTEXT**

Kahlo's husband Diego Rivera (1886–1957) was the most famous of three muralists who dominated 20th-century Mexican art (the others were Orozco and Siqueiros). The President of Mexico initiated a program of mural painting from 1920 to 1924. Following a violently unsettled period, the paintings were intended to help create a feeling of national identity among a population that was still largely illiterate.

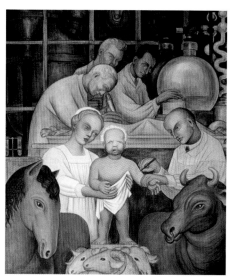

▲ *Vaccination Scene and Healthy Human Embryo Surrounded by Diseased Cells*, Diego Rivera, 1933, fresco, Detroit Institute of Arts, Detroit, US

Red Interior, Still Life on a Blue Table

1947 ▪ OIL ON CANVAS ▪ 45¾ × 35in (116 × 89cm)
▪ KUNSTSAMMLUNG NORDRHEIN-WESTFALEN, DÜSSELDORF, GERMANY

SCALE

HENRI MATISSE

The joyful spirit of this painting is so heartwarming that it is hard to believe the artist who created it was old and frail. It is, in fact, one of the last oil paintings Matisse ever produced, one of a glorious series of interiors he made between 1946 and 1948; at this time he was approaching 80 and was confined to bed or a wheelchair, following major surgery for cancer in 1941. He was active right to the end of his life, but after he completed these interiors he no longer worked in the traditional medium of painting: in 1948–51 he concentrated on the design of the Chapel of the Rosary at Vence, France (a gift of thanks for a Dominican nun who had nursed him). In his final years he devoted himself mainly to large paper cutouts (*découpages*), employing assistants to arrange the shapes according to his instructions (see p.233).

Tranquility through art

Throughout virtually the whole of his long career, Matisse was captivated by the theme of the interior, especially when it featured a window looking onto a garden or landscape. The fascination was an expression of his love of tranquility, as he greatly valued the peace of mind he found when working in a calm atmosphere. Even though the colors here are dazzling and the patterning bold, the feeling is peaceful rather than flamboyant.

Matisse was a renowned teacher with an orderly mind and a scholarly air (when he was still a student his friends nicknamed him "the professor"). He wrote no books, but he produced various statements on art in the form of interviews, catalogue introductions, essays, and so on. In one of these he eloquently summed up his aims: "What

I dream of is an art of balance, of purity and serenity…a soothing, calming influence on the mind, something like a good armchair that provides relaxation from physical fatigue." The words were written in 1908, but they could well be applied to this luminously beautiful painting produced 40 years later.

HENRI **MATISSE**

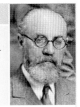

1869-1954

Regarded by many of his admirers as the supreme painter of the 20th century, Henri Matisse is celebrated for his exquisite sensitivity of line and radiant beauty of coloring.

Matisse was a late starter in art, taking it up after initially studying law. Early in his career, he suffered some of the critical abuse typically encountered by avant-garde artists, but he soon found sympathetic patrons and from the 1920s he enjoyed international acclaim. At first he worked mainly in Paris, but from 1916 he began spending winters on the French Riviera, where the strong sunlight encouraged his sparkling colors, and in 1940 he settled there permanently. His subjects were varied, including nudes, portraits, landscapes, interiors, and still lifes. Almost always they are life-affirming in attitude, "devoid of troubling or disturbing subject matter," as Matisse put it. In addition to paintings, he produced sculptures, prints in various techniques, book illustrations, and stage décor. One of his greatest achievements was the design of a chapel, 1948-51, in the French Riviera town of Vence, for which he designed everything from the stained glass to the priests' vestments.

My choice of colors does not rest **on any specific theory; it is** based on observation, **on sensitivity,** on felt experiences

HENRI MATISSE *NOTES OF A PAINTER*, 1908

Visual tour

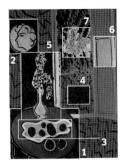

KEY

> **TABLE** Matisse freely varies the viewpoint from which he sees various objects in the painting, as visual impact and harmony were much more important to him than conventional naturalism. The table is the most obvious example, being viewed from above whilst other objects are seen from eye level. In his essay *Notes of a Painter*, 1908, Matisse wrote, "Composition is the art of arranging in a decorative manner the diverse elements at the painter's command to express his feelings."

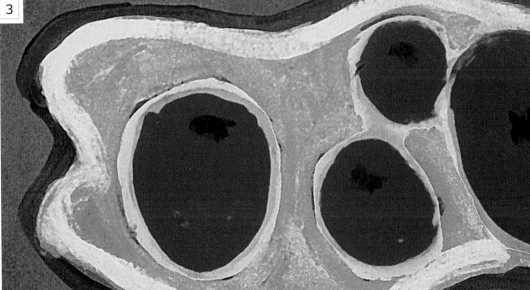

▲ **CLAY MEDALLION** The medallion is Matisse's first surviving piece of sculpture—a portrait of Camille Joblaud, a young woman he loved when he was a student. She bore him a daughter, Marguerite, in 1894, the same year that Matisse made the sculpture. Camille left him in 1897 and the following year he married another woman, Amélie Parayre, who became a loving adoptive mother to Marguerite. The medallion hung in Matisse's studio in Vence.

> **PULSATING PATTERN** The black, zigzagging lines create a vibrantly bold pattern against the red background, suggesting a discharge of electrical energy. Matisse wanted the whole of his picture surface to feel alive: "Expression, for me, does not reside in passions glowing in a human face or manifested by violent movement. The entire arrangement of my picture is expressive."

▲ **SHAPE AND COLOR** The sinuous, flowing lines of the bowl containing the fruit recall the Art Nouveau style, which was a major force in art at the turn of the century, when Matisse was taking his first steps as a painter. He was strongly influenced by it at the time, and echoes of the style recur in his work throughout his life. The vigor of the shapes here is matched by the lush beauty of the red and blue. Matisse had an extraordinary ability to place such rich colors against one another and make them harmonious rather than dissonant. As the art critic John Berger memorably put it, "he clashed his colors together like cymbals and the effect was like a lullaby."

◀ **VASE OF FLOWERS** Whereas the table is viewed from above, the vase is seen side on. Matisse loved flowers and often included them in his paintings, sometimes as the main subject but more often as a detail of a figure composition or an interior. He also regularly used floral motifs in his paper cutouts and his designs for stained glass—media that occupied much of his time in his final years.

▼ **COLOR BALANCE** The window shutter is rendered in a glowing orange punctuated with red stripes. In his writings on art, Matisse devotes a great deal of attention to color, which was of central importance to him. He was much concerned with achieving the exact balance of color and tone that satisfied him, and he did this intuitively, seeking "a living harmony of colors, a harmony analogous to that of a musical composition."

▶ **VIEW THROUGH WINDOW** A view through a window was a favorite motif in Matisse's work. In particular, he liked depicting tall windows that let in floods of strong Mediterranean light. He used this device at Coullioure in the south of France near the Spanish border, where he painted in the summer of 1905 (far right), as well as in numerous paintings set in his own homes on the French Riviera (he lived mainly in Nice but also for a time at Vence, a few miles inland). Even the dark colors in the garden here seem warmed by the sunshine.

ON **TECHNIQUE**

Matisse's love of pure color and bold shapes found its final expression in a series of large paper cutouts—his principal form of working from 1951 until his death in 1954. Assistants brushed gouache (opaque watercolor) onto sheets of white paper and Matisse cut shapes out of these with scissors—he referred to the technique as "painting with scissors." The cutouts were pinned and then glued onto a background sheet of paper according to Matisse's directions, and this was later mounted on canvas.

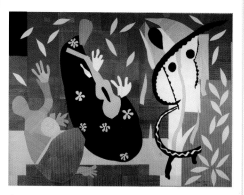

▲ *La Tristesse du Roi*, Matisse, 1952, gouache-painted paper cut-outs on canvas, 115 × 152in (292 × 386cm), Musée National d'Art Moderne, Paris, France

IN **CONTEXT**

Matisse first made a major impact on the art world in 1905, when he and a group of young painters exhibited together in Paris. They were called Fauves ("wild beasts" in French) because they used bright, non-naturalistic colors and bold brushstrokes, as in this painting of the small fishing port of Collioure in the South of France. Such works seemed crude and vulgar to conservative eyes and attracted mockery, but Fauvism is now recognized as the first of the innovative movements that shaped modern art.

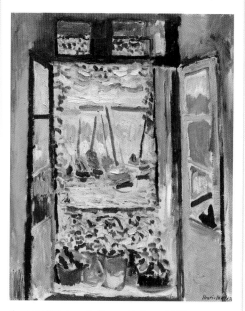

▲ *Open Window, Collioure*, Matisse, 1905, oil on canvas, 21¾ × 18in (55.3 × 46cm), National Gallery of Art, Washington DC, US

Autumn Rhythm (Number 30)

1950 ▪ ENAMEL ON CANVAS ▪ 105 × 207in (266.7 × 525.8cm)
METROPOLITAN, NEW YORK, US

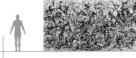

SCALE

JACKSON POLLOCK

Action painting, the physical engagement and emotional struggle of the artist with the canvas, is a hallmark of Jackson Pollock's work and is shown to exemplary effect in *Autumn Rhythm (Number 30)*. It is one of the artist's best-known drip paintings and its massive size and restless energy draw you into its complex web of swirls and splashes. With these dynamic works, Pollock revolutionized the way a painting was made. He abandoned the easel in favor of his studio floor, where he laid out his large canvases and flicked paint on them from the end of the brush, dripped it from sticks, or threw it on straight from the can. He worked in a spontaneous, yet highly

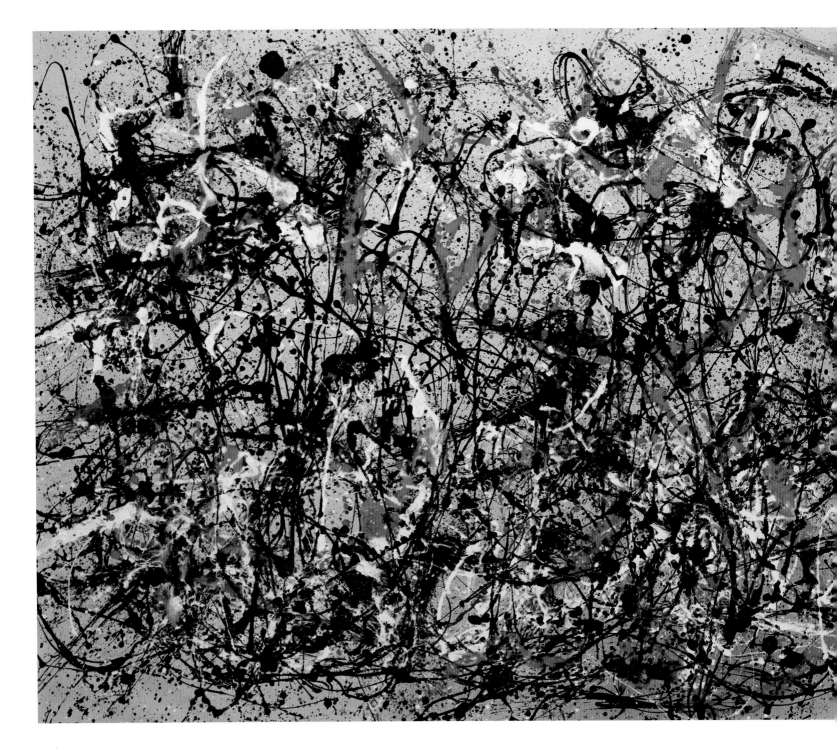

controlled, manner. In this painting Pollock appears to limit himself to four harmonious, earthy colors. These suggest the fading tones of the autumn landscape, while their energetic application hints at strong winds and swaying branches. Although Pollock dispensed with focal points, edges, and other conventional ideas of composition in his abstract works, the painting is neither wild nor chaotic. Layers of color combine in a rhythmic mesh of intricate patterns, flowing lines, and curves.

Photographs of Pollock at work in his studio on *Autumn Rhythm (Number 30)* show him moving around and over his canvas, reaching across it and swinging his arms or flicking his wrist to throw the paint down. This energetic form of action painting and Pollock's total absorption in the process created the powerful lines and arcs that are the characteristic feature of this work.

Influences

Pollock's innovative style drew on a wide range of diverse influences, from Picasso and aspects of Surrealism to the artists of the Mexican mural movement, such as Orozco and Siqueiros, as well as Jung's theories of the unconscious. He was also inspired by Native American artworks in New York museums and the ritual Navajo sand painting he saw in 1941. Indeed, Pollock's unusual working methods, which involved demanding physical activity as well as intense mental concentration, were often described as ritualistic.

This painting was made at the peak of Pollock's career, during a relatively settled period in his turbulent personal life. Its free, fluid style, subtle tones, and complex, web-like structure show his mastery of paint at its most expressive.

> These drip paintings by Pollock are so full of things to look at…that you can't avert your eyes. They pour thoughts into your mind "
>
> **PAUL RICHARD** *WASHINGTON POST*, 1998

JACKSON **POLLOCK**

1912–56

A leading American Abstract Expressionist, Jackson Pollock revolutionized art. His extraordinary drip paintings established him as one of the most original painters of his time.

Born in Cody, Wyoming, Pollock spent his childhood in Arizona. He moved to New York in 1930 and took classes at the Art Students League with painter Thomas Hart Benton. While making paintings, including landscapes, he worked in the mural division of the Federal Arts Project, part of a national funding program set up during the Depression. In his ongoing fight against severe alcoholism, Pollock sought treatment from a Jungian analyst. Paintings heavy with symbolism, such as *The She-Wolf* (1943) and *Guardians of the Secret* (1943), were included in his first one-man show at Peggy Guggenheim's Art of This Century gallery. Following his marriage to artist Lee Krasner in 1946, the couple moved from New York to Long Island, where Pollock made his first drip paintings in 1947. These abstract works were much larger than his previous canvases, giving him space for movement and self-expression. In 1956, depressed and still battling with alcoholism, Pollock died in a car crash.

Visual tour

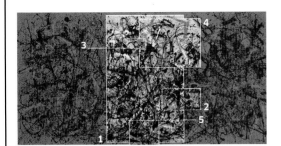

KEY

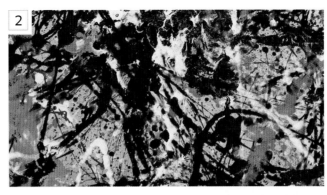

◀ **AUTOMATISM** Pollock was influenced by Surrealist automatism—allowing the subconscious to guide the artist's hand. He once said, "When I am in my painting, I'm not aware of what I am doing." He did not start the painting with an image in mind, but allowed it to develop as he worked.

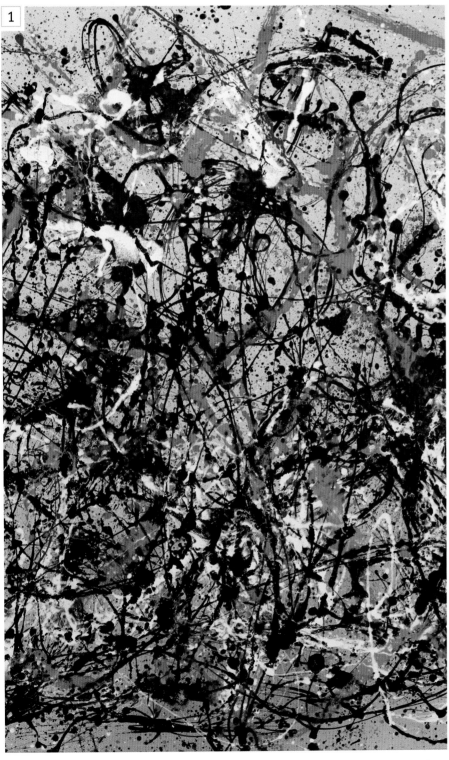

▲ **RESTRICTED PALETTE** Pollock preferred enamel house paint to artists' oils because it was more fluid. He only used four colors in this painting. He began by flicking thinned black paint on to the canvas from a stubby brush. The canvas was unprimed, so the paint sank in and the weave remained visible, adding texture to the work. An intricate network of white, brown, and blue-grey rhythmic lines was then built up over the black, making the black appear to come forward. If you look very closely, you can see that the thicker areas of paint dried slowly, giving them the texture of wrinkled skin.

◀ **SENSE OF MOVEMENT** The swirling tangle of lines, splashes, and dots looks explosive. Pollock's energetic, dance-like movements have been translated into dynamic sweeps of seemingly haphazard marks—elegant lines of diluted black paint collide and intersect with broader white and brown lines, smudges, and splatters. The whole canvas is full of movement; some marks are the result of chance, while others are not at all random, but carefully choreographed.

4

◄ PERSONAL INVOLVEMENT
The dazzling intricacy of the painting draws the viewer right into it. Although Pollock has painted an abstract work with no recognizable forms at all, you try to make sense of what you can see, following the switchback lines as they rise and fall, then double back upon themselves, like fireworks falling from the sky.

ON **TECHNIQUE**

Pollock made his drip paintings in a barn at his home in East Hampton, Long Island. His method was known as action painting. He unrolled a large canvas on the floor of his studio so that he could walk all the way around it and stretch across it to flick, pour, or throw paint where he wanted (see below). He even stepped on the canvas when necessary. His painting implements ranged from brushes and sticks to knives and turkey basters.

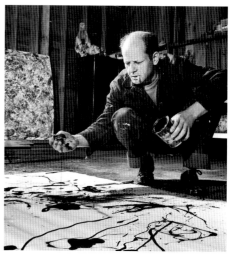

▲ *Pollock painting*, Hans Namuth, 1950

IN **CONTEXT**

In 1939, while undergoing treatment for alcoholism, Pollock began to take his drawings along to therapy sessions, exploring possible interpretations with his Jungian analyst. As an artist, he was interested in the idea that creative impulses came directly from the unconscious. He was also intrigued by the Surrealist automatism of André Masson, who advocated abandoning conscious control in order to create random images (see below).

In 1946, Pollock began to focus exclusively on the act of making a painting rather than worrying about its figurative or symbolic content. This was the turning point in his career, when he forged his distinctive personal style.

► ALL-OVER COMPOSITION There is no focal point in the composition and the center of the painting is no more important than the edges. Pollock said that his paintings had "no beginning or end" and they have been described as "all-over compositions." *Autumn Rhythm (Number 30)*'s huge size evokes the epic landscapes of the American West, where Pollock grew up.

5

▲ *Automatic Drawing*, André Masson, c.1924–25, Indian ink on paper, 9½ × 10¾in (24.2 × 27.1cm), on loan to the Kunsthalle, Hamburg, Germany

Untitled

c.1950-52 ■ OIL ON CANVAS ■ 74¾ × 39¾in (190 × 101cm) ■ TATE, LONDON, UK

SCALE

MARK ROTHKO

Glowing softly and mysteriously, with hazy forms that seem to pulsate gently, this sonorous canvas conveys a feeling of exalted contemplation. Its creator, Mark Rothko, was one of a loose group of American painters, now known as Abstract Expressionists, who changed the course of art in the late 1940s and 1950s. Before this, abstract art had always been something of a minority—even esoteric—taste, but the success of these painters put it center stage in world art. Their paintings were often very large, but they were even more remarkable for their emotional intensity. To these painters, abstract art was not a matter of arranging shapes and colors, but of conveying deep feelings about the human condition.

None of them cared more passionately about their art than Rothko—a melancholy, solemn, temperamental character. He said that his paintings were about "expressing basic human emotions—tragedy, ecstasy, doom, and so on," and although they are often tranquil in feeling, he found working on them intensely effortful ("torment," he once said). Even when they were finished, the struggle was not over, as he liked to have control over how they were hung and lit. He thought that ideally his paintings should be arranged in groups filling a whole room, without the presence of work by other artists.

MARK **ROTHKO**

1903-70

Rothko was one of the leading figures in a group of American abstract painters whose success helped New York replace Paris as the world capital of progressive art.

Born in Russia as Marcus Rothkowitz, Rothko settled in the US with his family when he was 10. He was mainly self-taught as an artist. Early in his career, his work showed varied influences, including Expressionism and Surrealism, but from the late 1940s, he developed the distinctive style of abstraction for which he became famous. Like many other American artists of his generation, he struggled during the Great Depression of the 1930s and also during the 1940s. However, in the 1950s, he finally gained critical and financial success. The seal was set on his reputation in 1961 when he had a major one-man exhibition at the Museum of Modern Art, New York (the world's most prestigious institution of its kind). In spite of enjoying great acclaim, Rothko became increasingly depressed (he had various personal problems, including overindulgence in alcohol, tobacco, and barbiturates), and he committed suicide in his studio in 1970.

Visual tour

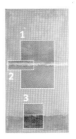

KEY

▶ **VARIED YELLOWS**
Rothko's paintings may look simple, but he made them with great care, first in the planning stage and then in the actual application of paint. He used layer after layer to create the subtle variations in color, tone, and texture he desired.

1

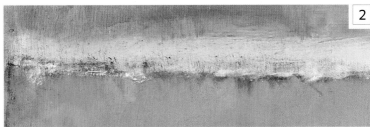

2

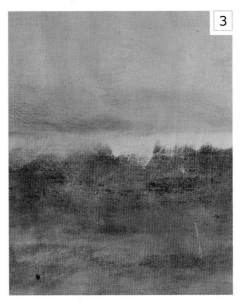

3

▲ **LINE** Just above center, a horizontal line shows the delicate modulations of Rothko's brushwork. A dedicated craftsman, he kept favorite brushes for many years. Contrary to what some say, he did not use sponges to apply paint.

◀ **NATURE COMPARISON**
Rothko disliked the notion that his paintings could be interpreted as abstracted landscapes. Still, to many observers they evoke the mystery and vast spaces of nature, as in a view over an ocean to a distant horizon. The blurred brushwork can suggest waves or mist.

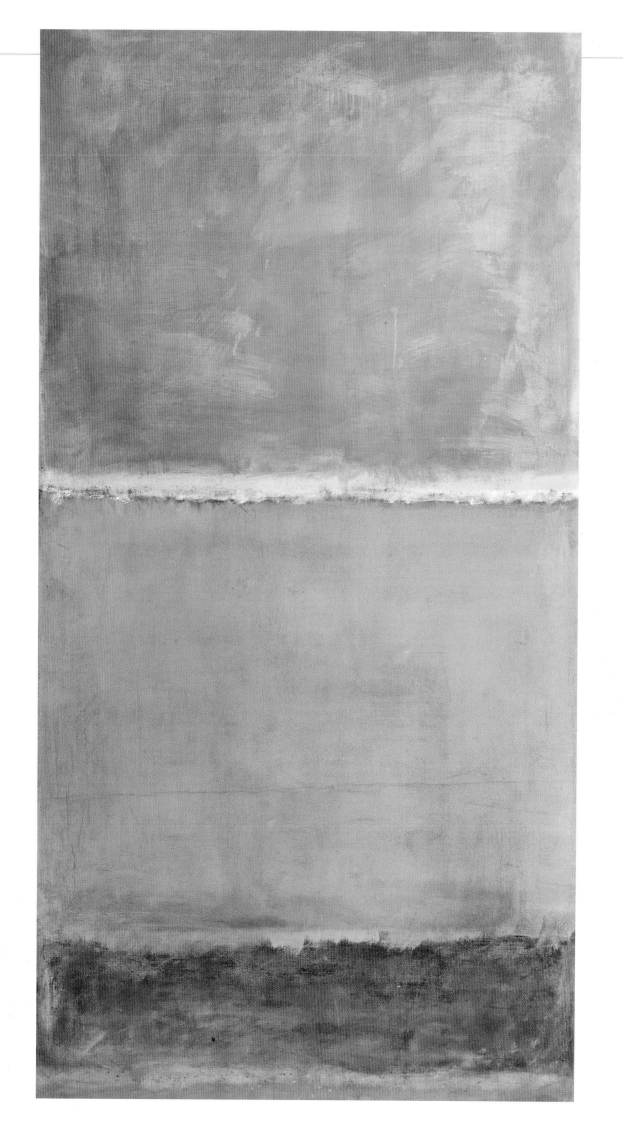

Marilyn

1967 ■ SCREENPRINT ON PAPER ■ 35¾ × 35¾in (91 × 91cm) ■ TATE, LONDON, UK

ANDY WARHOL

SCALE

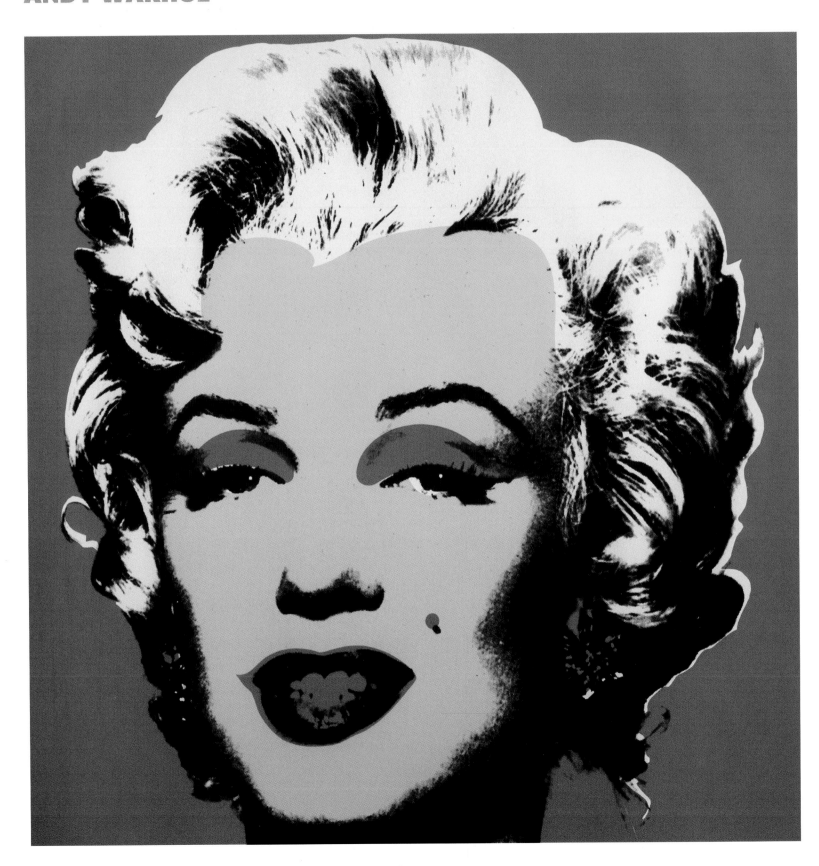

Shortly after the death of Marilyn Monroe in 1962, Warhol began work on his series of portraits of the actress. He transformed a single image–a black-and-white publicity still from the 1953 film *Niagara*–into an array of prints and paintings. In the original photo, Monroe seemed glamorous and carefree, but Warhol's alterations created a range of moods. In some images, Marilyn was exalted, like a religious icon, while in others she was turned into a grotesque victim of the celebrity culture that had brought her fame.

The high priest of Pop

Warhol mined a rich vein of new, popular imagery. Previous generations of artists had reached a saturation point in their attempts to shock. As Pop artist Roy Lichtenstein remarked, "It was hard to get a painting, which was despicable enough, so that no one would hang it. Everyone was hanging everything." Despite this attitude, the art world remained snobbish about one area of creative endeavor–commercial art. Critics paid no attention to advertisements, to labels and packaging, or grainy newspaper photos. Warhol had cut his teeth on this type of work and recognized its potential. From the 1960s, he focused on "comics, celebrities, refrigerators, Coke bottles–all these great modern things that the Abstract Expressionists tried so hard not to notice at all." Warhol's treatment of this imagery cast the objects in a new light. The rows of soup cans resembled the stacked shelves of a supermarket, while the smudged, fading strips of Marilyn photos underlined the illusory nature of stardom.

ANDY **WARHOL**

1928-87

The most celebrated exponent of Pop art, Warhol rose to prominence in the 1960s. He gained notoriety with his iconic images of movie stars, soup cans, and Coke bottles.

Andy Warhol (originally Andrew Warhola) was born to East European immigrants in Pittsburgh, and trained at the Carnegie Institute of Technology. Moving to New York, he became an award-winning commercial illustrator. Reacting against the highly personal, handmade art of the Abstract Expressionists, he began to create work that seemed mass produced, impersonal, and disposable. In a deliberate bid to counter the traditional association of the artist with craftsmanship and individuality, he used assistants and named his studio "The Factory."

Visual tour

KEY

1

◀ **LIPS** In traditional portraiture, every care is taken to perfect the completed picture. Warhol did the opposite. He deliberately mimicked the printing blemishes. Here, the pink blob of color does not precisely correspond with Marilyn's lips, and the artist has consciously neglected to whiten her teeth.

ON **TECHNIQUE**

Warhol produced many of his most memorable images using the silkscreen process. This type of screenprinting had been widely employed since the early 20th century, when it played a major role in textile production. Warhol had used the process in his own commercial work, but soon found that it was equally suitable for fine art, because "you get the same image slightly different each time." A photographic image was transferred onto a fine mesh screen, where it served as a form of stencil. The screen was placed over canvas or paper, and then paint was pushed through the mesh using a squeegee–a rubber blade. The paint was prone to clogging, but Warhol made a virtue of these accidental blemishes.

▲ **EYES** Warhol manipulated his source photo, here exaggerating the cosmetic elements to create a grotesque parody of conventional notions of beauty. Marilyn's eye-shadow, like her lipstick, is overpainted with a crude slab of color, while her peroxide hair is the same bilious shade of yellow as her eye.

▲ **HAIRLINE** Warhol did his utmost to make the real appear unreal. A firm, schematic line separates Marilyn's face from her hair, and neither component appears genuine. Her face resembles a mask and her hair looks like a wig. Their artificial appearance is emphasized further by the flat, unnatural colors.

To a Summer's Day

1980 ▪ ACRYLIC ON CANVAS ▪ 45½ × 110½in (115.5 × 281cm) ▪ TATE, LONDON, UK

SCALE

BRIDGET RILEY

One of Riley's most beguiling works, this painting takes its title from a Shakespeare sonnet: "Shall I compare thee to a summer's day?" Fittingly, the picture does precisely that. It conjures up memories of warm and sunny days during the artist's early years in Cornwall, "swimming through saucer-like reflections, dipping, and flashing on the sea surface."

A pioneer of Op art

Riley had forged her reputation 15 years earlier working in the heady atmosphere of the "Swinging Sixties" in London. There, she joined the vanguard of the Op art movement, which explored the artistic possibilities of visual illusions. For a brief period, this style was hugely popular in Britain and the United States. It influenced many branches of the arts, coinciding with a taste for eye-catching, psychedelic effects. Op art designs could be found on women's fashions, wallpapers, album covers, and commercial packaging. One American company even pirated a Riley composition for their range of clothing.

In her later work, Riley distanced herself from some of these trends. With the introduction of color, she began to create far more subtle effects. Basing her compositions on the simplest components—often just parallel bands of curved or vertical lines—she exploited the interaction between adjacent colors to create a calming sense of movement, rhythm, and depth. Even though her mature work is entirely abstract,

Riley's paintings often represent her response to the physical world. As she explained, "I draw from nature, although on completely new terms. For me, nature is not a landscape, but the dynamism of visual forces—an event rather than an appearance."

BRIDGET **RILEY**

1931–

One of the pioneers of the Op art movement, which blossomed in the 1960s, Riley is a major force in British art. She is famed for her mesmerizing, large-scale paintings.

Though born in London, Riley was influenced more by her childhood years in Cornwall, during World War II. These instilled in her a profound love of nature, which was to shape the future course of her art. On her return to the capital, she trained at Goldsmiths' College and the Royal College of Art. She had an early interest in the shimmering, optical effects achieved by Georges Seurat (see pp.172–75), but her own experiments soon took her into more abstract territory. Riley's breakthrough came with a series of dazzling, black-and-white pictures in the early 1960s. These created a huge impression at *The Responsive Eye*, a keynote exhibition for the Op art movement. Riley's later paintings relied less on optical trickery. Memories of Cornwall, as well as a seminal trip to Egypt in 1981, both had a telling effect on her style. Her paintings have been used to adorn public buildings and in the theater.

Visual tour

KEY

▼ **OPTICAL ILLUSIONS** From the 1970s, Riley produced a series of paintings of waves rippling the sea. She made a pattern of curved lines, which narrow and broaden at intervals. Diagonals, formed by the crest of each wave, add to the impression of a gentle swell of water.

1

2

► **COLOR INTERACTION**
Inspired, in particular, by Seurat and the Neo-Impressionists, Riley has always been meticulous in her choice of colors. She uses a restricted palette, but combines her tones carefully to create a lively interaction. Here, the two main colors are yellow ocher and light blue, but hints of violet and rose are also threaded into the composition.

ON **TECHNIQUE**

Riley's compositions are structured and precise, a tribute to her rigorous preparation methods. She begins by making small studies in gouache to test out her color combinations. If the results are satisfactory, she proceeds to create a full-size cartoon, outlined in pencil and gouache. She draws out the cartoon on cartridge paper, on the floor. Riley then hangs it on her studio wall, so that she can study its effects in detail. In view of the size of her pictures, she often uses templates, made out of hardboard, to help with the preparation of the cartoon and the final painting. On some occasions, she also employs assistants.

The Dance

1988 ▪ ACRYLIC ON PAPER LAID ON CANVAS ▪ 83½ × 107¾in (212.6 × 274cm) ▪ TATE, LONDON, UK

PAULA REGO

SCALE

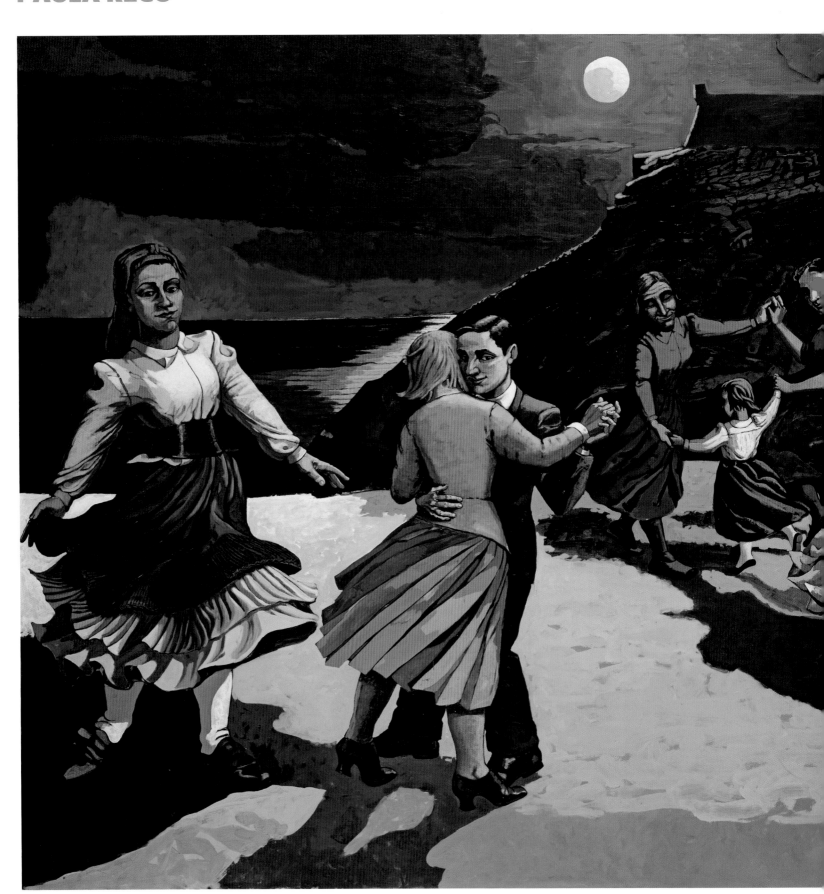

By the silvery light of a full moon, we see a group of figures dancing by a seashore. Painted in blues and greys, with splashes of intense color, the scene is bathed in an eerie glow that suggests an episode from a dream or a Surrealist fantasy. The dancing figures are short and stocky and their movements and dress are reminiscent of traditional folk dances and the fashions of the 1950s. Looming behind them on a rocky outcrop a sinister, fortress-like building adds to the strange, unsettling mood of the painting.

Stories and memories

Some of Paula Rego's best-known works draw upon folk and fairy tales; in others she creates ambiguous, uncomfortable images connected with her childhood memories, fantasies, and personal fears. Their narratives change and evolve as Rego works on her paintings and their meaning is rarely clear or resolved. Painted on an epic scale, The Dance appears to contain autobiographical references to Rego's Portuguese upbringing—primarily in the figure of the adolescent girl on the left—but the focus of this expressive and symbolic painting is the role of women. It represents the cycle of female life, from childhood to sexual maturity, motherhood, and old age. The composition bears a marked similarity to that of The Dance of Life, 1899–1900, by the Norwegian Symbolist painter Edvard Munch, which also shows groups of people dancing by a moonlit sea, with a figure of innocence on the left.

In contrast with the enduring solidity of the rock and building in the background, the dancers twirl and sway. The oddly proportioned figures, distorted perspective, and uneasy atmosphere are all hallmarks of Rego's distinctive style.

PAULA REGO

1935–

Rego was born in Portugal but has spent most of her life in Britain. A leading contemporary painter and printmaker, she creates subversive images based on storytelling.

The only child of wealthy parents, Rego grew up in Portugal, then attended an English finishing school. She trained at the Slade in London, where she met the artist Victor Willing, whom she later married. An accomplished draftswoman, Rego has developed a style of narrative painting that draws on real or imagined events, stories from her childhood, and fairy tales. For her large-scale figurative paintings she draws inspiration from specially made props and models in costume. Themes of sexuality, control, and submission recur in her work, such as The Policeman's Daughter, 1987. The Casa das Histórias (House of Stories) in Cascais, Portugal, is dedicated to her art.

Visual tour

KEY

▼ DARK BUILDING
In Rego's preliminary drawings, this building looked more like a castle. Its shape has been simplified and it is an oppressive and solid presence in the composition. Its meaning, as with other elements in the work, is very much open to interpretation.

◄ COUPLE The young couple dancing cheek-to-cheek convey a feeling of nostalgia, possibly for the artist's past. The bright yellows of the woman's clothes are intensified by the blues of the landscape and the grey of the suit.

1

3

4

◄ YOUNG GIRL Absorbed in the dance, the girl in Portuguese dress may represent the young Rego. Her white blouse and petticoats suggest inexperience. She is larger than the other figures, perhaps to signify her importance as the central character.

▲ CIRCLE OF LIFE The three figures dancing in a circle with their hands joined together look like a child, her mother, and her grandmother. Together, they represent the three main stages of a woman's life.

Athanor

2007 ▪ EMULSION, SHELLAC, OIL, CHALK, LEAD, SILVER, AND GOLD ON CANVAS
▪ 30 × 15ft (9.15 × 4.56m) ▪ LOUVRE, PARIS, FRANCE

ANSELM KIEFER

SCALE

A naked man is lying flat on his back on the ground, with his arms by his sides. It is not clear whether he is dreaming or dead. Rising above him and filling almost the entire space in this massive painting is the swirling, star-studded cosmos, to which his body is connected by a silvery thread of light. Kiefer uses a restricted palette and the work is monochrome, apart from tiny glimpses of blue and the reddish-brown earth that cakes the foreground. Horizontal lines of gold and silver break up the composition and the surface is dusted with silver and gold powder. As in other works, the artist has added words that are integral to the composition in his spidery handwriting.

This is a painting that poses fundamental questions about man's place in the universe and explores notions of space, time, and memory, as well as the transcendent power of art. The title, *Athanor*, refers to the furnace used by medieval alchemists to try to transform base metals into gold. The term was also sometimes used to describe the quest for spiritual rebirth. Kiefer gave the same title to earlier paintings, and the theme of transformation has been a recurrent motif throughout his work.

After the success of Kiefer's *Falling Stars* exhibition at the Grand Palais in Paris in 2007, which included a similar work, *Athanor* was commissioned by the Louvre for the permanent collection—the first piece to be commissioned by the museum since Georges Braque painted a ceiling in 1953, and an acknowledgement of Kiefer's international reputation. The artist made two sculptures, incorporating lead and sunflowers, to complement the painting, which is enclosed in an arch at the top of a staircase. These works

Visual tour

KEY

▼ **SELF-PORTRAIT** The head of the foreshortened naked male bears a strong resemblance to Kiefer. Indeed, in a 2007 interview when the work was first exhibited, the artist described the painting as a self-portrait, as well as an image of mankind. He said, "I am that man...man is linked to the universe, he is in metamorphosis, he will be reborn. But it is a sad work as he does not know why he is reborn."

▶ **THREAD OF LIGHT** A filigree shaft of light connects the figure to the sky and may also run down through the body into the earth. The light enters through the solar plexus, the place where *prana*—the life force—is stored, according to Eastern traditions such as yoga. The silvery thread helps to create a strong upward movement in the painting and links man and the universe: the microcosm and the macrocosm of esoteric thought.

2

3

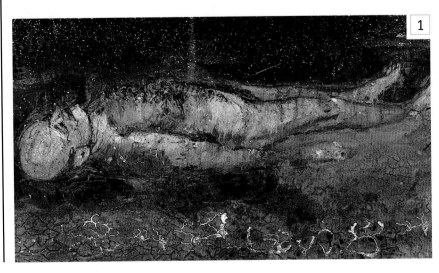

1

▲ **SILVER AND GOLD** Thick layers of black paint evoke the depths of the cosmos. The stars are pinpricks of light that appear to recede into infinity. Kiefer has used silver and gold powder; its lightness balances the heavy paint.

also allude to changing states: *Danaë*, a princess seduced by Zeus in the form of a golden rain shower; and *Hortus Conclusus* ("enclosed garden" in Latin), which was a medieval symbol of Mary's virginity and of paradise.

ANSELM **KIEFER**

1945–

Drawing largely on German mythology and history, Kiefer's paintings and sculptures blend imagery and medium to explore questions about human existence.

Born in Donaueschingen, Germany, Kiefer had a varied and intermittent training in art. Most of his works from the 1960s to the 1990s were based on German history, myth, and culture, often exposing the Third Reich's use of nationalistic imagery. Kiefer is best known for his vast paintings, which are often layered with thick paint, lead, minerals, and dried plant matter. Since the late 1960s, as well as paintings, drawings, and photographs, he has created many large-scale artist's books. Kiefer moved to the South of France in 1992. He has exhibited worldwide, and currently lives in Paris.

▼ **SCRIPT** Three hand-painted words can be seen at the right-hand side. Reading from bottom to top, they are: *nigredo*, *albedo*, and *rubedo*. These Latin terms correspond to the three main stages of the alchemical process and their associated colors—black, white, and red.

▲ **ROUGH TEXTURES** The thick, raised surface at the bottom of the painting is made of reddish soil from the artist's former home in southern France. Kiefer has poured molten lead into the cracks of its rough surface, creating a series of solidified rivulets, like hieroglyphics. Lead was the base material and starting point of the alchemical process.

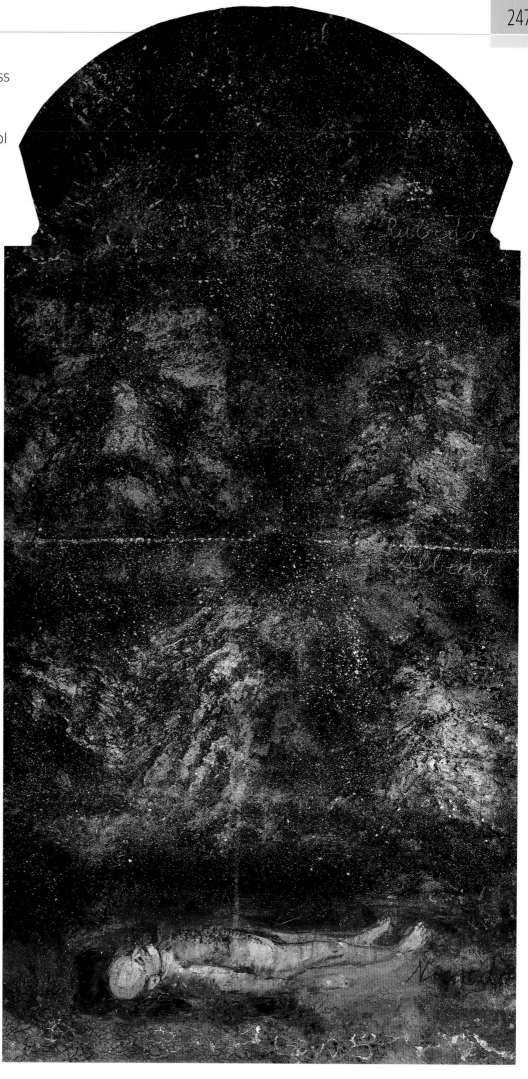

Glossary

ABSTRACT ART
Art that does not represent recognizable objects or scenes.

ABSTRACT EXPRESSIONISM
A type of abstract painting that emerged in New York in the 1940s and dominated American art through the 1950s. Abstract Expressionists mainly used large canvases and emphasized the sensuousness of paint.

ACADEMIC ART
Western art produced from the 16th century onward by artists trained at professional schools (academies). These tended to foster tradition rather than originality, so the phrase "academic art" is often used pejoratively.

ALLEGORY
A work of art in which the surface meaning is used as a metaphor to convey an abstract idea, often a spiritual or moral truth.

ALTARPIECE
A painting or other work of art placed on, above, or behind the altar in a Christian church. Altarpieces often depict multiple scenes, typically showing episodes from the Bible, or lives of saints *See also* predella.

ART NOUVEAU
A decorative style that spread throughout Europe at the end of the 19th century and the beginning of the 20th century. It featured curved shapes derived from tendrils, plant stems, flames, waves, and flowing hair.

AUTOMATIC DRAWING
A type of drawing in which the artist suppresses conscious control, to let the hand move randomly across the page, revealing the workings of the subconscious.

BAROQUE
The dominant artistic style during the 17th century (and in some places well into the 18th century). The style is characterized by rhetoric, intense emotion, and a sense of movement.

BRÜCKE, DIE (THE BRIDGE)
Pioneering group of German Expressionist artists, formed in Dresden in 1905 and disbanded in 1913. The leading member was Ernst Ludwig Kirchner.

BYZANTINE ART
Art produced in the Byzantine Empire (and in territories under its influence). The empire lasted from 330 to 1453. Byzantine art was overwhelmingly religious in subject, and highly formal and conservative in style.

CHIAROSCURO
A term (Italian for "light-dark") describing the use of strongly contrasting areas of light and shadow in a painting. Caravaggio was notable for his use of chiaroscuro.

CLASSICAL ART
The art and architecture of Greek and Roman antiquity and later art inspired by it. In its broadest sense, classical art describes art that is created rationally rather than intuitively, and in which adherence to traditional ideals takes precedence over personal expression.

COMPLEMENTARY COLORS
Colors that are considered the "opposite" of each other. The complementaries of the three primary colors (blue, red, and yellow) are made up of a mixture of the other two—so red is the complementary of green, which is made up of blue and yellow. When they are used next to each other, complementary colors appear to be stronger and more vibrant.

COMPOSITION
The arrangement of the various parts of a painting or other work of art to form a satisfactory whole.

CUBISM
A revolutionary and highly influential type of painting that was developed in 1907–14 in Paris by Braque and Picasso. Cubist paintings abandoned the fixed viewpoint that had dominated Western art since the Renaissance. Instead, objects are seen from multiple viewpoints, and forms are fragmented and rearranged.

DIVISIONISM
See pointillism.

ENLIGHTENMENT
An 18th-century philosophical movement in Europe that placed great value on reason.

EN PLEIN AIR
A term (French for "outdoors"), used to describe the practice of painting outdoors.

EXPRESSIONISM
Art in which the artist's subjective reactions and emotions take precedence over observed reality. Color and form are often distorted or exaggerated.

FAUVISM
A short-lived but influential movement in French painting, launched in 1905. The Fauves ("wild beasts" in French) were so called because they used fierce, expressive colors. Matisse was the leading figure of the group.

FIGURATIVE ART
Art that depicts recognizable scenes and objects. It is the opposite of abstract art.

FOCAL POINT
The place in a composition to which the eye is drawn most naturally.

FRESCO
A technique of painting on walls (and ceilings) in which pigments mixed with water are applied to wet plaster.

GENRE PAINTING
A painting that shows a scene from daily life, particularly popular in 17th-century Holland.

GLAZE
In painting, a transparent layer of thin paint (usually oil paint) that is applied over another layer to modify the color and tone.

GOTHIC
The style of art and architecture that flourished in most of Europe from the mid-12th to the early 16th century. Gothic architecture is characterized by pointed arches and elaborate tracery.

GOUACHE
Opaque type of watercolor, also called body color.

HIGH RENAISSANCE
The period from c.1500 to c.1520, when the great Renaissance painters Leonardo, Michelangelo, and Raphael were all working.

HISTORY PAINTING
Painting depicting momentous or morally significant scenes from history, myth, or great literature. For centuries history painting was traditionally considered the highest branch of the art.

ICON
A sacred image. The term is particularly applied to small pictures of saints and other holy personages in Byzantine art.

IMPASTO
Thick, textured brushwork applied with a brush or a knife. Many of Rembrandt's paintings contain impasto passages.

IMPRESSIONISM
A movement in painting that started in France in the late 1860s and spread widely over the following half century. Rather than producing detailed, highly finished paintings, the Impressionists worked with freshness and spontaneity, using broken brushwork to capture an "impression" of what the eye sees.

LINEAR
A term used to describe a work of art in which line (rather than mass or color) predominates.

MINIATURE
A term applied to two distinct types of small painting: illustrations in manuscript books (in Eastern as well as Western art); and portraits that are small enough to be held in the palm of the hand or worn as jewelery. The latter were popular in Europe from the 16th century.

MODELING
Creating the illusion of three-dimensional form in a painting.

NATURALISTIC
A term for art that looks realistic, faithfully imitating forms in the natural world.

NEOCLASSICISM
A movement based on Ancient Greek and Roman art that began in the mid-18th century, partly as a reaction to the frivolities of Rococo. It is characterized by seriousness of mood and clarity of form.

OP ART
A type of abstract art, popular in the 1960s, that used hard-edged flat areas of paint to stimulate the eye and create an impression of movement.

ORIENTALISM
The imitation or depiction of Eastern culture in Western art. The term often refers specifically to a fashion in 19th-century art (especially in France) for exotic imagery taken from the Near and Middle East and North Africa.

PAINTERLY
A approach to painting in which the artist sees in terms of color and tone rather than line. It is the opposite of linear.

PERSPECTIVE
A method of suggesting depth on a two-dimensional surface, by using such optical phenomena as the apparent convergence of parallel lines as they recede from the viewer.

PIETÀ
A term (Italian for "pity") applied to a painting or sculpture showing the Virgin Mary supporting the body of the dead Christ.

PIGMENT
The coloring matter, originally often made from clays or ground minerals, that is mixed with a binding agent, such as egg or oil, to make paint.

POINTILLISM
A technique of painting with dots of pure color that, when viewed from a suitable distance, appear to merge together to create a new color. Also called divisionism.

POP ART
Art that makes use of the imagery of popular culture, such as comic strips and packaging. Pop Art began in Britain and the US in the 1950s and flourished in the 1960s.

POSTIMPRESSIONISM
A term applied to various trends in painting arising from and after Impressionism in the period c.1880–1905. Cézanne, Gauguin, van Gogh, and Seurat are generally considered to be the leading Postimpressionist painters.

PREDELLA
A small painting or series of paintings set horizontally below the main part of an altarpiece.

REALISM
A mid-19th century French movement, in which contemporary subject matter, including urban and rural life, was painted in a sober and unidealized manner.

RENAISSANCE
A rebirth of the arts and learning that occurred from the end of the 14th century to the end of the 16th century, especially in Italy, the Germanic states, and Flanders. It was inspired by the classical cultures of Rome and Greece and informed by scientific advances, especially in anatomy and perspective. In Italy, the period is usually divided into the Early Renaissance until c.1500, the High Renaissance until c.1520, and the Late Renaissance until c.1580.

ROCOCO
A lighter and more playful development of the Baroque style that emerged c.1700. In some parts of Europe the style flourished until almost the end of the century, but in France, for example, taste turned to the severe Neoclassicism from about 1760.

ROMANTICISM
A broad movement in the visual arts, music, and literature in the late 18th and early 19th centuries. Romantic artists reacted against the reason and intellectual discipline of Neoclassicism and the Enlightenment. Instead, they celebrated individual experience and expression, and often sought inspiration in nature and landscape.

SALON
An official French painting exhibition, first held in 1667. In 1881 the government withdrew support, and it began to lose prestige to independent exhibitions—including the Salon d'Automne and the Salon des Indépendants.

SALON D'AUTOMNE
An annual exhibition first held in Paris in 1903. The Fauves made their public debut there in 1905.

SALON DES INDÉPENDANTS
An annual exhibition that was first held in Paris in 1884. Seurat was the most important figure in establishing it.

SALON DES REFUSÉS
A controversial exhibition held in Paris in 1863 on the orders of Napoleon III, to show works rejected from the official Salon.

SATURATED
A term for color that is concentrated and undiluted, so at its most intense.

SFUMATO
A term (Italian for "faded away") used to describe the blending of tones so subtly that there are no perceptible transitions—like smoke fading into the air.

SURREALISM
An artistic, literary, and political movement that flourished in the 1920s and 1930s, initially in France and then in several other European countries and in the US (it was the most widespread and influential avant-garde movement in the period between the two world wars). The main aim of Surrealism was to liberate the creative powers of the subconscious; it was envisaged as a way of life rather than a matter of style.

SYMBOLISM
Loose term for an artistic and literary movement that flourished from about 1885 to 1910. Symbolist artists favored subjective, personal representations of the world and were often influenced by mystical ideas.

TEMPERA
A binding medium, usually egg yolk, mixed with pigment. In Italy, egg tempera was the standard medium used for panel paintings from the 13th to the 15th century.

TRIPTYCH
A picture consisting of three panels, which are often hinged so that the outer wings can fold over the central panel.

VANISHING POINT
A term used in relation to perspective to denote an imaginary point in a painting toward which lines seem to converge as they recede from the viewer.

Index

Acknowledgments

Dorling Kindersley would like to thank the following for their assistance with the book: Megan Hill, Anna Fischel, Satu Fox, Simone Caplin, Neha Gupta, Bincy Mathew, and Priyaneet Singh for editorial assistance; Margaret McCormack for compiling the index; Lucy Wight for design assistance; Sarah and Roland Smithies (luped.com) for picture research; Adam Brackenbury for creative technical support; and Peter Pawsey for colour correction.

The publisher would like to thank the following for their kind permission to reproduce their photographs.

Key: a = above; b = below/bottom; c = centre; f = far; l = left; r = right; t = top

1 Photo Scala, Florence: (tr); White Images (tl). The Stapleton Collection: (bl). © Tate, London 2011: © 2011 Tate, London / Salvador Dali, Fundació Gala-Salvador Dali, DACS, 2011 (br). **2-3** Photo Scala, Florence: The National Gallery, London. **4-5** akg-images: Erich Lessing. **6** The National Gallery, London: (cl). Philadelphia Museum Of Art, Pennsylvania: Purchased with the W. P. Wilstach Fund, 1937 (tr). Photo Scala, Florence: (bl, br); Austrian Archives (tl); White Images (tc); The National Gallery, London (cr); Neue Galerie New York / Art Resource (bc). The University of Arizona Museum of Art & Archive of Visual Arts, Tucson: Gift of Oliver James, 1950.001.004 © Georgia O'Keeffe Museum / DACS, London 2011 (c). **7** The National Gallery, London: (tl). Photo Scala, Florence: The Metropolitan Museum of Art / Art Resource © ARS, NY and DACS, London 2011 (cl). © Tate, London 2011: © Andy Warhol Foundation for the Visual Arts, Inc. / ARS, NY and DACS, London 2011 (bl). **8-9** Photo Scala, Florence: Photo Opera Metropolitana Siena. **10-11** The Palace Museum, Beijing. **11** Alamy Images: TAO Images Limited (tr). **12-13** The Palace Museum, Beijing. **14-15** Photo Scala, Florence. **15** Photo Scala, Florence: White Images (cr). **16-17** Photo Scala, Florence. **17** The Art Archive: Scrovegni Chapel Padua / Dagli Orti (br). **18-19** Photo Scala, Florence. **21** Photo Scala, Florence: Photo Opera Metropolitana Siena (br). **22-23** Photo Scala, Florence. **23** Corbis: Sandro Vannini (crb). **24-25** Photo Scala, Florence. **25** akg-images: Rabatti Domingie (br). Photo Scala, Florence: (cb). **26** The Bridgeman Art Library: The National Gallery, London (cr). The National Gallery, London: (tr). **27** The National Gallery, London. 28 The National Gallery, London: (clb, tl, ca, bl, tr, bc). **28-29** The National Gallery, London. **29** The National Gallery, London: (tl, ca, br, cr, bl). **30-31** Photo Scala, Florence: The National Gallery, London. **31** Photo Scala, Florence: (crb). **32-33** Photo Scala, Florence: The National Gallery, London. **32** The Bridgeman Art Library: The National Gallery, London (bl). **33** The Bridgeman Art Library: The National Gallery, London (cra). **34-35** Ashmolean Museum, Oxford. **35** Photo Scala, Florence: (tr). **36-37** The Bridgeman Art Library: Ashmolean Museum, University of Oxford, UK (t). **36** The Bridgeman Art Library: Ashmolean Museum, University of Oxford, UK (cla, ca, cb, crb, bl). **37** The Bridgeman Art Library: Ashmolean Museum, University of Oxford, UK (bl, bc, c). Corbis: The Art Archive (crb). **38-39** Photo Scala, Florence: Courtesy of the Ministero Beni e Att. Culturali. **39** Corbis: Summerfield Press (br). **40-41** Photo Scala, Florence: Courtesy of the Ministero Beni e Att. Culturali (c). **40** Photo Scala, Florence: Courtesy of the Ministero Beni e Att. Culturali (bl, ca, tl). **41** The Trustees of the British Museum: (cra). Corbis: Summerfield Press (br). Photo Scala, Florence: Courtesy of the Ministero Beni e Att. Culturali (tl, c, bc). **42-43** The National Gallery, London. **44-45** Museo Nacional del Prado (Spain): (b). **45** Getty Images: Hulton Archive (tr). **46-47** Museo Nacional del Prado (Spain). **47** akg-images: Erich Lessing (br).

Albertina, Vienna: (cr). **48-49** Photo Scala, Florence: Austrian Archives. **48** Getty Images: Hulton Archive (bc). **50** The Bridgeman Art Library: Galleria degli Uffizi, Florence, Italy (crb). **51** Photo Scala, Florence: White Images. **52-53** akg-images: (c). Photo Scala, Florence: White Images (Various). **52** akg-images: (b, tr). **53** The Bridgeman Art Library: Private Collection / © DACS / Cameraphoto Arte Venezia (br); The Royal Collection © 2010 Her Majesty Queen Elizabeth II (cra). **54-55** Photo Scala, Florence. **55** Corbis: Summerfield Press (crb). **56-57** Photo Scala, Florence. **57** Corbis: Alinari Archives (cra); Joseph Sohm / Visions of America (ca). **58-59** akg-images: Erich Lessing. **59** The Bridgeman Art Library: Casa Buonarroti, Florence, Italy (cr). **60-61** akg-images: Erich Lessing. **61** Corbis: Ted Spiegel (cr). **62-63** The National Gallery, London. **63** Getty Images: Hulton Archive (cr). **64-65** The National Gallery, London. **65** akg-images: Erich Lessing (br). **67** Photo Scala, Florence: The National Gallery, London. **68-69** Photo Scala, Florence: The National Gallery, London. **70-71** National Palace Museum, Taiwan, Republic of China. Republic Of China. **72-73** National Palace Museum, Taiwan, Republic of China. Republic Of China. **74-75** Photo Scala, Florence: BPK, Bildagentur fuer Kunst, Kultur und Geschichte. **75** Corbis: Historical Picture Archive (cb). **76-77** Photo Scala, Florence: BPK, Bildagentur fuer Kunst, Kultur und Geschichte. **77** Photo Scala, Florence: The Metropolitan Museum of Art / Art; Resource (br). **78-79** RMN: Jean-Gilles Berizzi (A). **78** Getty Images: Hulton Archive (cra). **80-81** DNP Art Image Archives: TNM Image Archives. **82-83** DNP Art Image Archives: TNM Image Archives. **84-85** The Stapleton Collection. **86-87** English Heritage Photo Library. **88-89** Photo Scala, Florence: Courtesy of the Ministero Beni e Att. Culturali. **88** akg-images: Electa (cb, cr). **90-91** Photo Scala, Florence: The National Gallery, London. **90** The Bridgeman Art Library: Private Collection / Ken Welsh (bc). **92-93** Photo Scala, Florence: The National Gallery, London. **94-95** Photo Scala, Florence: The National Gallery, London. **94** The Bridgeman Art Library: (bc). **96-97** The Bridgeman Art Library: The Royal Collection © 2010 Her Majesty Queen Elizabeth II. **96** The Bridgeman Art Library: Private Collection (bc). **98-99** Museo Nacional del Prado (Spain). **99** Photo Scala, Florence: Courtesy of the Ministero Beni e Att. Culturali (crb). **100-01** Museo Nacional del Prado (Spain). **101** akg-images: © Succession Picasso / DACS, London 2011; Album / Oronoz (br). **102-03** English Heritage Photo Library. **102** Corbis: (cr). **104-05** English Heritage Photo Library. **105** Photo Scala, Florence: BPK, Bildagentur fuer Kunst, Kultur und Geschichte, Berlin (br). **106-07** Photo Scala, Florence: Austrian Archives; Austrian Archives. **106** akg-images: Erich Lessing (crb). **108-09** Photo Scala, Florence: Austrian Archives; Austrian Archives. **109** Photo Scala, Florence: White Images (br). **110-11** Image Courtesy National Gallery Of Art, Washington: Patrons' Permanent Fund and Gift of Philip and Lizanne Cunningham. **112-13** Image Courtesy National Gallery Of Art, Washington: Patrons' Permanent Fund and Gift of Philip and Lizanne Cunningham. **113** Courtesy of Sotheby's Amsterdam: (crb). **114-15** Image Courtesy National Gallery Of Art, Washington: Patrons' Permanent Fund and Gift of Philip and Lizanne Cunningham. **115** Photo Scala, Florence: The National Gallery, London (br). **116-17** The National Gallery, London. **116** The Art Archive: Tate Gallery London / Eileen Tweedy (crb). **118-19** The National Gallery, London. **119** The Bridgeman Art Library: Whitworth Art Gallery, The University of Manchester (br). **120-21** The National Gallery, London. **121** Corbis: Christie's Images (crb). **122-23** The National Gallery, London. **123** The Art Archive: Tate Gallery London / Eileen Tweedy / © David Hockney (br). **124-25** akg-images: Erich Lessing (b). **125** akg-images: Erich Lessing (br). **126-27** Bayerische Schlösserverwaltung: Photos

Achim Bunz. **127** Bayerische Schlösserverwaltung: Munich (br). Photo Scala, Florence: The Metropolitan Museum of Art / Art Resource (cr). **128-29** The National Gallery, London. **129** Getty Images: Science & Society Picture (crb). **130-31** The National Gallery, London. **131** Getty Images: (br). **132-33** © Royal Museums of Fine Arts of Belgium, Brussels: J. Geleyns / www.roscan.be. **132** Corbis: Summerfield Press (crb). **134-35** © Royal Museums of Fine Arts of Belgium, Brussels: J. Geleyns / www.roscan.be. **135** akg-images: Erich Lessing (br). **136-37** Photo Scala, Florence. **138-39** Photo Scala, Florence: White Images. **139** Corbis: Alinari Archives (br). **140-41** Photo Scala, Florence: White Images. **141** Photo Scala, Florence: Courtesy of the Ministero Beni e Att. Culturali (br). **142-43** Photo Scala, Florence. **143** Getty Images: (br). **144-45** Photo Scala, Florence. **145** Photo Scala, Florence: (br). **146-47** Corbis. **146** Corbis: The Gallery Collection (cr). **148-49** The National Gallery, London. **148** Getty Images: Hulton Archive (cb). **150-51** The National Gallery, London. **151** V&A Images / Victoria and Albert Museum, London: (cr). **152-53** Photo Scala, Florence: The National Gallery, London. **153** Getty Images: Imagno (crb). **154-55** Photo Scala, Florence: The National Gallery, London. **156-57** RMN: Gérard Blot / Hervé Lewandowski. **157** Corbis: Hulton-Deutsch Collection (crb). **158-59** RMN: Gérard Blot / Hervé Lewandowski. **159** Photo Scala, Florence: The Metropolitan Museum of Art / Art Resource (cr). **160-61** Photo Scala, Florence: White Images. **161** Getty Images: Time & Life Pictures (br). **162-63** Photo Scala, Florence: White Images. **163** Getty Images: (br). **164** Corbis: (crb). **164-65** Photo Scala, Florence: White Images. **166-67** Photo Scala, Florence: White Images. **167** Image Courtesy National Gallery Of Art, Washington: Harris Whittemore Collection (br). **168-69** Photo Scala, Florence. **168** Corbis: The Gallery Collection (crb). **170-71** Photo Scala, Florence. **171** Harvard Art Museums: Fogg Art Museums, Bequest of Meta and Paul J. Sachs, 1965.263 / Allan Macintyre © President and Fellows of Harvard College (br). **172-73** Photography © The Art Institute of Chicago: Helen Birch Bartlett Memorial; Collection, 1926.224. **173** akg-images: (br). **174-75** Photography © The Art Institute of Chicago: Helen Birch Bartlett Memorial; Collection, 1926.224. **175** Photography © The Art Institute of Chicago: Gift of Mary and Leigh Block, 1981.15 (cr). Photo Scala, Florence: The National Gallery, London (br). **176-77** The National Gallery, London. **177** Corbis: The Gallery Collection (crb). **178-79** The National Gallery, London. **179** akg-images: (br). **180-81** Photography © The Art Institute of Chicago: Robert A. Waller Fund, 1910.2. **180** Photo Scala, Florence: The Metropolitan Museum of Art / Art Resource (cra). **182-83** Photograph © 2011 Museum of Fine Arts, Boston: Tompkins Collection–Arthur Gordon Tompkins Fund, 36.270. **183** Corbis: Francis G. Mayer (tr). **184-85** Photograph © 2011 Museum of Fine Arts, Boston: Tompkins Collection–Arthur Gordon Tompkins Fund, 36.270. **185** Corbis: The Gallery Collection (br). **186-87** Photo Scala, Florence. **186** Corbis: Condé Nast Archive (crb). **188-89** Photo Scala, Florence. **189** Photo Scala, Florence: The Metropolitan Museum of Art / Art Resource (br). **190-91** © Tate, London 2011. **192-93** Photo Scala, Florence: The National Gallery, London. **192** Wikipedia: (tr). **194-95** Philadelphia Museum Of Art, Pennsylvania: Purchased with the W. P. Wilstach Fund, 1937. **195** Corbis: Francis G. Mayer (br). **196-97** Philadelphia Museum Of Art, Pennsylvania: Purchased with the W. P. Wilstach Fund, 1937. **197** The Bridgeman Art Library: Henry Moore Foundation (br). **198-99** Photo Scala, Florence: Austrian Archives. **198** Getty Images: Hulton Archive (br). **200-01** Photo Scala, Florence: Austrian Archives. **201** Getty Images: DEA / W.BUSS (br). **202-03** akg-images: © ADAGP, Paris and DACS, London. **202** Corbis: Bettmann (cb). **204-05** akg-images: © ADAGP, Paris and DACS, London. **205** akg-images: (cr, br). **206-07** Photo Scala, Florence: Neue Galerie New York / Art Resource. **206** Kirchner Museum Davos, www.kirchnermuseum.ch: Ernst Ludwig Kirchner, Self-portrait, c.1919, photograph (cra). **208-09** National Gallery Of Canada, Ottawa: Musée des beaux-arts du Canada. **209**

Library and Archives Canada: PA-121719 (cra). **210-11** Photo Scala, Florence: Photo Art Media / Heritage Images. **211** Corbis: Walter Henggeler / Keystone (br). **212-13** The University of Arizona Museum of Art & Archive of Visual Arts, Tucson: Gift of Oliver James, 1950.001.004 © Georgia O'Keeffe Museum / DACS, London 2011. **212** Corbis: Bettmann (cra). Photo Scala, Florence: The Metropolitan Museum of Art / Art Resource / © Georgia O'Keeffe Museum / DACS, London 2011 (br). **214-15** © Tate, London 2011: © 2011 Tate, London / Salvador Dali, Fundació Gala-Salvador Dali, DACS, 2011. **215** Corbis: Bettmann (tr). **216-17** © Tate, London 2011: © 2011 Tate, London / Salvador Dali, Fundació Gala-Salvador Dali, DACS, 2011. **217** Photo Scala, Florence: Courtesy of the Ministero Beni e Att. Culturali (br). **218-19** Museo Nacional Centro de Arte Reina Sofía, Spain: © Succession Picasso / DACS, London 2011. **219** The Bridgeman Art Library: Private Collection / Roger-Viollet, Paris (crb). **220-21** Museo Nacional Centro de Arte Reina Sofía, Spain: © Succession Picasso / DACS, London 2011. **221** The Bridgeman Art Library: Christie's Images (cra). **222-23** Photography © The Art Institute of Chicago: Friends of American Art Collection, 1942.51 / © Heirs of Joephine N. Hopper. **223** Corbis: Oscar White (br). **224-25** Photography © The Art Institute of Chicago: Friends of American Art Collection, 1942.51 / © Heirs of Joephine N. Hopper. **225** Photo Scala, Florence: The Metropolitan Museum of Art / Art Resource (br). **226-27** Museo Dolores Olmedo: © 2011 Banco de México Diego Rivera Frida Kahlo Museums Trust, Mexico, D.F. / DACS. **226** Getty Images: Popperfoto (crb). **228-29** Museo Dolores Olmedo: © 2011 Banco de México Diego Rivera Frida Kahlo Museums Trust, Mexico, D.F. / DACS. **229** The Bridgeman Art Library: Detroit Institute of Arts, USA / © 2011 Banco de México Diego Rivera Frida Kahlo Museums Trust, Mexico, D.F. / DACS (crb, br). Corbis: Susana Gonzalez / dpa (cra). **230-31** The Bridgeman Art Library / Kunstsammlung Nordrhein-westfalen: © Succession H Matisse / DACS, London 2011. **230** Corbis: Bettmann (cr). **232-33** The Bridgeman Art Library / Kunstsammlung Nordrhein-westfalen: © Succession H Matisse / DACS, London 2011. **233** Image Courtesy National Gallery Of Art, Washington: Collection of Mr and Mrs John Hay Whitney / © Succession H Matisse / DACS, London 2011 (br). Photo Scala, Florence: White Images / © Succession H Matisse / DACS, London 2011 (cra). **234-35** Photo Scala, Florence: The Metropolitan Museum of Art / Art Resource © ARS, NY and DACS, London 2011. **235** Getty Images: Arnold Newman Collection (crb). **236-37** Photo Scala, Florence: The Metropolitan Museum of Art / Art Resource © ARS, NY and DACS, London 2011. **237** The Bridgeman Art Library: Hamburg Kunsthalle, Hamburg, Germany (br). Getty Images: Martha Holmes / Time Life Pictures (cra). **238-39** © Tate, London 2011: © 1998 Kate Rothko Prizel & Christopher Rothko / DACS, London 2011. **238** Getty Images: Time & Life Pictures (cb). **240-41** © Tate, London 2011: © Andy Warhol Foundation for the Visual Arts, Inc. / ARS, NY and DACS, London 2011. **241** Corbis: Andrew Unangst (cra). **242-43** © Tate, London 2011: © Bridget Riley 2011. All rights reserved, courtesy Karsten Schubert, London. **243** Corbis: Hulton-Deutsch Collection (ca). **244-45** © Tate, London 2011: © Paula Rego 2011. **244** Rex Features: ITV (cra). **246-47** Musée du Louvre: Pierre Philibert. **247** Corbis: Reuters / Alex Grimm (cla).

All other images © Dorling Kindersley
For further information see: www.dkimages.com

GREAT HEROES
of MYTHOLOGY

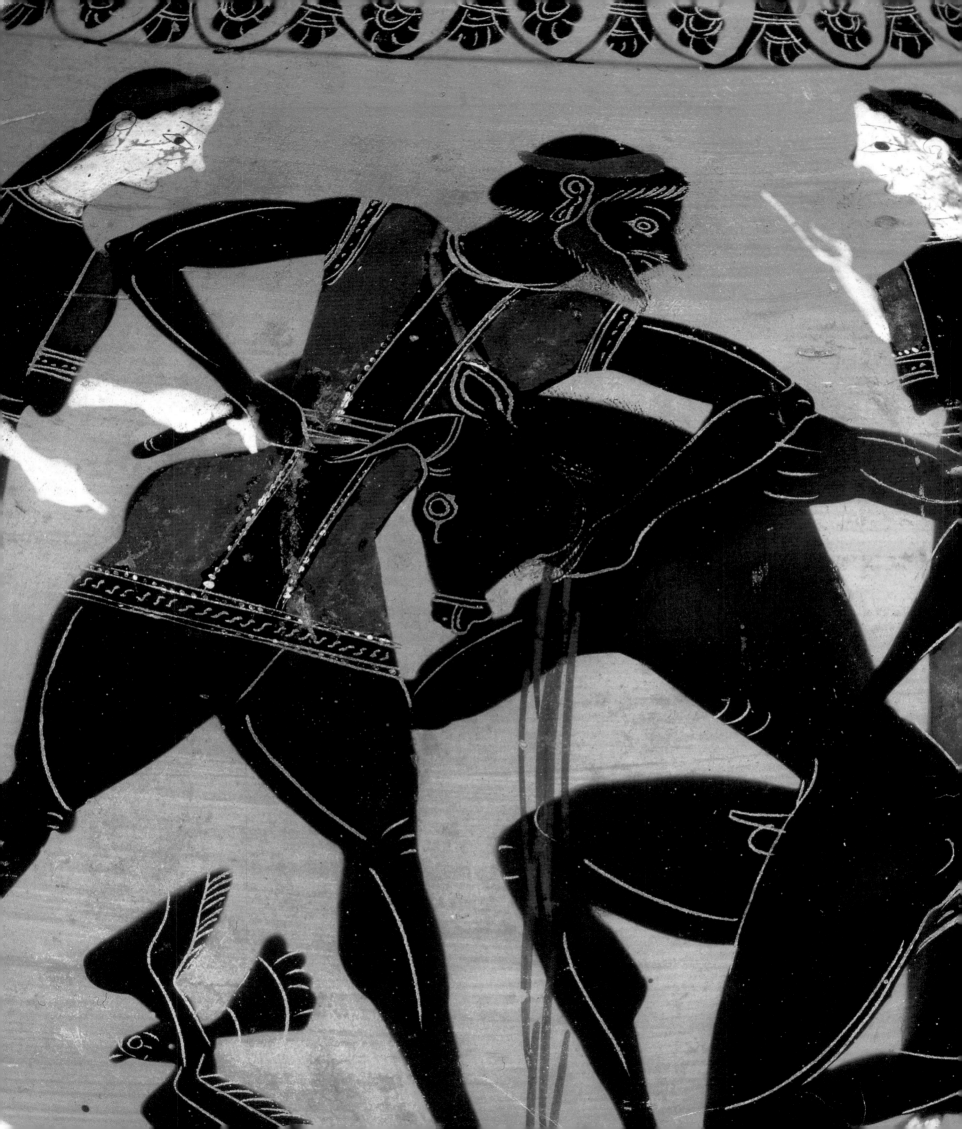

GREAT HEROES
of MYTHOLOGY

PETRA PRESS

MetroBooks

MetroBooks

An Imprint of Friedman/Fairfax Publishers

Library of Congress Cataloging-in-Publication Data

Press, Petra.
 Great heroes of mythology / Petra Press.
 p. cm.
 Includes bibliographical references and index.
 ISBN 1-56799-433-4
 1. Heroes—Mythology. I. TItle.
BL325.H46P74 1997
398.22—dc21 97-9045

Editor: Tony Burgess
Designers: Garrett Schuh, Diego Vainesman
Photography Editor: Deidra Gorgos
Production Manager: Camille Lee

Color separations by Bright Arts Graphics (S) Pte Ltd
Printed in England by Butler and Tanner Limited

For bulk purchases and special sales, please contact:
Friedman/Fairfax Publishers
Attention: Sales Department
15 West 26th Street
New York, NY 10010
212/685-6610 FAX 212/685-1307

Visit our website:
http://www.metrobooks.com

CONTENTS

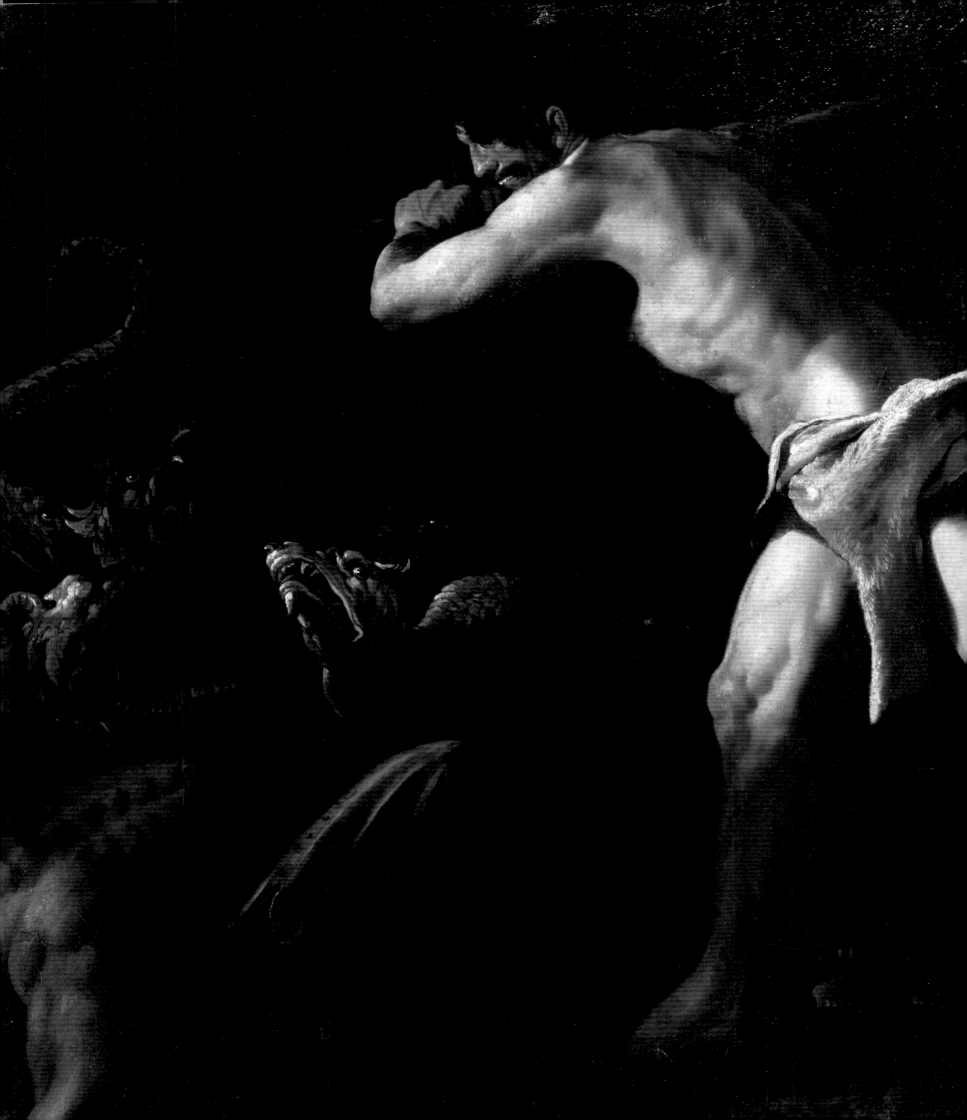

Introduction
What Makes a Hero?

Myths, Legends, and Folktales

The word *myth* comes from the Greek word *mythos*, which originally meant "word" or "story." Later, in about the fourth century B.C., the Greeks added another word for story, *logos*, meaning "word of truth." After that, *logos* was used to refer to "true" stories, historical accounts written by recognizable authors, and *mythos* came to mean the anonymous stories that were handed down (and embellished) by storytellers over the centuries until someone finally wrote them down. In other words, *mythos* came to mean fiction.

A legend is also an anonymous story handed down and embellished by storytellers over the centuries until someone finally writes it down. The difference between a myth and a legend, however, is that a legend is based on an actual historical figure or event.

A folktale, too, is an anonymous story handed down over time, but the difference between folktale and myth is that a folktale usually conveys a social message (that youngsters should respect their elders, for example) rather than dealing with the more cosmic subjects of death, heroism, tragic love, or the meaning of the universe. Folktales are also usually the product of societies which are based on agriculture.

A Search for Meaning

Whether myths are believed as truth or merely enjoyed as entertaining stories, they have had an almost magical appeal to every generation since humans invented language. While every culture has its own unique mythology, scientists and philosophers as early as the seventeenth century became fascinated with the similar themes and characters that seemed to surface all over the world. They began collecting and comparing myths and came up with some interesting theories.

At first, many Europeans held that myths were nothing more than strangely distorted Bible stories, while others were soon arguing that they were primitive, symbolic efforts to explain natural phenomena. One British anthropologist, James Frazer, proposed that myths show us how the welfare of each society depends on how well its kings rule.

In the twentieth century, scientists, philosophers, and anthropologists began looking into the human mind and psyche for answers. The Austrian psychoanalyst Sigmund Freud proposed that myths give shape to peoples' frightening unconscious fears and urges and provide a nonthreatening way to deal with them. For example, Freud claimed that the Greek myth of Oedipus, who killed his father and married his mother, symbolizes a stage all young boys go through when they feel hostility toward their fathers and attraction to their mothers.

The Swiss psychoanalyst Carl Jung took that theory a bit further and suggested that the reason myths have such a powerful hold on human imaginations is that they contain the same "archetypes" or principal symbolic characters in every human psyche or unconscious. By reflecting these universal archetypes, myths not only help people work out individual conflicts, but help them relate to society. These archetypes are characters like the Wise Old Man, the Good Mother, and the Fool.

opposite
One of the Twelve Labors of the Greek hero Heracles was to slay the Hydra, a nine-headed serpent which lived in a swamp near the city of Lerna. Whenever Heracles cut off one head, two more grew in its place.

This red-figure Greek amphora from about 330 B.C. shows the hero Perseus wearing the winged sandals and cap of darkness that enabled him to behead the snake-haired gorgon Medusa.

Traditional Heroes

One of the most powerful mythological archetypes is that of the Hero. The myths and legends of every culture feature extraordinary individuals who perform superhuman feats to aid society. Usually (although not always) these individuals are humans with supernatural strength and/or other magical abilities. Sometimes, however, the heroes are half mortal and half god, such as the Greek hero Heracles, whose father was the god Zeus but whose mother was mortal. Sometimes heroes are not human at all but gods who defy other immortals to aid humankind, such as Prometheus, who stole fire from heaven for the benefit of mortals only to be savagely punished by Zeus for his crime.

Cultural heroes can play a number of different roles. There are traditional warrior heroes like Gilgamesh and Beowulf, hero-kings such as Theseus and Arthur, tragic heroic lovers such as

Sigmund and Brynhild, even unlikely and often reluctant commoner heroes such as Aladdin.

Traditional hero types usually have a number of things in common: a call to adventure; a long, dangerous voyage and/or search for some person, place, or thing; the overcoming of formidable trials; the slaying of grotesque monsters or deadly enemies; and the rescue of the poor and helpless. They all either have superhuman powers themselves or they get help from the gods.

Not all the traits of traditional heroes are necessarily admirable, however. It depends on the culture. In ancient Greece, for example, heroes were worshipped for their superhuman strength, athletic ability, skill with weapons, and actions that benefited their community. There was no further expectation of morality. For example, the Greek term hero could be used to describe a homicidal boxer like Cleomedes of Astypalia. When the man was disqualified for

accidentally killing his opponent in the Olympic games, he became so angry that he knocked down a schoolhouse on top of sixty children. Yet he was still considered a hero.

Heracles is considered by many to be the Greek hero of all time, yet he was portrayed as a glutton, womanizer, rapist, and drunk, known as much for his brutal outbursts of rage as for his feats of superhuman strength.

Trickster Heroes

Many cultures throughout the world, especially those of North and South America, Oceania, and Africa, also feature another type of hero altogether—the trickster. The trickster is a rebel against authority and the breaker of all taboos. He is a creator and culture-bringer who is at the same time an imp and mischief-maker. He represents the lowly, small, and poor by playing pranks on the proud, big, and rich. Often the trickster hero is a shape-shifter who can assume the features of a man one minute and look like a coyote, bird, or rabbit the next.

Native American trickster figures such as Old Man Coyote, Raven, and Hare also play the role of cosmic joker, delighting their audiences when they outwit the enemies of humankind, even though they often make some ridiculous and even disastrous mistakes in the process. African cultures have similar shape-shifting animal tricksters such as the hare, tortoise, and spider that use their intelligence to outwit and frustrate the rich and powerful.

But like the more traditional heroes, tricksters definitely have their faults. They are often portrayed as selfish, lazy, vain, and envious, and almost always have amazingly gluttonous appetites.

Heroic Literature

Every culture on earth has developed its own rich collection of myths and has celebrated the exploits of mythological heroes in heroic literature such as the Greek *Iliad*, Mesopotamia's *Epic of Gilgamesh*, Mexico's *Popl Vuh*, the Anglo-Saxon *Beowulf*, the Native American Spider Woman tales, and Persia's *Arabian Nights*, to name just a very few.

It would be impossible to touch on all the heroes of every culture in a single book, but we have included several of the most vivid and memorable stories from each major culture in this volume. Consider this book a starting point, a place to whet your appetite for the incredible feast of heroic literature that awaits you.

Nigerian sculptors have used human and animal myths as inspirations for highly stylized bronze, terra cotta, and wood sculptures since the fourth century B.C. Sculptures such as this one are meant to tell an entire story drawn from the rich mythology of western Africa.

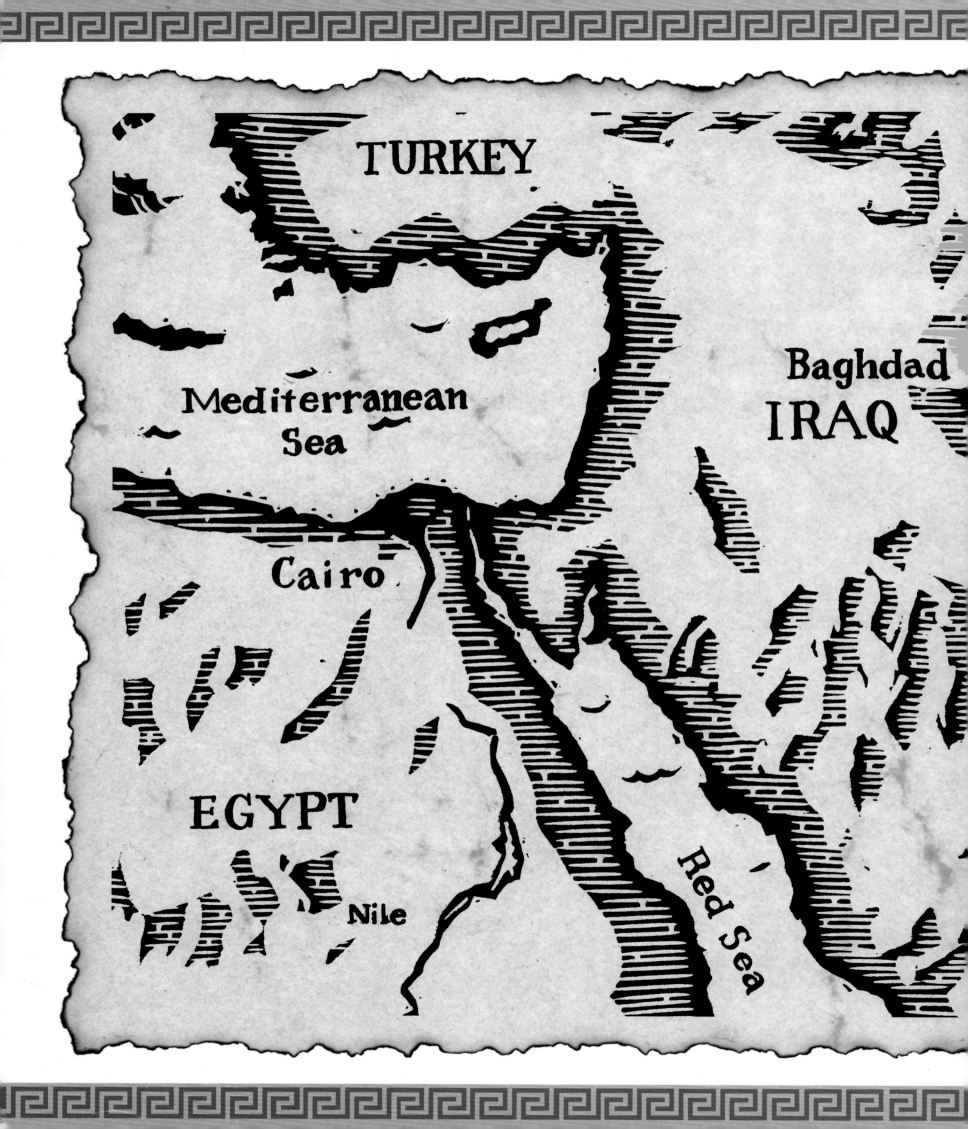

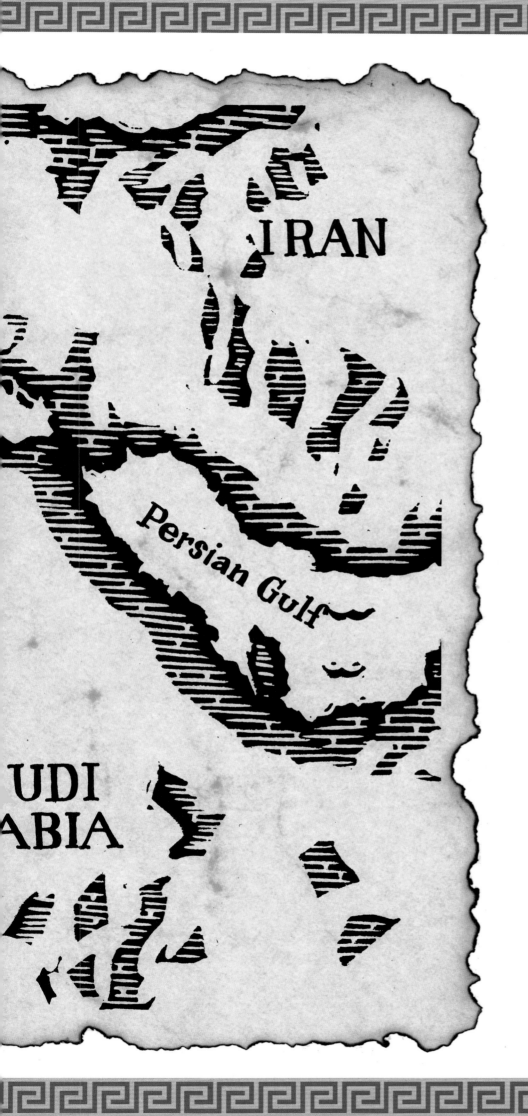

Chapter 1

Heroes of Egyptian and Middle Eastern Mythology

The myths of ancient Egypt were stories passed down by the priests and kings who tended the complex religious cults by which the many gods were cared for, and they were only concerned with the relationships between the different gods, never with individual humans. Although Egyptians covered their temples with many images of their gods' struggles, relatively few of their myths were ever written down. Most have had to be reconstructed from indirect sources such as funerary texts, cult rituals and hymns, and texts of magic.

Unlike Ancient Egypt, the Middle Eastern cultures that developed in the fertile valley of the Tigris and Euphrates rivers recorded their myths at length. Although the official state religion, tended to by important priests, involved a large pantheon of gods, the common people of Sumeria practiced an animistic faith that held that the world was populated by demons such as the "scorpion-man." A large number of texts were written to recount the legends and myths of semi-divine folk heroes such as Gilgamesh.

Isis and Osiris
A myth from ancient Egypt

This myth tells of a mighty pharaoh named Osiris, who, thousands of years ago, ruled the ancient land of Egypt along the river Nile. Tall and slender, he was a handsome man with beautifully plaited hair and a royal crown made of ivory and precious stones. It is said he was the great-grandson of Ra, the great god who created the world, and he ruled Egypt wisely and righteously for many years.

Over time Osiris taught his beloved subjects to give up their evil and savage ways and become civilized. He outlawed cannibalism and gave them a code of laws to live by that brought peace and order to what had been a chaotic and often frightening place to live. He showed people how to cultivate the rich earth of the Nile Valley to grow food, and taught them how to make bread and wine.

Osiris took as his wife his twin sister Isis, whom he had loved and embraced while they were still in their mother's womb. Isis was tall and slender like her brother, with beautiful green eyes and regal elegance. Her royal attire included a tall helmet with a gold disk set between two horns. Isis, too, took an active part in ruling the country and educating her people. She was also the mother of a young son named Horus.

Unfortunately, Osiris and Isis had a younger brother named Set who was the opposite of Osiris in every way. He was short and repulsively ugly with scraggly red hair, a pointed nose, and very bad teeth. He secretly hated Osiris and desperately wanted to be king of Egypt himself so he could reinstate some of the old practices Osiris had outlawed, such as cannibalism.

There came a day when Osiris announced to his wife that it was time he left Egypt and set out to bring the blessings of civilization to the rest of the world. He knew he was leaving Egypt in capable hands, for Isis was as great a ruler as he himself. So it was settled, and Osiris left for Asia the next day. He took no soldiers and no weapons with him, for he believed he could win the people over with music, kind words, and reason.

Set would have loved to take advantage of Osiris' absence to take over the kingdom, but Isis was in complete control and made it quite impossible. So Set hatched an evil plot for the day of his brother's return from Asia. He enlisted the aid of seventy-two accomplices to hold a banquet in honor of Osiris's return.

The feast went as planned. After a delicious dinner, Set announced that it was time for some entertainment, in the form of a contest. He

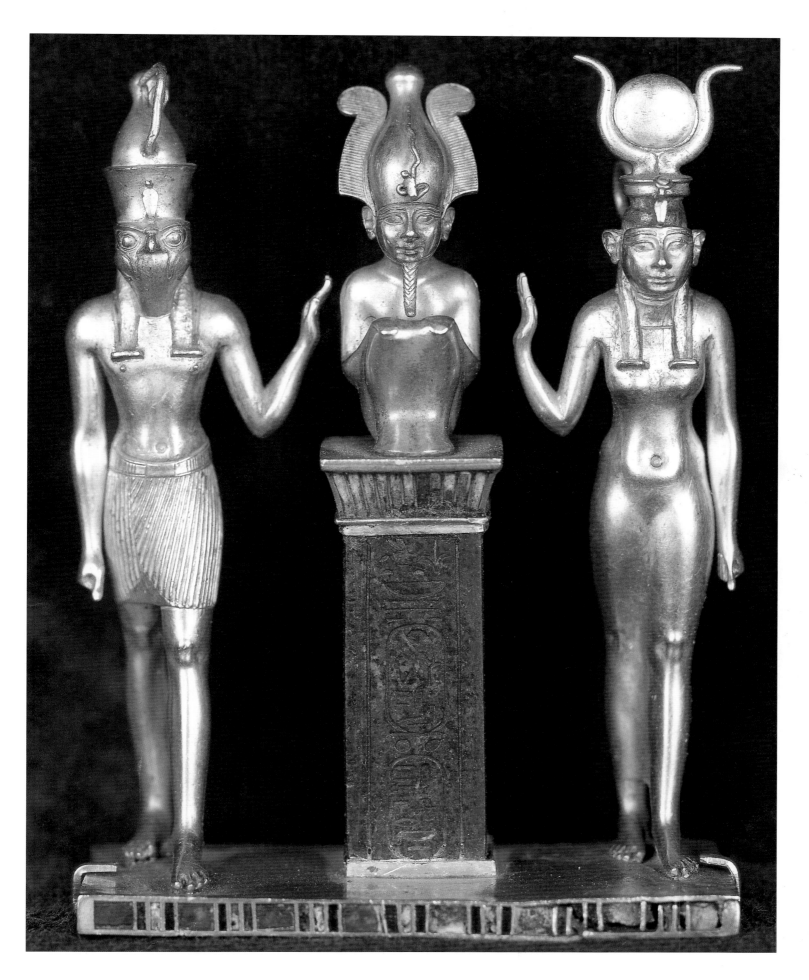

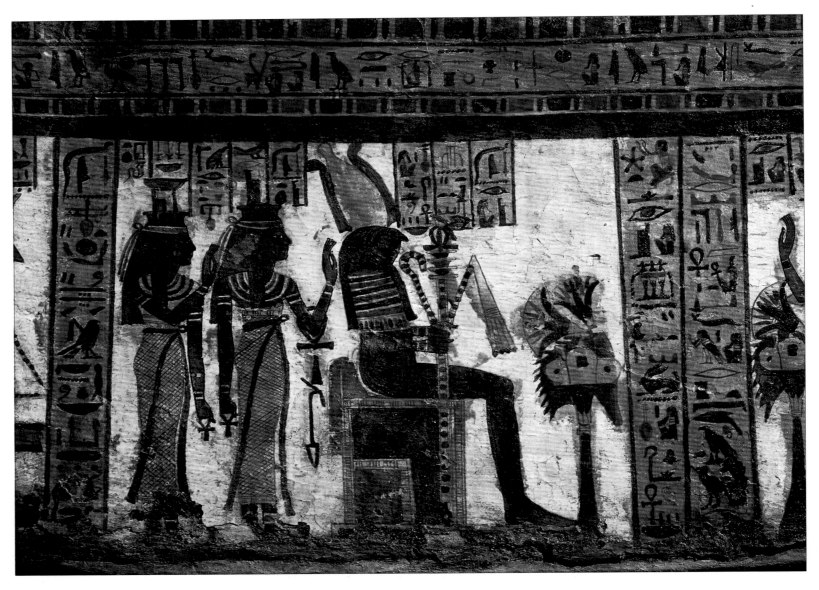

In this detail from the sarcophagus of Butehamon, a pharaoh of Egypt's Twenty-first Dynasty, Isis and her sister Nephthys guard the throne of King Osiris. According to legend, they watched over his mummified body in the form of sparrow hawks.

ordered his servants to bring in a beautiful gold and silver chest studded with jewels. The chest was to be both the challenge and the prize. It was simple; whoever could fit into the chest could claim it.

Now it happened that the seventy-two people Set chose to attend the banquet were all a little overweight and therefore too large to fit into the narrow chest. Since Set had had the chest built to his brother's exact measurements, he knew Osiris would fit into the chest perfectly. To humor his brother after everyone else had failed, Osiris climbed into the chest. Instantly, all seventy-two of the guests leaped on the chest,

slammed down the lid, and nailed it shut. Then they threw the chest into the river Nile.

The river carried Osiris's coffin out into the open sea where it floated until it finally washed ashore on the Phoenician coast near a tamarisk tree. The tree reached out with its branches, grabbed the chest, and pulled it into its trunk where it remained hidden for many years. One day a local king came across the tree and cut it down to use as a pillar in his palace. But a remarkable thing happened: the pillar started to give off a marvelous odor of honey and fresh summer blossoms that could be smelled all the way to Egypt.

One day Isis caught wind of the wondrous smell. She had been in deep mourning ever since Set had announced that Osiris was dead and had abandoned all of her royal duties to search for her husband's body. While she was busy searching from one end of Egypt to the other, Set seized the throne. He brought back the savage ways of old, practiced cannibalism, and ruled tyrannically.

Isis knew that the tree in Phoenicia that gave off the incredible smell must contain the body of Osiris and left immediately to bring it back. She carried it back to Egypt where she hid it on a small island in the middle of the Nile until she could arrange for a proper funeral. By unfortunate chance, however, Set came upon the chest one day when he was out hunting. When he recognized it, he pried open the lid, drew his sword, and cut the body of Osiris into fourteen pieces, which he then scattered all over Egypt.

It took Isis more than two years to find all the pieces of her husband, and even then she only managed to retrieve thirteen of them, for one piece had been eaten by crabs. Isis joined the pieces together, and when she was finished, Osiris woke up as if from a deep sleep. Having been smothered, drowned, trapped in a tree

trunk, hacked into fourteen pieces, and then embalmed, Osiris was weary and chose to ascend the ladder to the crystal floor of heaven. He left it to his son, Horus, to avenge his death and save Egypt.

Horus did just that. He and Set fought many battles, until finally one day Horus took a sharp harpoon and plunged it into Set's brain. Horus took over the throne and from then on ruled Egypt as wisely and kindly as his parents had done before him.

Gilgamesh the Wrestler
A Sumerian Tale from Mesopotamia

It is said that King Gilgamesh was two-thirds god and one-third human. He was born in the royal palace at Uruk, the son of a god-king and a mother who "knew all knowledge." He grew up to be a strong, powerful, and courageous king who became known as a great hunter of lions and wild bulls, a superb wrestler of awesome strength, and a heroic soldier.

His people worshiped the two-thirds of Gilgamesh that were a god, but were not always happy with the one-third of him that was a man. Gilgamesh was a handsome man with an unquenchable desire for women, and he saw nothing wrong with snatching maidens from their fathers' homes or wives who were out shopping in the marketplace, throwing them over his shoulder, and riding off with them. When he was not on the battlefield or out hunting, he strode about town with a pet monkey on each shoulder looking for more women to kidnap, his black

This bronze figure from the ninth or tenth century B.C. represents Osiris, who, after his death, was enthroned as judge of the underworld. Egyptians believed that when they died, Osiris weighed their souls to determine if their spirits were pure enough to join the gods in the underworld.

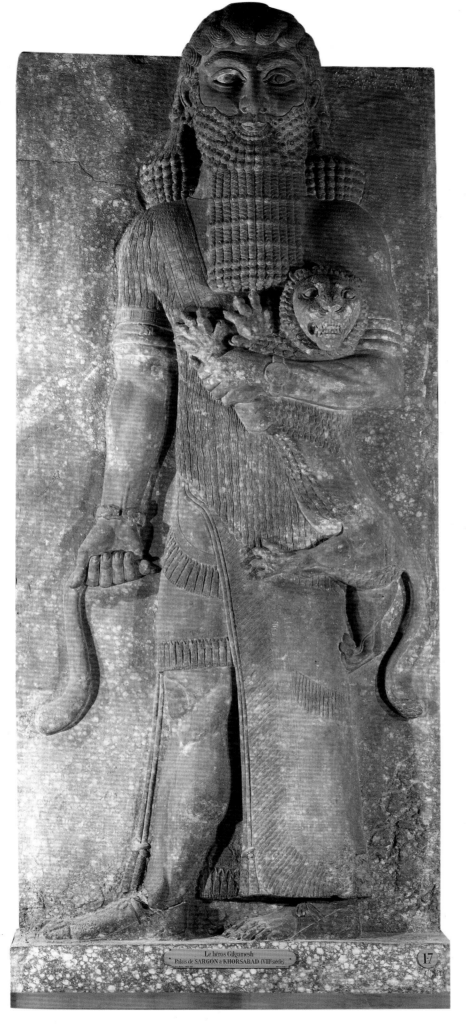

Le héros Gilgamesh
Palais de SARGON à KHORSABAD (VIIIᵉ siècle)

beard thick and curly and his long, wavy black hair falling below his shoulders.

This practice caused much anger and resentment among his people, but there was no one in the city or the surrounding countryside who dared to challenge the king in battle or defy him in open combat. So Gilgamesh continued to swagger through the streets, stealing maidens and bragging about his hunting exploits.

Finally, in desperation, a council of city elders visited the temple of Aruru, the great mother goddess, and pleaded with her to create a man strong and powerful enough to defeat Gilgamesh. Taking pity on the distraught people of Uruk, Aruru reached down from her throne to the riverbank, scooped up some clay, shaped it into an image, and then blew life into it. And that was how Enkidu was born.

Enkidu had the hoofs, thighs, and tail of a bull, yet from the waist up was an incredibly muscular man. He could run as fast as a gazelle and often used his strength and speed to come to the aid of his wild animal friends when they were being chased by hunters. In time, Enkidu's daring and swiftness became a legend around Uruk and Gilgamesh became annoyed and jealous.

Thinking that taming the creature was the only way to diminish its power, Gilgamesh came up with a plan. He promised a beautiful courtesan gold and jewels if she waited at sunset near Enkidu's watering hole and seduced

him. When his animal friends saw the woman, they fled in fear but Enkidu was too entranced with the woman's beauty to run. She used soft words and flattery to make him fall in love with her, then whispered to him about the delights and comforts of city life until she convinced him to return with her to Uruk.

When they arrived at Gilgamesh's palace, the astonished and awed Enkidu allowed the palace women to bathe him, trim his hair and beard, and even get him to put on a shirt. Over the next few weeks, they taught him table manners and how to behave at the royal court. As Enkidu became more and more civilized, he lost some of his brute strength; at the same time, he sharpened his intelligence and developed a strong sense of right and wrong.

One night, a drunk Gilgamesh left a party with a group of young men, including Enkidu, to roam the streets of Uruk in search of female companionship. However, when Gilgamesh was about to lead the group into a particularly evil house of debauchery, Enkidu was so outraged that he barred the door and refused to let Gilgamesh pass. Shaking with anger, Gilgamesh threw a powerful blow at his jaw that would have flattened a normal person, but Enkidu neatly parried the blow and grabbed Gilgamesh by the shoulders. Soon the two were wrestling and rolling on the ground.

It was the first time in his life that Gilgamesh had wrestled with someone of equal strength. For hours a gathering crowd watched as they grappled with each other, sweat pouring from their mighty muscles, but neither could budge the other. Then, suddenly, Gilgamesh released his hold on Enkidu and burst out laughing. Soon Enkidu was laughing too. All their anger had vanished and they realized that out of

their struggle a friendship had been born that would last for the rest of their lives.

From that moment on, Gilgamesh and Enkidu were inseparable. Enkidu even sat at King Gilgamesh's side when he held court. The people of Uruk were delighted at this new friendship, because Enkidu had an amazing influence on his new friend. From then on, Gilgamesh gave up the evil habits that had caused them so much concern. In spite of the peace, prosperity, and luxury of life in Uruk, however (or perhaps because of it), the two became increasingly restless and before long they set off on a series of remarkable adventures.

There are many stories that tell their exploits: how they subdued the hideous Huwawa, the giant guardian of the cedar forest, how they almost brought down the curse of the gods when Gilgamesh made the mistake of spurning the advances of Ishtar, the goddess of love, and how they slew the formidable Bull of Heaven.

After many such adventures that brought the two heroes much fame, Enkidu was felled by a fatal illness. Grief-stricken and realizing for the first time that he too would have to die some day, Gilgamesh set out on the most perilous journey of all, the search for immortality. In the course of his search, Gilgamesh endured a disastrous world flood, battled deadly serpents, and even crossed the Waters of Death—but he failed to find the secret of eternal life.

The tale ends with Gilgamesh back at the gates of Uruk. As he views the greatness of this city, with its high walls and beautiful masonry, he notices that at the base of the gates is a stone tablet on which the story of his exploits has been carved. Gilgamesh finally realizes that this is the only immortality he will ever achieve and gives up his quest.

The Thousand and One Nights
A Collection of Arabian and Persian Tales

There was once a sultan named Schahriar who had a wife whom he loved more than anything in the world. His greatest happiness was to lavish her with gifts of the finest dresses and the most dazzling jewels. It was therefore with the deepest shame and sorrow that he accidentally discovered, after they had been married several years, that she had been repeatedly unfaithful to him. In fact, her whole conduct during their marriage turned out to have been so bad that King Schahriar had no other choice than to order his grand vizier to put her to death.

So deep was the shock from his wife's betrayal that after much thought the sultan came to the conclusion that all women were as wicked as the sultana, and therefore the fewer there were in the world the better. So he decreed that every evening he would marry a fresh wife and would then have her strangled the following morning by the grand vizier, whose other duty it was to constantly find new brides for the sultan. The poor man, of course, was horrified with his duties, but there was no escape; every day he saw a girl married and a wife dead.

Needless to say, the people of the kingdom were shocked at this state of affairs and terrified that their own daughters or sisters who would be chosen as the king's next bride and victim. The grand vizier himself was the father of two daughters, Scheherazade and Dinarzade. Dinarzade was an average young girl, but her older sister, Scheherazade, was not only beautiful but exceedingly clever and very courageous. In addition, as the eldest, she had received a thorough education in philosophy, medicine, history, and the fine arts.

"Open, Sesame"

One day, Scheherazade told her father that she had a plan to stop the king's barbarous practice of murdering his wives and asked him to let her be the next girl he brought to marry the king. Knowing that he would be the one who would have to kill his own beloved daughter the next morning if the plan failed, the horrified grand vizier asked the girl if she had lost her senses. It took Scheherazade a long time to persuade him that her plan would work. Still, it was with a heavy heart that her father agreed. Then Scheherazade made a pact with her sister Dinarzade. "When his Highness receives me," she said, "I shall beg him, as a last favor, to let you sleep in our chamber, so that I may have your company during the last night I am alive. If he grants me my wish, be sure that you wake me an hour before dawn, and say, 'My sister, if you are not asleep, I beg you, before the sun rises, to tell me one of your charming stories.'" Dinarzade gladly agreed.

When the time came, the king did indeed grant Scheherazade her wish and Dinarzade was sent for. An hour before daybreak Dinarzade awoke and begged her sister to tell a story, as she had promised. When the sultan gave his permission, Scheherazade began.

Drawing on her great knowledge of history and literature, Scheherazade wove an exciting adventure story about a genie and a merchant but just as the tale had reached a particularly suspenseful moment of climax, the sun came up and she stopped. As planned, her sister cried out, "What a wonderful story!"

"The rest is even more wonderful," replied Scheherazade, "and if the Sultan would allow me to live another day, I could tell you the rest tonight."

King Schahriar, who had been engrossed in Scheherazade's delightful tale, said to himself, "I will wait till tomorrow. After all, I can always have her killed once I hear the end of her story." So the next morning, an hour before sunrise, Dinarzade again woke her sister and begged her to continue the story. Again the sultan agreed.

So Scheherazade went on telling stories. Each tale had a tale within a tale and thus one story led right into another so that she was never really finished. Every morning she'd stop at a point of exciting suspense, and every morning the sultan would let her live one more day to finish it. After a thousand and one nights of this, the sultan finally became so fond of Scheherazade that he gave up the idea of killing her.

𝕽𝕽𝕽𝕽𝕽𝕽𝕽𝕽𝕽𝕽𝕽𝕽𝕽𝕽𝕽𝕽𝕽

THE TALE OF THE FIFTH VOYAGE OF SINBAD THE SAILOR
A Tale from the Thousand and One Nights

When Sinbad was in his late teens he inherited considerable wealth from his parents and, at first, being young and foolish, squandered it recklessly on every kind of pleasure. He came to understand, however, that unless he changed his ways, he would soon be poor and miserable. So he sold all his household goods and joined a company of merchants who had bought a ship and they sailed to sea on a course toward the East Indies by way of the Persian Gulf. (In all, Sinbad made seven such memorable voyages before he finally returned home for good to retire a wealthy man.)

After enduring shipwrecks, hurricanes, snake-infested islands covered with diamonds and emeralds, evil, hairy dwarves, even more evil ogres, man-eating eagles, and an interesting assortment of other dangers and evil creatures, Sinbad returned home from his fourth voyage with a small fortune in spices and precious stones. One would think that everything he had gone through would make him look forward to a quiet life of pleasure and comfort, but he quickly became bored and longed instead for the adventure of a fifth voyage.

This time, he set out with a ship and crew of his own. They set sail with the first favorable wind, and after a long voyage upon the open seas landed upon an uninhabited island which they set out to explore. They had not gone very far when they spotted a huge roc's egg just starting to hatch. In spite of Sinbad's protests, the merchants immediately took their hatchets and smashed the egg, killing the young bird. Then they lit a fire, and as Sinbad watched aghast, they hacked the baby bird to bits and proceeded to roast the flesh. Just as they finished their meal, the air above them darkened with two

left
Whenever Sinbad returned from one of his Seven Voyages, he delighted and amazed his friends with tales of his harrowing adventures with shipwrecks, evil monsters, and lost fortunes of spices and precious stones.

opposite
In another of Scheherazade's tales, "Ali Baba and the Forty Thieves," the hero Ali Baba overhears the thieves use the magic words "open sesame" to enter the secret hideaway where they hid their plunder.

huge, ominous shadows. Running in terror, the men managed to make it to the ship and even get the sails hoisted, but before they could build up any speed, the parent birds dropped two boulders on the ship, smashing it into a thousand fragments, and crushing or drowning all the passengers and crew. Except for Sinbad, that is.

Sinbad survived by grabbing a piece of driftwood and floating until, many hours later, he was washed up on the green shores of a strange and delightful island. The lush place was thick with trees laden with flowers and fruit, and there was a crystal stream wandering in and out under their shadows.

As Sinbad started to explore the island, he came upon an old man, bent and feeble, sitting on the riverbank. When he greeted him, the old man made signs that he wanted Sinbad to carry him on his back across the river so he could gather some fruit.

Pitying his age and feebleness, Sinbad picked him up on his back and waded across the stream. But when they reached the other side, instead of getting down, this creature who had seemed to be so feeble and decrepit suddenly leaped quite nimbly up on Sinbad's shoulders and hooked his legs round his neck, gripping him so tightly that the sailor passed out and fell to the ground,

with the creature still wrapped tightly around his neck. When Sinbad came to, the creature prodded him first with one foot and then with the other, until he was forced to get up and stagger about under the trees while the beast on his shoulders gathered and ate the choicest fruits. This went on day after day, all day and all night, until Sinbad was half-dead with weariness.

One day the bored and weary Sinbad happened to notice several large, dry gourds lying under one of the fruit trees. While the creature on his shoulders was busy picking and eating fruit from the tree overhead, Sinbad amused himself by scooping out a gourd's contents and then filling it with the juice of the grapes which grew everywhere around them. When the gourd was full he hid it in the fork of a nearby tree.

A few days later, Sinbad steered the old man toward the same tree and, when he wasn't looking, snatched his gourd and took a long drink from it. The grape juice had fermented

into a wine so potent that for a moment Sinbad forgot his detestable burden, and began to sing and dance.

When the old monster noticed how Sinbad was enjoying himself, he stretched out his skinny hand and, seizing the large gourd, first cautiously tasted its contents, then drained it to the very last drop. Soon he too began to sing and after a while, the iron grip of his legs around Sinbad's throat began to loosen. Without a moment's hesitation, Sinbad threw the creature to the ground with such force that he died instantly.

Sinbad, overjoyed to have finally rid himself of this nasty creature, ran back down to the seashore where, by the greatest good luck, he ran into some mariners who had anchored off the island to enjoy the delicious fruits. They helped him celebrate his good fortune and then invited him to sail with them, first to the islands where pepper grew, then to Comari where the best coconuts and aloe wood were found. After that, they dove for pearls and soon had a cargo full of them, all very large and quite perfect.

Loaded down with all these treasures, Sinbad finally returned joyfully to Baghdad, to rest from his labors and enjoy the pleasures his riches could buy. When he told his friends about his adventures on this fateful fifth voyage, they exclaimed in amazement, "Don't you know who that was? You fell into the hands of the Old Man of the Sea, and it's a miracle that he didn't strangle you the way he has strangled everyone else on whose shoulders he perched! Any sailor worth his salt knows better than to ever go near that island!"

Sinbad did not remain home long before he was again overcome with a longing for change and adventure. Soon he would embark on his sixth, and even more amazing, voyage.

left
Often shipwrecked on uninhabited islands, Sinbad miraculously survived hurricanes, snake infestations, and even elephant attacks.

opposite
Sinbad's crew was terrorized by rocs, monstrous birds so huge they fed their young on elephants.

Aladdin and the Wonderful Lamp
A Tale from the Thousand and One Nights

There once lived a poor tailor who had a son called Aladdin, a lazy boy who would do nothing but play all day long in the streets with other little idle boys like himself. This upset his father so much that he died of grief, but even that didn't make Aladdin mend his ways. One day, when he was playing in the streets as usual, a stranger approached him and introduced himself as Aladdin's long-lost uncle. Aladdin's mother, who had never met her husband's brother, thought she saw a family resemblance in the man and gladly welcomed him into their home.

This stranger was really a notorious African magician; when he learned that Aladdin had been too lazy to bother learning a trade, the false uncle told the mother he'd set up a shop for the boy and stock it with merchandise. Aladdin's mother was overjoyed. Then the magician announced that before the boy began working, the two of them would take a short journey.

The next day, the magician led Aladdin out of the city gates, through some beautiful gardens, and up into the foothills of the mountains. At last they came to a narrow valley between two mountains where the false uncle announced that he had something wonderful to show Aladdin. They built a fire and when it was lit, the magician threw a strange powder into it while he muttered some magical words. The earth trembled a little and opened in front of them, disclosing a square, flat stone with a brass ring in the middle to raise it by.

By this time, Aladdin was scared to death. He tried to run away, but the magician caught him and hit him so hard that he knocked him down. Then his uncle's voice softened and he said more kindly that beneath the stone was a great treasure that would be Aladdin's alone if he did exactly as his "uncle" instructed him. When Aladdin heard the word treasure, he forgot his fears and grasped the ring as he was told. The stone came up quite easily and some steps appeared leading down into a deep cave.

"Go down," said the magician, "and at the foot of those steps you will find an open door leading into three large halls. Go through them quickly and without touching anything, or you will die instantly. These halls lead into a garden of fine fruit trees. Walk on till you come to a terrace where you'll see a lighted lamp. Pour out the oil it contains and bring it to me." Then he drew a magic ring from his finger and gave it to Aladdin for protection.

Aladdin found everything as the magician had said, although he ignored the advice about not touching anything and gathered some fruit off the trees. He found the lamp and started back. Just as he returned to the bottom of the steps, the magician demanded that he throw him the lamp. Now suspecting that the magician might be trying to trick him, Aladdin refused to give it to him until he was out of the cave. Trembling with rage because Aladdin was ruining the plan, the magician threw some more powder on the fire and made the stone with the brass ring roll back into place.

With that, the cunning magician fled, leaving Aladdin trapped within the cave. It was obvious now that he was no uncle of Aladdin's, but an evil thief who had read in his magic books about a wonderful lamp which could make him the most powerful man in the world. The magician's dilemma was that although he alone knew where to find the lamp, he could only

receive it from the hand of another. So he had picked out the foolish Aladdin for this purpose, intending to get the lamp and then kill him afterward.

Terrified, Aladdin remained in the dark cave for two days until he accidentally rubbed the magic ring which his false uncle had forgotten to take from him. Immediately an enormous and frightful genie rose out of the earth, saying, "What do you want with me? I am the Slave of the Ring, and will obey you in all things."

Without hesitation, Aladdin cried, "Get me out of here!" In the blink of an eye, he found himself back outside in the sunshine again. As soon as his eyes could bear the light he went home and told his mother what had passed, showing her the lamp and the strange fruit he had gathered in the garden—which turned out to be precious stones.

Aladdin was hungry after his ordeal but his mother had nothing in the house to eat. He looked at the old lamp and figured that if he polished it a bit, he could take it into town and sell it to buy some food. As he began to rub it, a hideous genie appeared and brought them twelve silver plates heaping with delicious food. The boy and his mother sat and ate for a long time. Although she begged her son to sell the lamp because it was obviously possessed by devils, Aladdin decided to keep it as it might prove to be very useful some day. Over the next few years, Aladdin sold the silver plates one by one, and he

and his mother lived quite comfortably.

One day Aladdin caught sight of the sultan's beautiful daughter as she rode through town and fell instantly and completely in love. He went home and told his mother that he loved the princess so deeply that he could not possibly live without her, and then asked his mother to go to the sultan, give him the jewels he had brought back from the magic cave, and request his daughter's hand on Aladdin's behalf.

The woman tried for over a week to get in to see the sultan; when she finally did, she told him of her son's all-consuming love for the princess. The sultan wasn't very impressed with her news until she showed him the jewels she had brought. Amazed, the sultan turned to his grand vizier and announced that anyone who placed such value on his daughter should surely be allowed to marry her. The vizier, who wanted his own son to marry the princess, begged the sultan to withhold her hand for three months, in the course of which he hoped his son could come up with a richer present for the sultan. The sultan decided it was good advice and told Aladdin's mother that, though he consented to the marriage, she would have to wait three months before coming back to set the wedding date.

After only two months had elapsed, Aladdin's mother returned one day from the city with the news that the son of the grand vizier was going to marry the sultan's daughter that very night. Aladdin was devastated at first, but

When Aladdin started to polish the old lamp so he could sell it for food, a huge and frightening genie appeared. It cried to him, "Here am I, thy slave and slave to whoso holdeth the lamp!" But the only thing Aladdin could think to wish for was food.

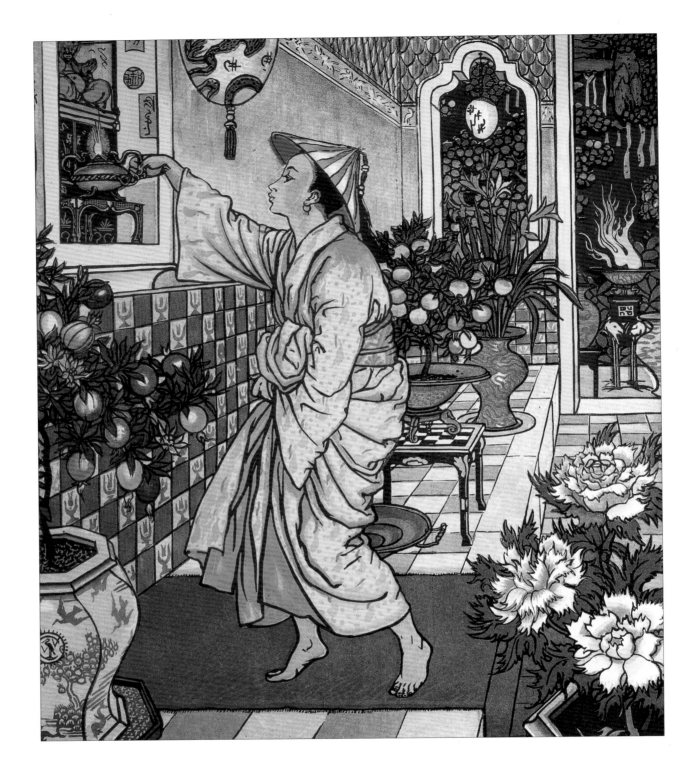

remembered the magic lamp and came up with a plan. As before, when he rubbed it a genie appeared asking him what he wished. This time he said that because the sultan had broken his promise and was allowing the grand vizier's son to marry the princess instead of him, he wanted the genie to go to the bride and bridegroom that evening in their bedchamber, kidnap the bridegroom, and make him stand out in the cold all night. The genie obeyed.

The princess passed the most miserable night of her life and by morning was too frightened to speak, even when the genie transported the shivering bridegroom back into her bed. The

next morning when the sultan greeted his daughter and new son-in-law, the unhappy grand vizier's son jumped up and hid himself while the princess just sat there and sobbed. When the same thing happened on the second morning, the sultan threatened to cut off his daughter's head if she wouldn't tell him what was wrong. Finally she told him. By this time the bridegroom, even though he claimed he dearly loved the princess, announced that he'd rather die than go through another night like that—he wanted an annulment. The sultan gladly granted his request.

When the three months were over, Aladdin's mother once again petitioned the sultan, and this time he decided he was willing to let Aladdin marry his daughter—that is, if he came up with forty gold bowls heaped with jewels and delivered to him by eighty slaves. Aladdin's mother figured that made it hopeless, but Aladdin wasn't worried a bit. He simply rubbed the lamp, summoned the genie, and arranged for the slaves and bowls of jewels.

Before they were wed, Aladdin had the genie build the princess a palace of the finest marble set with precious stones, with velvet carpets, and a domed gold and silver hall in the middle. When the princess finally met Aladdin on the day of their wedding, she was charmed at the sight of him. Love had truly changed Aladdin: the idle boy had grown into a fine handsome man who adored the princess and treated her with kindness and respect. They were very happy in their new palace. By this time, Aladdin had also won the hearts of the people for his courage and kindness.

Aladdin's fame eventually spread as far away as Africa, where the magician was living. When he realized that Aladdin, instead of per-

ishing miserably in the cave, had not only escaped but had married a princess and was living with her in great honor and wealth, he knew immediately that the poor tailor's son could only have accomplished all this by means of the magic lamp. One day when Aladdin was off hunting, the magician dressed as an old street merchant offering to trade new lamps for old ones. His trick worked and a servant at the castle gave him the beat-up old lamp that only Aladdin knew had magical powers.

The magician commanded the genie to transport the castle (with the princess in it) to Africa. When Aladdin returned and saw what had happened, he knew the only person evil enough to do such a thing was the magician, and he set out to find him. With the help of the genie of the ring, he found the palace, and after a joyful reunion with his wife, they plotted how they could kill the magician and get back the lamp.

The princess put on her most beautiful dress and invited the magician to have dinner with her. When he wasn't looking, she slipped some poison Aladdin had brought with him into the lecherous old man's wineglass. When the magician drained his glass and fell back lifeless, the princess let Aladdin in and he took the lamp from the dead magician's vest. Taking the princess by the hand, he commanded the genie of the lamp to transport them and the palace back to the sultan's kingdom.

When Aladdin told the sultan what had happened, and showed him the body of the magician as proof, the overjoyed sultan proclaimed a ten-day feast in his honor. Aladdin had many more adventures, which are related in other tales of the *Thousand and One Nights*.

Chapter 2

Heroes of Classical Greek Mythology

Greek mythology, which can be traced back to before 1000 B.C., is based on a complicated hierarchy of major and minor divinities ruled over by Zeus, King of the Olympian Gods, and his wife, Hera. Under them were various lesser gods and goddesses such as Poseidon, God of the Sea, Athena, Goddess of War and Wisdom, and Hermes, the Messenger of the Gods as well as the God of Thieves and Moneymakers. Next in order of power came the minor divinities such as the River Gods, the Muses, and the Fates.

Heroes such as Achilles, Ajax, and Heracles were considered almost as important as the gods themselves, even though they were not as powerful. A hero was usually the off-spring of the union between a god and a mortal.

The Romans took over the Greek gods pretty much in their entirety, although they did change most of the names, giving the Greek gods the names of preexisting Roman deities (which made things pretty confusing for many Romans at first).

Perseus, Slayer of Medusa

After an oracle prophesied that his own grandson would one day kill him, King Acrisius of Argos locked his only daughter, Danaë, in a bronze tower to prevent her ever having children.

The poor girl, locked in the tower for eighteen years, grew into a beautiful young woman. One summer afternoon a shower of gold streamed through the tower's only window and magically turned into a handsome god with a thunderbolt in each hand. He was Zeus, and he had come to make Danaë his lover.

opposite
Greek heroes have remained popular subjects for artists long after the decline of Greek civilization. In this seventeenth-century painting, Perseus and Andromeda, *Italian painter Giuseppe Cesari shows the winged Perseus rescuing the beautiful Andromeda, who has been chained to a rock.*

He didn't have the power to free her from the tower, he said, but he could transform her horrible prison into a sunny, flower-filled meadow. When the handsome young god kept his promise, Danaë agreed to lie with him, and they lived happily in their meadow home for over a year. But when King Acrisius saw a mysterious, radiant light coming out of his daughter's small tower window, he became suspicious. He had his men rip a hole in one of the walls, then climbed up into the tower to inspect for himself. To his horror, he saw his smiling daughter Danaë with a baby on her lap. Furious, he immediately had his men lock Danaë and baby Perseus up in a large chest and cast them out to sea.

Somehow mother and son managed to get safely to the island of Seriphus where Polydectes was king. The king's brother, who was a fisherman, caught the chest in his net and pulled them to shore. Unknown to King Polydectes, Perseus grew up on the island to become a strong young man and a soldier in the king's army.

One day, King Polydectes was riding through his kingdom and caught a glimpse of the still-beautiful Danaë. He immediately declared his intention of marrying her; as he was a repulsive old man, she rejected him. If Perseus hadn't been there to protect her, the outraged king would have forced her to marry him anyway. It didn't take King Polydectes long to come up with a plan to get rid of Perseus. It was the custom in the kingdom for everyone to give the king a present when he announced his engagement, so he pretended to be marrying another woman, knowing that Perseus was too poor to buy him anything. When Perseus arrived at the engagement dinner empty-handed, Polydectes acted furious, calling the boy lazy and worthless.

As the king had predicted, the proud and hot-tempered youth declared, "I can bring you any present in the world! *Anything*, only name it!" "Bring me the head of the gorgon Medusa," replied Polydectes. Although it was common knowledge that all the men who had tried before had not lived to tell about it, Perseus readily agreed.

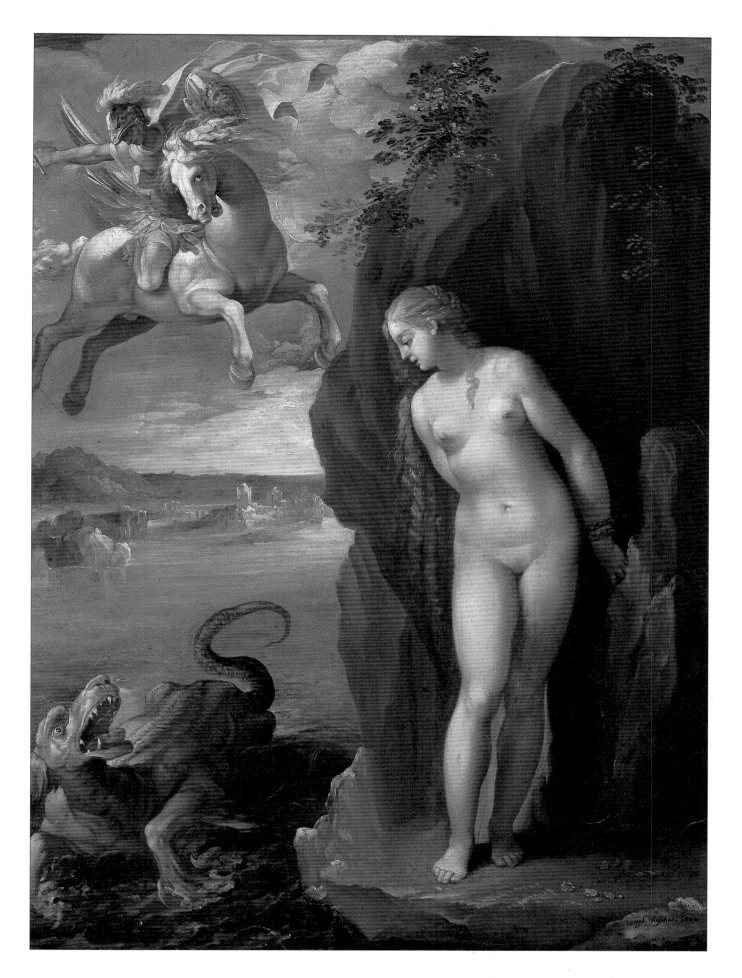

For weeks Perseus wandered around the countryside searching for the lair of the gorgons without success. Finally one night, tired and hopelessly lost, he was overcome with despair. Even if he ever found the gorgons, he knew the idea of killing them was nearly hopeless. They were hideous monsters with black serpents writhing on their heads instead of hair and brass hands that could squash a man as if he were a mere mosquito. And most deadly of all, they were so ugly that anyone who looked at them immediately turned to stone.

Suddenly a tall woman and a young man with winged sandals appeared at his campsite. The man said, "I am your brother Hermes and this is our sister Athena. We know that you too are a son of Zeus and we've come to help you slay Medusa." They gave Perseus the winged sandals, a magic sickle, and a shield to reflect the image of the gorgon so he wouldn't be turned into stone. Before they disappeared, they told him how to find the Nymphs of the North, the only creatures who could tell him how to get to the gorgons' lair.

The kindly Nymphs of the North not only gave Perseus directions, they gave him the Cap of Darkness (which has the power to make its wearer invisible) and a magic wallet.

The next morning, Perseus traveled north until he found the gorgons' island; their lair was surrounded by eerie stone statues that used to be live men. He raised his shield and in its reflection saw that Medusa and her sisters were asleep. He put on the Cap of Darkness and crept down to them. Before the sisters could awaken and defend themselves, Perseus furiously swung the magic sickle until he could feel it tearing through the bone and sinew of Medusa's neck. Still careful to look only at the reflection in his

shield, he took Medusa's severed head and carefully wrapped it in the magic wallet. Suddenly Medusa's sisters woke up and attacked Perseus, but he flew quickly out of their reach.

Perseus had several exciting adventures on his way back to Seriphus with the gorgon's head. He came across the titan Atlas struggling under his burden of holding up the sky. Perseus took

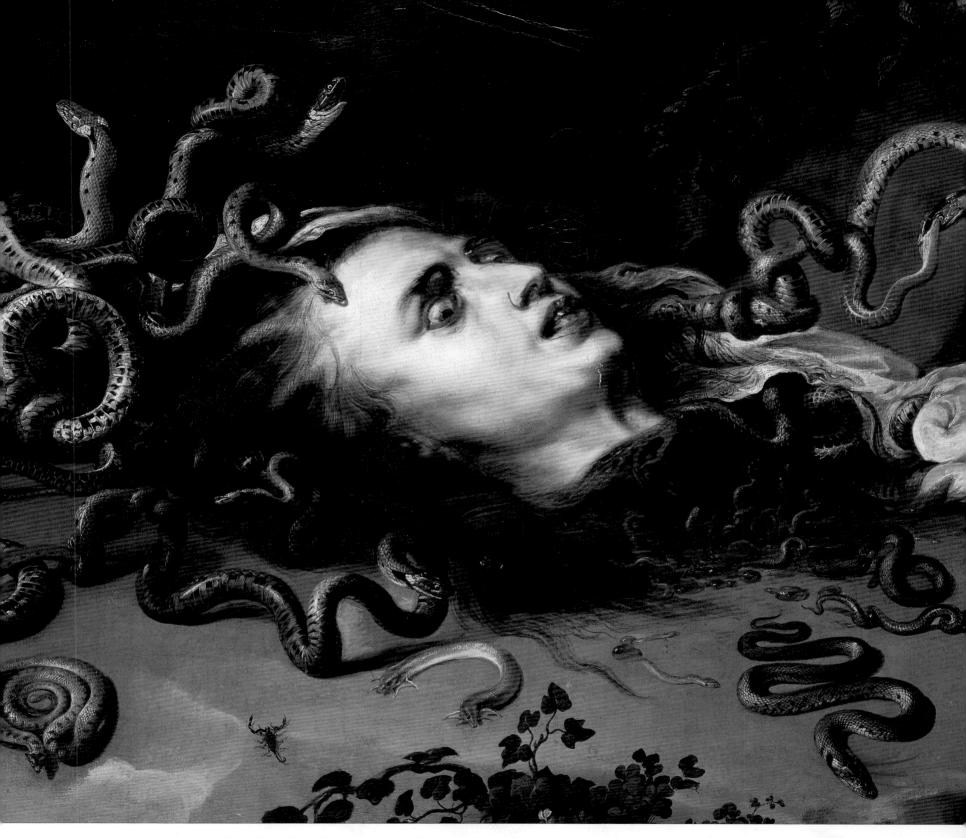

pity on Atlas, and to release him from the terrible weight of his burden, showed him Medusa's head and turned him into stone.

Next Perseus came upon a girl named Andromeda chained to a rock at the edge of the sea. Her mother had boasted that the girl was more beautiful than the Nereids, which so angered Poseidon, god of the sea, that he ordered Andromeda sacrificed to a sea monster. Just as the monster rose from the sea, Perseus swiftly pulled Medusa's head out of the wallet and turned the creature to stone. He cut Andromeda's chains and took her to her father, King Cepheus of Phoenicia, who was so grateful for the return of his daughter that he granted Perseus Andromeda's hand in marriage.

The snake-haired gorgon Medusa, depicted here in a painting by Peter Paul Rubens, The Head of Medusa, *was so hideous that anyone who looked directly into her face was immediately turned to stone.*

Perseus continued his journey back to Seriphus in the company of his new wife until they reached Larissa, where Perseus wanted to compete in an athletic competition that was being held. That afternoon, however, when Perseus threw a discus, he accidentally hit and killed an old man up in the stands. The old man was none other than his grandfather, King Acrisius. The prophecy had come true.

Perseus and Andromeda lived happily and ruled the kingdom of Argos well for many years. A number of their descendants became great heroes and kings; perhaps the greatest of these was Heracles, the strongest man in the world.

Theseus and the Minotaur

Theseus was the son of King Aegeus, but his father had left his mother, Aethra, before he was even born. His mother raised him to manhood by herself in a small town called Troezen. Just before Aegeus left, he said to Aethra, "If we have a son, when he is old enough and strong enough, tell him to lift this rock and take my sword and sandals from under it." Then King Aegeus placed his sword and sandals under a large boulder and set sail for Athens.

Theseus grew into a remarkably strong young man. One day, Aethra took him to the large boulder and told him to try to lift it. Theseus wrapped his arms around the huge boulder and lifted it as easily as if it were an empty basket, and tossed it into a nearby forest. Aethra told him that he was to take the sword and sandals and go to Athens to visit his father.

After a number of adventures with thieves and giants along the way, Theseus arrived at the palace in Athens. He was happy and excited at the prospect of meeting the father he had never known. He did not know that Aegeus had been tricked into marrying a sorceress named Medea. With her evil powers, Medea knew exactly who Theseus was as soon as he reached the outskirts of town. She was also smart enough to know that Theseus would try to get rid of her when he realized how she had tricked his father. So she devised a plan.

Medea told Aegeus that this young man had come to kill him and the best way to outwit him was to invite him in and then slip him some poisoned wine. Aegeus, not knowing that Theseus was his own son, agreed and immediately sent his couriers to invite Theseus to a special banquet. When all the guests were seated, King Aegeus proposed a toast. Just as Theseus was about to drink his wine, Aegeus recognized the sword he was wearing and dashed the goblet of poison to the floor. In that instant, the spell Medea had cast over the king was broken. Theseus and Aegeus were overwhelmed with joy at their reunion and as they talked happily long into the night, Medea made her timely escape in a chariot drawn by dragons. No one missed her.

There was great joy in Athens for many months until the day a large ship with black sails approached the harbor. The eldest son of King Minos of Crete had been accidentally killed while he was in Athens and the angry king was demanding retribution. Seven young men and seven young women from Athens were to be shipped to Crete every year to be sacrificed to the man-eating Minotaur, a creature half man and half bull. He lived in the Labyrinth,

a large maze of tunnels from which no mortal had ever escaped.

Angry and horrified, Theseus went to Aegeus and demanded to be sent to Crete as one of the victims so he could slay the beast. At first Aegeus refused to let his beloved son and heir risk such an adventure, but finally he gave his reluctant approval. Before Theseus left, his father made him promise that if he returned alive, he would change the sails on the ship from black to white before it reentered the Athenian harbor.

As soon as Theseus and the thirteen other victims landed on Crete, King Minos paraded them through the city on their way to the Labyrinth. One of the spectators lining the streets to watch the Athenian victims was Ariadne, the beautiful daughter of King Minos; she fell in love with Theseus the moment she saw him.

That night, she sent in secret for Daedalus, the royal architect who had designed the terrible and deadly Labyrinth, and demanded that he show her a way to escape from it. He did and she immediately sent for Theseus and told him she would help him escape if he promised to marry her afterward and take her back to Athens with him. Theseus gladly made this promise to the beautiful Ariadne and she showed him the trick she had learned from Daedalus: to take a ball of thread with him, tie it to the door as soon as he entered the Labyrinth, and then unwind it as he roamed through the Labyrinth's tunnels.

As planned, the next day Theseus and the others were forced into the Labyrinth. Theseus

tied the string to a rock near the entrance and told his thirteen companions to stay close and follow him. After many hours of frustrating twisting and turning, he led them to the center of the Labyrinth where the Minotaur lay sleeping. Theseus had only his fists with which to

Before the terrifying Minotaur could slaughter and eat the youths, Theseus grappled the beast and ripped off its horn.

fight the beast, but without hesitating he jumped on him and ripped off one of his long spiked horns. He took the horn and started poking the Minotaur with it; by this time, the beast was pawing and snorting with rage. Theseus ran to a safe distance and threw the horn like a javelin— it ripped through the monster's neck and killed him instantly.

His companions cheered their new hero as they followed the thread back to the Labyrinth's

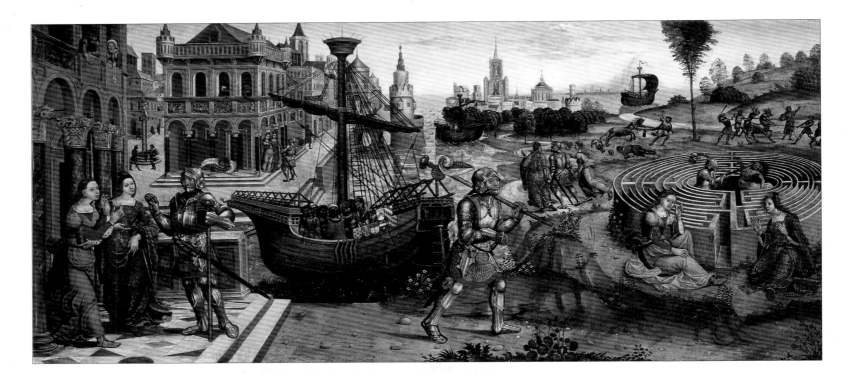

entrance. They met Ariadne at the black-sailed ship and quickly set sail for Athens. One night at sea, the god Dionysus came to Theseus and said, "You mustn't marry Princess Ariadne for I have chosen her as my own bride. Leave her on the island of Naxos."

Theseus reluctantly did as the god told him. Afterward, he was so overcome with sadness that, nearing Athens, he forgot his promise to change the sails from black to white. Old Aegeus had been sitting on a cliff, watching and waiting for Theseus. When the King saw the black sails, he believed his son was dead and he threw himself into the sea in despair. That fatal stretch of water is still called the Aegean Sea.

Theseus went on to become a great king— and to have many more adventures. While having all the traditional heroic qualities such as strength and courage, he also proved to be intelligent and wise.

The Labors of Heracles

Zeus, the most powerful of all the gods, was known to be unfaithful to his wife, the goddess Hera, on a number of occasions with mortal women. One of these mortal women was Alkmene, Queen of Tiryns, who gave birth to a boy named Heracles. He grew up to be the strongest mortal who ever lived and one of Greece's most celebrated mythological heroes.

Hera did not take Zeus's unfaithfulness lightly, however, and was extremely jealous of his mortal children. When she heard that Heracles had been born to Alkmene, she sent two snakes to kill him in his cradle; but to everyone's amazement, the child quickly strangled the snakes with his bare hands.

As he grew up, Heracles was taught the use of weapons by the centaur Chiron, who also trained him to be an excellent sportsman. He was taught the arts of chariot driving, music, and

archery by the best teachers in the land. When he was old enough, he married Megara, the daughter of Creon, King of Thebes.

Hera, in the meantime, was not one to simply forgive and forget and she remained Heracles' bitter and sworn enemy. No longer content to kill him, she bided her time until he and Megara had started a small family, and then used her powers to make him go insane just long enough to burn his wife and children alive.

Afterward, when he recovered his sanity, the despairing Heracles suffered terrible agony over what he had done. One day he consulted the oracle at Delphi and begged for a way to atone for his horrifying deed. The oracle ordered him to become the servant of his cousin Eurytheus, King of Argos, who lived in Mycenae and was only too happy to come up with twelve challenging labors for Heracles to complete before he could be forgiven for his crime. Any one of these tasks would have been impossible for a normal human, but Heracles was no average mortal.

The first labor was to kill the lion of Nimea, a beast that no weapon had ever been able to wound. Heracles solved the problem by simply choking the animal to death, then carrying the carcass back to Mycenae on his back.

The second task was to go to the swamps of Lerna and kill the nine-headed creature that lived there—the Hydra. For every head that was chopped off, this monster grew two right back in its place. On top of that, one of the Hydra's heads was immortal and couldn't be killed at all. Heracles used a red-hot brand to sear the creature's neck as he cut off each one, preventing it from sprouting new heads. Then he chopped off the immortal head and buried it securely under a huge rock.

The third labor was even trickier—bringing back alive the stag with golden horns that lived in the forests of Cerynita. Simply shooting it would have been easy, but catching it alive took Heracles a whole year.

The creature he had to capture for his fourth task was a great boar that had its lair on Mount Erymanthus. This, too, required a long time because he had to chase the beast from place to place until it was exhausted. He finally managed to trap it by driving it deep into a snowbank.

For the fifth task, Heracles was supposed to clean the Augean stables in a single day. Augeas had thousands of cattle and his stables had not been cleaned in many, many years—this was truly an overwhelming task. But Heracles came up with an ingenious and effective plan: he diverted the courses of two rivers and made them flow through the stables in a great flood that washed out the filth in no time at all.

In his final labor, Heracles wrestled the fierce three-headed dog Cerberus who guarded the gates of the underworld.

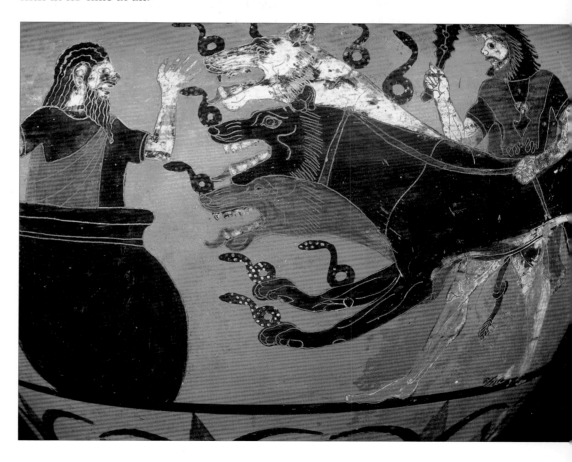

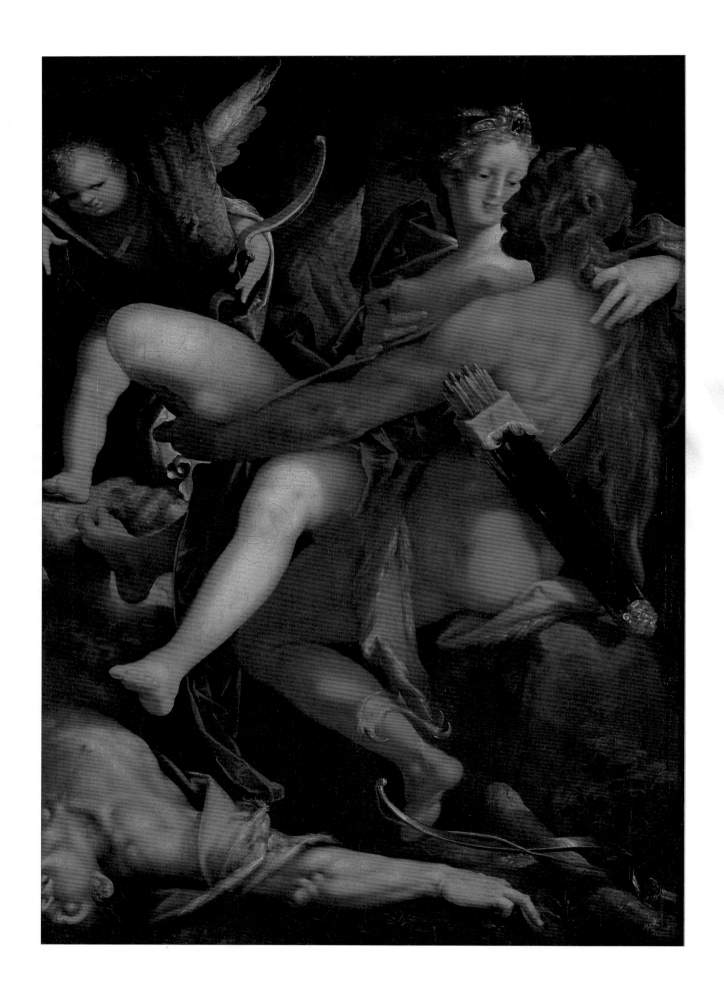

Heracles borrowed a rattle from the goddess Athena to complete his sixth labor. His task was to drive away the enormous number of brass-clawed, man-eating birds that had been plaguing the people of Stymphalus. He frightened the birds out of the marsh with Athena's rattle (which was filled with dried dragon's eyes) and then shot them dead as they flew with his poisoned arrows.

Heracles's seventh labor was to capture the mad, fire-belching bull that was terrorizing the people on the island of Crete. He captured it single-handedly, then heaved it across his shoulders and carried it to a ship that would take it back to King Eurytheus.

The eighth labor was to capture the wild horses of Diomedes, which ate human flesh. To do this, Heracles first killed their owner, Diomedes, then subdued the horses by feeding them Diomedes's flesh. He carried them back on his shoulders to his cousin.

The ninth labor was to bring back the girdle of Hippolyta, Queen of the Amazons. At first it seemed that this would be an easy task; when Heracles arrived, Hippolyta treated him kindly and even agreed to give him the girdle. But Hera, who still hadn't forgotten her bitter grudge, stirred up trouble by making the fierce Amazon women believe that Heracles was really there to carry off their queen. When they charged his ship, he immediately assumed that Hippolyta had put them up to it, and, without any hesitation at all, killed her. He somehow managed to fight off the others long enough to seize her girdle and sail away.

Heracles's tenth labor was to capture yet another monstrous creature—the "cattle of Geryon"—an animal with three bodies that lived on the island of Erythia. To do that, he first had to kill the giant Erytion and the giant's two-headed dog.

The eleventh labor made the ones before it look easy. Heracles was simply supposed to bring back the golden apples of the Hesperides (nymphs), but he had no idea where to even look for them. Finally, he asked Atlas, the father of the Hesperides, to help him. Atlas, who carried the world upon his shoulders, agreed to get the apples for Heracles if Heracles took up the heavy burden for him while he did so. Atlas quickly found the apples, but then, seeing a chance to rid himself of his heavy task forever, refused to take the world back again. He said he'd bring the apples to Eurytheus himself. Atlas might have actually gotten away with it if he'd been a little smarter. Heracles pretended to agree to the plan on the condition that Atlas could just take the burden again for a minute or two while Heracles found a good cushion for his shoulders. Of course the minute Atlas took the world back on his shoulders, Heracles left with the apples.

The twelfth labor was the worst of all. Heracles was to descend to Hades, the underworld, and bring back Cerberus, the three-headed watchdog that guarded its gates. He finally managed to wrestle the monstrous dog into submission and then carried it all the way up to earth and back to Mycenae where he wearily presented it to Eurytheus. The king, however, was so terrified of the animal that he hid in a large jar and demanded that Heracles take it back to Hades immediately. Heracles did just that, and it proved to be his last labor. Through his incredible efforts, he had earned his freedom and had atoned for his terrible deed.

opposite
This 1580 painting by Bartholomaeus Spranger shows Heracles carrying his wife Deianeira away from the dead centaur Nessus, whom Heracles has killed for trying to rape her. Nessus did have time to give Deianeira a potion he said would help her keep her husband's love forever; but it was really a terrible poison that destroyed Heracles' body as it killed him.

A Difference in Philosophy

The Greeks and Romans may have shared the same gods, but they looked at life from two very different perspectives. Greek mythology, like Greek society, valued individualism and differences in personality and character. Greek civilization was conducted mostly from small, self-governing city states. The Greeks loved life but did not believe in any sort of heavenly existence after death. They believed that the afterlife, even for the greatest of men, would be an eternity of unpleasantness, or at the very least of boredom. The only sort of positive eternity that a man could achieve came by performing great deeds that would be remembered after his death.

The Greeks were very aware of the contradiction that the very virtues that make a human being great are often those that can also lead to his or her undoing. As a result, their gods and heroes were depicted with both strengths and weaknesses. They accomplished great deeds, but they also made mistakes, and their pride, jealousy, and greed often got them into trouble. Heracles, for example, was known to mistreat women. But gods and heroes could also be brave, wise, and compassionate. By defying the gods, it was the heroes who enriched the lives of mankind.

But even though a hero was usually the offspring of a mortal parent and a god or goddess, he was rarely allowed to reach the stature of a god himself, no matter how great his deeds.

The Romans, on the other hand, developed a much more disciplined, less imaginative culture. They valued power, war, and engineering much more than the Greeks did and maintained a vast empire for centuries.

There were two other significant differences between the Greeks and the Romans that colored the myths of their gods and heroes. The average Roman was willing to put up with more hardships and less freedom in this life because he or she believed that there would be a better life in the next world after death. Romans also believed that if a hero (whether all mortal or just half mortal) were powerful enough, he could become a god, an option several Roman emperors decided they were entitled to take.

The Huntress Atalanta

One year, during the annual sacrifice to the gods, King Oeneus of Calydon somehow managed to forget Artemis. The angry goddess responded by unleashing on his kingdom the largest, most savage boar ever seen. The boar quickly destroyed all the crops, killed many men and livestock, and drove the people off the land to the protection of the city walls. It became obvious that they would soon starve if someone didn't get rid of the boar.

Offering the boar's skin as the prize, King Oeneus sent word out imploring the bravest hunters in the kingdom to come forth and try to kill the beast. Heroic hunters from far and wide soon responded to the call, including the king's son, Meleager, and several other famous Argonauts. It was an impressive group and the hunters were excited about getting started on the hunt until a woman, Atalanta, showed up to join them. In spite of Atalanta's superior shooting skills, none of them wanted a woman in the group. When Meleager finally stepped in and

opposite

Abandoned by her father because she wasn't born a boy, the beautiful Atalanta nevertheless grew up to be as able an archer and hunter as any man in the land.

forced the rest of the hunting party to accept Atalanta, they immediately suspected he did it because he was in love with her. It never occurred to them that Meleager might simply have been impressed with her hunting skills.

For Atalanta, this sort of rejection was not a new occurrence. Her father, King Iasus, had been so disgusted she wasn't born a boy that he ordered her carried into the woods and abandoned. But Atalanta didn't die like her father wished. Instead she was adopted by a mother bear who raised her to be strong and tough and to love the outdoors. As she grew up she began to spend time with the hunters who roamed the woods and soon became an expert shot herself.

By the time she was sixteen, Atalanta was as good as or better than any of the Argonauts, but Jason didn't want any women in his outfit. She was also strikingly beautiful, but had no interest whatsoever in getting married, especially after an oracle foretold of a marriage that would end in disaster.

The Calydonian boar hunt started off badly. When the hunters finally found the animal, he attacked them first, savagely killing Ancaeus and several of the others. Peleus threw a javelin at him but ended up hitting his friend Eurytion instead. No one, it seemed, could wound the beast. Eventually it was Atalanta who turned the battle around by drawing first blood with one of her well-aimed arrows. Amphiaraus wounded him again, then Meleager closed in on the boar and finished him off.

But instead of celebrating the death of the beast that had caused so much destruction, a quarrel broke out over whether or not Atalanta deserved the prize of the boar's skin. When it was over Meleager and several of his uncles lay dead.

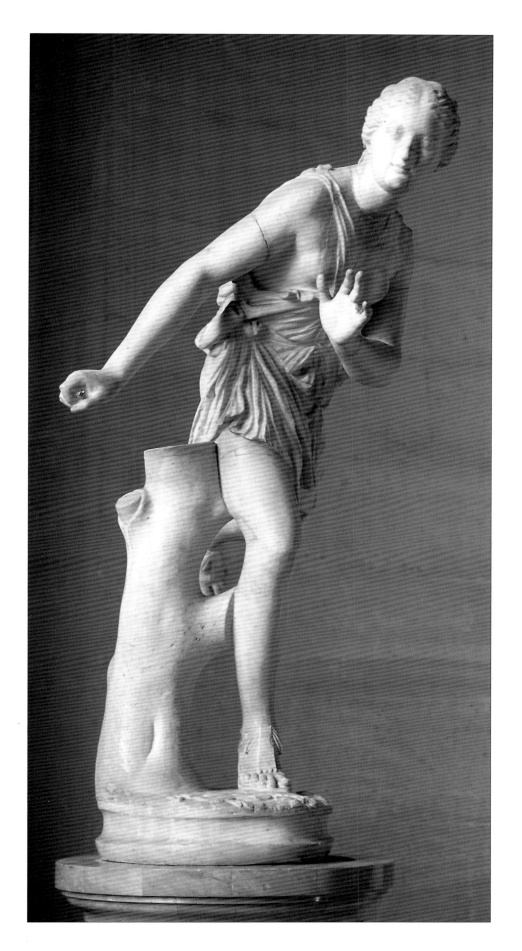

At the traditional funeral games that were held to honor those who had died in the hunt, Atalanta amazed her fellow hunters even more by beating the legendary Peleus in a wrestling match. Her skills and victories soon became so famous throughout the land that her father forgave her for not being born a boy and told her to return home. He immediately decided that he needed to fulfill his fatherly obligations by finding his daughter a suitable and (of course) rich husband.

Still frightened and suspicious of her father, Atalanta knew that to simply refuse to get married would make the man dangerously angry. Instead she proposed a test. To win her hand, she declared, a suitor would have to beat her in a footrace. Furthermore, losers would be promptly beheaded. Because Atalanta was one of the fastest runners alive, this worked for quite some time. To be fair, though, she always gave her suitors a head start and often wore armor while she ran to even out the odds. Even so, the heads quickly stacked up. Many suitors were willing to risk death to win Atalanta's hand.

One day, a young man named Melanion fell hopelessly in love with her. He knew that he was not fast enough to win the race, so he prayed to Aphrodite, the goddess of love, for help, promising sacrifice and eternal devotion in return for her assistance. Taking pity on Melanion,

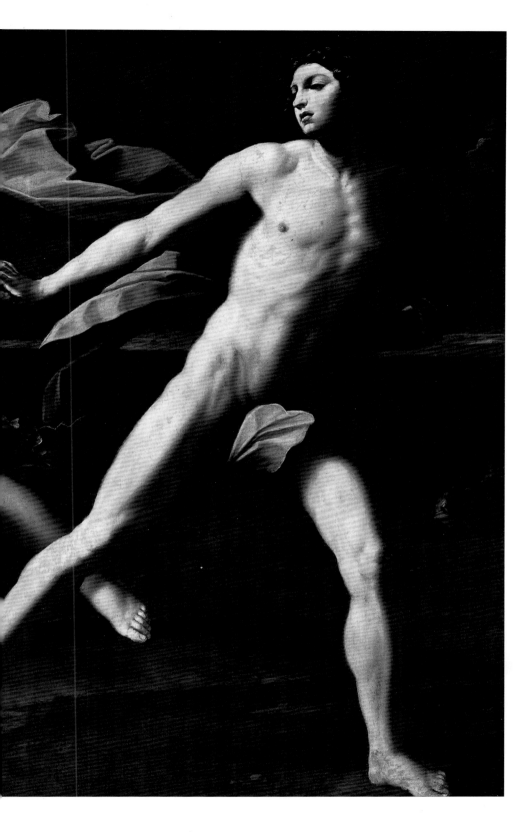

with him. Atalanta gave him a good head start, but soon caught up to him anyway. As she approached, he turned and tossed the first of the three apples at her feet. The sight of the magic golden apple was irresistible and she stopped running to pick it up, confident that she could easily make up the time. Soon enough, she was once again catching up with her opponent. Melanion threw the second golden apple, this time further to the side. Again, Atalanta lost time retrieving the apple, and when she caught up to Melanion the finish line was very near. Stopping to chase the third golden apple cost her the race.

To her great surprise, Atalanta discovered that marriage was not that bad after all. Melanion was a gentle and loving husband. But his happiness and joy were so great that he completely forgot his promises of devotion and sacrifice to the goddess Aphrodite. He forgot what terrible fates befall mortals who forget to give proper

Atalanta could have won the race easily if she had not stopped to pick up the golden apples Aphrodite had given Melanion to distract her.

Aphrodite presented him with three golden apples and a plan to win the race.

When Melanion ran his race with Atalanta, he secretly carried the golden apples thanks to the gods. Thus, it's really no wonder that Aphrodite became angry and turned Melanion and Atalanta into a pair of magnificent lions.

Chapter 3

Heroes of the British Isles

The myths and legends of the British Isles come mainly from the ancient Celtic and Anglo-Saxon cultures. The Celts probably arrived in England around 400 B.C., and their influence is most clearly apparent in the long, romantic fairy tales and hero legends of Scotland, Ireland, and Wales.

The Angles and the Saxons conquered Britain in the fifth and sixth centuries A.D. The influence of Anglo-Saxon culture can especially be seen in Old English epic poems such as Beowulf.

Until the seventh or eighth century A.D., the rich mythology and folklore of the British Isles was handed down only by word of mouth, but in the early seventh century, monks in Canterbury started to write down what they knew of Anglo-Saxon history and culture.

In 1066, a Norman named William the Conqueror invaded England and established a rule that was almost entirely Norman-French, greatly changing English life and culture. Many of the ideas of chivalry and knighthood that developed during this time were woven into existing Celtic and Anglo-Saxon tales, creating legends such as King Arthur and his Knights of the Round Table.

The Celtic Legends of Ireland

opposite

The rich mythology of the British Isles is the result of numerous conquests and invasions. In 1066, a Norman named William the conqueror crossed the English channel, killed Harold II, the last of the Anglo-Saxon kings, and crowned himself King of England. These events are depicted in the eleventh-century Bayeux tapestry.

below

The warlike Celts who inhabited Ireland before the fourth century B.C. developed myths of epic battles, disastrous floods, and invasions.

Although many Celtic myths and legends were started centuries before the birth of Christ, they had their roots in an oral tradition and were only written down much later, in books such as *The Book of the Dun Cow* (written in the eleventh century), *The Book of Leinster* (twelfth century), *The Book of Ballymote*, *The Yellow Book of Lecan* (fourteenth century), and *The Book of the Dean of Lismore* (fifteenth century).

The first cycle of legends deals only with the age of the gods, primarily recounting their battles with the evil Fomorians of the Land Under the Sea. The exploits of mortal heroes such as Finn MacCool (also sometimes known as Fionn MacCumhall), the Fianna, and Cuchulain

are recounted in the subsequent "Fenian" cycles. These detailed stories cover every aspect of the heroes' lives, including births, elopements, adventures, voyages, battles, feasts, courtships, visions, invasions, destructions, expeditions, sieges, dragon-slayings, and, of course, violent deaths.

Finn MacCool and the Fianna of Erin

Some of the most romantic and colorful of the Celtic legends are the stories about the hero Finn MacCool and his elite band of fighting men, the Fianna. The Fianna's main function was to uphold order within Ireland. During the summer months the men lived entirely outdoors, hunting and fishing for food and sport when they weren't off doing their heroic deeds. It was considered a great honor to be a member of the Fianna, and the entrance requirements were far from easy. First of all, a man had to be versed in the *Twelve Books of Poetry* and had to prove he was a man of culture. He also had to pass a number of rigorous initiation rites that tested his superior athletic ability, his skill as a warrior, and his courage.

The leader of this perfect band of warriors, Finn MacCool, was not considered the strongest or most skilled of the Fianna, but he was the truest, wisest, kindest, and most trusted of them.

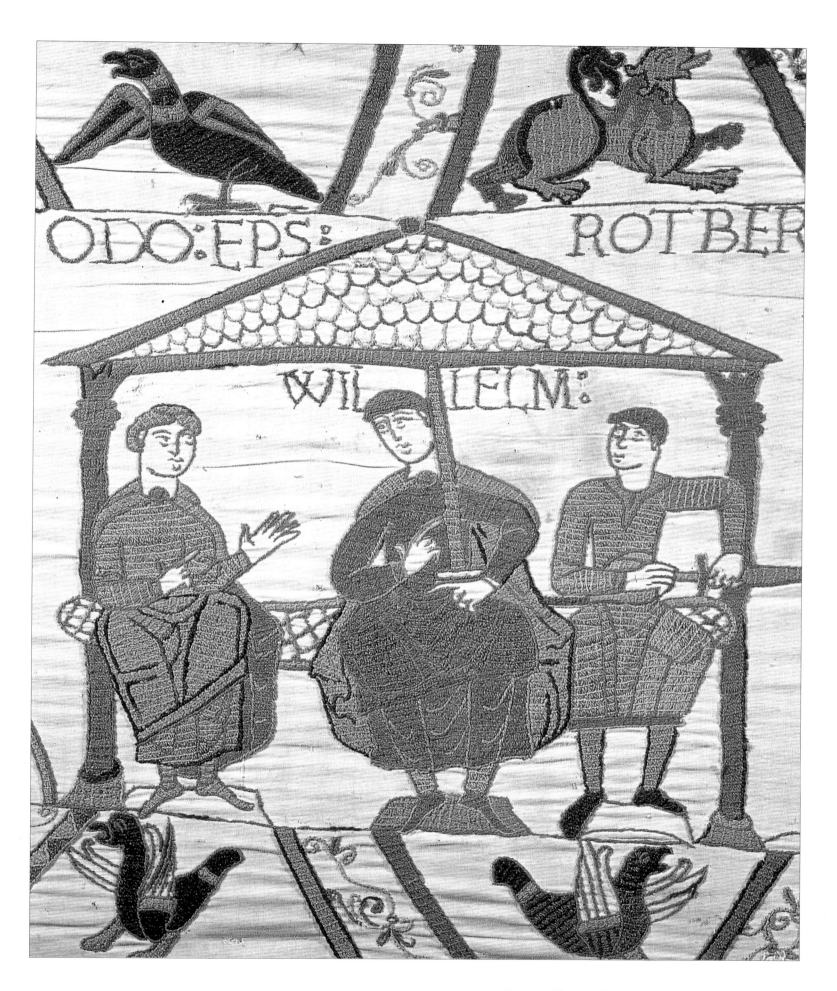

ODO:EPS: ROTBER

WILLELM:

He was not just the leader of his people, he was a poet and magician, the pinnacle of achievement for a Celtic warrior. The cycle of legends start with the story of how Finn came to power.

Finn and the Salmon of Knowledge

Originally called Deimne, Finn grew up in the care of two druid women who took him to the wood of Slieve Bladhma when he was ten. Here he was given excellent training in the ways of the warrior. He also spent time with a troupe of poets who taught him the way of words. When he was ready, this fine, good-looking, and highly skilled young lad set out on his own to seek his fortune.

Deimne soon came across a man named Finnegeas who lived by the river Boyne. For seven years Finnegeas had waited on the riverbank, watching for the white-and-red speckled Salmon of Knowledge. He knew that eating this fish would give the first man that tasted it all knowledge. Finnegeas caught the salmon while Deimne was with him and with much joy put it on a spit over an open campfire, entrusting the cooking to Deimne but warning him not to taste it.

After a time, Deimne went to see if the fish was cooked. He couldn't tell just by looking at it, so he touched it with his thumb and promptly burnt himself, leaving a blister. To ease the pain,

he put his thumb in his mouth, and thus became the first person to taste the salmon. When Finnegeas looked at the boy's face, he saw the wisdom shining in it, and knew that the salmon was no longer of any use to him.

The boy then gave Finnegeas the fish. After looking at it for a while Finnegeas said to Deimne: "What is your name, boy?" "It is Deimne." he replied. "No, it is not," said Finnegeas. "It was prophesied that someone named Finn would gain the knowledge from the salmon, so your name must be Finn." From that day on, his name was Finn MacCool, and if he needed to know something, all he had to do was put his thumb into his mouth and the knowledge came to him.

above
It's said that Finn built this "Giant's Causeway" so he could walk over to Scotland. The rock in the foreground is believed to be his foot. •

According to Irish legend, coming across the mischievous elves known as leprechauns was considered especially lucky because legend had it that if you could catch them, they would reveal the hiding place of their buried treasure.

The Enchanted "Otherworld"

Whether in nursery stories or hero legends, the rich folk literature of the British Isles involved the magical Otherworld in one form or another. In England there were the "drolls," whose devious plots always involved some act of stupidity or cunning. In Scotland there were goblins and witches, bogeys and kelpies, and strange mermen and mermaids who lived in a land beneath the sea. Scotland also had brownies, lovable creatures who were kindly disposed toward people if they were well treated, but capable of terrible mischief if people treated them badly. Ireland and Wales had their faeries and elven "little people." Some Otherworld characters were more evil, like the Irish Lugh, ruler of the Land Under the Sea, or giants with five heads, or wicked stepmothers with enchanted powers. Sometimes the creatures gave heroes help in the form of special skills or knowledge. Sometimes they were minor obstructions the hero had to outwit or distractions which threatened to lead him away from his true tasks. Often they were so feared and treacherous that only a true hero could kill them.

Finn Becomes Leader of the Fianna

After tasting the Salmon of Knowledge, Finn traveled to the court of Conn Ceadchathach at Tara for its much-renowned annual November feast. The king was desolate, however. For the last nine years the feast night was no night of celebration. Instead, his citadel was burned down by an Otherworld being called Aillen, who first lulled everyone, including the soldiers, to sleep with its magical harp music. The desperate king promised that if a man came forward who could save Tara from this fate, he would grant such a man whatever he wanted.

Finn offered to stand guard. With the help of a magical spear, he was able to withstand the enchantment. When he heard Aillen's magical

music, he pressed the point of the spear into his forehead—the pain kept him awake. He jumped up to face the monster, who released a blaze of fire from its mouth, but Finn quenched the blaze with his cloak, then cast his spear at Aillen and killed the beast. When he heard the news, Conn Ceadchathach was so grateful that he appointed Finn as leader of Ireland's most elite and powerful army, the Fianna.

Finn's Hound Cousins

Finn was a great hunter of deer and wild pigs and had many hunting dogs. One story tells about the two great hounds, Bran and Sceolaing, who were his favorites. Bran and Sceolaing were not just excellent hunting dogs, however; they were also Finn's cousins.

It all started when the king of the Dal nAraidhe announced that he desired Finn's aunt Uirne as a wife and Finn happily agreed to the marriage. But the king's first wife was not quite so enthusiastic. In her jealousy, she used her limited knowledge of sorcery to turn Finn's aunt Uirne into a dog. Luckily for Uirne, the warrior Luaghaidh Lagha (who had always been enamored of her) rushed to her aid and killed the king and his treacherous first wife.

Uirne immediately regained her shape and in a short time gratefully married her hero, Luaghaidh. There was still a bit of hound in her, however, and when she bore triplets nine months later she also gave birth to two pups. She gave the pups to Finn, who named them Bran and Sceolaing and trained them as hunting dogs.

Bran was Finn's favorite; Finn loved him intensely. Bran and Finn made great noise together at feasts, and whenever any of the Fianna were hungry Bran would go into the forest and bring them their meals. One day, however, when Bran

When Finn MacCool proved he had the courage and magical powers to stand up to the monsters of the Otherworld, the people gratefully honored him as leader of their elite army, the Fianna.

was yelping impatiently, Finn got angry and struck him on the head with his whip. Bran stared at his master with tear-filled eyes, then wrenched free, and raced to a lake where he drowned himself. Forever after, when Finn heard the baying of a hunting hound, his heart nearly broke.

Finn and the Bad Servant of Lochlan

One of the Fianna's most harrowing battles took place against invaders from Lochlan, the Land Under the Sea where the evil Fomoire dwell. The story begins with the appearance of a somewhat malformed man; with an iron bit he dragged behind him a dilapidated horse so awkward in its walk, it was a wonder the beast did not fall over. The man announced that he was a man of the Fomoire and that his name was Gille-Decair ("Bad Servant"). He told Finn he wanted to become a member of the Fianna. But instead of acting as though he was worthy of the honor, he behaved obnoxiously. First, he insulted some of Finn's men; and then he demanded double wages, claiming that he was a horseman and that horse-

Another of the extraordinary rock formations to be found at Giant's Causeway, in Ireland.

men deserved to be paid more than common foot soldiers. Even his horse was nasty: while Gille-Decair talked, the animal set about maiming and killing the horses of the Fianna.

One of Finn's men, Conan, tried to control the man's horse by jumping on it, but immediately found himself hanging on for dear life as the steed reared and bucked. This was, after all, no ordinary horse. It was Aonbharr, the gallant steed of none other than Lugh, evil ruler of the Land Under the Sea. Other men jumped on to try to subdue it when the horse abruptly took off. Fourteen of Finn's men suddenly found themselves galloping off on a journey they had had no intention of starting, with no idea where they would end up. When Finn looked around, Gille-Decair had also disappeared, leaving Finn with the question of how he could possibly save his men.

Drawing on his magical powers, Finn summoned Otherworld aid to help him in his quest. Two men immediately came to help him—with only three blows one of them could create a ship that could hold three thousand men. In these special ships, Finn and his remaining men set off on the tracks of Aonbharr and the fourteen abducted men. For three nights and three days the sea was relentless in its wildness and fury, yet Finn and

his men carried on as if the waves were mere ripples on a pond.

On the fourth day a huge gray mountain whose slopes were sheer, smooth rock rose out of the sea before them. The mountain was obviously impossible to climb. Then the other man aiding Finn set to work. His special skill was a superhuman ability to scale sheer cliffs. On his way up, he pounded staves into the mountainside to provide footholds, allowing Finn and his men to quickly scale the mountain and rescue the fourteen warriors kidnapped by Lugh's horse Aonbharr.

A stone carving of the head of a Celtic hero.

The Irish Achilles

Another important Irish Celtic hero, Cuchulain, bears a striking similarity to the Greek Achilles, even though Ireland and Greece are at opposite ends of the European continent. Like Achilles, Cuchulain is portrayed as extremely courageous (but reckless), impressively fierce, and unafraid to speak his mind. Even his childhood was remarkable: by the time he was eight he was already known all over Ireland for his skill and courage as a warrior. By the time he was seventeen, Cuchulain was, without question, the best warrior in Ireland. Time after time he went after and killed the fearsome giants and grotesque monsters no one else dared to face. One story tells how he killed a particularly hideous dragon that was terrorizing the countryside by springing up, thrusting his arm down the beast's throat, and ripping out its heart.) But above all, Cuchulain was respected for his honor, loyalty, and passion for the truth, qualities which made him a true Celtic hero.

The Celtic Myths of Scotland

Like the other British Isles, Scotland was also overrun by Celts after 400 B.C. Many Celtic myths are common to both Scotland and Ireland, while others are distinctly Scottish. There are a number of creation myths about gods such as the fearsome one-eyed Cailleach Bheare (also known as Mag Moullach or the Storm Hag), who supposedly shaped the many mountains and lakes of the Scottish countryside by throwing peat and rocks into the sea from

Ireland. There are also great cycles of tales about heroic mortals who are either transformed by visits to magical islands of the Otherworld or who are aided by superhuman powers in their noble adventures. One such story is about Prince Iain.

the stepmother knew she had to have the magic bird it came from. She put a spell on Iain, saying that until he brought her the Blue Falcon, slimy, brown bog water would constantly run through his shoes.

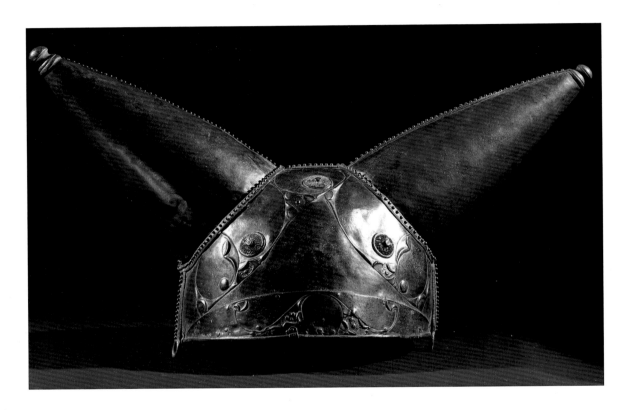

Celtic Scottish warriors fought with bronze swords and helmets such as this one.

Prince Iain's Adventure

It is told that in ancient times a Scottish king and queen gave birth to a son they named Iain. When the queen died, the king soon took another wife. Meanwhile, Prince Iain grew up to be a handsome young man and an excellent hunter. But one day Iain didn't even see a deer, let alone shoot one, and when he aimed an arrow at the Blue Falcon, all he did was knock a feather out of her wing. He put the feather into his bag and went home. When his evil and jealous stepmother demanded to see what he had killed, Iain showed her the feather. As soon as she saw it,

Prince Iain went off as fast as his cold, wet feet could carry him and walked all day looking for the Blue Falcon. When night fell, he found shelter under a briar bush; then who should pass by but Gillie Martin, the Fox. The Fox told him that the Blue Falcon he was looking for belonged to the Big Giant with Five Heads. He advised Iain to become the giant's servant and volunteer to look after his cows, goats, and sheep. In time, the Fox promised Iain, the giant would trust him to feed his Blue Falcon. Then all he had to do was wait until the giant was away from home and carry her off.

So Iain started to work for the giant, who was soon so pleased with how well he tended the

animals that he even gave him his Blue Falcon to look after. One day when the giant was gone, Iain saw his chance and grabbed the bird. He threw open the door and was about to take off when the doorpost screamed and the giant came running home. The giant told Iain there was no way he could ever have the Blue Falcon unless he brought the giant the White Sword of Light from the Seven Big Women of Jura.

So Prince Iain was once again wandering the countryside and once again he met Gillie Martin, the Fox. The Fox took him down to the edge of the ocean where he turned himself into a boat. Iain rode the boat over to Jura where the Big Women lived and offered to be their servant. He told them he was good at polishing steel and gold and soon they trusted him to take care of the White Sword of Light. When the women left one day, Iain grabbed the White Sword and was about to make a run for it when the door frame screamed. The Seven Big Women came running home and took the Sword from him. They told him they'd give him the Sword, but only if he brought them the Yellow Filly of the king of Erin (Ireland). So Iain went back to the shore where he listened to the Fox's new plan.

In Erin, it was the same story. When Iain tried to escape with the king's Yellow Filly, the king demanded that Iain first bring him the daughter of the king of France. In France, however, Iain finally got lucky. He actually managed to get the princess on board his ship and was sailing back to Erin to trade her for the Yellow Filly, when the princess announced that she'd much rather be Iain's wife. Iain thought that was a wonderful idea, but he still needed to get the Blue Falcon to get rid of his stepmother's curse. So the Fox once again helped him come up with still another plan.

When the ship came to the shores of Erin, the Fox changed himself into a woman as beautiful as the king of France's daughter. When the king of Erin saw the lovely maiden, he gratefully gave Iain the Yellow Filly, which Iain quickly

rode back to the princess waiting by the seashore. That night, when the king and his new wife were in bed, Gillie Martin changed back from a beautiful young woman and became the Fox again. He tore the flesh from the king and killed him.

Evil monsters often appeared as malformed or gigantic men.

Next, they all sailed back to Jura. Leaving the princess and the Yellow Filly at the shore, the Fox changed himself into a yellow filly and went with Iain to the house of the Seven Women. When the amazed Women saw the magnificent horse, they gladly gave Iain the White Sword of Light. Iain quickly took the sword back to the shore as all Seven of the Big Women eagerly climbed on the back of the yellow filly and went off riding. That is, until the horse kicked up its hind legs and threw all seven of them over a cliff.

Their next stop was the home of the Big Giant with Five Heads. Here, the Fox changed himself into a white sword, which Iain gave to the giant in return for the Blue Falcon. While Iain carried the Blue Falcon back to the seashore where he had left the princess, the giant was having fun fencing with his new sword, swinging it round his head. Suddenly the sword bent itself and, before the giant realized what was happening, he cut off his own heads—all five of them.

When they finally made it back to the stepmother's house, Iain was especially careful to follow the Fox's instructions so she wouldn't turn him into a tree stump—or worse. Riding the Yellow Filly with the princess of France sitting behind him with the Blue Falcon on her lap, Iain galloped toward his stepmother, the queen. When he pointed the White Sword of Light at her, she magically turned into a bundle of firewood which Prince Iain and the Fox quickly burned to wood ash.

Now Iain not only had the best wife in Scotland, he had a horse so fast that she could leave one wind behind her and catch the wind in front, the magic Blue Falcon to keep them supplied with an endless supply of game, and the magnificent White Sword of Light to defend them all from harm. When Iain and the princess thanked the Fox, he merely smiled, wished them well, and went on his way.

Hero Legends of Wales

The *Mabinogion* is a collection of Welsh tales handed down orally for centuries until they were written down during the thirteenth, fourteenth, and fifteenth centuries. *Mabinogi* means "instruction for young poets" in Welsh. The tales are divided into four main parts: Pwyll, Prince of Dyfed; Branwen, the Daughter of Llyr; Manawyddan, the Son of Llyr, and Math, the Son of Mathonwy. Each part tells of members of the Welsh royal households, their battles, heroic journeys, misfortunes in love, and interactions with the magical and supernatural Otherworld.

Pwyll and Rhiannon

An example from the first part of the *Mabinogion* is about Pwyll and the woman he marries, Rhiannon. When the story opens, Pwyll, the noble young Prince of Dyfed, has already held his own against a number of gods, including Arawn, the King of Annwvyn (hell) with whom he was forced to exchange shapes for a year as penance for killing some of the king's dogs. Near Pwyll's palace was a mound upon which, people believed, one could sit and see visions. One day Pwyll decided to visit this mound, and as he sat on it he saw a beautiful lady in golden robes ride past on a white horse, furiously trying to outride

Gwawl, the sun god who obviously wanted to marry her. Pwyll saw her again the next day, and this time she stopped. The two soon fell in love and set about devising a plan to get rid of Gwawl, to whom she was unfortunately already betrothed.

At the feast just before Rhiannon and Gwawl's wedding, Pwyll, carrying a magic bag, showed up disguised as a beggar; he begged Gwawl for food. But no matter how much food was put into the bag, it never became full. Exasperated, Gwawl asked whether it would ever be filled, and Pwyll admitted ᴜld not, unless a ɪn were to stomp ʜe contents of the ; with both of his et. When Gwawl got up and stepped into the bag, Pwyll quickly pulled up the sides, trapping Gwawl within. Gwawl begged for mercy, and Pwyll released him, but only after making ᴏmise to leave taking revenge. ʟeft, the wedding feast continued, but this time Pwyll was the bridegroom.

After tricking Gwawl into leaving his own wedding ceremony, Prince Pwyll marries Rhiannon in his place.

Pwyll took his new bride back to Dyfed where they lived happily and ruled for many years. Some years later, Rhiannon gave birth to a baby boy and there was great rejoicing through-

out the kingdom. But on the very night of his birth, while Rhiannon and her women servants slept, the baby mysteriously disappeared. The servants awoke first, and when they found the baby gone, they were terrified. Afraid they'd be punished for allowing the baby to disappear, they decided to make it look as if his own mother had killed and eaten him. They killed a young dog, and laid its bones by Rhiannon, rubbing blood onto her face and hands.

Horrified that she had killed her own child, Rhiannon took on a penance, sitting each day outside the castle, telling passersby the terrible tale, and offering to carry them on her back.

But Rhiannon's wasn't the only baby to disappear. As it happened, the same night Rhiannon was giving birth, another strange birth was taking place nearby. Teirnyon, the lord of Gwent, had a mare that would foal every year on the first of May. And every year, the colt would immediately disappear. Baffled and annoyed by these annual disappearances, Teirnyon had finally taken the mare into his house to let her foal there. She bore a large and beautiful colt, but then there was a terrible racket outside, after which a clawed arm came in through the window and attempted to drag the colt away. Teirnyon jumped up and cut off the arm, and then ran outside to see what was trying to steal his colt. To his surprise, he found an infant boy lying on the doorstep.

Teirnyon and his wife took the child in and after a few months began to see his resemblance to Pwyll. Thinking back on the news of Rhiannon and her punishment, they decided that the boy must be her child. They returned the child to his true parents and Rhiannon and Pwyll were overjoyed. They named their beautiful son Pryderi.

The Arthurian Legends

According to the many legends written about him, Arthur was the son of the Welsh king Uther Pendragon. Immediately after his birth, the elves bestowed on him long life, riches, and virtues. His father gave Arthur into the keeping of Merlin the Magician, who later took him to Sir Hector to bring the child up as his own son. When Arthur was only fifteen, his real father, Uther, died.

Arthur could not just take his father's place, he had to prove his right to the throne by pulling out a special sword fixed in a great stone. No one else had been able to budge it. This was the first of Arthur's two magic swords, both called Excalibur. (The other was given to him by the Lady of the Lake. According to the story, her arm appeared above the surface of the lake with the sword in hand. When Arthur took it, her arm disappeared.) Arthur took the throne as king of Britain and waged many battles until he finally conquered Scotland, Ireland, Iceland, and the Orkneys. King Arthur later married Guinevere, a lady of noble Roman family, and they held court at Camelot, on the River Usk in England, near the Welsh border. Around him he gathered many strong and brave knights. Because they all sat as equals about a great round table, they eventually came to be known as the Knights of the Round Table. King Arthur extended his conquests far and wide. One day he was summoned to pay tribute to the Emperor Lucius of Rome; he refused and instead declared war on Rome. He went off to war, leaving the kingdom in the hands of Mordred, his nephew, a decision which proved to be a terrible mistake for the kingdom.

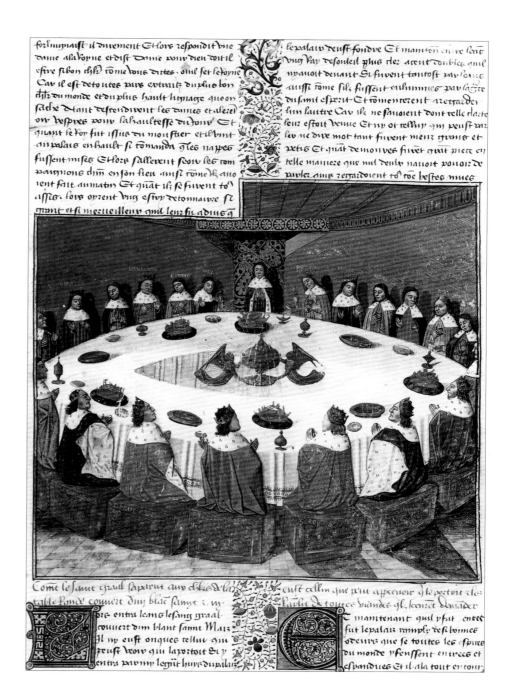

On his way to Rome, Arthur bravely slew the giant of St. Michael's Mount. He finally fought his way to the outskirts of Rome and was about to lay siege to the city when he learned that the traitorous Mordred had seized the kingdom in his absence. Arthur immediately rushed home, and killed Mordred in a great battle. But in that battle, Arthur himself was mortally wounded. According to the legend, however, he didn't die. His body was mysteriously carried to the island of Avalon to be healed, and he is expected to return at some future time and resume his rule.

King Arthur seated his brave and noble knights around a round table so they would all be honored equally.

After battle, King Arthur and his knights tend to the wounded and dying.

Central to the Arthurian legends is the downfall of Arthur's kingdom, but there are many different versions as to how that was ultimately accomplished. Some say it failed due to the treachery of Mordred. Others show that the treachery was only made possible because of the illicit love between the knight Lancelot and Arthur's wife, Guinevere. There are a great number of other romantic and exciting Arthurian legends, such as those involving the search for the Holy Grail, the Fisher King, how the Lady of the Lake got the magic sword, the rise and fall of Merlin the Magician, and many others.

Was There Really a King Arthur?

Although almost every European country has had a version of the romance of Arthur (and knights of the Round Table such as Lancelot, Gawain, and Tristam), most scholars agree that Arthur first appeared in the fourth book of the Welsh *Mabinogion* in stories about the Lady of the Lake, Bedivere, Kay, and Gawain. But in these stories, Arthur was not a mortal King, but King of Fairyland. Over the years, other stories then attached themselves to the name of Arthur, especially myths of ancient Celtic gods and

Otherworld tales of the supernatural embodied in characters such as Merlin. Later, the Norman knights and poets made Arthur a knight like themselves, even though his stories started long before the age of chivalry. They added details of their own with stories of other knights such as Lancelot and Galahad.

Some historians believe that many of the legends began as fact—that there actually was a hero named Arthur living in Britain in the fifth or sixth century A.D. who gained fame as a leader of the Christian Celts in the wars against the heathen Saxon invaders. After Arthur was defeated and killed in battle, his people then fled to the mountains of Wales and to Brittany, where they told stories of Arthur's valor and goodness.

Many writers have interpreted the Arthurian legends. In the fifteenth century Sir Thomas Malory translated many of these romances from Welsh to English. They appeared as *Le Morte Darthur* (The Death of Arthur), one of the first books to be printed in England. T.H. White's *The Once and Future King* became the basis for the musical *Camelot* (1960) and the animated film *The Sword in the Stone* (1963).

Robin Hood

The Anglo-Saxon songs and legends about Robin Hood and his merry outlaws have been entertaining people for over six hundred years. Some people believe the heroic figure of Robin Hood actually existed; others believe only that he should have. According to the story, during the reign of King Richard I, also known as Richard the Lion-Hearted, Robin was an outlaw living in Sherwood Forest with one hundred tall men, good archers all. Robin and his men robbed from the rich, using part of the spoils they acquired for their food, drink, and clothing, and giving away the rest to the needy poor. They were also staunch defenders of womanhood, and did what they could to make sure that no women were oppressed or molested. Needless to say, Robin Hood and his men were very popular with the common people and a constant annoyance to the ruling elite.

One of the best-known Robin Hood stories is a tale about an archery contest as told by Sir Walter Scott in his book *Ivanhoe*. King Richard was out of the country, fighting in the Holy Land at the head of an army of crusaders, and had left the inept Prince John in charge, when Robin Hood decided to compete for the longbow-shooting prize at a royal archery tournament the prince was holding at Ashby. Had anyone known who he was, Robin would, of course, have been arrested; he came in disguise and refused to give his name. After a number of rounds, the competition was narrowed down to just two archers, Robin and Hubert, a forester in the service of one of the king's nobles.

Although Hubert shot his first arrow of the final round close to the center of the target,

Robin pointed out to him that he could have gotten it closer had he allowed for the wind. Then Robin stepped up to the mark and carelessly shot his arrow, making it seem as if he had not even looked at the target before shooting. His arrow was two inches closer to the center than Hubert's had been. Prince John was furious that a stranger was beating one of his own men and yelled to Hubert that he'd better win this or he would make things very hard for him. So Hubert stepped up to the mark, took Robin's advice about compensating for the wind, and hit the target dead center. The crowd roared with delight, rooting for Hubert over this stranger.

The prince mocked Robin, pointing out to him that there was no way he could top Hubert's shot, so he didn't even have to bother to try. Robin simply walked up to the mark and shot his arrow. He also hit a bull's-eye—but he hit his by splitting the shaft of Hubert's arrow right down the middle. The crowd was so flabbergasted they couldn't even cheer. Even Prince John admired the stranger's skill so much that he forgot to dislike him. He declared Robin the winner and gave him all the prizes. He also offered Robin a job as his personal bodyguard, an offer Robin was quick to decline. Although he had beaten Hubert fair and square, Robin Hood gave him half the prize before he disappeared into the lights and shadows of his beloved Sherwood Forest.

above
Will Scarlet, one of Robin's merry outlaws, kills a buck for their evening meal.

opposite
Little John offers encouragement as Robin Hood practices his archery for the Royal Tournament.

Beowulf

When the Anglo-Saxons invaded the British Isles in the fifth and sixth centuries, they brought with them songs about their hero Beowulf. But it was not until the seventh or eighth century that some unknown poet wove the tales into a great epic. The hero, Beowulf, is a courageous Swedish prince who fights three major battles in the course of the tale, all against monsters.

The first part of the poem, the prologue, begins with a history of Danish kings, starting with the funeral of King Shild and leading up to the reign of King Hrothgar, Shild's great-grandson. King Hrothgar has just finished building a lavish hall called Herot and has thrown a gala celebration to honor his army's successes in war. But the joy in his kingdom soon turned to fear and despair: the nighttime singing and carousing of Hrothgar's men angered Grendel, a terrible half monster, half man who lived at the bottom of a nearby swamp. Grendel appeared at Hrothgar's hall later that night and killed thirty of Hrothgar's warriors in their sleep. Then, night after night for the next twelve years, the monster crept into the king's palace to slay more sleeping knights; there was nothing Hrothgar and his advisers could do to stop him.

When he heard about Hrothgar's troubles, Beowulf, prince of the Geats, gathered fourteen of his bravest warriors, and set sail from his home in southern Sweden. Beowulf claimed to be an accomplished warrior with particular success in fighting sea monsters. Hrothgar eagerly promised Beowulf great treasures if he could rid them of Grendel.

Beowulf wasted no time. When Grendel appeared later that night, the prince wrestled the monster bare-handed and tore off the monster's arm at the shoulder. Grendel managed to escape, only to die soon afterward in his muddy lair at the bottom of the snake-infested swamp. Delighted, Hrothgar threw a banquet in Beowulf's honor and rewarded him with treasures while his Danish warriors sang songs in praise of Beowulf's triumph.

What none of them knew was that Grendel had a mother who was a monster even more terrible. In the second part of the poem, Grendel's mother takes her bloody revenge. She arrived at the hall late the next night when all the warriors were asleep and

A page taken from a sixth-century version of the epic poem Beowulf, written in Old English.

carried off Esher, Hrothgar's trusted chief adviser. Once more, Beowulf went to the aid of the Danes. He and his men tracked the she-monster to a cliff where they saw Esher's bloody head floating on the surface of the swamp below. Beowulf dove to the bottom of the snake-infested muck where he found the monster's lair. After a terrible fight, Beowulf stabbed her with his magical sword, Hrunting, then used his bare hands to wring her neck.

Grateful to Beowulf for purging Denmark of its race of evil monsters, King Hrothgar held one more feast in his honor. In the morning the Geats sailed for home. When King Higlac of Sweden heard how Beowulf had killed both Grendel and Grendel's mother, he proclaimed him a national hero and made him his most trusted counselor. In the beginning of part three, Higlac had died and the Geats had chosen Beowulf as their king. Beowulf reigned wisely; his people lived in prosperity and happiness for fifty years, until a great terror fell upon the land. A thief had stupidly stolen a jeweled cup from the den of a sleeping dragon, and the beast now wanted revenge. The dragon terrorized the kingdom by flying through the night and lighting up the darkness with his blazing breath. It burned houses, men, and cattle to ashes with the flames from his hideous mouth.

When the aging King Beowulf heard that even his bravest warriors were terrified of confronting the beast, he took up his sword and shield one last time and set off to find the dragon's den. When he found the cave, he stood at the entrance and cursed the monster until it rushed out at him, roaring hideously and flapping its glowing wings. Beowulf fought bravely but his strength was not as great as it had been when he fought Grendel many years earlier. He managed

to pierce the dragon's scales with his sword, but before it died, the dragon engulfed Beowulf in flames and gashed him in the neck with its poisonous fangs.

His men rushed into the cave. The dragon was dead, but it was too late to save Beowulf. He had fought his last battle. His men built a funeral pyre for him at the top of the cliff, then buried the dragon's treasure alongside Beowulf's ashes. And so the poem ends as it began—with the funeral of a great warrior.

Grendel as Hero

In 1971, superb writer and storyteller John Gardner wrote a book called *Grendel*, in which he told the story of Beowulf from the monster Grendel's point of view. In the original poem, Grendel is a symbol of absolute evil and corruption, a loathsome being whose only feelings are hatred and bitterness toward mankind. In Gardner's version, however, even though Grendel is still a hideous-looking beast "crouched in the shadows, stinking of dead men, murdered children, and martyred cows," the reader begins to identify with his pain, frustration, and his terrible loneliness. Although he's supposed to strike fear into the hearts of man and beast, his inept efforts to do so are often more ridiculous than frightening. For example, when an old ram refuses to run and just stands there laughing at him, Grendel stamps his feet, howls, even throws stones at him, yet still the ram won't budge. So Grendel just stares at him in horror and hisses "Scat!" When Beowulf finally hunts him down and slays him, Grendel's death is a sad and pathetic one.

ICELAND

Norwegian
Sea

NORWA

SW

UNITED
KINGDOM

North
Sea

DENMARK

Copenh

Heroes of Scandinavian Mythology

The mythology that evolved in the cold lands of northern Europe reflected an endless struggle against ice and cold. The stories of Norse gods and heroes were preserved in two ancient books called the Eddas. The older of the two was written in poem form in the eleventh century (possibly by a writer named Saemund) and consists of fragments about the lives of the Norse gods and two heroic families—the Volsungs and the Nibelungs. The later Edda was written in the early thirteenth century by Snorri Sturluson. Written in prose, this collection was partly a textbook on poetry and partly a chronicling of the Norse gods and their fates.

Long before the myths and legends were ever written down, however, they were kept alive by skalds, traveling poets who made their living reciting the sagas (as the myths and legends were called), primarily at the feasts and banquets of warriors.

The Saga of the Volsungs

The Volsungs were a heroic people descended from the Norse god Odin. The saga begins with the story of Odin's son Sigi, who was declared an outlaw and driven into exile after he murdered another man's thrall (slave). Odin set him up in a new life as king of a place named Hunland. Sigi had a son named Rerir who took the throne many years later. But Rerir was unhappy because he and his wife could not have children. Frigg and Odin heard their prayers and sent a Valkyrie named Ljod to bring them a special apple. Ljod turned herself into a crow and dropped the apple

onto the queen's lap; when she ate the apple, she became pregnant. King Rerir died and for six long years the weary queen carried her unborn child, then died in childbirth. She lived just long enough to give her newborn son the name Volsung and kiss him good-bye.

Volsung became the next king of Hunland, and when he grew up he took the Valkyrie Ljod for a wife. Volsung and Ljod had eleven children—a daughter named Signy and ten sons. The oldest and bravest of the sons was Signy's twin brother, Sigmund. The Volsungs were a family of true heroes and were stronger, braver, and fitter than all other men. King Volsung built a palace around a tree and called it Branstock (or Stem of the Children). The trunk of the tree was in the palace and its fruitful boughs stretched out over the roof.

The Hero Sigmund Escapes Siggeir's Treachery

When the Volsung children were older, Siggeir, the mighty king of Gautland (Sweden), decided he wanted to marry Signy. He got her ten brothers to agree to promise him her hand in marriage, even though she wanted absolutely nothing to do with him. At the wedding banquet at

the Volsung palace, an elderly one-eyed man wearing a cape and hood stuck a magnificent sword into the trunk of Branstock and declared that whoever pulled the sword out could have it. (The old man was actually the god Odin in one of his disguises.) Everyone tried, but only Sigmund succeeded. Siggeir was jealous and wanted the sword for himself. He offered Sigmund three times its weight in gold and when Sigmund refused, Siggeir became incensed and immediately began to plot his revenge. Smiling, he invited King Volsung and all of his sons (including Sigmund) to visit him and his new wife, Signy, in Gautland in three months.

The invitation was, of course, just a ruse. Three months later, Volsung and his sons set out on their voyage with three well-manned ships. As soon as they arrived, Siggeir and his army attacked them. King Volsung and his sons fought with great courage, but in the end Volsung was killed and all of his sons taken prisoner. When Signy pleaded with her husband to bind her brothers in stocks out in the forest instead of killing them quickly, Siggeir agreed, since he thought they deserved to be tortured.

For nine nights, Siggeir's mother, a dead sorceress, came back to life in the shape of a she-wolf and ate a Volsung each night until only Sigmund remained. On the tenth day, Signy had her trusted manservant (who had brought her the news) smear honey on Sigmund's face and in his mouth. That night the she-wolf licked the honey and when she stuck her tongue into Sigmund's mouth, he bit it off, killing her. Then Sigmund managed to escape. When Signy heard the news, she went out to find him and convinced him to build an earthen house and hide in the forest. She promised to bring him anything he might need. In the meantime, her bru-

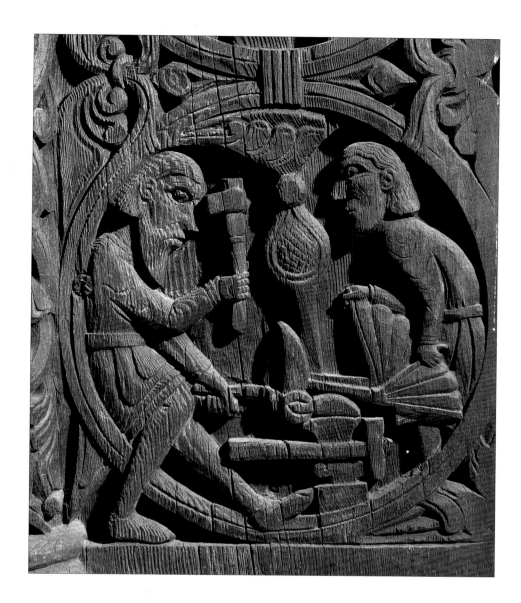

tal husband was celebrating because he thought all the Volsungs except Signy were now dead.

This betrayal sets in motion the first of the saga's many tragic retributions. For years, Signy and Sigmund plotted a way to avenge the death of their father and brothers. Signy had two sons with Siggeir and when the oldest was ten, she sent him to help Sigmund. Sigmund tested the boy's courage by asking him to knead flour, with a serpent in it; the boy would not touch the flour, so Sigmund didn't want him as a helper. Signy told Sigmund to kill the boy, as he was worthless. Sigmund did so. It was the same with Signy's other son.

Wooden door panels on a twelfth-century Norwegian church show how Sigurd's sword was reforged so he could go out and slay the dreaded dragon Fafnir.

Not a Pretty Bunch

The mythology of the north European countries of Norway, Sweden, Iceland, and Denmark did not have gods of physical strength and beauty like those in Greek and Roman mythology. Odin, the chief god, had only one eye and Tyr, the god of war, had one arm. But then, the Greeks and Romans did not have to struggle against the and cold, or endure rugged landscape, towering mountains, and long, dark winter nights as the Norse did.

The sworn enemies of the Norse gods were a terrible race of evil frost giants. Another class of beings, inferior to the gods but still powerful, were the Elves. The Elves of Light looked like beautiful young children and were kind toward humans, but the Black or Night Elves were ugly, long-nosed dwarves who turned into stone if exposed to light. They possessed knowledge of the mysterious powers of nature and the ability to create magical weapons and tools out of metal and wood.

The gods chose as their home a plain named Ida, where they built the city of Asgard. The chief god, Odin (known in Teutonic legend as Wotan or Woden) was regarded as a war god and the protector of fallen heroes. His magical horse, Sleipnir, had eight legs and was able to gallop through the air and over the seas. Odin was very wise, but the price he paid for that wisdom was the loss of one eye. Some of the many other Norse gods included Thor the Thunderer, who had a magic hammer named Mjollnir; Balder, the beautiful god of light (who was killed by mistletoe, the only thing that could hurt him); Frey, the god of sun and rain; Freyja, the goddess of love and beauty; and Hel, the goddess of death. Loki was the evil trickster, half human and half god.

The gods had made the earth from the body of Yimir, a slain giant. Then they created man from an ash tree and woman from an elm and set them to live in this new place they called Midgard. Heimdal was the keeper of the rainbow bridge over which the gods passed from Asgard to earth.

Unlike most other mythologies, Norse legends did not have happy endings. The Norse gods were deities who knew intense suffering and lived with the knowledge that in the end there would be Ragnarok—a Twilight of the Gods in which they would be horribly defeated by the frost giants. Even mortals had nothing to look forward to. Only courageous warriors who fell in battle went to the heaven of Valhalla. Nevertheless, Norse mythology was based on the belief that heroic action was the highest good. This foreknowledge of doom gave the legends a great sense of tragic nobility.

opposite
Thor, the Thunder God, drove a wagon drawn by goats across the heavens and over mountains to slay his enemies the giants. Known for his awesome strength, fiery temper, and magic hammer, Thor was the most popular—and most feared—Viking deity.

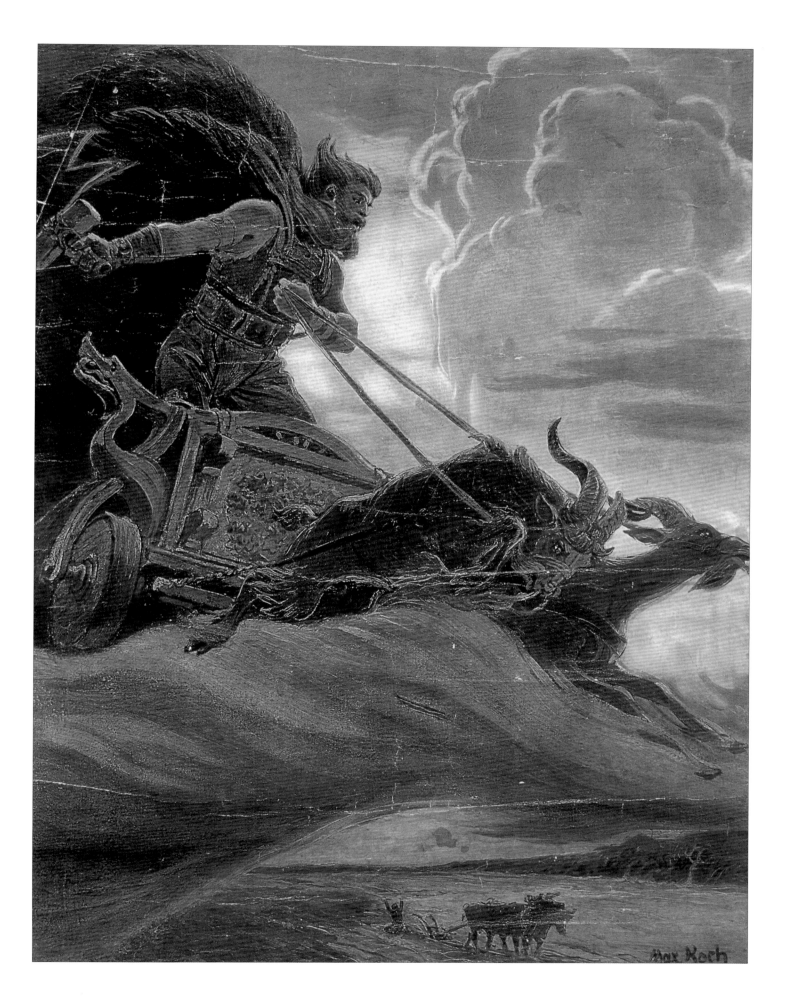

The Birth of Sinfjotli and Sigmund's Revenge

Signy then got a beautiful sorceress to exchange shapes with her and she went to Sigmund in disguise. After sleeping with him for three nights, Signy returned home and assumed her former shape once more. Some time later she gave birth to Sigmund's child, a large, strong, and handsome boy she named Sinfjotli. When he was old enough, she sent him to Sigmund. Having no idea that Sinfjotli was really his own son, Sigmund put him through the usual tests. Not only did Sinfjotli willingly knead the dough with the live serpent in it, he baked it into bread and was willing to eat it.

When Sigmund finally decided that Sinfjotli was ready, he led him to Siggeir's house to hide in an anteroom and wait for nightfall. In the meantime, two small children of Siggeir and Signy spotted the intruders and ran to tell their father what they had seen. Signy told Sinfjotli to kill them so that they would tell no more tales. He did as she asked him to.

The outraged king gave orders to seize the intruders, and after a long and brave struggle, Sigmund and Sinfjotli were captured and buried alive under a large pile of stones. But with the help of a magic sword that could cut through stone as if it were wood, they escaped. They went straight to the king's hall, heaped wood all around it, and set it on fire. Siggeir was trapped in the hall; when Sigmund called to Signy to escape, she refused. She said that her revenge against Siggeir was complete, and because she had caused her own children to die in the search for that revenge, she now gladly gave up her own life in atonement. Just before she died, she told Sigmund how she had exchanged shapes with the sorceress and revealed that Sinfjotli was really his own son.

Sigmund and Sinfjotli mustered a band of men, commandeered a ship, and set sail for Hunland, the kingdom Sigmund's father, Volsung, had once ruled over. Sigmund took over the government and became a mighty and famous king.

opposite
The German version of the complicated saga of the dragon Fafnir's treasure is often called the Nibelungslied or "Song of the Nibelungs," illustrated here in this nineteenth-century manuscript.

left
This small eleventh-century bronze figure represents the Viking god of fertility and prosperity, Frey. The cult of Frey was popular in Sweden in the Viking age and later spread to Norway and Iceland.

Viking heroes were often buried not only with their helmets and swords, but with all their other possessions, including hoards of gold and silver. This helmet, known as "Sigurd's Helmet," was found in a pre-Viking grave at Vendel, Sweden.

The Death of Sinfjotli

Sigmund's first queen was Borghild of Bralund, with whom he had two sons, Hamud and Helgi Hundingsbane. (Helgi grew up to be a brave and fierce warrior who married a Valkyrie named Sigrun and later died a tragic death. A number of heroic *lays* or stories are written about him.) Unfortunately, it was Borghild who ended up

bringing about the death of Sigmund's first son, Sinfjotli.

Sinfjotli proved to be an excellent warrior who spent most of his time engaged in warfare. One day, however, he saw a beautiful woman and fell in love with her. He wanted to marry her, but Borghild had a brother with the same intention. Hatred immediately sprang up between the two rivals, and when Sinfjotli killed her brother, Borghild tried to drive him away. When that

didn't work, she prepared a funeral banquet at which she offered Sinfjotli a large drinking horn in which she had mixed poison. Sinfjotli drank and at once fell down dead.

After burying his son, the enraged and grieving Sigmund drove Borghild away.

The Death of Sigmund

Some years later Sigmund fell in love with Hjordis, the fair daughter of a powerful king named Elylimil, and asked for her hand in marriage. But so did King Lyngvi. Hjordis's father let her decide who she wanted to marry and she chose Sigmund. Not long after, Lyngvi and several of his brothers marshaled their forces and declared war on Sigmund.

Sigmund fought so valiantly that no one was able to stand against him until an old, one-eyed man dressed in a broad-rimmed hat and a blue cloak and carrying a spear in his hands (Odin again) entered Lyngvi's ranks. When Sigmund advanced upon Odin, his great sword broke and the battle took a dreadful turn for the worse. In the end, Sigmund and Hjordis's father, Elylimil, fell, along with most of their men.

The Birth of the Hero Sigurd Fafnirsbane

After Sigmund's death, Hjordis gave birth to his son, Sigurd, a boy who would grow up to be the greatest Volsung of them all. Fearing for their safety, she and her son boarded a Viking ship under the command of Prince Alf of Denmark, who later married her.

Sigurd received his early education in the king's court under the tutelage of a blacksmith, Regin, skilled not only in preparing for warfare, but in sorcery and the reading of magic runes. Regin taught him well.

Regin's story is an interesting one. He had two brothers, Oter and Fafnir, who also had magical powers. Oter often took the shape of an otter because he liked to pass the time catching salmon in a nearby waterfall owned by the dwarf Andvari. The waterfall hid the dwarf's hoard of gold. One day when the gods Odin, Loki, and Hïnir were on a journey, they stopped at the waterfall to rest and saw an otter

Wooden Viking warships like this ninth-century sixteen-seater were sleek and formidable. Dead warriors were often honored with funerals in which they were cast adrift after their ships had been set on fire.

In the Teutonic version of Sigurd's story, his name becomes Siegfried and the treasure is a hoard of gold protected by the Rhine Maidens at the bottom of the Rhine river. While some of the names and details change, however, the plot remains pretty much the same.

feeding on a salmon it had caught. Loki picked up a stone and threw it at the otter, killing it. Taking the pelt with them, the gods stopped at Regin's father's house where they asked for a night's lodging. Regin and Fafnir immediately recognized the otter pelt as their brother and, with the aid of their father, Reidmar, took the gods captive. In fear for their lives, the gods promised the men anything; Reidmar, Fafnir, and Regin decided that they wanted the otter filled with gold. The gods agreed.

The Gold Ring

Not wanting to give up his own riches, Loki immediately started scheming to get the dwarf Andvari's gold to give to Reidmar and his sons. Using a borrowed fishing net, he caught the dwarf and threatened to kill him if he did not immediately surrender his hoard of gold, which included a small but precious gold ring. As the dwarf darted back into the safety of his rocks, he put a curse on the ring and whoever possessed it—starting with the brothers Regin and Fafnir. It didn't take long for the curse to begin taking its terrible effect.

The gods kept their word, filling the otter pelt with Andvari's gold and giving it to the father. When the greedy Reidmar refused to share it with his sons, Fafnir promptly killed him in his sleep and took all the gold for himself. This meant the penniless Regin had to get a job as the king's blacksmith—which was how he became young Sigurd's tutor.

After stealing the gold, Fafnir transformed himself into a huge, venomous serpent and made a lair for himself on Gnita Heath. There he remained, brooding over his hoard of gold.

S mo hvi brá ec sverzni hör felðr g. ru jarlvar navб. þ svar
igmðar bvr sleir f. leomo hrafns hvelveð hior tighar. Þ en
gi ec svar. lengi ec sofnoþ v long ero lyða lę. oþ iþ þvi velde
er er eg marre bregða bluŋstavþō. Sig. lettiz niþ Þ siþ ha
nazni. hō roc þa hœn þvilt nuaþar iga. hō miniл veig.
eill dagr heilir dagl syn heil not Þ nipt. orviþō avgō briþ
ocr hinig Þ gefir srrionðō sigr. Heihr es heilar asyniœ
heil sia in fiolnyra folð. mal Þ man vit geirr ocr meþom
tveim Þ lecnil henðe með lyfo. hō nerndu sigrðryra æ ƀ
valkyria. hō ſ. at tveir kar bœrðuz. h. anar hialm gvn
ar h ſ þa gamall Þ in mesti h ψ. Þ hapði oþ iþ hō sigri
heirib. Eʒ anar h. agnar haþo broþ er vetr egi vildi þio
ia. Sigrðʒa feldi hialmgvn. iorostorn. Eʒ oþiʒ stac ha
svernþorni iþefnð þ Þ g. ha alð seylðo syp sigr vega ion
osto. Þ q. ha gvprar seylðo. eʒ ec sagðac hō at ec strengðac
heir þar unot at gvprar ongō þei ne é hrofar kyni. H ſ
Þ byþ ha kena ſ speki ef hō villi riþinði œ ollō heimō
Sigrðryra g. Biœ þœu ec þ brynþings apalde magni blan
diʒ Þ megin tiri fullr er h boþa Þ hen staya godra galdra
Þ gaman tvna. Sigrvnar þv ſkr rista ef þv vilt sigr ha
fa Þ rista ahiali hnœs. sumar averinom svar avalbvsto
Þ nefna tysvar oþ. Ol rvn ſtev kvna ef þv vill anarſ qven
veltr þic trygð ef þv tir. ahorni ſk þer rista Þ ahanðar
baki Þ mikia anaglt navþ. fvll ſk signa Þ við parr sia Þ bpa
lavki ilazs. Biargr. ſ.k. ef þv biarga vilt Þ leysa kinð fʒ
konð. alofʒo þer ſk rista Þ ofr liþo spena Þ biþia þa diſ dv
ga. Bin r. ſ.r. ef þv vilt borgir hafa alvði segl marrō Þ
astapni ſk rista Þ asriornar blaþi Þ leoia eld iar. era sva
bracir breki ne ſ blar vñ þo kœtto heill g. ha:i. ſim.r.
ſ. k. ef þv vilt lœn va Þ kvna far at sia. aƀki ſk rista
Þ abaðmi viðar þei er lvra avſtr limar. Mal r. ſ. k.
ef. þv vilt at magni þ heiprō galdi harm. þer vm
vinðr þer ṽ vefir þer ṽ setr allar saman. aþ þingi er
þioþ ſko i fulla doma fara. Hvg r. ſ. k. ef þv vilt hv

The Slaying of the Serpent Fafnir

Regin's plan was to have Sigurd kill the serpent Fafnir so that he, Regin, could finally get the gold he felt was rightfully his. But Sigurd insisted on avenging the death of his father first. Riding his magnificent horse, Grani, Sigurd set out to battle the sons of Hunding. After he killed the Hundings and got his revenge, Sigurd set off with Regin to find the terrible serpent Fafnir.

Sigurd did indeed slay the serpent with his powerful sword; afterward, when he touched a finger bloody with Fafnir's blood to his lips, he could hear the birds around him warning him about Regin's treachery. So Sigurd cut off Regin's head, ate part of Fafnir's roasted heart for courage, loaded up the cursed hoard of gold, and rode off. That is how he got the name Fafnirsbane.

Siegfried slays the terrible dragon Fafnir in the Teutonic version of the Viking myth.

The Warning

After slaying Fafnir, Sigurd rode south until he reached Mount Hindarfjall. There he met the Valkyrie Sigridrifa who read her magic runes and advised him on the future. She implored him not to seek revenge if any of his kinsmen wronged him or to let a fair woman deceive him.

The Magic of Runes

Runes were the letters of the ancient alphabet said to have been invented by the Norse god Odin. They were probably first used by Norsemen about the second or third century A.D. At first runes were simply used for scratching names on personal belongings or for marking gravestones. Later they also came to be used for divination and magic amulets. Some people were believed to have the power to "throw" a set of stones marked with rune figures and then read a person's fortune. They knew which rune figures could be best used as amulets. For example, a woman with "birth-runes" carved on the palms of her hands was a trustworthy midwife. "Wave-runes" were carved on the prows and rudders of ships to keep them safe from rough storms and high seas. "Thought-runes" carved onto shields and helmets gave their owners wisdom. A wide range of other magic runes were engraved, carved, or burned into every possible object made of stone, wood, or gold, and were shaved into the fur or cut into the hooves, tongues, beaks, and claws of every possible animal—all to give their owners special protection or powers.

was too much in love with Brynhild to even consider it, Grimhild had to resort to magic to get her way. She gave Sigurd a drink capable of stealing away a person's memory; as soon as he drank it, Sigurd forgot all about Brynhild and fell in love with Gudrun. Sigurd and Gudrun soon married. Grimhild then decided that Brynhild would be a good match for her son Gunnar and sent him off with Sigurd to bring her back.

A ring of fire burned around Brynhild's hall, and she made it known that she would only marry the man who had the courage to ride through the flames. Gunnar tried, using first his own horse, then Sigurd's horse, Grani, but failed both times. But Sigurd knew that he himself could do it, so he and Gunnar agreed that Sigurd would dress up like Gunnar, ride through the flames on Grani, and wed Brynhild in her own hall. The earth shook and the flames stretched up as far as the heavens, but he did it.

That night, before going to sleep, Sigurd (disguised as Gunnar) laid his sword between himself and Brynhild. They exchanged rings, so that Sigurd once more got possession of the ring of Andvari and gave her another ring in its place. The next day, Sigurd and Gunnar resumed their true identities. As soon as Gunnar and Brynhild were officially married, the magic potion wore off and Sigurd remembered his all-consuming love for Brynhild. But they were both married to other people now, and the noble Sigurd would say nothing that would betray his true feelings.

Stone runes were used by the Vikings for divination and as magic amulets.

Sigurd Falls in Love

From Mount Hindarfjall, Sigurd traveled to the Dales of Lym where he chanced to meet and fall in love with Brynhild, a Valkyrie shield maiden. He placed the ring of Andvari on her finger as a symbol of that love.

But Sigurd's travels were not over yet, and from the Dales of Lym he rode still further south until he came to the court of King Gjuki. Gjuki's sons were named Gunnar, Hogni, and Guttorm, while his daughter's name was Gudrun. Their mother, Queen Grimhild, was a scheming, ambitious woman skilled in the use of magic.

Sigurd was a very eligible bachelor and Grimhild soon decided she wanted Sigurd to marry her daughter, Gudrun. But since Sigurd

Brynhild's Revenge

Some time later, Brynhild and Gudrun got into a fight over who had the best husband. When Gudrun asserted that no one, not even Gunnar, could compare with her hero husband, Sigurd Fafnirsbane, Brynhild pointed out that nothing could be braver than riding through the ring of fire—which was what Gunnar had done to win her hand. It was then that Gudrun laughed spitefully and said, "Do you really think it was Gunnar who rode through the fire that day? No, it was Sigurd! Afterward he took the ring of Andvari from your hand—and gave it to me!"

Brynhild grew pale with rage and grief when she finally understood what had happened, but said nothing. Sick at heart, she took to her bed and could not be consoled by anyone. Finally Sigurd came and confessed his love for her. He even promised to kill Gudrun so that he and Brynhild could run away together and be married. But Brynhild was too proud to listen. Rather than marry Sigurd on such terms, she decided she'd rather see him dead. Unwilling to do the deed himself, Gunnar got Sigurd and Gudrun's own young son, Guttorm, drunk on serpent's and wolf's blood and had him stab Sigurd in his sleep.

After calling out to her brother Atli to seek revenge after she was gone, Brynhild planned the funeral. Just before she killed herself, Brynhild's final stipulation was that her body would be burned along with Sigurd's. The magnificent funeral pyre, heaped with Sigurd's slaves and servants who had the honor of being burned along with him, shot its flames up to the very heavens.

Atli's Revenge

Gunnar and his brother Hogni inherited all of Sigurd's treasures after his death and the power of the curse continued. Atli, Brynhild's brother, claimed that the two of them had caused Brynhild's death and threatened them with war. Their scheming mother, Grimhild, however, kept the peace by brewing up another batch of her potion of forgetfulness and married Atli off to the widowed Gudrun.

But Atli had his eye on the gold, too. He invited his brothers-in-law Gunnar and Hogni to a great banquet with the secret intention of killing them and seizing the treasure. But, sensing that something was wrong, the brothers decided to hide Fafnir's gold at the bottom of the river before they left.

As the two brothers neared Atli's court, Atli's men sprang out and attacked them, and a terrible battle took place. The brothers fought bravely but in the end were captured. Atli tortured them to find where they had hidden the

below
The morning after he rode through flames to win Brynhild's hand in marriage, Sigurd (disguised as Gunnar) woke her so that they could exchange rings. Later that day, Sigurd and Gunnar resumed their true identities.

opposite
Brynhild's treacherous brother Atli tries to coerce his brother-in-law Gunnar into revealing where he hid the Nibelung's treasure.

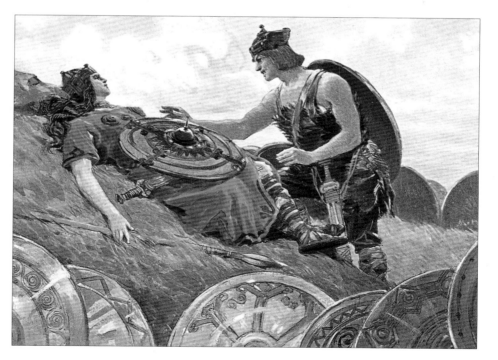

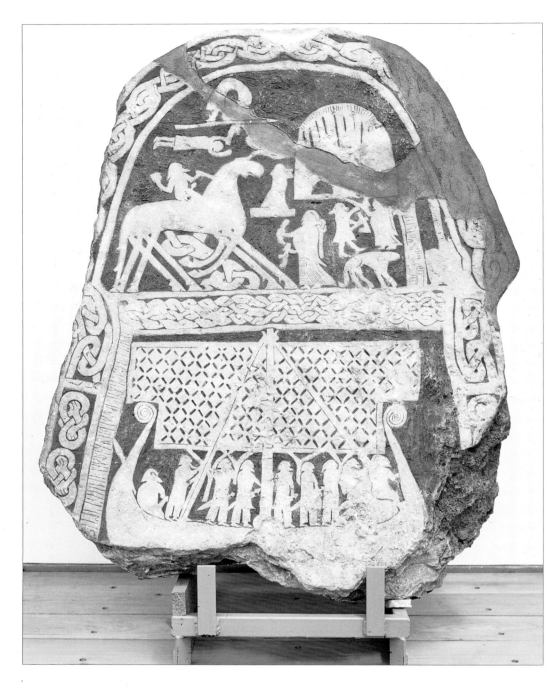

This eighth-century stone carving shows Gudrun killing her two young sons in her gruesome plot to get even with her husband Atli.

gold, but they bravely kept their secret until they died.

Gudrun Seeks Revenge

Horrified at the death of her brothers, Gudrun then plotted her own revenge, and her plan was a gruesome one. First she killed the two small sons she had had by Atli. She made drinking vessels from their skulls and gave him wine to drink mixed with the blood of his children. She also served him their hearts at dinner. When she told him afterwards what she had done, Atli was filled with sorrow or the death of his sons—and with fear for what Gudrun might try to do next.

He was right to be afraid. That night she waited until he was asleep, then crept to his bedside and stabbed him in the breast. Afterward she set fire to his hall, killing most of his men.

The Ring of the Nibelungen

Almost all the Germanic cultures (Scandinavian, Icelandic, Teutonic) that existed in northern Europe had the same legends, only the names of the characters and some of the plot details varied. For example, in the old Teutonic saga *The Song of the Nibelungs* (the story that became the subject of Richard Wagner's Ring operas), the Norse characters of Sigmund and Signy are named Siegmund and Sieglinda, while Sigmund's son Sigurd and his wife Gudrun become Siegfried and Kriémhild.

In the Teutonic version of the story, the hoard of gold originally exists in the depths of the Rhine River, guarded by the innocent and beautiful Rhine maidens. But one of the Nibelungs, a dwarf named Alberich, tricks the Rhine maidens into giving him the gold, which he then fashions into a powerful magic ring. Trouble starts when the gods don't have the money to pay the giants they commissioned to build them a castle. After the gods Wotan and Loki steal the ring from Alberich to give to the giants, Alberich lays a terrible curse on the ring and all those who will ever own it.

The curse begins at once when one giant, Fafner, kills his brother to get the treasure, then turns himself into a dragon to guard his wealth. The plot follows the Volsung Saga pretty closely except that Siegfried's tutor (the character who convinces Siegfried to slay the dragon) is Mime, Alberich's scheming brother, who is plotting to double-cross Siegfried and get the gold ring for himself. After Siegfried falls in love with the ex-Valkyrie, Brünnhilde, he is tricked by Alberich's evil dwarf son, Hagen, into forgetting his love for Brünnhilde and marrying Hagen's half-sister Gutrune instead. As in the Norse version, Siegfried is killed. Out of her all-consuming love for him, Brünnhilde takes the magic ring from his finger, places it on her own, and dies riding her steed into the flames of Siegfried's funeral pyre.

The four operas that make up Wagner's Ring Cycle are *Prologue: Das Rheingold*; *Part I: Die Walkyrie*; *Part II: Siegfried*; and *Part III: Götterdämerung* or Twilight of the Gods. The ending to the Ring Cycle, *Götterdämerung*, is more dramatic than the Norse version of the myth.

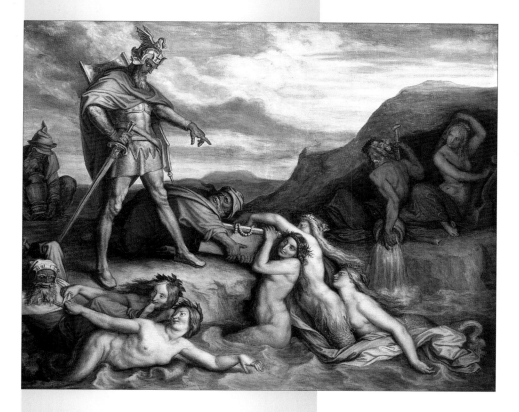

Valhalla, the hall of the gods, collapses and the Rhine River overflows. Hagen the dwarf manages to snatch the gold ring from the ashes in all the confusion but is immediately pulled under and drowned for his treachery by the Rhine maidens, who then reclaim their ring treasure. The gods are destroyed, but the world has been purged by love and a new era awaits.

Hagen the evil dwarf manages to snatch the gold ring but is then drowned by the Rhine Maidens.

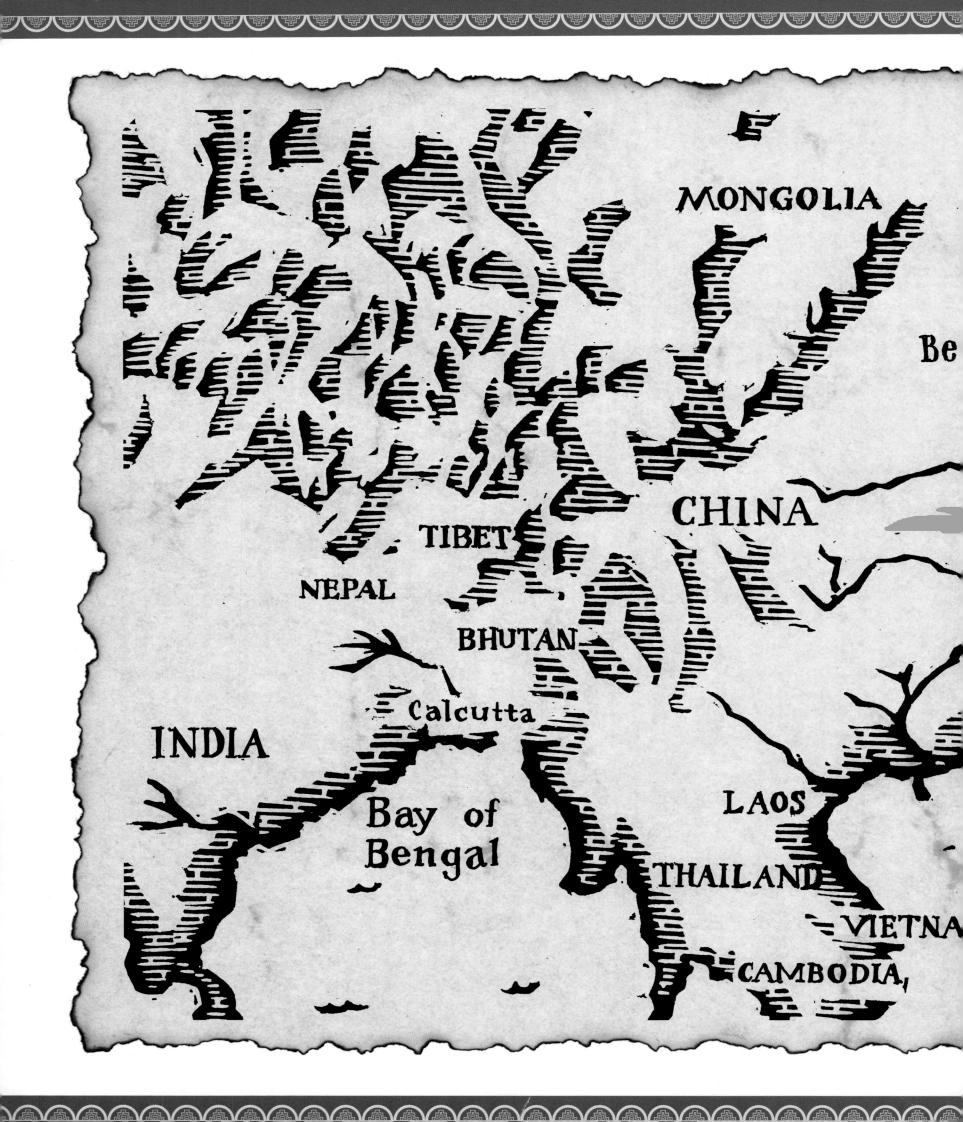

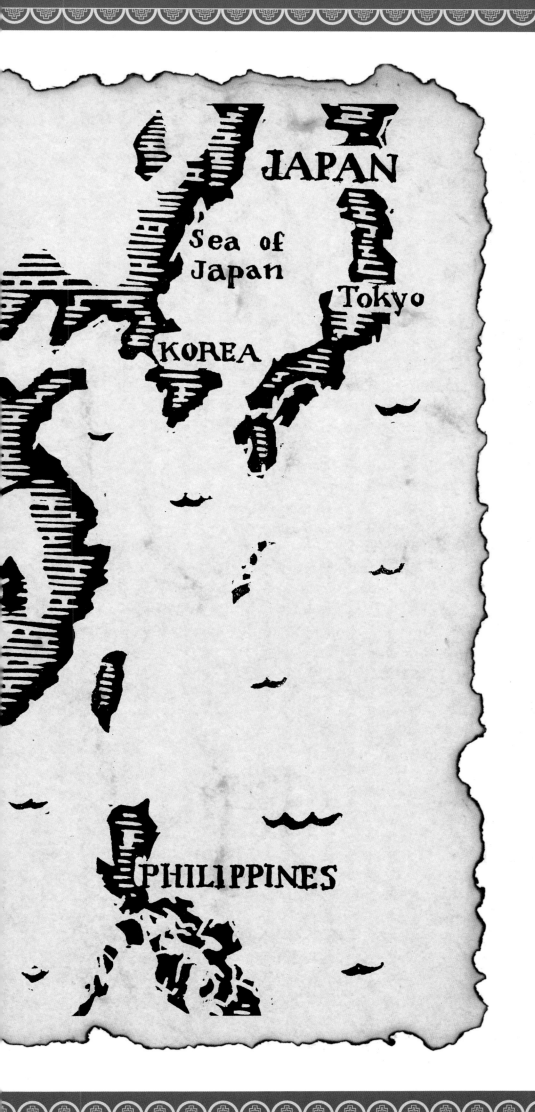

Chapter 5

Heroes of Asian Mythology

Some of the oldest cultures and mythologies in the world originated in Eastern Asia, a large area that includes Japan, Korea, China, India, and all the countries of Southeast Asia such as Cambodia and Thailand. Ancient myths about spirits, ghosts, dragons, and monstrous snakes can be traced back more than 4,000 years. Some of the old myths were very complex, with hundreds of different gods ruling in the kingdoms of Heaven and the Underworld as well as on Earth. Except in India, ancestor myths were also very widespread.

Many of the original myths changed when they came into contact with widespread religious influences such as Buddhism, Confucianism, and Hinduism, all of which have their own myths and hero legends. Other old stories simply continued to exist alongside the newer ones.

Some of the most colorful hero stories can be found in such great Hindu poems as the Mahabharata *and* Ramayana, *which depict epic battles between good and evil.*

Haemosu and the River Earl's Daughters
A Korean Tale

When the hero Haemosu, a true Son of Heaven, first came to earth one summer very long ago, his arrival was glorious: he soared down from the heavens in a five-dragon chariot followed by hundreds of robed followers all riding on swans. The mountains echoed with chiming music and banners floated on the colorfully tinted clouds. The men chosen to rule on earth had always come down from heaven, but never like this. From then on, King Haemosu lived and ruled on earth among humans during the day, but every evening he climbed into his dragon chariot and

Processioners played beautifully decorated horns and drums and waved colorfully embroidered banners to announce the arrival of their celestial hero.

journeyed the hundreds of thousands of miles back to his palace in Heaven.

One day King Haemosu was out hunting near the Green River when he caught sight of the River Earl's three beautiful daughters playing among the green waves of the Bear's Heart Pool. Their jade ornaments tinkled as they splashed in the water and their modest, flowerlike beauty made them seem as delicate as fairies. The king was immediately enchanted and started toward the girls, but when the three sisters saw him coming, they plunged under the water and fled.

Obsessed with the idea of meeting them, Haemosu built a magnificent palace near the riverbank. When the three maidens came upon the seemingly deserted palace, they entered and found elegant cushions and golden goblets of wine which the king had set out for them. Delighted with their good fortune, they drank the wine and soon became a little tipsy. When the king emerged from his hiding place where he was spying on them, the startled girls ran. But the oldest, Wildflower, tripped and fell and so the king caught her.

When the River Earl heard about this, he raged in anger. He sent a speedy messenger to the king demanding an explanation. Eager to clear up the matter, Haemosu got into his dragon chariot and flew to the Ocean Palace where the River Earl lived. He explained to the River Earl that he was a true Son of Heaven, sent to earth to rule as king, and that he wanted Wildflower by his side. The River Earl admonished him, pointing out that not even kings could simply go

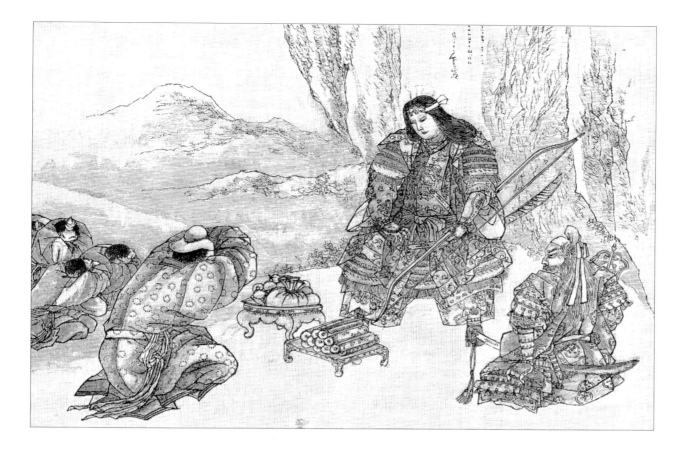

Korean mythology includes several stories about powerful woman warriors. In this engraving, the defeated men of Shinra submit themselves to the conquering Queen Jingu.

around kidnapping the women they want to marry. Besides, how could he be sure Haemosu was really the Son of Heaven as he said he was?

To test the king's powers of transformation, the River Earl leapt into the river's rippling green waters and changed himself into a carp. The king immediately turned himself into an otter and seized the carp before it could swim away. So then the River Earl sprouted wings and transformed himself into a pheasant, but the king became a golden eagle and immediately swooped down on the pheasant with his talons.

After a number of other tests, the River Earl finally conceded that the king was, in fact, divine. He poured some of his best wine and proposed a toast to the wedding couple. But just to make sure the king really intended to marry his daughter, he got Haemosu drunk and put him in a leather bag. Then he set the bag in the dragon chariot beside Wildflower and sent the chariot

off to the heavens. But before the dragons had even left the ground, Haemosu awoke from his stupor. Angrily seizing the girl's golden hairpin, he pierced the leather, slid out through the hole, and took off for the heavens—leaving his new wife behind. He did not return.

Although it was certainly not Wildflower's fault, the furious River Earl punished his daughter by having her lips stretched three feet wide and then throwing her into the river Ubal. Eventually a passing fisherman from a nearby kingdom saw the strange and frightful sight and took her home in his net to show to his ruler, King Kûmwa.

Wildflower's stretched-out lips had made her mute and the King's servants had to trim her lips three times before she could finally speak. After hearing her sad story, King Kûmwa took pity on her and offered to let her stay in his palace. Four years later, Wildflower gave birth to

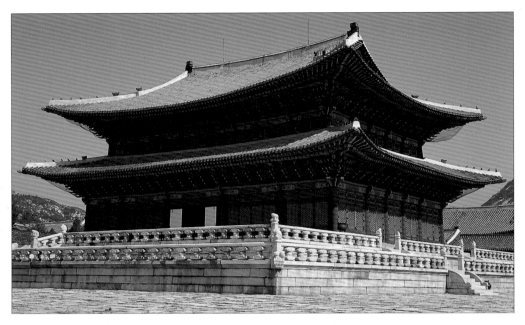

a large, strangely shaped egg that frightened everyone who saw it. She named the egg Chumong. Even though he knew its father was Haemosu, King Kûmwa believed that anything born from an egg like that would be monstrous and inhuman and should therefore be destroyed. He ordered the egg put out into the horse corral, but the horses took great care not to trample it. Then the king ordered it repeatedly thrown down steep hills, but the wild beasts all protected it.

Finally, a fox retrieved the egg and gave it back to Wildflower, who carefully nurtured it until an infant boy hatched. As Chumong grew to be a strong and intelligent child, his mother told him how his father, Haemosu, had come to earth from Heaven in a dragon chariot and how Chumong himself was destined to become a great king one day when he was grown. She made him a bow and arrows and he soon became an expert marksman.

As the years passed and Chumong became an impressive warrior, King Kûmwa's sons became jealous and begged their father to do something. So the king put Chumong in charge of tending horses. Humiliated, Chumong decided he would rather die than live in such shame; he

took his trusty stallion, said good-bye to his tearful mother, and made his escape. King Kûmwa, who didn't want Chumong setting up an enemy kingdom nearby, sent his warriors in hot pursuit.

Chumong traveled south until he reached the River Om, but then could find no ferry to cross it. He raised his whip to the sky and uttered a long, sad cry imploring his father to help him in his flight from danger. To his amazement, as soon as he touched the water with his bow, all the fish and turtles hurried to put their heads and tails together to form a great bridge. Chumong hurried across just as the king's troops caught up with him. When the king's men tried to set foot on the bridge, the animals all let go and it simply melted away.

Free at last, Chumong rode until he found an unspoiled land of mountains and streams and beautiful, thick-wooded hills. There, he proclaimed himself King Tongmyông. No sooner had he uttered the words than thousands upon thousands of carpenters descended from the heavens to build the new king a royal palace. Tongmyông became a great and beloved king who reigned for many years.

The King Who Was Fried
A Tale from India

A long time ago, there lived an Indian king named Karan who had made a vow never to eat breakfast until he had given away one hundred pounds in gold to the poor. Early each morning the palace servants would come out with baskets and baskets of gold pieces to scatter among the throngs of poor people crowded around the palace gate. Then, after the last piece of gold had been given away, King Karan would sit down to his breakfast and enjoy it the way he felt a man as charitable as he deserved to enjoy it.

The king's subjects worried that sooner or later the king's treasury would be used up and then everyone in the kingdom (including the king) would starve, but every day, day in and day out, for years and years, the king continued to give away one hundred pounds of gold every morning.

There was, of course, a secret to King Karan's bottomless supply of gold, which none of his servants or subjects knew about. It was quite simple: he had made a pact with the hungry old fakir (a hermit with powers of sorcery) who lived on top of the hill. Every day the fakir would conjure up one hundred pounds of gold to give to the king, on the condition that every day the king would allow himself to be fried and eaten by the fakir.

If an ordinary person had fried and eaten the king, of course, the king would have been dead the first day. But the fakir was no ordinary person. After he had eaten the king and picked his bones clean, he would simply put the bones back together, say a charm or two, and the king would suddenly be alive again, as fat and jolly as ever. While the king certainly did not find it pleasant to be sizzled in a frying pan every morning until he was crisp and brown, and then eaten, he soon got used to it and considered it a small price to pay to be able to give away gold daily to his poor subjects.

When King Karan heard the beautiful birds singing in his neighboring ruler's kingdom, he became intensely jealous and ordered his servants to kidnap them.

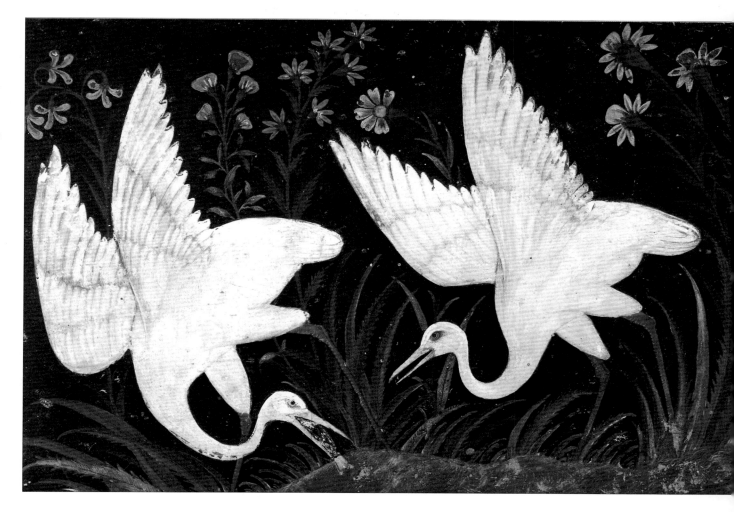

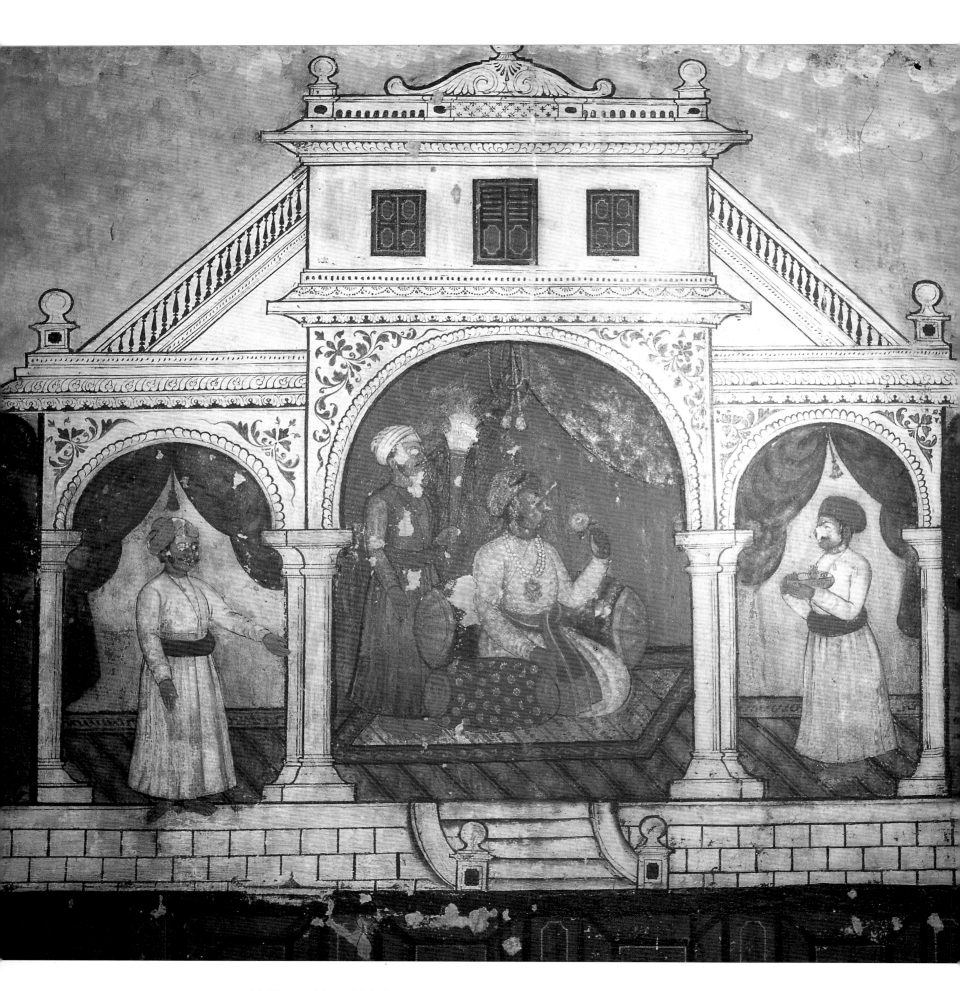

It also happened that around a nearby lake there lived beautiful wild swans that could only eat pearls. One day pearls had become so scarce that the swans were forced to fly throughout the land in a desperate search of more. When Bikramajit, the king of a nearby kingdom and Karan's enemy, saw the starving birds, he ordered his servants to spread pearls out for them in the courtyards. The wild swans were so grateful that they flew through the countryside singing the praises of King Bikramajit.

King Karan heard the birds singing as he breakfasted each morning, and he soon became jealous. After all, look at all the trouble he put himself through each day to be charitable and no one was singing *his* praises. King Karan ordered his servants to catch and cage the wild swans so he could give them his own pearls to eat. But the birds refused King Karan's pearls and just kept singing about how great King Bikramajit was.

When word got back to King Bikramajit that King Karan was holding the swans captive, he disguised himself as one of Karan's servants to spy on him. Guessing that there must be a secret to all the gold King Karan was giving away, King Bikramajit followed him one morning and watched as the fakir fried and ate him before sending him back down the hillside with one hundred pounds of gold.

The next morning, King Bikramajit got up at the crack of dawn and slashed himself all over with a carving knife. Then he rubbed a mixture of salt, pepper, and spices into the gashes, and when he was through climbed up the hill to the fakir's house and popped himself into the waiting frying pan. The fakir was still asleep but soon woke when he heard the sizzling.

Amazed at how appetizing King Karan smelled when he was "deviled" with such won-derful spices, the fakir gobbled up King Bikramajit, and afterward shook out his magic coat to give him the gold. Still thinking his breakfast had been King Karan, the delighted fakir implored him to show up deviled every morning, promising him anything he wanted in return. King Bikramajit asked for the old fakir's magic coat and received it.

Feeling stuffed and sleepy from his delicious breakfast, the fakir soon fell sound asleep. By the time the real King Karan showed up to be fried, the fakir was not the least bit hungry. "But it wasn't me who showed up deviled this morning," the king shouted. "At least give me the gold then since I'm still more than willing to be eaten!" "Sorry," said the fakir, "but I can't. That fine-tasting man I had for breakfast took my magic coat."

So King Karan returned home in despair and ordered his servants to take the day's gold out of the royal treasury so he could eat his breakfast in peace. By the fourth day, the royal treasury was empty and because he was a man of his word, the king stopped eating breakfast.

Days passed and King Karan became thin-ner and thinner. Finally, King Bikramajit took pity on the gloomy old man and showed him the magic coat he had taken from the fakir. He offered to give it to King Karan in exchange for freeing the wild swans.

When the birds were set free, they contin-ued to sing the praises of King Bikramajit, but this time King Karan hung his head in shame. "The swans' song is true," he said. "I let myself be fried so I could give away gold every day— only so that I could eat my breakfast without feeling guilty. Bikramajit not only let himself be fried but deviled, too, and he endured all that just to free some swans!"

Flood Legends

Almost every ancient civilization has a legend about a terrible flood that covers the whole earth and destroys almost all the living plants and animals, with only a chosen few spared. Western society has the story of Noah and the Ark as recounted in Genesis, the first book of the Bible. In Greek mythology, Zeus decides to destroy the earth with a flood, and it's King Deucalion and his family who take refuge in an ark.

Eastern mythology has its own powerful flood heroes. Indian texts dating back to the sixth century B.C. tell the story of how Manu is warned by a giant fish with golden scales about the coming of a terrible seven-day deluge. The magic fish directs him to build a huge boat, then to gather up a pair of each of the earth's creatures, as well as the seeds of every plant.

The flood legends in Chinese mythology (and there are several) have a different twist. In ancient China, floods were feared because they wiped out precious crops and caused famine. In one story, the legendary hero Yü the Great not only rescues the world from devastating floodwaters, but with the help of a magic dragon and turtle, dredges gullies and valleys into the land so that future floods will have a way to recede out to the sea without washing away fields of crops.

Southern China has a flood myth called the Gourd Children in which a poor farmer hears distant thunder and fears a coming flood, so he tricks Wen Zhong, the terrible, red-haired God of Thunder, by impaling him on his hay fork and locking him in a cage. Intending to pickle him, the farmer goes off to the village to buy some herbs.

Meanwhile, the Thunder God bursts out of his cage and starts a terrible deluge of rain. The farmer returns just in time to put his children into hollow gourds so they will float on top of the floodwaters. All the people on earth (including the farmer) are wiped out by the flood except for the farmer's children bobbing around in the gourds; they become known as Fu Xi, the gourd children. When the waters finally subside and the children are grown, they marry and eventually repopulate the earth.

Eyebrows Twelve Inches Apart
A Chinese Hero Legend

As in other cultures, there are many popular Chinese hero stories that fall into the category of revenge myth. The hero of this revenge story is named Ch'ih Pi (which means "eyebrows twelve inches apart") and he's the son of another legendary hero, the sword maker Kan Chiang.

Kan Chiang was a master sword crafter, perhaps the best in the kingdom of Wu. He and his wife, Mo Yeh, had only one son, a fine-looking lad whom they named Ch'ih Pi because his eyebrows were twelve inches apart.

When their son was only six, Kan Chiang sent three swords of exceptionally fine workmanship to King Ho Lü as a gift. The king was so impressed that he ordered Kan Chiang to make him two more. Kan Chiang carefully selected only the purest iron and gold from the five mountains and then waited for the perfect day on which to forge them, the day when the cos-

mic forces of female and male (Yin and Yang) were in perfect harmony. He waited three years.

In spite of all his best efforts, however, the molten essences of the gold and iron refused to fuse and liquefy. Kan Chiang just could not understand it, but his wife and assistant, Mo Yeh, knew that it was because the gods of metallurgy had not been properly appeased. She knew exactly what to do: she cut off her hair and fingernails and threw herself into the fire.

As Mo Yeh's body burned in the fire, the gold and iron liquefied as if by magic and the metal was transformed into two of the most wondrous of swords. Kan Chiang decorated them with turquoise stones and ornate inscriptions. He hid one of the swords under a rock up on the mountainside, and then rode off to present the other to the king.

The king loved the sword but was angry that it had taken more than three years to make. He was even more angry that there was only one sword and not the two he had requested. Kan Chiang told him that yes, he had produced two swords as ordered, but he had hidden the other in a safe place, just in case the king threatened to kill him. The king was so angry he ordered Kan Chiang killed anyway.

Kan Chiang had arranged for a trusted servant to tell his young son, Ch'ih Pi, where the sword was hidden when he was old enough to use it. Ten years later Ch'ih Pi split the rock apart

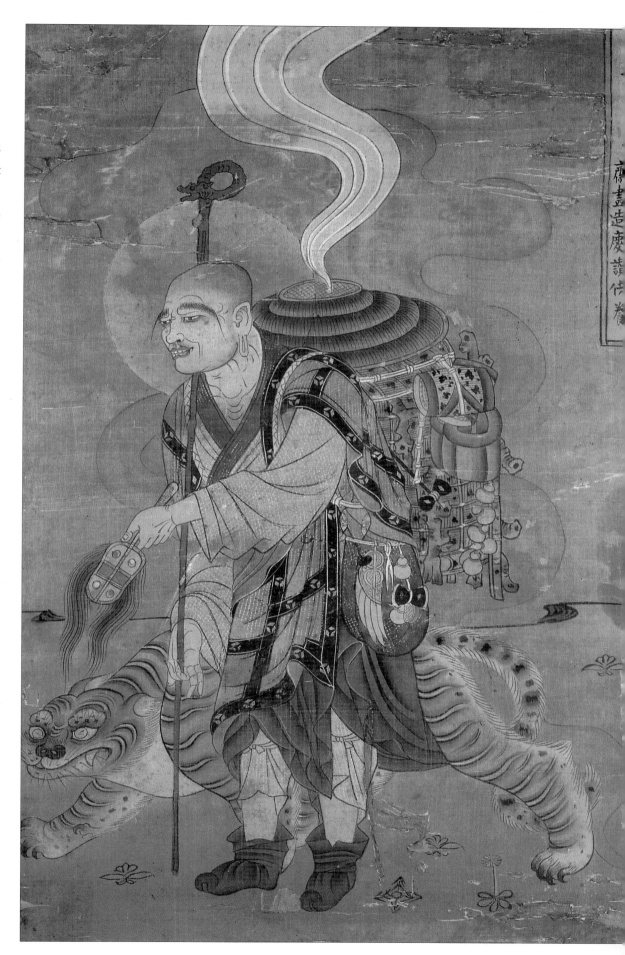

with an ax, and from the moment he saw the beautiful sword, all he could think about was killing the king to avenge his father's death.

About that same time the King started having nightmares. He dreamt he saw a young lad with eyebrows twelve inches apart trying to kill him, a boy screaming for revenge. The king was so upset that the next day he immediately offered a ransom of a thousand pieces of gold for anyone who brought him the boy answering this description. When Ch'ih Pi heard of this, he fled to the forest in despair.

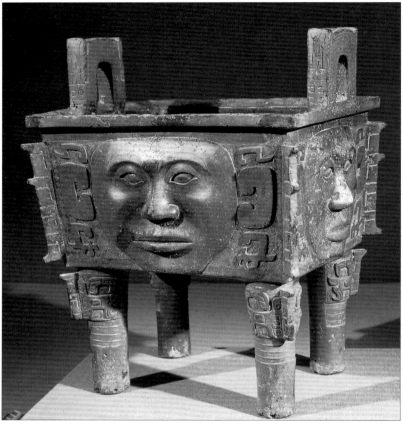

The king's servants boiled the head of Ch'ih Pi in a fandang, *an immense, rectangular cooking vessel made of bronze and traditionally decorated with human faces.*

One day a stranger met him in the woods and asked him why he was so sad. Ch'ih Pi explained how the king had killed his father and now it was practically impossible for him to get revenge. "Well," said the stranger, "the king is offering a ransom of a thousand pieces of gold for your head, right? I could get in to see him—and get your revenge for you—if I could bring him your head and your sword."

"That is a very good idea," said Ch'ih Pi, who promptly slit his own throat and handed his head and sword to the stranger. Before Ch'ih Pi's headless corpse toppled over, the startled stranger said, "I will not fail you!"

When the stranger showed up with the boy's head, the king was overjoyed. The stranger told him that since it was the head of a very brave man, it should be boiled in a large pot. The king agreed and had his servants get a cauldron ready. Though the servants boiled the head for three days and three nights, it would not cook through. Ch'ih Pi's head just kept bobbing angrily on top of the water, its blazing eyes flashing with rage. Finally, the stranger suggested that maybe if the king looked at it himself the head would be more likely to cook properly.

The king got up at once and approached the cauldron. As soon as he reached it, the stranger crept up behind him and lopped off his head with the boy's sword, toppling it into the boiling water. Then the stranger lopped off his own head, and still another head fell into the cauldron. The three heads now cooked quickly, and by the time the flesh finally fell from the skulls, it was impossible to tell anymore who was who. The servants took the pile of flesh and buried it up on the mountainside. They named the site the Grave of the Three Kings.

The Monkey King
A Chinese Adventure Story

The Monkey King is a renowned classical Chinese novel that dates back over four hundred years. It's a book with everything: an amazing plot filled with adventure and mingled with an assortment of Chinese fables, fairy tales, legends, superstitions, monster stories, and battles.

According to legend, Monkey was a rebellious and most extraordinary human being. Born out of a rock and fertilized by the grace of Heaven, he was extremely smart and capable even as a child. He was raised by a master Taoist who carefully taught him all he knew about magic and kung fu, so that by the time he was a young man, he had the ability to transform himself into seventy-two different images—everything from a tree to a mosquito to a beast of prey. Monkey learned to travel by using clouds, but could also easily cover thousands and thousands of miles in a single graceful somersault.

Monkey became even more rebellious as he got older, despising feudal authority and claiming that there was no higher authority than his own, anywhere. That included not just the earth but the heavens, the seas, and the subterranean world of hell as well. The rulers of these realms did not appreciate Monkey's treasonous attitude and sent their massive armies to fight him.

After many showdowns, the armies of Heaven finally persuaded the emperor of the earthly kingdom to offer Monkey an official title to appease him. Monkey accepted the offer on a trial basis. However, when he learned a few days later that the position he was given was actually nothing more than the emperor's stable keeper, he was outraged. He had been cheated and he knew that everyone on earth and in Heaven was laughing at him for it. Enraged, he declared himself Supreme King and immediately declared war on everyone in the universe.

It was a long fight and it took the help of all the warrior-gods in heaven, but eventually the Monkey King was defeated. The plan was to execute him, but every method of execution they tried failed. They couldn't even behead him because he turned his head into bronze and his shoulders into iron. Finally, as a last resort, the emperor commanded that the Monkey King be burned in the same furnace where the emperor's ministers were working on refining his immortality pills. But instead of killing him, the white-hot fire and choking smoke only crystallized the Monkey King's eyes into golden fire crystals, giving him extraordinary powers of sight. With the help of his new vision, Monkey escaped.

Finally, when all else failed to stop the Monkey King, the armies of Heaven and earth called upon the Buddha for help. The Buddha caused the great mountain known as the Mount of Five Fingers to fall upon him, yet the tenacious Monkey somehow miraculously survived the enormous weight and pressure. He was alive and saw through things ordinary people

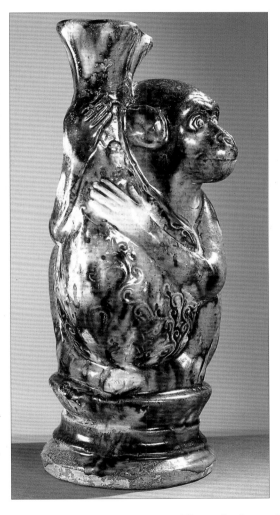

The monkey has symbolized many different things in Chinese culture, from trickster to Buddhist god.

couldn't—but he wasn't able to move for about five hundred years!

Finally, a Tang monk named Xuan Zang came along and rescued him. In gratitude, Monkey agreed to become his disciple and to escort him on his holy journey west. And that is the start of a whole new chapter of the Monkey King's adventures: he befriends an over-the-hill sea monster and a grumpy pig that was once a high-ranking general, until he is punished for assaulting a fairy.

A Japanese demon mask from a thirteenth-century Noh drama.

No Place to Hide!

The heroes of Japanese myths and legends had to battle some of the weirdest and most terrifying monsters in world mythology. Here are just a few examples:

Oni—An Oni is a huge, fanged ogre with the muscles and horns of a bull. His tough skin can be red, blue, or black and he has the ability to reconnect and heal severed limbs instantly. Most live in Jigoku (Hell), although many prefer to live on earth, usually disguised as beautiful women. Oni are considered to be highly intelligent and extremely difficult to kill. They also have a passion for eating human flesh.

Tengu—The tengu are supernatural creatures

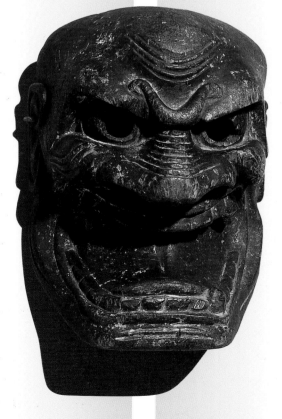

with the bodies of humans and the spirits of mountains. A Tengu usually looks like a tall, thin man with a very large nose and a red face, although some are small and have the head and wings of a black crow. A Tengu is usually seen wearing a pair of *geta* (Japanese wooden sandals) and carrying a magic fan made of bird feathers with which to create terrible tornadoes. Although they have no wings, Tengu have the ability to fly. Their main function is to keep human society in chaos by provoking war and civil disorder.

Kappa—Every river is inhabited by at least one Kappa, an evil dwarf with green, scaled skin, dangerous razor-sharp sickles for appendages, and a hollow in the top of a flat head to hold poisonous water. A Kappa's idea of fun is to gash a person's abdomen and then steal his or her *shirokodama* (bowels). But their all-consuming passion is eating cucumbers, which is why cucumber sushi is called "Kappa-maki."

Henge—The Henge are certain foxes, raccoons, and other wild animals who have the ability to transform themselves into human beings and to create other illusions. Living mostly in the mountains, they take particular delight in tricking hunters and woodsmen. (They can make leaves look like money bills, for example, or horse excrement look like roast beef.) Henges often try to divert heroes

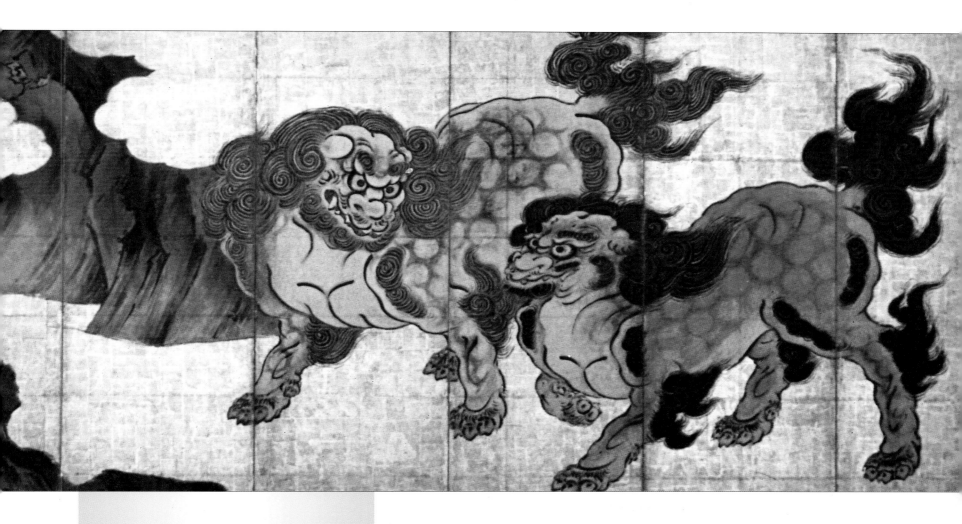

from their quests by turning themselves into beautiful and seductive women.

Gaki—The Gaki are ghastly, thin, undead creatures from *Jigoku* (Hell) who are condemned to wander for eternity suffering endless hunger and thirst. In their desperate need to satisfy their appetites, these ghoulish monsters will eat anything, but prefer human flesh and blood.

Nurikabe—A Nurikabe is a huge invisible wall with arms and legs that allow it to move around the countryside and block roadways. Nurikabes can be very frustrating to heroes in a hurry.

Ittan-momen—An Ittan-momen is a nasty little creature that looks like a simple white cloth flapping in the breeze. Appearing suddenly in the night, it suffocates its victim by wrapping itself around the person's mouth and nose.

Minamoto-no-Yorimitsu and the Evil Oni
A Japanese Hero Legend

A thousand years ago a terrible oni by the name of Shuten Doji was terrorizing Kyoto. He looked like a huge, hideously disfigured blue ox with leering fangs, and lived in his own palace high atop a nearby mountain. He hadn't always been an oni. Once he had been a human robber, but because he had killed so many people, he was made to look like the monster he really was.

The emperor called upon the kingdom's most respected sword master, Minamoto-no-

The wild and hideous Henge delight in tricking hunters and woodsman with their ability to transform themselves into humans and to create other illusions.

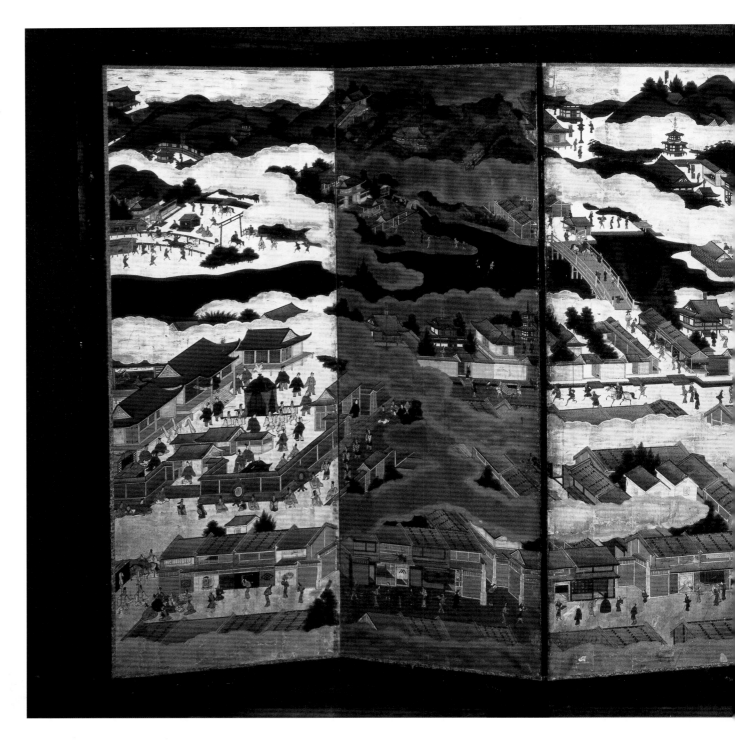

Yorimitsu, to track down and slay the hideous monster. Yorimitsu took four of his best men and headed for the oni's castle on Mount Oe. The men disguised themselves as mountain hermits, and as they climbed up the mountain, they met three mysterious old men who gave Yorimitsu a magic helmet and a bottle of magical wine called Shinbenkidokushu.

When they reached the castle of Shuten Doji on Mount Oe, Doji looked at their hermit clothing, then invited them in and asked them to stay for dinner. Although the oni seemed quite friendly and hospitable, Yorimitsu knew the banquet was really a test; when Doji served them human flesh, they ate every morsel so their host would believe their false identities. The ruse

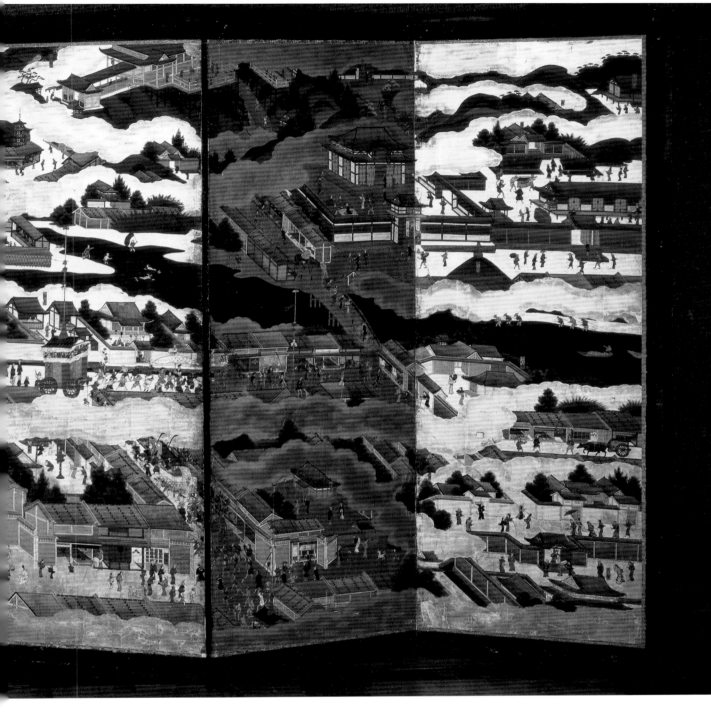

The emperor called on Minamoto-no-Yorimitsu to stop the hideous oni Shuten Doji from terrorizing the Japanese kingdom of Kyoto, depicted on this seventeenth-century screen.

worked. When they offered to share their wine with their generous host and poured him a cup of the magic Shinbenkidokushu, the thirsty Doji drank it down in a single gulp.

The wine did in fact make Doji very sleepy, but even though it was five against one and even though the monster was practically unconscious, it was still a long and bloody battle. Over and over again, Yorimitsu and his four great swordsmen assaulted Doji, sticking their spears through his body and cutting at his head, but Doji resisted violently. Finally, with a tremendous swipe, Yorimitsu cut off the oni's head. But before the oni died, his disembodied head jumped up and tried to take a bite out of *Yorimitsu's* head with his enormous jaws. If Yorimitsu had not been

wearing the magic helmet the old men had given him, he would have been killed instantly. With a great shudder, the oni Shuten Doji finally died. When they brought his head back to the emperor as proof, Minamoto-no-Yorimitsu was proclaimed a great hero throughout the land.

Izanagi and Izanami
A Tragic Japanese Love Story

Many, if not most, of the heroes of Asian mythology are gods and goddesses whose heroic feats were responsible for creating all the phenomena of the universe. Often they take on very human characteristics and emotions when dealing with each other, as in this story of the hero Izanagi's attempt to rescue his beloved Izanami.

Izanagi and Izanami were the first male and female deities brought forth by the gods. Their job was to form the oceans, mountains, and islands of the earth and to give birth to all the other deities which would rule them. Joined together as husband and wife, the two created the earth by throwing their spears into the muddy chaos of the universe from a celestial bridge. Then they descended to the earth and Izanami gave birth to the islands and continents.

Izanami had already given birth to a number of deities (including Ohowatatsumi, the God of the Sea, Shimatsuhiko, the God of the Wind, and Kukunoshi, the God of the Mountains) when she became so burned giving birth to the God of Fire that she died. Sick with despair, her husband Izanagi cried over her, and from the tears that dropped onto her pillow sprang still other divinities into existence. Izanagi was so enraged by his wife's death that he took his sword and cut off his newborn son's head, and from the blood that spurted all over the room, still more deities were born.

Izanami descended to the Land of Darkness, the underworld of the dead, where she built a castle for herself. Izanagi, who could not bear the thought of living without her, implored her to return, but she hesitated, saying it was too late because she had already tasted the food of the Land of Darkness. Finally, Izanami went to ask the gods of the Land of Darkness if they could

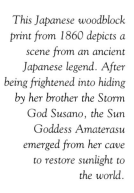

This Japanese woodblock print from 1860 depicts a scene from an ancient Japanese legend. After being frightened into hiding by her brother the Storm God Susano, the Sun Goddess Amaterasu emerged from her cave to restore sunlight to the world.

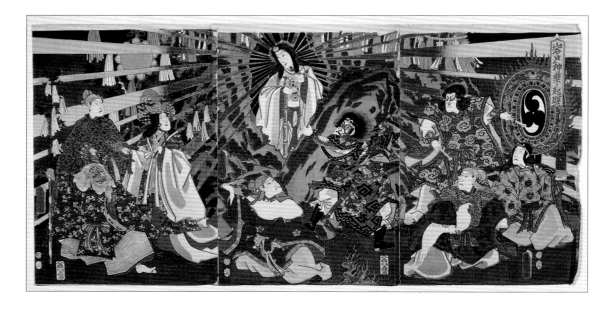

make an exception in her case and let her return to earth. They said yes, on the condition that her husband would promise to wait for her without trying to see her.

Izanagi agreed, but the waiting was long and he soon grew impatient. One day he broke off the left tooth of his comb, set it on fire so he could see where he was going, and entered the Land of Darkness to look for Izanami and find out what was taking her so long. He finally found Izanami, but the sight of her was shocking and horrible. Her badly decomposing, maggot-ridden corpse was lying on the ground guarded by the Eight Thunders.

Angry and humiliated to be seen in such a shameful state, Izanami sent the horrible *Shikome* (the Ugly Females of the Land of Darkness) after her husband. Izanagi managed to outwit them as he fled, by taking his headdress off and throwing it behind him; it immediately turned into grapes which the old hags stopped to devour. Izanami then sent an army of fifteen hundred warriors after her husband. They almost captured him, but just as he reached the Even Pass, the place where the world of light meets the Land of Darkness, he found three magic peaches with which to pelt his pursuers and so he managed to escape.

Feeling defiled by his visit to this impure and disgusting place, Izanagi immediately purified himself in the waters of the river Woto. As he plunged into the water, he created the God of the Deep Sea, and as he bathed he created still more deities. Washing his nose, he gave birth to the god Takehayasusanowo; washing his right eye, he created the Goddess of the Moon, Tsukiyomi; and when he washed his left eye, he produced Amaterasu, the Goddess of the Sun.

Heroes and Creation Myths

In addition to ancestor tales of ancient rulers and stories about magic, ghosts, and other supernatural phenomena, many of the old myths in East Asia concerned themselves with creation stories.

One Chinese creation myth tells how the universe was created out of an egg that existed in total emptiness. Inside the egg was Chaos and the first god, Pangu. When the egg broke, the universe burst out and was immediately split into two parts: the heavens (yang) and the Earth (yin). This principle of opposites—yin and yang, male and female, darkness and light—continues to play an important part in Chinese Taoist philosophy and religious practice.

In the 700s A.D., Japanese scribes recorded the first written compilation of thousands of years of oral Japanese mythology. Called the *Kojiki* ("Records of Ancient Matters"), the book told how the world's first couple, Izanagi and Izanami, helped create the world.

Similar themes can be found in ancient myths throughout Southeast Asia. There are many stories that tell about fantastic animal beasts like the World Serpent Antaboga who created the World Turtle, the Underworld, and other aspects of the universe. For centuries, most of the people in these countries have lived in small communities, making their living from growing rice. As a result, myths about gods, goddesses, and heroes who can insure a good rice harvest are also common. Many other stories tell about heroic ancestors whose spirits return to protect the living from evil.

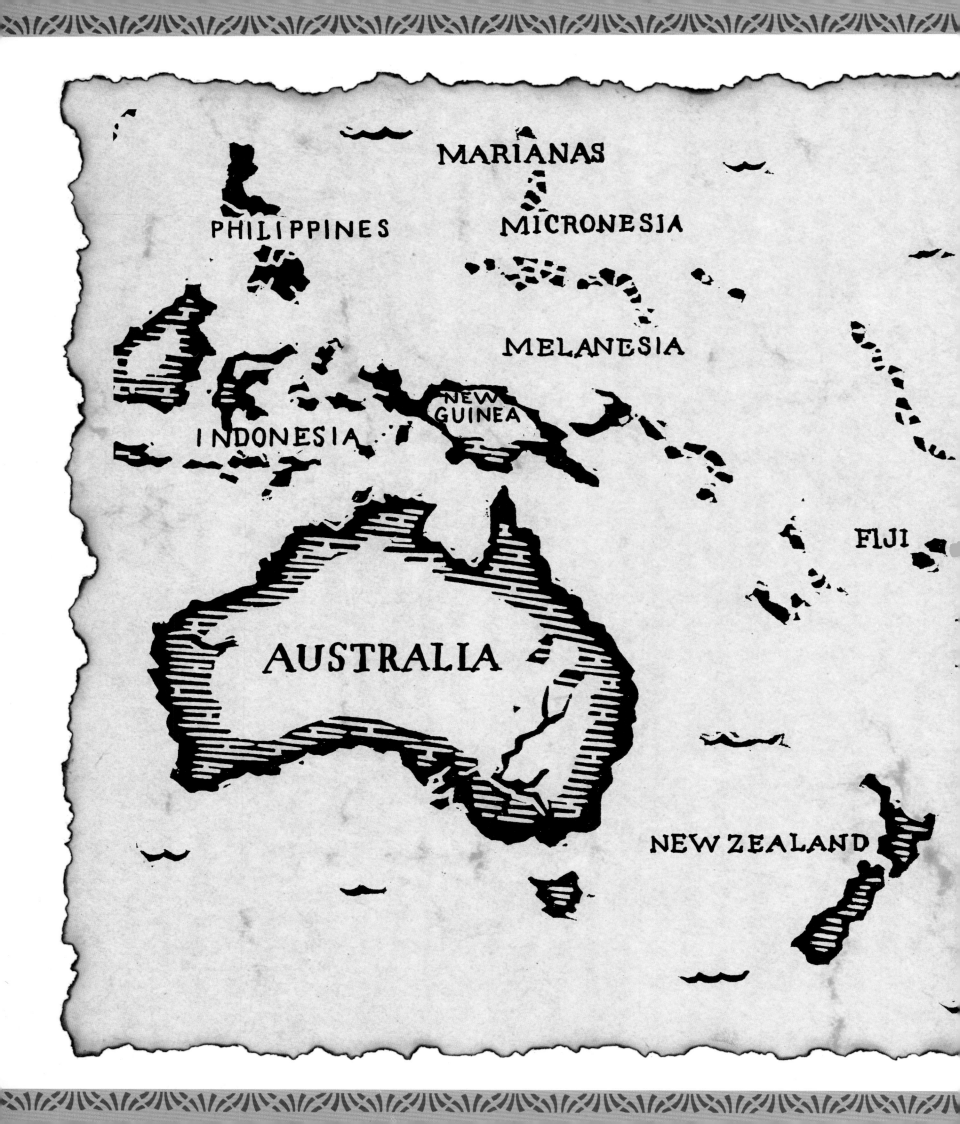

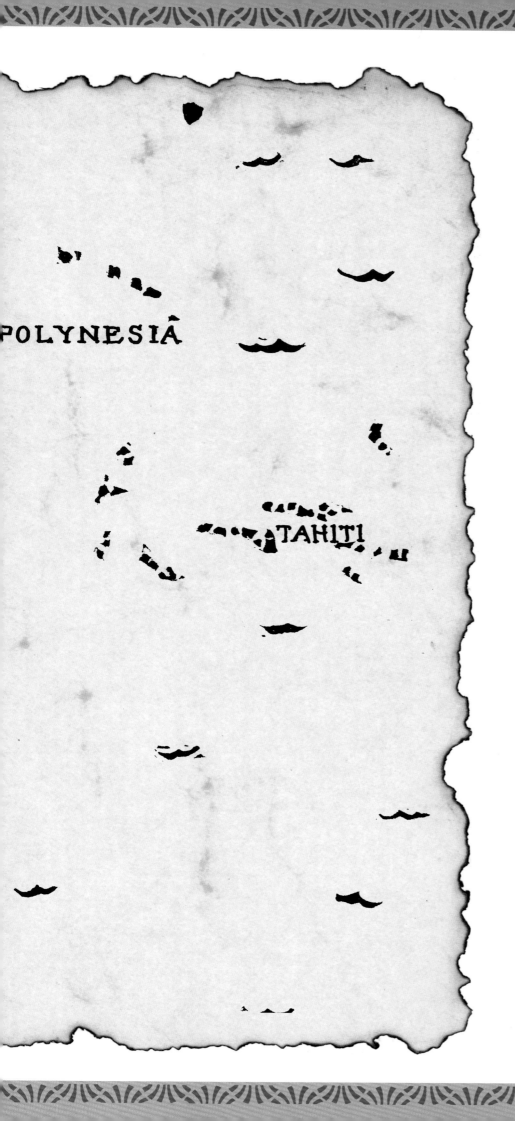

POLYNESIA

TAHITI

Heroes of Oceanic and Australian Mythology

The South Sea Islands of Oceania are divided into three areas—Melanesia, Micronesia, and Polynesia. Each geographical area has its own mythological traditions, although all have myths that are centered around a seafaring way of life. All also tell stories about how ancestors made the sea journey from Southeast Asia to populate the islands of the South Pacific. (Anthropologists believe this migration occurred approximately 50,000 years B.C.)

Australia, which is a separate continent and therefore not considered part of Oceania (even though it is in the South Pacific), has its own distinct myths and legends. Unlike the islands of Oceania, Australia's native population is not descended from people who migrated from Southeast Asia but from the Aborigines who have lived in Australia for at least the last 50,000 years. Their myths and legends concern a "Dreamtime" when the spirits that sleep beneath the ground rose and traveled about, shaping the landscape, making people, and teaching the arts of survival. Many of their heroic ancestors were women, such as the Wawalak Sisters who fought the Great Rainbow Serpent.

How Maui Made the Sun Slow Down
A Maori Trickster Legend from Polynesia

One of the best-known cultural heroes in all of Oceania is the Polynesian trickster Maui. Not only is he famous for slaying monsters, rescuing maidens, defeating rivals like Tuna the Eel, and recovering his wife from the eight-eyed Bat, but also for constantly challenging the authority of the gods in order to better things for humankind.

In the hundreds of stories that have been handed down about him, Maui is portrayed as a rebel and seducer, someone who is always thumbing his nose at society's strict rules and taboos. It was through Maui's actions (sometimes inadvertent) that the world came to be as it is today. He stole the secret of fire for humans from the goddess Mahuika, fire-keeper of the underworld, by tricking her into giving him her burning fingernails. He created all of the world's islands by pulling them out of the sea with fishhooks. But in spite of all his noble and courageous deeds, Maui was still a prankster, one with a definite mean streak in him. After all, they say it was Maui who decided to permanently transform his brother-in-law into a dog just for the fun of it.

In one of the most-told stories in Polynesia, some women brought it to Maui's attention that the sun traveled so quickly that the days were too short to cook anything. No sooner did they heat their cooking stones than the sun went down and their families had to eat their half-cooked food in the dark.

Actually Maui didn't think it was a particularly challenging problem. As he told his brothers, all they had to do was make a giant noose and snare the sun with it. Then they would make it move more slowly. His brothers scoffed at him, saying the sun was far too hot and fierce to try something so ridiculous. Maui reminded them of all the wonderful and amazing things he had already accomplished—feats other people had called impossible. Besides, he said, this time he had their dead grandmother's enchanted jawbone, which he had recently acquired.

In the end, his brothers were persuaded by his arguments and agreed to help him. First they all went out collecting flax, then spent many long days spinning, twisting, and plaiting it into very stout ropes. When they had made all the ropes they needed, they stocked up on provisions and set off on their journey. They were careful to travel only by night so the sun wouldn't see them and become suspicious. At the first light of dawn each morning, they hid themselves in the forest and slept, then resumed their journey in the evening after the sun had set.

Buildings like this Maori food storehouse near the village of Rotrua, New Zealand, were often decorated with carved illustrations of trickster heroes.

They traveled eastward this way for a great long time until they finally came to the edge of the enormous pit from which the sun rose each day. Here they built a long, high wall out of clay, with huts at each end to hide in. When the wall was finished, the brothers gathered together the ropes they had made and used them to fashion a huge noose, which they tied as securely as they possibly could and placed around the rim of the pit. As they huddled in one of the huts waiting for dawn to break, Maui sat with the jawbone of their grandmother in his hand and gave his brothers their final instructions.

They were to remain hidden until the sun had risen just far enough so that his head and shoulders were through the noose. Then, when Maui shouted, they were to pull on the ropes as hard as they could and not let go for even a moment. At that point, Maui was going to jump up and knock the sun on the head with the jawbone until he was nearly (but not quite) dead. Only then would they let him loose. Whatever

you do, Maui cautioned his brothers, don't be silly and start feeling sorry for him when he screams.

Finally the day dawned. The sun came up from his pit as usual, flaming red and suspecting nothing. The mountains to the west looked like they were on fire with his light. When the sun had risen far enough out of his pit so that his head and shoulders were through the noose, Maui gave the cry and his brothers pulled the noose tight. Everything went according to plan. No matter how hard the huge creature thrashed and struggled, the brothers held the ropes tight. Then Maui rushed at the sun with the enchanted jawbone and beat him so savagely about the face and head that the sun screamed and shrieked in agony.

Finally, when he knew the sun had had enough, Maui gave the signal for his brothers to let go of the rope. Once freed, the sun resumed his usual daily course, but crept slowly and feebly because of the severe pain of his wounds. And that is exactly why the sun has crept so slowly across the sky each day ever since. Thanks to Maui and his brothers, people now have time to cook their meals and to eat them while it is still daylight.

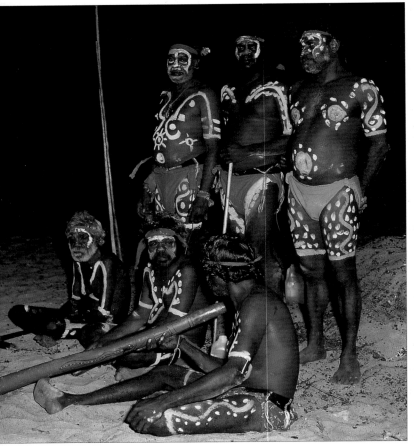

Aboriginal dance groups at Corroboree Mandora and other villages in Australia still act out myths and legends from the Dreamtime.

Dreamtime

For the aboriginal peoples of Australia, the earth was once formless and flat. Then came the Dreamtime, the period when the world was formed and all things were named. Some believe the earth's lagoons, gorges, mountains, and rivers were formed when the Giant Rainbow Serpent, Yurlunggur, wriggled and slithered across the land. During the Dreamtime, the aboriginals' ancestors traveled across the Australian landscape naming all the different land and water formations and depositing the spirits of unborn children throughout the land.

But Dreamtime (also known as Ungud or the Dreaming) is more than just a distant period of time; for many it is also a state of being. While there is a definite difference between the present, the past within a person's memory, and the distant Dreamtime past of one's ancestors, for many believers the edges of these periods can often become blurred. For example, participants in certain important rituals can enter a trance-like state in which they *become*, briefly, the wandering ancestors who originally made the legendary Dreamtime journeys. It is said that shamans have the power to slip in and out of Dreamtime to draw on knowledge for healing. Many dying people seem to slip into the Dreamtime before their deaths.

The Seven Wawalak Sisters and the Big Flood
A Yolngu tale from Northeastern Australia

The Yolngu believe that it was Yurlunggur, the Giant Rainbow Serpent, who caused the great flood during the Dreamtime. It all started when the seven Wawalak sisters set out from somewhere in the distant interior of the continent on a long and hazardous journey to the northern coast. The youngest sister was pregnant, while the oldest had a small child she carried in a paper bark cradle under her arm.

As they traveled, legend has it, the sisters hunted lizard, possum, and bandicoot and gathered plants to eat. As they walked through places, they gave names to all the plants and animals as well as to the lakes and streams and land formations—the names these things and beings still have today. One day, when the youngest sister was ready to give birth, the other sisters searched for a water hole and then collected soft bark to make her a comfortable bed. What they did not know was that the water hole they had found was inhabited by Yurlunggur, a huge, semi-human rainbow-colored serpent.

After the baby was born, one of the sisters accidentally allowed some blood to fall into the water hole when she bathed the infant. Yurlunggur rose up out of the water hole in such a rage that the water erupted and flooded the countryside. Then rain began to fall and the flood worsened.

The terrified sisters began singing songs in an attempt to stop the rain and drive the snake

Aboriginal myths tell how Australia's magnificent mountains, gorges, lagoons, and rivers were formed by the Giant Rainbow Serpent, Yurlunggur.

away, but as they slowly tired, Yurlunggur inched his way toward them. When they finally became so exhausted that they fell asleep, Yurlunggur instantly pounced on them and swallowed them all up whole.

Now it happened that all the serpents in the land had a daily ritual that they shared, even though they all spoke different languages. They would all raise themselves up to the sky and tell each other what they had eaten that day. When it came to Yurlunggur's turn, he was so ashamed that at first he refused to say anything. But at last he admitted to having eaten the seven sisters and their children.

No sooner had he said the words than he fell to the ground in agony and spewed them back out. Although the sisters and their children were stone dead by that time, the green ants who rushed to bite them managed to revive them. As soon as they were conscious, however, Yurlunggur swallowed them up again. Then, again mortified at what he had done, the snake immediately regurgitated them again. This went on for quite a while until at last the serpent became too exhausted to continue. The flood-waters subsided and the seven Wawalak sisters and their children hurried away, grateful that they could continue their journey.

More Flood Myths

The Australian story of the Wawalak sisters is only one of the many flood tales in Oceanic mythology. In the Lake Tyres region of Australia, people tell how once all the world's water was trapped inside a giant frog and all living things

were dying of thirst. The hero Eel got the frog to release the water by making silly faces at him until he laughed, but it caused a terrible flood in the process.

The legends of the Tiwi people off Australia's northern coast tell how their islands became separated from the mainland during a strange sort of Dreamtime flood when a blind old woman called Mudungkala emerged from the ground carrying three infant children—the first people on earth. As she crawled across the featureless landscape, water bubbled up in her tracks and caused a flood that permanently cut off the islands from the Australian mainland.

On the Palau Islands it is said that before humans existed, one of the Kalith gods visited an unfriendly village and was killed by its inhabitants. When his worried friends went searching for him, all the villagers were hostile and rude except for a young woman named Milathk, who told them how their friend had been murdered. The Kalith gods got their revenge by flooding the village, but only after they warned Milathk to save herself on a raft. According to the legend, it was Milathk who went on to become the mother of humankind.

In Tahiti, legends talk about a flood so terrible that it covered the whole earth except for the very tops of the highest mountains. The flood was caused by a sea god who became enraged when his hair became entangled with the hooks a fisherman had lowered too far into the water.

A Samoan myth tells the story still another way. After the primeval octopus Hit gave birth to Fire and Water, the two children got into a terrible fight. Their splashing and thrashing about caused a terrible flood that destroyed the world, and it was then up to the god Tangaloa to re-create it.

In the islands of the New Hebrides, the story goes that Tilik and Tarai, who lived near a sacred spring where they were busy forming mountains and riverbanks, discovered to their horror that their evil mother had been urinating in their food. They exchanged the food and ate hers. When she discovered what they had done, she was so angry that she rolled away the boulder she had been using to hold back the sea. The waters immediately poured out over the land in a great and terrible flood.

left
Trickster heroes were often called upon to fight evil spirits like the Hawaiian fire goddess Pele, represented by this figurine, who lived in the crater of the Kilauea volcano.

opposite
The Maori of the Marquesas Islands and other areas of Polynesia believed in a pantheon of gods headed by the two creator beings, Rangi, the male sky, and Papa, the female earth. They also told stories of many human heroes such as Tawhaki and Rata.

Kae and the Whale
A Hiva Oa tale from the Marquesas Islands

There was once an island of women called Vainoi on which there were no men at all. The women who lived there did have husbands, however, and did give birth to children. But their husbands were simply pandanus roots that they visited once in a while out in the fields.

One day, while on a sea journey, the trickster hero Kae's ship was wrecked, and he was cast ashore on this unknown island not far from the women's daily bathing spot. Kae hid himself in some bushes and spied on them until he finally realized that he was the only man on the whole island. Delighted, he came out to introduce himself to Hina, who was the island's chieftess. Hina was quite delighted herself about his being there, and the two of them were soon married.

After a while, however, Kae started to feel depressed. Part of the reason was homesickness, but the main reason was his discovery that while he grew older every day, his wife, who had supernatural powers, could regain her youth any time she wanted to just by surfing. Every month or so, all she had to do was head down to the beach and ride the waves three times in a row. On the third time, she would be carried onto the beach "as fresh as a shrimp with the shell removed." One day Hina noticed that Kae's hair was getting a little gray and suggested he come surfing with her: all Kae

got from surfing were sore muscles and a bump on the head.

After a while, Hina became pregnant and gave birth to their son, but Kae continued to feel discontented. He insisted that he return to his own island for a visit to prepare certain important ceremonies for their new son. Hina knew in her heart that he would never return, but she eventually gave in and let him go. She even loaned him the use of her brother Tunua-nui, the whale, for him to ride to speed him on his journey. Before Kae left, Hina very carefully explained to him that once he reached his own island, it was very important that he turn the whale around and point him back toward the island of Vainoi.

Kae was so happy when he arrived back on his own island that he didn't bother to follow Hina's instructions. As soon as his people saw the poor animal waiting in the bay, they killed and ate him.

While Kae was busy building a house for his new son back on his own island, the boy, who was still living on Vainoi with his mother, was being tormented by his playmates for having a strange father. The boy was so miserable that, although his mother was still angry and outraged that Kae had allowed her brother to be killed and eaten, she finally agreed to let her son go to his father's island and live there with him. She put her son on the back of another great whale and gave him the same instructions she had given Kae about turning the animal around once he had reached port.

The obedient boy did as he was told, but when the greedy people on his father's island saw the whale, they rushed out to grab his tail and pull him in so they could kill and eat him like they had killed and eaten the first one. This

time, though, it was the whale who pulled all of *them* out into deeper water where they drowned.

Meanwhile, the boy climbed up the hill looking for the house his father had built for him. When he found it, he happily bathed in the pool, ate the bananas that had been planted for him, and waited for his father. But none of the neighbors recognized him and, thinking he was a scoundrel out to steal from Kae's property, they came after him with large sticks. They would have killed him, too, if he had not shouted out his father's name at the last minute and babbled on and on about his father being the first man to ever live on the island of women. When Kae heard the boy, he ran to his side and hugged him fiercely. The next day, a great feast was held throughout Kae's land in his new son's honor.

Captain Cook collected mythological artifacts on his three voyages to the South Seas. This sculpture of the Hawaiian war god Kukailimoku has red feathers for hair, mother of pearl eyes, and real dog's teeth.

Qat, Marawa and the Sky Maiden
A tale from Banks Island and the New Hebrides

There are a number of legends in Oceanic mythology about bands of brothers. One of the brothers in a typical band (usually either the oldest or the youngest) is a hero who spends his time trying to do noble, creative deeds. The other brothers invariably give him a hard time, either through mischief, stupidity, jealousy, or greed. The most famous of these bands of brothers is the Tangaro clan: the hero Qat and his eleven brothers.

It is said that Qat and his siblings came into existence in an unusual way: on the island of Vanua Lava their mother, a large rock, suddenly burst into small pieces, which became her sons. Using tree stumps for canoes, Qat became a great seafarer and frequently went off on long journeys during which he created the seasons and the tides; he used fishhooks to pull new islands out of the sea. On his return Qat set out to create the island's mountains and rivers, then its trees and pigs and, finally, humans. When his brothers were tired of the constant daylight, he created the night and taught his brothers how to sleep.

In addition to having so many brothers, Qat also had an almost constant companion named Marawa, who took the shape of a spider whenever it suited him. Marawa was a bit of a trickster and was not all that smart. Although Marawa's practical jokes often exasperated Qat, Marawa had, after all, come to his rescue when Qat's wicked brothers had tried to crush him in a land-crab's hole. And when Qat was trapped in the "stretching tree," Marawa extended his long white hair as a ladder so Qat could climb down and escape.

Marawa could be good-hearted, but if it hadn't been for his foolishness, humans today

would be as immortal as the gods. When Qat created human beings, he did it by carving the bodies of three men and three women from a tree and decorating them with swatches of palm fronds. Then he carefully hid them for three days in the shade of a clump of trees. On the fourth day, he brought the figures to life by dancing and beating a drum in front of them.

As Marawa watched Qat start to carve the figures, he wanted to make some people, too, and began to imitate him. When Qat carved, Marawa carved; when Qat hid his figures in the shade for three days, so did Marawa. But on the fourth day, when the six figures began to move in response to Qat's singing and dancing, Marawa snatched them up and ran away. He quickly dug a deep hole in the forest floor and buried them under a pile of leaves and branches. After seven days, when he reluctantly dug them back out again, the figures were lifeless, rotting bodies. Because of what Marawa did, it is said, humans can never be immortal. They are condemned to live for only a brief time on earth and then to die. Qat may have given them life, but Marawa gave them death.

According to one of the legends about Qat, it was love that finally did him in. Like the rest of his brothers, Qat acquired his wife by stealing her. One day he came upon a group of sky maidens who were bathing in a stream. While they were splashing around in the water, he crept down to the riverbank where they had laid their belongings and buried a pair of wings so one of the girls would have to stay behind when the others left. It worked, and since the poor girl had nowhere to go without her wings, she finally agreed to marry Qat.

After they were married, however, the girl became terribly sad and homesick. One day she went down to the bathing spot where she had last seen her sisters and friends. As she sat on the riverbank, she cried so hard that her tears washed away the earth that Qat had used to bury her wings. Overjoyed, she put her wings back on and flew away.

When Qat realized that his wife had left him, he became determined to find her and bring her back. First, he attached a thick rope to the end of a large, sturdy arrow, then shot the arrow up into the heavens. A long banyan root immediately appeared and wound its way down along the rope, making it easy for him to get a foothold. Qat quickly climbed up the rope into the sky world where he met a giant farmer hoeing his garden. Remembering the handy banyan root that climbed down his rope, Qat begged the man not to disturb the root until he was safely down on earth again.

Qat searched and searched the sky world until he found his estranged wife. He threw her over his shoulder and had just started climbing down the rope with her when the banyan root snapped and the rope unraveled. He let go of the girl as he fell and she quickly flew away, back up to her home in the sky world. Qat, however, could not fly, and plunged to his death.

The Exploits of Olifat
Trickster Hero of Micronesia

His name may vary a bit from island to island (some call him Iolofath or Orofad or Wolphat), but the character Olifat is well known throughout Micronesia as a notorious and often mean-spirited trickster. Although he brought many skills and benefits to humans, he also liked to make fools out of them, and many of his practical jokes caused serious injury and even death.

Olifat was like this from the moment he was born. He came into being when his father, the sky god Lugeiläng, flew down to earth to marry a mortal woman he had fallen in love with. But Lugeiläng already had a wife in the sky world, and when she found out what he was up to, she was so angry that she followed him to earth to try and stop the marriage.

It turned out that the woman Lugeiläng wanted to marry was really only *half* mortal; her mother was Hit, the primeval octopus. Hit liked Lugeiläng and approved of his marrying her daughter; each time his first wife showed up, Hit started to perform an erotic dance. This so mortified Lugeiläng's first wife that the third time she saw it, she died of embarrassment, and her attendants had to carry her dead body back up to heaven.

Lugeiläng and Hit's daughter got married as planned, but when the woman became pregnant, Lugeiläng began to feel tired of his new marriage and returned to his home in the sky. Before he left, however, he cautioned his wife never to allow their child to drink milk from a coconut through a small hole.

Like many other heroes and tricksters, Olifat had a strange birth. When the time came, his mother simply pulled on the end of a coconut leaf that she had twisted into her hair and the infant sprang out of her head. The child could run as soon as he was born.

Olifat ate a great deal and grew very quickly. One day, when his mother wasn't watching, Olifat was thirsty. After experimenting for a while, he figured out how to punch a small hole into a coconut to get to the milk. As soon as he had his head tipped back far enough to drain the last drop, his eyes looked up at the heavens and he caught sight of his father. In spite of his mother's protests, Olifat immediately wanted to visit him. When he made up his mind, there was no stopping him. Without even saying good-bye, he scrambled up to heaven on a column of

The Gilbert Islands and other areas of Micronesia have vivid creation myths that tell how the islands, the salty sea, and the heavens were created when a caterpillar died trying to pry open a primordial clam.

smoke that was rising from some burning coconut shells.

Olifat didn't become mean when he got older; he was *born* nasty. He had to travel through the three lower levels of heaven to reach his father and managed to cause total havoc on the way. On the first three levels, children were having fun playing with the friendly and harmless fish they kept as pets, but Olifat soon put an end to that by making their scorpion fish sprout spikes, their gentle sharks grow razor-sharp teeth, and their stingrays develop painfully poisonous stingers.

When Olifat finally reached the fourth level, he saw a group of workers building a *fārmal*, a house for the spirits of the dead. In these times, house builders in Micronesia had a special (and rather drastic) custom to ensure the new building's strength. As they were building it, they would kill someone and bury the body (or sometimes just the bloody head) in the bottom of one of the building's postholes before putting the posts in. Since the friends and family of the building's owner usually got more than a little upset when one of them was chosen to be sacrificed this way, people often killed and buried any strangers who were unlucky enough to be passing by at that particular time.

This custom was also followed in the sky world, and when the workers saw the strange boy wandering around, they figured he'd be the perfect victim for their posthole. Olifat may have been mean, but he certainly wasn't dumb. The men threw him down into the posthole, but seconds before they rammed the heavy post down into the hole to kill him, he quickly dug out a hollow cave off to one side and pressed himself into it. Confident that the boy was dead, the workers went off to finish their building.

Olifat, in the meantime, talked some termites into helping him tunnel through the post and up through the building's rafters. Suddenly the workers heard weird laughter and when they looked up they were astounded to see the boy they were sure they had murdered, perched in the rafters above them. Then, just in time or they would have killed him for sure, Olifat's father, Lugeiläng, showed up and ordered him to come down.

That was just the first of many times in which people would try to kill the trickster Olifat, and it was usually because he was such an infuriating and aggravating fellow. He was able to get away with so much mischief partly because he could transform himself into everything from insects and animals to coconut leaves and piles of dung. In one very strange story, he turned himself into a mosquito so he could be swallowed by his brother's wife in her drinking water. Nine months later he traumatized the whole family by being born as her son.

People blamed Olifat for everything from spoiling their food to stealing their wives, and most of the time they were right in their suspicions. His most vicious prank, however, was the murder of his own brother. It turned out that his father, the sky god Lugeiläng, had kept it secret from Olifat that he had a son by his first wife before he left heaven to marry Olifat's mother on earth. When Olifat discovered this brother everyone had kept hidden from him, he vowed revenge. This other son lived on the third level of heaven, but Olifat learned that each night after the boy came home from fishing, he proudly brought his catch up to show his father. Olifat crept up on him one night, chopped off his head, and then left it at his father's doorstep in place of his brother's usual nightly offering of fish.

Lugeiläng, of course, was outraged. He immediately restored his son's head to his body and breathed life back into him, but when he yelled at Olifat for his heinous act, Olifat just looked surprised and said how could he have killed someone who didn't exist?

Lugeiläng promptly kicked Olifat out of the sky world and that was the beginning of a long war that Olifat waged single-handed upon the heavens. To make his father and the other gods angry, he stole the secrets of fire and other immortal knowledge from them and brought them down to earth to give to humans. Finally, in an effort to make peace, Lugeiläng allowed Olifat to make his home in the god's sky palace. Olifat accepted, but still only spent half his time there. The other half he spent on earth tormenting (but also helping) humans.

The Tricksters of Oceania

Some areas of Oceania have creation myths, others assume the universe was always just there. Some cultures in Melanesia trace their ancestors back to spiritually powerful animals such as the crocodile or snake, while some Polynesian myths tell stories of heroic ancestors who made fantastic voyages to faraway places like the Sun, the Moon, and the Underworld. But one aspect of mythology almost all the islands of Oceania have in common is the concept of the trickster hero.

In Polynesia, it's the famous trickster hero Maui who battled the gods on behalf of mankind. In Melanesia, which is made up of an incredible number of small, isolated mountain communities, many of the stories are the same, but the names of trickster heroes vary from village to village. Here you can find the humorous adventures of Qat, Takaro, and To Kabinaba. In Micronesia, a constellation of tiny islands north of Melanesia, most of the stories have to do with worshipping divine ancestors, which included fish gods and the spider trickster hero Nareau. Other popular trickster heroes in Melanesia are Motitik and Olofat.

Throughout Oceania, trickster legends were handed down from generation to generation orally, by way of highly respected poets and storytellers. Australia's Aborigines passed on their hero myths orally too, but they also used rock, sand, cave, and bark paintings to illustrate their Dreamtime stories.

The vivid Aboriginal Dreamtime stories of the Giant Rainbow Serpent were often painted on walls of caves such as this one on Wessel Isle off the coast of Australia.

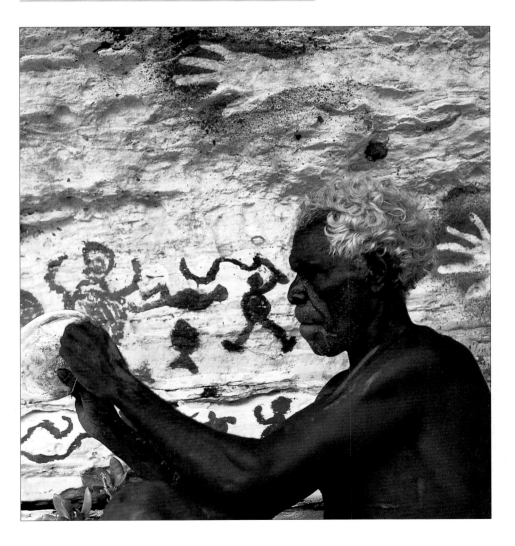

MOROCCO

ALGERIA

L

Sahara
Desert

MALI

NIGER

SENEGAL

NIGERI

IVORY
COAST

C

NA

SOUTH
ATLANTIC
OCEAN

Heroes of African Mythology

In African cultures, the rich oral tradition of storytelling has been passed down from generation to generation for thousands of years. The stories have taken many forms, from creation myths, hero legends, and adventure tales to proverbs, animal fables, songs, poems, and even riddles. And there are thousands and thousands of them. Not only do these stories still thrive in African cultures today, they have been transplanted to many other nations as well, especially those in the Western Hemisphere. Many of the folktales of black America and the Caribbean (such as Brer Rabbit and Uncle Remus) are rooted in this rich and vivid African heritage.

Anansi the Spider
A Tale of a West African Trickster Hero

Long ago the first spider, Anansi, traveled throughout the world on his web strings—although he sometimes looked and acted more like a wise old man than a spider. In that long-ago time, things were dull because there were no stories on earth for people to tell. The sky god, Onyame, kept all the stories for himself, locked away in a wooden box high in the sky. Anansi yearned to be the owner of all these stories so that he could know why and how all things existed. So did many others. Many people had offered to buy the stories from the sky god, but the price had proved too high for even the richest families.

Leopards were popular characters in the animal fables of the Nigerian Obas.

Nevertheless, Anansi was determined to have them. When the sky god saw the thin, old spider, Anansi, climbing up his web to ask for the stories, he laughed at him. "What makes you think that you, of all creatures, can pay the price I'm asking?" he said.

"Well, tell me the price and we'll see," said Anansi.

Onyame said the only way he'd part with the stories was if someone brought him the three most fearsome creatures: Mmoboro, the nasty, swarming hornets; Onini, the python that swallowed men whole; and Osebo, the leopard who had teeth like spears. Anansi replied, "No problem. I will bring them."

Bowing, the spider quietly turned and crept back down his web through the clouds. First he devised a plan to capture Mmoboro, the nasty hornets. He filled a large, hollowed-out gourd with water, and then went walking through the bush until he saw the swarm of hornets hanging in a tree. He sprinkled some of the water out all over their nest. Then he poured the rest all over himself and covered his head with a large leaf. Still dripping, he called out to the hornets, "The rain has come, you foolish hornets, why don't you do as I do and protect yourself from the storm?" "Where will we go?" they asked. "Just fly inside this dry hollow gourd," he advised them.

The hornets thought it was a good idea and flew into the gourd. Anansi quickly plugged the hole, spun a thick web over the opening, and then took it to Onyame.

The sky god accepted the hornets Anansi brought him but said, "You have two more to go." Next Anansi set about to capture the

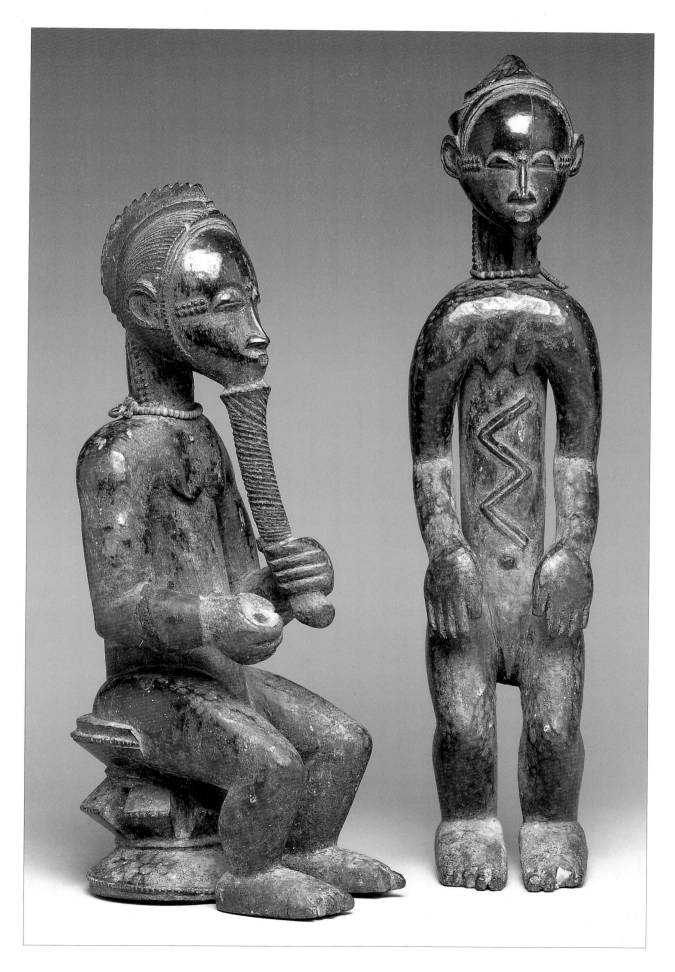

One of the most famous trickster figures in African mythology is the West African character known as Eshu to the Yoruba and as Elegba or Legba in Benin. A homeless, wandering spirit, he is said to be responsible for all quarrels between human beings and between humans and gods.

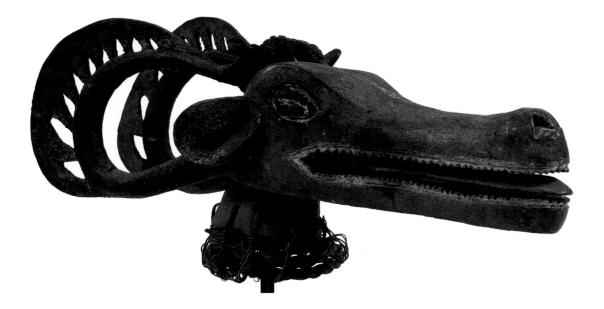

python that swallowed men whole. First, he cut off a long branch from a palm tree and gathered some strong vines. Then, as he walked to the swampy stream carrying these things, he began arguing out loud with himself, "This branch *is* longer than he is!—you lie, it is not!—no, it's true, this branch is longer!—no way, *he's* longer, *much* longer!"

The python, who couldn't help overhearing, asked "What are you muttering, Anansi?"

"My wife and I have been arguing," he replied. "She says that you are longer than this palm branch and I say that you are not."

Onini, the python, said, "Well there's an easy way to find out. Come over here and lay that branch down next to me and we will see if your wife is a liar or not."

So Anansi put the palm branch next to the python's body and watched as the large snake stretched himself out alongside it. Then quick as a flash, Anansi wrapped the vines around and around the python until he had the snake tied firmly to the branch. Anansi spun a web around the bound-up snake and dragged him back through the clouds to the sky kingdom. On seeing

the gigantic snake, Onyame merely said, "There is still one thing more to go."

So Anansi came back to earth to find the next creature, Osebo the leopard, who had teeth like spears. After following the tracks of the leopard to see where he hunted, Anansi dug a very deep pit, which he disguised with branches. When he returned the next morning, he found Osebo the leopard pacing nervously on the bottom of the pit. Anansi told the leopard that if he crawled up the side as far as he could, he'd give him a hand and help him out, but as soon as Osebo got within reach, Anansi hit him over the head and pushed him back into the pit. Anansi quickly spun a tight web around the unconscious leopard and then carried his final trophy back to the sky god.

This time Onyame was impressed. He called together all of his nobles and told them how Anansi the Spider had done what no one else had been able to do. Then he announced in a loud voice that rang through the sky, "For now and forever, all my stories belong to you, Anansi. I give them to you with all my blessings, and from now on they will be called "spider stories."

Heroes of Animal Fables

Animal fables have always been one of the most popular forms of African storytelling. While some of these are just silly stories to entertain young children, most have a purpose. Animals are often portrayed with human weaknesses (like envy, gluttony, or greed) and the fables offer

angry with the Hare, unfairly claiming that he stole their food. The Hare calms the Elephant down by handing him one end of a rope and promising him that all he has to do is pull and he'll find a great treasure chest on the other end of the rope. Then the Hare walks through the woods to the river, hands the other end of the rope to the Hippopotamus, and tells him the same thing. The two huge animals pull and strain

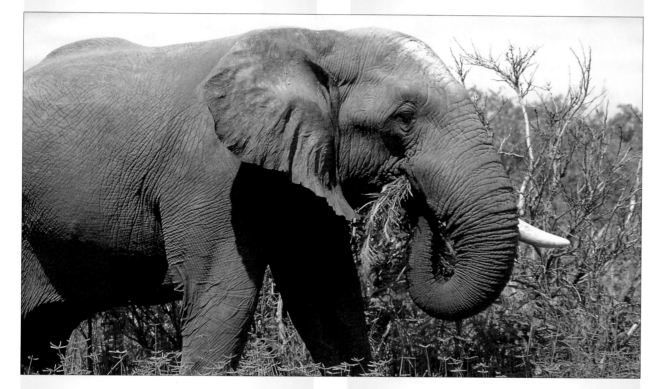

The animal pranksters found in so many African cultures like Hare, Mantis, and Anansi the Spider are heroes because they outwit more powerful animals such as elephants and hyenas and trick them into helping humans.

their listeners a moral, such as "Be very careful what you wish for—because you just might get it!" In many fables, an animal hero like the Hare or the Tortoise may be smaller and weaker than his elephant, rhinoceros, and crocodile neighbors, but with patience and cunning, he can often outwit them. They become appealing characters the listener can identify with, because no one likes to be pushed around or taken advantage of.

There is a Yoruba story, for example, in which both the Elephant and the Hippopotamus are

against each other for hours, each thinking they'll be pulling in a treasure, while the delighted Hare hops between them egging them on. Eventually the two animals get tired and the thirsty Elephant lumbers down to the river for a drink. When he compares notes with the panting Hippopotamus, they angrily realize they've been had, but by this time the laughing Hare has long since run off to safety.

Animal fables are also often used to explain natural phenomenon. There's a story told in

Sierre Leone about how the leopard got its spots. It tells how Leopard and his wife were very friendly and often visited their neighbor, Fire. They begged Fire to visit them in return, but Fire never came. Finally, Fire agreed that if they created a road of dry leaves right up to the door of their house, he would come. They did, and sure enough, Fire soon came to visit them. But when Leopard and his wife opened the door, the wind whipped Fire's fingers of flame toward them. They managed to escape just before their house burned down, but as you can see, to this day their bodies are still marked with black spots where the fingers of Fire touched them.

Thousands of other fables explain things like why bats hang upside down and only fly at night, why snakes shed their skin, why rams paw the ground, why frogs swell up and croak, why spiders got to be bald, and why crocodiles don't die underwater.

One of the most popular animal heroes is Anansi the Spider, a trickster character in the folklore of many African cultures. He sometimes has names like Mr. Spider or Kwaku (Uncle) or Gizo (as the Hausa call him), but he's still the same rascally hero of hundreds of stories and fables. Although Anansi the Spider can be wise and sympathetic, more often he's characterized as a greedy, gluttonous, and cunning prankster. Either way, he is endlessly preoccupied with outwitting everybody and everything around him. Often the stories are about his frequent encounters with Onyame, the supreme sky god, and are told to explain the beginnings of

This warrior has put his knife to good use. In African mythology, a divine blacksmith often plays a crucial role by stealing fire from the gods and teaching humans how to fashion tools and weapons.

certain natural phenomena (how the moon came into being, for example) or how certain customs and traditions got started (how men came to use hoes or why humans were given tongues). Many of the stories are morality fables in which Anansi's antics and weaknesses only get him into trouble.

Ogbe Baba Akinyelure, Warrior of Ibode
A Yoruba Myth from Nigeria

There was a time when war raged throughout the land and people knew the names of many great warrior heroes. But no man was more famous than Ogbe, a warrior who lived in the town of Ibode in the west. In those times, people believed that a warrior should never drink palm wine when his country was at war because it made his arms heavy, slowed his spear, and clouded his judgment. Ogbe, however, believed that he was so strong and skilled a warrior that it was fine for him to drink. It was even fine for him to ride into battle with the warmth of palm wine inside him. Because he was such a great hero, no one dared to say out loud that he shouldn't.

Ogbe had many wives and children in Ibode, but he loved his son Akinyelure the best, perhaps because Akinyelure's mother was Ogbe's most beloved wife. He loved his son so much that after the boy was born he changed his own name to Ogbe Baba Akinyelure (Ogbe, Father of Akinyelure).

One day the town held a great festival in honor of one of Ogbe's victories. The drumming, dancing, and singing went on all day and far into the night, and Ogbe drank many cups of wine. Very early the next morning a messenger came to the town and woke everyone with the news that an enemy force was rapidly approaching. As Ogbe and the town's other warriors took up their weapons and prepared for battle, young Akinyelure announced that this time he too would go along to fight the enemy. His father looked at him and decided that maybe he really was old enough to fight. Ogbe handed his son a spear and battle-ax and told him that they would proudly fight side by side. Without letting Akinyelure's mother know her son was going along, Ogbe and the other warriors went out to meet the enemy.

The battle was great and glorious. Hour after hour Ogbe and Akinyelure fought side by side until finally the enemy began to tire. When one of the warriors cried out that the enemy was fleeing into the bush, Ogbe, delighted, turned to look. It was only then that he noticed that Akinyelure was no longer at his side. He searched frantically across the fields until he found the body of his dead son, then dropped to the ground beside him in grief and despair.

The other warriors tried to convince Ogbe to return with them to Ibode, but he refused. How could he go back and face the dear wife whose son he had allowed to die? He said he would stay where he was because there was now nowhere else for him to go. As Ogbe said those words, he took root where he stood and turned into an iroko tree. But the great hero was never forgotten by the townspeople. Every year they came out to the field and laid sacrifices at the foot of the iroko tree in his memory.

Akokoaa and the Monster Sasabonsam
A Sefwi Tale from Ghana

Yoruba artists from Northern Yorubaland in Nigeria carved wooden figures and often decorated shrines representing female fertility myths.

A weary hunter was about to head home after wandering all day without firing so much as a single shot when he saw an antelope. He shot and killed it and was about to tie up the carcass with some vines when he heard a voice behind him. "Hunter," it said, "cut off the animal's legs."

When the hunter turned around he was horrified to see a gigantic, thin man with hair that reached down to his knees and teeth like red-hot spears. The monster's eyes were huge balls of fire that flashed when he again ordered the terrified hunter to cut off the animal's legs. After the hunter did what he was told, the monster Sasabonsam picked up the rest of the carcass and swallowed it whole, leaving only the legs for the hunter to take home.

The same thing happened the next day, the day after that, and the day after that. The hunter never told his pregnant wife what was happening, however, and she started to get a little angry and suspicious about her husband only coming home from his hunts with legs. She wanted to know what was happening to the rest of the meat. So she devised a plan to spy on him. She pounded a tiny hole in his powder box, and

then filled it with ashes, and when he set out the next morning for his usual hunting grounds, all she had to do was follow the trail of ashes he left behind.

She was hiding behind a tree, watching, when her husband shot and killed a small black duiker antelope. She jumped about a foot when she heard the ghastly voice tell her husband to cut off the animal's legs. But this time Sasabonsam was not pointing at the animal the hunter had just killed but to the tree she was hiding behind. The hunter thought for a moment that a stray bullet must have killed a second animal—until he looked behind the tree and saw his wife, who had fainted from shock.

Smoke poured out of Sasabonsam's mouth as he again demanded the hunter cut off her legs. When the hunter didn't move, he angrily picked

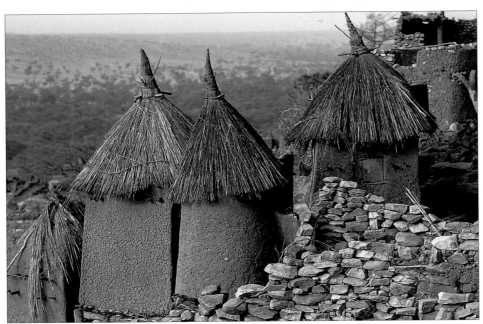

A Dogon village in Mali.

her up himself and was about to swallow her whole when her belly opened and her baby jumped out. The child's name was Akokoaa Kwasi Gyinamoa and he grew so fast that in a flash he was a smoke-breathing monster as big as Sasabonsam himself. Howling, the two began to fight over the woman's body. In their terrible

fight, they uprooted trees and scattered all the wildlife in the forest. Finally, in a moment when Sasabonsam was trying to catch his breath, the child-giant grabbed the monster's magic hammer from his belt and hit Sasabonsam on the head three times.

Fatally wounded, Sasabonsam fell full-length on the ground and immediately turned into a great river. As for Akokoaa, he shrank back down to infant size, crawled back into his mother's womb, and patiently waited there to be born.

The Legend of Samba Gana
A Fulbe Tale from the Upper Niger Valley

There once was a very beautiful and wise princess named Annallja Tu Bari. Many knights came to seek her hand in marriage but soon left when they heard what she demanded of them. Her father had owned all the farming villages in the area until the day a warrior from a neighboring village challenged him to a duel for possession of the town. Annallja Tu Bari's father lost both his life and the town in that duel. Annallja Tu Bari wanted revenge.

In her anger and grief, Annallja demanded that any suitor who wanted a chance to marry her had to not only win back the town her father had lost, but conquer eighty other towns and villages in the surrounding area as well. Since that meant, in effect, mounting an all-out war, no one particularly cared to take her up on her offer. Years passed and Annallja remained unmarried

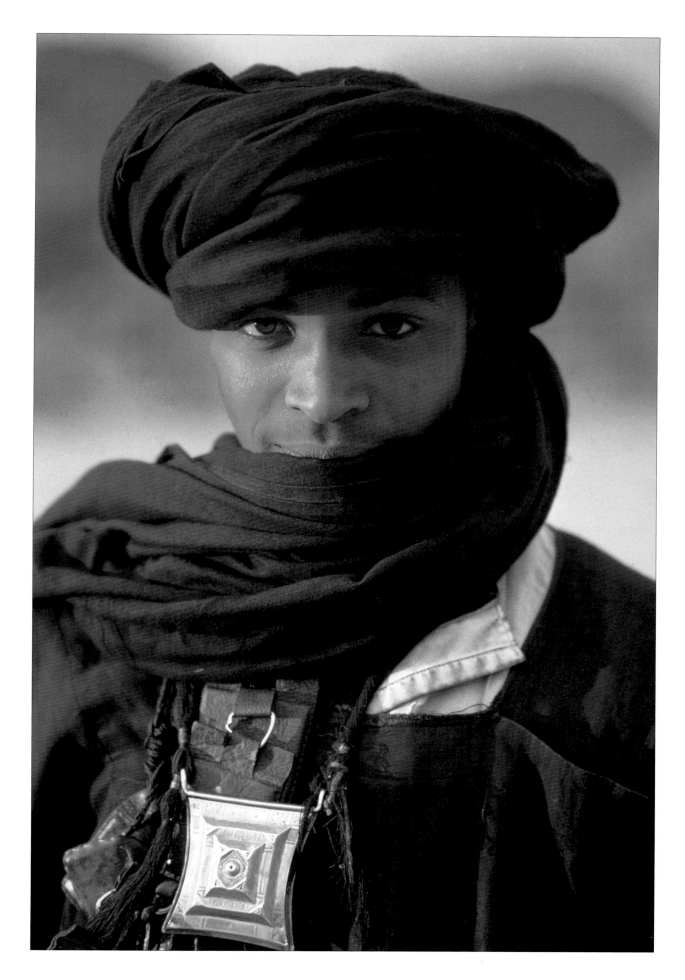

This man is wearing the traditional dress of Niger. The cultures of the Upper Niger Valley, including the Yoruba, Bambara, and Dogon, developed some of the richest cosmologies of the world, with creation myths rivaling those of India and Mesoamerica in grandeur and subtlety.

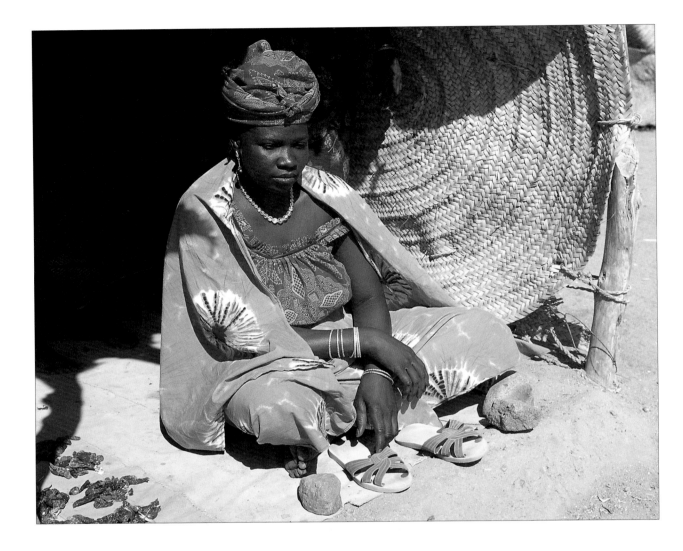

but grew more beautiful—and more melancholy—with every passing year. Her sadness affected everyone around her, and soon no one in her kingdom ever laughed.

In Faraka, a land far away, there lived a prince called Gana who had a strong and courageous son named Samba Gana. It was the custom in this land that when a son came of age, he would take his bards and servants and set out to find (and fight for) his own land. Samba Gana set out on his journey with great joy and laughter. Each town he came to, he challenged the prince who owned it and then fought with him until the prince conceded defeat. But Samba Gana always gave back what he had won. He not only let each vanquished prince live, he also

let him keep his town. Samba Gana just laughed and went on his way.

One day when he was camped along the Niger River, one of his bards sang him a song about a sad and lovely princess named Annallja Tu Bari who would only marry the man who could conquer eighty towns and make her laugh. Samba Gana immediately sprang to his feet and demanded that they set off at once to find her. When they did, he saw that she was indeed incredibly beautiful—and incredibly sad. After getting a list of the towns she wanted conquered, Samba Gana instructed his bards to spend every day that he was gone singing to her about the land of Faraka and its noble heroes. They even sang to her about the great and terrible serpent

of the Issa Beer that made the river rise and flood the land so that one year the people had too much rice and the next they went hungry.

As Annallja Tu Bari was learning everything there was to know about Faraka, one by one Samba Gana conquered all eighty of the towns on her list. Soon she ruled over all the princes and the knights in the land and when Samba Gana returned, she agreed to be his wife. But he said, "Why don't you laugh? I will not marry you until you laugh." She explained that, before she could not laugh because of her grief and anger; now she could not laugh because people in his Kingdom were hungry. She said the way she could ever laugh again was if he conquered the serpent of Issa Beer that caused so many people to suffer.

So Samba Gana set out to conquer the terrible serpent. When he finally found him on the Upper Niger, the fight was long and difficult. They fought for eight long years, and as they struggled the waters of the Niger churned and overflowed its banks. Mountains collapsed, and the earth opened up in yawning chasms. It took Samba Gana eight hundred broken lances and eighty swords, but he finally did conquer the serpent. But Annallja Tu Bari still wasn't satisfied. She sent word that Samba Gana was to bring her the subdued serpent so she could have it as her slave. Only then, she said, would she laugh.

This time Annallja Tu Bari had gone too far. When Samba Gana heard her final demand, he said she asked too much. He took his sword and stabbed the serpent in the

heart, killing it. Samba Gana laughed one last time and then plunged the same bloody sword into his own breast.

Horrified when she heard the news of his death, Annallja summoned all her knights and rode with them night and day until they reached Samba Gana's bloody body on the banks of the river Niger. She ordered her people to build him the highest, most magnificent tomb that was ever built for any hero, a tomb so huge that it took thousands of workers eight years to build. When it was finally finished, Annallja Tu Bari climbed to the very top. As she stood on top, she commanded her knights and princes to spread all over the world and become heroes as great as her Samba Gana had been. Then she actually laughed—just once—and died. Her people

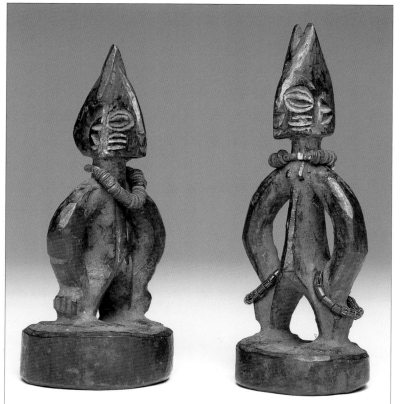

Twins play an important part in the creation myths of many African cultures including the Yoruba, Dogon, and Bambara of the Upper Niger Valley.

buried her beside Samba Gana in his burial chamber.

Aiwel Longar and the Spear Masters
A Dinka Legend from the Upper Nile

In a time long ago, lions held great dances and often invited people to attend. One night a young man was in the middle of a rather wild dance when a lion decided that he liked the man's bracelet. The lion demanded that the man give it to him and, when he refused, the lion bit the man's thumb off and he quickly bled to death. The young man left behind an infant daughter but no son, which saddened his grieving young widow even more. When a river spirit found her weeping on the riverbank, he told her she would have a son if she rolled up her skirts and waded in the river.

What the river spirit had promised soon came true, and the woman named her new son Aiwel. The baby was born with a full set of teeth, a sure sign of spiritual power, and it was soon obvious he had other powers as well. One day his mother left Aiwel asleep on the floor in the care of his sister. When she returned home, the large gourd in which she kept his milk was empty. She punished her daughter for drinking it, but in fact it was the infant Aiwel who drank it, not the girl. When the same thing happened three days in a row, the mother became suspicious and only pretended to leave so she could spy on her son. When she caught him in the act, Aiwel warned her that if she told anyone about it she would die. But the woman just couldn't keep the secret and she soon died just as Aiwel had predicted.

After that, Aiwel left home and went to live with his father, the river spirit, where he stayed until he grew up. When he became a man the river spirit gave him a magnificent, multi-colored ox named Longar, and from that day on Aiwel's name became Aiwel Longar. He built

As in other world cultures, African trickster heroes such as Hare and Anansi the Spider often taught humans the crucial skills they needed to farm and raise cattle. This illustration depicts a Dinka cattle farm.

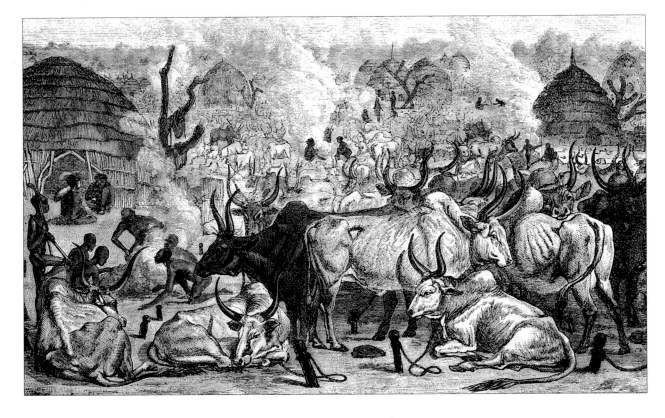

himself a house in the village and made a good living tending the cattle that had belonged to his mother's first husband (the unfortunate man who had been bitten by the lion).

One year there was a terrible drought and people had a difficult time finding enough grass and water to feed their cattle. Many of their animals became thin and died, but not Aiwel's; his cattle were fat and strong. Angry and resentful, a few of the villagers decided to spy on Aiwel and find out how he was feeding and watering his herd. They followed him to where some tufts of scraggly, long-rooted grass were growing. The grass didn't look like much, but when Aiwel pulled clumps of it up by the roots, there was water underneath. When Aiwel saw them spying on him, he warned the villagers not to tell his secret to anyone else or they would die. Of course, as soon as they returned to their village the men told everyone else about their discovery, and, of course, by the next day they were dead.

Aiwel Longar then had a talk with the village elders and advised the remaining people of the town to leave their land and follow him. He pointed out that their cattle were sure to die anyway and if they came with him he would take them to a sacred land of endless pastures, plenty of water, and no death. But the elders didn't believe him, so Aiwel set out alone, crossing great mountains and rivers on his journey.

In the end, a few brave villagers were willing to make the journey after all. To these few, Aiwel taught prayers and gave special fishing and war spears. He showed them the spiritual path. It was these trusted few, it is said, who became the first "spear masters," the elite clan of priests who, forever afterward, handed down their special powers and prayers to their children and to their children's children.

Kwasi Benefo's Journey to the Land of the Dead
An Ashanti Tale from Ghana

A long time ago there lived a young and prosperous Ashanti farmer named Kwasi Benefo who had flourishing fields and many cattle, but no wife to bear him children or care for his household. So Kwasi Benefo went looking for a wife. He soon fell in love with a village woman and they were married. They lived happily until one day his wife took ill and died. Grief-stricken, he dressed her in beads and a silk *amoise* (burial shroud) so she could be buried.

The Ashanti culture in the heart of Ghana's tropical rain forest has long been considered one of the best organized, most prosperous, and most influential cultures in Western Africa. It was traditionally the chief or odikro's job to preserve traditional myths and customs.

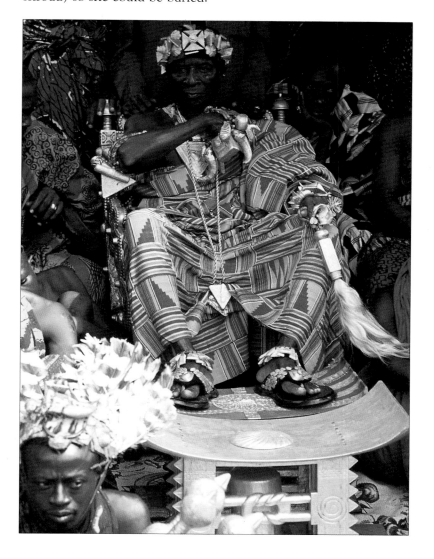

But Kwasi Benefo could not forget her. For a long time he missed her so much that his heart was no longer with the living. His brothers and friends implored him to go on with his life and find another woman to marry. At last, he did. They married and they too lived happy, contented lives until she became ill during her first pregnancy and died. He dressed his second wife in beads and a silk amoise and buried her.

Kwasi Benefo no longer wanted to live. For a long time, he would not even go out of his house. It took a long time for friends and family to convince him he should try to get over his

grieving and go on with his life. The family of his second wife were so saddened by his suffering that they offered him their only other daughter as a wife in consolation. After a while, Kwasi Benefo let himself be persuaded and he and the young woman were married. Soon he came to love his new wife as much as he had loved the first two. He returned to tending his fields and cattle and they lived contented, prosperous lives. When he and his third wife announced the birth of a baby boy a year later, the village celebrated with much dancing and singing. Life was good.

But one day when he was working out in his fields, people from the village came to him with terrible news. His wife had gone down to the river to fetch water, they said, and on the way back, as she stopped to rest, a tree suddenly fell over and killed her. Numb with grief, Kwasi Benefo dressed his wife in her burial garments. After the funeral, he abandoned his farm and went off to live a meager, miserable life in the bush, barely staying alive on roots and seeds. Years passed and he had been alone so long he nearly forgot his name. But little by little his grief subsided and the desire for life came back to him once again. He cleared some new fields and began to farm again. After a while he was again a prosperous farmer and began to yearn for a wife and children.

Kwasi Benefo married a fourth time. It was not long before this wife, too, took ill and died. Now he was beyond despair. That night he as he lay sleepless, the thought came to him that he should go to Asamado, the Land of the Dead, so he could be with the four young women he had loved. So he went to Nsamandow, the cemetery where his dead wives were buried, and from there groped his way through a pitch black, silent forest until he came to a dimly lit spot on

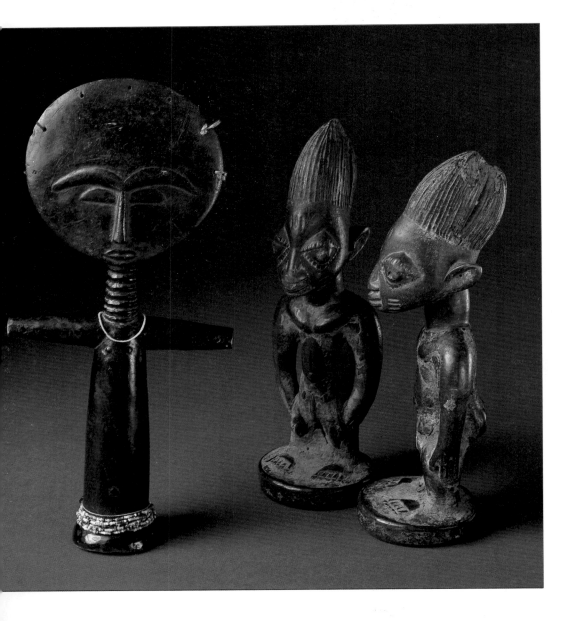

The akuaba, or wooden doll, on the left was carved in the image of the Ashanti moon goddess Nyame, a symbol of revered woman-hood and the fullness of life. The Yoruba ibeji figurines on the right represent twins, a favorite mythological theme of many African cultures.

a riverbank. On the far bank opposite him sat an old woman washing women's beads and burial amoises in a large brass pan. Kwasi knew at once she was Amokye, the welcomer of the souls of dead women to Asamado. The dead gave her their beads and burial shrouds when crossing the river.

Amokye told him to go away, that he was a living soul and therefore not allowed to pass to the other side. But when he told her the sad story about the deaths of his four beloved wives, she took pity on him and allowed him to cross just long enough to speak to their spirits. Kwasi Benefo crossed the river and walked until he came to a house where he heard his wives singing him a song of welcome. Since they were invisible, he could not see them, but as they prepared him dinner and laid it on the table before him, they soothed him with their gentle and loving voices. They sang to him of how much they loved him and what a good and kind husband he had been to each of them. Then they told him that one day, after he died, they would all be together in this spirit world, but that now he had to return to the world and go on living. They advised him to get married yet one more time, promising that this time his wife would not die. Hearing those sweet words from the women he loved, Kwasi Benefo lay down and fell into a deep sleep.

When he awoke he was no longer in the land of Asamado but in the forest. He made his way back to the village and began to rebuild his house and fields. Not long after that he met a young woman from a neighboring village and asked her to marry him. Kwasi Benefo and his new wife had many children and lived a long and happy life.

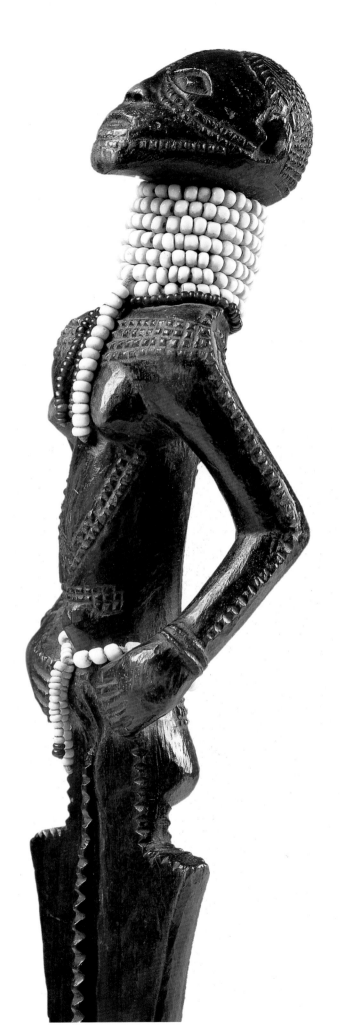

The Dogon artists of Mali, in western Africa, have long been famous for their carved wooden sculptures of mythological female figures known as tellem.

Heroes of Central and South American Mythology

It's believed that the peoples who settled the Americas are the descendants of groups who migrated across the Bering Strait more than 30,000 years ago. They spread south and east across the North American continent, eventually pushing their way down through Mexico and Central and South America until they reached Tierra del Fuego.

Many of the groups remained small communities of hunters, fishermen and food gatherers. Their relatively simple cultures developed mythologies with local, mostly human characters. The stories often concerned themselves with rites of passage such as birth, reaching puberty, marriage, and death. But a few of the groups, like the Aztecs, Mayans, Toltecs, Olmecs, and Incas, developed highly organized cultures with complex mythologies.

Whether simple or complex, almost all the cultures had some mythological themes in common. For example, most worshipped the sun, most had myths that told of a great and devastating flood, and many revered the jaguar as a powerful mythological figure.

 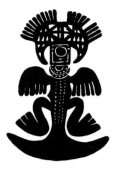

The Flight of Quetzalcoatl
An Aztec Legend from Mexico

Quetzalcoatl, the "feathered serpent," was both a god and a hero to people in parts of Mexico and Central America for many centuries. Legend has it that he was the one who taught people the fine arts of smelting silver and setting precious stones, sculpting statues, and writing in books with hieroglyphics. He taught them how to keep accurate clocks and calendars by studying the sun and the planets and how to build magnificent temples. He was also the one who taught people about *maize* (corn).

The Aztec hero Quetzalcoatl was depicted not only as the feathered or plumed serpent god shown in this codex, but as the wind god Ehecatl, the benevolent god of learning and crafts, and the god of twins.

The story goes that when Quetzalcoatl first arrived, the people were half starved because they only had roots to eat. Quetzalcoatl turned himself into a black ant to burrow into the mountainside where maize was hidden and then laboriously dragged the kernels back to the villagers so they would have crops to grow and food to eat.

But of all the arts he taught his people, one in particular was lacking. He refused to teach them the art of war. While other peoples in Mexico and Central America were making bloody sacrifices to the gods by tearing out the hearts of living men and women, Quetzalcoatl wanted only offerings of bread, flowers, perfumes, and butterflies. There are stories that tell how demons tried repeatedly to trick him, even getting him drunk, so that he would declare war on neighboring civilizations and order human sacrifices. But he never yielded or consented because he loved his people too much to put them in jeopardy.

Quetzalcoatl dressed in the magnificent plumage of colorful bird feathers and lived in a huge silver and gold house set with precious stones as bright and colorful as himself. He kept flocks of beautiful birds around his house that

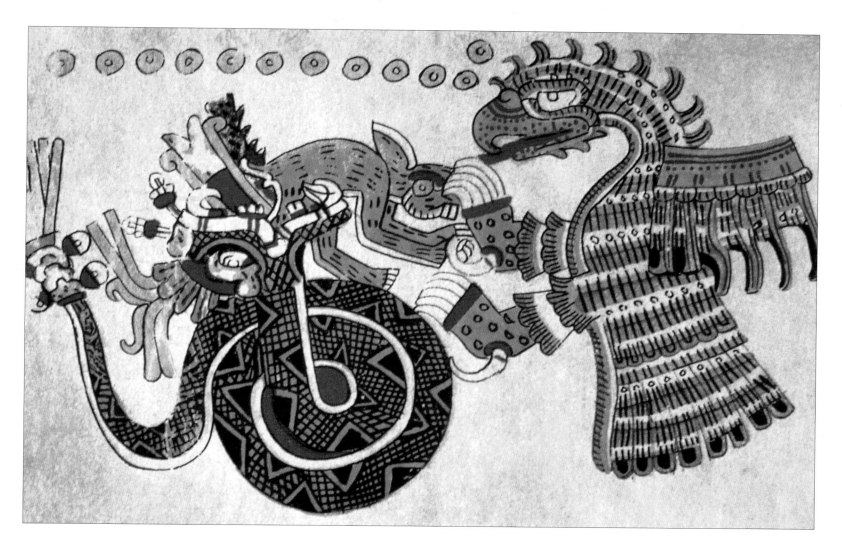

filled the air for miles around with their sweet songs. Quetzalcoatl's house stood on the outskirts of Tollan, overlooking maize fields where the stalks grew so big that a man could only carry one cob at a time. And there were astonishing cotton fields where the cotton grew thick and fluffy and was already colored in vibrant shades of red, yellow, blue, and black, so that no one had to dye the cotton before making it into cloth. Inside the house were many fiercely loyal dwarves who attended Quetzalcoatl.

Because of Quetzalcoatl, the people were prosperous and happy. Life was good for a long time—that is, until the day that Tezcatlipoca showed up. Tezcatlipoca was an evil sorcerer who wandered all over the earth stirring up strife and

war among men, getting them to kill each other and destroy the countryside. Now he was after the peace-loving god-king Quetzalcoatl.

Tezcatlipoca was crafty and his ways were often subtle. First he frightened everyone in the city by causing thick spiderwebs to descend upon it. Then he rode down from the mountain on a blast of wind so cold that all the bright flowers shriveled up and died. When Quetzalcoatl felt the coldness, he knew it meant that Tezcatlipoca was out to get him; he told his servants that it would be better if he left before all of Tollan was destroyed. After all, it wasn't the people of Tollan that Tezcatlipoca was really after.

His servants watched in despair as Quetzalcoatl burned down his silver and gold

Here Quetzalcoatl personified as an eagle joins the figure of Quetzalcoatl as a feathered snake to depict the rising morning star, the planet Venus.

house with all the precious stones. Suddenly, Tezcatlipoca appeared beside him and challenged Quetzalcoatl to a ball game. All the people of Tollan came to the stadium to watch the game, the object of which was to score points by successfully throwing a large ball through a ring mounted high on one wall of the court.

No one really expected Tezcatlipoca to play fair. As Quetzalcoatl caught the ball and turned to shoot it up at the ring, Tezcatlipoca transformed himself into a vicious jaguar and sprang at him.

Quetzalcoatl fled the stadium, running as fast as he could with Tezcatlipoca hot on his heels. The jaguar chased him through the streets of the city and out into the countryside before he lost him in the maize fields. But Quetzalcoatl knew he had to keep running if he wanted to stay alive.

Quetzalcoatl's loyal dwarves knew their master was no longer a young man and that the running would soon exhaust him. They knew where he would be hiding and ran to join him. The dwarves guarded Quetzalcoatl as he rested, and when he went on, they played music on their flutes to give him heart. Even so, whenever he looked back at Tollan in the valley below, he wept with grief.

There were two mountains Quetzalcoatl had to cross if he hoped to escape: the Fire Mountain and the Mountain of Snow. He and his followers managed to make it across the Fire Mountain, but the Mountain of Snow was so bitterly cold that all of his dwarves died. Brokenhearted, Quetzalcoatl stood on the mountaintop for hours wailing a sad song of bereavement for his noble friends.

He descended the other side of the Mountain of Snow alone and made his way, finally, to the seashore. One version of the legend says that here he made a raft of snakes and sailed out to sea until he came to the Land of Tlappallan in the Country of the Sun, where he found the Water of Immortality. The legend prophesied that he would return someday as a magnificent young warrior.

Another version tells how some of the dwarves survived the Mountain of Snow after all and reached the seashore with him. There Quetzalcoatl dressed himself in his best robes and feathers and asked his loyal servants to build him a funeral pyre, upon which he threw himself and was consumed in flames. They say that a flock of birds flew into the fire and rescued Quetzalcoatl's heart. They took it high up into the heavens where he was reborn as the planet Venus. If you look hard into the night sky, you can see still see him sitting upon his throne.

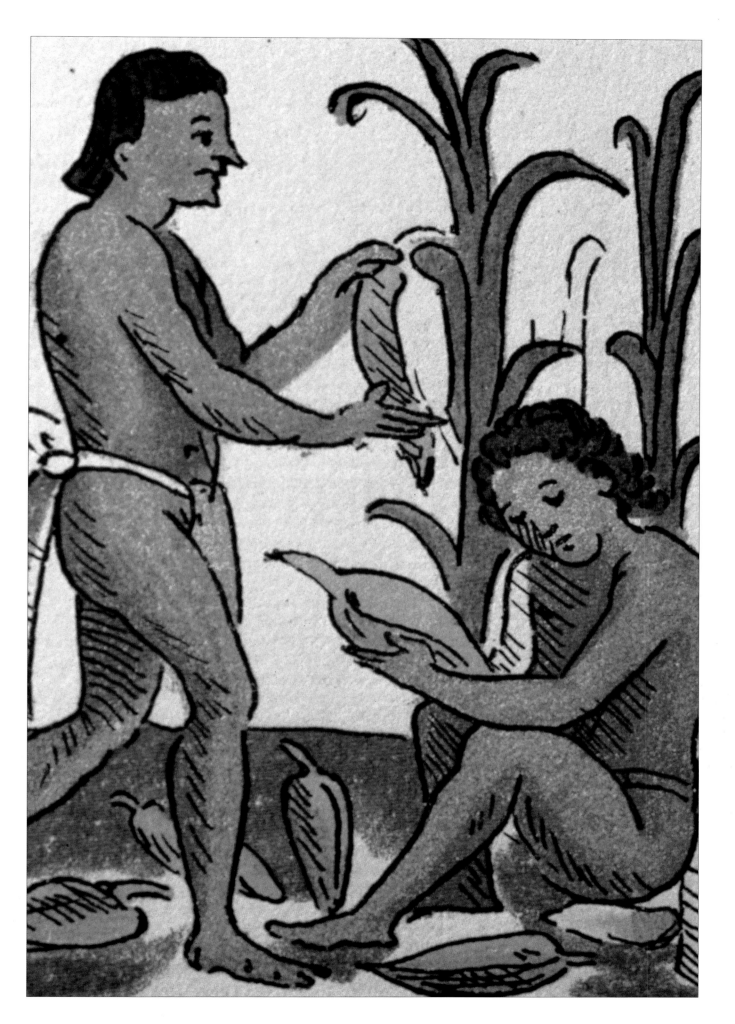

Quetzalcoatl, from the city of Tula in the twelfth century. As for the mystical prophecy that Quetzalcoatl would someday return, the belief was so strong that when the first Spaniard, Hernán Cortés, landed in 1519, the Aztecs believed that he was their returning hero and therefore did not defend themselves against the Spanish onslaught until it was too late. It's hard to blame them. The conquistador Cortés not only fit the description of their light-skinned, resplendent god-king, he arrived on the exact calendar day of Quetzalcoatl's birth, the date of the prophesied return.

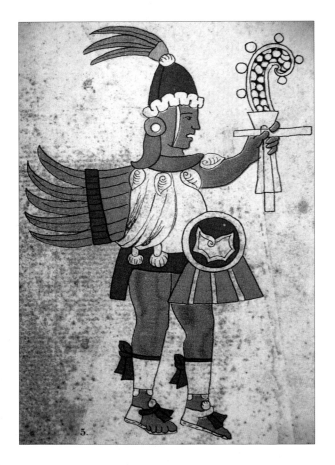

Anthropologists continue to search for the origins of the Quetzalcoatl myth— are the myths based on the story of a real man?

The Twins of Popol Vuh
A Mayan Tale from Mexico

God or Human?

The god-king Quetzalcoatl was worshiped in Mexico as early as A.D. 300 and over the centuries was adopted by both the Aztec and the Mayan cultures. But historians have had a hard time separating myth from fact. The Quetzalcoatl legends are often confusing because the name Quetzalcoatl was adopted over the centuries by several actual human rulers and many of their heroic exploits are interwoven into the god myths. For example, historians believe that the myth of Quetzalcoatl's flight and disappearance from Mexico probably refers to a real event, the driving out of a priest-king who was actually named Topiltzin, but who called himself

According to the ancient *Popol Vuh* or "council book" (which was first transcribed from hieroglyphics into Spanish in the sixteenth century by a Spanish friar) the gods made the earth with its land masses and bodies of water, then created plant life to cover it. At this point, there was still no sun; the only light came from the glow of the spirit powers within the water. The gods decided that they needed creatures on earth who would worship them, so they created mammals and birds. But instead of reciting prayers, all these animals did was hiss, bark, and cackle. So the gods decided to create humans.

The first time they used clay, but that was a disaster. Not only were these creatures soft and mindless, but they couldn't stand and they dissolved too easily in water. Next the gods tried wood. That was a little better because the men

they formed could talk and multiply, but had neither souls nor minds. They immediately forgot all about their creators and started crawling around on all fours. These wooden men treated everything around them, including their dogs, so badly that the gods sent a great flood to destroy them. When that didn't work, they turned them into monkeys.

While the gods were figuring out what to try next, a dangerous and quite conceited impostor god appeared who claimed to be the sun, the light, and the moon all rolled into one. He was a giant with a gaudy, glittering face of silver and emeralds who called himself Gukup-Caquix. Sitting on his silver throne, he claimed to be so beautiful and so powerful that the whole earth actually lit up in his presence. (In reality he was an ugly and clumsy oaf.) It became obvious to the gods that before they could devote any more time to creating humans, they had to get rid of this intruder.

It was the twin-heroes Hunapú and Ixbalanqué who waged the war against Gukup-Caquix and finally defeated him. After spying on him for a while, the twins realized that the giant's weakness was food, especially the fruit of a certain tree. So they hid themselves in the forest and when the giant came for his daily meal, they shot him with arrows. Before he died, however, Gukup-Caquix managed to crawl home and tell his two sons, Zipacna and Caprakan, what had happened.

Zipacna and Caprakan demanded revenge for their father's death, and they turned out to be every bit as evil and intimidating as their father had been. Among their many heinous deeds was intoxicating four hundred young warriors and then crushing them to death—they did this just for the fun of it.

First the twins went after Zipacna. Just like his gluttonous father, Zipacna's weakness was food, and his special passion was hunting along the riverbanks for crabs; so the twins tied a long string to a fake crab and placed the crab at the entrance to a nearby cave. After luring Zipacna into the cave, they caved in the mountain and crushed him. The twins also used the food approach to kill Zipacna's brother, Caprakan. His weakness was succulent, golden-brown birds roasting on a spit. Unfortunately for him, he didn't realize until it was too late that

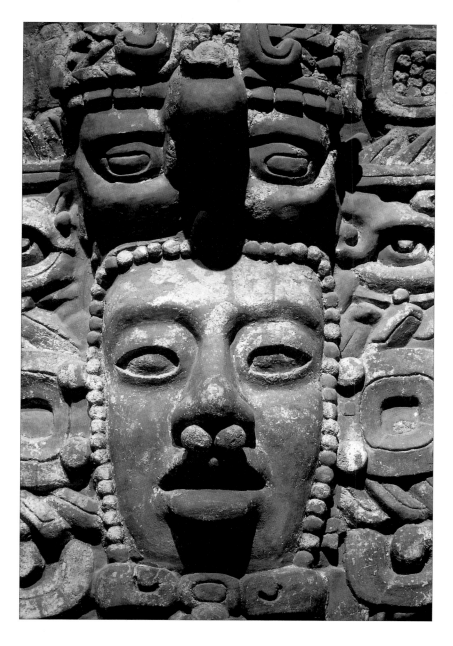

The Mayan sun god, Ahau Kin, was portrayed as both young and old. Between sunset and sunrise it was believed he journeyed through the underworld as the Jaguar God.

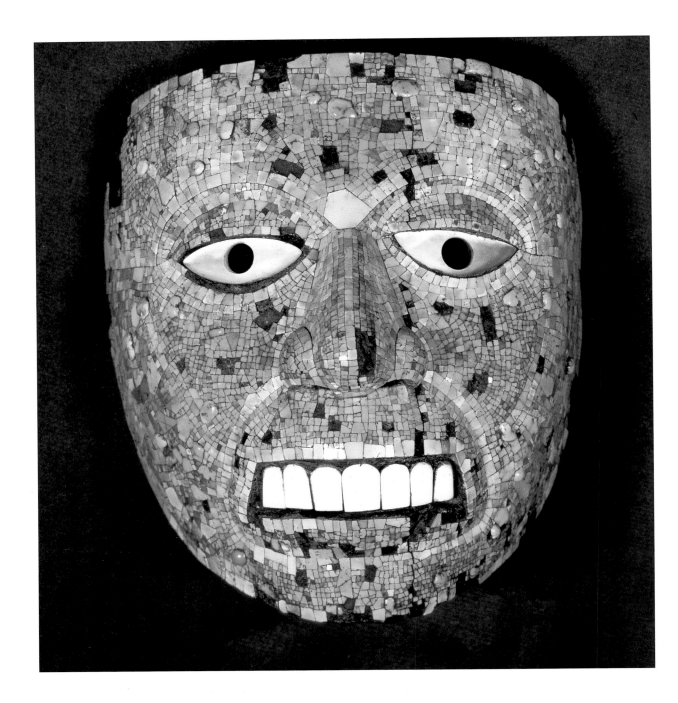

This Aztec mosaic mask represents the god Quetzalcoatl.

the twins had basted the birds with poison.

According to the *Popol Vuh*, the twins Hunapú and Ixbalanqué went on to have a number of heroic adventures in which they fought evil and avenged wrongs. By far the most famous and exciting of these exploits was their final victory—the day they defeated the gods of the underworld in a ball game.

Actually, it had all started many years before when the twin's father, Hun-Hunapú, had

been lured to the underworld to play ball. The Xibalba, the lords of the underworld, had not only beaten him, they had cut off his head and hung it on a calabash tree as a warning to anyone else who might be brash enough to challenge them.

Hunapú and Ixbalanqué believed it was their duty to go down to the underworld and avenge their father's death; the best way to do that was to challenge the Xibalba to another ball

game. The lords of the underworld accepted the challenge, but only on the condition that the twins first be subjected to a series of trials to prove their skill and courage.

They survived the first night in the pitch-black House of Gloom, mainly because they resisted the temptation to light the "cigars" they had been given. The next night they were shut up in the House of Knives, not only did they survive, they talked the knives and some friendly ants into cutting a bouquet of flowers which they gave to their captors the next morning. The next night, they lit fires to survive the House of Cold, and the night after that, fed magic bones to the hideous animals in the House of Jaguars to keep from being eaten alive. They even managed to live through their night in the House of Fire.

But they weren't quite so lucky when they reached the final trial, a night in the House of Bats. Here Hunapú was decapitated by one of the bats. Nevertheless, his twin Ixbalanqué managed to charm some of the other creatures living in the House of Bats, and convinced a turtle to climb up on his twin's shoulders and disguise himself as Hunapú's head so it would look as though he had never been decapitated. Then the brave brothers set off for the ball court to play the match as planned.

It was a very odd game. The twins pretended to play ball with the evil Xibalba as if nothing was wrong, even though the gods had suspended Hunapú's real head over the ball court with a rope. As the game got underway, one of the gods threw the ball at the head, but it bounced off into a corner where it startled a rabbit out of its hole. The gods were momentarily distracted by the rabbit and didn't notice how Ixbalanqué grabbed Hunapú's suspended head and swapped it with the turtle perched on Hunapú's shoulders.

The head reattached itself instantly and Hunapú was as good as new.

When the Xibalba realized what had happened they were dumbfounded at the power the twins had to repair themselves after they had been cut up. Obsessed with acquiring their secret ability, the gods asked the twins to perform on them too, so they could see how it was done. The twins gladly obliged them—except for one small detail. After they dismembered the Xibalba, they didn't bother to put them back together again.

In honor of their tremendous victory over the evil underworld, Hunapú and Ixbalanqué were reborn as the Sun and Moon and have bathed the new earthly world in light ever since.

Twins in Mythology

Humans were fascinated with twin births long before they developed religions. In the earliest cultures, the birth of twins was considered a very bad omen, and the faster the babies were killed, the better. A twin birth might foretell the coming of a famine (symbolic of too many mouths to feed and not enough food), for example, or be a sign from the gods that the parents had, perhaps unknowingly, violated strict tribal taboos and therefore should be punished.

But as cultures advanced, the custom of killing twins stopped and instead twins became much-revered symbols of fertility. Almost every culture in the world has at least one twin-heroes myth, including the Aztecs, Zunis, Ashantis, and Babylonians. The Greeks have Castor and Pollux as well as Helen and Clytemnestra; the Romans

have Romulus and Remus. Early Egyptians and Ugandans believed the placenta was an incomplete twin that possessed a soul and was to be given a burial and treated with special respect. Some Native American cultures in the northwest United States have myths that tell how twins are actually salmon in human disguise.

In many cultures, the twins are both heroes, but in some, they are rivals. In some Iroquois legends, for example, one twin is a hero but the other is an evil trickster. Feuding twins who appear in the Bible include Jacob and Esau (twin sons of Isaac and Rebekah who even fought over who would be born first), and Jacob's fighting grandsons, Pharez and Zarah.

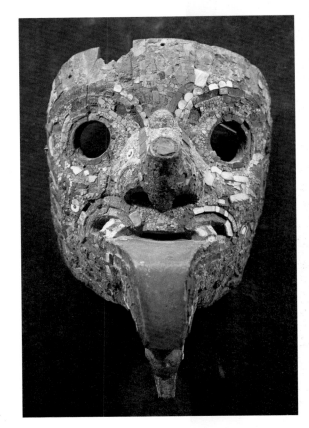

This Aztec mask represents Quetzalcoatl's evil twin named Xolotl, who tried to destroy the human race by collecting the bones of those who died from the underworld.

In Mexican and Central and South American cultures, doubleness in nature was often interpreted as a manifestation of the supernatural or as a divine intervention by the gods, which is why many of the Incan, Aztec, and Mayan gods (such as Quetzalcoatl) were twins or superhuman twins. They usually played the roles of warriors, builders, healers, or fertility symbols, and they were often the offspring of air, water, or thunder. Peruvian Indians once revered twin gods Apocatequil and Piquerao and believed they were responsible for thunder and lightning.

The Tauma Indians of Guyana have legends of twin heroes named Tuminikar and Duid. Tuminikar is the good and wise twin who does good deeds to help mankind, while his brother Duid is an idler who constantly plays tricks on him and tries to undo his good efforts.

In the Greater Antilles, the Taino Indians have an intriguing twin legend called the *Four Twins of One Birth* in which the four heroes have a number of cosmic adventures before settling down and creating mankind. The first man actually emerges from a neck tumor that one of the four twins develops after an old fisherman spits tobacco on him.

Another people whose legends attribute the creation of mankind to twin heroes are the Bakari Indians of Brazil. In addition to making the first men, the twins Keri and Kame also stole feather balls from a vulture and turned them into the sun and moon. They gave humans the gift of sleep by stealing a lizard's eyelids.

Another twin-heroes myth, this one from the Cariban cultures of the northern Venezuelan rain forests, is the *Cycle of the Twin Heroes.* Here the twin boys Shikiemona and Iureke steal fire from the Toad-Woman (by slitting her throat and letting it gush up from her belly where she kept it hidden) and then hide it in the wishu and kumnuatte trees for humans to find.

Even the Great Feathered Serpent Quetzalcoatl had a twin, the dog-headed god Xolotl. It is said that after the first humans had been wiped out in the four cosmic upheavals, the twin bothers descended to Mictlan (the underworld) to collect the human bones so they could resurrect them. But when they were fleeing from the Death Lord, they dropped the bones and they shattered. Picking up the pieces, Quetzalcoatl escaped and took them to the earth goddess Cihuacoatl (Snake Woman) who ground them into meal. Quetzalcoatl sprinkled his own blood on the meal and re-created the human race.

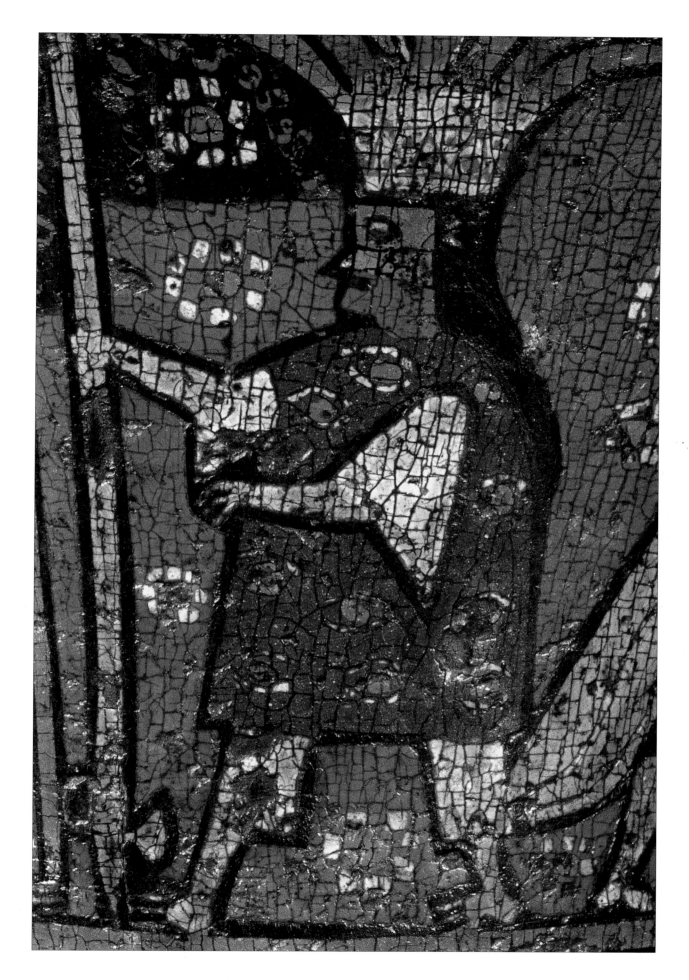

By the time of the Spanish conquest in 1532, the Inca emperor ruled a remarkably advanced empire that extended along the Andes and Pacific Coast from the northern border of present-day Ecuador in the north to central Chile in the south.

El Dorado—The Kingdom of the Gilded Man
An Incan Legend from the Colombian Highlands

In parts of Mexico and Central and South America, people still whisper the legends of El Dorado, a mysterious country somewhere on the continent whose cities were paved with gold. The land was named El Dorado, or "gilded man," after its fabled priest-kings who were said to be covered from head to toe with gold dust. They and their country have eluded explorers for centuries.

Although later adopted by the Aztec, Mayan, and especially Incan cultures, the legend of El Dorado probably originated among the Chibcha Indians who inhabited the highlands around present-day Bogota, Colombia.

According to the story, El Dorado is such a wealthy country that not only are its streets paved with gold, but all the buildings in each of the cities are encrusted with emeralds and other

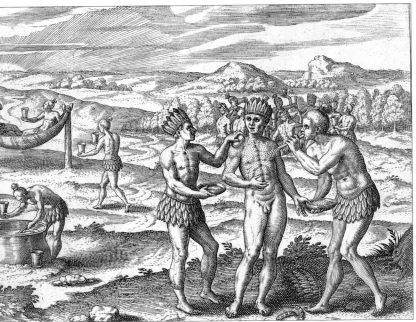

It is said that the priest-kings of the fabled country of El Dorado were so wealthy they had their subjects smear them with resin and then gild them from head to toe in gold dust.

precious stones. In spite of their wealth, however, the people of El Dorado are a spiritual people, and each new warrior who becomes the priest-king of El Dorado has to follow a strict traditional daily ritual.

Every morning, the king's attendants anoint their ruler by smearing his body with resin and then blowing gold dust all over him through a tube. The king then goes about his daily business completely gilded with gold. In the evening, the king's attendants take him out on a fantastically decorated raft to the middle of sacred Lake Guatavita, where he dives into the water and washes off the gold as an offering to the gods. Meanwhile, all of the people lined up on shore throw their own offerings of gold and gems into the water.

The Spanish, who conquered the rich cities of the Incas and the Aztecs in the sixteenth century, became obsessed with the legend of El Dorado and went to great lengths to find the country and its gilded rulers. Many of the Spanish conquistadors, including Gonzalo Pizarro (brother of the man who conquered the Incas), spent years cutting through the pathless jungles and fevered swamps of the Amazon River valley in a vain search. Thousands of men died on these fruitless expeditions; hundreds of others contracted leprosy.

In 1569, a Spanish conquistador named Gonzalo Ximenes Quesada found what he believed to be the fabled Lake Guatavita in the mountain highlands of Colombia. He tortured several local Chibcha chieftains over a slow fire to find out where they were hiding their gilded priest-king—but with no success. Since then, countless explorers of every possible nationality have searched not only South America, but also Central America, Mexico, and even parts of the southwestern United States for the legendary land of El Dorado. In 1913, a British company even tried draining the lake Quesada in a fruitless effort to get at the riches they were convinced were at its bottom.

his journey, and some magic leaves to ward off sickness and evil spirits.

With much excitement, Alcavilu waved goodbye to his father and set off alone on his journey. He rode through broad valleys and crossed bubbling streams until he came to a deep forest where he stopped to take his meal. Thinking he had to be the only person within hundreds of miles, Alcavilu was startled to hear the voice of an old man behind him, bidding him good day. The old man was dressed in such ragged garments that he shivered from the cold. Alcavilu quickly wrapped the old man in his blanket and offered him food.

After they had finished eating, the old man sat a long time without speaking, then told Alcavilu that he had looked into the boy's future and could foresee that he would have many strange adventures before returning home to his father—and that he would not return from his journey alone.

When the old man got up to leave, Alcavilu insisted that he take the horse with the silver saddle and a blanket because he obviously needed them more than Alcavilu would. In gratitude for his kindness, the old man gave Alcavilu a small, green magic leaf that gave the person who chewed it the power to understand the language of animals and birds. The boy thanked him and they went their separate ways.

Alcavilu set off on foot chewing the old man's magic leaf. He slept in the forest that night and, when he awoke, he saw a lion stretched out nearby. The lion spoke softly to

In Inca myths, a hero's journey often took him over the perilous and starkly beautiful Andes mountains.

The Strange Adventures of Alcavilu
A Tale Told by the Araucanian Indians of Chile

Alcavilu, the handsome son of a chieftain, was noble and wise even as a child. One day, when he was about sixteen, Alcavilu told his father that he longed to take a journey and find out what was beyond the great mountains that encircled their village. The chieftain was sad to see his son go, but gave him his blessing nevertheless. He also gave Alcavilu a fine horse with a silver saddle, a deerskin sack filled with food for

him in a language the astonished Alcavilu could understand, saying that an old man had asked him to protect the boy as he journeyed through the forest. The lion then plucked a pure white hair from his chest and gave it to Alcavilu. He told him it was a magic hair, and that it would give Alcavilu the power to change himself into any bird or animal or to fly anywhere he wished in the world.

After he left the forest, Alcavilu held the pure white hair tightly in his fist, closed his eyes, and wished that he could go to some wondrous place he had never before visited. All of a sudden, he was standing on the rim of a great volcano. Loud roars and tremendous billows of smoke belched forth menacingly from the volcano's mouth. Alcavilu was amazed to see a cottage up there, and even more amazed to see a pale young girl standing in the doorway. "Run for your life!" she screamed. "If Cherufe, the god of the volcano, wakes up and finds you here, he will throw you into the crater!" When Alcavilu demanded to know why she didn't run away herself, she told him she was Cherufe's servant and had no choice but to stay. She pleaded with him to leave until he finally turned himself into a bird and flew away.

Alcavilu flew for many hours until he finally saw a small house in a meadow. He perched for a moment on a plant outside its door and was so tired that he fell fast asleep. The next thing he knew, a young girl had picked him up lovingly and put him in a cage in the kitchen to keep her company while her father and brothers worked out in the field. Every time she passed the cage, she whispered to her new pet, "I love you." The girl's name was Kallfury and she was so kind and so beautiful that Alcavilu immediately fell in love with her.

Later, when her father and brothers came in from the fields and sat down to dinner, Alcavilu could smell the delicious dinner that Kallfury had cooked and longed to join them at their table. That night he had an idea. First he turned himself into a tiny black ant to escape the

cage, then he turned himself back into a boy. He went to the cupboard and was just about to take a bite out of a piece of juicy leftover meat when the girl's father woke up and caught him. In seconds, the whole family was awake and demanding to know who he was and what he was doing there.

Alcavilu told them the whole story, and when he got to the part about the cabin at the mouth of the volcano, the father exclaimed that the girl he saw must be his long-lost other

above
Pipe and flute music and ceremonial dance still play an important part in the myth and ritual of Peruvian culture.

opposite
The Inca emperors built a vast system of roads to be used only by their powerful military force to control the empire. Warriors like the one in this painting were important members of the Inca culture.

Heroes of Central and South American Mythology **149**

daughter, Murtilla, who had been stolen by the volcano god months before and then hidden away where no one could find her. Alcavilu immediately volunteered to rescue her.

He changed himself back into a bird and flew off to the volcano, where he turned into a boy again just long enough to advise Murtilla of his plan. He told her that as soon as he turned himself into a lion, she was to climb on his back and hang onto his mane as hard as she could, no matter what happened. She obeyed him without a word. They could hear Cherufe snoring from inside the volcano as they fled.

When Alcavilu brought Murtilla back to her home, there was great rejoicing. The grateful father, however, was distraught because he was too poor to give Alcavilu the reward he so richly deserved. "There is only one gift I long to have," said Alcavilu, "and that is your daughter Kallfury's hand in marriage. I love her with all my heart!" Overjoyed, Kallfury rushed to her father's side and assured him that she had loved Alcavilu even when he was a bird.

Just then, they all heard a horse neighing in front of the cottage. It was the old man from the forest, returning Alcavilu's horse and blanket. In thanks, he had filled the saddlebags with gold and precious stones because he had known that Alcavilu would be needing a wedding present.

Alcavilu and Kallfury rode the horse back to his father's kingdom where the chieftain greeted them both with open arms. He gave them a magnificent wedding and many years later, when he died and Alcavilu took his place as ruler, he and Kallfury ruled the kingdom wisely and kindly for many long years.

When the Spanish conquered the Incas in 1532, Catholic priests tried to suppress what they saw as native paganism. In most cases, the Incas either continued to practice their old beliefs or adopted a form of Catholicism that incorporated many of their old gods and spirits.

Using myths for political power

In large cultures such as the Inca and Aztec, rulers used mythology to reinforce their power over the people they conquered. Claiming to be gods themselves, or the descendants of gods, these rulers used often used existing myths and religious beliefs to justify the use of human sacrifice, which proved to be a very formidable and persuasive political tool.

Sometimes larger cultures like the Aztecs merged the beliefs of the people they conquered with their own, creating an even more complex mythology with hundreds of different gods. The most important and powerful of these gods had names like Tlaoc, Tezcatlipoca, Xipe Totec, Huitzilopochtli, and Quetzalcoatl.

In the isolated hunting and fishing communities of the Amazon basin in South America, it was often the shamans or medicine men who used myths for political power. People believed in a spirit world teeming with ogres, demons, and powerful spirits who could make both good and terrible things happen to people. They also believed it was only the shamans who had the special knowledge to communicate with those spirits—and thereby protect the people—through elaborate rituals.

Botoque Steals Fire from Jaguar's Wife

A Kayapo Tale from the Rain Forests of Brazil

In the beginning, because people did not possess fire, they had to eat their vegetables raw and warm their pieces of meat on rocks in the hot sun. One day a boy named Botoque and his older brother-in-law were out hunting for food when they spotted a macaw's nest high on a cliff. They quickly made a makeshift ladder out of some branches and vines and Botoque climbed up and reached the nest. In it he found two large eggs, which he carefully threw down to his brother-in-law; but on the way down, the eggs turned into stones and broke the young man's hands when he tried to catch them. Botoque's brother-in-law was so angry that he pushed away the ladder and left Botoque stranded on the cliff.

Botoque was up there many days before he finally saw a jaguar carrying a bow and arrow along with a pack full of game he had caught. The jaguar didn't see Botoque, but did see his shadow on the ground. Thinking it was some kind of animal, the jaguar pounced on the shadow before he realized his mistake. Feeling a little foolish and also taking pity on the stranded boy, the jaguar promised he wouldn't eat him and said he instead wanted to adopt him as a son. Botoque agreed, and the jaguar set the ladder back against the cliff so that the boy could climb back down.

The jaguar sincerely liked Botoque and gladly took him into his home, where the boy saw fire for the first time and ate the delicious meat that had been cooked over it. The jaguar's wife, however, was not so friendly. She hated Botoque, and whenever the jaguar was off hunting, she refused to give Botoque any of the meat she was roasting. One day she bared her claws so threateningly that Botoque fled and hid up in a nearby tree.

Although the jaguar scolded his wife and demanded that she treat Botoque better, she ignored his warnings and, as the days passed, became ever more hostile toward the boy. Finally, out of concern for the boy's life, the jaguar showed Botoque how to make a bow and arrow and how to use it to defend him The next tim jaguar's wife threatened th boy with her claws, he kill Then, horrified at what he had done, he grabbed the cooked meat, wrapped a burning ember from the fire in a deer pelt, and fled back to his own village.

When the men in the village saw the strange and wonderful things Botoque had brought back with him—the bow and arrows, the cooked meat, and the fire—they rushed out to the jaguar's house to steal some for themselves. Legend has it that the jaguar was so hurt and angry at the boy's ingratitude that he vowed to eat his food raw from then on, and to hunt only with his fangs and claws. To this day, if you look into a jaguar's mirror-like eyes, you can see the reflection of the fire he lost so very long ago.

Jaguar cults were popular throughout South America but especially in the Amazon basin. Shamans claimed they could magically transform themselves into these powerful predators to divine the future, bring death and destruction to their enemies, and protect villages from evil spirits.

CANADA

Great
Plains

UNITED STATES
of
AMERICA

Mississip

Chapter 9

Heroes of Native North American Mythology

It's believed that the native peoples of North America migrated across the Bering Strait from Siberia more than 30,000 years ago. They spread south and eastward in small groups across the continent, with each group adapting to the particular area in which it settled. Some developed agricultural societies, some had cultures based on hunting or fishing. By the time the first Europeans arrived in the fifteenth century, there were more than five hundred unique cultures on the North American continent, each with its own language and mythological traditions.

Some basic themes were common to most or all of these many cultures. Almost all had myths that explained how the earth was created and where people came from. Animals who could change into human form whenever they chose often played an important part in these stories— trickster heroes who gave humans their laws and traditions or taught them skills such as weaving or planting corn.

Native Americans did not traditionally write down their myths, but passed them on by word of mouth. Certain members of the community were chosen as storytellers, often as much for their excellent memories as for their ability to tell good stories.

Coyote and the Giant
A Navajo Hero Legend

Coyote is one of the most loved and famous Native American cultural heroes and he can be found in the legends of Indian cultures throughout the Southwest, the West, and the Central Plains. In some, he is portrayed as a creator or a sorcerer, while in others he's a hero, a trickster,

right
According to the sacred teachings of the Navajo, or Diné, as they call themselves, when a person becomes ill, he or she is out of harmony with the universe. As part of the healing process, a Singer or medicine man may create a ceremonial sand painting near the patient using the sacred colors of white, yellow, black, blue, and red.

opposite
Because many Native American peoples in the Southwest depended on the cultivation of maize (corn) for food, hero myths were often about tricksters like Coyote who showed people how to raise and harvest it.

or even a lover. In the following Navajo myth, Coyote plays the trickster hero.

A very long time ago there were huge, evil giants who roamed the earth looking for little children to eat. One day, Coyote saw one of the giants skulking around the edge of a small village and decided he was going to teach him a lesson. Knowing how incredibly stupid these monsters were, Coyote convinced the giant that if he wanted a keen mind and the power to perform the magic that he himself had, he needed to take sweat baths. Coyote even offered to help build him his own sweat lodge.

After the lodge was built, Coyote and the giant heated large rocks and filled the interior with steam until it was hot enough for a good sweat bath. As he and the giant sat in the dark lodge, Coyote announced that he would demonstrate some of his magic. He would break his own leg, he said, and then instantly mend it again.

What they giant didn't know was that Coyote had hidden an unskinned deer leg in the back of the lodge when he wasn't looking. In the steamy darkness, Coyote took a rock and smashed the deer leg with a loud crack and then let the giant feel the skin and bone where it was broken. The giant was completely fooled—and very impressed.

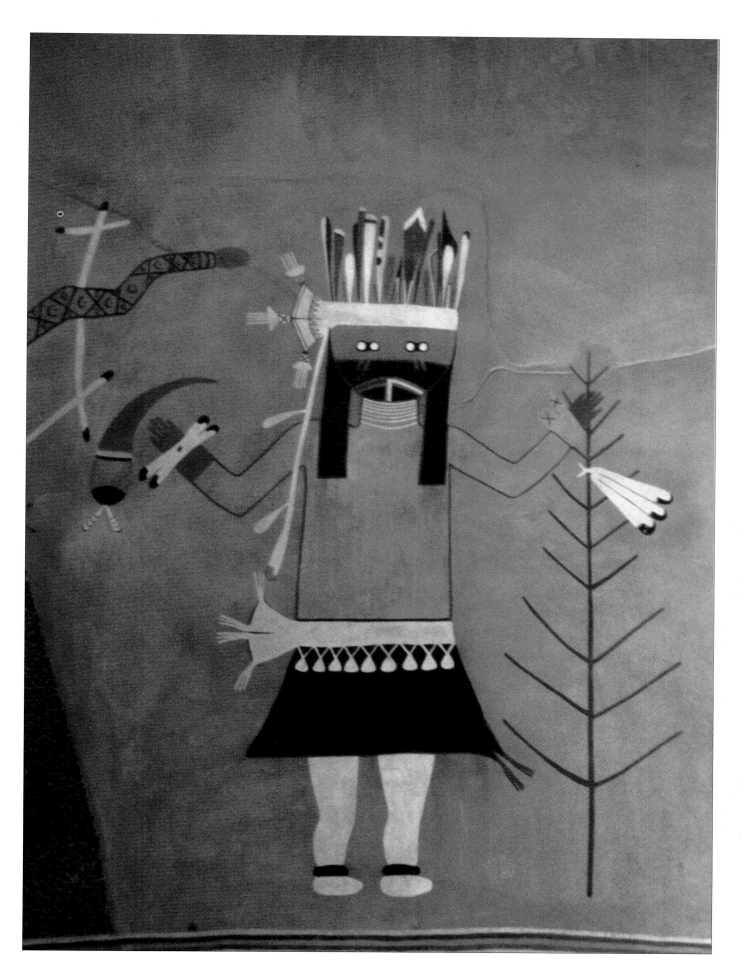

Then Coyote spat on the leg and cried out, "Leg, be whole again!" When the giant reached over and felt Coyote's real leg, he was astounded to find it whole and unbroken.

Coyote offered to repeat the miracle on the giant's leg, and the monster readily agreed. But as soon as Coyote started smashing his leg with the rock, the giant was screaming in agony. Coyote comforted him by pointing out that all the giant had to do to mend it was to spit on it. Well, the giant spat until his mouth was dry and he had nothing more to spit, but still the leg refused to mend. The pain became unbearable and finally the monster begged Coyote for help. "Just keep spitting," Coyote reassured him as he slipped out of the sweat lodge. It would be a long time before that evil giant could chase after little children again.

The Warrior Maiden
The Legend of an Oneida Heroine

Long ago, before the white man came to North America, the Oneida were constantly beset upon by their old enemies, the neighboring Mingoe. It was a terrible time: Mingoe warriors attacked the Oneida villages, set fire to their longhouses, and destroyed their cornfields. They killed all the men and boys they could find and abducted the women and girls.

The Oneida were so outnumbered that those who survived deserted their villages and fled through the forests up to the rocks and caves of the surrounding mountains. There, they were faced with a terrible dilemma: they could stay where they were and die of starvation, or they could creep down to the forest to search for food and almost certainly be caught and killed by Mingoe warriors. The tribal elders called a council out on a large cliff, well hidden from the forest below, but no one could suggest a way out—until a young girl named Aliquipiso came forward and asked to be heard.

Aliquipiso told them the Great Spirit had sent her a dream showing her how to save her people. She pointed out that the mountainside above the cliff was covered with large boulders and heavy, sharp rocks. She told them to collect as many of these as they could and then wait for her signal.

Awed by the girl's courage and wisdom, they did what she suggested. That night, Aliquipiso crept down from the cliff and into the forest by way of a secret path. As the day dawned, she wandered around the woods, pretending to be lost. It didn't take long for the Mingoe scouts to find her. They took her at once to their warrior chief who ordered the girl tied to a stake and tortured with fire until she told them where her people were hiding.

For hours, Aliquipiso refused to say a word to her tormentors. Then, at last, she pretended that the pain had become too much for her and agreed to lead them to the place where her people were hiding.

That night, hundreds of Mingoe warriors from all over the countryside gathered at the campsite. They bound Aliquipiso's hands behind her back and pushed her ahead of them to lead the way, threatening to kill her if she made one wrong move. Soundlessly, the warriors crept behind her as she led them through thickets and across streams, until they finally reached the foot of the towering cliff where the Oneida were hidden.

Nomadic and warlike, the buffalo-hunting peoples of the Plains have given the world its classic image of the traditional Native American way of life. Many Plains cultures believed in an all-powerful Great Spirit such as Wakan Tanka among the Lakota and Tirawa among the Pawnee.

"Come closer, Mingoe warriors," she whispered to them, "so you can all hear me. The Oneida are sleeping soundly right on that cliff above us, thinking they're safe. Gather around me and I'll tell you how to find the secret path that leads up to the cliff." As they crowded around Aliquipiso, she suddenly cried out, "Now, my people! They're here! Crush them!"

The Mingoe warriors had no time to flee the rocks and boulders that started raining down on them. It seemed as though the whole mountain had crumbled and buried them. So many Mingoe warriors died that night that those who

survived no longer had the heart to attack and pillage the Oneida. They returned to their own hunting grounds and never again made war on Aliquipiso's people.

As for the Oneida, they told the story of the girl's incredible courage and self-sacrifice forever after, handing the legend down from grandparent to grandchild for the rest of time. It is said the Great Spirit changed Aliquipiso's beautiful spirit into two sacred plants: her hair is now the healing woodbine, and her body the fragrant honeysuckle, which is known among the Oneida as the "blood of brave women."

The Hungry Hero
A Trickster Tale from the Northwest Pacific Coast

Raven stories play a popular role in many Northwest Pacific Coast cultures, especially among the Tlingit, Haida, and Tsimshian peoples. Raven is not only one of their principal cultural heroes, he's also an infamous trickster whose insatiable appetite often gets him into trouble. While it's true that tricksters everywhere tend to overeat, Raven outdoes them all, as can be seen in the following story about Raven and the fisherman.

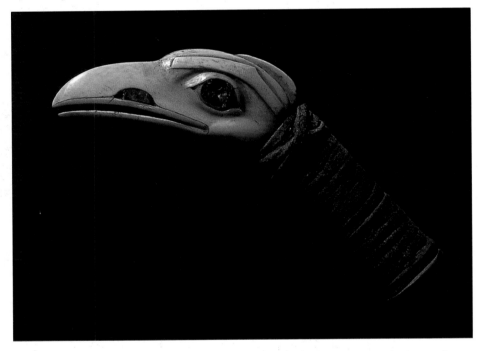

One day, just for fun, Raven stuck a red robin feather in his hair and then walked through the village. When the wife of one of the village fishermen saw him, she immediately decided she had to have a feather just like it for her own hair and asked him where she could get one. Raven remembered hearing that this woman was supposed to be the best cook in the village and his eyes lit up with mischief. He said he'd be happy to show her husband where there were lots of robin feathers.

The next day, Raven and the fisherman paddled out to a deserted, wooded island to hunt for robins. Actually, there were no robins on that island at all, but Raven tricked the fisherman into believing there were hundreds. While the fisherman was looking the other way, Raven took pieces of rotten wood and threw them up into the trees, putting a spell on them so that they changed into robins. Then Raven told the fisherman that the most beautiful robins lived on the center of the island and sent him deeper and deeper into the woods. Raven soon slipped away and raced back alone to the canoe.

Raven quickly paddled back to the mainland, where he turned himself into a large man with a face just like the fisherman's. He walked into the fisherman's cottage, where the fisherman's wife was preparing a big meal. She assumed it was her returning husband and placed his dinner on the table. Raven gulped down everything on his plate, then ate everything on hers, and then licked out the pots.

Just as he was finishing, the real fisherman returned home and was outraged to find Raven sitting at *his* table eating *his* dinner, especially since Raven had abandoned him out on that island and left him to swim home. On top of all that, when the fisherman threw down his soggy bagful of dead robins, the birds immediately changed back into a heap of rotten wood. That did it: he became so enraged that he chased Raven around the house until he caught him and clubbed him into insensibility. Then he threw the body into the ocean.

Before long, a hungry halibut came along and swallowed Raven's lifeless body whole. Once

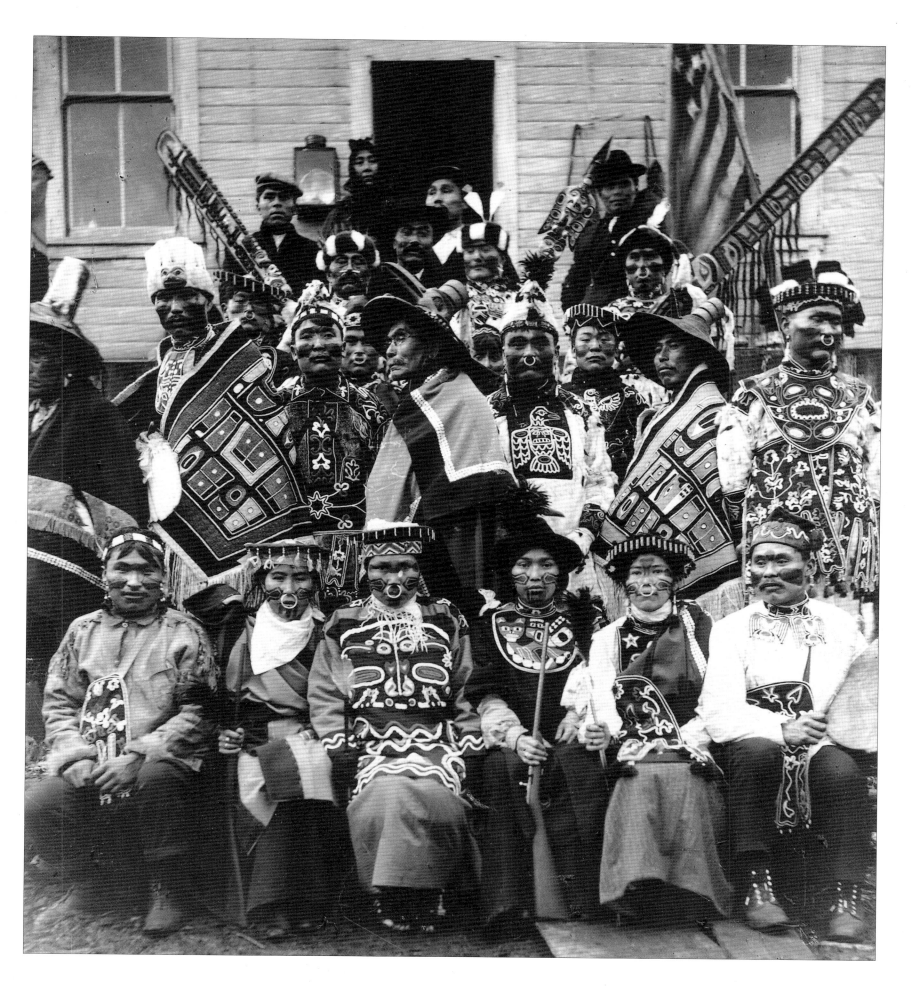

inside the big fish, however, Raven revived and changed himself back into his old bird shape and tickled the fish until it went crazy and swam up on the shore. A number of delighted fishermen grabbed the huge fish and began to cut it up for cooking. To their astonishment, when they cut open its belly, Raven burst out and started cawing madly. "If you don't leave with your families at once," he cried, "I'll destroy you all!" The fishermen were so frightened they ran home, gathered up their wives and children, and fled to another village. What Raven counted on, of course, was that they would leave their food supplies behind. They did.

Glooscap Fights the Water Monster
An Algonquian Tale from the Northeast

In the myths and legends of many Algonquian cultures, Glooscap (sometimes spelled Gluskap) is the first man, a cultural hero, a trickster, and a god all rolled into one. His amazing exploits include conquering a race of magic giants and matching wits with an evil race of sorcerers. He defeated Pamola, the wicked spirit of the night and destroyed hundreds of fiends, goblins, cannibals, and witches. It seems there was no greater hero on earth than the awe-inspiring Glooscap.

Legend has it that he still lives somewhere at the southern edge of the world. He never grows old and will never die, although sometimes he gets so tired of running the world and advising people how to live that he throws up his hands and says, "That's it. I'm tired of all this and I'm going to die now." With that, he paddles off in his magic white canoe and disappears into the clouds, but people know that he'll come back. Legend says that he always comes back—he doesn't have it in his heart to abandon us forever because he knows we can't live without him.

Glooscap created everything in the world with the welfare of human beings in mind, but sometimes his original creations needed a little adjusting. When he formed the first squirrel, for example, it was as big as a whale and started chewing up whole trees like they were nothing more than little acorns. The first beaver was as big as a mountain and dammed up so much water that it flooded the country from horizon to horizon. Even moose were so huge they flattened mountains as they walked. So Glooscap went around and gave these first creatures a gentle tap on the back of the head to make them shrink to a less destructive size, which is why they are the size they are today. But some animals, like the ugly toad, were made small for other reasons, as this story explains.

When Glooscap created the first village, he taught the people there about hunting, fishing, and raising children. He made sure the village had a spring that always flowed with pure, clear, cold water—that is, until the day when it mysteriously ran dry. It even stayed dry through the spring when the snows melted and the rains came. By summer, the village elders were very worried and sent a man north to find the source of the spring and why it had run dry.

The man walked for a long time, and when he finally reached the source, he trembled in fear at what he saw. A huge, disgusting monster was

sitting in a deep hole he had dug in the valley and in which he had damned up all of the spring's water. The monster was so gigantic that the top of his head disappeared in the clouds. The water around him stank with filth and poison, and the hideous monster sat in the middle of it, filling the whole valley and grinning from ear to ear, warts as big as mountains sticking out all over from his bloated body. The monster stared at the man with his dull, yellow protruding eyes and asked him what he wanted.

The man was terrified, but spoke up anyway and explained how his people were dying of thirst because the giant was hoarding all the water. In answer, the monster opened his mouth wide enough for the man to see the bits and pieces of all the many creatures he had recently killed stuck between his teeth. When he smacked his lips like a clap of thunder, the frightened man bolted and ran for home as fast as he could. He told his people in despair that there was nothing they could possibly do to get the monster to give up the water.

When Glooscap heard about all this, he knew he had to set things right and the only way to do that was to fight the monster himself. That took careful preparation. First he made himself twelve feet tall and painted his body blood red with bright yellow rings around his eyes. Then he added two huge clamshell earrings and a hundred black and white eagle feathers. For a weapon, he grabbed a nearby mountain and crushed it flat in his hand until it became a

deadly flint knife with a blade as sharp as a weasel's tooth.

Now he was ready. He twisted his mouth up into his worst snarl and summoned a cloud of thunder and lightning to encircle him as he stomped off to confront the deadly giant.

"Slimy lump of mud!" he cried. "You're wallowing in water that belongs to my people—and you're turning it into slime!" With that the two started fighting and the very mountains shook as they threw each other around. The earth split open and the forests burst into flames. Just as it looked as though the monster would swallow up Glooscap with his mile-wide mouth, Glooscap made himself taller than a mountain; while the monster was trying to figure out what to do next, Glooscap took the great flint knife he had made and used it to slit the monster's belly from top to bottom. So much water gushed from the monster's terrible wound that it formed a mighty river that tumbled and foamed down the mountains, past the villages, and out toward the sea.

As for the monster, Glooscap took what was left of him and squashed him in his palm until he squeezed him into a nasty-looking little toad. Then he took the slimiest part of the water and flung it with the toad off into another valley, creating the world's first swamp. It's said that the monster's relatives still live there to this day.

This ceremonial Iroquois rattle depicts Hino the Thunder Spirit, Guardian of the Sky.

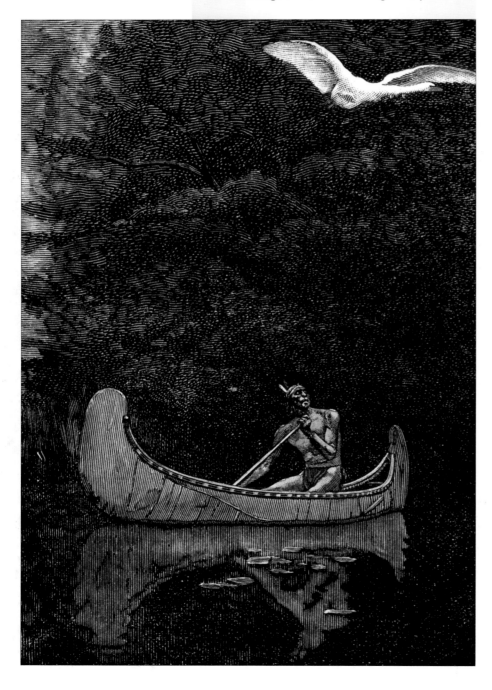

Native American myths reinforced a strong spiritual belief in the creative force present in all living and non-living things.

The Little People

One of the most vivid recurring themes in North American Indian mythology is a conflict between opposites: good versus evil, strong versus weak, and clever versus stupid, for example. In many hero stories, the conflict is often between large and small. And it's generally not the big strong guys who are the heroes. Instead, Indian cultural heroes are often elfin in size, ranging from about ten inches (25.4cm) to three feet (3.6m) in height. They are portrayed as highly intelligent and brave, and, whether human or magical, they perform remarkable deeds to help mankind. (Giants, on the other hand, are usually portrayed as the villains—strong but oafish, evil, and more than a bit stupid.)

The twin war gods in Pueblo mythology are dwarf-size, and so is the Naskapi cultural hero Djokábesh. Like many small heroes, *Djokábesh* is a monster-slayer whose numerous exploits include killing monster bears, man-eating fish, and fierce cannibal women. It's even said he snared the sun so as to teach it not to be so hot. The legends of the Yurok Indians of northern California tell of the *woge*, a race of little people so old and wise that they remember helping to save mankind during the first flood.

Even cultures who do not have dwarf heroes (like the Wabanaki, Mohawk, and Iroquois) have magical elves and fairies who live in caves or inside rocks and trees, and have the power to grant wishes to humans who befriend them. Not all the magical little people are alike, however. Some, like the *kiwalatamos'suk*, are said to have the gift of prophecy, while the *lumpegwonos'suk* live in water and brew a magic soup that's used to make people fall in love. It's also been said that they know how to make bread out of snow.

Some little people, like the *pukalutumush* of the Micmac, are just mischievous pranksters who love to play tricks on humans at night, like hiding household items and tying knots in their horses' manes.

White Buffalo Woman
A Lakota Sioux Legend

One summer many, many years ago, the seven councils of the Lakota nation came together to light a sacred council fire to discuss their plight: there was no game and their people were starving. Each day scouts went out hunting and each day they came home empty-handed.

One day, while two of the scouts were out searching for food, a strange mist suddenly floated up on a hillside ahead of them. As they got closer, the mist lifted and they saw a beautiful young maiden with long, raven-black hair and a tanned, buffalo skin outfit so purely white that it glowed. Her clothes were embroidered with sacred designs in radiant colors they had never seen before, and her dark eyes sparkled with great power.

It would have been obvious to almost anyone that this White Buffalo Woman was a *wakan*, a holy spirit, who had to be treated with great respect. But one of the two scouts saw only a beautiful woman whom he wanted to possess and reached out in his lust to touch her. He was instantly covered by a cloud of rattlesnakes who, in a matter of minutes, reduced him to a mere pile of bones.

The other scout, however, greeted the White Buffalo Woman with the awe and respect she deserved and was therefore entrusted with a message to bring back to his camp. The woman asked the young hunter to tell his chief to prepare the camp for her arrival by building a special medicine lodge with a sacred altar. She taught him the sacred prayers and rituals that his people needed to perform.

The Lakota people followed the instructions exactly, and four days later, the White Buffalo Woman approached the camp, carrying a bundle wrapped in buffalo skin which she presented to the chief. The holy thing it contained was the *chanupa*, the sacred pipe of the Buffalo Nation. She showed the chief how to hold the pipe by its stem and bowl and explained how the smoke from its fire was Tunkashila's breath, the living breath of Great-Grandfather Mystery.

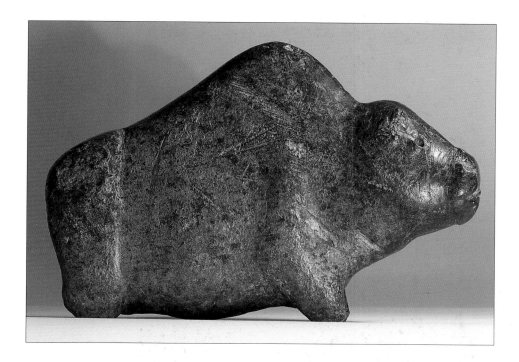

As long as the Lakota revered this pipe, she said, they would be a great nation. Then the White Buffalo Woman walked off in the same direction from which she came. Just before she disappeared over the horizon, she stopped, rolled over four times, and turned into a white buffalo calf. As soon as she vanished, great herds of buffalo appeared on the plains, allowing themselves to be killed so that the people could survive. And from that day on, the buffalo supplied the Lakota with everything they needed: meat for food, hides for clothing and shelter, and bones for tools.

The Plains Indians, who depended on the buffalo for food, shelter, and clothing, honored the spirit of the animal in many sacred myths and rituals.

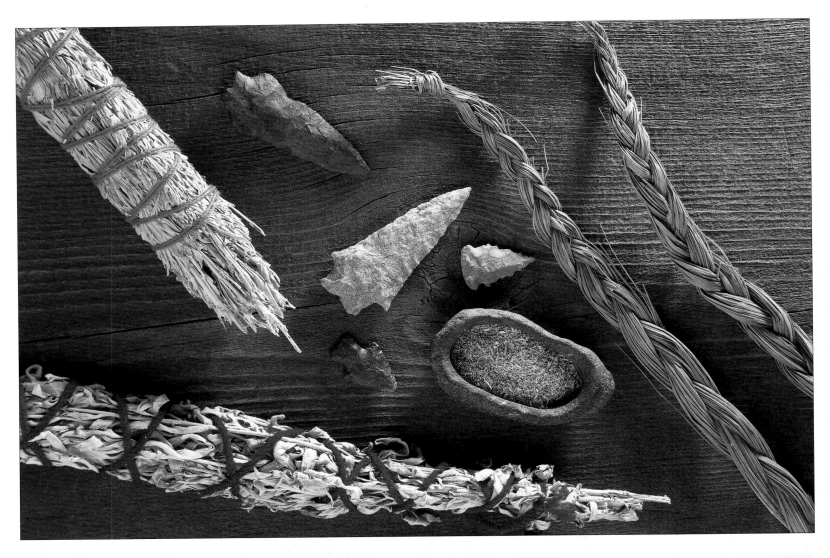

Hero Myths of the European Newcomers

The European settlers who started arriving in the mid-seventeenth century and the Africans they kidnapped and brought to North America as slaves had their folk heroes, too. Some, like Paul Bunyan, Pecos Bill, Rip van Winkle, and Brer Rabbit were purely tall tales—the inventions of storytellers—while others, like Johnny Appleseed, Mike Fink, Davey Crockett, and John Brown, were real-life heroes who were inflated into near superhumans with fabulous strength, courage, and endurance, heroes whose exploits and adventures often became exaggerated, romanticized legends.

One of the best-known heroes of the tall-tale variety is Paul Bunyan. It's said that Paul Bunyan was a gigantic lumberjack of such superhuman strength that just by swinging his great ax in a circle around him, he could chop down every tree within a one-mile (1.6km) radius. It took twelve boys with bacon fastened to their feet to grease his pancake griddle each morning. His constant companion and helper, Babe the Blue Ox, was so huge he could drink rivers dry and his shoes were so heavy that a blacksmith carrying just one sank knee-deep into solid rock at every step.

Pecos Bill, another purely mythological hero, was supposedly a legendary cowboy who was raised by coyotes and whose exploits include scooping out the Grand Canyon and putting fishhooks into his liquor to give it more kick. Rip van Winkle was a New England character who

got so drunk playing ninepins with a bunch of ghostly Catskill Dutchmen that he passed out and slept for twenty years while the world changed around him. Brer Rabbit was the trickster hero of a whole series of African-American animal fables told by the beloved mythical storyteller, Uncle Remus.

As for real-life mythological heroes, there really was an American pioneer who planted apple trees throughout Pennsylvania, Ohio, and Indiana, but Johnny Appleseed (as John Chapman came to be known) quickly became a larger-than-life character who was said to roam the countryside carrying his seed sack in one hand and his Bible in the other, wearing a coffee sack for a shirt and saucepan for a hat. In some stories, he not only spent his life flinging appleseeds throughout the countryside, his very steps forever changed the American landscape.

Mike Fink was a real fur trader and boatman along the Mississippi River who was forever getting himself in and out of dangerous adventures. The stories of his exploits and abilities were often greatly exaggerated, if not outright fictionalized. He was such a crack shot, supposedly, that he could drive a nail into wood with a bullet from a hundred yards (91.4m) away.

Another crack shot (and legendary figure) was Davey Crockett, ace frontier scout and Indian fighter, who became the romanticized hero of countless books, movies, and even a television series. John Brown was a true hero, a radical abolitionist and expert guerrilla fighter whose fierce fights against pro-slavery forces in the years before the Civil War helped make him a larger-than-life legend. After he was hanged in 1859 for his most famous exploits (the seizing of a government arsenal at Harper's Ferry) he became a hero and martyr to blacks and Northerners with anti-slavery sentiments. The true stories of John Brown's heroic deeds often became romanticized and exaggerated in the many stories and songs that were later written about him.

Wunzh and the Origin of Maize
An Ojibwa Hero Myth

Many historians believe the following story inspired parts of Longfellow's poem "Hiawatha."

A long time ago there was a poor man who lived with his wife and children in a very beautiful part of the country. This man was not just poor, however; he had so little knowledge about how to find food for his family that they often went hungry. But he was a kind man, nevertheless, and a person who always gave thanks to the Great Spirit for everything he and his family did receive. He taught his children to do the same.

The man's oldest son was named Wunzh, and when the boy turned fifteen, he became old enough to undertake the *Keiguishimowin*, the ritual fast which would determine what kind of spirit would be his guardian and spiritual guide throughout his life. His father built him a small lodge in a secluded spot, where he could be alone to meditate.

Wunzh spent the first two days rambling through the woods, wondering about all the plant life. He realized that there must be many plants his family could eat, but how could one tell which were good to eat and which were poi-

Weak from fasting, Wunzh suddenly saw an appariton descend from the sky and challenge him to a wrestling match.

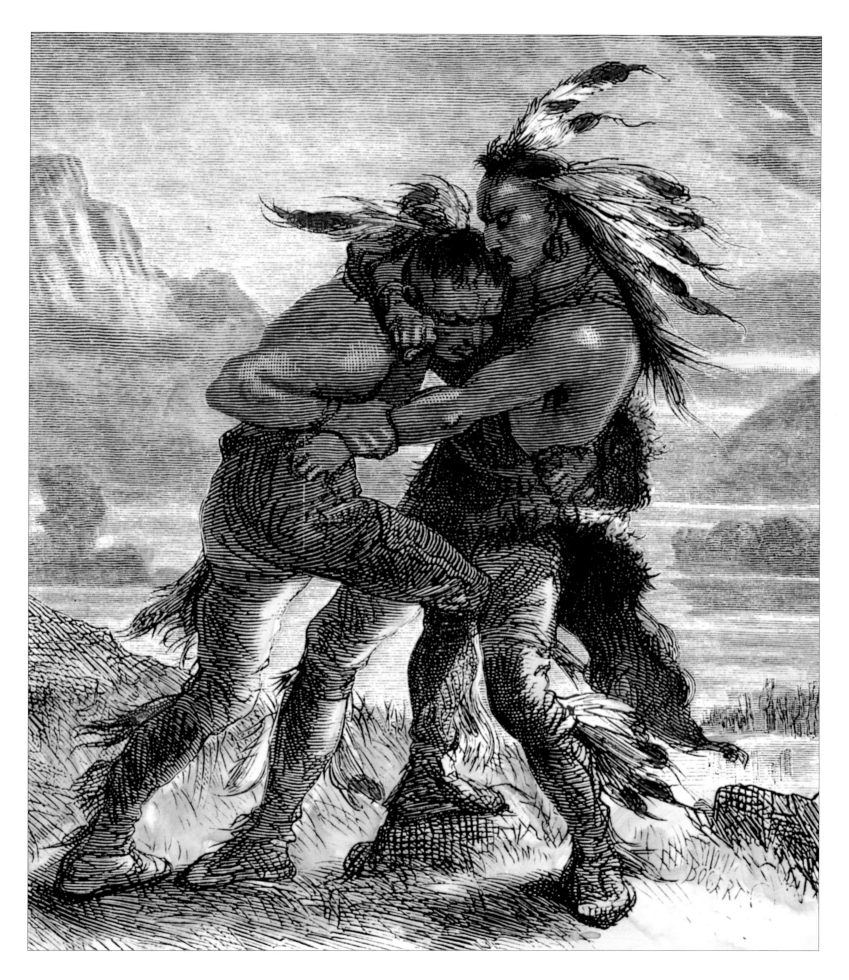

sonous? He realized that if a person could understand how plants grew, they could grow them instead of having to depend on foraging through the forests looking for them. During those first two days, he came to hope that his vision, when it arrived, would not be one that made him a great warrior or a healer or a hunter, but instead would show him an easier way than hunting and fishing to get food for his family.

By his third day of fasting, Wunzh felt so weak and faint that he stayed in the bed of leaves he had made for himself on the forest floor. Suddenly he saw an apparition coming toward him from the sky, a handsome youth dressed all in yellow with a magnificent plume of green feathers on his head. "I am sent by the Great Spirit to teach you how to help your people," the apparition said. "But even though you do not seek fame as a warrior, you must pass certain tests."

With that, the apparition challenged Wunzh to a wrestling match. Weak as the boy was, he did his best and they wrestled for a long time until he could hold out no longer. The next day the spirit returned and challenged Wunzh to another

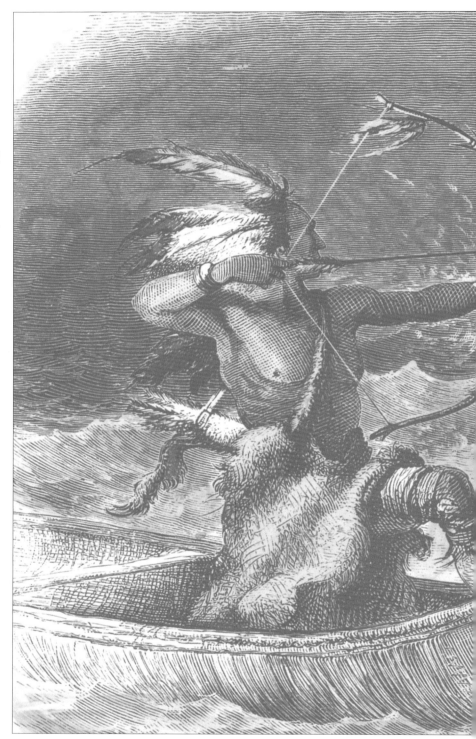

wrestling match, and although the boy was even weaker than he had been the day before, he courageously accepted the challenge and wrestled again until he was exhausted. The day after that was the same, except that when they finished, the spirit took Wunzh into the small lodge and told him that there was just one more test to pass before he could be rewarded with what he desired. This was to be the hardest test of all.

"Tomorrow," he told Wunzh, "we will wrestle one last time. This time you will win the match and kill me. When I am dead, you are to clean the roots and weeds off a sunny plot of earth, bury me there, and then leave. But you

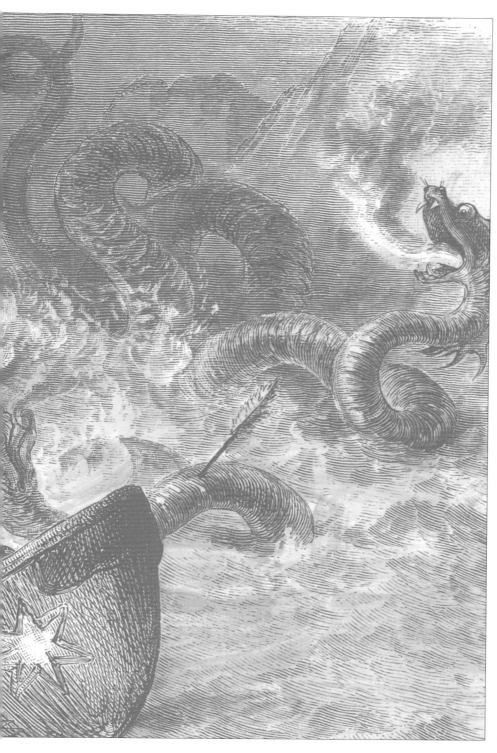

with food to bring him back from his vision quest. In the months that followed, he asked his son many times if he had had a vision, but Wunzh refused to tell a soul about what had happened to him. When he returned to tend the secluded grave, he always did so in secret, and even though he did not know what it was supposed to mean, he never lost faith.

One day when he got to the spot, he was amazed to see the green plumes of the spirit's headpiece coming up through the ground, and in the weeks that followed he watched with great delight as they grew into a tall, graceful plant with brightly colored silken hair and golden clusters on each side.

Finally understanding the great vision he had been given, Wunzh brought his father to see the magnificent plant, which he introduced as his dear friend Mondawmin (maize). Wunzh learned from his spirit friend how to pull the husks from the golden cobs, and how to grind, cook, and bake the kernels of maize. He learned how to plant some of the kernels and how to tend the growing plants until they brought forth corn-

Historians believe Longfellow based his poem Hiawatha *on the Ojibwa warrior hero Wunzh.*

must keep coming back to keep the grass and weeds from my grave and to see if I have returned to life. Under no circumstances are you to tell anyone, even your father, about this."

When the spirit returned the next day, Wunzh did everything he had been instructed to do. The next day, Wunzh's father showed up

cobs of their own.

That was how Wunzh's people received the gift of corn. Each year they held a special feast in honor of the Great Spirit who had shown them that they no longer had to rely on hunting for food. They gave special thanks to the Great Spirit for sending this vision to Wunzh.

Conclusion

Study the myths and legends of any culture in the world—past and present—and you'll find that the one common theme they all share are heroes who perform extraordinary feats of bravery and risk the hazards of fantastic journeys to benefit mankind.

As we've seen in the stories presented in this book, in most mythologies, ordinary humans are powerless against gods who see and use them as their playthings, as chess pieces to be moved, played and sacrificed as they see fit. Heroes defy the gods on behalf of mankind. They refuse to give in no matter what obstacles the gods put in their way. No matter how difficult, they perform all the tasks the gods put before them, and whether by bravery, trickery, endurance, or a simple refusal to submit to their fate, heroes impress the gods so much that the gods allow them to continue living. In some cultures, the hero even becomes a god or demigod himself.

These great heroes, whether in human shape or transformed into animals, meet fantastic people and creatures along their journey, often performing what are seen as great miracles or feats of power on the way to fulfill their quest. It's no wonder their adventures are told and retold for centuries, often long after the cultures themselves have grown and changed.

A noted scholar and popular mythologist named Joseph Campbell spent a lifetime studying and comparing the hero myths of different cultures. In his book, The Hero With a Thousand Faces, he states, "A legendary hero is usually the founder of something—the founder of a new age, the founder of a new religion, the founder of a

new city, the founder of a new way of life. In order to found something new, one has to leave the old and go in quest of the seed idea, a germinal idea that will have the potentiality of bringing forth that new thing."

Looking at the story of the hero's quest in mythologies from around the world, Campbell found great similarities. Look back at the hero stories in this book and you'll see that they follow a three-stage pattern: the hero's Departure, his Journey and his Return.

The hero departs from the everyday world of common people into a region of supernatural wonder, a world that is unfamiliar and strange to him. There is always a call to adventure in some form, some signal which calls the hero forth upon his journey, although the hero may not recognize the call or may even initially refuse it.

When he does finally accept the call, the hero ventures forward and passes through a gate that divides the world he has known into the world of his quest. Now his adventures have really begun. This journey is often represented in mythology as being upon a path over land, a voyage upon water, or a frightening descent into the Underworld. On this journey, the hero must often complete tasks, such as the feats of Hercules, or overcome great obstacles and fight monsters, as Glooskap did. The journey can also be in quest of a reunion with a beloved or of an object that can be brought back to heal or better society, such as the use of fire.

Some heroes like Coyote and Great Spider change shape on their adventures. Some have humorous exploits, like Maui or Qat when they use cunning to outwit the gods.

Although the journey is always a very personal one for the hero, his achievements must always be shared with his community wen he

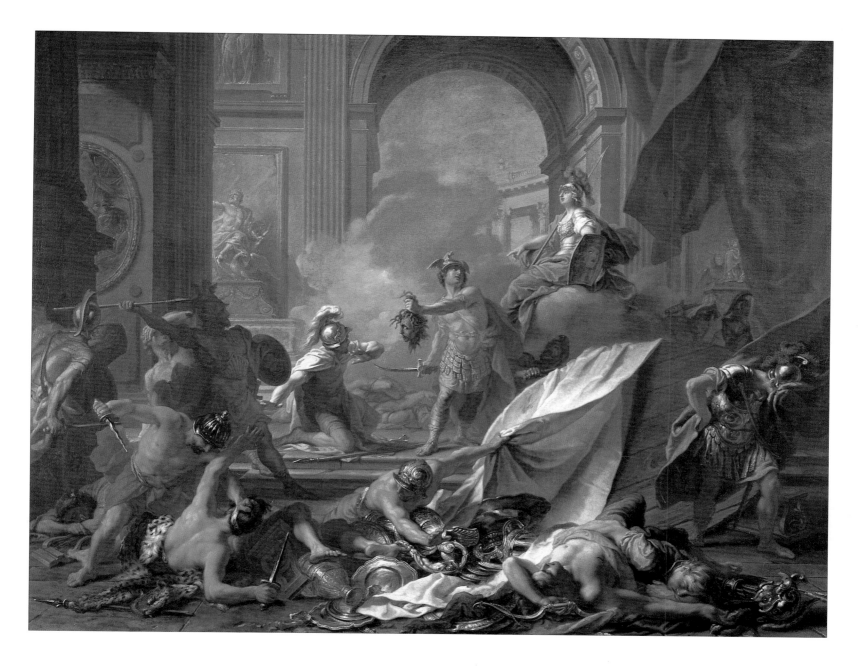

returns, as Maui did in Polynesia when he brought islands to the surface from the bottom of the sea and captured and harnessed the Sun. This stage is sometimes the hardest, however, because the hero's hard-won wisdom and achievements are often rejected by the very people they are meant to benefit.

Hero myths appeal to us on several different levels. First of all, they are often terrific adventure stories, filled with harrowing escapes, bloody battles, and buried treasure, in which the forces of good always triumph over evil. Second, on a deeper level, the hero's journey reflects our passage each of us has to experience to transcend to a higher spiritual level. And third, the hero's journey represents our collective growth as a community as well as the spiritual growth of mankind.

Whether personal or cosmic, the journey is always upon a razor's edge, that sharp and narrow line upon which a hero must walk in the quest for self-discovery. The more you read of the thousands of exotic hero legends from all the corners of the world and from all eras of history, the more you will understand how much alike we really are.

Perseus, like all great heroes, risked a fate worse than death when he set off to slash off the head of the hideous gorgon Medusa.

INDEX

A

Aborigines, 103, 106, *106*
Achilles, 29
Acrisius, (King of Argos), 30, 34
Aegeus (King), 34, 35, 36
Aethra, 34
Africa, 9, 9, 118–133
Aillen, 51
Aiwel Longar, 130–131
Ajax, 29
Akokoa, 125–126
Aladdin, 8, 24–27
Alcavilu, 147–150
"Ali Baba and the Forty Thieves," 20, 21
Aliquipiso, 156–157
Amaterasu, 101
Amazons, 39
Anansi, 120–122
Andromeda, 30, *31*, 33, 34
Andvari, 75, 76, 79, 81
Anglo-Saxons, 45, 64
Annallja Tu Bari, 126, 128–129
Aonbharr, 52, 53
Aphrodite, 42, 43
Arabia, 18
Arabian Nights, 9
Argonauts, 40, 41
Argos, 30, 34, 37
Ariadne, 35, 36
Artemis, 40
Arthur, King, 8, 45, 59, *59*, 60–61, *60–61*
Asia, 84–101
Atalanta, 40, 41, *41*, 42, *42–43*, 43
Athena, 29, 32, 39
Atlas, 32–33, 39
Atli, *80*, 82
Augean stables, 37
Australia, 102–117

B

Balder, 70
Beowulf, 8, 9, 45, 64–65
Bikramajit, 91
Blue Falcon, 54, 55, 57
The Book of Ballymote, 46
The Book of Leinster, 46
The Book of the Dean of Lismore, 46
The Book of the Dun Cow, 46
Borghild, 74, 75
Botoque, 151
Bran, 51, 52
Branstock, 68, 69
Brer Rabbit, 119, 164, 166
Britain, 44–65
Brünnhilde, 83
Brynhild, 8, 78, 81
Bull of Heaven, 17

C

Cailleach Bheare, 53
Calydonian boar, 41
Camelot, 59
Cannibalism, 12, 15
Cap of Darkness, 32
Celts, 45, 53, 61
Centaurs, 36
Cepheus, (King of Phoenicia), 33
Cerberus, 37, *37*
Cerynita, 37
Chaos, 101
Ch'ih Pi, 92–94
China, 92–96
Chiron, 36
Chumong, 88
Cleomedes of Astypalia, 8
Comari, 23

Conan, 52
Conn Ceadchathach, 51
Coyote, 154–156
Creon (King of Thebes), 37
Cretan bull, 39
Crete, 35
Cuchulain, 53
Cults, 11

D

Daedalus, 35
DalnAraidhe, 51
Danaë, 30
Debauchery, 9, 15, 17
Deianeira, 38, 39
Delphic oracle, 37
Demons, 11, 96, *96*
Deucalion (King), 92
Dinarzade, 18, 20, 21
Diomedian horses, 39
Dionysus, 36
Dragons, 34, 53, 85, 86, 88
Dreamtime, 103, 106, 107
Dwarves, 21, 70, 75, 83, 96, 138

E

Eddas, 67, 77, *77*
Egypt, 10–15
El Dorado, 146
Elves, 50, 70
Elylimil, 75
Enkidu, 16, 17
Epic of Gilgamesh, 9
Erythia, 39
Erytion, 41
Eurytheus (King of Argos), 37, 39
Excalibur, 59

Q

Qat, 112–113
Quetzalcoatl, 136–140

R

Ra, 12
Ragnarok, 70
Raven, 9, 158–160
Regin, 76, 78
Reidmar, 76
Rerir, 68
Rhiannon, 57, 58, 58
River Earl, 86–88
Robin Hood, 62, 63
Runes, 75, 78, 79, 79

S

Salmon of Knowledge, 49, 51
Samba Gana, 126, 128–129
Sasabonsam, 125–126
Scandinavia, 66–83
Sceolaing, 51
Schahriar, 18, 18, 20, 21
Scheherazade, 18, 18, 20, 21
Scorpion Man, 11
Scotland, 45, 53–57
Seriphus, 30, 32, 34
Serpents, 17, 32, 76, 78, 103, 108, 128
Set, 12, 14, 15
Shape-shifters, 9
Shimatsuhiko, 100
Shinbenkidokushu, 98, 99
Shuten Doji, 97, 99, 100
Siegfried, 76, 78, 83
Siggeir, 68, 69, 73
Sigi, 68

Sigmund, 8, 68, 69, 73, 74, 75
Signy, 68, 69, 73
Sigridrifa, 78
Sigrun, 74
Sigurd, 69, 75, 78, 81, 81
Sinbad the Sailor, 21, 21, 22, 23, 23
Sinfjotli, 73, 74, 75
Skalds, 67
Slave of the Ring, 25
Sleipnir, 68, 68, 70
Sorcerers, 34, 69
South America, 9
Spider Woman, 9
Stymphalian birds, 39
Sumeria, 11

T

Taboos, 9
Takehayasusanowo, 101
Tengu, 96
Tezcatlipoca, 137, 138
Thebes, 37
Theseus, 8, 34, 35, 35, 36, 36
Thor, 70, 71
Thousand and One Nights, 18–27
Titans, 32
Tongmyûng (King), 88
Troezen, 34
Tuna the Eel, 104, 109
Tunua-nui, 110
Twelve Books of Poetry, 46
Twins, 129, 132, 140–144

U

Uime, 51
Uncle Remus, 119, 166

Underworld, 15, 37, 39, 85
Uruk, 15, 16, 17

V

Valhalla, 68, 70, 83
Valkyries, 68, 78, 79, 83
Volsung, 67, 68–82, 83

W

Wales, 45, 57–61
Waters of Death, 17
Wawalak Sisters, 103, 107–108
Wen Zhong, 92
White Buffalo Woman, 163
Wildflower, 86–88
William the Conqueror, 45
Wotan, 70, 83
Wunzh, 166, 167, 168–169

Y

The Yellow Book of Lecan, 46
Yellow Filly, 55, 57
Yin and Yang, 93, 101
Yorimitsu, 98
Yurlunggur, 106, 107, 108
Yü the Great, 92

Z

Zeus, 8, 29, 30, 32, 36, 92

PHOTOGRAPHY CREDITS

AKG Photos: pp. 69, 76, 77, 78, 79, 80, 81, 82, 83, 142, 144, 151

American Museum of Natural History/Courtesy Department Library Services: Neg# 328740: p. 159

Art Resource, NY: pp. 15, 59, 90, 97; Bridgeman: pp. 8, 19, 22, 26, 98-99; Giraudon: pp. 13, 16, 36, 47, 89, 94, 171; Erich Lessing: pp. 2, 31, 32-33, 35, 37, 38, 53, 54, 93; Nimatallah: p. 14; The Pierpont Morgan Library: p. 60-61; Scala: p. 6, 25, 42-43; SEF: pp. 41, 88, 105; Aldo Tutino: p. 132; Werner Forman Archive: pp. 70, 72, 73, 74, 95, 96, 109, 110, 112, 120, 138, 158, 163

©Deborah Bernhardt: pp. 49, 52

©Richard Todd Photography: pp. 121 (The Dumonstein Collection), 122 (The Baker Collection), 124 (The Walt Disney-Tishman Collection of African Art), 125, 129, 133 (Stanoff Collection)

E.T. Archive: pp. 71, 75, 100, 136, 137, 139, 140, 141, 145, 146, 148

FPG International: ©Gerald French: p. 162; ©Richard Harrington: p. 128; ©Spencer Jones: p. 164; ©Alan Kearney: p. 147; ©Robert Pastner: p. 126

©Lois Ellen Frank: p. 154

©Jason Laure: pp. 9, 123

Leo de Wys, Inc.: ©J. Aigner: p. 149; ©Leo de Wys/Sipa/Garrigues: p. 127; ©J. Dressel: p. 107; ©Richard Saunders: p. 130

North Wind Picture Archive: pp. 18, 20, 21, 23, 46, 51, 62, 63, 64, 86, 87, 108, 111, 113, 131, 150, 155, 157, 160, 161, 162, 167, 168

Sienna Art Works/©Michael Friedman Publishing Group: pp. 55, 56, 58

Superstock: pp. 48, 106, 114-115, 117; Christie's Images: p. 50

BIBLIOGRAPHY

Alpers, Anthony. *Legends of the South Seas*. New York: Thomas Y. Crowell Company, 1970.

———. *Maori Myths & Tribal Legends*. Boston: Houghton Mifflin, 1966.

Barlow, Genevieve. *Latin American Tales: From the Pampas to the Pyramids of Mexico*. Chicago: Rand McNally & Company, 1966.

Berry, Jack, transl. *West African Folktales*. Evanston, IL: Nothwestern University Press, 1991.

Bierhorst, John. *The Mythology of Mexico and Central America*. New York: William Morrow & Company, 1990.

———. *The Mythology of North America*. New York: William Morrow and Company, 1985.

Birrell, Anne. *Chinese Mythology: An Introduction*. Baltimore: The Johns Hopkins University Press, 1993.

Bullfinch, Thomas. *Bullfinch's Mythology*. Modern Library, 1993.

Burland, Cottie. *North American Indian Mythology*. New York: Tudor Publishing, 1965.

Campbell, Joseph. *Historical Atlas of World Mythology*. Vol. II. New York: Harper & Row, 1989.

Courlander, Harold. *A Treasury of African Folklore*. New York: Crown Publishers, 1975.

Davidson, Hilda. *Gods and Myths of Northern Europe*. Baltimore: Penguin Books, 1964.

Erdoes, Richard, ed. *American Indian Myths and Legends*. New York: Pantheon Books, 1984.

Goodrich, Norma Lorre. *Myths of the Hero*. New York: Orion Press, 1962.

Gray, John. *Library of the World's Myths and Legends: Near Easten Mythology*. New York: Peter Bedrick Books, 1969.

Grimal, Pierre, ed. *Larousse World Mythology*. London: Paul Hamlyn Press, 1965.

Hackin, J., and Clement Huart, et. al. *Asiatic Mythology*. New York: Thomas Y. Crowell Publishers, 1963.

Hinnels, John R. *Library of the World's Myths and Legends: Persian Mythology*. New York: Peter Bedrick Books, 1985.

Horowitz, Anthony. *Myths and Legends*. New York: Kingfisher Books, 1994.

Ions, Veronica. *Indian Mythology*. London: Paul Hamlyn Press, 1967.

Leeming, David Adams. *Mythology: The Voyage of the Hero*. New York: Harper & Row Publishers, 1981.

Munch, P.A. *Norse Mythology: Legends of the Gods and Heroes*. Translated by Sigurd Bernhard Hustvedt. New York: AMS Press, 1970.

Nicholson, Irene. *Mexican and Central American Mythology*. London: Paul Hamlyn Publishers, 1967.

Osbourne, Harold. *South American Mythology*. London: Paul Hamlyn Publishers, 1968.

Parrinder, Geoffrey. *African Mythology*. London: Paul Hamlyn Publishers, 1967.

Patrick, Richard. *All Color Book of Egyptian Mythology*. New York: Crescent Books, 1972.

Poignant, Roslyn. *Oceanic Mythology, The Myths of Polynesia, Micronesia, Melanesia, Australia*. London: Paul Hamlyn Publishers, 1967.

Reed, A.W. *Maori Legends*. David & Charles Publishers, Ltd., 1972.

Roughsey, Dick. *The Rainbow Serpent*. Milwaukee: Gareth Stevens Publishing, 1988.

Rugoff, Milton, ed. *A Harvest of World Folk Tales*. New York, The Viking Press, 1969.

Smyth, Daragh. *A Guide to Irish Mythology*. Dublin, Ireland: Irish Academic Press, 1988.

Willis, Roy ed. *World Mythology*. New York: Henry Holt & Company, 1993.

Yolen, Jane, ed. *Favorite Folktales from Around the World*. New York: Pantheon Books, 1986.